THE

ACTOR'S

IMAGE

Print Makers
of the Katsukawa School

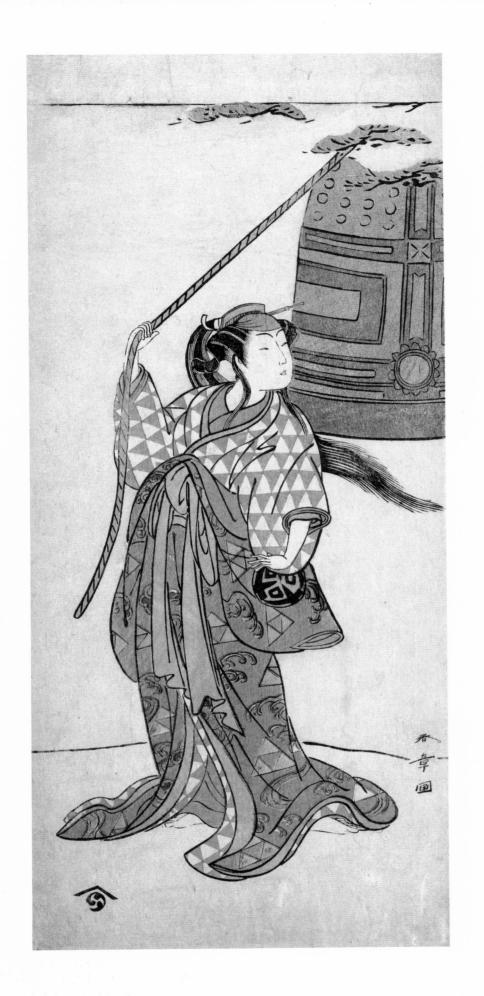

The Actor's Image

Print Makers of the Katsukawa School

TIMOTHY T. CLARK

and OSAMU UEDA

with DONALD JENKINS

NAOMI NOBLE RICHARD, Editor

THE ART INSTITUTE OF CHICAGO

in association with PRINCETON UNIVERSITY PRESS

This book was made possible by generous grants from
The Japan Foundation,
The Kajima Foundation for the Arts, and
The National Endowment for the Arts,
as well as the continuing support of the
Kate S. Buckingham Endowment Fund.

Executive Director of Publications: Susan F. Rossen

Associate Director of Publications/Production: Katherine Houck Fredrickson

Production Assistant: Manine Rosa Golden

Editorial Secretary: Cris Ligenza

Managing Editor: Terry Ann R. Neff, Wilmette, Illinois

Designer: Greer Allen, New Haven, Connecticut

Typography: Paul Baker Typography, Inc., Evanston, Illinois

Printing: Nissha Printing Company, Ltd., Japan

Actors' mon by Anne Kitagawa, Chicago

Calligraphy by Fumiko E. Cranston, Cambridge, Massachusetts

Photography credits: Unless otherwise indicated in the captions,
all illustrations were produced
by the Department of Imaging and Technical Services,
Alan Newman, Executive Director.

Cover: Katsukawa Shunshō.
The actor Ichikawa Danjūro IV in a "Shibaraku" role (No. 35)

Frontispiece: Katsukawa Shunshō.
The actor Arashi Hinaji I dancing "Musume Dōjō-ji" (No. 62)

Library of Congress Cataloging-in-Publication Data

Clark, Timothy T. (Timothy Thornburn), 1959–
 The actor's image: print makers of the Katsukawa School / by Timothy
T. Clark and Osamu Ueda, with Donald Jenkins; Naomi Noble Richard,
editor.
 p. cm.
 Includes bibliographical references and index.
 ISBN 0-86559-097-4: $125.00
 1. Katsukawa School—Catalogs. 2. Color prints, Japanese—Edo
period, 1600–1868—Catalogs. 3. Ukiyoe—Catalogs. 4. Kabuki in
art—Catalogs. 5. Actors—Japan—Biography. 6. Printmakers—
Japan—Biography. I. Ueda, Osamu. II. Jenkins, Donald.
III. Richard, Naomi Noble. IV. Title.
NE1321.85.K38C53 1994
769.952—dc20 93-6382
 CIP

PRINTED IN JAPAN

Table of Contents

Foreword

In eighteenth- and early nineteenth-century Japan, artists of the Katsukawa school, named for its founder and most prolific member, Katsukawa Shunshō (1726–1792), produced a great number of woodblock prints celebrating the theater world, and especially featuring portraits of Kabuki actors. Although actor prints were being made prior to Shunshō's time, it was the Katsukawa artists who first rendered the actors not as types but as recognizable individuals with distinctive personalities. The Katsukawa artists also enhanced the visual impact of actor prints by expert use of full-color printing techniques developed in the mid-eighteenth century.

In their high quality and complexity of conception, Katsukawa prints suggest the important cultural role of Kabuki theater. Popular theater and print making were two means through which a newly emergent merchant class learned of Japan's classical heritage. Because amusement frequently took precedent over historical accuracy, narratives were conflated and legends adapted to the demands of theatrical formulas.

The complex relationship between dramatic articulation and the printed format is the underlying theme of *The Actor's Image: Print Makers of the Katsukawa School.* An essay by Donald Jenkins discusses the artists of the Katsukawa school, their styles, and the types of prints they created. A second essay, by Timothy T. Clark, employs aficionados' diaries, theater playbills and handbills, popular fiction, and other contemporary accounts to depict the "Kabuki scene" of the 1780s and to chronicle a particular production of one exceedingly popular play. In addition, 136 prints are presented in color and analyzed in detail by Mr. Clark. A catalogue reproducing and giving specific data for 740 of the prints, along with biographies of the actors and the print makers, constitutes the second part of the volume. Much of this information is based on nearly twenty years of research conducted by Osamu Ueda, Keeper of the Buckingham Print Collection at The Art Institute of Chicago from 1971 to 1990. His determination of the dating and subject for the actor prints was based on careful studies of eighteenth-century theater playbills now housed in European, American, and Japanese archives.

The Buckingham Collection is named in honor of Clarence E. Buckingham, a prominent Chicagoan who assembled an exemplary collection of Japanese prints that was first shown at the Art Institute in 1908 as a major component of an exhibition organized and designed by a fellow collector, the architect Frank Lloyd Wright. Wright had a particular affinity for actor prints and at one time had the definitive collection of Katsukawa school *hoso-e* woodcuts, numbering, he states in his autobiography, over eleven hundred. After Mr. Buckingham's death in 1913, his sister Kate Sturges Buckingham, in consultation with Frederick Gookin, Curator of Oriental Art at the Art Institute, continued to make important additions to the collection. In 1925, when she donated approximately two thousand prints to the Art Institute, she also endowed the collection, making possible future conservation, acquisition, and research.

A systematic publication program for the Buckingham Collection was initiated in 1955 with *The Clarence Buckingham Collection of Japanese Prints, Vol. I, The Primitives,* by Helen Gunsaulus. Volume II, subtitled *Harunobu, Koryusai, Shigemasa, Their Followers and Contemporaries,* by Margaret Gentles, was published in 1965. Although Mr. Ueda's research was originally intended for a third volume in the series, the long hiatus and radically different format establish this book as an independent entity. It is a great pleasure to bring to realization the dedicated and painstaking labor of Mr. Ueda and the analytic insights of Mr. Jenkins and especially Mr. Clark, who wrote the entries as well as a ground-breaking essay, and who provided invaluable assistance to Naomi Noble Richard in her editing of the book.

JAMES N. WOOD
Director

Acknowledgments

It was in 1987, while I was a graduate student in Tokyo, that James N. Wood, Director of The Art Institute of Chicago, and his Curator of Asian Art, Yutaka Mino, first approached me to assist in preparing volume three of the catalogue of the Clarence Buckingham Collection of Japanese Prints. I thank them for placing their faith in one completely unproven at that time.

Osamu Ueda, former Keeper of the Buckingham Collection, authored a catalogue of the Katsukawa school prints in the Art Institute's famed Buckingham Collection of Japanese Prints that is the result of many years of painstaking research into Kabuki and *ukiyo-e* history. I am honored to have been permitted to assist him in shedding light on an aspect of *ukiyo-e* hitherto largely uncharted: the dating of Katsukawa school actor prints.

My editor, Naomi Noble Richard, brought her sharp eye and friendly, but implacable, rigor to bear on ambiguities and imprecisions, gaps in information, and infelicities of expression. The volume's authors and readers are equally in her debt. James Ulak, Associate Curator of Japanese Art at the Art Institute, assisted by Mary Albert, answered myriad questions about the prints; his expert knowledge of Japanese and of Japanese prints provided many a timely rescue.

The entire Publications Department of the museum, under Executive Director Susan F. Rossen, provided sterling support in orchestrating the production of this most complex book. I should particularly like to thank Associate Director of Publications/Production Katherine H. Fredrickson and her assistant, Manine Golden, for the monumental efforts required of them to bring the project to completion as well as for the enthusiasm and talents they brought to bear on the project. Editorial Secretary Cris Ligenza's daunting task was not only to type, and retype, all of the manuscript but to help to obtain obscure photographs and to keep track of all of the pieces. My thanks go to Managing Editor Terry Ann R. Neff, who was engaged to expedite the production process. Without her considerable organizational abilities and common sense the manuscript might never have emerged as a book.

I am grateful to Fumiko E. Cranston of Harvard University, who brought her great knowledge of Japanese art and her superb calligraphy to the task of reproducing the print designers' signatures; and to Anne Kitagawa, doctoral candidate in Japanese art, assisted by Elinor Pearlstein, Associate Curator of Chinese Art, for checking endless details and supplying the actors' *mon*. In Greer Allen, the book was blessed with a designer of great ability and long experience who also delights in Japanese prints. And I wish to thank Elizabeth Powers, Art Acquisitions Editor at Princeton University Press, for her support.

Finally, I should like to acknowledge certain individuals who have been particularly helpful in securing photographs for us: Watanabe Tadasu and his son Watanabe Shoichiro, Asano Shugo, Naito Masato, Miyazaki Shuta, and Kasuya Hiroki. And I join with Osamu Ueda in thanking the many institutions and individuals cited by him for their kind cooperation in this work.

TIMOTHY T. CLARK

I am honored to have been granted the privilege to work on the third volume of the Clarence Buckingham Collection of Japanese Prints. Concentrating on The Art Institute of Chicago's extraordinary collection of actor prints from the Katsukawa school, this book continues the chronological sequence established in the previous two volumes (*The Clarence Buckingham Collection of Japanese Prints, Vol. I, The Primitives*, published in 1955 and *Vol. II*, subtitled *Harunobu, Koryusai, Shigemasa, Their Followers and Contemporaries*, published in 1965) by my predecessors, former Curators Helen C. Gunsaulus and Margaret O. Gentles, respectively.

The identification of actor prints requires extensive research into Kabuki playbills and programs issued at the time of performance, and these are scattered in numerous institutions around the world. Of the 740 actor prints represented in this volume, over 250 could be dated by reference to such original performance records. Other reference materials served to identify most of the remaining prints. I hope that my work will benefit scholars, students, collectors, and other lovers of Japanese actor prints and the history of Japanese theater.

In the decade-plus that I devoted to my work for this volume, I became indebted to many more people than I can name here. First, I would like to express my deep appreciation to James N. Wood, Director and President of The Art Institute of Chicago, for his support of me and my research. My former and longtime research assistant, Louise Virgin, was invaluable: her great love for and knowledge of Japanese art, facility for languages, and many useful suggestions were indispensable. At the Art Institute, my manuscript was reviewed in part by former Curator Jack V. Sewell, Education Department Lecturer George Schneider, and Suzanne Sparagana.

I am deeply grateful to the late Adachi Toyohisa and to Professor Suzuki Juzo for their advice on technical questions and problems. I should like to thank the following print connoisseurs and collectors: Dr. Money Hickman, Jack Hillier, Professor H.R.W. Kühne, George Mann, and Mr. and Mrs. Watanabe Tadasu. Professors Tsuchida Makoto and Matsudaira Susumu were critical in helping me to obtain Kabuki documents and pertinent information. Adachi Isamu and Nakayama Yoshiaki of the Adachi Institute of Woodblock Prints kindly spent many hours helping me to locate photographs and rare reference books. Editorial staff members of the Shogakukan Publishing Company also provided valuable information on *ukiyo-e* collections around the world.

My sincere thanks go to the following museums, libraries, and private collectors who supplied me with various photographs, photostats of prints and playbills and programs, and other reference material: Amstutz collection, Mannedorf, Switzerland; Aoki Tetsuo collection, Tokyo; The Art Institute of Chicago; Arthur M. Sackler Museum, Harvard University Art Museum, Cambridge, Massachusetts; Ashmolean Museum of Arts and Archaeology, Oxford, England; Bauer collection, Geneva; The British Museum, London; The British Library, London; Chester Beatty Library, Dublin; Fitzwilliam Museum, Cambridge, England; Freer Gallery of Art, Smithsonian Institution, Washington, D.C.; Irma E. Grabhorn-Leisinger collection, San Francisco; Hibiya Library, Tokyo; Honolulu Academy of Arts; Ikeda Bunko Library; Japan Ukiyo-e Museum, Matsumoto; Keio University Library, Tokyo; Kyoto University Japanese Literature Study Library; H.W.R. Kühne collection, Basel, Switzerland; Matsuura Historical Museum, Nagasaki-ken; The Metropolitan Museum of Art, New York; Museum für Ostasiatische Kunst, Berlin; Museum of Fine Arts, Boston; National Diet Library, Tokyo; The Nelson-Atkins Museum of Art, Kansas City, Missouri; Nihon University Library; Nippon University Library; Osaka Women's College Library; Ota Memorial Museum, Tokyo; Riccar Art Museum, Tokyo; Royal Ontario Museum, Toronto; Succo collection; Tenri University Library, Tenri City, Japan; Tokyo Metropolitan Central Library (Kaga Bunko); Tokyo National Museum; Tokyo University Library; Toyo Bunko Library, Tokyo; The Tsubouchi Memorial Theater Museum, Waseda University, Tokyo; Tsuchida Makoto collection; Watanabe Tadasu collection, Tokyo.

OSAMU UEDA

Actor Prints:
Shunshō, Bunchō, and the Katsukawa School

DONALD JENKINS

The Two Poles of the Floating World

Among the many entertainment districts that flourished in eighteenth-century Edo, two enjoyed a prestige that set them apart from the rest. One was the theater district in and around Sakai Street, in the crowded heart of the city less than half a kilometer from the fish market at Nihombashi. The other was the Yoshiwara, the so-called licensed prostitution district, more than five kilometers to the north, surrounded by rice paddies at the very outskirts of the city. What distinguished these two districts was not so much their popularity— though they certainly attracted their full share of pleasure seekers— as what they symbolized. By the late seventeenth century these two districts had become closely associated with the "floating world." By the early eighteenth century they virtually represented that world.

The "floating world" was an urban phenomenon, appearing first in the seventeenth century and continuing to flourish in Japan's cities till the end of the Edo period. The term refers to a way of life avowedly hedonistic, centered around the houses of pleasure, theaters, restaurants, teahouses, and wine shops— establishments accessible to money and indifferent to rank. Repudiating equally the duty-bound, puritanic Confucian ethic championed by the shogunal establishment and the rarefied aesthetics of the courtly tradition, the floating world instead idealized fashion, chic, and urbanity. In its beginnings, at least, it was a mode of life adopted primarily by the *chōnin*— that is, urban merchants, craftsmen, and tradespeople— who found in the floating world outlets for expression that were unavailable to them elsewhere within the rigid confines of Edo-period society.

In that society the *chōnin* occupied an anomalous position. Officially, they were at the very bottom of a social hierarchy in which economic success was *not* a key to social advancement. Neither rank nor government position were available to the successful *chōnin*. But *chōnin* constituted a large and growing proportion of the population, and many of them also enjoyed considerable wealth. Already in the seventeenth century money had begun to replace rice as the primary unit of exchange, a development that favored merchants over samurai, whose stipends were paid in rice. This trend not only continued but accelerated, so that by the middle of the next century,

many samurai found themselves at a distinct economic disadvantage vis-à-vis their *chōnin* contemporaries. Some impecunious samurai even chose to give up their status and become, in effect, *chōnin* themselves. Regardless of these realities, the thrust of official policy throughout the Edo period was to keep the *chōnin* in their theoretical place.

Yet much as the regime might try to curtail what it considered unseemly displays of *chōnin* wealth or spirit, it proved unable to suppress the growing economic power of this class or to extinguish the arts and entertainments with which it regaled its leisure. Harassing regulations and sumptuary laws were repeatedly enacted and sporadically enforced but more often deftly evaded. And though the theaters and the licensed quarters were subjected to all kinds of restrictions, their existence seems never to have been called into question.

One might characterize the theater district and the Yoshiwara as the "two poles of the floating world." The metaphor is not as farfetched as it might seem. In many respects each of the two districts was a world unto itself, with its own standards, its own rituals, even, to some extent, its own patois (this latter was particularly true of the Yoshiwara). Yet the two districts also had much in common. Each exerted a most compelling attraction on its habitués, through its ability to substitute its own social reality for the more onerous, more restrictive version that prevailed outside, and the habitués of one were for the most part also devotees of the other. Each had its "stars"— popular actors in the one, celebrated courtesans in the other— whose qualifications were "assessed" (when not touted) in periodic publications called *hyō-banki*. Each was at the center of a complex web of supporting activities and services provided by, among others, teahouses and publishers. Finally, and most significantly from our point of view, each provided— and to almost equal degrees— the bulk of the subject matter in Japanese prints.

This may surprise many Westerners, for whom the mention of Japanese prints evokes Hokusai's *Great Wave* and Hiroshige's *Cloudburst at Shōno*. Yet landscapes constitute only a small proportion of the hundreds of thousands of Japanese prints that were produced during the Edo period (1615–1868). Landscape prints as we know them hardly existed during the eighteenth century, and even during their peak of popularity, from 1830 on, they were

outnumbered by prints of Kabuki actors and beautiful women.

It has been estimated that one third to one half of all the prints published during the Edo period depicted Kabuki actors. So large was the market for such prints that whole schools of artists specialized in designing them. The Torii school, which virtually monopolized the actor-print field through the 1750s, was one of these. The Katsukawa school, which is the subject of this essay, was another.

Actor Prints

Today most Westerners (and even many Japanese) hardly know what to make of actor prints— which is scarcely surprising. Being thoroughly unfamiliar with the theatrical experience represented, how could they find pictures of (apparently gratuitously) scowling and posturing actors anything but boring or even grotesque? Nor is unfamiliarity with the plots or the stage conventions of Kabuki the only obstacle to an appreciation of actor prints. All too often, prints that were designed as parts of a diptych or triptych have become separated. Though the isolated images that result often remain visually satisfying, without the information provided by the adjoining designs we can never be sure what the looks and gestures really mean. It is hard to interpret them without knowing what stimulated them or what they are directed at.

So far we have been rather loosely using the terms "Japanese prints" and "actor prints." For the sake of accuracy, the vast majority of woodblock prints that began to appear in Edo (present-day Tokyo) toward the end of the seventeenth century and continued to be produced there in growing numbers until well after the Meiji Restoration of 1868 should be called *ukiyo-e* prints. These were not the only prints published in Japan during the Edo period, nor is the history of woodblock printing in Japan limited to the two hundred years or so during which *ukiyo-e* prints flourished.

Ukiyo-e means, literally, "pictures of the floating world." We have already touched on the "floating world." The "pictures" could be any depiction of the pastimes or personalities of that world. Moreover, they could be in the form of paintings or book illustrations as well as prints. Since works in any of these mediums could be called *ukiyo-e*, special words had to be coined to refer to the prints specifically. These words changed over time as the prints themselves changed in appearance or in the ways they were used. The term most commonly employed from the 1760s on, after the development of full-color printing, was *nishiki-e*, "brocade pictures," or, more specifically, *Azuma nishiki-e*, "brocade pictures of the East (i.e., Edo)."

Though *ukiyo-e* prints are now esteemed as rare works of art and fetch huge prices, in their own day they were regarded more as we regard posters or inexpensive souvenirs. They were commercial products intended for sale to a popular market. The artists whom we credit with their creation usually provided only the designs. Actual production was the province of specialized craftsmen (block carvers and printers). More important than any of these, however, was the publisher. It was he who first conceived of a print project, and it was he who commissioned the artists and hired the craftsmen. It was also the publisher who saw to the distribution and sale of the final product. This is not to suggest that the artist's role was negligible. Ultimately, it was the artist's designs that people sought, and the more successful the artist, the greater his popularity, the more say he probably had in other aspects of the project.

The Kabuki Theater

It is impossible to talk about actor prints without knowing something about the Kabuki theater. Elsewhere in this catalogue Timothy Clark not only describes in vivid detail a visit to a Kabuki theater of the 1780s but takes us, scene by scene, through an actual performance of the period. Here all that is necessary, therefore, is a general description of Kabuki and some of its unique conventions.

Kabuki is difficult to describe to one who has never experienced it. Though music is an important component and it has certain elements in common with opera, ballet, and even (perhaps not so surprisingly) Broadway musicals, it has no real counterpart in the West. Like most of these other musical forms of drama, it is highly stylized.

In many Kabuki plays the action is described or commented on by a narrator, whose sung or chanted lines supplement the dialogue as in Nō theater. In other plays— or in other scenes of some of the same plays— the action may be mimed in dance form (*shosagoto*). Such dances were a feature of Kabuki from the start, but about the middle of the eighteenth century more elaborate dances with specialized vocal and orchestral accompaniment (known as *nagauta*) became increasingly popular. *Musume Dōjō-ji* (The Maiden at Dōjō-ji), first performed in 1753, and *Sagi Musume* (The Heron Maiden), staged for the first time in 1762, are two of these. Scenes from both of these dance sequences appear frequently in *ukiyo-e*.

Though music is an essential part of every Kabuki performance, the form it assumes and functions it serves will vary depending on the particular play or type of scene involved. Sometimes, particularly as a *nagauta* accompaniment to a dance, it will be lyrical and richly orchestral; at other times it will simply underscore the chanted narration. For the latter use, the principal instru-

ment is the *shamisen*, which has a range remarkably similar to that of the human voice. Other frequently used instruments are the flute and a variety of drums and wooden clappers. Because Kabuki music is less formal, more fluid, than Western music, it can follow the twists and turns of the action on stage more freely, moving abruptly from descriptive passages resembling sound effects to something more lyrical or melodic. The range of sounds and contrasts of timbre as well are extraordinary by Western standards.

Kabuki has been called an "actor centered" form of drama. It was primarily the actors, rather than the plays, that drew audiences to the theaters. Probably it is no accident that the scripts of so few eighteenth-century Kabuki plays have survived. One suspects that most of them were not great literature. They were, however, splendid vehicles for the strengths and skills of the leading actors. Often, in fact, whole scenes were added to a play simply to afford an opportunity for an actor to "do his stuff." If the addition was something of a non sequitur, the audience hardly seemed to mind. Most of the plots in any case were variations— the more fantastic and improbable the better— on well-known stories. What captivated the audience was the acting; what kept it in suspense was how a favorite actor would interpret a well-remembered sequence of events. Would his performance equal— or surpass— previous performances? Would this be the moment when the actor transcended himself?

Kabuki acting styles are quite different from anything we are used to. Even in the more realistic plays, movements, gestures, and speech are often stylized or exaggerated for dramatic effect. Strong men seem to swell in size as they stride across the stage or perform superhuman feats. Villains, with uncanny blue-and-white striped facial makeup (*hannyaguma*), leer or tower threateningly over their victims. Women mince and simper or coyly hide their faces. Overdrawn as some of these characterizations may seem, however, they are almost all based on natural movements and expressions. If this underlying realism is not always apparent, it is because it is so often overshadowed by the theatrical and musical effects that are such a spectacular part of any Kabuki performance.

One of the most unusual features of Kabuki is the *mie*— an exaggerated pose struck and held by a leading actor at a particularly climactic moment in the action. Sometimes these poses seem to embody passions that have reached a point of culmination, sometimes they seem to be introduced purely for visual effect. In either case the audience reacts with applause and shouts of approbation, much as opera lovers do when a singer produces a perfect high C. The resonant sound of wooden clappers (*tsuke*) rapidly struck together heightens the dramatic tension. For the Kabuki devotee these *mie* provide some of the most enjoyable moments in a play. They are also thought to constitute the supreme test of an actor's skill. *Mie* may be struck (or "cut," as the Japanese put it) either by a single actor or by several simultaneously. The effect of the latter is tableau-like, particularly when the curtain opens or closes on the *mie*.

There are many *mie*, differing from each other radically or slightly, each with its own descriptive name. Though the nuances of these different poses will escape the uninitiated, tradition dictates how they are to be executed in every detail. Many, perhaps a majority, of actor prints show their subjects "cutting" a *mie*. Given the dramatic impact of these poses and their importance as a measure of an actor's abilities, this is hardly surprising. It has, however, made the appreciation of actor prints difficult for Westerners unfamiliar with this convention and its significance.

Another unusual feature of Kabuki from a Western point of view is that all female roles are played by men. There is a certain irony in this, since the origins of Kabuki can actually be traced back to colorful (and frequently risqué) performances by troupes of female entertainers. This early form of Kabuki was frowned on by the authorities, however, whose Confucian sense of propriety it offended, and in 1629 women were banished from the stage. This made it necessary for men to play female roles, and before long certain actors began to specialize in these roles. Some of these *onnagata*, as they were called, became extremely popular. Segawa Kikunojō II (1741–1773), who appeared frequently in prints by Bunchō and Shunshō, was one of these. Even those *onnagata* whose masculine features and bone structure are not apparent in their portraits can be recognized by the purple kerchiefs or skullcaps covering a small shaven patch at the front of the scalp. (The law required this concession to the standard male practice of shaving the entire top of the head.) By covering these shaven patches, the kerchiefs helped maintain the illusion of femininity.

All Kabuki actors, whatever their specialties, were trained from childhood. Most of them were born into theatrical families and gradually worked their way up through the ranks. Their progress could be traced by the successive names conferred on them, which were jealously treasured family possessions. Only the most accomplished actors, those most capable of carrying on the family's distinguished traditions, could enjoy its most illustrious names. The name Danjūrō, for instance, immediately proclaims its owner to be the most accomplished actor of his generation in the Ichikawa family. The standards associated with that name were so high, in fact, that if no natural heir deserved it, the family would adopt an actor who did.

The origins of Kabuki, like those of *ukiyo-e*, can be traced back to the earliest years of the Edo period, but it was not until the Genroku era (1688–1704) that it began to as-

sume its classical form. Plays, which until then had largely been improvised by the actors, began to be composed by professional playwrights, who either wrote expressly for Kabuki or adapted puppet plays for live actors. At the same time actors such as the great Ichikawa Danjūrō I (1660–1704) developed unique styles of acting that in some instances are still perpetuated today. Many of the great families of Kabuki actors trace their origins back to these years as well.

Genroku was a formative period, and by the early 1700s many of the features that would characterize Kabuki through the remainder of the eighteenth century were already in existence, even if not always in their most developed form. One of these features was the *hanamichi*, a raised walkway that allowed actors to pass from the rear of the theater to the stage through the midst of the audience. The dramatic possibilities this provided were exploited to the full in one of the most famous of all Kabuki plays, *Shibaraku*, in which the hero makes his appearance on the *hanamichi* just in time to prevent an unjust execution on stage.

Still, the Kabuki theater of 1700 would have seemed small and primitive by comparison with what it became later in the century. New forms of music (such as *nagauta* and *tokiwazu bushi*) were developed; the plays themselves became more complex; and the stage expanded to either side of the original gabled platform derived from Nō (which, however, survived as a kind of vestigial feature of theater architecture until the 1790s). The invention in the 1750s first of the trapdoor, then of the revolving stage, made all kinds of special dramatic effects possible that would have been inconceivable earlier. The midcentury also saw the introduction in three successive years— 1746, 1747, and 1748— of three plays that would become perennial favorites in the Kabuki repertory: *Sugawara Denju Tenarai Kagami* (Sugawara's Secrets of Calligraphy), *Yoshitsune Sembon-zakura* (Yoshitsune's Thousand Cherry Trees), and *Kanadehon Chūshingura* (Model for Kana Calligraphy: Treasury of the Forty-seven Loyal Retainers). Scenes from these three plays figure prominently in the work of Shunshō and his followers.

The Dating of Actor Prints

Since they depict specific actors in specific performances, Kabuki actor prints are more often precisely datable than most other kinds of prints. They can therefore shed considerable light on the chronological development of *ukiyo-e*. Even actor prints, however, are by no means all securely datable. An actor can often be identified by the *mon* (personal emblem or crest) on his costume, but it is not so easy to establish what play he is appearing in. Thousands of Kabuki plays were performed in Edo during the eighteenth century, not all of them recorded.

Moreover, such records as exist are often spotty. A case in point is Tachikawa Emba's famous *Hana Edo Kabuki Nendaiki* (Flower of Edo: Kabuki Chronicle— generally abbreviated to *Kabuki Nendaiki*), illustrated by Katsukawa Shuntei and published 1811–1815. Though Emba's intention was to record for posterity the glories of "187 years" of Edo Kabuki, often he is able to provide only a play's title and the names of one or two of the leading actors— precious little to go on given the often improbable plot lines and complexity of so many of the plays. Surviving librettos are scarce as well, and cannot in any case be relied on to provide the details of specific performances, since actors had considerable freedom to improvise and might even add entire routines not called for in the text. To complicate matters further, revivals, or at least updated versions, of perennial favorites were quite common. If the same actor appeared in the same role in both versions, which frequently happened, it is easy to mistake one performance for another. Even identifying actors by their *mon* is not foolproof. Actors' names and *mon* were passed on (as we have seen) from generation to generation, and— especially where a strong family likeness may have been inherited as well— an actor might easily be mistaken for his predecessor, particularly if depicted in a role that his predecessor made famous.

Yet some actor prints can be dated with considerable confidence. The Kabuki theater was big business and employed signs and posters as well as all kinds of promotional literature such as playbills and programs. This material was ephemeral by its very nature, but some of it has survived and is capable of yielding detailed information about specific performances. Another valuable source of material is provided by the annual reviews, the so-called *yakusha hyōbanki*, which ranked actors' performances in order of merit.

Among the various ephemeral publications mentioned above, three have proved particularly helpful in dating actor prints. One is a kind of playbill called a *tsuji banzuke*, which was posted at intersections (*tsuji*), bathhouses, and other public gathering places. These named the play, listed the cast, and illustrated a scene from each act; they also cited the opening day and month— but not the year— of the production. *Kaomise banzuke*, published by each theater at the beginning of the season, cited the year and depicted and named the theater's entire acting company for that year. *Ehon banzuke*, while including much of the same information as the *tsuji banzuke*, concentrated on telling the story of the play through pictures; these too gave the year of the production, but, unfortunately for our purposes, in the late eighteenth century they were not yet being published regularly. Both *tsuji banzuke* and *ehon banzuke* show actors in costume in scenes that are also sometimes depicted in the prints. When an actor's pose and costume in a print closely match those in a *banzuke*, there can be

little doubt— all other indications pointing in the same direction— that both record the same production. Some correspondences are startlingly close, others more approximate. Obviously, careful comparison of the various types of *banzuke* (and of the theatrical annals called *Kabuki Nendaiki*, also dated to the year they chronicle) can help to date actor prints that resemble the *banzuke* illustrations.

Probably the most reliable evidence for the dating of at least some actor prints comes from what might at first seem an unexpected quarter. Over the years quite a number of actor prints bearing handwritten notations, seemingly contemporary, have turned up in collections around the world. Most of these inscriptions name the actors, the roles, the theaters, and the precise dates (but not the play titles) of the performances depicted. Interestingly, a surprisingly high proportion of the inscriptions seem to be in the same hand. All these prints are in virtually mint condition, and all date from the same brief period (ca. 1770–1772), strengthening the likelihood that the inscriptions were the work of one person. It would be fascinating to learn who the original collector was and how the prints managed to survive so long in such good condition. The Buckingham Collection contains a significant number of these prints (e.g., Nos. 12, 16, and 19 by Bunchō and Nos. 43 and 47 by Shunshō).

A Major Turning Point

The early years of the Meiwa era (1764–1772) mark a major turning point in the history of the *ukiyo-e* print. Artists and styles popular until then suddenly disappeared, to be replaced by new artists and new styles previously unheard of. New colors and a more advanced method of color printing were introduced, along with a new format, the *chūban*. Changes in fashion had occurred in *ukiyo-e* before (as was only to be expected of an art form that had always sought to reflect popular tastes), but none so abrupt or so profound as the changes that took place within a year or two of 1765. In fact compared with the relatively gradual evolution that had characterized the history of *ukiyo-e* until then, the suddenness and seeming discontinuity are as striking as a geological fault line.

These changes are traditionally explained as the result of technological advances, in particular the perfection of full-color printing. The technology necessary for full-color printing seems to have been in existence well before this time, however, though scarcely utilized by *ukiyo-e* publishers. For that matter, there had been *ukiyo-e* prints antedating 1765 that utilized three and sometimes even four color blocks in addition to the key block, but such multicolor prints look completely different from full-color prints produced after 1765. The difference lies not in the *number* of blocks but in *how* they were used.

The colors in the earlier prints— green and pink or yellow and blue— contrast strongly, creating a sprightly but often somewhat checkered or piebald effect. The backgrounds, which are left blank, serve as a foil to what is depicted and set off the colors to advantage but have no representational or expressive function otherwise. In the later prints colors are far more graduated; furthermore the backgrounds are almost always colored and either help establish the setting or contribute to the emotional atmosphere of the work. In other words, the coloring becomes subtler and the figure-vs.-ground contrast of the earlier prints is abandoned, with the entire print surface utilized for descriptive or expressive ends. Every portion of the print acquires meaning— even unprinted areas, which can become sky, water, a patch of ground, or whatever the artist decides to make them.

But this new use of color was not the only change that occurred. It was simply one result of a basic shift in attitude regarding the expressive potential of the printed image. Prints created after 1765 are *different in kind* from prints created earlier, and they reflect a whole new range of interests and concerns, even when they deal with the same ostensible subject matter. They are at once more realistic and more poetic. Making use of an expanded repertory of aesthetic and descriptive devices, they draw the viewer more completely into their imaginary world.

In earlier prints, furnishings and other objects seem little more than props, introduced as needed to explain an action or clarify a reference. Like props, they appear in isolation rather than forming part of a coherent, believable setting. Also like props, they seem to stand for, rather than represent, the objects they nominally depict.

In the later prints, objects acquire more weight. Not only are they depicted more convincingly in themselves but they contribute more effectively to the delineation of the setting and the establishment of the mood. Each object picks up additional meaning from its association with others. In Bunchō's 1766 portrait of the actor Arashi Otohachi I as Numatarō (No. 1), for instance, the snow weighing down the bare willow branches, covering the peak of the actor's hat, and piled up in icy clumps on the ground creates a sense of chill that is reinforced by the odd, somewhat acid, palette, and makes the cold, wet, lifeless forms of the dangling fish almost palpable.

Bunchō's portrait also illustrates another way in which prints produced after 1765 differ from earlier ones: it is truly a portrait. Bunchō has carefully delineated all the features that gave Otohachi, a well-known comic actor, his distinctive appearance— his broad forehead, widely separated eyebrows, prominent cheekbones, and narrow chin. No one could possibly mistake this portrayal of

Otohachi I for one of Bunchō's portraits of Nakamura Nakazō I (No. 8), say, or Matsumoto Kōshirō III (No. 12). Earlier actor prints purported to depict specific actors in specific performances, but in fact within the oeuvre of each artist the faces of the actors were indistinguishable from one another and all but interchangeable.

Probably the new measure of realism in the portrayal of actors owes more to Shunshō than to Bunchō. Certainly Shunshō was the more skillful of the two at capturing likenesses. It is questionable, however, whether any one artist can be credited with an innovation as profound as this, particularly when that innovation seems to be so intimately connected with all the aforementioned contemporary changes, in which Shunshō participated but which he cannot be said to have introduced.

In fact if any one artist can be convincingly credited with introducing more expressive coloring and settings, and with popularizing the *chūban* format, that artist is Suzuki Harunobu (ca. 1724–1770), not Shunshō. In late 1764 Harunobu designed, or collaborated in the design of, a group of privately circulated *egoyomi* (picture calendars) which are now generally recognized to be among the first true full-color *ukiyo-e* prints ever published. And even the earliest of these (a certain understandable tentativeness notwithstanding) display almost all the features referred to previously as marking such a revolution in *ukiyo-e*. In subject matter, format, and atmosphere, they are totally different from anything published previously.

Harunobu has become so closely associated with these developments that it is hard to tell which changes he might have initiated and which he adopted due to a general shift in taste. To attempt such a distinction may well be pointless in any case. Clearly Harunobu's sensibility must have been particularly well attuned to the tastes of his time, for within a year or two after the appearance of the *egoyomi* mentioned above, virtually every *ukiyo-e* print sold was in the new style they introduced. It is almost impossible to find an *ukiyo-e* print of the late 1760s that does not reflect the new vogue.

If there is anything that distinguishes Harunobu's prints from those of his contemporaries, anything that is exclusively his, it is probably his dainty, almost childlike figures. His frail, delicate men and women are unlike any that appeared before or after in *ukiyo-e*. Their charm was such that, for a while at least, almost every artist of the time tried to imitate them. Actor-print artists seemed to be the one exception, but even their figures soon became daintier and less flamboyant, reflecting the dominance of the new Harunobu type.

Although Harunobu played a key role in the immense changes that occurred in *ukiyo-e* at this time, the exact nature of that role remains uncertain. The few prints he produced prior to 1764 are completely unlike those he created later—so unlike as to make it difficult to think of

them as the work of the same man, let alone as earlier stages in a process of natural stylistic evolution. Yet it is in Harunobu's work that the changes in *ukiyo-e* that we have been speaking of first become evident. How are we to explain this?

Part of the explanation may be that Harunobu's *egoyomi* were privately commissioned and, as such, presumably reflected the particular tastes and interests of those who ordered them—tastes and interests apparently quite different from those to which publishers had been catering previously. Among those who commissioned *egoyomi* from Harunobu in 1764, one name occurs with greater frequency than any other: Kyosen. Kyosen was the nom de plume of a government retainer (*hatamoto*) who wrote and published haiku and was at the center of a circle of amateur poets, most of whom are thought to have been of samurai background.

The literary interests of such men are clearly reflected in the subject matter of the *egoyomi*, many of which take the form of *mitate-e*, witty parodies of material drawn from Chinese and Japanese classical literature. But it is generally assumed that when Kyosen and his friends commissioned these prints, they did more than simply suggest the subject matter. Often they signed the prints in a way that implies that they were involved in the design as well. If this is so, the prints must reflect their artistic as well as literary tastes. And if that is the case, the role these men played in the revolution in *ukiyo-e* that we have been describing may have been much greater than has generally been recognized. Our picture of Edo society in the 1760s seems to support this possibility.

By the 1760s many of the social barriers that had separated the samurai from the *chōnin* had begun to break down. One evidence of this was the growing role played by samurai or men of samurai background in the literary life of the floating world. Samurai had never exactly been strangers to the floating world—one of the stock characters in early *ukiyo-e* is the samurai wearing a basket hat or a bandana over his face, visiting the entertainment districts incognito—but social sanctions had prevented them from taking conspicuous part in that world. Now such sanctions seemed to have lost their force. Samurai began to frequent the theaters and licensed quarters quite openly, and some of them became so fascinated by what they found there that they began to spend much of their leisure writing about it. Among these were men such as Ōta Nampo (1749–1823), whose father served as one of the shogun's military guards, and Hiraga Gennai (1728–1779), who had been an assistant to the official herbalist of his domain before resigning and moving to Edo. Both were men of formidable talents and wide-ranging interests who experimented in a variety of literary genres; and despite the difference in their ages they seem to have had a great deal in common. In 1767 Gennai provided the

preface for Nampo's first major literary venture, *Neboke Sensei Bunshū* (The Collected Writings of Master Sleepy-head); and in 1770 the two authors collaborated again, this time on a book with illustrations by Harunobu.

Undoubtedly this sort of thing could not have occurred but for the relaxed atmosphere created by the easy-going, and often corrupt, regime of Tanuma Okitsugu (1719–1788), who was in power from 1767 to 1786. Be that as it may, at least by the late 1760s samurai were beginning to participate actively in the floating world and some of them were becoming highly influential in that world. Moreover this occurred at the very time that *ukiyo-e* itself was undergoing major changes.

It may be difficult, if not impossible, to identify a distinctive "samurai sensibility," particularly as refracted through the peculiar distorting medium created by the values and conventions of the floating world. Yet it seems inevitable that at least something of their samurai background would be reflected in the writings and activities of such men. The mock-learned tone that appears in so much floating world literature at this time (one thinks of the popular stories called *sharebon*, with their pseudo-Chinese titles and prefaces, or *kyōshi*, humorous verse dealing with the entertainment districts in the forms and language of classical Chinese poetry) is precisely the kind of affectation that one might expect from men who had been steeped from childhood (as many samurai had) in the Confucian classics.

During the 1770s samurai contributions to the literature of the floating world became even greater. Ōta Nampo's influence grew steadily, especially in such witty verse genres as *kyōshi* (in Chinese) and *kyōka* (in Japanese); Koikawa Harumachi (1744–1789), a high official serving in the Edo residence of the daimyo of Kojima, became one of the leading writers of *kibyōshi*, a new form of illustrated novelette; and Manzōtei (Morishima Chūryō, 1754–1808), the second son of one of the official surgeons to the shogun, was beginning his multifaceted career as a writer of puppet plays, *kibyōshi*, *kyōka*, *sharebon*, and miscellaneous essays. It will be important to keep all this in mind as we turn our attention more directly to the life and work of Katsukawa Shunshō.

Katsukawa Shunshō

As with most *ukiyo-e* artists prior to the late eighteenth century, solid information regarding Shunshō's life is meager in the extreme. We do not know where, or even for sure when, he was born.[1] We know nothing about his family background or the circumstances that motivated him to pursue a career in art. No one has found any letters by him or any business documents relating to him, and the paucity of contemporary printed mention of him is surprising, given his unquestioned popularity as an artist. We do know when he died — his tombstone still exists — but almost everything else we know (or think we know) about him, other than what we can conclude from his work, is based on second- or third-hand information if not downright hearsay. Indeed were it not for the indisputable evidence of his work, one might be tempted to doubt Shunshō's very existence. Yet this elusive figure was one of the most significant *ukiyo-e* artists of the eighteenth century.

This must seem strange compared with the more ample information available on most Western artists of the same period, but it is not at all unusual for Japanese art. We know even less about Shunshō's great contemporary Harunobu and only marginally more about some of the illustrious artists, such as Utamaro, who followed him. In part this reflects the relatively humble status of *ukiyo-e* in the Edo period, but the situation is not much different with artists from other schools. Often all that is recorded is an artist's teachers, his alternative names (most Japanese artists had several *gō*, or "studio names"), and an anecdote or two illustrating his talents.

This is essentially the kind of information found in *Ukiyo-e Ruikō*, the earliest known listing of *ukiyo-e* artists, the first version of which is thought to date from about 1790, three years before Shunshō died. The author is believed to have been none other than Ōta Nampo, the multitalented samurai writer and critic whose key role in floating world literature of the 1760s and '70s was mentioned earlier. Nampo's wide circle of acquaintance included many well-known *ukiyo-e* artists. We have already mentioned his association with Harunobu. Though we can find no evidence that he was personally acquainted with Shunshō, he certainly would have known *of* him. He and Shunshō had too many friends and interests in common to imagine otherwise. Their paths must have crossed, as we will soon see.

The entry on Shunshō in *Ukiyo-e Ruikō* is disappointingly brief. It says that he was a pupil of Katsukawa Shunsui, that he lived in Ningyō-chō, and that he became famous for his portraits of Kabuki actors in the Meiwa era (1764–1772). It then goes on to say that he began his actor portraits with a depiction of the *Gonin Otoko* (The Five Chivalrous Commoners, presumably the set of 1768). It also says that, having no studio name of his own at the time, he used the seal of Hayashiya Shichiemon, in whose house in Ningyō-chō he was then living. The seal consisted of a jar (*tsubo*) with the character for *Hayashi* written inside. As a result, he came to be called Tsubo and his pupil Shunkō became Little Tsubo. Apart from this, the entry provides only two other bits of information: that Shunshō sometimes used the art surname Katsumiyagawa and that he also designed warrior prints.

Assuming Nampo's authorship and its comparatively early date of compilation, the information in this entry

ought to be fairly trustworthy, and most of it probably is. Though scholars have challenged the accuracy of several details— pointing out, for instance, that the Katsukawa family burial records indicate that Shunshō lived in Tadakoro-chō instead of the admittedly nearby Ningyō-chō— no one has questioned the entry's basic reliability. Nampo, after all, was not writing as a modern art historian but as an amateur, who could afford to be somewhat relaxed about minor details. In short, the entry in *Ukiyo-e Ruikō* is just about what one would expect from a combination of firsthand and secondhand information put together by a near contemporary. As such, it provides a useful point of departure for tracking down additional information about Shunshō's life.

Another point of departure is provided by the burial records of Zonshin-in, a subtemple of Saifuku-ji, where Shunshō's tombstone is located. In keeping with Japanese custom, the ashes of other family members were buried with Shunshō's under the same stone. The records list the posthumous names[2] and death dates of four persons, two women and a man in addition to Shunshō himself. Unfortunately the records give no indication of how these individuals are related, and the only other information they provide, in a note to the first entry, is Shunshō's personal name and his address.

As mentioned before, we do know that Shunshō wrote haiku. One of his verses was included in a collection of poetry published in 1774, and there is also the evidence of his very moving death poem, which is carved on his tombstone.[3] He may have tried his hand at other forms of writing as well. The fact that the brilliant Manzōtei knew of him, referring to him in his *Hogo Kago* (Waste Paper Basket) as a *zatsugakusha*, "a man of wide learning," would tend to support such a supposition. Manzōtei was a successful writer, equally at home in virtually all of the genres of light literature popular at the time. The son of one of the shogun's physicians, he occasionally practiced medicine himself but clearly found writing and frequenting the pleasure districts (where he had a reputation as a man-about-town) more to his liking. He studied *rangaku* (Western science as transmitted by the Dutch) with Hiraga Gennai and was a central figure, along with his friend and fellow samurai Ōta Nampo, in developing a distinctive Edo style of *kyōka* during the late 1770s.[4] That Shunshō was known to such a person, even if perhaps only in passing, gives some indication of his milieu.[5]

It would probably not have been out of character for Shunshō to have written at least some *kyōka* during the 1780s; but since *kyōka* were written under pseudonyms, many of which have never been identified, we may never know whether he did or not. *Kyōka*, literally "crazy poems," were witty, often sardonic verses, totally contemporary in outlook but cast in classical *waka* form— i.e., employing the same number of syllables and length of lines. *Kyōka* poets did not reject the classical tradition; they simply appropriated it for their own ends. In fact a recurrent feature of many *kyōka* is allusion, either direct or in the form of a parody, to some well-known poem of the past. Though writing *kyōka* might be considered an amusement, therefore, it was a pastime that required not only wit and verbal ingenuity but a thorough grounding in classical literature.

The so-called "*kyōka* craze" of the Temmei era (1781– 1789) seems to have drawn together people from different social backgrounds, and even different parts of the country, more effectively than almost any other shared interest of the time— except perhaps Kabuki. *Kyōka* parties, at which the participants ate and drank and then composed poems on a specific theme, provided opportunities for merchants, officials, professionals, and visitors from the provinces to mingle as equals to an extent that was almost unheard of otherwise. Given the intellectual requirements for writing *kyōka*, the phenomenon says a great deal about the general level of education enjoyed by at least the more affluent sectors of the population at the time.

But to get down to specifics and ultimately back to our original subject, Shunshō, let us turn to a slender *kyōka* book edited by Ōta Nampo and published in 1782, *Ichikawa Hiiki Edo no Hana Ebi.*[6] The *kyōka* included were all composed at a party held in honor of Ichikawa Danjūrō V and attended by admirers of his from various parts of Edo. The occasion was the first performance by Danjūrō's young son under the acting name Ichikawa Ebizō. The boy's appearance, in the role of Ise Ebi no Akambei, had been part of the *kaomise* performance for 1782 at the Nakamura Theater.

The first two of the three characters used to write the name Ebizō normally designate a kind of lobster which was thought to have particularly auspicious associations and was frequently used as an emblem of felicity at New Year and other occasions when good wishes were appropriate. The same two characters form part of the name of the role the young Ebizō had played. This inspired the conceit of having the poems written as though they were offerings from the various sea creatures serving in the court of the mythical Dragon King of the Deep.

The two aspects of this intriguing little book that are of particular relevance here, however, are: (1) the clarity with which the book points up the kinds of relationships that brought leading literary figures of the time and Kabuki actors together; and (2) the number of contributors who had some sort of contact with Shunshō. We have already pointed out that Nampo must have been acquainted with Shunshō; Manzōtei, whose commendation of Shunshō was mentioned a moment ago, was another contributor. A third contributor, Koikawa Harumichi (1744–1789), is thought to have had even closer

associations with our subject. Like Nampo and Manzō-tei, he was a samurai, but unlike them he continued to serve his lord while pursuing his interests in light literature. Though an accomplished *kyōka* poet, he is best known for his novelettes (*kibyōshi*), which he illustrated himself in a style that obviously owed much to the Katsukawa school. In fact it is generally assumed that he must have studied, if only informally, with Shunshō as well as with his acknowledged master, Toriyama Sekien.

Unfortunately, much of the above provides only indirect information about Shunshō, not concrete facts. What, then, can we say about him with certainty? Probably very little. As pointed out above, we cannot even say for sure when he was born, though previous writers have been all but unanimous in asserting that he was born in 1726. It has also been asserted that Shunshō came from a samurai background. Here the evidence is somewhat stronger, though still not conclusive. His reputation as a "man of wide learning" (*zatsugakusha*) would certainly be consistent with a samurai upbringing, which often included instruction in classical literature; and his association with samurai literati might be thought to point in the same direction. Moreover several other well-known *ukiyo-e* artists of the time were, or are thought to have been, of samurai stock, including, most significantly, Shunshō's friend and sometime collaborator Bunchō.

Amid so much conjecture, the indisputable fact remains that Shunshō created literally thousands of designs, and enough of this large body of work has survived to give us not only a good idea of his importance as an artist but some sense of his character and personality as well.

One of the most striking features of Shunshō's work is its consistency. Though it did evolve stylistically over the years, it seems to have done so gradually. His early work does differ from his late work, but not as much as one might have expected given the time span of nearly thirty years. The contrast with some of his contemporaries in this regard— Isoda Kōryūsai, for example, whose style changed dramatically in the late 1770s— is instructive.

This consistency seems to be related to another characteristic of Shunshō's work, one that almost certainly reflected something very fundamental in his personality, and that is its restraint. Even in the most dramatic of the prints this quality is apparent. One senses a sobriety in Shunshō, perhaps even a certain fastidiousness, that led him to avoid anything that might have smacked of excess. Though bombast and exaggeration are inseparable from the Kabuki stage, Shunshō's own approach to the theatrical nature of his subject matter seems to have been rational and measured to an almost scrupulous degree. It is an approach that is not to everyone's taste. About Shunshō's mastery of his craft, however, there can be no question. He was a consummate technician who held himself to the highest standards. This is evident in every-thing he did, even in his earliest actor prints, no matter how tentative they might appear in other respects. It is one of the principal features that set Shunshō's work apart from that of his contemporaries.

Another aspect of Shunshō's artistry— undoubtedly the most important one for a designer of actor prints— was his skill in capturing likenesses. None of his contemporaries could touch him in this regard, not even Bunchō, who came closer (in prints like Nos. 1 and 5) than anyone else, and it is hard to think of any later print artist who could equal him. Shunshō's abilities as a portraitist must have seemed all the more remarkable in that no such portrayals had ever been attempted in the actor print genre before.[7]

So far we have been discussing Shunshō's art in general. Over the years his work did change, however, and the changes, though gradual, are fairly noticeable when an early work from the 1760s is set against a more mature work from the 1770s. Compare, for example, *Bandō Matatarō IV as Gempachibyōe* of 1769 (No. 40) with *Bandō Mitsugorō I as the Abbot Saimyō-ji Tokiyori Disguised as a Monk* (No. 68) of 1773. Granted, the roles portrayed could hardly be more dissimilar, but the differences between the two prints far transcend anything attributable to this. The first and most obvious difference is the lack of any real setting in the earlier work. The actor has no place to plant his feet and as a result seems to be hovering in air, like a genie rising from a bottle. His peculiar off-balance stance— feet and legs pressed together, torso bent, and arms gesticulating in comic rage— adds to the effect. In the later print, by contrast, Mitsugorō stands firmly on the snow-covered ground, his stable posture reinforced by the strong vertical of his staff. The setting is simple, almost rudimentary, but perfectly adequate for the artist's purposes. The low horizon line and empty sky effectively evoke the desolate, snow-swept landscape in which the figure is supposed to be standing. Repeated horizontals (in the ground, the fence, the actor's arms, and the brim of his hat, among other things) keep the center of gravity low, adding to the effect of resolute firmness conveyed by the figure's stance.

In the earlier print the actor looks as two-dimensional as a shadow puppet or paper doll. His tiny arms stick out to either side in the same plane as his body, and the few lines and folds drawn on his costume are insufficient to counter the flattening effect of the insistent overall pattern, which extends even to his gauntlets and leggings. In the later print the actor appears much more solid. His clothes seem to have substance and weight. He is surrounded by real space. His hands rest on a staff which is planted firmly in the snow in front of him. The fence stands at a palpable distance behind him.

Obviously the differences between these two prints are considerable, even though they are separated in time

by a mere four years. Do we find similar differences between other prints of the 1760s and 1770s? I believe we do. Many of Shunshō's early prints lack settings, and there is a dainty, toy-like quality to the figures, whose gestures, as a result, often seem tentative or ineffectual. Harunobu's influence is strongly apparent not only in the figures but in the overall delicacy of treatment. From the 1770s on, however, settings become more frequent and the figures more weighty and solid. Stances become more secure and gestures more forceful. The air of tentativeness that pervades so much of the earlier work disappears.

All the elements of Shunshō's mature style are present in the so-called *Red Danjūrō* of 1777 (No. 84). It is a daring composition, from which everything not essential to the artist's expressive purposes has been eliminated. The actor is shown in profile, his shoulders hunched and his head half buried in the voluminous garments that engulf him. In such a mode of depiction the actor's body could easily appear flat, but it does not. Instead it seems to fill the garments to the bursting point, an effect cleverly enhanced by the richly decorated under-robe showing through the brick red *suō* jacket (as though the body were swelling within it) and by the three Ichikawa crests partly disappearing around the contours of the robe. The figure is deliberately cut off at the right, as if it were too bulky to be contained by the *hosoban* format. The octagonal crest of the Nakamura Theater, emblazoned on the curtain in the background, rises above Danjūrō's shoulders and head, contributing a theatrical touch of its own to the work. But this seemingly incidental note also fulfills another function. The flatness of the curtain emphasizes, by contrast, the three-dimensionality of the actor. The contrast becomes all the more pointed when one notices how the straight-edged outlines of the theater's crest are roughly mimicked by Danjūrō's silhouette.

So far we have concentrated on those aspects of this print that best illustrate a key feature of Shunshō's mature style: his growing ability to endow his figures with a sense of forcefulness, presence, and weight. Clearly there are other aspects to this work, which has long and deservedly been considered one of Shunshō's masterpieces. Drama, of course, is at the heart of most of Shunshō's actor prints. Much of his greatness as an artist derives from his unerring instinct for recognizing (and capturing for all time) the most telling moments in a play. In print after print we see him concentrating on these moments, rigorously excluding everything that is irrelevant to their inherent drama. It is an ability he seems to have had from the start, evident even in his earliest prints. Between those and later prints, like the *Red Danjūrō,* the chief difference is the greater sense of presence in the later figures, which cannot help but add to their impact.

The *Red Danjūrō* depicts one of the most dramatic scenes in the entire Kabuki repertory, the moment in *Shibaraku*

when the hero makes his sudden appearance on the *hanamichi* walkway behind the audience. Equally unforgettable moments occur in other plays, however, one of these being the culmination of the "Carriage-Stopping" (*Kuruma-biki*) scene in *Sugawara Denju Tenarai Kagami* (No. 80). This scene too combines spectacle with drama in a manner unique to Kabuki, but it is more complex, involving four figures and various stage properties, and presents an entirely different kind of challenge to the artist who attempts to portray it.

The scene depicts the moment when the malevolent Lord Fujiwara no Shihei first reveals himself to the two brothers, Umeō-maru and Sakura-maru, who had been attempting to stop his carriage. Shihei rises from his dismantled carriage like an evil spirit incarnate. His beard and sideburns stream from his grotesquely painted face, his eyes glare, and his red tongue protrudes from his mouth. The two brothers, who a moment earlier had been quarreling with a third brother (they were triplets) serving as Shihei's retainer, are overawed by the sheer force of the evil lord's personality and stay their hands. All four actors then hold their poses in a highly choreographed final tableau-like *mie.*

The stylistic changes that occurred in Shunshō's work around the early 1770s clearly reflect his growing maturity as an artist. At the same time he began to explore a broader range of subject matter and to try out new formats. Already in the late 1760s he had designed an occasional print of young women in the Harunobu mode, but most of these seem stiff or uninspired compared with his actor prints of the same years. His first successful venture into different subject matter is his *Tales of Ise* series (No. 63). There is some question as to when this series was actually created. Gookin, among others, has argued for the 1760s;[8] Ueda favors a date closer to 1772. It is unquestionable, however, that the series was designed by an artist of considerable self-assurance who felt completely at ease with classical subject matter.

Shunshō was not the first *ukiyo-e* artist to utilize such subject matter. References to the literary classics appear frequently in *ukiyo-e* from the late seventeenth century on. Sometimes these references take the form of parody[9] (though never malicious parody); more often they simply entail the "mining" of the classics for ideas, much as Kabuki drew many of its plots from Nō. It was Harunobu, however, who probably made the greatest use of the classics. One of the hallmarks of his art was its incorporation of literary and poetic associations.

In taking his subject matter from the *Tales of Ise,* therefore, Shunshō must have known that he was inviting direct comparison with Harunobu. That he was willing to do so says much about his self-confidence. To be sure, these prints still owe much to Harunobu. His influence is discernible not only in the fragility of the figures but in

the general air of delicacy and refinement that pervades the series as a whole. In other important respects, however, the series reveals how far Shunshō had been able to liberate himself from Harunobu's dominance. His interest in— and ability to exploit— the narrative aspects of *Tales of Ise* give the series a liveliness and variety rarely found in Harunobu's oeuvre. The approach is objective: each print differs from the next according to the requirements of the incident being illustrated. It is an approach that clearly sets Shunshō apart from Harunobu, for whom establishing a mood seems to be more important than telling a story.

The independence and versatility apparent in the *Tales of Ise* are, if anything, even more evident in Shunshō's illustrations for *Nishiki Hyakunin Isshu Azuma-ori* (An Eastern-Weave Brocade of One Hundred Poems by One Hundred Poets), a book published in 1775 but probably designed in 1774. *Hyakunin Isshu* is perhaps the most famous of the many Japanese anthologies of classical poetry. Consisting of one hundred poems, each by a different poet, it was put together sometime in the thirteenth century, though most of the poems are of much earlier date. By the Edo period this anthology had long since become a classic, and its popularity had inspired numerous imitations and parodies. Since many early manuscript copies of the anthology had included imaginary portraits of the poets along with the poems, such portraits also became a feature of many of the later copies and imitations. Almost all of these so-called portraits, however, were highly stylized or conventional. There was little to distinguish one individual from another apart from clothing or an occasional attribute, such as a fan or a quiver of arrows, and since most of the poets were courtiers, even their dress was largely the same. Shunshō's illustrations break dramatically with this tradition. He invests each of the poets with a believable personality and distinctive features. If one seems fat and placid, the next may be gaunt and intense. The conventional attributes, the quivers or fans, remain, but little else that can be called conventional. The drawing is as refined as in *Tales of Ise* but even more precise, and the figures have the kind of substance and rootedness one would expect from a work of the mid-1770s.

By 1775 no one could question Shunshō's mastery of classical subject matter. There was another area, however, in which he had yet to prove his skill. Ironically, it was an area in which *ukiyo-e* artists had long excelled, and that was the depiction of beautiful women (*bijin*). Since most *ukiyo-e bijin-ga* (paintings of beautiful women) were of courtesans, it was in depictions of these women of the "flower and willow world" that the challenge lay. Shunshō took on the challenge in a characteristically bold fashion. Instead of designing single-sheet prints, as was customary for that genre, he composed a whole series of pictures in the form of an album or book;[10] and

rather than portraying the women individually and as they would appear in public, as most artists did, he chose to depict them in private and in the company of other women. (He was to do something similar with actors in his *Yakusha Natsu no Fuji* of 1780.) To be sure, these ideas may have been only partly his. The book was a collaborative work in which perhaps as many as half the illustrations were provided by another artist, Kitao Shigemasa (1739–1820). Moreover the two publishers, one of whom was the enterprising Tsutaya Jūzaburō (who wrote the preface), almost certainly would have had some say in the concept. Whoever originated the format, the book turned out to be ideal for Shunshō's purposes. It offered much greater scope to his imagination than any single-sheet print could possibly provide, and he rose to the occasion brilliantly.

Published in 1776, *Seirō Bijin Awase Sugata Kagami* (A Comparison of Beauties of the Green Houses: A Mirror of Their Forms) became an immediate success. The timing was fortunate. The fashion in women's hair styles had changed only a short time before, and the book was one of the first to show the new *tōrōbin* coiffures with their stiff "wings" of hair at either side of the head. This was only part of its appeal, however. What must have particularly intrigued the public were the glimpses it provided (or pretended to provide) of life behind the scenes in the pleasure districts. The pretense gained credibility from the fact that the women, all of whom were supposed to be celebrated courtesans of the day, are actually named. The book clearly attempted to capitalize on some of the mystique surrounding these noted beauties by offering its readers a sense of privileged access to them. In a number of the illustrations this sense of direct contact with real-life people is augmented by reproducing poems actually composed by the women portrayed.

Following an old tradition, the book is divided into four sections corresponding to the four seasons, beginning with spring and ending with winter. This framework offered several advantages. The seasonal progression by its nature afforded variety and a sense of movement. More important, it provided the artists with a stock of imagery rich enough to challenge their inventiveness. The resulting compositions are some of the most appealing in all of *ukiyo-e*, e.g., the summer scene in which young women find distraction from the heat by burning sparklers, or the even more delightful winter scene in which one of the women uses a dipper to pick up the ice that has formed on the surface of an outdoor wash basin. The colors, primarily pinks, yellows, and soft reds with occasional passages of charcoal gray and dark black, are rich but restrained. The disposition of the figures is graceful and inventive yet dignified.

Though this landmark publication established once and for all Shunshō's reputation in the *bijin-ga* genre, the ma-

jority of his prints continued to be of actors. But Shun-shō, like most *ukiyo-e* artists, was also a painter; during the last few years of his life he seems to have devoted himself almost exclusively to painting, and his growing fascination with the medium quite likely dates from this time. Shunshō has been called one of the "four or five finest painters in ukiyo-e."[11] Interestingly, most of his paintings are of women. In fact more often than not they are of groups of women engaged (as in *Seirō Bijin Awase Sugata Kagami*) in some game or seasonal pastime. Shun-shō's most celebrated achievement as a painter, a set of twelve scrolls that is thought to have been commissioned by the ninth daimyo of Hirado, follows this same formula.[12]

That Shunshō and Shigemasa created such an immediate sensation with *Seirō Bijin Awase Sugata Kagami* is hardly surprising, given the fashion-conscious, novelty-seeking nature of the Edo public. What *is* surprising is the extent and duration of the book's impact on other, later works of art. Such influence is not always easy to document, but at least one instance can hardly be questioned. The book undoubtedly provided the inspiration for *Yoshiwara Keisei Shin Bijin Awase Jihitsu Kagami* (A Mirror Comparing the Handwriting of the Beautiful New Courtesans of the Yoshiwara), designed by Kitao Masanobu (1761–1816) and published by Tsutaya in 1784. The postscript in *Yoshiwara Keisei* specifically refers to the precedent set by Shunshō and Shigemasa, and the influence of the earlier publication is obvious not only in the subject— well-known courtesans at leisure— but in the way that Masanobu has expanded on the idea of including verses by the courtesans themselves, making it the unifying motif of the entire work.

It should be clear by now that prints represent only one aspect of Shunshō's total oeuvre. This is an important point to remember, particularly in a publication such as this that concentrates on prints. To write about Shunshō's growth and development as an artist by referring solely to his prints is not only to ignore whole areas of his artistic activity but, quite possibly, to miss out on plausible explanations for changes that occur in the prints themselves. A curious fact about *ukiyo-e* is that the range of subject matter found in illustrated books (and to a lesser extent in painting) seems to have been much greater than that found in the prints. Print subjects seem to have been drawn, for some reason, from a limited number of pre-determined categories. When the subject matter changed, as it did from time to time, the reasons for the changes are seldom clear. Some of the most striking changes in the subject matter of Shunshō's prints, however, seem to be a direct outgrowth of ideas he had first experimented with in illustrated books. His large-scale "big head" fan prints in the *Azuma Ōgi* (Fans of the East) series (Nos. 72, 73), for instance, almost certainly owe their inspira-

tion to *Ehon Butai Ōgi* (A Picture-Book of Stage Fans), published in 1770, which Shunshō designed together with Bunchō. In a sense, the *Azuma Ōgi* prints (the earliest of which date from about 1775) are simply the pages of that book writ large. Similarly, Shunshō's innovative large-scale prints of actors in their dressing rooms (Nos. 93–95) might never have seen the light of day had it not been for his book *Yakusha Natsu no Fuji* (Actors: Mt. Fuji in Summer [i.e., actors in mufti, like Fuji without snow]) of 1780. Both of these print series significantly enriched the stock of imagery available to the print medium, the first by introducing bust or half-length portraits of actors, the second by showing them out of character.

Shunshō did not always first experiment with new subject matter, or new ways of presenting familiar subject matter, in the illustrated book format. Some time about 1782 he began designing prints of sumo wrestlers— apparently the first appearance of this subject in *ukiyo-e* print form. The prints are impressive works in every sense of the word and must have created something of a sensation when they first appeared. By utilizing the large-scale *ōban* format, then filling it to its margins with the great bulk of the wrestlers' bodies, which seem about to burst its confines, Shunshō hit upon a brilliant device for conveying the sheer massiveness of these improbable figures. He seems to have been genuinely intrigued by this subject, which eventually joined actor portraits as a specialty of the Katsukawa school.

As *Ukiyo-e Ruikō* (cited earlier) makes clear, prints of great warriors of the past were another genre for which Shunshō was well known, and here too some of his pupils followed his lead. There is yet another type of art, however, with which Shunshō has less often been associated but which nonetheless occupies a significant place in his total oeuvre, and that is the erotic or pornographic pictures known as *shunga*. As the very word *shunga* (literally, "spring pictures") implies, the Japanese attitude toward this kind of subject matter, at least in the past, was quite different from that in the West. There was no social stigma attached to depictions of what is, after all, one of the most elemental human activities. The *shunga* tradition in Japan is a long and honorable one and includes an impressive number of works that can make a fair claim to be considered masterpieces.

According to at least one count, Shunshō may have designed as many as eighteen *shunga* albums.[13] Some of these are relatively routine productions, but others are quite distinguished, and one, his *Ehon Haikai Yobokodori* of 1788, has been characterized by Jack Hillier as "... one of the most splendid productions of the period...." Having passed this judgment, however, Hillier then goes on to say that the work "... falls short, as every other book must do, of the incredible standard set by Utamaro's *Utamakura*...published in the same year.... Indeed, a

comparison with [that work] makes Shunshō's book seem relatively orthodox and unadventurous...."[14]

Somewhat similar assessments have been made of other aspects of Shunshō's work. There are even those who have found his actor prints wanting when compared with Sharaku's intense, satiric portraits of the mid-1790s. But such comparisons seem inappropriate, and not just because the two artists worked in different periods. They were doing entirely different things. Sharaku mocked; Shunshō celebrated. Too often mockery gets more attention. It is important to remember that the spectacular prints of the 1790s would have been impossible had it not been for the pioneering work of Harunobu and Shunshō in the late 1760s. Though in retrospect that work may sometimes seem modest and unadventurous, in fact it was nothing short of revolutionary.

Of the two artists, Harunobu was undoubtedly the more influential at first, but though he had many imitators, he seems to have had no pupils. When he died prematurely at the height of his powers in 1770, he left the field open to Shunshō. Shunshō, who remained active until his death in 1792 and saw every other major artist of the Meiwa era either die or retire before him, thus became the single most important link between the 1760s and the 1790s. His pupils, who included for a time the legendary Hokusai (then called Shunrō), carried his influence into the nineteenth century. Shunshō's work has been called "one of the important milestones in the historical development of the Japanese print."[15] There can be no question of that.

Ippitsusai Bunchō

If we know little about Shunshō, we know even less about Bunchō. The entry in *Ukiyo-e Ruikō* merely says that he was "active in the Meiwa era," that he was an "unskillful painter of actors and the everyday life of men and women," and that "he often portrayed Yaozō II." We have no way of knowing when he was born, and our only clue to his date of death is a *surimono* designed by Kubo Shunman (1757–1820) commemorating the seventh anniversary of his death. The *surimono* is undated but is probably of the late 1790s at the earliest, which suggests that Bunchō died in the early 1790s—in other words, at about the same time as Shunshō.

To learn more about Bunchō, we must turn to his work. Fortunately his prints have survived in considerable numbers; some estimates go as high as eight hundred.[16] There are also a few paintings by or attributed to him. On examination, this body of work seems to date almost entirely between 1766 and 1773, but Bunchō is known to have illustrated a book of popular fiction in 1755 and to have designed a calendar print (*egoyomi*) for 1790, which is currently accepted as his last known work. The sug-

gestion that most or all of Bunchō's prints and paintings were designed within a span of eight years may seem improbable, but it is not impossible. In fact there are good reasons why Bunchō's activity might have been limited to this particular period. As we have already seen, 1765–1766 marked a turning point in *ukiyo-e*. It was a favorable moment for a new artist to make his debut. The death of Harunobu in 1770 marked another, albeit less dramatic, turning point. Within a year or two of his death the Harunobu style of the 1760s had disappeared and a new, more robust style had arisen in its place. Artists who felt uncomfortable with the change either retired or fell out of favor. It is quite likely that Bunchō was one of those.

There can be no question of the extent of Harunobu's influence on Bunchō. It is at its most marked in the prints of lovers and women of the pleasure districts (cf. Nos. 11, 20), but it is apparent throughout his work in his evocative use of landscape elements and frequent references to poetry. Yet one would never mistake a print by Bunchō for one by Harunobu. Bunchō's style is distinctive. His figures are taller than Harunobu's and less dainty (even, at times, somewhat ungainly), and the faces of his women are longer, with lower foreheads and narrower, more slanting eyes. Often a look of faint distaste or superciliousness seems to play across their features, which may account for the air of aloofness that some viewers have detected in Bunchō's work. Bunchō also seems to have preferred rather acerbic color harmonies, with yellow-greens, tans, dark browns, and oranges predominating.

The extent to which Bunchō was influenced by Shunshō is much harder to determine. Some of Bunchō's portrayals of actors in male roles seem quite similar to Shunshō's, but his portraits of *onnagata* are distinctive, with a seductive charm all their own. And even where similarities do exist, it is impossible to determine who was influencing whom, since both artists seem to have begun designing prints at about the same time. However one might have influenced the other, they apparently considered one another equals, because they collaborated on several projects. The most notable of these was the remarkable *Ehon Butai Ōgi* (A Picture-Book of Stage Fans), published in 1770. This was the first *book* to exploit the expanded range of color effects that had already been utilized for several years in full-color single-sheet prints (*nishiki-e*). Interestingly, the two artists' contributions to this book would be very difficult to distinguish were it not for the signatures or seals that appear on most of the pictures. A year later, however, when the two artists collaborated on a diptych, each contributing one panel, they seem to have made no attempt to disguise their stylistic differences.[17]

In general it can be said that Shunshō and Bunchō have very distinct styles. The differences between them be-

come particularly clear in those instances when they each treat the same subject. One of Shunshō's most widely admired prints of the 1760s is his depiction of the quarrel between Giheiji (played by Nakamura Nakazō I) and Kurobei (Nakamura Sukegorō II) in a scene from "Murder in the Back Street off Nagamachi" (No. 26). Bunchō's version of the same scene (fig. 26.1) is much less familiar, probably because the only known impression of it is in a private collection in Japan and has rarely been reproduced.[18] The similarities and differences between the two versions are instructive. Both are in the *chūban* format, which was an unusual one for actor prints at the time (the *hosoban* being most commonly used), and the overall palette, consisting primarily of grays, gray-blues, red-browns, tans, and ivory-whites, is roughly the same. Both use in the background a distinctive opaque ivory color, probably created by combining *gofun*[19] with lead white. Moreover Sukegorō's scowling features and rather unusual pose— kneeling on one leg and extending the other, right arm bared and fist clenched— are all but identical in both prints. With Nakazō I, however, the resemblances stop. Shunshō's Nakazō seems animated with impotent rage. He kicks at his antagonist, glares at him, and rolls back his sleeves as though preparing to strike him with his fists. The agitated lines of his garments seem to echo his fury. Bunchō's Nakazō seems stolid by comparison. He is stouter and his gestures are more ponderous. Though he thrusts a sandal in Sukegorō's face and presumably shouts abuse at him, there actually seems to be little interaction between the two figures. Furthermore the two are not as clearly separated as in Shunshō's composition, which emphasizes the negative space between them.

Shunshō's portrayal of the two characters being represented is nothing short of brilliant. Nakazō's skinny shanks and petulant gestures emphasize his impotence. His white hair and scraggly beard proclaim him old. His pink skin reflects his rage. Touches of blue *kumadori* makeup under his eyes add to the malevolence of his gaze. Shunshō cleverly contrasts his agitation, scrawny figure, and off-balance pose with Sukegorō's iron self-control and physical solidity.

As one might expect, Bunchō's version of the scene includes landscape elements, while Shunshō's does not. Shunshō seems to have been chiefly interested in the dramatic possibilities offered by the figure. Therefore he often reduced or even eliminated settings, except those that could be made to enhance the human drama taking place. Yet his backgrounds are never merely blank, like the backgrounds in earlier prints. Here, for instance, the opaque ivory background, though in no way distracting us from the interplay between the two figures, definitely adds to the atmosphere. The low dike depicted in the Bunchō print, on the other hand, contributes very little to the expressiveness of the work; its role seems to be purely informative, i.e., that the scene in question was supposed to have taken place near low, watery ground, perhaps next to a rice paddy.

Those settings that Shunshō did provide, he generally handled differently from Bunchō. To explain the difference, one has to remember that settings make an artist's task much more difficult. Suddenly he has to concern himself with an added dimension, depth. The figure must take its place in a believable environment, where every object makes sense and spatial relationships are clear. *Ukiyo-e* artists met this challenge in several ways. One way, the way favored by Bunchō and Harunobu, was to make use of the conventions traditionally found in narrative handscrolls and in many screens. Among these conventions, which collectively form what might be thought of as a system of perspective, are: (1) a high, "bird's eye" vantage point, (2) a steeply tilted ground plane, (3) the notion that objects at the bottom of a picture are closer to the viewer than those at the top, and (4) implied lines of recession that move diagonally, or in a series of zigzags, from bottom to top of the composition and remain more or less parallel rather than converging as in traditional Western perspective.

The steep ground planes and insistent diagonals can be particularly hard to read within the limited confines of the *hosoban* (*hoso-e*) format. Bunchō's portrait of Arashi Hinaji I receiving the applause of the audience (No. 2) is a case in point. The audience is crowded into the lower left corner, the floor boards of the stage run steeply up to the right in parallel diagonals, and a tree stands behind the actor in the upper right corner. Architectural details, especially those involving such features as *shōji* and *tatami*, which have no exact equivalents in the West, often cause the greatest difficulty for those unfamiliar with these spatial conventions. The cropping and crowding imposed by the narrowness of the format also contribute to the difficulty, as a glance at Numbers 3, 6, and 7 will make clear.

Shunshō used these traditional Japanese spatial conventions much more sparingly. From the start he seems to have preferred to present his subjects head-on rather than from above, which necessitated a lower horizon line. There are exceptions, however, such as Number 69 and, most notably, the illustrations for *Seirō Bijin Awase Sugata Kagami* (No. 75). In the latter instance, the wish to be stylistically consistent with his collaborator may have been a determining factor.

Shunshō was not the first *ukiyo-e* artist to employ a low horizon line and a head-on view of his subjects, but he *was* the first to do so— and do so consistently— after the development of full-color printing, amid a new em-

phasis on placing figures in spatial settings. Moreover he chose to do so at a time when the most influential *ukiyo-e* artist of the period, Harunobu, seemed to be moving in another direction. As it turned out, history sided with Shunshō. By the 1780s most *ukiyo-e* artists had abandoned the earlier spatial conventions.

Shunshō's Pupils and the Katsukawa School

In *The Japanese Print: Its Evolution and Essence*, Muneshige Narazaki and C. H. Mitchell asserted that "in all probability [Shunshō] was the most important and influential teacher in the history of ukiyo-e."[20] There is much to bear out this fairly sweeping statement. Shunshō taught a great many students, a high proportion of whom were significant, if not major, artists in their own right. Moreover some of these students had students of their own who kept the Katsukawa name alive well into the nineteenth century.

Shunshō's first student (or the first we know of) was Shunkō (1743–1812). Shunkō began designing prints and illustrated books in 1771 and soon acquired the nickname "Ko Tsubo" (Little Jar) because he used a jar-shaped seal similar to his master's. In 1791, at the age of forty-five, he suffered a mild stroke which deprived him of the use of his right arm. At this time he gave up print making but continued to paint, using his left hand and taking the studio name (*gō*) Sahitsusai, "Studio of the Left Brush." Clearly he was a man of no little courage and determination.

At first Shunkō followed his master's style quite closely, but in 1780 he designed two *aiban* actor prints (Nos. 112, 113) that are totally different from anything created in the genre prior to that time. Their distinctiveness lies in the degree to which Shunkō has moved in on his subjects, concentrating on their faces and the upper part of their bodies and cropping everything else. It is a technique so familiar today that we take it for granted, but it was completely without precedent at the time. The drama and intensity of these portraits must have startled contemporary viewers. Curiously, it seems to have taken some time before anyone— even Shunkō— began to follow up the possibilities of this new approach. It was not until 1788 that Shunkō designed the series of "big head" actor prints in *ōban* format that are now regarded as the direct forerunners of the *ōkubi-e* bust portraits made famous by Sharaku and others in the mid-1790s. What Shunkō himself might have achieved with this kind of print if he had not suffered a stroke is anyone's guess.

Shun'ei (1762–1819) was another of Shunshō's more successful followers. His earliest recorded work seems to be an illustrated book published in 1782, but his period of greatest activity— at least as a designer of actor prints— extends from the mid-1780s through the 1790s. This means that he was working in the same genre and at the same time as two artists, Tōshūsai Sharaku and Utagawa Toyokuni, whose subsequent fame has far overshadowed his. How their contemporaries viewed the relative merits of these three artists is much harder to determine. There is evidence to suggest that the Edo theater-going public found the very qualities we most admire in Sharaku's work, its intensity and exaggeration, too extreme for their taste. Did they find Shun'ei's prints, which generally seem less forceful to us, more to their liking?

Though Shun'ei's prints may seem somewhat diffident by comparison with Sharaku's, they do have a dramatic flair of their own. Richard Lane has written of the "pronounced element of facial exaggeration that adds to the individuality and dramatic force of [Shun'ei's] actor prints."[21] These qualities are particularly evident when one sets his work alongside that of his master. By comparison with Shunshō, Shun'ei's lack of reticence and penchant for striking effects seem almost glaring. These traits surfaced early in his work and were well developed by 1790, when he provided the spine-chilling illustrations for an extraordinary book of ghost stories called *Ima wa Mukashi* (Once Upon a Time).

In 1795 Shun'ei designed a group of prints commemorating concurrent performances of *Kanadehon Chūshingura* (Model for *Kana* Calligraphy: Treasury of the Forty-seven Loyal Retainers) at the Miyako and Kiri theaters (No. 132). The prints, which are in the large-scale *ōban* format, are all full-figure portraits of actors shown in isolation against a soft gray background. Because they are so similar in format and treatment, these prints inevitably invite comparison with Utagawa Toyokuni's slightly earlier *Yakusha Butai no Sugata-e* series. In general Shun'ei's portrayals seem less exaggerated and one suspects that they are truer to life. If so, that would certainly be in line with the Katsukawa tradition.

In the actor print genre none of Shunshō's other pupils equalled Shunkō and Shun'ei, though several, such as Shunjō, produced some work of merit (e.g., No. 136). At least one of his students, Shunchō (act. ca. 1780–1795), achieved considerable distinction as a designer of *bijin-ga* and is particularly well known for his handsome triptychs in the manner of Kiyonaga or the early Utamaro. Shunshō's best-known pupil, however, is one who is seldom associated with the Katsukawa school, and that is Hokusai (1760–1849). He began studying with Shunshō in 1778 and subsequently, under the name of Shunrō, produced a fair number of prints in his master's style. He left the Katsukawa school about 1795, two years or so after Shunshō's death.

The End of an Era

The last years of Shunshō's life were spent under the shadow of the Kansei Reforms of 1787–1793. The reforms, instituted in response to severe financial crisis in the shogunal government and the samurai class, began with purges of corrupt and inefficient officials and renewed attempts to restrict commerce and enforce sumptuary laws. They soon extended, however, to a more general crackdown on "inappropriate" behavior, particularly on the part of samurai. Levity was generally frowned upon; humor at the government's expense brought instant punishment. Idleness was not only considered unseemly but actively discouraged. The change in climate was clear, and samurai writers of popular fiction and comic or sardonic verse scurried for cover. Some, such as Ōta Nampo, entered government service; others simply chose to lie low. The convivial literary parties of the Temmei era (1781–1789), where samurai and chōnin openly mingled, quickly became a thing of the past.

The impact of these far-reaching constraints on the floating world and on ukiyo-e in particular is hard to assess. Yet there can be no doubt that with the arrival of the 1790s the entire look and spirit of ukiyo-e changed dramatically. The restraint that had characterized prints of the previous two decades disappeared in a quest for ever more sensational effects. This resulted, at first, in works of arresting presence and extraordinary glamour, such as the mica-ground bust portraits of beauties and actors by Utamaro and Sharaku. But this glorious blooming was momentary and seemed to lead nowhere. Sharaku ceased working altogether, and Utamaro's later prints are slack and uninspired. By the end of the century the great days of the figure print were over.

Seen from this vantage point, Shunshō's strengths and accomplishments stand out with particular clarity. He introduced a realism to the portrayal of Kabuki actors from which he never wavered. His portraits never degenerate into caricature and are never overdrawn, because he respected his subject matter too much to indulge in cheap effects. That same sense of respect animated everything he did. He had an uncanny sense for the dramatic, but even his most dramatic works are never sensational, never untrue to the theatrical experience on which they were based. He was clearly a man of measure, of balance, and an artist of extraordinary integrity. It would be hard to find a better exemplar of the classic period of ukiyo-e.

Notes

1 Shunshō's grave bears the date eighth day, twelfth month, fourth year of the Kansei era. By Western reckoning this falls in early 1793, though many scholars cite the date as 1792 since most of Kansei 4 falls in 1792. Many contemporary Japanese scholars state that he was sixty-seven when he died, making his date of birth 1726, but there is no evidence to support (or refute) this consensus. With this caveat, and for lack of any more exact information, this book employs the conventional birth date.

2 Prior to burial almost all Japanese are given posthumous names, usually with some religious significance. This custom further complicates historical research.

3 *Kare yuku ya/Ima so yū koto/Yoshi ashi mo* (Now the talking about either good or bad is withering away). The words *yoshi* and *ashi*, "good" and "bad," can also refer to two different species of reeds. Quoted in Gookin (1931).

4 See reference to Manzōtei in Okamoto and Kira (1985).

5 See Iwasaki (1984). This fascinating discussion of literary activity in Edo during the Temmei era draws particular attention to the extent of the samurai contribution to the light literature of the time and describes in detail the kinds of gatherings that brought samurai and *chōnin* together.

6 Hamada (1985), pp. 89–104.

7 Though an occasional portrait-like print had been produced earlier (one famous example is Okumura Masanobu's depiction of the storyteller Shikōden in the collection of The Art Institute of Chicago [1935.405]), likenesses were not common in actor prints prior to 1765.

8 Gookin (1931), pp. 79–80.

9 Such parodies, known as *mitate-e*, were a well-known genre of *ukiyo-e* already during the early eighteenth century. *Mitate-e* occur frequently in the work of Okumura Masanobu (ca. 1686–1764), among others.

10 Harunobu's *Yoshiwara Bijin Awase* of 1770, though ultimately quite different in concept (there are no settings and the women are shown one to a page), provided something of a precedent. (This work is also known as *Seirō Bijin Awase* or as *Yoshiwara Seirō Bijin Awase*.)

11 Narazaki and Mitchell (1966), p. 106.

12 The scrolls were in the possession of the Matsuura daimyo family of Hirado until well into the twentieth century. See Narazaki (1982), pls. 13–24 and pp. 38, 122–28.

13 See Hayashi (1963).

14 Hillier (1988), vol. 1, p. 345.

15 Narazaki and Mitchell (1966), p. 106.

16 Rose Hempel, as quoted in de Bruijn (1979), p. 20.

17 The diptych, one of the few known instances of such a collaboration, is reproduced in Narazaki and Mitchell (1966), p. 100, pls. 29, 30.

18 Ibid., p. 98, pl. 28.

19 A white pigment derived from seashells.

20 Narazaki and Mitchell (1966), p. 102.

21 Lane (1978), pp. 122, 327.

Edo Kabuki in the 1780s

TIMOTHY T. CLARK

"So, why don't you go over to Higurashi for the day?"

"I would prefer the theater."

"You could take the boat to Fukagawa for the day."

"I prefer the theater."

"Won't you come to the festival on the fifteenth?"

"I prefer the theater."

This is what you call "liking something better than food."

> — Maids looking at a playbill, from *Yakusha Natsu no Fuji* (Actors: Mt. Fuji in Summer), by Ichiba Tsūshō, illustrated by Katsukawa Shunshō, 1780 (fig. 1).

Theater Row

Evening of the seventeenth day of the tenth month, 1784, and the weather in Edo (present-day Tokyo) is clear and pleasant but rather cold.[1] It is on this evening that the new Kabuki theater season can truly be said to begin, for in theater dressing rooms and theater teahouses (*shibai-jaya*) the acting companies for the coming season are assembling, in a ceremony known as "first coming-together" (*yorizome*).[2] At some point in the proceedings the actors gather in the street in front of their theater and formally greet the management: this is the scene drawn by Torii Kiyonaga (1752–1815), artist of the popular "Floating World" (*ukiyo-e*) school, in an extra-large (*bai ōban*) color woodblock print (fig. 2).[3]

On the far right is the main public entrance to the Naka-mura Theater, flanked by lanterns bearing the theater's gingko-leaf crest and auspicious flying cranes. Just to the left of this entrance are the green reed blinds and lanterns of the management office and ticket counter (*shi-kiriba*) and then another door leading to the boxes (*sajiki*). A long signboard half cut off by the right-hand border of the print reads: "[We will be staging] a new opening-of-the-season play from the first day of the coming eleventh month, year of the dragon [1784]." In front of the main public entrance a group of theater employees are clapping with raised hands— a common ritual for auspicious occasions. In this they are led by the actor Ichikawa Dan-jūrō V, who wears a long black *haori* jacket and faces to the right.

The name Ichikawa Danjūrō is the most prestigious in Edo Kabuki, passed from generation to generation. The present incumbent, Danjūrō V— easily recognizable by his large nose and small, close-set eyes as well as by the crest on his sleeve of a carp leaping a waterfall— is in his early forties, at the height of his powers, and considered the leading actor of his day. He appears in many of the actor prints in this volume. Behind Danjūrō V stands Ichikawa Yaozō III, another mainstay of the Ichikawa act-ing dynasty, holding the hand of Danjūrō V's six-year-old son, who had made his precocious debut under the name of Ichikawa Ebizō IV some two years earlier. Behind the Ichikawa group is the rest of the season's company, dressed in formal *kamishimo* (wide-shouldered surcoats and wide trousers) over their kimono, in the order of precedence appropriate on such a ceremonial occasion. A bevy of female impersonators (*onnagata*— all female parts were played by men), wearing the required purple head kerchief (*murasaki bōshi*) and "feminine" kimono with long hanging sleeves (*furisode*), are led by Mimasu Tokujirō I (an Osaka actor working in Edo for the sea-son) and Nakamura Rikō I. Then comes Sawamura Sōjūrō III, a handsome young male lead in his early twenties, side by side with Ōtani Hiroemon III, shown as a graying elderly man (actually in his late fifties) look-ing to the left. These are the leading actors at the Naka-mura Theater for the 1784–1785 season; those crowding in behind them will be performing minor supporting roles. In two weeks time they will open the season with the *kaomise* (literally, "face showing") production *Ōakinai Hiru ga Kojima* (Prosperous Business on Hirugashima Island). In the foreground servants squat beside large lan-terns bearing the crest of each leading actor.

Edo, with a population of over a million, was one of the largest cities in the world in the eighteenth century. Its three Kabuki theaters, all government-licensed, were lo-cated in the heart of the downtown area: the Nakamura in Sakai Street, the Ichimura in continuing Fukiya Street (on the right at the far end of the street in Kiyonaga's print, fig. 2), and the Morita close by in Kobiki Street. Tucked in among these large playhouses were dozens of theater teahouses, their names blazoned on lanterns hung out-side. Teahouses provided refreshments during the inter-vals, served as convenient places for actors to meet their patrons, and acted as intermediaries in arranging box seating for wealthy clients.

In Kiyonaga's print the women leaning over the upstairs balconies of the teahouses have an excellent view of the festivities below, and it is important to note that Danjūrō V, though a superstar, is out among his public, arousing by his mere presence their support and patronage during the coming year. Individual productions succeeded or failed in large measure according to the skill of the actors and musicians on stage, but Kabuki as a whole enjoyed a huge reserve of popular support, both financial and emotional. Actors and audience inhabited the same world— the close-knit, downtown world of crowded two-story tile-and-timber buildings— a world which was very much the preserve of the artisans and merchants, the so-called townsman (chōnin) class. If the feudal lords or their samurai retainers from the large mansions surrounding Edo castle, seat of government of the Tokugawa shoguns, attended the Kabuki theater— and this was not uncommon— they mingled with the townsmen on the townsmen's terms, forgoing for the occasion their entitled forms of respect. Kabuki theater was a popular obsession, perhaps *the* main focus and expression of townsmen's values. Sakai Street and its environs were a separate world, Theater Row.

A glimpse can be had into that vanished world by relating the events surrounding a typical opening-of-the-season (kaomise) production, the grandest event in the theatrical calendar, by describing the theaters and theater teahouses, and by touching on the personalities of a leading actor and his illustrious patron. The kaomise productions were highly structured affairs, with strict conventions governing such matters as the sequence and general content of the acts, the stage sets, and the types of musical accompaniment. The production that will be considered in detail was a new drama entitled *Jūni-hitoe Komachi-zakura* (Twelve-Layered Robes: Komachi Cherry Tree), which admirably illustrates all these various conventions and exemplifies the highly convoluted, often fantastic plots of Kabuki in the An'ei (1772–1781) and Temmei (1781–1789) eras. It was specially written for the opening of a new theater, the Kiri (competitor of the Nakamura described above), to serve as its kaomise production in the eleventh month of 1784.

The Kiri "Temporary" Theater

Kiyonaga's large color print of actors gathering in front of the Nakamura Theater in the tenth month of 1784 (fig. 2) clearly shows the curtained turret (yagura) of the rival Ichimura Theater at the far end of the street (actually Fukiya Street, the continuation of Sakai Street) on the right-hand side. In this Kiyonaga was exercising artistic license, for after years of accumulating debts compounded by unusually frequent destruction by fire, the Ichimura Theater had been forced to close in the fourth

month of that year and by the beginning of the sixth month the building had been completely demolished.[4] Such closure was relatively commonplace for the Morita, always the lowest-ranking and financially the most precarious of the three government-licensed theaters, but this was the first time in its more than one-hundred-and-fifty-year history that the Ichimura had succumbed in this way. Plans were immediately put forward, however, to open a new theater on the site, and the appropriate office of the feudal authorities, the city magistrate (machi bugyō), was petitioned accordingly. The new managers, the Kiri family, boasted a history of two hundred and forty-five years' involvement in the theater, and an exhaustive account of their theatrical genealogy was published in a printed broadsheet (fig. 11), presumably in an attempt to impress both the city magistrate and the theater-going public with the viability of the new venture.[5]

On the eighteenth day of the tenth month (the day after the ceremony shown in fig. 2) permission was duly granted for Kiri Chōkiri to operate a "temporary theater" (kari shibai or kaeyagura) for a period of five years. The whole exercise can in fact be seen as a legal maneuver, probably on the part of Ichimura Uzaemon IX, to evade the crushing debts the Ichimura Theater had incurred.

On the very same day the empty site of the old Ichimura Theater was fenced in and banners raised bearing the name of the new Kiri Theater. On the twenty-second the turret went up at the front of the building, and three days later an army of workmen moved in. This may seem very fast work, but theaters were often destroyed completely by the great fires that swept the city every few years or so and were designed as simple timber-and-tile edifices which could be reconstructed in a matter of days.

The Theater Diary of Lord Yanagisawa Nobutoki

At this point in the narrative of events we can switch to the more personal account provided by Lord Yanagisawa Nobutoki (1724–1792), retired lord of the Kōriyama fief and ardent theater fan, in his diary, *Enyū Nikki* (Diary of Banquets and Pleasures).[6] Lord Yanagisawa had relinquished his official duties in 1773, at the age of fifty, and retired to a villa at Somei in the Komagome district of Edo to pursue his twin passions: composing haikai (haiku) poetry and attending the Kabuki theater.[7] He also commenced a diary, written every day of the next thirteen years, that mentions no fewer than one hundred and nineteen visits to the three Edo Kabuki theaters.[8]

This in itself would have been unusual in a member of the feudal aristocracy, whose appropriate entertainment was considered to be the venerable, august, and poetical

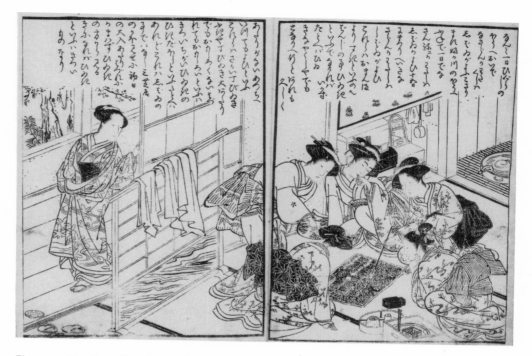

あさりがら一口ひらくの
かうべよそ
ほそんうくほそ
そじなごてこちら
てのかさいすびなき
でもありこくくなこう
でもありごくくなこ
さん猫こ門のかこ
子で二日でな
さん猫こ門
そのうくひきち
さらうくひきち
そのうくなんすの
ちらくがもん
しびらんがもん
それつらこちまは
より子さいこめへ
んとのすびなんも
とつとそれが
たくびなん
さるやらをても
そろうくきとられも
とくーく

あらつくないあうち
んすてもよさくと
それくこらいちびなき
の人さあさうかれふ
のくそくそふ初日
あれどこれにそくの
さてこ一て芝店
あれどこれにそくの
すでしいへきち初日
きよいちちいひんた
ひびらたからと云さい
そのいちちいひん
きよいちちらい
てもありんちくべ
でもありこくくなこ
きふられがひんた
とくびそらぎらい
ものなり

Figure 1. Katsukawa Shunshō. *Maids looking at a playbill.*
From *Yakusha Natsu no Fuji*. British Museum, London

Figure 2. Torii Kiyonaga. *Gathering of actors in front of the Nakamura Theater*. Museum of Fine Arts, Boston

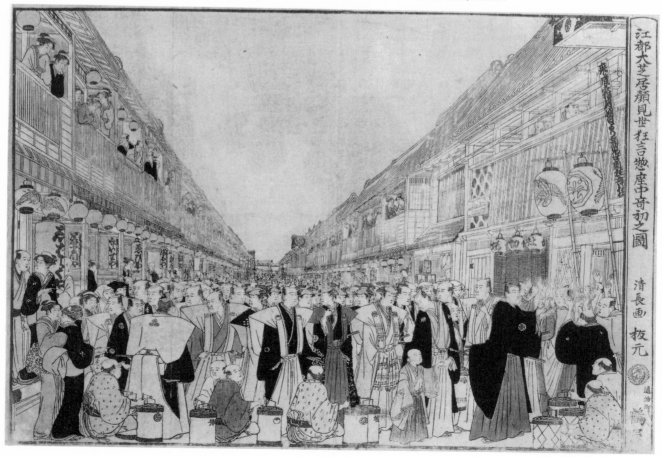

Nō drama rather than the melodramatic and low-class Kabuki, but Lord Yanagisawa's enthusiasms went much further. Several times a year he had a stage constructed inside his mansion and put on amateur Kabuki theatricals, generally of plays written by himself. The "actors," to whom he assigned professional-sounding names such as Ichikawa Benzō or Bandō Shitsugorō, were none other than the maids of his household. Following the performance he would write critiques of the "actors," and on one occasion he even commissioned color woodblock prints to immortalize their efforts (by one Beisha, an otherwise unknown artist).[9]

Such an un-lordly mania for Kabuki became a focus of popular gossip and was parodied in the comic illustrated novel (kibyōshi) Kyōgen-zuki Yabo Daimyō (The Theater-Mad Boorish Lord) of 1784, with text by Kishida Hōsha and illustrations by Kitao Masayoshi.[10] Umanosuke, the fictional young lord, becomes so enthralled with the theater that he commands his retainers, in language peppered with stage jargon, to act out scenes. Courtesans from the exclusive Matsubaya house of pleasure are even invited to the mansion to put on the famous play about the Soga brothers' revenge! One illustration from the book (fig. 3) shows the young lord seated on the verandah of his mansion, issuing instructions. He wears a summer kimono decorated with the triple-rice-measure (mimasu) crest of the leading Ichikawa acting dynasty, and the cloth cap of a theater-going dandy, and he holds his pipe with studied nonchalance—the very epitome of the man-about-town. At Kabuki a common curtain-raiser was a scene in which minor actors played servants: while sprinkling water to freshen the ground outside a feudal mansion, they warmed up the audience with gossip about the leading stars. In the illustration Lord Umanosuke has his real servants doing just this, to the lively rhythm of a hand drum, but the text has him complaining, "You're all sprinkling water like I said, but if you don't gossip about me it just won't be like real theater."[11] Lord Yanagisawa was quite likely the direct object of this satire.[12]

Lord Yanagisawa's diary reveals that he was in the habit of exchanging gifts with many leading actors, but makes clear that he extended special patronage to the veteran of villain's roles Nakamura Nakazō I (1736–1790, referred to in the diary by his pen name, Shūkaku). It was Nakazō I who would lead the troupe at the new Kiri Theater in the kaomise production Jūni-hitoe Komachi-zakura. Lord Yanagisawa would attend a performance and write about it in his diary. But before "accompanying" the theater-mad lord to the play, let us examine the career of this actor who, perhaps more than any other, typified the Edo stage in the 1770s and 1780s.

The Actor Nakamura Nakazō I (1736–1790)

Nakazō I probably appears in more prints in this volume than any other actor. His career took off in 1766, just as Shunshō was beginning to design actor prints, and he died in 1790, just two years before the artist. Both men seem to have striven toward a new degree of realism in their respective professions; Shunshō for a recognizable likeness of actors' faces (nigao-e), Nakazō I for a reinterpretation of such traditional roles as the robber and murderer Sadakurō in Chūshingura (Treasury of the Forty-seven Loyal Retainers) and the villain Kudō Suketsune in Soga plays. Particularly revolutionary was his interpretation of Sadakurō in act five of Chūshingura, "Murder on the Yamazaki Highway," in the production that opened in the ninth month of 1766. From the plot Nakazō I reasoned that Sadakurō should not be played as a loutish mountain bandit but as a masterless samurai (rōnin) fallen to evil ways and hard times. Thus he dressed in a tattered black kimono with allover white body makeup and an unkempt wig with half an inch of hair grown out on the normally shaven pate. Since the scene took place during a storm at night, he doused himself with a bucket of water before coming on stage and carried a battered snake's-eye umbrella.[13] Shunshō and his pupils designed several prints of Nakazō I as Sadakurō in various of the eight productions in which he acted the role: a hosoban from 1768 in which he appears every inch the slick young killer (fig. 73.1); the striking large fan print from the series Azuma Ōgi (Fans of the East) of 1776 (No. 73); and a hosoban by Shun'ei from 1786 (No. 122), twenty years after he first performed the role, in which, though still vigorous, he sports a portly belly. After his success as Sadakurō, Nakazō I came to specialize in the roles of evil lover (iro aku) and out-and-out villain (jitsu aku).[14]

Though not tall, Nakazō I had great masculine presence, and was praised for the expressive power and variety of his facial expressions. The fact remains, however, that although many of Nakazō I's costumes offered a new realism of appearance, his acting style was grand and artificial and his delivery of lines completely unrealistic and old-fashioned.[15] His voice was inelegant, described in an actor critique (yakusha hyōbanki) of 1786 as even "painful to listen to" (kiki-gurushii).[16] Nakazō I can thus be seen as an important transitional figure, master of an acting style halfway between the fantasy and bombast of the original Edo Kabuki of the late seventeenth and early eighteenth century and the realism of the contemporary domestic dramas (sewamono) which would be written by Tsuruya Namboku IV in the early nineteenth century. Nakazō's acting style to a very considerable extent characterized Edo Kabuki of the 1770s and 1780s as a whole.

Nakazō I excelled also as a dancer. His father was a masterless samurai called Saitō, but his parents separated and

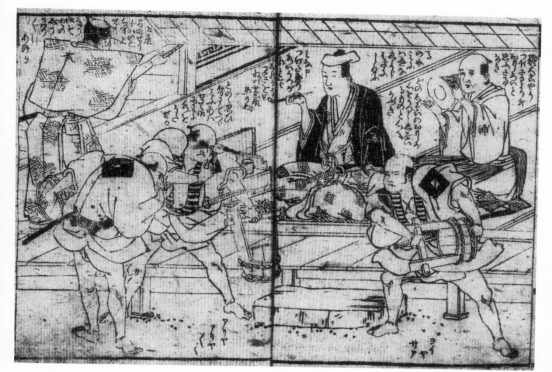

Figure 3. Kitao Masayoshi. *Amateur Kabuki.* From *Kyōgen-zuki Yabo Daimyō*. Tokyo Metropolitan Central Library, Hiroo

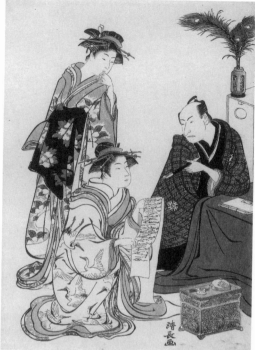

Figure 4. Torii Kiyonaga. *The actor Nakamura Nakazō I and two courtesans.* British Museum, London

Nakazō I was brought up from the age of five by Shigayama Oshun. The Shigayama family were dance masters at the leading Nakamura Theater, and Oshun's husband was the famous *nagauta* stage singer Nakayama Kojūrō III.[17] The early training Nakazō I received from them in the dance and music of the theater was to stand him in good stead. From the mid-eighteenth century onward mimetic dancing (*shosagoto*) came to play an increasingly significant role in Edo Kabuki; such dancing, in combination with *jōruri* chanting to *shamisen* accompaniment (borrowed from the puppet theater), formed the brilliant dance sequences with onstage musical and chanted accompaniment (*jōruri shosagoto*) that customarily brought a *kaomise* performance to a close. In these sequences dialogue would be interspersed with singing to *shamisen* accompaniment, as onstage musicians took up the narrative while actors danced, often miming the events of the text.[18] The highlight of the play *Jūni-hitoe Komachi-zakura* would be these final dance sequences.

In the mid-eighteenth century dancing was generally the province of the great female impersonators (*onnagata*), Segawa Kikunojō I and Nakamura Tomijūrō I, who brought the new style to Edo from their native Kamigata (the Kyoto-Osaka region of western Japan). Nakazō I seems to have been active in introducing male lead characters (*tachi yaku*) into these dances, bringing to them his own particular blend of "fantasy, cruelty, and humor," to produce the mature full-length dramatic dance sequences

(*buyō geki*) of the 1770s and 1780s.[19] For instance, Nakazō I wanted to dance "Musume Dōjō-ji" (Maiden at Dōjō-ji), the story of a young woman's consuming, unrequited passion for a young monk of the temple Dōjō-ji, but this was the special preserve of the two aforementioned female impersonators, Kikunojō I and Tomijūrō I. So the playwright Kawatake Shinshichi devised an ingenious alternative version of "Dōjō-ji," in which the evil monk Dainichibō appeared disguised as a woman selling hare's-foot fern (*shinobu*), and Nakazō I first performed the *Shinobu Uri* (Seller of Hare's-foot Fern), including a dance sequence, to great acclaim at the New Year of 1775.

Nakazō I was exceptional among eighteenth-century actors in being also a writer, mostly of diaries. Sadly, however, what survives is both fragmentary and often in the form of corrupted later copies.[20] The style is colloquial, even brusque, with little in the way of literary flourish, and paints a vivid picture of Nakazō I's childhood ("I soiled and wet the bed night after night").[21] It also provides firsthand (highly partial) accounts of the great backstage storms and scandals of the day. These include the sudden exodus from the troupe of Danjūrō IV and V plus three other leading actors in the fifth month of 1774,[22] leaving Nakazō I the mainstay of the Nakamura Theater; or the incident in the eighth month of 1778, when Danjūrō V publicly criticized Matsumoto Kōshirō IV and Iwai Hanshirō IV in a pre-performance speech from the stage, after Kōshirō IV had spread

rumors of an affair between Danjūrō V and Ichikawa Yaozō II's widow, Oruya.[23] Nakazō I was in fact a pupil of Danjūrō IV in all but name, having been permitted to attend his lectures on the art of acting in the later 1750s.[24] He remained a loyal colleague to the young Danjūrō V, often playing the arch-villain opposite Danjūrō V's consummate hero.

In general Nakazō comes across as a highly conscientious, hard-working actor who, without the advantage of birth into a prominent theatrical family, succeeded in reaching the highest levels of his profession. Once established, he was punctilious in his loyalty to those who had helped him: breaking his contract with the Kiri Theater and returning to try to restore the fortunes of the Nakamura in the eleventh month of 1785; or taking the name Nakamura Kojūrō IV in memory of his deceased adoptive father and reviving the Shigayama school of dancing of his adoptive mother.

Two pictures of Nakazō I in "private" life in the 1780s, at the height of his career, present disparate impressions of the man. The first is a lovely *aiban* color print (fig. 4) from a series by Kiyonaga showing leading actors, each with two courtesans from the Yoshiwara pleasure district; the series dates from about 1783, and eleven of the prints are known. Nakazō I sits at a covered brazier (*kotatsu*), smoking, while a courtesan reads him a letter. The courtesan's young apprentice (*shinzō*) stands behind, giggling. The book box behind Nakazō I and the book lying on the brazier hint, perhaps, at his writing interests. The juxtaposition of Nakazō I and the two young beauties, however, is most likely factitious, though persuasively beautiful; there is no evidence that Nakazō I was intimate with any particular courtesan. The public idolized actors and courtesans, and probably Kiyonaga was simply catering to that public— perhaps to its fantasies— by presenting the idols in tandem.

An illustration by Shunshō from the book *Yakusha Natsu no Fuji* (Actors: Mt. Fuji in Summer) of 1780 is much more specific in its references (fig. 5). Nakazō I, seated with his back to the tokonoma alcove, is holding audience for actors of the Nakamura lineage: the female impersonator Rikō I, in feminine attire, holds out a sake cup, and behind him sit respectfully Yoshizō, Konozō, and Dengorō, their faces carefully differentiated (*nigao-e*) in the manner of single-sheet prints. Nakazō I is perhaps lecturing from the open volume in front of him, and prominent on the table behind him is a pile of books marked "diary" (*nikki*). Clearly his diary was well known even at the time. The serious atmosphere of this scene accords better with what we know of Nakazō I's character from his writings. Except for Rikō I, the female impersonator, each of the actors bears on his sleeve Nakazō I's alternative crest (*kaemon*), the stylized character for "man" three times side by side. Legend

has it that Nakazō I vowed to become one of the three greatest actors in Japan and had the superstitious habit of tracing the character for man three times on his palm with one finger just before going on stage.[25] He certainly fulfilled his ambition.

A Trip to the Kiri Theater

Nakazō I's wife, Okishi, died on the second day of the tenth month, 1784,[26] and on the fifteenth Lord Yanagisawa paid a condolence call, bringing the actor a present of buckwheat noodles (*soba*).[27] The feudal authorities classified actors as "non-persons" (*hinin*), a pariah class excluded from normal society; yet what could belie this empty law more poignantly than the visit of the retired feudal lord to his old friend the actor, to console him in his bereavement. Preparations for the *kaomise* performance to be led by Nakazō I at the new temporary Kiri Theater went ahead despite Nakazō's loss. On the eighteenth day Lord Yanagisawa received a note from Nakazō I saying that construction work had begun on the theater (as we have seen, p. 28), and on the twentieth he purchased a printed announcement for the new Kiri Theater from a vendor in the street at Nakabashi.[28] When he walked past Fukiya Street on the twenty-fourth, he noted, "Construction is in full swing on the Kiri Theater. . . . the turret is up and the entrance way completed."

On the twenty-seventh he received from the Sakaeya Theater Teahouse a printed sheet listing the new company of actors (*yakusha tsuke*) for the Kiri Theater. And on the same evening Nakazō I sent two more copies of the same sheet, one for the lord's wife, Oryū. There is a further note in Lord Yanagisawa's diary that these were delivered first to the head of the acting troupe (*za-gashira*, who was Nakazō I), distributed (privately) that evening, and then put on (public) sale the following morning.[29] The sheet referred to is almost certainly a *kaomise banzuke* (opening-of-the-season playbill) (fig. 6). This single *ōban*-sized sheet, printed in black and white, simply lists the actors and musicians who will be working at a particular theater for the coming season. Their names appear at the top (larger characters for more prominent actors) and their pictures at the bottom (leading actors in the center). At top center is the curtain of the theater, bearing its paulownia (*kiri*) emblem. As yet there is no mention of the title of the forthcoming play.

On the fourth day of the eleventh month, another gift of buckwheat noodles from Shinano Province was sent to Nakazō I,[30] and on the ninth Lord Yanagisawa received a *Kiriza banzuke* (playbill for the Kiri Theater). This might have been a *yakuwari banzuke*, which matched the actors to their roles, or else the printed sheet giving the family tree of the Kiri Theater managers (fig. 11). On the thirteenth he got word from Sana (of the Wakazuruya

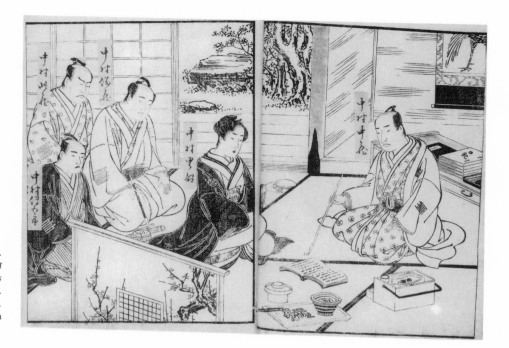

Figure 5. Katsukawa Shunshō.
*The actor Nakamura Nakazō I
holding audience for actors
of the Nakamura lineage.
From Yakusha Natsu no Fuji.*
British Museum, London

Figure 6. Torii Kiyomitsu. *Opening-of-the-season playbill* (kaomise banzuke) *for the Kiri Theater.* Akiba Bunko, Tokyo University Library

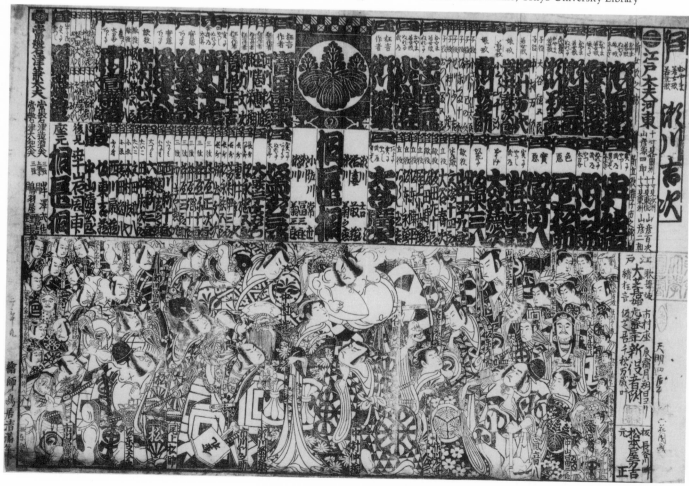

Theater Teahouse?) that performances had begun.[31] Negotiations were conducted with the teahouse for places in boxes (normally a box held seven people), and the trip to the Kiri Theater was fixed for the twenty-eighth.[32] The night before it was decided which retainers would accompany him.

At about seven in the morning on the twenty-eighth a group of eight retainers and ladies-in-waiting were sent ahead, with additional maidservants. Oryū, Lord Yanagisawa's wife, went in a palanquin with five retainers, but his lordship preferred to walk, accompanied by two retainers.[33] They went to the Wakazuruya Theater Teahouse, to find that Nakazō I had been sending people all morning to see if they had arrived. After meeting Nakazō I "with his wig off," word came that the company was going to repeat a scene and skip another scene in which Nakazō I did not appear. Then a messenger arrived to say that the "Shibaraku" scene (see below, p. 39) was about to begin, and so the party proceeded directly to boxes five, six, and seven on the west side of the theater.

Theaters and Theater Teahouses

We have already seen Kiyonaga's large print of the theater street during the *yorizome* (first coming-together) ceremonies (fig. 2). In the early 1770s the *ukiyo-e* artist Utagawa Toyoharu (1735–1814) designed a view of the same street on the night before the *kaomise* performances were to begin (fig. 7). This is the kind of scene that would have greeted Lord Yanagisawa and his retinue: the sky still largely dark, but with a glimmer of dawn on the horizon; the street thronged with theater-goers; large painted signboards by artists of the Torii school showing scenes from the plays, lit by lanterns above the entrance to the theater; front-door entertainers (*kido geisha*) seated on platforms by the entrance, dressed in *haori* jackets with scarves around their heads, waving fans and imitating the actors— while to one side employees sold door passes (*tōri fuda*).

Before their arrival during the third act, and between acts, the party retired to the Wakazuruya Theater Teahouse for refreshment. An illustration by Kiyonaga from the book *Ehon Monomi ga Oka* (Picture Book: Hill With a View), published in 1785, shows the second-floor parlor of such a teahouse, with a wealthy patron seated in the center attended by women and an *onnagata* actor (fig. 8). Decorating the first-floor balcony over the street are branches of artificial plum flowers, hung with poem slips (*tanzaku*), for the eleventh month was New Year in the theater world and required the flower appropriate to New Year (never mind that it was actually midwinter!).

Another perspective print (*uki-e*) by Utagawa Toyoharu, from the later 1770s or 1780s, shows the interior of the Nakamura Theater while a performance is in progress (fig. 9). We are at the back of the theater looking toward the stage at the far end, which still retains the gabled roof of the medieval Nō stage from which it ultimately derived. A female impersonator (*onnagata*) in travelling costume is making an entrance along the *hanamichi* (literally, "flower path") on the left-hand side, a raised walkway which passed through the audience from the *kirimaku* curtain at the back to the main stage. The most expensive seats are the boxes (*sajiki*) raised up along the east (right) and west (left) sides, some eighteen times the price of a place in the ground floor *kiriotoshi*, the "crush" directly in front of the stage.[34] Even cheaper is the *rakan-dai* enclosure behind the stage whence the spectator can see only the backs of the actors, so named because the spectators are ranged (standing) in ranks, like statues of enlightened sages (*rakan*) in a Buddhist temple. The triangular wedge of floor between the *hanamichi* walkway and the west side is known as the *ōkubi*. From the ceiling hang lanterns bearing the crests (*mon*) of the actors, and above each box hangs a lantern with the name of the theater teahouse that is renting it out. Daylight floods in to illuminate the stage from high windows along each side, for candles are a fire hazard. The curtain, here shown drawn to one side, is pulled along a rail above the front of the stage. Music and sound effects emanate from the small room with lattice blinds (*geza*) at the back right of the stage. The area backstage is described in the commentary to Shunshō's prints of actors in their dressing rooms (Nos. 93–95).

The theater served as a meeting place for a wider cross section of Edo society than perhaps any other institution: from feudal lords and high-ranking courtesans in the boxes to manual laborers on the ground floor. *Kabuki no Hana* (Flowers of Kabuki), a popular novelette (*sharebon*) published in the spring of 1782, consists mainly of conversations between members of the audience at a Kabuki theater and goes to great lengths to introduce a wide range of social types and to describe their characteristic dress and reproduce their characteristic (and often comic) speech. An old man and his teenage daughter from out of town encounter the sharp-tongued doorman; a teacher of amateur Kabuki arrives with his pupils dressed like actors (presumably in *haori* bearing actors' *mon*); maids from a feudal mansion fix their makeup in the toilet; a samurai in the already crowded floor area has an argument with some young toughs who want to squeeze their way in; theater connoisseurs entertain young male prostitutes and middle-ranking actors in a downstairs box; five upper boxes on the east side are occupied by Yoshiwara courtesans and clients, with the samurai in the adjoining boxes trying to strike up a conversation (Shunshō depicts a similar scene in *Yakusha Natsu no Fuji*, fig. 10); three

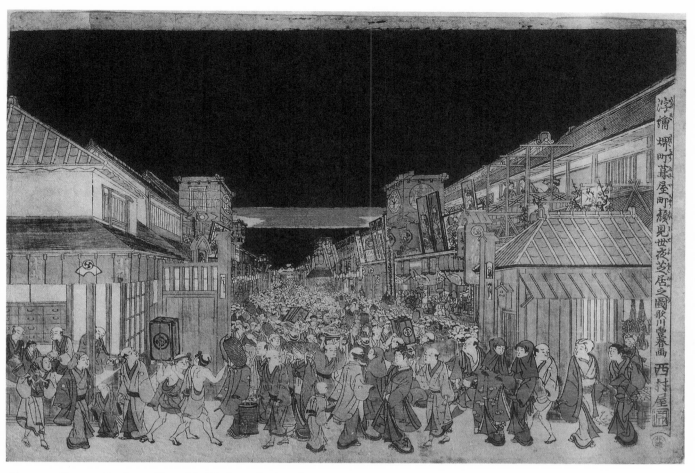

Figure 7. Utagawa Toyoharu. *View of the Edo theater district at dawn,*
just before the beginning of a kaomise *performance.* Tokyo National Museum

Figure 8. Torii Kiyonaga.
Second-floor parlor of a theater teahouse.
From *Ehon Monomi ga Oka.*
British Museum, London

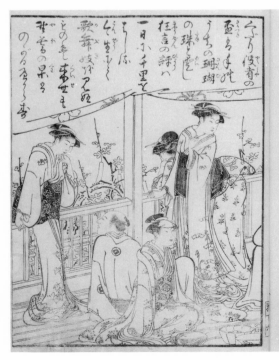

matrons in the floor area decide they have not brought enough food with them....[35] Toyoharu's print shows an audience far from hushed or reverential: they chatted and snacked during the performance, with hawkers peddling food and tea along the eastern walkway through the auditorium (*higashi no hanamichi*).

Lord Yanagisawa, of course, knew many in the audience and was continually sending and receiving gifts of food and sweets. At the performance on the twenty-eighth day of the eleventh month, 1784, the boxes next to his were taken by the retired Lord of Akizu, his daughters, and seven or eight women, who were visited by a steady stream of the principal actors at the end of the performance. He recorded also that "someone dropped a wooden sandal from the third floor which landed amongst the samurai at the front of the floor (*kiriotoshi*). There was a bit of an altercation, and the play was briefly interrupted."[36]

The Play: "Jūni-hitoe Komachi-zakura" (Twelve-Layered Robes: Komachi Cherry Tree)

Lord Yanagisawa began watching the play at the "Shibaraku" scene (see p. 39 below), the third act (*santateme*) of the first part (*ichibamme*), which by custom was the point where the plot really got going. Before this, however, since the first light of dawn, various preliminary ceremonies and short skits would have been presented, as required by the strict traditions governing the structure of a *kaomise* production. By the day of Lord Yanagisawa's visit, the play had been on the boards for several weeks, but at least during the first three days of the run the auspicious dances described below would have been performed.

Since this was the first performance in the new Kiri Theater as well as the opening of the season, the day began with a speech and performance by the new manager, Kiri Chōkiri. He entered down the *hanamichi*, wearing court robes, a gold headdress, a long sword, and carrying a ceremonial fan (*chūkei*). The stage was laid with polished boards and hung with a curtain painted with an ancient pine tree, in imitation of a Nō theater.[37] A blanket was spread and he knelt to address the audience, as illustrated on the printed sheet sold or distributed to mark the occasion (fig. 11). The text of this sheet relates the genealogy of the Kiri family and something of their long association with the theater; this was probably also the substance of Chōkiri's speech. Then the musician Tanaka Satarō III brought a large drum (*ōdaiko*) on stage, and to its accompaniment Kiri Chōkiri danced and chanted in Nō style a battle piece, which was the forte of the Kiri family, and a cherry tree dance.

This done, the *kaomise* itself began, against the same Nō style backdrop, with a performance of *Okina Watashi*, also shown in a special printed sheet (fig. 12). *Okina Watashi*, with its solemn Nō chanting and slow, stylized movements, provided a suitably formal, quasi-religious opening for the new season, being an invocation at once for peace in the realm, a bounteous harvest, and prosperity for the Kabuki theaters.[38] The cranes-and-pines hexagonal diaper decorating the robes of the three dancers all symbolize long life. Okina (center) was danced by Ichimura Uzaemon IX, former actor-manager of the Ichimura Theater, and Sambasō (left) by his son, Ichimura Kamezō II, with Senzai (right) played by Azuma Tōzō III. Clearly, even though the Ichimura Theater had closed in name, the Ichimura family was still taking a major role in the proceedings.

Now the play proper could begin. *Jūni-hitoe Komachi-zakura* was, as custom demanded, a historical piece (*jidaimono*), set in the ninth century (the courtly Heian period) and mingling events of a failed attempt to depose an emperor (the Jōwa Incident) with the characters of three of the so-called Six Immortal Poets (Rokkasen): Yoshimine no Munesada (Bishop Henjō), Ono no Komachi, and Ōtomo no Kuronushi. Prominent in the plot were two parallel love affairs, between the courtier Yoshimine no Munesada and Ono no Komachi and between Munesada's younger brother Yasusada and the courtesan Sumizome. The villain, Ōtomo no Kuronushi, was of the well-established "evil courtier (*aku kuge*) who seeks to seize power" type. *Kaomise* plays were, as a rule, not intended to be repeated and were often strung together from previously written material. *Jūni-hitoe* took many elements from an earlier play, *Kuni no Hana Ono no Itsumoji* (Flower of Japan: Ono no Komachi's Five Characters), performed at the Nakamura Theater in the eleventh month of 1771, and its antecedents go back even further. This patchwork approach to play writing is reflected in the number of "authors": *Jūni-hitoe* was created by Segawa Jokō (elder brother of the *onnagata* actor Segawa Kikunojō III), Takarada Jurai, and no fewer than five other writers.

The play culminated in the dance sequence *Tsumoru Koi Yuki no Seki no To* (Love upon Love: Snow Piled at the Mountain Barrier)—known simply as *Seki no To* (The Mountain Barrier). *Seki no To*, a dance sequence to Tokiwazu school chanting, was the one new element added to older material in 1784 and, significantly, is the only part of the play still performed today. As already stated, eighteenth-century Edo Kabuki was increasingly influenced by the more realistic styles of the "contemporary domestic dramas" (*sewamono*) that were the forte of Osaka and Kyoto actors. By the later eighteenth century it was customary for the first part (*ichibamme*) of an Edo *kaomise* to be a historical drama (*jidaimono*) and the second part

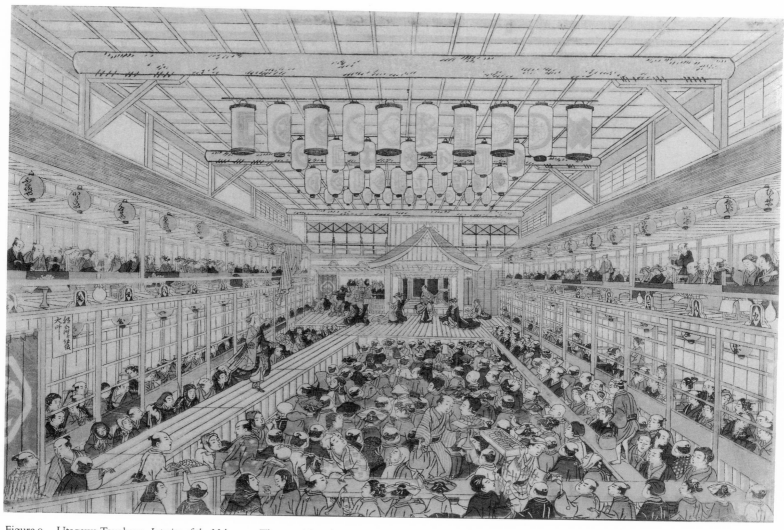

Figure 9. Utagawa Toyoharu. *Interior of the Nakamura Theater with a play in progress.* The Art Institute of Chicago

Figure 10. Katsukawa Shunshō. *Courtesans and samurai in theater boxes.* From *Yakusha Natsu no Fuji.* British Museum, London

Figure 11. *Printed broadsheet showing Kiri Chōkiri, manager of the Kiri Theater, at the first performance of Jūni-hitoe Komachi-zakura, together with genealogy of the Kiri family.* National Diet Library, Tokyo

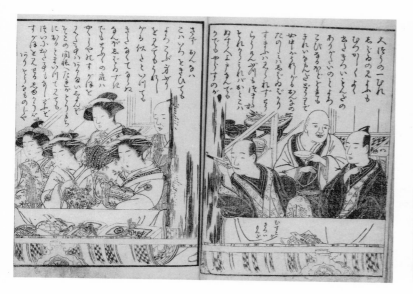

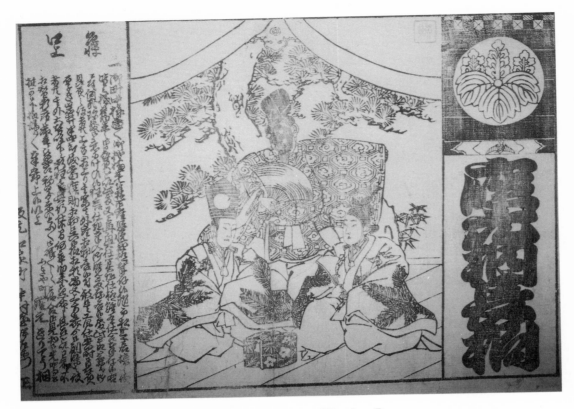

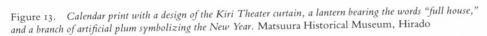

Figure 12. *Printed broadsheet of* Okina Watashi *dance*. Museum of Fine Arts, Boston

Figure 13. *Calendar print with a design of the Kiri Theater curtain, a lantern bearing the words "full house," and a branch of artificial plum symbolizing the New Year*. Matsuura Historical Museum, Hirado

Figure 14. *Jūni-hitoe Komachi-zakura: title page of the illustrated program*. Akiba Bunko, Tokyo University Library

(*nibamme*) a "domestic" drama that ostensibly continued the plot of the first. Increasingly, characters from the domestic part found their way into the historical part—as we shall see in the case of *Jūni-hitoe Komachi-zakura*.

As with so many eighteenth-century plays, a complete libretto does not survive, but theater historians have been quite successful in reconstructing the plot of the entire day's performance.[39] Their main sources are two "actor critiques" (*yakusha hyōbanki*) published in the New Year of 1785, just weeks after the play had finally ended a highly successful run. Actor critiques were small, pocket-sized printed booklets, published mainly at the New Year but occasionally later in the year as well, which commented on plays and performances and ranked the season's actors (according to a system first devised in the mid-seventeenth century). The comments took the form of lively, often humorous, conversations between stock characters such as "Mr. Fan" (*hiiki*) and "Mr. Detractor"

(*waruguchi*). This means, however, that plots have to be pieced together from a conversation which flits from act to act in no particular order.[40]

Kabuki plots tend in the main to be wildly convoluted and fantastical, not to say preposterous, and none more so than those of *kaomise* productions. Lacking the grand spectacle, a bald plot synopsis can be ludicrous, or numbing. But something of the flavor of *Jūni-hitoe Komachi-zakura* may be conveyed by flicking through the pages of the illustrated program (*ehon banzuke*), drawn by the young Katsukawa Shun'ei (1762–1819), and briefly describing some of the scenes depicted.[41] These small printed booklets, which contain snippets of plot and an occasional line of dialogue scattered around pictures of the principal scenes, went on sale in the theaters and teahouses once the play opened.[42] When Lord Yanagisawa writes in his diary that he sent a "catalogue" (*mokuroku*) to this or that acquaintance in the audience, presumably

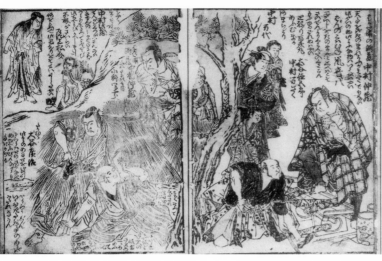

Figure 15. Katsukawa Shun'ei.
Jūni-hitoe Komachi-zakura: at the Myōjin Shrine, Seto.
From the illustrated program.
Akiba Bunko, Tokyo University Library

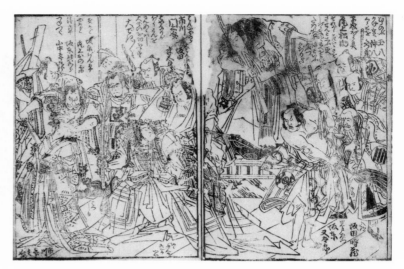

Figure 16. *Jūni-hitoe Komachi-zakura: the "Shibaraku" scene.*
From the illustrated program.
Akiba Bunko, Tokyo University Library

he refers to an illustrated program of this kind (see fig. 14). These small booklets seem to have been issued in attractive color-printed envelopes. No such envelopes survive from the eighteenth century, but a calendar print (*egoyomi*) of 1785 seems to imitate the envelope for an illustrated program of a *kaomise* production at the Kiri Theater: the design comprises the Kiri Theater curtain, a lantern marked "full house" (*ōiri*), and a branch of artificial plum (fig. 13).[43]

Figure 15, right: The Myōjin Shrine, Seto. The disguised arch-villain Ōtomo no Kuronushi (played by Nakamura Nakazō I) contemptuously refuses a bribe from lesser villains to join their plot against the emperor. He kicks over the stand bearing their proffered bolts of silk.

Figure 15, top left: A Burial Mound on Saga Plain. The corpse of Tachibana no Hayanari (played by Onoe Matsusuke I) is resurrected by the evil monk Jakumaku (played by Nakamura Konozō) to lead the lesser villains.

Figure 16 (the "Shibaraku" scene): The Worship Hall of a Ruined Temple (the conventional setting of such a scene). The villains assemble to lay plans when, with cries of "Shibaraku!" (Stop right there!), onto the scene stalks the young hero Hannya no Gorō (played by Ichikawa Monnosuke II), wearing a voluminous persimmon-colored costume (*suō*) and wielding an enormous sword (fig. 16, center). He shines a magic mirror at Tachibana no Hayanari (standing on the dais), and with agonized cries Hayanari withers again into a skeleton. The hero then swings his mighty sword, cutting a great swathe through the villains. The showpiece "Shibaraku" scene was de rigueur at the end of the third act of a *kaomise* performance, and is described in greater detail in Number 44.

Figure 17, right: Viewing Cherry Blossoms at Kiyomizudera. The courtier Yasusada (played by Ichikawa Monnosuke II) and the courtesan Sumizome (played by Segawa Kikunojō III) meet while flower viewing and fall in love.

Leaning on the sake bucket is a servant (played by Ōtani Hiroji III). This is the first scene of the play for which color prints exist (figs. 18, 19), both by Shunshō.

Figure 17, top left: Yasusada, keeper of the emperor's falcon, inadvertently cuts its leash with his sword, loosing the prized bird. As Yasusada tries to recapture it, a stray arrow shot by an enemy wounds him in the foot.

Figure 18: An *ōban*-sized color print (larger than most Shunshō prints of this date) showing the courtesan Sumizome leaning over the servant Taketora. He sits resting his elbow on the sake bucket, with a large lacquer cup marked "full house" (*ōiri*) tucked under his other arm. Presumably a comic scene.

Figure 19: This *hosoban* triptych by Shunshō presents Yasusada, Sumizome, and the servant on separate sheets. Here the falcon is still secure on Yasusada's wrist.

Figure 20, right: Another episode of love at first sight, that of Princess Ominaeshi (played by Segawa Tomisaburō II, standing, right) for the courtier Ono no Yorikaze (played by Bandō Hikosaburō III) in black *haori* jacket and woven rush basket hat.

Figure 20, left: Ono no Yoshizane's Mansion. Villains accuse the nobleman Yoshizane (played by Nakamura Nakazō I) of treasonous plots. They also attempt to abduct his daughter. A mysterious black-clad spy descends from a pine tree and is fought with by a servant of the house. Not illustrated in the program is the dance interlude in which Yoshizane mimes his fury ("Kyōran Kumoi no Sode" [Mad Rage: Sleeve of the Imperial Court]).[44] This was performed to *nagauta* chant and *shamisen* accompaniment and allowed Nakazō I to display his dancing skills.

Figure 21: The Garden Behind Yoshizane's Mansion. Yoshizane, standing on the verandah, is taunted by the villain second from left. But Yoshizane's wife (played by Osagawa Tsuneyo II) has a supposedly incriminating letter placed in a basin of water, whereupon Yoshizane's name (newly inscribed thereon by the villains) washes away and his implication in the treasonous plot is shown to be a forgery. (This of course is a parody of the famous Nō play *Sōshi Arai Komachi*, in which Komachi is falsely accused by Ōtomo no Kuronushi of plagiarizing a poem and vindicates herself by washing the poem off the scroll onto which Kuronushi had newly inscribed it.) The taunting villain commits suicide, bringing the historical (*jidaimono*) part of the play to a close.

Part two of the play was by convention a "contemporary domestic piece" (*sewamono*), in which the historical characters of part one continued the plot in new, contemporary guises. The Osaka setting emphasizes that this style of acting had originated in the Kamigata (Osaka-Kyoto region) theaters: almost no domestic pieces were set in

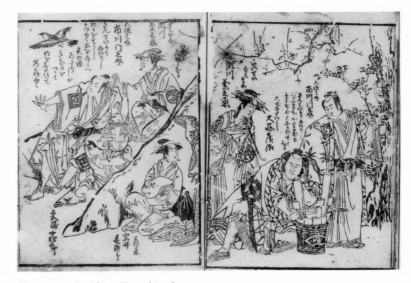

Figure 17. *Jūni-hitoe Komachi-zakura:*
Viewing Cherry Blossoms at Kiyomizu-dera.
From the illustrated program.
Akiba Bunko, Tokyo University Library

Figure 18. Katsukawa Shunshō.
The actors Segawa Kikunojō III and Ōtani Hiroji III
in the "Kiyomizu-dera" scene
from Jūni-hitoe Komachi-zakura.
Watanabe Tadasu collection, Tokyo

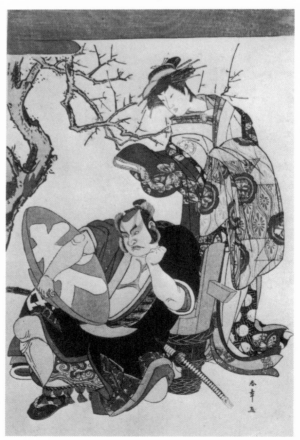

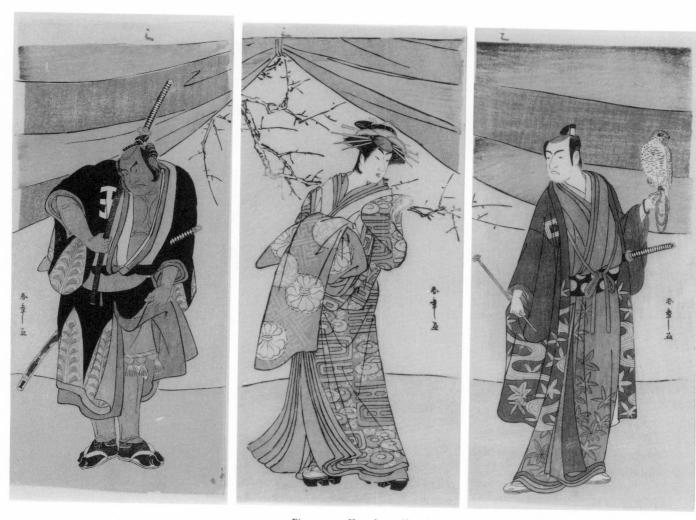

Figure 19. Katsukawa Shunshō. *The actors Ichikawa Monnosuke II, Segawa Kikunojō III, and Ōtani Hiroji III in the "Kiyomizu-dera" scene from* Jūni-hitoe Komachi-zakura. Ōta Memorial Museum, Tokyo

Figure 20. *Jūni-hitoe Komachi-zakura: Ono no Yoshizane's Mansion.* From the illustrated program. Akiba Bunko, Tokyo University Library

Figure 21. *Jūni-hitoe Komachi-zakura: Garden Behind Yoshizane's Mansion.* From the illustrated program. Akiba Bunko, Tokyo University Library

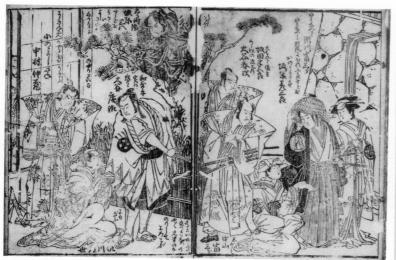

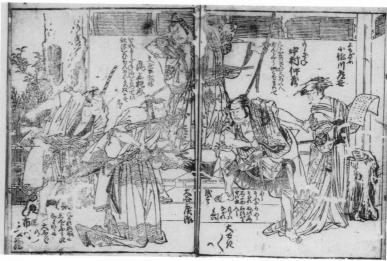

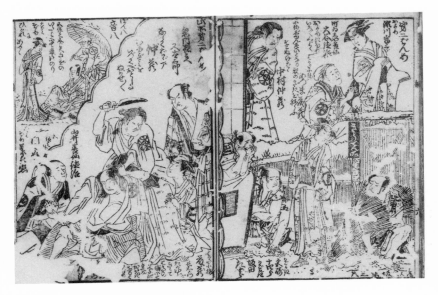

Figure 22. *Jūni-hitoe Komachi-zakura:*
Establishment of a Doctor of Moxa Treatment and Annex.
From the illustrated program.
Akiba Bunko, Tokyo University Library

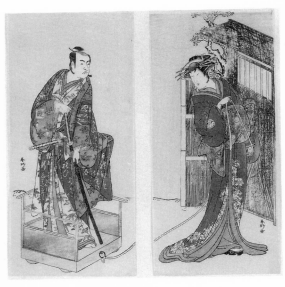

Figure 23. Katsukawa Shunkō.
The actors Segawa Kikunojō III
and Ichikawa Monnosuke II
in part two of Jūni-hitoe Komachi-zakura.
Watanabe Tadasu collection, Tokyo

Edo until the nineteenth century.[45] Also conventionally, part two opened with a snow scene. Unfortunately little of the plot is shown in the illustrated program, which must be supplemented considerably from other sources.[46]

Figure 22, top right: Establishment of a Doctor of Moxa Treatment. Oyome (played by Segawa Tomisaburō II), beautiful daughter of Chōemon the doctor, is being pestered with the unwelcome attentions of Yamai Yōsen (played by Ōtani Tokuji, kneeling). Yōsen is plotting with Naraku Baba (played by Nakamura Nakazō I, standing by the *shōji*), to turn in the young couple renting the annex, believing them to be Yasusada's elder brother Munesada and his beloved Komachi, for whose arrest a reward has been offered.

Figure 22, left: The Annex. The young couple are in fact Yasusada himself (Ichikawa Monnosuke II), still incapacitated by the wound in his ankle, and Sumizome (played by Segawa Kikunojō III, upper left), who pulls her beloved about in a cart. They resolve to die in place of his elder brother and Komachi, but Sumizome, who is the spirit of the ancient Komachi Cherry Tree, which is about to be chopped down, leaves to defend her tree. Yasusada, besieged by officers of the law, commits suicide, but not before the emperor's escaped falcon reappears, enabling Yasusada to write in his own blood the message "Two brothers in one boat," tie it to the bird's

leg, and bid it fly to his brother. Figure 22, left, also shows Naraku Baba about to decapitate Chōemon, but other sources omit this episode.

Figure 23: A *hosoban* diptych by Shunkō, showing the wounded Yasusada being pulled along in the invalid cart by Sumizome (as in fig. 22, upper left).

Popularly known as *Seki no To* (The Mountain Barrier), the gorgeous danced finale (*ōgiri*) with onstage chanting and *shamisen* accompaniment (*jōruri shosagoto*) is the only part of the play still performed, and it preserves much of the original action and movement of the 1784 production.[47] Figure 24, right, shows chanters and *shamisen* players seated on a dais behind the actors, the lead chanter being Tokiwazu Kanedayū (second from right). *Seki no To* is perhaps the most famous piece of Tokiwazu school chanting. The words were by the playwright Takarada Jurai, and combine a kaleidoscope of gorgeous poetic images drawn from classical poems and Nō plays (particularly those relating to Ono no Komachi) with lines of often colloquial dialogue. The music was probably composed by Kishizawa Shikisa, here seen playing the *shamisen*. *Jōruri* chanting is difficult to describe: a mixture of high, floating song, sung with great emotion, and exaggeratedly declamatory dialogue.

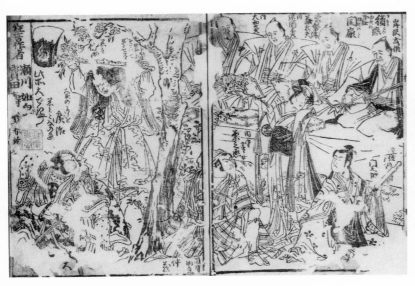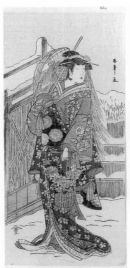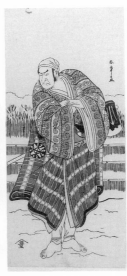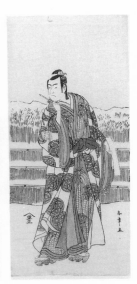

Figure 24, right. *Jūni-hitoe Komachi-zakura: finale, called "Seki no To."*
From the illustrated program. Akiba Bunko, Tokyo University Library

Figure 24, left. *Jūni-hitoe Komachi-zakura: Ausaka Mountain Checkpoint, showing Komachi cherry tree.*
From the illustrated program. Akiba Bunko, Tokyo University Library

Figure 25. Katsukawa Shunshō. *The actors Ichikawa Monnosuke II, Nakamura Nakazō I, and Segawa Kikunojō III in the "Seki no To" portion of* Jūni-hitoe Komachi-zakura.
Watanabe Tadasu collection, Tokyo

Figure 24, left: Ausaka Mountain Checkpoint, including the ancient Komachi cherry tree and the villain brandishing a huge axe with which to cut it down.[48]

Figure 25: A *hosoban* triptych by Shunshō showing Ono no Komachi (played by Segawa Kikunojō III), her lover Munesada (played by Ichikawa Monnosuke II) disguised as the checkpoint official, and the arch-villain Ōtomo no Kuronushi (played by Nakamura Nakazō I) disguised as his watchman assistant, a woodsman's axe tucked ominously and conspicuously through his belt. The lovers are certainly beautiful, but it is Nakazō I who dominates the print, as indeed he dominated the whole final act. Plays of this kind from the 1780s are sometimes referred to as "thick-padded pieces" (*atsuwata-mono*), after the thickly padded costumes like the jacket worn by the supposed watchman. Nakazō I's style of movement was described as "rounded, expansive... with the shoulders lifted high."[49] This, combined with the padded costumes, produced a grand, ample, essentially nonrealistic style of acting that characterized Temmei-era (1782–1789) Kabuki as a whole.

Figure 26: The same three figures as in Figure 25, in a *hosoban* triptych designed by Shunshō's pupil Shunkō. The brushwood fence of Figure 25 is seen again here, but the snow has disappeared.

Figure 27: An *ōban* print by Torii Kiyonaga, showing Komachi and Munesada at the climactic moment of a dance miming their love, the watchman kneeling between them. Kiyonaga has created strongly individualized portraits of the chanters and *shamisen* player on the dais (cf. fig. 24).

Figure 28: Where Kiyonaga (fig. 27) presents a moment from the actual production, complete with individualized portraits of onstage musicians, this print by Shunkō simply shows the three principals in tableau, with branches of the cherry tree extending into the picture. As in Figure 26, Kuronushi has his axe, Komachi her straw raincoat, walking stick, and basket of blooms, and Munesada the poem slip (*tanzaku*) on which he is about to inscribe a courtly poem.

Figure 29: The stars have revealed to Ōtomo no Kuronushi that he must cut down the Komachi cherry tree in order for his evil plans to succeed, and he sharpens his axe with bravura flourishes. A small picture calendar (*egoyomi*) of 1785 by one Seisai (an unrecorded, probably amateur, artist) shows Nakazō I in a famous pose still performed today: in profile, legs braced, grimacing as he checks the keenness of the blade.

Figures 30, 31, 32: As if from out of the trunk of the cherry tree, the beautiful courtesan Sumizome (played by Segawa Kikunojō III) appears.[50] After a dance interlude

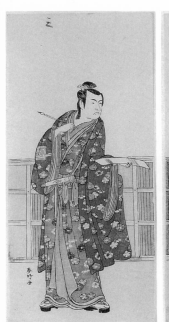
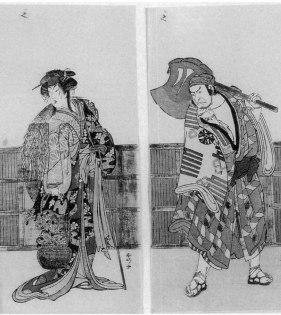
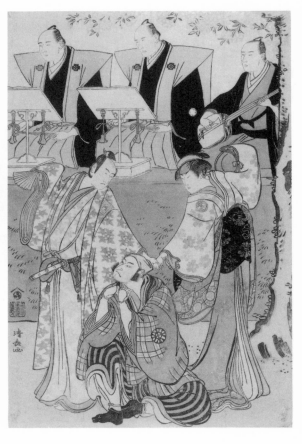

Figure 26. Katsukawa Shunkō. *The actors Nakamura Nakazō I, Segawa Kikunojō III, and Ichikawa Monnosuke II in the "Seki no To" portion of* Jūni-hitoe Komachi-zakura. Watanabe Tadasu collection, Tokyo

Figure 27. Torii Kiyonaga. *The actors Segawa Kikunojō III, Nakamura Nakazō I, and Ichikawa Monnosuke II, with chanters and* shamisen *player, in the "Seki no To" portion of* Jūni-hitoe Komachi-zakura. The Art Institute of Chicago

with the comically smitten watchman, she reveals her true identity as the spirit of the tree (a revelation indicated in fig. 32 by letting down her hair) and challenges the watchman to declare himself likewise. With an astonishing series of movements Nakazō I lets down his hair and flips back the top of his costume (a quick-change technique known as *bukkaeri*), revealing the black robes of the evil courtier Ōtomo no Kuronushi and proclaiming his ambition to seize power in the realm. Figures 30 and 31, both *hosoban* triptychs by Shunshō, give, as it were, "before and after" depictions of the three principals.

Figure 33: In the present-day version of *Seki no To* Kuronushi pursues Sumizome with his axe till she subdues him by magic powers, as shown in this diptych by Katsukawa Shunkō (1743–1812). In modern productions Munesada does not figure in this scene, but since he appears in both *hosoban* triptychs by Shunshō (figs. 30, 31) and in the *ōban* print by Kiyonaga (fig. 32), we can assume that he did appear in the 1784 version, probably to help vanquish Kuronushi with the aid of the magic mirror that he holds and to reveal his own true identity.

Figure 34: In this *aiban* print by Katsukawa Shunkō the courtier Munesada and the courtesan Sumizome are shown together without Kuronushi— probably an imaginative grouping by the artist rather than a faithful rendition of the final scene as staged in 1784.

So perhaps Kiyonaga's grand print of the three principal characters (fig. 32) depicts the final tableau of the play as performed in 1784. Sumizome, her hair loosed as the spirit of the cherry tree, brandishes the cherry branch in triumph as petals cascade around them. The gorgeous costumes, the monumental, self-contained poise of each character, and the pervading atmosphere of fantasy— all these elements epitomize Temmei-era Kabuki at its most magnificent.

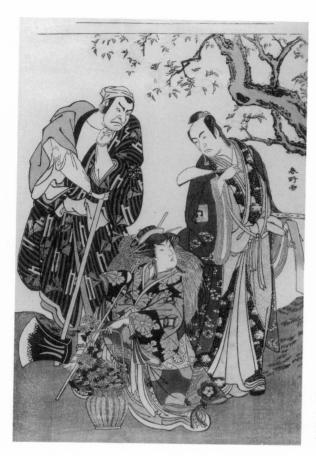

Figure 29. Seisai. *Picture calendar showing the actor Nakamura Nakazō I as Sekibei testing his axe.* From *Jūni-hitoe Komachi-zakura.* Matsuura Historical Museum, Hirado

Figure 28. Katsukawa Shunkō. *The actors Ichikawa Monnosuke II, Segawa Kikunojō III, and Nakamura Nakazō I in the "Seki no To" portion of* Jūni-hitoe Komachi-zakura. British Museum, London

Epilogue: The Prints

It has been possible to assemble no fewer than twelve color woodblock prints by leading *ukiyo-e* artists of the 1780s—Shunshō, Shunkō, and Kiyonaga—which depict scenes from this one play (nine of these showing the final act, *Seki no To*). As other collections of Katsukawa school prints come to be catalogued, more prints relating to *Jūni-hitoe Komachi-zakura* are likely to be discovered. Many actor prints from the eighteenth century have survived only in single impressions; in general they seem to have been less regarded in their own day than prints of beautiful women (obviously because they were souvenirs of a particular Kabuki performance and had lasting meaning only to a fervent aficionado of the play). Like cotton kimono, towels, and scarves printed with an actor's crest (*mon*), or samples of an actor's calligraphy on fans or poem papers (in effect, autographs), actor prints must have been regarded, even by Kabuki fans, as ephemeral souvenirs of an enjoyable day in the theater.

It has been suggested that full-color prints of actors from this period may have been specially commissioned by theater patrons or theater teahouses to give as gifts, since they so rarely bear the mark of a commercial publisher.[51] But perhaps the publisher's mark—or the name of the actor or role (found on prints of an earlier period)—was omitted simply because it would have cluttered the design. On present evidence we cannot determine whether or not full-color actor prints by artists of the Katsukawa school were published for commercial public sale in print shops.

To cut the dozen or so cherry wood printing blocks required to make one full-color print seems economically unfeasible for an edition of less than several hundred prints. If only a single example of an edition of that size has survived, then clearly the number destroyed has been very considerable. An illustration from a comic novel (*kibyōshi*) of the day suggests the fate that must have awaited many prints: two *hosoban* prints of actors have been stuck onto a low screen placed close to an oil lamp (fig. 35).[52] The colors will steadily fade in the light as the paper browns in the smoke from the lamp. But then of course they can easily be replaced with prints of next season's plays....

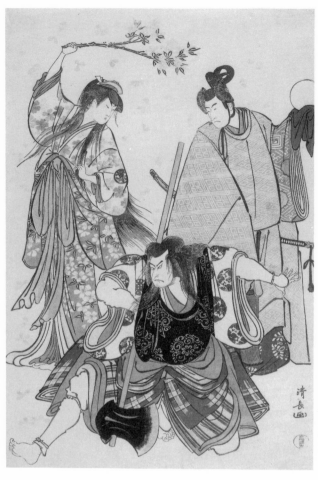

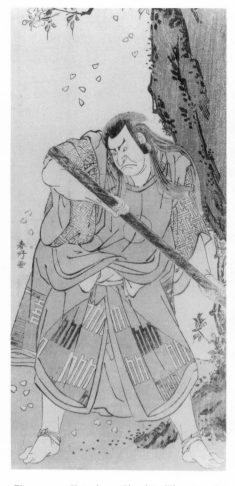

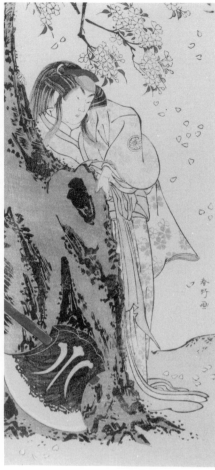

Figure 32. Torii Kiyonaga. *The actors Ichikawa Monnosuke II, Nakamura Nakazō I, and Segawa Kikunojō III in the "Seki no To" portion of* Jūni-hitoe Komachi-zakura. Museum of Fine Arts, Boston

Figure 33. Katsukawa Shunkō. *The actors Segawa Tomisaburō II and Nakamura Nakazō I in the "Seki no To" portion of* Jūni-hitoe Komachi-zakura. Aoki Tetsuo collection, Tokyo

Figure 30. Katsukawa Shunshō. *The actors Ichikawa Monnosuke II, Segawa Kikunojō III, and Nakamura Nakazō I in the "Seki no To" portion of* Jūni-hitoe Komachi-zakura. Watanabe Tadasu collection, Tokyo

Figure 31. Katsukawa Shunshō. *The actors Ichikawa Monnosuke II, Nakamura Nakazō I, and Segawa Kikunojō III in the "Seki no To" portion of* Jūni-hitoe Komachi-zakura. Watanabe Tadasu collection, Tokyo

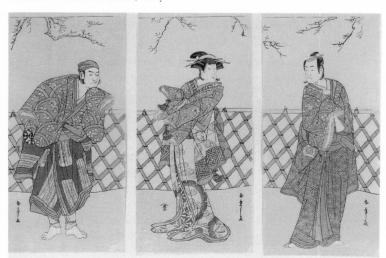

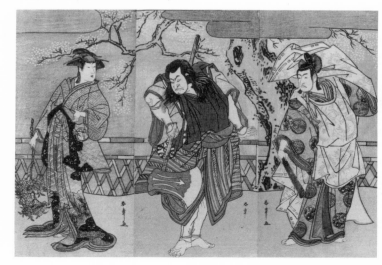

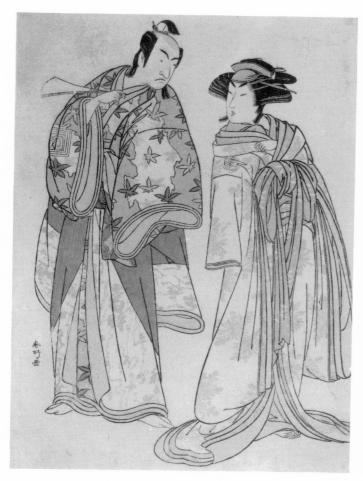

Figure 34. Katsukawa Shunkō. *The actors Segawa Kikunojō III and Ichikawa Monnosuke II in* Jūni-hitoe Komachi-zakura. The Art Institute of Chicago

Figure 35. Katsukawa Shun'ei. *Two actor prints pasted onto a screen.* From the comic novel *Kotsuzui Shibai-zuki*, 1784. The Art Institute of Chicago

Notes

For a general account in English of the history, conventions, character, and development of Kabuki, see Earle Ernst, *The Kabuki Theatre* (London: Secker and Warburg, 1956); for synopses of major plays, see Aubrey S. Halford and Giovanna M. Halford, *The Kabuki Handbook* (Rutland, Vt. and Tokyo: Charles E. Tuttle, 1956).

1 Geinō-shi Kenkyūkai, gen. eds., *Nihon Shōmin Bunka Shiryō Shūsei*, 16 vols. (Tokyo: San'ichi Shobō, 1977), vol. 13: *Geinō Kiroku 2: Enyū Nikki*, ed. Nishiyama Matsunosuke and Hattori Yukio, p. 801. Abbreviated below as *Enyū Nikki* (1977).

2 Koike Shōtarō, *Kōshō Edo Kabuki* (Tokyo: Miki Shobō, 1979), p. 39. Abbreviated below as Koike (1979).

3 This print has been described by Money Hickman in *Ukiyo-e Shūka*, suppl. vol. 2 (1985), no. 178.

4 *Kabuki Nempyō*, vol. 4 (1959), p. 528; Sekine (1984), pp. 539–52.

5 *Kabuki Nempyō*, vol. 4 (1959), pp. 540–43; Sekine (1984), pp. 553–57.

6 *Enyū Nikki* (1977).

7 Ibid., pp. 1–2.

8 Ibid., p. 9.

9 Ibid., pp. 6–7.

10 *Edo no Parodii Ehon*, vol. 2 (1981), pp. 97–132.

11 Ibid., pp. 106–7.

12 Ibid., pp. 129–31.

13 Ihara (1913), pp. 134–35. See also No. 73.

14 Ibid., p. 146.

15 Ibid., pp. 149–51.

16 Ibid., p. 146.

17 Ibid., p. 129.

18 *Kabuki Jiten* (1983), s.v. shosagoto, jōruri.

19 Suwa Haruo, "Temmei Kabuki no Saihyōka," in Nishikawa Matsunosuke Sensei Koki Kinenkai, eds., *Edo no Geinō to Bunka* (Tokyo: Yoshikawa Kōbunkan, 1985), p. 91.

20 The main surviving writings are: *Shūkaku Nikki*, in Yoshida Teruji, ed., *Kabuki-e no Kenkyū* (Tokyo, Rokuen Shobō, 1963), pp. 263–319, describing the fifth to eleventh months of 1780; "Shosa Shūgyō Tabi Nikki," published serially in *Kabuki* magazine, vols. 77–82 (Sept. 1906–Feb. 1907), describing Nakazō I's journey to Osaka; *Shūkaku Zuihitsu*, in *Shin Enseki Jūshu*, vol. 5 (1913), pp. 244–79; *Getsusekka Nemonogatari*, in *Nihonjin no Jiden*, suppl. vol. 1 (1982), pp. 399–474, also in *Nihon Shōmin Seikatsu Shiryō Shūsei*, vol. 15 (1971), pp. 833–73, which contains miscellaneous reminiscences from all periods of Nakazō I's life.

21 *Nihonjin no Jiden*, suppl. vol. 1 (1982), p. 405.

22 *Kabuki Nempyō*, vol. 4 (1959), p. 235.

23 *Kabuki Nempyō*, vol. 4 (1959), pp. 339–42. See also No. 87.

24 Ihara (1913), pp. 133–34.

25 Ibid., p. 159.

26 *Enyū Nikki* (1977), p. 799.

27 Ibid., p. 800.

28 Ibid., p. 801.

29 Ibid., p. 803.

30 Ibid., p. 804.

31 Ibid., p. 805.

32 Ibid., p. 807.

33 This and the following account of the visit to the Kiri Theater are taken from *Enyū Nikki* (1977), pp. 929–30.

34 Prices of seats are given in Koike (1979), p. 301.

35 *Sharebon Taisei*, vol. 12 (1981), pp. 67–81, 359–60.

36 Ibid., p. 930.

37 *Kabuki Nempyō*, vol. 4 (1959), pp. 537–38; Sekine (1984), p. 553. The various accounts quoted in these works do not agree, however, about the order in which the ceremonial events were performed.

38 *Kabuki Jiten* (1983), s.v. "Sambasō-mono" (p. 204).

39 The first attempt was by Kōdō Tokuchi in *Shin Shōsetsu*, vol. 9, no. 2 (1904), pp. 200–218, and all later reconstructions seem to be based more or less on this. Examples are: Kōno Tatsuyuki in *Hyō-shaku Meikyoku Sen* (Tokyo: Fuzambō, 1926), pp. 91–168; Hattori Yukio in *Engekikai* (Dec. 1968), pp. 108–11; Kokuritsu Gekijō Geinō Chōsashitsu, eds., *Jōen Shiryō Shū* 148 (Jan. 1978), pp. 12–124. Kōdō claimed to base his reconstruction mainly on a synopsis written by a theater enthusiast of the period, but no reference is given and the document has not subsequently come to light.

40 The two actor critiques in question are *Yakusha Hatsu Egao* and *Yakusha Nenshi-jō*. Unfortunately these have not yet been transcribed into modern printed Japanese.

41 Inconsistencies between the various "reconstructions" mentioned above (n. 40) and the illustrations in the program suggest that this latter source was not known to the historians concerned. My synopsis tries to reconcile the various sources wherever possible but takes the program as the document of greatest authority and authenticity.

42 *Kabuki Jiten* (1983), s.v. "*banzuke*" (pp. 334–37).

43 *Egoyomi* were sent as a kind of New Year greeting card. They contain hidden pictorial references designating the "long" and "short" months of the coming year (these changed every year according to the lunar calendar). Here the numbers of the "long months" of 1785—1, 3, 6, 7, 9, 10, 12— are playfully hidden in the "folds" of the theater curtain.

44 Asakawa (1956), pp. 67–72.

45 Suwa (1985), p. 114.

46 See sources listed in note 40 above; also "Seki no To," in *Nihon Buyō Zenshū*, vol. 3 (1979), pp. 471–513.

47 *Nihon Buyō Zenshū*, vol. 3 (1979), p. 471.

48 These are the modern stage settings given in *Nihon Buyō Zenshū*, vol. 3 (1979), pp. 507–9.

49 *Nihon Buyō Zenshū*, vol. 3 (1979), p. 509.

50 One account has it that in the first performance Sumizome flew down out of the tree on a wire. See *Nihon Buyō Zenshū*, vol. 3 (1979), p. 513.

51 Roger Keyes, *Japanese Woodblock Prints: A Catalogue of the Mary A. Ainsworth Collection* (Oberlin: Allen Memorial Art Museum, 1984), p. 32.

52 The *kibyōshi* novel is *Kotsuzui Shibai-zuki*, with text by Ichiba Tsūshō and illustrations by Katsukawa Shun'ei, published 1784.

Entries and Plates

TIMOTHY T. CLARK

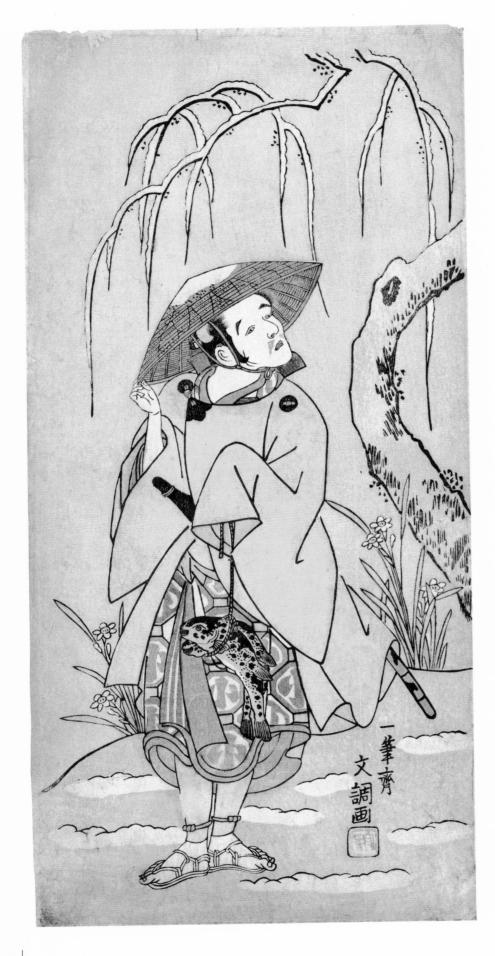

I IPPITSUSAI BUNCHŌ

(active ca. 1755–1790)

The actor Arashi Otohachi I as Numatarō, the retainer of Utou Yasukata, in part two of the play *Kogane no Hana Gaijin Aramusha* (Gold Flowers: The Triumphal Return of Fierce Warriors), performed at the Nakamura Theater from the first day of the eleventh month, 1766

Hosoban; 32.0 x 15.4 cm
The Clarence Buckingham Collection 1928.992

Otohachi I, in the role of the retainer Numatarō, stands beneath the snow-laden branches of a willow, wearing a travelling cloak and broad straw hat, and dangling a pair of frogfish (*ankō*) on a piece of string. Clumps of narcissus bloom at the foot of the tree. Knowing that his master, Yasukata, desperately needs three hundred *ryō* (large gold coins), Numatarō is willing to risk eternal damnation to obtain the money. For legend had it that anyone striking the bell of Mukenzan Kannon Temple at Sayo no Nakayama in Tōtōmi Province would receive untold riches in this life but would be cast to the nethermost hell in the next.[1] By a peculiar theatrical convention it is the two frogfish rather than the Mukenzan Temple bell which Numatarō strikes with a knife. He is shown doing so in the top left-hand corner of an illustration from one of the actor critiques (*yakusha hyōbanki*) relating to the performance (fig. 1.1). Later Numatarō shakes from a tree a hoard of money that had been cached there by thieving monkeys.

Bunchō's few prints of Otohachi I in various roles always show him with the same odd facial features: small, sunken eyes, turned-down mouth, bulbous nose, mismatched eyebrows, and tufts of hair at the temples. Doubtless his appearance helped to make him the favorite actor of buffoon roles (*dōke yaku*) until his death in 1769. Here the gaping frogfish seem to accentuate the actor's ill-shaped features in a manner at once comic and poignant: the artists' new interest in depicting an actor's actual likeness (*nigao-e*) extended to the bad points as well as the good.

The Chicago impression of the print is somewhat faded: another specimen in the collection of the Tsubouchi Memorial Theater Museum, Waseda University, Tokyo, shows a bottle green cloak and stronger red and purple on the kimono underneath.[2] At present no other prints by Bunchō relating to this performance are known.

1 *Kabuki Saiken* (1926), pp. 466–67.
2 Riccar (1978), no. 1.

SIGNATURE *Ippitsusai Bunchō ga*
ARTIST'S SEAL *Mori uji*
PROVENANCE Alexander G. Mosle collection
OTHER IMPRESSIONS
The Metropolitan Museum of Art, New York; Riccar Art Museum, Tokyo; Tsubouchi Memorial Theater Museum, Waseda University, Tokyo

1.1 *The actor Arashi Otohachi I as Numatarō Striking the Frogfish.* From an actor critique. Tōyō Bunko Library, Tokyo

2 IPPITSUSAI BUNCHŌ

(active ca. 1755–1790)

The actor Arashi Hinaji I, possibly as Yuya Gozen in the play
Ima o Sakari Suehiro Genji (The Genji Clan Now at Its Zenith),
performed at the Nakamura Theater from the first day
of the eleventh month, 1768

Hosoban; 31.2 x 15.0 cm
The Clarence Buckingham Collection 1928.998

This print deliberately breaks the magical illusion of the theater.
Unique among designs of the 1760s and 70s, it shows an actor on
stage interacting with his audience; it shows the boards of the stage
as boards and the trunk of a stage tree as a flat piece of scenery
supported by a wooden pillar behind. Until the 1780s prints
normally depicted actors as the characters they played within the
world of the plot, be it the machinations of mighty warriors in the
distant Kamakura period or contemporary domestic dramas set in
an Osaka back street. Here, however, the artist is showing us the
actor as actor and the stage as stage— an important psychological
break with the traditional manner of portraying actors in color
prints. In the 1780s this direction would be further explored in
prints showing actors in their dressing rooms and in private life
(Nos. 93–95), as well as in designs that include the musicians and
chanters seated on stage behind the actors (*degatari-zu*).

The actor Arashi Hinaji I seems to be leading the audience in the
rhythmic hand-clapping that was practiced by fans and claques on
special theatrical occasions. The event in this case may be Hinaji's
return to Edo in 1768, after three years working in the theaters
of Osaka. If so, the role is that of Yuya Gozen, younger daughter
of Hokkyō the Umbrella Maker, in the play *Ima o Sakari Suehiro
Genji*, performed at the Nakamura Theater in the eleventh month
of that year. The present catalogue includes five designs by Shunshō
that relate to this play (Nos. 31–35).

Bunchō brilliantly contrasts the uninhibited enthusiasm of the
working-class fans crowding the "floor" (*doma*) of the house, the
cheap area in front of the stage, with Hinaji I's cool, feminine poise.
Both literally and metaphorically, he has the audience at his feet.

SIGNATURE *Ippitsusai Bunchō ga*
ARTIST'S SEAL *Mori uji*
PROVENANCE
Hayashi Tadamasa (seal); Alexander G. Mosle collection
OTHER IMPRESSIONS
Achenbach Foundation for Graphic Arts, San Francisco

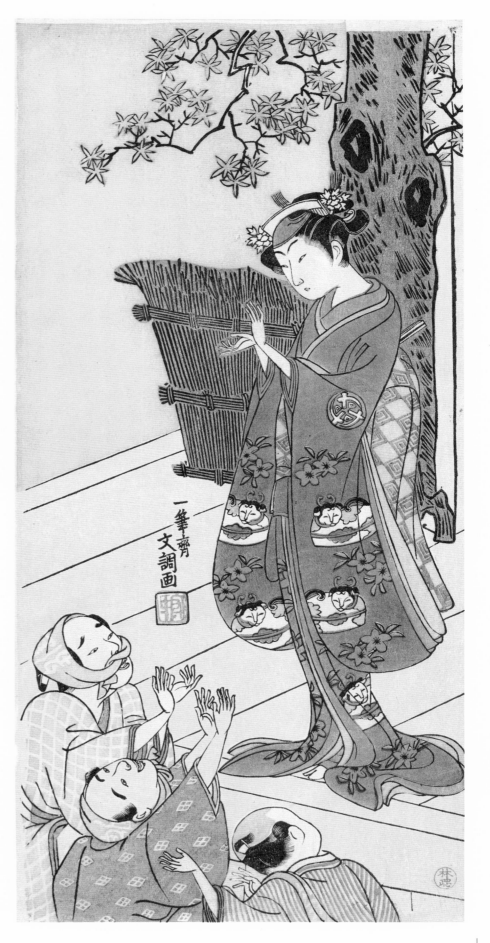

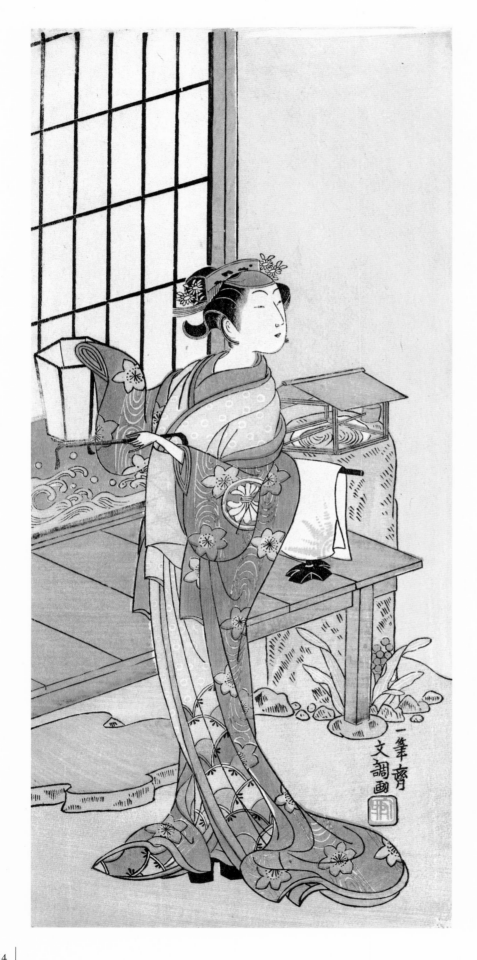

3 IPPITSUSAI BUNCHŌ

(active ca. 1755–1790)

The actor Segawa Kikunojō II, possibly as Princess Ayaori in the play *Ima o Sakari Suehiro Genji* (The Genji Clan Now at Its Zenith), performed at the Nakamura Theater from the first day of the eleventh month, 1768

Hosoban; 31.5 x 14.3 cm
Gift of Mr. and Mrs. Gaylord Donnelley 1970.495

Kikunojō II is here attired as a young lady of noble family, possibly as Princess Ayaori, daughter of Fujiwara no Nobuyori, in the play *Ima o Sakari Suehiro Genji*. If so, this is a further scene from the same play depicted in Number 2, as well as in five designs by Shunshō (Nos. 31–35). *Kabuki Nempyō*[1] notes that Kikunojō II was indisposed for the first four days of the run and could not perform until the fifth day.

In the absence of a firm identification, we can do little more than describe the scene portrayed. A young lady is standing in a garden, next to a verandah, partly shielding the light from a hand-lantern (*teshoku*) with the sleeve of her over-kimono (*uchikake*). Her expectant mien suggests a nighttime tryst with a lover. The kimono is decorated with a pattern of fans around the skirts, and the over-kimono with blossoms in swirling water. A bustle-like bulge occurs at the back, where the over-kimono covers the knot in the obi. At the end of the verandah is a towel on a rack and, in the garden immediately adjacent, a stone hand-basin protected by a small, roof-like wooden cover.

Arthur Davison Ficke, the American poet and influential critic of *ukiyo-e*, writing in 1915, detected a certain "intangible spiritual abnormality" in Bunchō's portraits of Kikunojō II and imagined a "curious relation between the two."[2] Now that we know many more prints by Bunchō, it is clear that the portraits of Kikunojō II constitute a reasonable proportion of his total works, given the actor's popularity. It is true that Bunchō has drawn Kikunojō's face in an idiosyncratic, not to say quirky, style— long nose, small mouth, small close-set eyes, arched eyebrows— but he used essentially the same conventions for all his portrayals of female figures. Ficke's fanciful inferences are unsupported even by his own tenuous evidence. Unquestionable, however, is Bunchō's skill in capturing the curves of Kikunojō II's arched, elegant stance.

1 *Kabuki Nempyō* is a chronological history of Kabuki, compiled from contemporary sources by Ihara Tōshirō, published 1956–63.
2 Ficke (1915), p. 189.

SIGNATURE *Ippitsusai Bunchō ga*
ARTIST'S SEAL *Mori uji*
PROVENANCE Mrs. George T. Smith collection

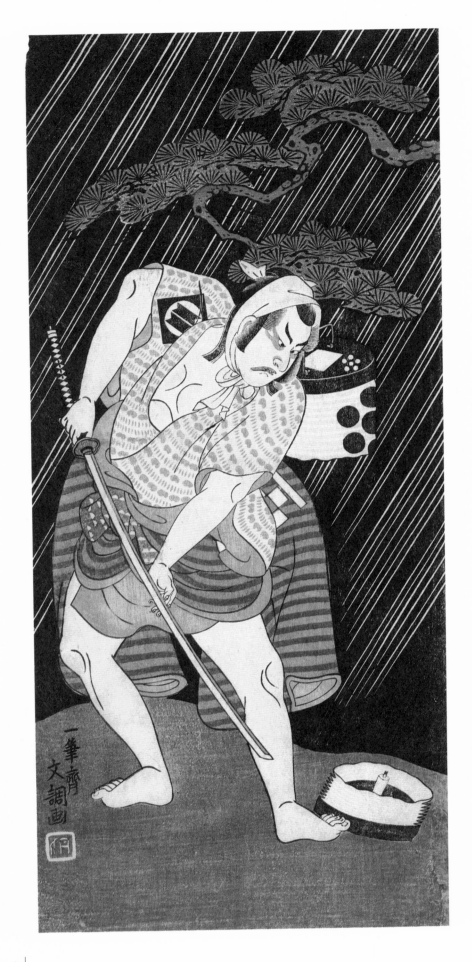

4 IPPITSUSAI BUNCHŌ

(active ca. 1755–1790)

The actor Sakata Sajūrō I as a samurai's manservant (*yakko*)
Ca. 1768–1770

Hosoban, left sheet of a diptych; 31.2 x 13.9 cm
The Clarence Buckingham Collection 1928.999

Sakata Sajūrō I, in the role of a samurai's manservant, stands in a heavy night rain, brandishing the long sword with which he has just sliced right through the paper lantern hanging from the pine tree behind him. His striped kimono has been shrugged off his shoulders, and a scarf is tied around his head. This is the left sheet of a diptych, whose right sheet shows Ōtani Hiroji III also dressed as a *yakko* and in a similarly powerful pose, holding an upturned sedge hat in one hand and clasping the trunk of a pine tree with the other arm (fig. 4.1).

Sajūrō I's "alternative" crest (*kaemon*) was three squares topped by a line, visible here on his left sleeve.[1] He appeared together with Ōtani Hiroji III many times between 1768 and his death on the third day of the fifth month, 1770. Presently published Kabuki records do not mention either actor in such a scene in the rain at night. Identification of the play must await further evidence.

It is sometimes said that Bunchō excelled at depicting actors in delicate female roles, in contrast to his rival Shunshō, who was superior in portraying actors in male roles. This diptych certainly demonstrates Bunchō's ability to create convincing images of muscular masculinity.

1 The actors' crests are listed in an appendix to the illustrated book of theater scenes *Ehon Sakae-gusa*, designed by Kitao Shigemasa, published in 1771.

4.1 Ippitsusai Bunchō.
The actor Ōtani Hiroji III as a yakko.
Tsubouchi Memorial Theater Museum,
Waseda University, Tokyo

SIGNATURE *Ippitsusai Bunchō ga*
ARTIST'S SEAL *Mori uji*
PROVENANCE
Hayashi Tadamasa (seal); Alexander G. Mosle collection
OTHER IMPRESSIONS Tokyo National Museum

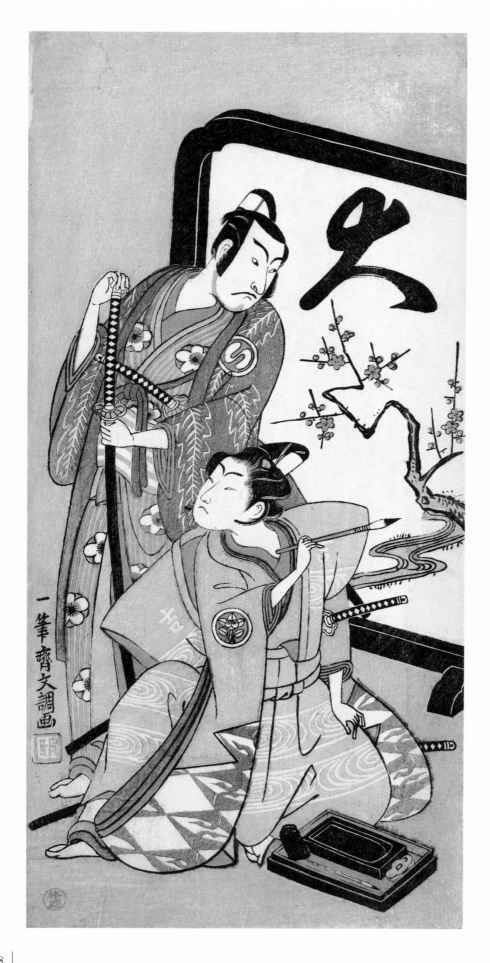

5 IPPITSUSAI BUNCHŌ
(active ca. 1755–1790)

The actors Sawamura Sōjūrō II and Ichimura Kichigorō
in unidentified roles
Ca. 1768–1770

Hosoban; 30.9 x 14.7 cm
The Clarence Buckingham Collection 1925.2529

Ichimura Kichigorō, dressed in a blue long-sleeved kimono
under a pink *kamishimo* (formal dress of a male aristocrat,
comprising wide-shouldered surcoat and wide-legged, extra-
long trousers), kneels with a writing set in front of him,
holding a large writing brush primed with ink. He is watched
by Sawamura Sōjūrō II, who stands behind him leaning on his
long sword. On the free-standing single-panel screen (*tsuitate*)
is the character *dai* ("big") above a landscape of a red plum
tree in blossom beside a meandering stream. Sōjūrō II is
wearing a striped kimono with a pattern of plum blossoms
(*ume*), and it is tempting to identify him as Umeō-maru in
the play *Sugawara Denju Tenarai Kagami* (Sugawara's Secrets
of Calligraphy). In the eighth month of 1768, at the Ichimura
Theater, Kichigorō played Prince Tokiyo in a "Sugawara"
play, but in that production Sōjūrō II played not Umeō-maru
but Matsuō-maru, Umeō-maru's elder brother, whose
costume would have been decorated with pines (*matsu*).
Identification of the present print will have to await further
study of Kabuki records.

Bunchō's composition is most elegant, the inward arch of the
standing figure counterbalanced by the outward curve of the
kneeling figure's long sleeve. The expressions are typically
enigmatic; the two young men may be glancing conspirato-
rially around to be sure the calligraphy is being written
unobserved.

Though the purple and red pigments are strong and unfaded,
the indigo blue of Kichigorō's kimono and of the background
has modified to a light sand color. Since the character *kichi*
appears as a crest on Kichigorō's sleeve, the print must date
before the eleventh month of 1770, when he succeeded to the
name Bandō Hikosaburō III.[1]

1 *Kabuki Nempyō*, vol. 4 (1959), p. 150.

SIGNATURE *Ippitsusai Bunchō ga*
ARTIST'S SEAL *Mori uji*
PROVENANCE Hayashi Tadamasa (seal)
OTHER IMPRESSIONS
Tsubouchi Memorial Theater Museum, Waseda University, Tokyo

6 IPPITSUSAI BUNCHŌ

(active ca. 1755–1790)

The shrine dancers (*miko*) Ohatsu and Onami
1769

Hosoban; 32.7 x 15.5 cm
The Clarence Buckingham Collection 1925.2526

We can turn to Ōta Nampo's diary *Hannichi Kanwa*
(A Half-Day's Idle Chat) for a contemporary description
of this scene:

"*Worshipping the Image of Ebisu at Yushima*

"From the fourth day of the third month [1769], the image
of the god Ebisu from the Great Shrine at Ishizu in Izumi
Province was on display for public worship in the precincts
of the Tenjin Shrine at Yushima. It attracted large crowds.
On the shrine dance platform, two maidens performed
sacred shrine dances for the gods. Their names were
Onami and Ohatsu. Over their long-sleeved kimono they
wore sacred robes. They were very beautiful and popular
with the people who came to worship.... These two
shrine maidens appeared in color prints.[1]"

As Nampo describes, the shrine maidens wear sacred white
robes (*chihaya*) over their kimono with long hanging
sleeves (*furisode*) and formal *hakama* trousers. Each dancer
carries a painted fan and a kind of wand (*nusa*) composed
of a branch from a sacred *sakaki* tree decorated with
consecrated paper streamers. Extending from the dance
platform is a small altar on which are offerings and other
accessories used in the performance. The platform is
protected from the elements by a simple lattice roof. In
the late 1760s print artists—led by Suzuki Harunobu (ca.
1724–1770)— "discovered" a succession of beautiful
women working in ordinary professions and promoted
them in their works. Harunobu designed several *chūban*
and at least one pillar print showing one or both of the
shrine maidens Ohatsu and Onami (fig. 6.1), and Bunchō
produced another *hosoban* print of the pair.[2] Stylistically
these works are so close that only minute nuances in the
manner of drawing the faces serve to distinguish the shrine
maidens of Harunobu from those of Bunchō.

Further on in his diary Nampo reports that the following
year's (1770) festivities at the Yushima Tenjin Shrine saw
the two lovely shrine maidens replaced by small girls.[3]

6.1 Suzuki Harunobu.
*The shrine maidens
Ohatsu and Onami.*
British Museum, London

1 *Nihon Zuihitsu Taisei*, vol. 4 (1927), p. 454.
2 Hillier (1976), no. 221.
3 *Nihon Zuihitsu Taisei*, vol. 4 (1927), p. 457.

SIGNATURE *Ippitsusai Bunchō ga*
ARTIST'S SEAL *Mori uji*

7 IPPITSUSAI BUNCHŌ

(active ca. 1755–1790)

The actor Iwai Hanshirō IV as Okaru in act seven of the play *Chūshingura* (Treasury of the Forty-seven Loyal Retainers), performed at the Morita Theater from the third day of the fourth month, 1769

Hosoban; 32.0 x 14.3 cm
The Clarence Buckingham Collection 1930.930

To raise money that will help her husband, Kampei, redeem his honor, Okaru has allowed herself to be sold into prostitution at the Ichiriki Teahouse in Kyoto. At the same teahouse Ōboshi Yuranosuke, leader of the band of forty-seven *rōnin* (masterless samurai) who are plotting revenge against the evil Kō no Moronao, is feigning a life of dissipation to lull his enemies into a false sense of security. His allies and enemies alike put him to various tests, but Yuranosuke successfully acts the dissolute buffoon— playing drunken blindman's bluff with the courtesans and wolfing down delicacies even on the anniversary of his lord's tragic ritual suicide.

At the teahouse a letter is delivered to Yuranosuke in secret by his son, detailing the movements of the evil Moronao. Thinking to read it unobserved, he comes out from the party onto the verandah of the teahouse. By coincidence, Okaru has come out onto the second-floor balcony above to sober up from the unaccustomed sake; more dangerously, Moronao's henchman Kudayū is hiding under the verandah where Yuranosuke stands. Okaru, convinced the letter is a love-letter, is curious and tries to make out the contents. The characters of the letter have been written back to front as a kind of code, however, and she can only read them reflected in her pocket mirror. Meanwhile, as Yuranosuke peruses the long letter-scroll, he lets the portion he has already read hang down below the verandah, where Kudayū busily attempts to read it. Suddenly one of Okaru's hairpins comes loose and drops to the floor with a clatter. As Yuranosuke hurriedly rolls up the letter, its other end tears off in Kudayū's hand. Yuranosuke realizes that he has been spied on by at least two people.[1]

This comic scene of "double spying" in act seven of *Chūshingura* is among the most popular of the whole cycle, and *Kabuki Nempyō* records that on this occasion Hanshirō IV's interpretation was particularly well received (*ōatari*). Bunchō spares no pains to capture the florid setting of the house of pleasure, including an elaborate screen-painting of a crane perched on the trunk of a pine tree, and a small bell hanging from the eaves as a wind chime to indicate that the season is summer. The pose of the figure is one of Bunchō's most elegant: impossibly slender body and legs arched into a lovely curve.

1 For a full synopsis of *Kanadehon Chūshingura*, see Halford (1956), pp. 138–65.

SIGNATURE *Ippitsusai Bunchō ga*
ARTIST'S SEAL *Mori uji*
PROVENANCE Frederick May collection

(active ca. 1755–1790)

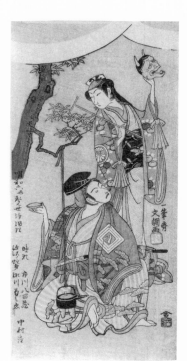

The actor Nakamura Nakazō I as Yamaoka no Saburō in "Momiji Kumo Nishiki no Tsuri Yogi" (Maple Clouds: A Brocade of Coverlets Hung Up), act three of the play *Kawaranu Hanasakae Hachi no Ki* (The Ever-Blooming Potted Tree), performed at the Nakamura Theater from the first day of the eleventh month, 1769

Hosoban; 32.7 x 15.2 cm (untrimmed)
The Clarence Buckingham Collection 1925.2532

In this print we see the stage set for a maple-viewing scene, with a striped curtain hanging from one of the trees to create a private enclosure. Several other prints by Bunchō show a similar setting,[1] and all relate to a maple-viewing dance interlude, "Momiji Kumo Nishiki no Tsuri Yogi," performed in the third act of the play *Kawaranu Hanasakae Hachi no Ki*. The dance, basically a duet between Ichikawa Yaozō II as the warrior Hōjō Tokiyori and Segawa Kikunojō II as the courtesan Tamagiku, with onstage musical accompaniment by the chanter Tokiwazu Moji-tayū, is depicted in another *hosoban* print by Bunchō (fig. 8.1). Nakazō I played what appears to have been a supporting role as the servant Yamaoka no Saburō. Theatrical records describe his costume as a "stiff white hunting cloak and court hat" (*shirahari eboshi*);[2] an illustration in an actor critique (*yakusha hyōbanki*) of the following year shows Nakazō I, seated with a wooden pail, wearing this costume (fig. 8.2). The libretto for the play has not survived, so it is difficult to say exactly why Nakazō I is brandishing a demon mask in the air. We do know, however, that this demon mask was a Hōjō family treasure which Tamagiku was trying to steal.[3] A similar combination of themes— maple-viewing party, beautiful women, and demons— occurs in the famous Nō play *Momiji-gari* (Maple Viewing), and this new Kabuki dance interlude of 1769 was probably a creative reinterpretation of that ancient drama.

Since Nakazō I was much in demand for his remarkably sinister interpretations of villainous roles, it is likely that Yamaoka no Saburō was an evil character.

As in so many eighteenth-century prints, the fugitive indigo blue pigment— used here in the sky and in the stripes of the curtain— has changed to a dull sand color.

1 See Hayashi (1981), nos. 58, 59, 75, 163, 274 (fig. 8.1). It does not seem, however, that any of these prints were composed as diptychs or triptychs.
2 *Kabuki Nempyō*, vol. 4 (1959), p. 120.
3 Ibid.

SIGNATURE *Ippitsusai Bunchō ga*
ARTIST'S SEAL *Mori uji*

8.1 Ippitsusai Bunchō.
*The actors Ichikawa Yaozō II
as Hōjō Tokiyori
and Segawa Kikunojō II
as Tamagiku
in a dance interlude.*
The Nelson-Atkins Museum of Art,
Kansas City, Mo.

8.2 *The actor Nakamura Nakazō I as the servant Yamaoka no Saburō.*
From an actor critique. Tōyō Bunko Library, Tokyo

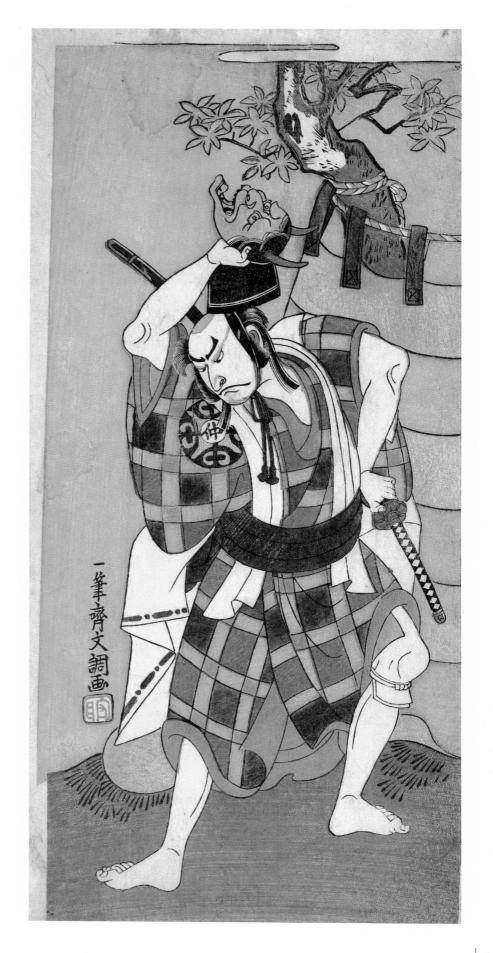

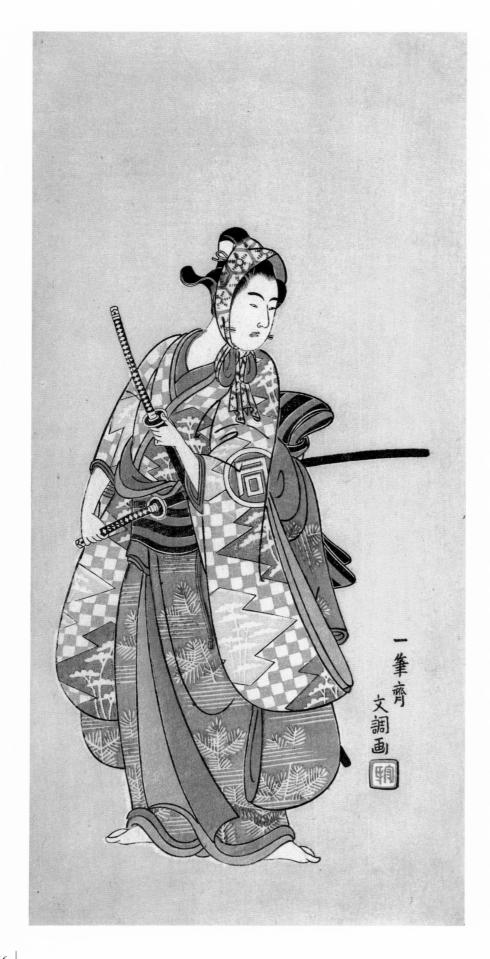

9 IPPITSUSAI BUNCHŌ

(active ca. 1755–1790)

The actor Sanogawa Ichimatsu II in the costume of a fashionable young man (*wakashu*)
Ca. 1769

Hosoban; 31.1 x 14.6 cm
The Clarence Buckingham Collection 1925.2523

Sanogawa Ichimatsu II is easily identified by the crest (*mon*) on his sleeve, consisting
of the character *onaji* inscribed within a circle. He wears a gorgeous kimono with long
hanging sleeves (*furisode*) whose checkerboard (*ishi-datami*) pattern, here rendered in
pink and white, was made famous by his illustrious predecessor Ichimatsu I. Scattered
over this checkerboard background are overlapping-diamond shapes called "pine-bark
lozenge" (*matsukawa-bishi*), with clumps of pine trees (*matsu*) within each lozenge. Over
the *furisode*, shrugged off his shoulders and held at the waist, is a purple over-kimono
decorated with pine sprigs in the mist. This abundance of pine motifs calls attention to
the *matsu* character in Ichimatsu's name. The outfit is completed by a red-and-black
striped obi tied in a large, rather feminine bow at the back, a pair of swords, and a hand
towel tied under the chin like a head kerchief (*hōkaburi*). The whole costume is of the
type often sported by young dandies. Its rich patterns are set off against a plain back-
ground which—before it faded—would have been pale blue. Though the figure is placed
off center, Bunchō brings the composition back into balance by allowing the black
scabbard of one sword to project to the right.

Sanogawa Ichimatsu I (1722–1762) was the leading interpreter of "young dandy"
(*wakashu*) roles in the middle years of the eighteenth century (though he played female
roles as well), and his handsome looks brought him phenomenal popularity. After
Ichimatsu II succeeded to the title in 1767, he followed closely in his predecessor's
footsteps, even adopting Ichimatsu I's distinctive costume, as we see. As a sideline to
acting he ran an incense shop, which is illustrated in Kitao Shigemasa's picture book
Ehon Sakae-gusa (fig. 9.1).

The role has been tentatively identified by Suzuki Jūzō as that of Shida no Kotarō,
performed by Ichimatsu II twice: once at the Ichimura Theater in the first month of
1769 in the play *Edo no Hana Wakayagi Soga* (Flowers of Edo: A New Young Soga), and
again at the same theater in the seventh month of 1770 in the play *Shinasadame Sōma no
Mombi* (Comparing Merits: Festival Day at Sōma).[1]

1 *Ukiyo-e Shūka*, vol. 5 (1980), no. 76.

SIGNATURE *Ippitsusai Bunchō ga*
ARTIST'S SEAL *Mori uji*
REFERENCE *Ukiyo-e Shūka*, vol. 5 (1980), no. 76

9.1 Kitao Shigemasa.
The actor Sanogawa Ichimatsu II's incense shop.
From *Ehon Sakae-gusa.*
British Museum, London

10 IPPITSUSAI BUNCHŌ

(active ca. 1755–1790)

Ofuji of the Yanagi Shop
Ca. 1769

Hosoban; 32.6 x 15.5 cm
The Clarence Buckingham Collection 1925.2533

During the later 1760s a succession of beautiful shop girls, waitresses, and shrine maidens from around the city of Edo were "discovered" by samurai writers and artists and adopted as the heroines of their humorous novels, plays, and woodblock prints. This was part of a general celebration of contemporary urban life, a trend to realism in all the arts. By establishing such ordinary working girls as the new aristocrats of popular culture, these intellectuals undoubtedly had in mind to unthrone some of the fabled beauties of Japan's ancient aristocratic culture. Thus Osen, waitress at the Kagiya Teahouse by the entrance to Kasamori Shrine, was universally acclaimed the reigning beauty, with Ofuji, daughter of Niheiji, the owner of the Moto-Yanagiya,[1] a toothbrush and tooth-powder shop, running a close second.

The beautiful Ofuji sits at the front of the store as a "come-on" (*kamban musume*, literally, "signboard girl"). Beside her is the small grindstone used to crush the gallnuts found on sumac (*nurude*) into the black powder painted onto their teeth by married women of the premodern period. Ofuji is preparing packets of the powder and the split-bamboo toothbrushes with which this was applied. The advertisement on the wall behind her, written under the willow-branch (*yanagi*) emblem of the store, gives the name of the powder as "Genji Perfumed Gallnut Powder" (*Genji Nioi Fushi*). The walls are topped with the trademark of the business— crossed scrolls on a circle in the center of a fan— and behind her a small screen is decorated with a painting of the Chrysan-themum Boy (Kikujidō), a classical Chinese, hence elegant, subject. Down the left-hand side of the design is a poem printed in white reserve against the (faded) blue background:

Keuchi suru	As they dye their teeth
nurude Ofuji no	With gallnut powder,
okami kana	Does Ofuji slip them a glance?[2]

Much of the information concerning Ofuji is derived from the pages of *Hannichi Kanwa* (A Half-Day's Idle Chat), a diary written by the author Ōta Nampo (1749–1823). The Moto-Yanagiya was apparently located beneath a large gingko tree, behind the main worship hall of the Asakusa Kannon Temple, and Ofuji was sometimes referred to by the nickname Miss Gingko (Ichō Musume). Nampo says that she first appeared before the public at her father's store halfway through the exhibition of treasures of the Kannon Temple, held from the eighteenth day of the third month to the eighth day of the sixth month, 1769.[3] Ofuji must have been well known before this, however, because Bunchō also designed a *hosoban* print that shows her being impersonated by the actor Segawa Kikunojō II in the dance interlude "Sugatami Asamagatake," performed at the Nakamura Theater from the fifteenth day of the first month of that year (fig. 10.1).[4]

Though portrayed in color prints less often than Osen, Ofuji appears in several designs by Harunobu and Bunchō.[5]

1 *Moto-Yanagiya* means "the main Yanagi shop"— as opposed, presumably, to branches of the same firm.
2 The poem contains a pun on the word *okami*, which can mean both "sideways glance" and "married woman" (who would of course black her teeth).
3 *Hannichi Kanwa*, bk. 12, in *Nihon Zuihitsu Taisei*, vol. 4 (1927), pp. 455–56.
4 As this was a New Year play, and therefore by immutable tradition a play dealing with the Soga brothers' revenge, Kikunojō II appeared as Soga no Jūrō's beloved, Tora Gozen, disguised as Moto-Yanagiya Ofuji. See *Kabuki Nempyō*, vol. 4 (1959), p. 99.
5 For prints of Ofuji by Harunobu, see Hillier (1976), no. 147; Smith (1988), no. 50.

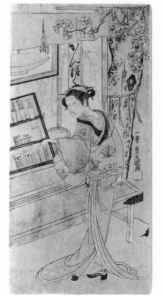

SIGNATURE *Ippitsusai Bunchō ga*
ARTIST'S SEAL *Mori uji*

10.1 Ippitsusai Bunchō.
The actor Segawa Kikunojō II as Yanagiya Ofuji in a dance interlude.
Tsubouchi Memorial Theater Museum, Waseda University, Tokyo

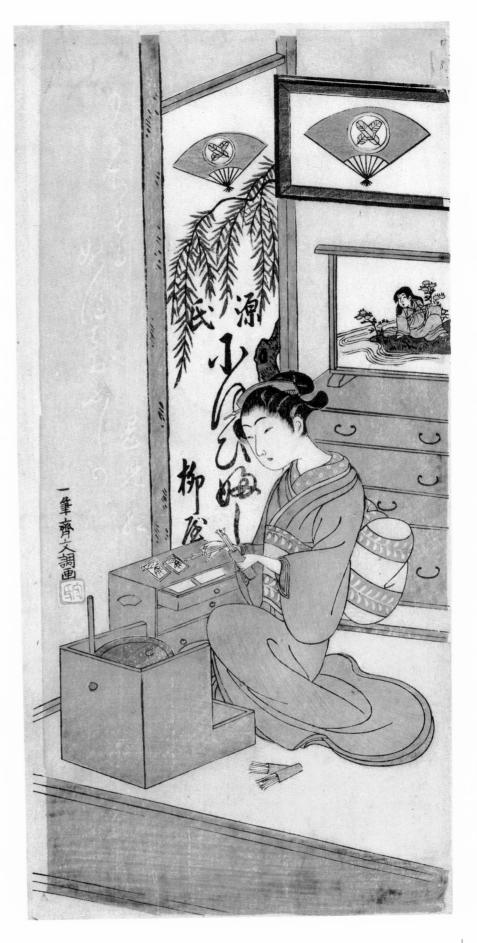

II IPPITSUSAI BUNCHŌ

(active ca. 1755–1790)

The courtesan Handayū of the Nakaōmiya house of pleasure
Series title: *Fūji-bumi* (Folded Love-letters)
Ca. 1769–1770

Hosoban; 31.9 x 15.1 cm
The Clarence Buckingham Collection 1925.2542

The courtesan Handayū of the Nakaōmiya house stands by the entrance of the establishment, lost in thought. She wears a pure white kimono, bright red under-robes, and a purple obi, and has pulled her hands up inside her kimono and holds them under her chin. At her feet is a large folding lantern bearing the circular dwarf bamboo (*nezasa*) emblem of the house, along with a design of a red peony which must be her personal crest. She has probably been engaged to entertain at a party and is waiting for a maid or manservant to come and accompany her, for no high-ranking courtesan would venture out unescorted, to say nothing of carrying her own lantern. Beside the staircase leading up to the second-floor apartments of the women is an elaborate planter containing dwarf pine and chrysanthemums, indicating that the season is autumn.

Autumn in the Japanese literary tradition is a symbol and cue for melancholy, and this design is unusually pensive in a normally sunny genre. In this respect Bunchō's print may be contrasted with the work of Suzuki Harunobu (ca. 1724–1770), the leading designer of prints of beautiful women of the day. Not one of the hundred and more courtesans in Harunobu's *Seirō Bijin Awase* (Comparison of Beauties of the Green Houses), published in 1770 (almost contemporaneous with Bunchō's *Handayū*), looks as though a clouded thought had ever passed through her head.

The titles of the seventeen prints known from the series are all contained inside cartouches shaped like a folded love-letter; they give the name of the woman and the house to which she belonged, and the words *mairase-soro*, a feminine epistolary form that can also mean "love-letter." Each letter-shaped cartouche is addressed "to my patron" (*on-tono*).[1] It is tempting to think that Handayū might be brooding over the contents of some letter she had written, but the other prints in the series— showing courtesans seated in their apartments or parading in the quarter— do not seem to have any particular connections with love-letters.

The red, purple, and blue pigments of the Chicago impression are somewhat faded.

1 The seventeen designs from the series currently known are: Handayū of the Nakaōmiya (The Metropolitan Museum of Art, New York; Tsubouchi Memorial Theater Museum, Waseda University, Tokyo; The Art Institute of Chicago, No. 11); Chibune of the Ebiya (The Art Institute of Chicago, cat. no. 25); Hinaji of the Chōjiya (The Art Institute of Chicago, cat. no. 26); Chōzan of the Chōjiya (The Metropolitan Museum of Art, New York; Museum of Fine Arts, Boston); Katsuya of the Kazusaya (H. George Mann collection, Chicago); Hanamurasaki of the Tamaya (Nelson-Atkins Museum of Art, Kansas City, Mo.); Matsuyama of the Tamaya (The Metropolitan Museum of Art, New York); Shizuka of the Tamaya (Musées Royaux d'Art et d'Histoire, Brussels); Hatsukaze of the Yamashiroya (Musées Royaux d'Art et d'Histoire, Brussels); Matsukaze of the Yamashiroya (Musées Royaux d'Art et d'Histoire, Brussels); Somenosuke of the Matsubaya (The Art Institute of Chicago, cat. no. 24); Nanamachi of the Shinkanaya (Musée Guimet, Paris; Museum of Fine Arts, Boston); Utanosuke of the Ebiya (Nakau Ei collection, Kobe); Takigawa of the Ōgiya (Musées Royaux d'Art et d'Histoire, Brussels); Nishikigi of the Kanaya (The Metropolitan Museum of Art, New York); Karasaki of the Wakanaya (Museum of Fine Arts, Boston); Morokoshi of the Echizenya (Museum of Fine Arts, Boston); Takamura of the Komatsuya (Museum of Fine Arts, Boston).

SIGNATURE *Ippitsusai Bunchō ga*
ARTIST'S SEAL *Mori uji*
REFERENCE Riccar (1973), no. 100
OTHER IMPRESSIONS
The Metropolitan Museum of Art, New York;
Tsubouchi Memorial Theater Museum, Waseda University, Tokyo

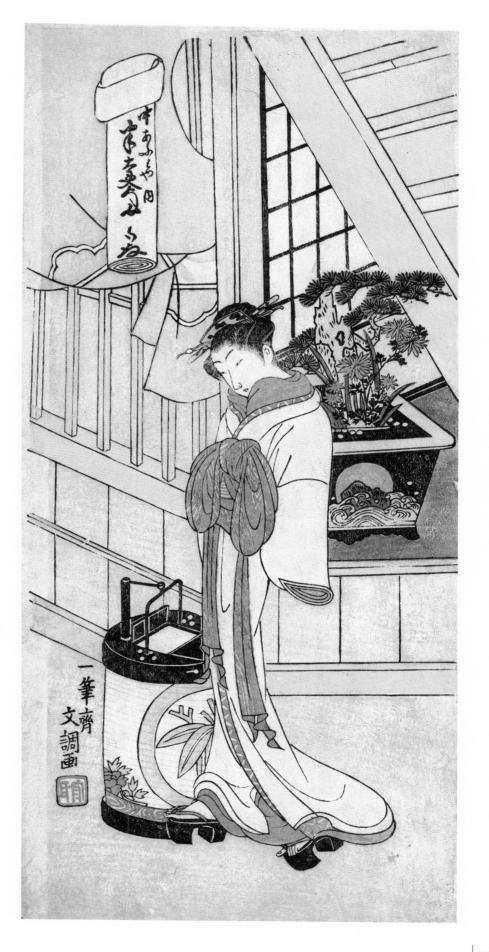

12 IPPITSUSAI BUNCHŌ

(active ca. 1755–1790)

The actor Matsumoto Kōshirō III as Kikuchi Hyōgo Narikage in the play *Katakiuchi Chūkō Kagami* (Vendetta: A Model of Loyalty and Filial Duty), performed at the Nakamura Theater from the fifth day of the sixth month, 1770

Hosoban; 31.7 x 14.3 cm
The Clarence Buckingham Collection 1925.2402

The hand-written inscription added to the top left-hand corner of the print identifies the subject as Kikuchi Hyōgo, played by Matsumoto Kōshirō III (later Ichikawa Danjūrō V) at the Nakamura Theater in the autumn of Meiwa 7 (1770). *Kabuki Nempyō* describes Kōshirō III appearing on this occasion in the guise of an old, white-haired man.[1] He stands resolutely beside a stone lantern at the approach to a shrine, his sword drawn and an open umbrella over one shoulder. The costume consists of a long black *haori* jacket over a lime green kimono decorated with purple panels bearing the actor's crest (*mon*).

An advance publicity handbill (*tsuji banzuke*) for the play includes in the top left-hand corner a scene showing Kōshirō III engaged in a sword fight with Sakata Tōjūrō III, who played the role of Shinoda no Shōji, at the stone gateway (torii) to a shrine (fig. 12.1). In the handbill Kōshirō III is shown beardless and wearing long *naga-bakama* trousers, but such differences in costume between advance handbills and color prints are common. It is thus likely that Bunchō's print shows Kōshirō III in this fight scene, and it may even form a diptych with another, now lost, sheet of Sakata Tōjūrō III as Shinoda no Shōji.

The colors of the print are relatively unfaded, with only the pale blue background having modified to a shade of sand.

1 *Kabuki Nempyō*, vol. 4 (1959), p. 139.

SIGNATURE *Ippitsusai Bunchō ga*
ARTIST'S SEAL *Mori uji*
PUBLISHER Okumura Genroku
PROVENANCE Jacquin collection
OTHER IMPRESSIONS Tokyo National Museum

12.1 Publicity handbill for the play *Katakiuchi Chūkō Kagami*. Bigelow collection, Museum of Fine Arts, Boston

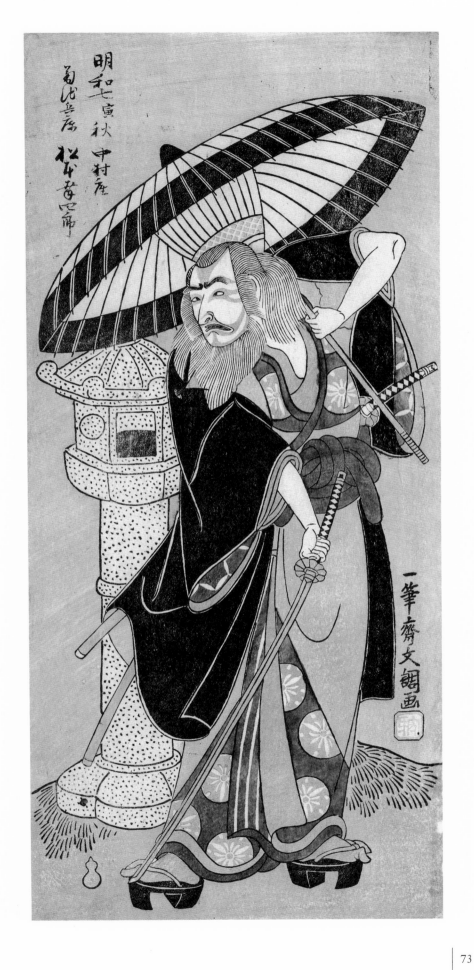

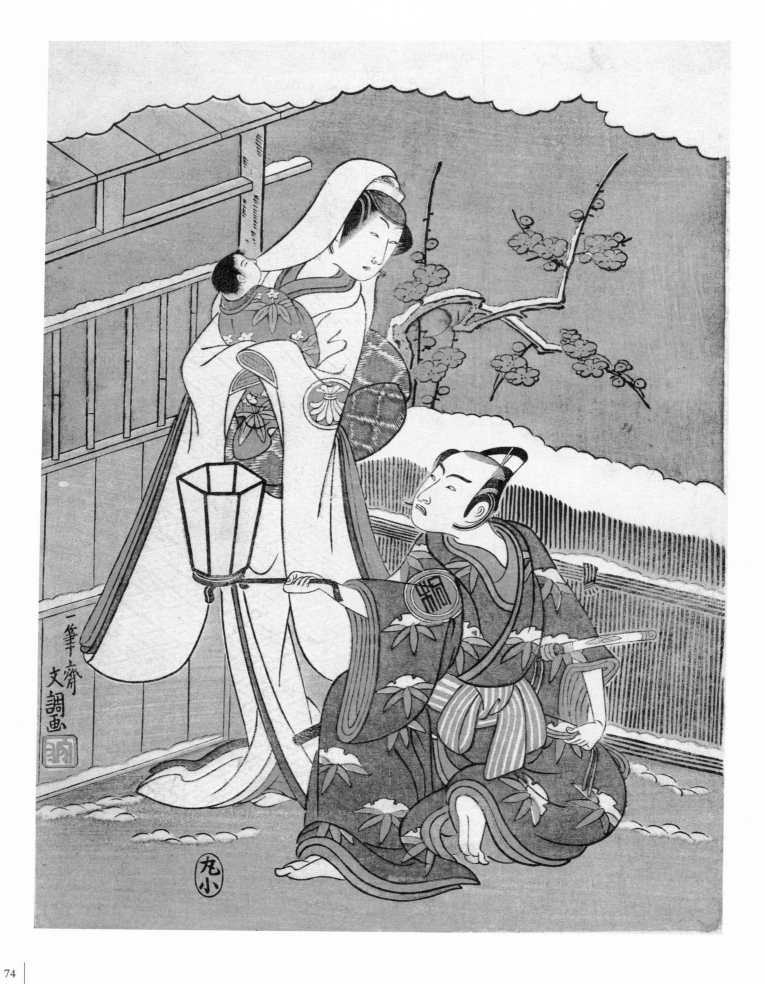

13 IPPITSUSAI BUNCHŌ

(active ca. 1755–1790)

The actors Arashi Sangorō II as Minamoto no Yoritomo disguised as the Hat Maker (Eboshi Ori) Daitarō, and Segawa Kikunojō II as the Snow Woman (Yuki Onna), in the dance sequence "Oyama Beni Yuki no Sugao" (Courtesan's Rouge on a Snow White Face), from the final act of the play *Myōtogiku Izu no Kisewata* (Cotton Wadding of Izu Protecting the Matrimonial Chrysanthemums), performed at the Ichimura Theater from the first day of the eleventh month, 1770

Chūban; 26.2 x 19.9 cm
The Clarence Buckingham Collection 1925.2538

SIGNATURE *Ippitsusai Bunchō ga*
ARTIST'S SEAL *Mori uji*
PUBLISHER Maruya Kohei
REFERENCE
Michener (1954), no. 40;
Ukiyo-e Shūka, vol. 5 (1981), no. 1
OTHER IMPRESSIONS
Arthur M. Sackler Museum, Harvard University Art Museums, Cambridge, Mass.; ex-coll. Henri Vever (present location unknown)

13.1 Katsukawa Shunshō. *The actors Arashi Sangorō II as Minamoto no Yoritomo, Segawa Kikunojō II as the Snow Woman, and Ichimura Uzaemon IX as Kajiwara Genta no Kagetoki. From Yakusha Kuni no Hana.* The Art Institute of Chicago

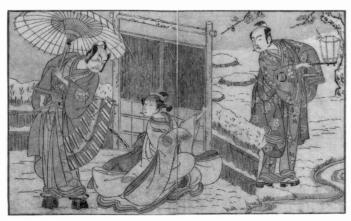

Behind a gateway in a snow-covered brushwood fence blossoms a red plum tree. Before it, Sangorō II as the young Minamoto (Genji) lord Yoritomo kneels in the snow, holding up a lantern whose light reveals Kikunojō II, looking almost ghostly in the pure white kimono of the Snow Woman. The child in her arms also bears on his small kimono the combined dwarf bamboo and bellflower (*sasa rindō*) crest of the Murakami branch of the Minamoto (Genji) clan. Kikunojō II was the unchallenged superstar of female roles during the 1760s and Sangorō II a promising newcomer to Edo, praised for his "manly good looks and fine voice, unusual in a Kyoto actor."[1]

In the book *Yakusha Kuni no Hana* (Prominent Actors of Japan) a more prosaic illustration by Katsukawa Shunshō reveals that the same dance sequence (fig. 13.1) also included the character of Kajiwara Genta no Kagetoki, played by Ichimura Uzaemon IX, actor-proprietor of the Ichimura Theater. The genius of Bunchō's design, however, lies in its dramatic intensity, created by excluding all extraneous details and concentrating our attention on the charged postures and glances of the handsome duo sculpturally posed in the tight corner formed by fence and gate.

A review of Kikunojō II's performance, published the following spring, tells that he followed this scene with a solo dance, "Sagi Musume" (The Heron Maiden), a role he had created to great acclaim in 1762. "Heron Maiden" called for the same pure white costume, which made for an easy transition, and included elaborate turns flourishing a paper umbrella. Bunchō designed at least three more prints, in *hosoban* format, illustrating Kikunojō II in these dance sequences.[2]

The colors of the Chicago impression are miraculously unfaded, giving a rare opportunity to savor the rich combination of red, purple, and blue. Kikunojō II's white costume has been elaborately embossed with a diamond pattern.

1 From the actor critique *Yakusha Saitan Jō*, published in the spring of 1771. Quoted by Suzuki Jūzō in *Ukiyo-e Shūka*, vol. 5 (1980), no. 1.
2 Riccar (1978), no. 71; Hayashi (1981), nos. 165, 166.

14 *Attributed to* IPPITSUSAI BUNCHŌ

(active ca. 1755–1790)

White chrysanthemums and pinks in a black vase
Ca. 1765–1770

Hosoban; 33.0 x 15.0 cm
The Clarence Buckingham Collection 1949.31

The "flowers of autumn" (*akigusa*), a principal motif in Japanese art and literature, include chrysanthemums and pinks. Here they are deftly arranged off center in a vase whose shape suggests that it may be a treasured Chinese metal import. The matte jet black of the vase provides a sophisticated foil for both the pure white chrysanthemums and the colorful dappled pinks, whose hue is echoed in the square carved-lacquer (?) stand underneath the vase. A sharp diagonal separates the background from the horizontal plane on which the vase stands, implying that we are looking down from above; perhaps the mustard yellow horizontal is meant to suggest the low shelf of a tokonoma, where, of course, flowers would normally be displayed. One can imagine this tasteful arrangement lovingly created for the admiration of fellow sophisticates at some autumn tea gathering.

In assigning the print to Bunchō we are simply following the traditional attribution, for no flower prints of this type bearing his signature are known.[1] Perhaps early critics detected in it the same quiet, rather astringent quality sometimes found in Bunchō's designs of Kabuki actors of female roles (*onnagata*). If the print was designed by another professional *ukiyo-e* artist, possible candidates would be Suzuki Harunobu, Kitao Shigemasa, or Isoda Koryūsai.

On the other hand, in subject matter and execution the print bears a resemblance to certain calendar prints[2] designed by amateurs in 1765 and 1766— for instance, the *Pot of Pinks* "conceived by Hōshi," which has calendar marks for 1765 printed around the body of the pot (fig. 14.1). Though the present print bears no calendar marks, it is elaborately embossed to bring out the petals of the white chrysanthemums and to suggest a floral decoration on the black vase. This is typical of the technical experimentation and meticulous workmanship of the few years following 1765, when commercial full-color printing was new.

1 For another flower-arrangement print from this period attributed to Bunchō, see Rijksmuseum, Amsterdam (1977), no. 108.
2 Calendar prints (*egoyomi*) first appeared in the early eighteenth century. They were customarily exchanged among friends at New Year, and have the numbers of the "long" and "short" months of the new lunar year hidden in some part of the design.

UNSIGNED
PROVENANCE Louis V. Ledoux collection
REFERENCE Ledoux (1948), no. 9

14.1 *Pot of Pinks*. Baur collection, Geneva

15 IPPITSUSAI BUNCHŌ

(active ca. 1755–1790)

The flying tea ceremony kettle (*tonda chagama*)
Ca. 1770

Chūban; 27.5 x 20.3 cm
The Clarence Buckingham Collection 1935.384

By what curious shift in meaning did the English expression
"piece of crumpet" come to mean a sexually attractive woman?
(The *Oxford English Dictionary* does not seem to know:
"17th c., of uncertain origin.") In Edo of the 1770s "flying tea
ceremony kettle" (*tonda chagama*) meant the same thing. In his
diary *Hannichi Kanwa* (A Half-Day's Idle Chat), Ōta Nampo
relates a saying current in Edo about the second month of 1770:
"The tea ceremony kettle flew away and turned into a common
teakettle" (*Tonda chagama ga yakan nito baketa*). This was a
piece of wordplay spun around some popular gossip: Osen, the
waitress whose celebrated beauty drew clients to the Kagiya
Teahouse by the Kasamori Shrine, had run off, leaving her
old, bald father to cope with the customers.[1] *Yakan*, besides
meaning a humble teakettle, was also slang for a bald head.
Nampo also records that Ofude, a former Yoshiwara courtesan
who had become a waitress at the Hayashiya Teahouse in
Ueno, was popularly known as Chagama Musume (Miss Tea
Ceremony Kettle).

Bunchō has drawn a literal visual equivalent of the wordplay.
A casually dressed, buxom countrywoman seated by the open
hearth of her farmhouse is about to scoop water from a bucket
into the fancy round cast-iron tea ceremony kettle to brew
tea, when the tea ceremony kettle sprouts wings and flies into
the air and its place is taken by an ordinary teakettle. Her little
boy dances around in delight, and the woman brandishes the
bamboo fire-blowing tube as if to knock down the flying
kettle. Perhaps the attractive countrywoman is supposed to be
the counterpart of Osen, and the boy— with his shaven head—
represents her father. The wall of the house is covered with
sheets of paper on which practice calligraphy has been corrected
in red ink. If the characters are read in a certain order, they
form the words of the saying quoted above.

A print such as this shows just how closely *ukiyo-e* were attuned
to popular fads.

1 *Nihon Zuihitsu Taisei*, vol. 4 (1927), p. 457.

SIGNATURE *Ippitsusai Bunchō ga*
ARTIST'S SEAL *Mori uji*
PROVENANCE Carl Schraubstadter collection
OTHER IMPRESSIONS
Tsubouchi Memorial Theater Museum, Waseda University, Tokyo

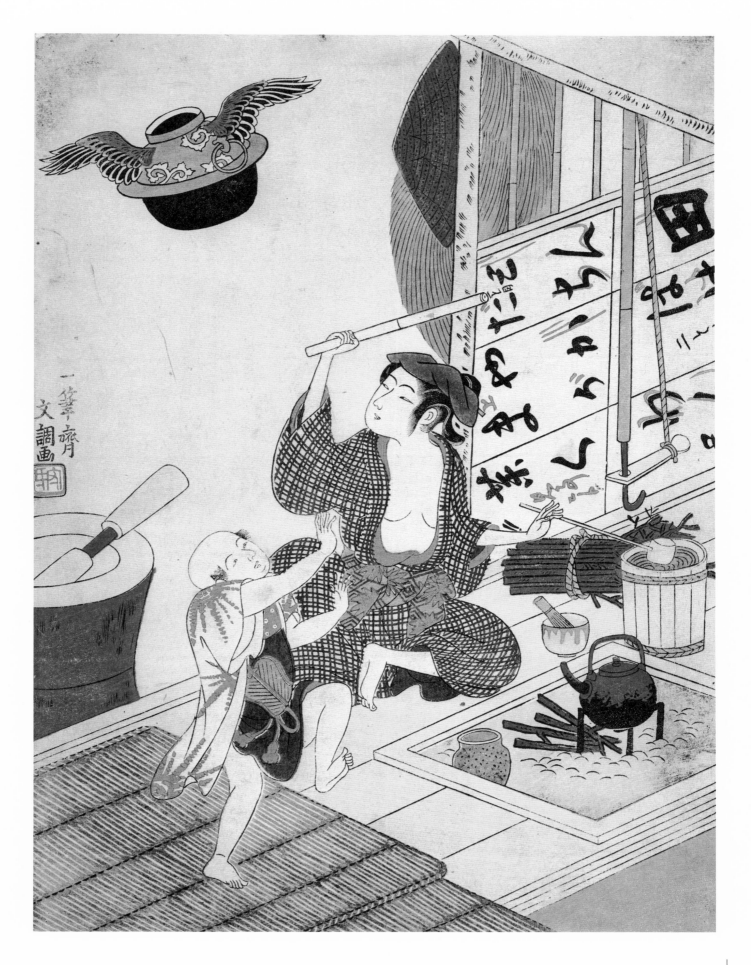

16 IPPITSUSAI BUNCHŌ

(active ca. 1755–1790)

The actor Segawa Kikunojō II as the courtesan Hitachi in part
two of the play *Wada Sakamori Osame no Mitsugumi* (Wada's
Carousal: The Last Drink With a Set of Three Cups), per-
formed at the Ichimura Theater from the ninth day
of the second month, 1771

Hosoban; 31.7 x 14.3 cm
The Clarence Buckingham Collection 1925.2405

As with Number 12, a hand-written inscription in the top
right-hand corner of the print identifies for us the actor and role:
Segawa Kikunojō II as the courtesan Hitachi in a performance
at the Ichimura Theater in the spring of Meiwa 8 (1771). As was
customary at all New Year performances, the main play was a
version of the famous revenge of the Soga brothers Gorō and
Jūrō against their father's murderer, Kudō Suketsune. In the
second part, however, it appears that some new material was
introduced into the plot: Bandō Mitsugorō I appeared as both
Jūrō and Inosuke the Ferryman, Segawa Kikunojō II was the
courtesan Hitachi, and Onoe Matsusuke I, as the sumo wrestler
Shakagatake, made a spectacular entrance down the *hanamichi*
(raised walkway through the audience to the stage), between
waist-high curtains painted to look like plaster walls.[1] No other
details of part two are recorded.

Kikunojō II is depicted as a high-ranking courtesan making a
formal progress in the Yoshiwara pleasure district, escorted in
front by a maid or manservant carrying a large collapsible lantern
and behind by a parasol bearer. Neither of these boorish types is
actually shown in the print, however, so as not to distract from
the beauty of the courtesan. On the lantern, which would nor-
mally carry the emblem of the house of pleasure to which the
woman belonged, appears the personal acting crest (*mon*) of
Kikunojō II— a tied bundle of floss silk (*yuiwata*). The lavish
brocade over-kimono (*uchikake*) is decorated with chrysanthe-
mums (*kiku*) in baskets— a pointed reference to Kikunojō II's
name— and the obi bears a novel design of fish swimming
among water weeds.

When this performance took place, Kikunojō II was aged thirty
and at the height of his powers and popularity as the leading
actor of female roles (*tate onnagata*). He died tragically young,
in the third month of 1773.[2]

1 *Kabuki Nempyō*, vol. 4 (1959), pp. 170–71.
2 For a discussion of the character of Bunchō's depictions of Segawa Kiku-
 nojō II, see the commentary to No. 3.

SIGNATURE *Ippitsusai Bunchō ga*
ARTIST'S SEAL *Mori uji*
PUBLISHER Okumura Genroku
OTHER IMPRESSIONS British Museum, London

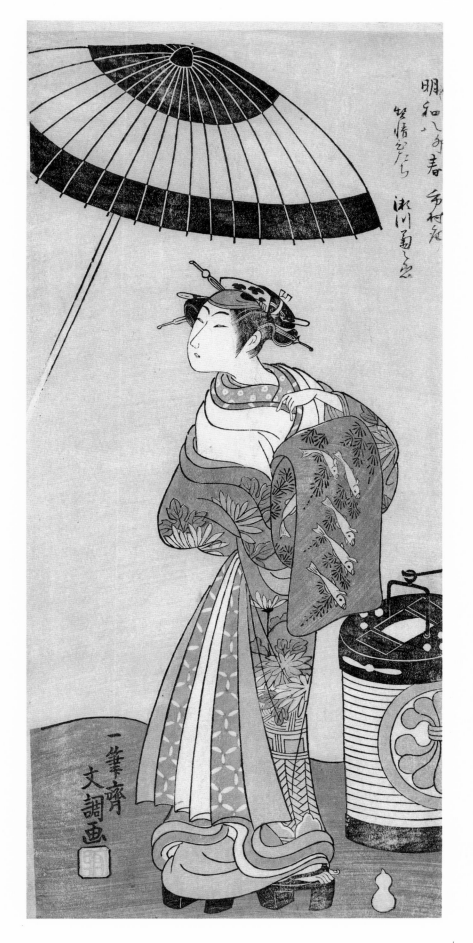

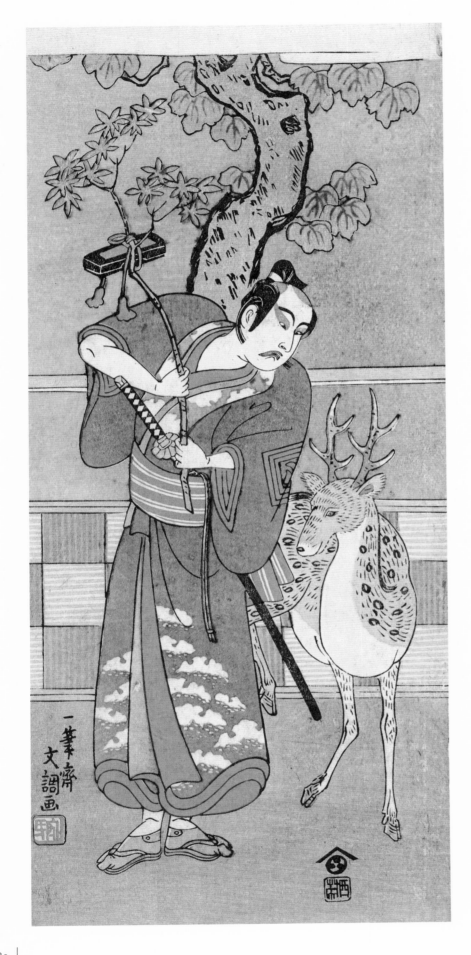

(active ca. 1755–1790)

The actor Ichikawa Yaozō II as Goi no Shō
Munesada with a deer, in the play *Kuni no Hana
Ono no Itsumoji* (Flower of Japan: Ono no
Komachi's Five Characters), performed at the
Nakamura Theater from the first day
of the eleventh month, 1771

Hosoban; 30.1 x 13.6 cm
The Clarence Buckingham Collection 1925.2406

Ichikawa Yaozō II here appears in the role of the
courtier Goi no Shō Munesada, in a historical
drama based on legendary episodes in the life of
the ninth-century beauty and poet Ono no
Komachi. Later in the play Munesada takes the
tonsure and the monastic name Henjō; it is under
this name that he is celebrated as one of the Six
Immortal Poets (*Rokkasen*)— a constellation to
which Komachi also belongs. He wears a purple
kimono decorated with a pattern of drifting snow
(the crenellated white circles, here shown as half-
circles, are called *yuki-wa*, "snow circles"), and
holds up a branch of maple to which is attached a
lacquer document box (*fubako*) tied with tasselled
silk cords. It is as if the deer, coming up inquisi-
tively behind him, has surprised him, and he is
holding the branch up out of the animal's reach.
Theatrical records make no mention of a deer in
this play, but an illustration in the program (*ehon
banzuke*) shows the deer coming to life out of a
votive painting (*ema*) by the court artist Kose
no Kanaoka (played by Nakamura Nakazō I)
(fig. 17.1).

The brilliantly preserved colors of this print—
with its strong, unfaded purples, blues, and
red— remind us how striking *ukiyo-e* prints were
when first issued.

17.1 *The actor Ichikawa Yaozō II
as Goi no Shō Munesada.*
From the illustrated program.
Tenri University Library, Tokyo

SIGNATURE *Ippitsusai Bunchō ga*
ARTIST'S SEAL *Mori uji*
PUBLISHER Nishimuraya Yohachi
OTHER IMPRESSIONS
Tsubouchi Memorial Theater Museum,
Waseda University, Tokyo

The actor Nakamura Noshio I as the Third Princess (Nyosan no Miya) in the play *Fuki Kaete Tsuki mo Yoshiwara* (Rethatched Roof: The Moon also Shines Over the Yoshiwara Pleasure District), performed at the Morita Theater from the first day of the eleventh month, 1771

Hosoban; 32.5 x 15.0 cm
The Clarence Buckingham Collection 1929.735

SIGNATURE *Ippitsusai Bunchō ga*
ARTIST'S SEAL *Mori uji*
PUBLISHER Nishimuraya Yohachi
OTHER IMPRESSIONS
Tokyo National Museum;
Tsubouchi Memorial Theater Museum,
Waseda University, Tokyo;
The Metropolitan Museum of Art,
New York

A pivotal moment in *Tale of Genji* (Lady Murasaki's famous novel written about A.D. 1000) occurs when the young courtier Kashiwagi accidentally glimpses the Third Princess (Nyosan no Miya), Prince Genji's wife, and instantly falls passionately in love with her. The scene occurs in chapter 34, "New Herbs: Part One" (*Wakana no Jō*), at Prince Genji's mansion. Young courtiers, led by Kashiwagi and Yūgiri, are playing a kind of football (*kemari*) under blossoming cherry trees, while Genji watches from the verandah. Suddenly there is a commotion: a pet cat on a lead, chased by a larger cat, runs out onto the verandah, with ladies-in-waiting in pursuit. The cat's lead catches in one of the hanging blinds, pulling the blind aside just long enough for Kashiwagi to catch sight of the Third Princess standing inside the room. For such a high-ranking woman to allow herself to be seen by a man was a grave lapse of propriety, made even worse by the fact that she was standing rather than seated. Lady Murasaki describes how Kashiwagi sees her:

"A lady in informal dress stood just inside the curtains beyond the second pillar to the west. Her robe seemed to be of red lined with lavender, and at the sleeves and throat the colors were as bright and varied as a book of paper samples. Her cloak was of white figured satin lined with red. Her hair fell as cleanly as sheaves of thread and fanned out towards the neatly trimmed edges some ten inches beyond her feet. In the rich billowing of her skirts the lady scarcely seemed present at all. The white profile framed by masses of black hair was pretty and elegant— though unfortunately the room was dark and he could not see her as well in the evening light as he would have wished. The women had been too delighted with the game, young gentlemen heedless of how they scattered the blossoms, to worry about blinds and concealment. The lady turned to look at the cat, which was mewing piteously, and in her face and figure was an abundance of quiet, unpretending young charm."[1]

Doubtless because the ensuing love affair was both illicit and tragic, and because the scene afforded artists the chance to depict a beautiful woman with a charming pet, the Third Princess and her cat became a popular subject for *mitate-e* (allusive or travestied versions, by *ukiyo-e* artists, of serious or classical painting subjects).

As Bunchō's print illustrates, the story was also adapted for the Kabuki stage in 1771, with Nakamura Noshio I as the Third Princess and Bandō Mitsugorō I as Kashiwagi no Emon (see also No. 56B). A page from that production's illustrated program (*ehon banzuke*) shows the Third Princess almost at the verandah and only slightly concealed behind a blind, with her kitten on the end of its leash (fig. 18.1). The latter-day Third Princess depicted in Number 18, totally unencumbered by Heian courtly decorum, affects no concealment whatever but stands right out on the verandah, well in front of the blinds: no Kabuki actor could ever resist the limelight.

This performance marked Ichikawa Danjūrō V's first appearance after his promotion to head of the acting troupe (*za-gashira*). Numbers 55 and 56C, by Shunshō, show Danjūrō in the final scene of the play, in the role of the Buddhist deity Fudō.

1 Murasaki (1981), pp. 583–84.

18.1 *Nakamura Noshio I as the Third Princess.*
From the illustrated program. Keiō University Library, Tokyo

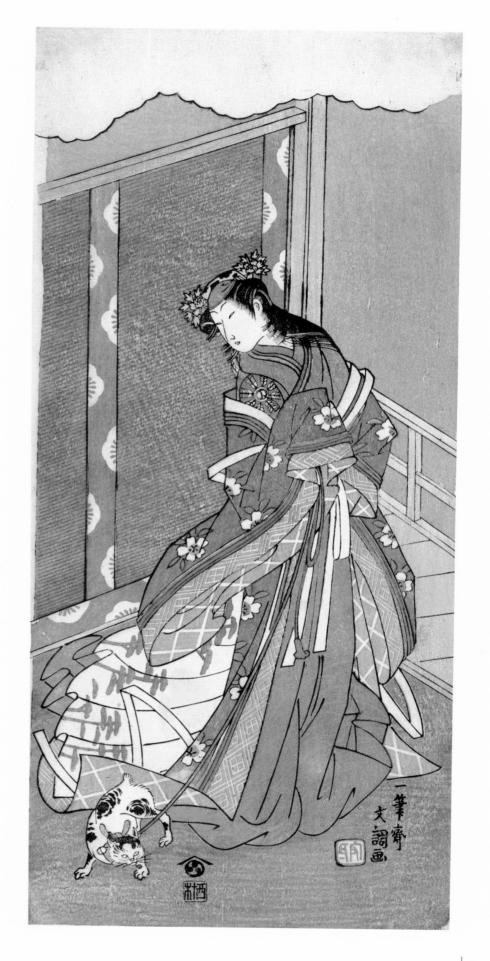

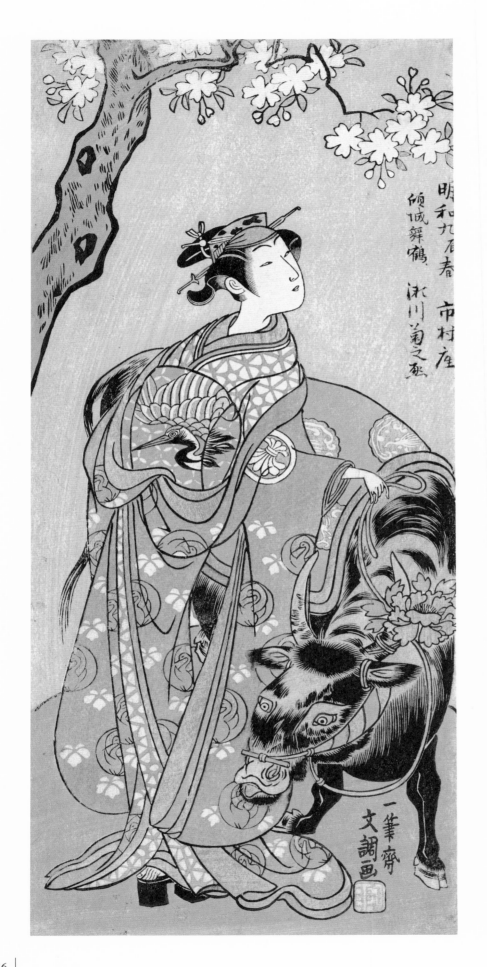

The actor Segawa Kikunojō II as the courtesan Maizuru in the play *Furisode Kisaragi Soga* (Soga of the Long, Hanging Sleeves in the Second Month), performed at the Ichimura Theater from the twentieth day of the second month, 1772

Hosoban; 30.2 x 13.8 cm
The Clarence Buckingham Collection 1925.2524

Once again, a hand-written inscription in the top right-hand corner of the print identifies the actor and role: Segawa Kikunojō II as the courtesan Maizuru at the Ichimura Theater in the spring of Meiwa 9 (1772). He wears a kimono with a pattern of "dancing crane" (*maizuru*) roundels— referring to the character's name— and leads an ox, which has one horn jauntily sporting a peony. This was a very special occasion for Kikunojō II, marking his return to the stage after an illness that had begun the previous summer. To celebrate his recovery, the Ichimura Theater and theater teahouses treated the production as if it was the season's opening (*kaomise*) that he had missed in the eleventh month of the previous year. The theatrical record *Kabuki Nempyō* describes the elaborate preparations:

"The first day of the performance was planned for the twentieth of the second month, and on the night of the nineteenth all the teahouses hung out branches of red plum from which were tied round blue lanterns decorated with Kikunojō's crests, 'bundle of floss silk' (*yuiwata*) and 'butterfly on a chrysanthemum' (*kiku-chō*). It was just like the last day of the tenth month [the night before the gala] in a normal year. In front of the theater were piled up gifts of thirty-three rice steamers, with a decoration of a treasure ship on top; also a presentational curtain, and thirty-three sake kegs, with a decoration of Mt. Fuji on top of that. There was dried bonito fish on freshly planed wooden stands. Up on the drum turret at the front of the theater they put a huge square kite, which had a red background with Kikunojō's 'bundle of floss silk' crest in white relief. On the kite was written 'full house' (*ō-iri*) in large characters, and it was decorated with a tail and string just like the real thing...."[1]

It is also recorded that last-minute rehearsals and the opening day's performances were observed by no less august a person than the retired feudal lord Matsudaira Munenobu (Nankai, 1729–1782).[2]

Being a New Year play, the plot was a variation on the evergreen theme of the revenge of the Soga

brothers, Jūrō and Gorō, on their father's murderer, Kudō Suketsune. Apparently Kikunojō II as Maizuru made his entry via a trap door in the stage, leading the (real-life?) ox with Onoe Kikugorō I as Kudō Suketsune seated on its back while a host of other characters lined the *hanamichi* walkways on both sides of the audience to deliver their lines. After all had proceeded to the stage, and Jūrō and Gorō had made their entrance carrying hobbyhorses,[3] no less than twelve stars formed a glittering lineup surrounding the central tableau.[4] An advance publicity handbill (*tsuji banzuke*) gives a good idea of what this crowded array must have looked like (fig. 19.2).

Doubtless because it was such an extraordinary theatrical event, Bunchō designed a second *hosoban* print of Maizuru and the ox, very similar to Number 19 except that the positions were reversed (fig. 19.1). Competing publishers must have been very keen to offer for sale portraits of Kikunojō II in this talked-of production.

The production, though overwhelmingly successful, was short-lived: on the night of the twenty-ninth—just ten days into the run—fire broke out at the Daien Temple in Meguro and soon destroyed large areas of the city, including the Nakamura and Ichimura theaters. Not long afterward Kikunojō II's health once more deteriorated, and he passed away in the spring of the following year, without ever returning to the stage.[5]

1 *Kabuki Nempyō*, vol. 4 (1959), p. 192.
2 Ibid.
3 The hobbyhorses allude to the *harugoma* ("spring pony") dance, which was performed around New Year and used wooden hobbyhorses. *Harugoma* dance interludes were incorporated into Kabuki performances.
4 *Kabuki Nempyō*, vol. 4 (1959), p. 191.
5 Ibid., p. 192.

SIGNATURE *Ippitsusai Bunchō ga*
ARTIST'S SEAL *Mori uji*
PROVENANCE John H. Wrenn collection

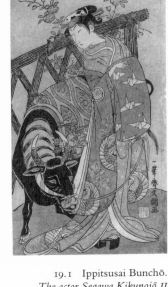

19.1 Ippitsusai Bunchō.
*The actor Segawa Kikunojō II
as Maizuru with an ox.*
Fitzwilliam Museum, Cambridge

19.2 The lineup of actors for the play
Furisode Kisaragi Soga. A publicity
handbill. Bigelow collection,
Museum of Fine Arts, Boston

20 IPPITSUSAI BUNCHŌ

(active ca. 1755–1790)

The lovers Ohatsu and Tokubei
Print title: *Chizuka no Fumi no Bosetsu*
(The Evening Snow
of a Thousand Bundles of Love-Letters)
Series title: *Sugata Hakkei* (Eight Views of Lovers)
Ca. 1772

Chūban; 26.5 x 19.5 cm
The Clarence Buckingham Collection 1929.727

SIGNATURE *Ippitsusai Bunchō ga*
ARTIST'S SEAL *Mori uji*
OTHER IMPRESSIONS
The Metropolitan Museum of Art, New York;
Vignier and Inada (1910), pl. XLIV (present location unknown);
Ukiyo-e Taika Shūsei (1931), pl. 64 (present location unknown)

The doomed love affair between the courtesan Ohatsu and the shop clerk Tokubei is the subject of one of Chikamatsu Monzaemon's most famous love-suicide plays, *Sonezaki Shinjū* (Double Suicide at Sonezaki). It was first performed at the Takemoto Puppet Theater in Osaka in 1703 and later adapted for the Kabuki stage. Their story was an obvious choice for inclusion by Bunchō in a print series of eight celebrated stage love affairs.[1] These eight prints were a witty allusion (*mitate-e*) to the "Eight Views of Lake Biwa" (*Ōmi Hakkei*), a subject often treated by classical landscape painters. On each of Bunchō's prints a cartouche in the form of a folded love-letter contains the series title and the names of the pair of lovers depicted. The term *hakkei* ("eight views") in both series titles makes the allusion unmistakable.

The plot of *Sonezaki Shinjū*, based on an actual love-suicide that occurred in Osaka in 1703, shows the pure love of Ohatsu and Tokubei overwhelmed by the blindness and selfishness around them: a well-meaning, officious uncle who wants to arrange a rich but loveless marriage; an aunt who spends the dowry in advance; a perfidious friend who borrows money and then denies the loan. All these conspire to drive the lovers to their desperate but ultimately redeeming final act.[2]

Such dark themes, however, were antithetical to the lively nature of eighteenth-century *ukiyo-e* prints, and Bunchō has chosen to depict a more cheerful scene early in the courtship, when Tokubei visits Ohatsu at the Temmaya house of pleasure to which she belongs, and receives a love-letter from her through the lattice of the brothel's "display window" (*harimise*). In the entrance hall to the left is a large lantern bearing the orange-blossom (*tachibana*) crest of the establishment, and a spotted dog dozing under a bench; since sleeping dogs do not bark, this one will not give the lovers away. Tokubei wears a fashionable wraparound overcoat, black silk hood, and high black lacquer clogs, and carries a large, half-open umbrella. The fact that he is visiting on a snowy evening provides the link with "Evening Snow on Mt. Hira" (*Hira no Bosetsu*), one of the "Eight Views of Lake Biwa" to which the eight prints in the series allude. A classical poem quoted in the stylized cloudbank across the top of the picture makes the association explicit:

Yuki haruru	The beauty of an evening
Hira no takane no	When the snow clears from
yūgure wa	Mt. Hira's lofty peak
hana no sakari ni	Surpasses even
suguru koro kana	The cherry trees in bloom.

The colors of the print have faded considerably.

1 At present only seven of the eight designs from the series are known: Ohatsu and Tokubei (The Art Institute of Chicago); Okiku and Kōsuke (ex-coll. Vever); Osome and Hisamatsu (Museum of Fine Arts, Boston); Oume and Kumenosuke (Tsubouchi Memorial Theater Museum, Waseda University, Tokyo); Umegawa and Chūbei (Tsubouchi Memorial Theater Museum, Waseda University, Tokyo); Yūgiri and Izaemon (Japan Ukiyo-e Museum, Matsumoto; Museum of Fine Arts, Boston); Wankyū (Wanya Kyūemon) and Matsuyama (Tokyo National Museum; Museum of Fine Arts, Boston).

2 For an English-language summary of the plot of *Sonezaki Shinjū*, see Halford (1956), pp. 303–6.

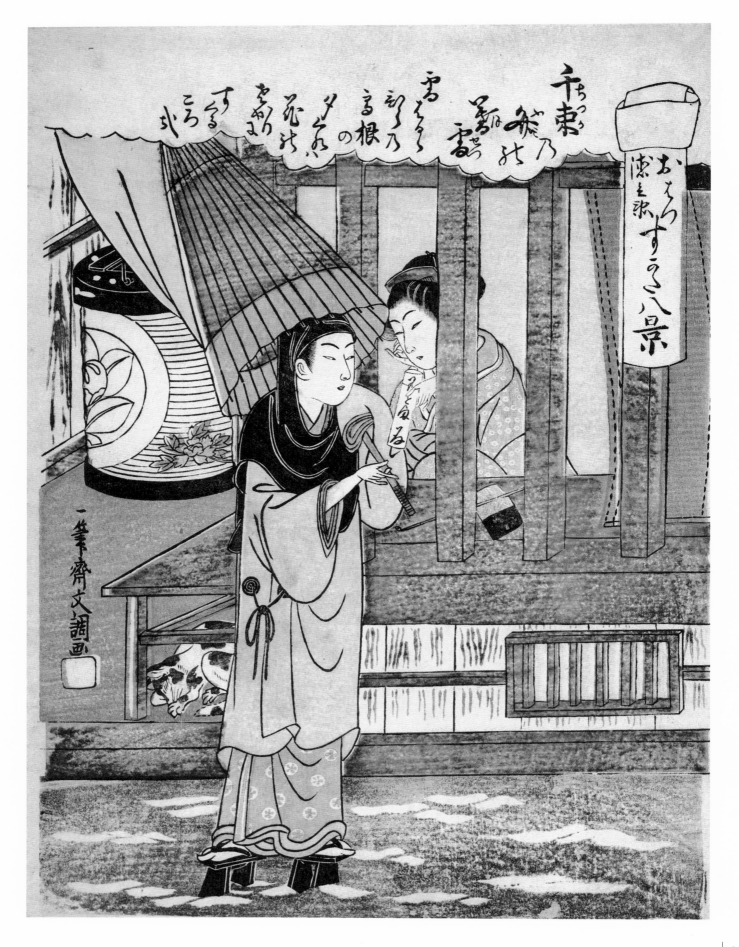

21 KISHI BUNSHŌ

(1754–1796)

Monkey trainer with a monkey at the New Year
Ca. 1780s (1782?)

Hosoban; 29.3 x 14.9 cm
Gift of Mr. and Mrs. Harold G. Henderson 1968.329

Printed entirely in shades of red ink, this print would have been pur-
chased as a household talisman against smallpox. The type was known as
red picture (*aka-e*), or smallpox picture (*hōsō-e*). It may well have been
sold door-to-door at the New Year holiday by the very monkey trainer
shown in the print. The monkey is dressed for the auspicious New Year
Sambasō dance and carries a drum, and his trainer wears a similarly festive
costume and carries a branch of bamboo to decorate a gateway. Hanging
from the fan he waves is a long, narrow poem card (*tanzaku*) inscribed
with a surprisingly lighthearted poem linking the dancing monkey, small-
pox lesions, and red and white plum blossoms, which bloom about
New Year:

Ume no hana	Flowers of the plum—
kazoete mireba	Let's count them and see:
yotsu itsutsu	Four, five [smallpox],
akaku shiroki wa	Red and white like
saru no manzai	The costume of the dancing monkey!

The short poem above the figures (probably by Bunshō) is more of a
straightforward plea:

Waga yado wa	In our home
hōsō karushi	May the smallpox be light:
ume no hana	Flower of the plum!

It is followed by yet another popular incantation against sickness: "Sasara
sampachi!" A smallpox epidemic is known to have hit Edo in the year
1782, so the print may have been issued at the New Year of 1782 or
1783.[1] The block cutting and printing are fairly crude, as befits a piece
of ephemera.

Bunshō was the art name (*gagō*) used by a town official of Kamei-chō
called Kishi Masayuki(?), who is said to have studied print designing
under Ippitsusai Bunchō. He was better known as a poet than an artist,
however, writing comic linked verse (*kyōka*) first under the pen name
Tsumuri no Hikaru, then under the name Hajintei II, bestowed on him
by Ōta Nampo, who had become his poetry teacher. In the later 1780s
Bunshō became leader of the Hakuraku *kyōka* poetry group. He died
in 1796, aged forty-three.[2]

1 *Edogaku Jiten* (1984), p. 811.
2 *Genshoku Ukiyo-e Daihyakka Jiten* (1982), p. 127.

SIGNATURE *Kishi Bunshō ga*

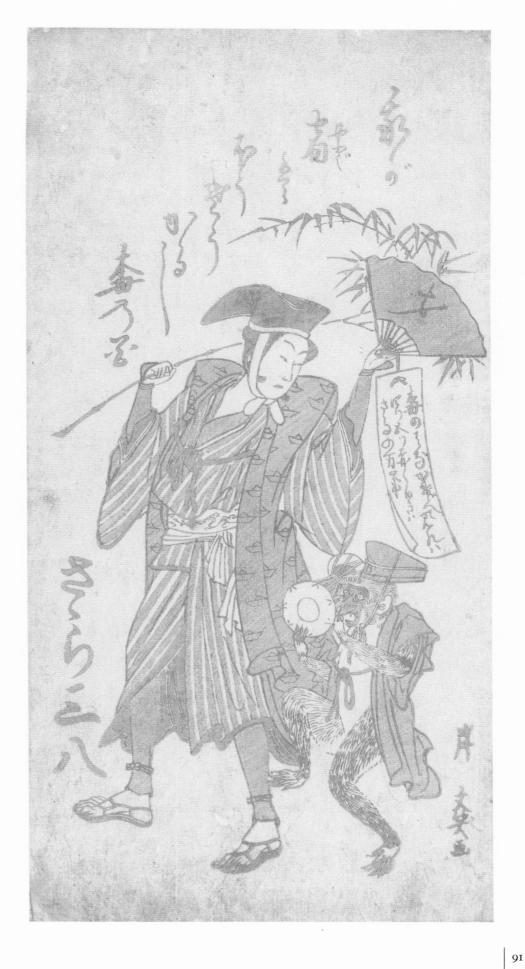

(act. 1740s–early 1760s)

Print title: A Triptych of Fashionable Nō Plays
(*Fūryū Utai Sambukutsui*)
Ca. late 1750s

Benizuri hosoban triptych (uncut); 31.1 x 47.3 cm
The Clarence Buckingham Collection 1925.2357

The three scenes of this triptych form separate compositions, each bearing a signature and publisher's seal. This suggests that they were intended to be cut apart and viewed separately, though perhaps placed side by side. Each shows a courtesan and a modishly dressed young man (*wakashu*) in a scene of dalliance based on an episode from a well-known Nō play. "Parody pictures" (*mitate-e*) of this kind, in which fashionably dressed figures from the contemporary demimonde enacted trivialized versions of scenes from classical literature, were common in *ukiyo-e* since its origins at the end of the seventeenth century.

On the right a young couple toy with a miniature kite in the shape of a kimono. The woman holds the spool of kite thread, an allusion to the Nō play *Miwa* (Origin of Miwa Shrine), in which a woman attaches a thread to the hem of her mysterious lover, follows the thread, and discovers that he is the deity of the Miwa Shrine. The short poem above reads:

Aibore no	Lovers quarrel—
ito kuri-kaeshi	But continually reel
ada-kuzetsu	The threads of affection that bind them.

The scene in the center mimics the encounter in *Eguchi*, in which the courtesan Eguchi no Kimi refuses a night's lodging to the wandering monk-poet Saigyō so as not to compromise his holy virtue. In the up-to-date print version we see a young man wearing a striped obi tied (like a courtesan's) in an extravagant bow in front and carrying a bucket of chrysanthemums. As he passes the brothel entrance, a courtesan emerges and looks after him admiringly. The poem over her head expresses her thoughts:

Shin tomuna	Don't lose your heart,
to wa omoedomo	I think to myself—
wakashu	But oh, that young man!...

The play *Izutsu* (The Well-Curb), based on episode 23 from *Ise Monogatari* (Tales of Ise), tells of a couple who as children played together by the well-curb, looking at their reflections in the water. Growing up, they fell in love. Once married, the husband grew mistrustful, but was won back by his wife's devotion and womanly charm. Shunsui translates this into a scene of a young woman combing the hair of her lover, who sits looking into a makeup mirror. Through the open *shōji* can be seen graceful willow fronds hanging above the well-curb:

Kurabegoshi	How graceful her form!
yanagi wa ika na	Just like a willow
kushi-zukai	As she plies the comb.

Shunsui was a pupil of Miyagawa Chōshun (1683–1753) and used the surnames Miyagawa, Katsu-Miyagawa, and Katsu (as in this print). He is regarded as the founder of the Katsukawa school and teacher of Shunshō. From the 1740s to early 1760s he designed a small number of two-color prints (*benizuri-e*), in which the colors, generally pink and green, were block-printed instead of hand-painted. He also painted hanging scrolls on paper in the delicate figure style prevailing during the middle years of the century. Shunsui's stylistic influence on his pupil Shunshō seems to have been limited: Shunshō's earliest works are much more in the manner of Suzuki Harunobu (ca. 1724–1770), who so dominated contemporary *ukiyo-e* artists.

SIGNATURE *Tōbu eshi* ("Artist of Edo") *Katsu Shunsui*
ARTIST'S SEAL *Mangyo*
PUBLISHER Tsuruya Kiemon of Ōdemma-chō san-chōme
PROVENANCE Ernest F. Fenollosa collection

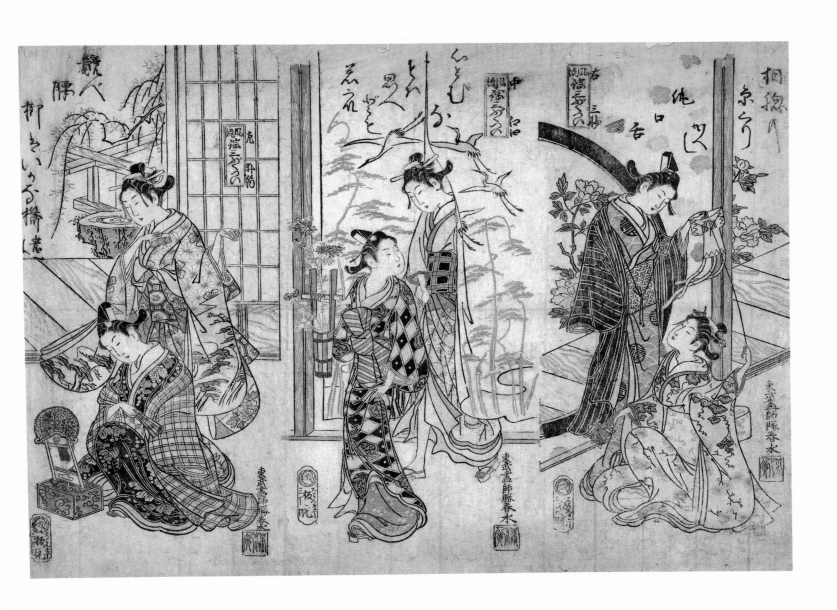

23 KATSUKAWA SHUNSHŌ
(1726–1792)

The actors Ichikawa Raizō I as Hanakawado no Sukeroku (right), and Ōtani Hiroemon III as Hige no Ikyū (left), in "Sukeroku," part two of the play *Hitokidori Harutsuge Soga* (The Soga Play: Announcement of the Spring Season by the Bush Warbler), performed at the Nakamura Theater from the ninth day of the second month, 1764

Hosoban diptych(?); (right) 31.6 x 14.2 cm; (left) 33.8 x 14.5 cm
The Clarence Buckingham Collection 1925.2358a (right)
Frederick W. Gookin Collection 1939.726 (left)

These are the two earliest prints known to have been designed by Shunshō. There could be no more appropriate subject for his artistic debut than the ever popular confrontation scene between dashing young Sukeroku (played by Ichikawa Raizō I), a chivalrous commoner (*otokodate*), and white-bearded Ikyū (played by Ōtani Hiroemon III), a pompous, evil old samurai.

Sukeroku and Ikyū are rivals for the affections of the courtesan Agemaki, but also belong to opposing factions in an ancient political quarrel. Sukeroku has been deliberately picking fights with samurai in the Yoshiwara pleasure district in an attempt to discover (and thereby recover) a precious sword stolen from the Minamoto clan. Shunshō has portrayed the climactic moment when Ikyū, in a moment of forgetfulness, draws the stolen sword from his scabbard, thus revealing himself to be the thief.

So great indeed was the popularity of the Sukeroku theme that three different versions of the story were running in competition at Edo theaters in the spring of 1764: the "normal" version (depicted here) at the Nakamura, a "woman" Sukeroku at the Ichimura, and a "youth" Sukeroku at the Morita. It is even said that a shaven-headed doctor named Murata starred in his own amateur production of the play at the same time, calling it the "priest" Sukeroku.[1]

Each of the prints here uses six colors: black, two shades of crimson, yellow, purple (for Sukeroku's famous headband) or green (for the dragons on Ikyū's robe), and a pale blue background (faded to a sand color). If the dating of the prints is correct— and there seems no reason to doubt the theatrical records on which this is based[2]— then Shunshō's actor portraits printed in full color (*nishiki-e*, "brocade prints") antedate Harunobu's full-color calendar prints produced in the summer of 1765. These calendar prints, long thought to be the earliest *nishiki-e*, may owe their astonishing technical excellence to a year and more of prior experience in full-color printing.

New printing technology coincided happily with a revolutionary new way of depicting the theater. Shunshō was the first print artist to give a recognizable portrayal of the particular facial features of an actor in a given role, rather than the generalized depictions that had been the staple of the Torii school of print artists up to that time. The dramatic effectiveness of these individualized portrayals was even further enhanced by Shunshō's vigorous use of the extensive palette newly available to printmakers.

1 *Kabuki Nempyō*, vol. 3 (1958), p. 543.
2 Ibid. and *Kabuki Nendaiki* (1926), p. 298 concur that Raizō I played Sukeroku and Hiroemon III played Ikyū at the Nakamura Theater in the second month, 1764. There is no record of these actors playing the same roles on another occasion. Raizō I died in the fourth month, 1767 and was not succeeded by Raizō II until the fifth month, 1769. On this occasion Raizō II played Sukeroku in memory of Raizō I, but Hiroemon was appearing at the rival Morita Theater. Some authorities maintain, however, that Shunshō's earliest *nishiki-e* actor prints date from 1768; see, for example, Roger Keyes's comments in *Ukiyo-e Shūka*, vol. 13 (1981), no. 126.

UNSIGNED
ARTIST'S SEAL *Hayashi* in jar-shaped outline
PROVENANCE (right) Colonel H. Appleton collection
REFERENCE Gookin (1931), (right) no. 7a, (left) no. 6
OTHER IMPRESSIONS
(right) Honolulu Academy of Arts; (left) *Shibai Nishiki-e Shūsei* (1919), no. 127 (present location unknown)

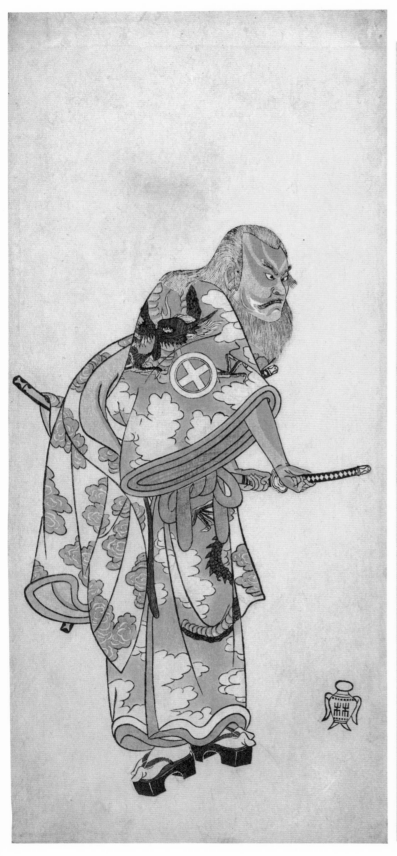
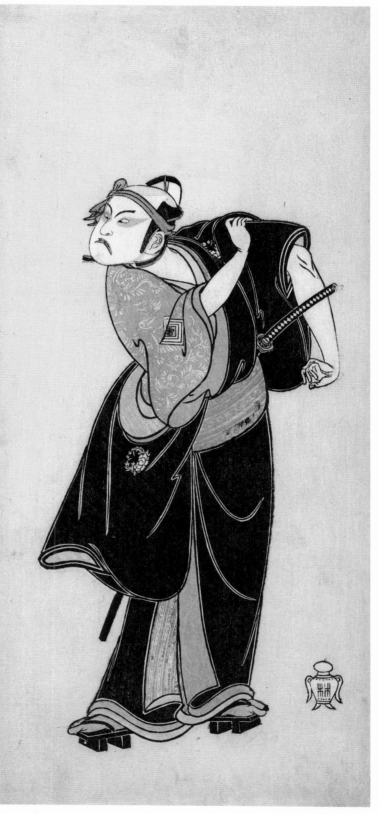

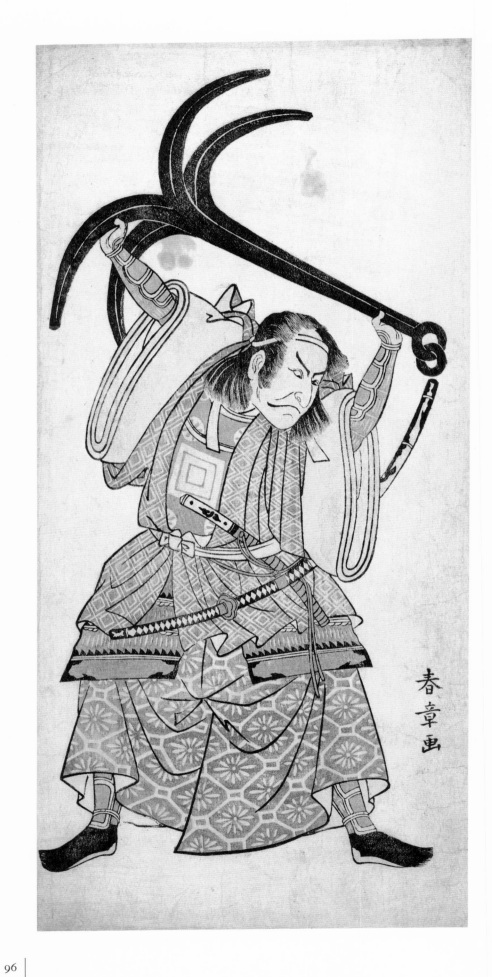

春章画

24 KATSUKAWA SHUNSHŌ

(1726–1792)

The actor Ichikawa Danjūrō IV as Taira no Tomomori disguised as Tokaiya Gimpei, in the scene "Ikari Tomomori" (Tomomori with the Anchor), from part two of *Yoshitsune Sembon-zakura* (Yoshitsune's Thousand Cherry Trees), performed at the Nakamura Theater from the fifteenth day of the seventh month, 1767

Hosoban; 32.2 x 15.4 cm
Frederick W. Gookin Collection 1939.665

The civil wars of the late twelfth century, between the rival Taira and Minamoto clans, were a source of countless tales of military valor in later literature and drama. The brilliant young Minamoto general Yoshitsune became Japan's most popular hero, whose life quickly passed over into legend. That legend, combining real and apocryphal events, is treated in one of the most enduring Kabuki plays, *Yoshitsune Sembon-zakura*, first performed in 1747.

Ichikawa Danjūrō IV here plays the tragic role of Taira no Tomomori who, rather than endure defeat at the naval battle of Dan no Ura in 1185, drowned himself by leaping into the sea tied to a giant anchor. In the Kabuki version of the story Tomomori has in fact survived the battle of Dan no Ura and, disguised as the boatman Gimpei, awaits the chance to be revenged upon Yoshitsune by attacking him unawares at sea. This reworking offered the device of hidden identity so popular in Kabuki, and also provided the opportunity to scale down a major naval battle scene to more manageable theatrical proportions. Again, however, Tomomori suffers defeat, and again he casts himself into the sea with the anchor. In modern stagings Tomomori appears mortally wounded and with the anchor rope tied around his body. Perhaps the Shunshō print shows Tomomori, in an act of hopeless defiance, trying to attack Yoshitsune with the anchor at Daimotsu Beach. His eyes and ears are printed with red, giving him an even more ferocious aspect.

Gookin suggested that this design shows Danjūrō IV as Tomomori in the *kaomise* (opening-of-the-season) production at the Nakamura Theater in the eleventh month of 1761, which would make this Shunshō's earliest known actor print.[1] This dating seems much too early, however; full-color prints (*nishiki-e*) such as this one probably first appeared in 1764 (see No. 23). Much more likely is the date suggested here: the seventh month of 1767.

Only two impressions of the design were known to Gookin: this one, which was in his own collection, and one in the Schraubstadter collection (now in the Sackler Museum, Harvard University). Both impressions were faded, making it difficult for him to reconstruct the original color scheme. On the Chicago impression the buff color of the *sujiguma* "streaked" makeup and the kimono was probably once blue; the *jimbaori* battle jacket and wide-legged trousers (*hakama*) are beautiful gray-and-white brocades; the brown color of the armor looks like a faded purple. The background, which appears slightly darker than the "white" areas of the design, may be a faded light blue.

Until about 1770 Shunshō drew all his actors against plain or very simple backgrounds. These early prints have an arresting vigor that is lost in some of the later designs, where the figures are placed farther back from the picture plane in more complex settings.

1 Gookin (1931), p. 54.

SIGNATURE *Shunshō ga*
REFERENCE Gookin (1931), p. 54
OTHER IMPRESSIONS
Gookin (1931), no. 5; Arthur M. Sackler Museum, Harvard University, Cambridge, Mass.
(ex-coll. Carl Schraubstadter)

25 KATSUKAWA SHUNSHŌ

(1726–1792)

The actor Ichikawa Danzō III as the holy hermit Narukami in the scene "Naru-kami," from the final act of the play *Miyakodori Azuma Komachi* (Bird of the Capital: Komachi of the East), performed at the Morita Theater in the third month, 1768

Hosoban; 31.1 x 15.1 cm
Frederick W. Gookin Collection 1939.672

Narukami, the story of the seduction of the holy recluse Narukami by the beautiful Princess Taema, is one of the oldest Kabuki plays still performed today. Created by Danjūrō I in 1684, its strong, simple plot is typical of plays written during the formative period of Edo Kabuki in the last quarter of the seventeenth century. In 1832 *Narukami* was selected by Danjūrō VII as one of the Eighteen Great Kabuki Plays (*Kabuki Jūhachiban*) which were the preserve of the Danjūrō line. This one-act play could be easily incorporated into longer programs, as it was in the production at the Morita Theater in the third month of 1768, when Ichikawa Danzō III as Narukami played opposite Nakamura Matsue I as Taema.

An angry Narukami has imprisoned the rain dragon below a waterfall near his mountain retreat, thereby causing a terrible drought throughout the land. Princess Taema volunteers to seek him out and secure the release of the dragon. The hermit Narukami has never before seen a beautiful woman. He swoons with desire. This is the cue for Princess Taema to begin his seduction: first she revives him with a mouthful of water from the falls, administered with a kiss; then she feigns a con-vulsion and gets Narukami to feel her breast to see if there is any constriction! The now less-than-holy hermit is utterly captivated, and begs her to marry him. Taema agrees, and is then able to lull Narukami into a drunken stupor with celebratory cups of sake. He presently wakes to find the holy rope across the waterfall cut, the dragon released, and the woman gone. In his rage Narukami flips back the top part of his white priestly robes (a quick-change technique called *bukkaeri*) to reveal a different costume, patterned with angry flames. With fierce red makeup and a wild, bristling wig he stomps off in bravura *aragoto* style in pursuit of the princess. Shunshō's print probably represents the climactic moment, when Narukami makes the costume change and strikes a resolute pose (*mie*). The indigo blue of the back-ground, which has faded to the usual buff, must have been a strikingly effective background for the powder blue of Narukami's under-kimono and the diamond pattern of the over-kimono printed in white. The red flames on the robe and red face makeup have also faded considerably.

Gookin wrote that he knew of three prints signed with a combination of the printed character *ga* ("drawn by") and the jar-shaped seal containing the character *Hayashi* (thought to be the accounts seal of Hayashiya Shichiemon of Ningyō-chō, with whom Shunshō is supposed to have lodged at the time).[1] All are among Shunshō's very earliest prints.

1 Gookin (1931), pp. 30–31.

UNSIGNED
ARTIST'S SEAL
Hayashi in jar-shaped outline, preceded by the printed character *ga* ("drawn by")
REFERENCE Gookin (1931), no. 10, text p. 68
PROVENANCE Frederick W. Gookin collection (*Gōkin* seal)

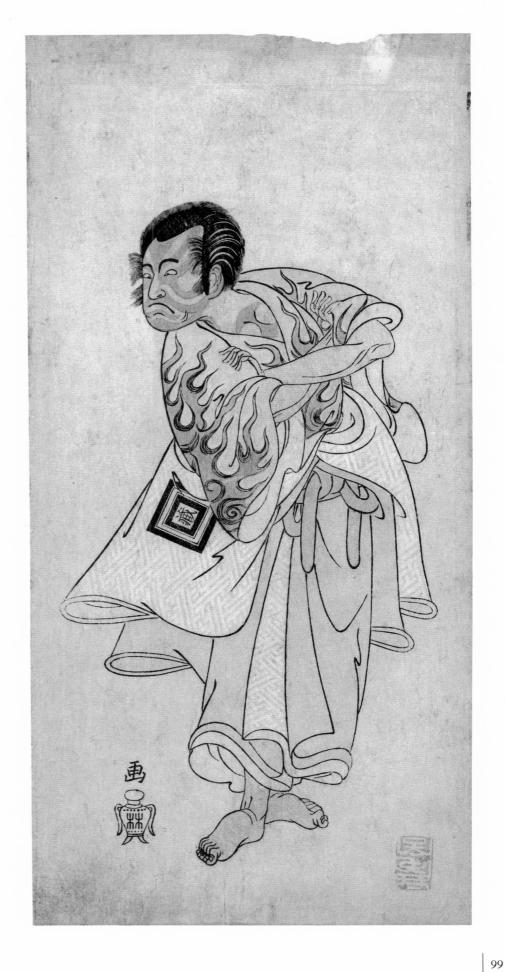

The actors Nakamura Nakazō I as Mikawaya Giheiji (right), and Nakamura Sukegorō II as Danshichi Kurobei (left), in "Nagamachi-ura" (Murder in the Back Street off Nagamachi), act seven of the *jōruri* "Natsu Matsuri Naniwa Kagami" (Mirror of Osaka in the Summer Festival), played as one act in *Ayatsuri Kabuki Ōgi* (Mastery of the Fan in Kabuki), performed at the Nakamura Theater from the twentieth day of the seventh month, 1768

Chūban; 24.4 x 18.9 cm
The Clarence Buckingham Collection 1925.2387

Sukegorō II (kneeling) plays the role of Danshichi Kurobei, one of the *otokodate*, or "chivalrous commoners," who protected ordinary townspeople from injustice at the hands of evil samurai. Indeed in this play he has just been released from jail, where he was serving time for wounding a retainer of the samurai Ōtori Sagaemon. The other character depicted is Kurobei's father-in-law, Giheiji, who is forever scheming unscrupulous ways of making money. There was no better actor to play such a role than Nakamura Nakazō I, who was a master at interpreting villainy.

In this confrontation scene, set in a gloomy back alley during the colorful Osaka summer festival, Kurobei is trying to stop old man Giheiji from abducting the courtesan Kotoura to sell her to Kurobei's old enemy, the samurai Sagaemon. Kurobei promises Giheiji money if he will send back the palanquin carrying the courtesan. But when it becomes clear that Kurobei has no money with which to make good his promise, the argument becomes acrimonious. The old man first kicks Kurobei, then beats him about the head with a straw sandal. Kurobei, abused and humiliated beyond endurance, draws his sword and runs his own father-in-law through. In Edo-period Japan, a society governed according to Confucian morality, patricide was considered the most heinous of crimes.

Shunshō has produced a brilliant study in contrasting characters. Nakazō I, as Giheiji, is shown as an unkempt old miser with sickly yellowish skin, unshaven whiskers, and straggly white hair, wearing a dreary green kimono and tatty old brown *haori* jacket. Grim-faced and nasty-looking, he is bullying his son-in-law, confident that Kurobei will not dare fight back. On the other hand Kurobei, as played by Sukegorō II, looks powerfully muscular. As he wards off a kick, he stares out at us in fierce exasperation as if to say, "How can I be expected to bear this any longer?"

It is surely more than coincidence that Bunchō also designed a *chūban* print of the same actors in the same scene (fig. 26.1). Though the two prints are almost identical in composition, suggesting that one artist copied from the other, they reflect a very different attitude toward physical likeness. In particular Nakazō I as Giheiji is virtually unrecognizable from one print to the other, with a face of completely different shape. In Bunchō's design the costumes have been printed in novel manner, without outlines.

SIGNATURE *Shunshō zu*
ARTIST'S SEAL *Hayashi* in jar-shaped outline
REFERENCE Gookin (1931), no. 26
OTHER IMPRESSIONS
H. George Mann collection, Chicago (ex-coll. Henri Vever); Honolulu Academy of Arts; Portland Art Museum; Keiō University Library, Tokyo (ex-coll. Takahashi Seiichirō)

26.1 Ippitsusai Bunchō.
The actors Nakamura Nakazō I as Mikawaya Giheiji and Nakamura Sukegorō II as Danshichi Kurobei.
Ex-collection
Mitsuno Kōjirō, Tokyo

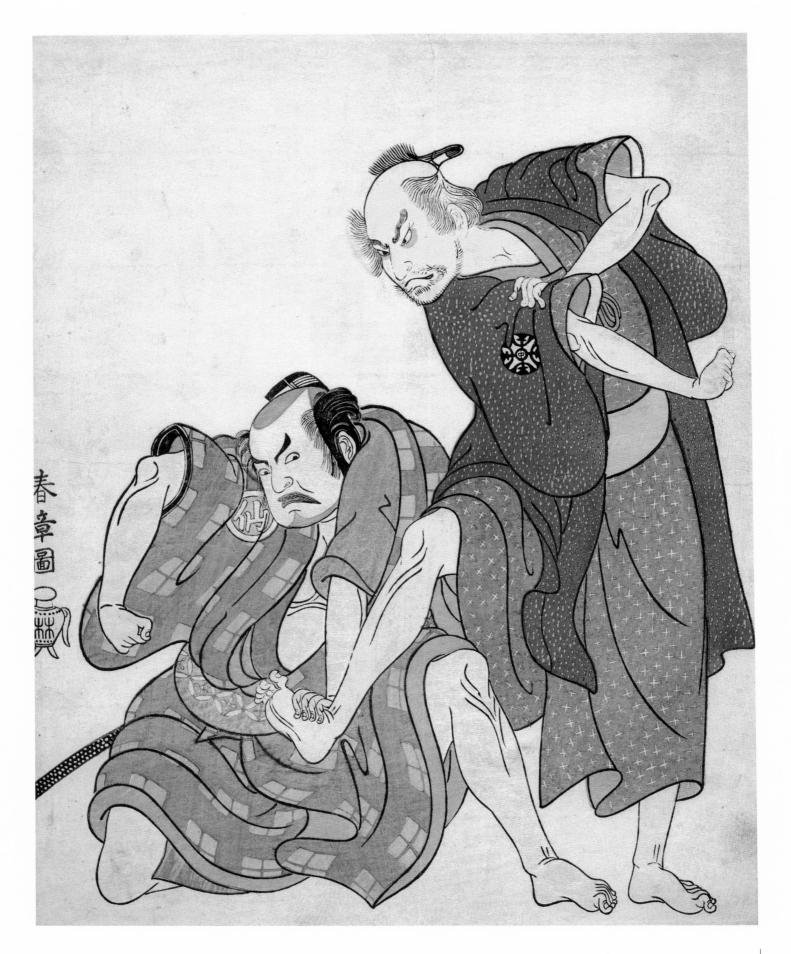

27 KATSUKAWA SHUNSHŌ
(1726–1792)

The actor Nakamura Sukegorō II as Kaminari
Shōkurō in the *jōruri* "Gonin Otoko" (Five Chiv-
alrous Commoners), played as one act
in *Ayatsuri Kabuki Ōgi* (Mastery of the Fan
in Kabuki), performed at the Nakamura
Theater from the twentieth day of the seventh
month, 1768

Hosoban, one sheet of a pentaptych; 31.0 x 14.0 cm
Frederick W. Gookin Collection 1939.683

The Nakamura Theater program for the seventh
month of 1768 consisted of a medley of famous plays
about greathearted stalwarts, including the *Gonin
Otoko* (depicted here), *Natsu Matsuri Naniwa Kagami*
(Mirror of Osaka in the Summer Festival; No. 26),
and *Sugawara Denju Tenarai Kagami* (Sugawara's
Secrets of Calligraphy; cf. No. 5). Shunshō appears
to have produced exciting designs for all of these
dramas, but they survive, alas, only in fragmented
form. Particularly striking was the design he pro-
duced for the *Five Chivalrous Commoners*, with each
hero in a defiant attitude on one sheet of a five-sheet
hosoban print. The present design, which comes from
this set, shows Nakamura Sukegorō II as Kaminari
Shōkurō— a role identified by the crest of crossed
drumsticks over a drumhead (as used by the Thunder
God; *kaminari* means "thunder") on the right shoul-
der of Sukegorō II's kimono. The actor's expression
is appropriately resolute. He wears a plain brown
kimono with a design of ink-painted bamboo on the
skirt front. Probably the now mottled gray back-
ground was originally a solid pale blue; the lead
white pigment mixed with indigo blue has tarnished.

No complete set of all five sheets survives, but the
design can be pieced together from three different
groups: three sheets formerly in the Arthur Davison
Ficke collection (fig. 27.1),[1] four sheets in The
Metropolitan Museum of Art collection (fig. 27.2),
and three sheets formerly in the Walter Amstutz
collection in Switzerland (fig. 27.3).[2] The following
order for the five-sheet print is suggested (right to
left), giving each actor's name and role: Ichikawa
Komazō II as Karigane Bunshichi; Nakamura Suke-
gorō II as Kaminari Shōkurō; Ichikawa Yaozō II as
An no Heibei; Matsumoto Kōshirō III (the future
Danjūrō V) as Gokuin Sen'emon; Arashi Otohachi I
as Hotei Ichiemon. In addition, the Amstutz group
contains a *hosoban* by Bunchō showing Ichikawa
Yaozō II as An no Heibei (fig. 27.4), suggesting that
Bunchō may have published his own five-sheet
design in competition with Shunshō's.

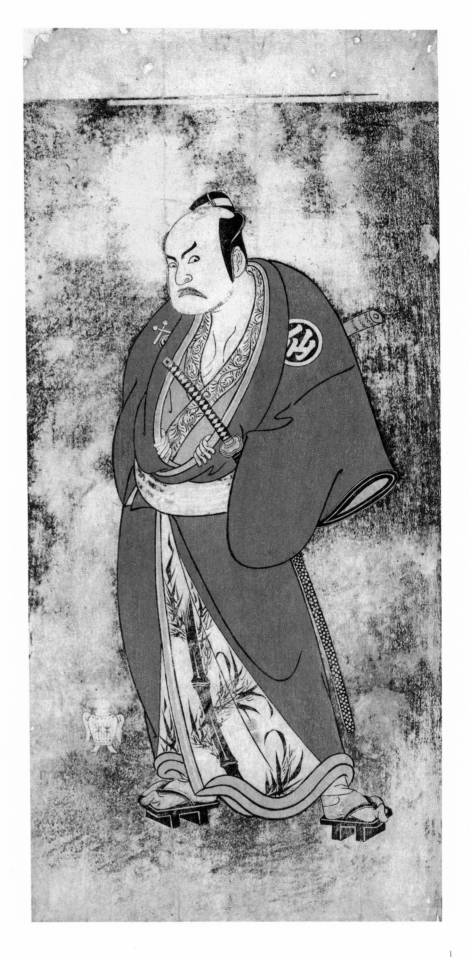

Interestingly, each of the various groups represents a slightly different edition of the pentaptych: the Art Institute's print of Sukegorō II seems to be the only one with a thick opaque blue (?) background and the jar-shaped seal cartouche left in white reserve; Yaozō II in the Metropolitan Museum print has a pattern of swirls on the under-kimono visible at the collar, which in the ex-Ficke print have become the character *an* (for An no Heibei); the ex-Ficke group has neither *Hayashi* seals nor stylized mist at the top. What these differences may signify as to the dates of the various impressions will be deduced only after careful comparison of the original prints.

Ukiyo-e Ruikō, the late eighteenth-century biographical history of *ukiyo-e* artists, credits Shunshō with inventing such five-sheet prints and notes that they were a huge success. This account is repeated in the antiquarian "scrapbook" *Sunkin Zattetsu* (Snippets of Brocade, Variously Bound) by Morishima Chūryō, published as a woodblock-printed book circa 1800, where a key-block impression of the sheet showing Arashi Otohachi I as Hotei Ichiemon is reproduced (fig. 27.5— an interesting byway in the historiography of *ukiyo-e*). It is likely, however, that the *Gonin Otoko* was not Shunshō's earliest five-sheet design; in the Art Institute are

three sheets from what was probably a set of five, relating to the play *Shuen Soga Ōmugaeshi*, performed in the second month of 1768 (cat. no. 68).

The vivid facial expressions of the actors and their forceful poses reflect the strength and freshness of an artist in the process of creating a new formal vocabulary. Shunshō would design many five-sheet prints during his career (see No. 90), but it is the earliest of these whose vigorous immediacy reveals the excitement of an artist breaking new ground.

1 Anderson Galleries (New York), *The Japanese Print Collection of Arthur Davison Ficke* (sale catalogue of 25 January 1925), lot 100.
2 Jack Hillier, *Japanese and Chinese Prints: The Walter Amstutz Collection* (sale catalogue, Sotheby's Tokyo, 15 April 1990), lot 89.

UNSIGNED
ARTIST'S SEAL
Hayashi in jar-shaped outline [white reserve]
REFERENCE Gookin (1931), no. 23, text pp. 85–91
OTHER IMPRESSIONS
ex-collection Arthur Davison Ficke;
The Metropolitan Museum of Art

27.1 Katsukawa Shunshō. *The actors Nakamura Sukegorō II, Ichikawa Yaozō II, and Matsumoto Kōshirō III as three of the Five Chivalrous Commoners.* Ex-collection Arthur Davison Ficke

27.2 Katsukawa Shunshō. *The actors Ichikawa Komazō II, Ichikawa Yaozō II, Nakamura Sukegorō II, and Matsumoto Kōshirō III as four of the Five Chivalrous Commoners.* Metropolitan Museum of Art, New York

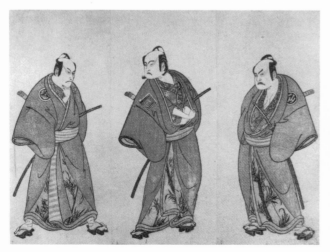 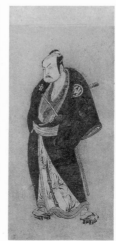 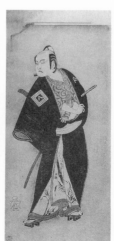 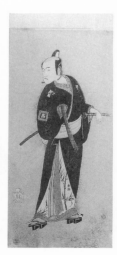

27.4 Below, left: Ippitsusai Bunchō. *The actor Ichikawa Yaozō II as An no Heibei.* Ex-collection Walter Amstutz, courtesy of Sotheby's London

27.3 Katsukawa Shunshō. *The actors Ichikawa Komazō II, Matsumoto Kōshirō III, and Arashi Otohachi I as three of the Five Chivalrous Commoners.* Ex-collection Walter Amstutz, courtesy of Sotheby's London

27.5 Below, right: After Katsukawa Shunshō. *The actor Arashi Otohachi I as Hotei Ichiemon.* Key-block impression from *Sunkin Zattetsu.* The Art Institute of Chicago

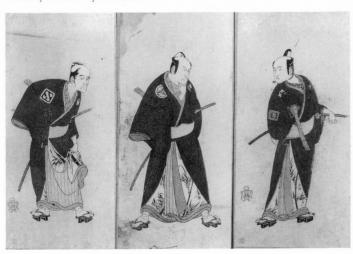

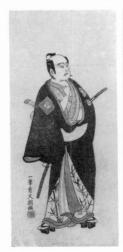

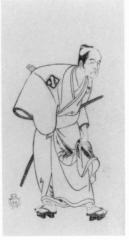

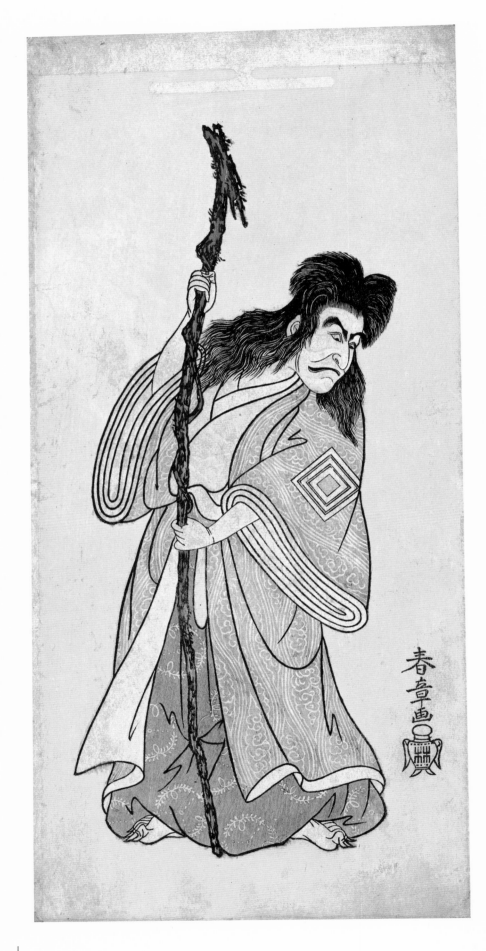

28 KATSUKAWA SHUNSHŌ

(1726–1792)

The actor Ichikawa Danjūrō IV in the role of an Immortal Hermit (*sennin*), possibly Tenjiku Tokubei in the play *Tenjiku Tokubei Kokyō no Torikaji* (Tenjiku Tokubei Turns the Helm Toward Home), performed at the Nakamura Theater in the eighth month, 1768

Hosoban; 32.8 x 15.4 cm
The Clarence Buckingham Collection 1925.2385

With his mane of unkempt hair, rough-hewn staff, and preternaturally long toenails, Danjūrō IV certainly looks the Immortal Hermit, and scholars have not hesitated to identify the role as Ki no Natora in the opening-of-the-season (*kaomise*) production at the Nakamura Theater in the eleventh month of 1765.[1] Kabuki records do indeed describe Danjūrō IV making his entrance in this production dressed as a mountain hermit.[2] Contradicting this identification, however, are illustrations in the actor critiques published the following year[3] and a print by Bunchō— all of which show Danjūrō IV as Ki no Natora wearing a different wig and a costume with leaves around his shoulders and waist (fig. 28.1).

A later date, about 1767 or 1768, is suggested by the style of the figure (cf. Danjūrō IV as Tomomori, No. 24); by the form of the signature— *Shunshō ga* in large, bold characters; and by the formula used for the background, in which a small, stylized white band of mist hovers at the top center of the (faded) indigo blue ground. In the eighth month of 1768 Danjūrō IV appeared as Tenjiku Tokubei, a Japanese sea captain who learned supernatural skills in India, in the play *Tenjiku Tokubei Kokyō no Torikaji* at the Nakamura Theater. The early plot of the story is not known, but in nineteenth-century versions Tokubei was able to take on the form of a giant toad to escape his enemies.[4] In this print Danjūrō IV's appearance as an Immortal Hermit with a staff may be intended to suggest that he has come from the far-off and exotic land of India and possesses magical skills. A definite identification, however, will have to await further evidence.

The colors of the present impression are severely faded: the indigo blue background and "streaked" (*sujiguma*) blue face makeup are now sand-colored, and the originally purple (?) baggy trousers have faded to brown. In another impression in the Rijksmuseum, Amsterdam, these trousers are printed in dark gray.[5]

1 Most recently in *Genshoku Ukiyo-e Daihyakka Jiten* (1980), p. 24.
2 *Kabuki Nendaiki* (1926), p. 304.
3 *Yakusha Tōjibai* and *Yakusha Nennai Risshun*.
4 *Kabuki Saiken* (1926), pp. 619–23.
5 *Ukiyo-e Shūka*, vol. 13 (1981), no. 126.

SIGNATURE *Shunshō ga*
ARTIST'S SEAL *Hayashi* in jar-shaped outline
PROVENANCE C. B. Hoyt collection
REFERENCE Gookin (1931), no. 12, text p. 74
OTHER IMPRESSIONS
Clarence Buckingham Collection 1938.478 (opaque blue background);
Rijksmuseum, Amsterdam; *Shibai Nishiki-e Shūsei* (1919), no. 124

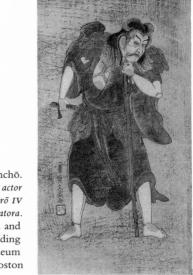

28.1 Ippitsusai Bunchō. *The actor Ichikawa Danjūrō IV as Ki no Natora*. William S. and John T. Spaulding collection, Museum of Fine Arts, Boston

The actors Sawamura Sōjūrō II as the priest Shunkan and
Azuma Tōzō II as Oyasu in act three of the play *Hime
Komatsu Ne no Hi Asobi* (Outing to Pick Pine Seedlings on
the Rat-Day of the New Year), performed at the Ichimura
Theater from the ninth day of the ninth month, 1768

Hosoban; 31.7 x 14.3 cm
The Clarence Buckingham Collection 1925.2410

Shunkan, head monk of the Kyoto temple Hōshō-ji, was a
historical figure who in 1177 was exiled to the remote island of
Kikaigajima for his part in an unsuccessful plot against the Taira
clan's domination of court and government. Though his co-
conspirators were soon pardoned, Shunkan was left on the island
to die. This tragic episode became the basis for a medieval
Nō play which was later reworked into much more elaborate
Bunraku and Kabuki versions.

In the Kabuki play Shunkan manages to escape his island exile
on a secret mission to guard the emperor's concubine Kogō no
Tsubone while she gives birth to a royal heir in a remote retreat
at Horagadake. Since they will need a midwife, Shunkan enlists
the services of a village girl called Oyasu, who fortunately is
a secret supporter of the Genji cause. Oyasu wishes to learn the
true identity of Shunkan and the noblewoman who is to give
birth. In order to demonstrate her trustworthiness, she is about
to swear an oath of secrecy on a pair of metal hand-mirrors, just
as a warrior would swear on his sword. Fearful of revealing his
secret, Shunkan stays her hand, but as he catches sight of his aged
features in one of the mirrors the story of his lonely banishment
inadvertently slips out (the scene shown here). With Oyasu's
assistance the little prince is born safely into the world.

Though both figures are drawn with the somewhat stiff and
unyielding line common in his earliest prints, Shunshō
makes much of the contrast between them. Sōjūrō II, his stern,
almost fierce expression accentuated by dramatic makeup and his
sword gripped resolutely in one outflung hand, looms hugely
over the small, white-faced Tōzō II, who looks open and
vulnerable and whose mirror dangles weakly from her hand.
Gookin observes that this is probably Shunshō's earliest print
showing a female character.[1] Certainly actors in male roles must
have been far easier to portray as recognizable individuals than
actors in female roles— who tended to look very much alike
under the necessary white powder and wig.

1 Gookin (1931), p. 85.

SIGNATURE *Shunshō ga*
ARTIST'S SEAL *Hayashi* in jar-shaped outline
PROVENANCE Hirakawa Kenkichi collection
REFERENCE Gookin (1931), no. 20; *Ukiyo-e Shūka* (1980), no. 16

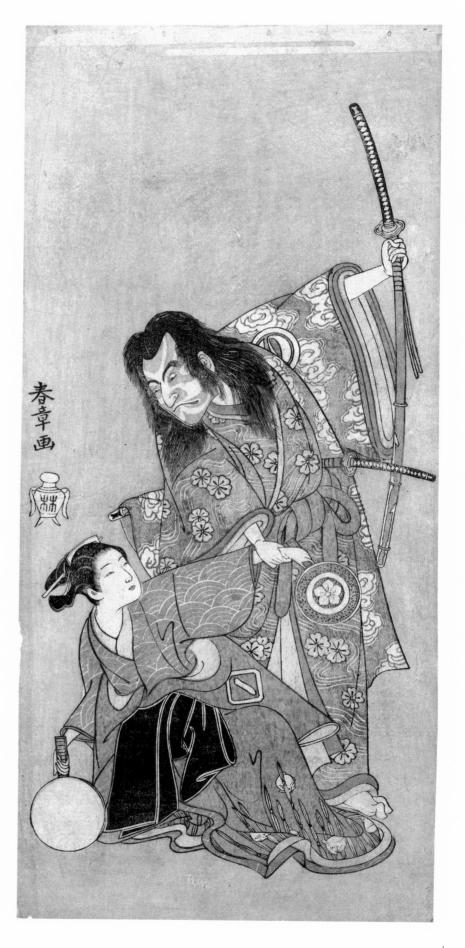

30 KATSUKAWA SHUNSHŌ
(1726–1792)

The actor Ichikawa Danzō III as Shōki the Demon Queller in the play
Date Moyō Kumo ni Inazuma (Dandyish Design: Lightning Amid
Clouds), performed at the Morita Theater from the fifteenth day
of the tenth month, 1768

Hosoban; 33.2 x 15.2 cm
Frederick W. Gookin Collection 1939.698

The production at the Morita Theater in the tenth month of 1768 seems
to have been based on a famous love triangle: the rivalry between the hand-
some playboys Nagoya Sanza and Fuwa Banzaemon for the affections
of the courtesan Katsuragi. Shunshō made at least one more *hosoban*
print of this production, this one showing Danzō III in Banzaemon's
characteristic costume decorated with the striking cloud-and-lightning
pattern (see cat. no. 78) that gave the play its name.

The libretto for the day's proceedings does not survive, but the hodge-
podge of roles recorded indicates that a plethora of extra material was
piled onto the basic Nagoya Sanza/Fuwa Banzaemon story. Danzō III is
recorded as having also played the sumo wrestler Inazuma (literally,
"Lightning," a further reference to Banzaemon's costume), as well as
ferocious Shōki the Demon Queller, shown here. Sakata Hangorō II
played, among other roles, the Ghost of Daruma (Bodhidharma), possibly
opposite Danzō III's Shōki!

Shōki (C: Zhong Kui), a character from Chinese mythology, has acquired
a host of legends, but in all of them he figures as a repeller of sickness
and evil and a formidable chastiser of demons, and he is always depicted
with bulging eyes and a profusion of hair and beard, wearing the black
robe, cap, and boots of an official, and brandishing a sword. In Edo-
period Japan Shōki became a popular folk deity who, as in China, cured
sickness and warded off evil, and who often appears in paintings and
prints wielding his sword against small horned demons.[1] He is generally
depicted in a pseudo-Chinese ink-painting style, evident even in this
"Kabuki" version, particularly in the exciting calligraphic ink lines that
Shunshō used to describe the flying drapery.

Perhaps because this forceful character is here incarnated in the vehement
aragoto style of Kabuki acting, in this print Shōki seems even more than
usually dynamic. His boots are planted so solidly upon the ground that he
appears immovable, but his arms and sleeves and the ribbons on his cap
all seem to be flying off in different directions.

When the background was its original unfaded blue, the flesh-colored
body makeup and the few small areas printed in white must have
contrasted even more sharply with the somber blacks, grays, and blues
of the costume.[2]

1 Shunshō designed a pillar print of Shōki and also included him in several paintings.
2 A second impression of this rare design is in the Buckingham Collection
 (1932.1006) (cat. no. 80).

SIGNATURE *Shunshō ga*
ARTIST'S SEAL *Hayashi* in jar-shaped outline
REFERENCE Gookin (1931), text pp. 95–96

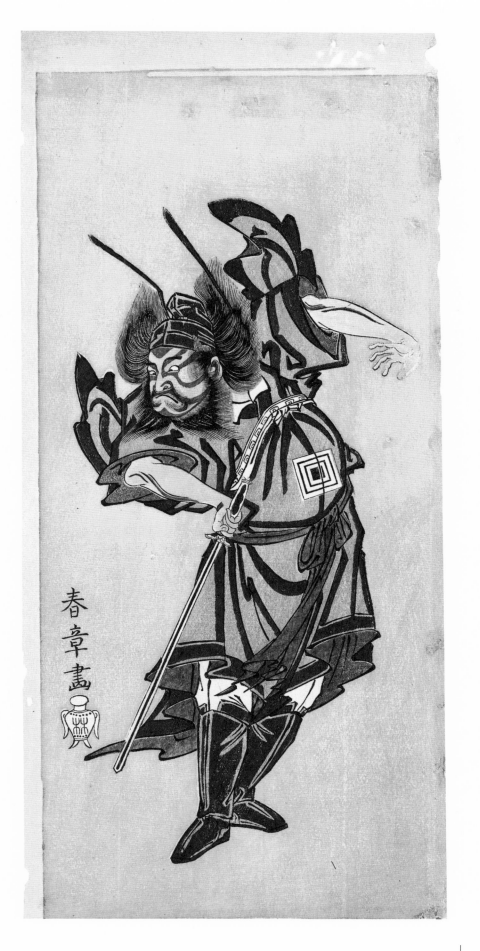

3I KATSUKAWA SHUNSHŌ
(1726–1792)

The actor Nakamura Sukegorō II as Asō no Matsuwaka, a *ninja* (shadow warrior), in the play *Ima o Sakari Suehiro Genji* (The Genji Clan Now at Its Zenith), performed at the Nakamura Theater from the first day of the eleventh month, 1768

Hosoban; 32.5 x 14.9 cm
The Clarence Buckingham Collection 1925.2409

This print and the following four in the catalogue (also possibly No. 2, by Bunchō) show various scenes from one play, *Ima o Sakari Suehiro Genji*, which opened the new season at the Nakamura Theater in the eleventh month of 1768. The cast was notable for the presence of the great Kamigata (Kyoto–Osaka region) star Nakamura Utaemon I, who was just beginning his second major appearance in Edo. Utaemon I's interpretation of a famous scene in which Taira no Kiyomori forces the setting sun to rise again was, apparently, particularly well received,[1] though no print showing this scene has yet been identified. As with so many eighteenth-century plays, the libretto does not survive. We do know which actors played what roles, however, and by supplementing this information with miscellaneous comments contained in the actor critiques (*yakusha hyōbanki*) published the following spring, identification of the prints becomes possible.

The first print shows Sukegorō II as a *ninja*, or shadow warrior (a spy, sometimes an assassin, typically dressed in black), a role he played opposite Danjūrō IV as Kisanda. An actor critique describes the scene: "... next he [Sukegorō] came on as Asō no Matsuwaka. Overhearing Kisanda reciting the Tiger Scroll, [Sukegorō] made the nine magic signs in the air and cast a spell. With a clap of thunder he caused Kisanda to fall unconscious, stole the scroll, and handed it over to Osada...."[2] Shunshō's powerful design surely captures the moment when the triumphant Matsuwaka sloughs off the shadow warrior's black disguise to reveal his true identity. With one clenched hand thrust rigidly downward, legs straight, and heels held close together (this positioning of the legs being known as *soku mie*), he poses with the stolen scroll held between his teeth, bulging eyes glaring defiantly. The striking palette of black, crimson, purple, and white must have been even more spectacular when the background was still unfaded blue. It is often with such simple, strong designs that Shunshō reached the height of his expressive powers.

1 *Kabuki Nempyō*, vol. 4 (1959), p. 77.
2 Ibid., p. 80.

UNSIGNED
ARTIST'S SEAL *Hayashi* in jar-shaped outline
REFERENCE
Gookin (1931), no. 35, text p. 99; *Ukiyo-e Taikei* (1976), no. 79
OTHER IMPRESSIONS ex-collection Theodor Scheiwe

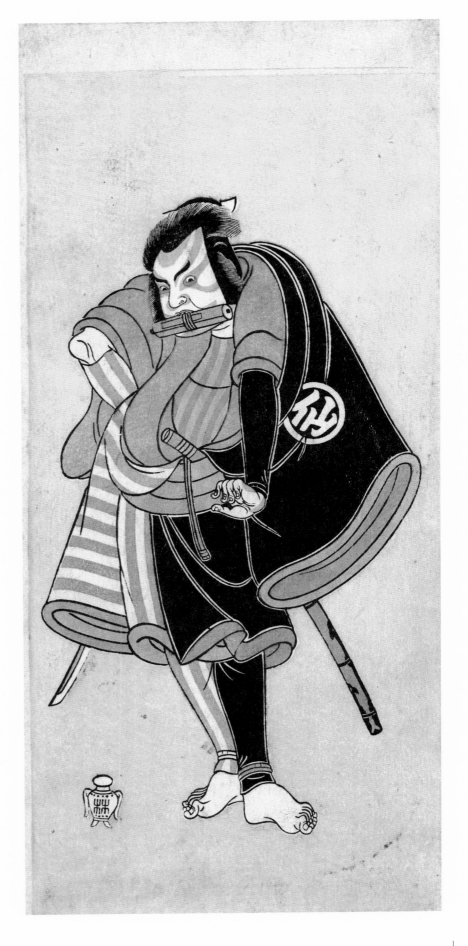

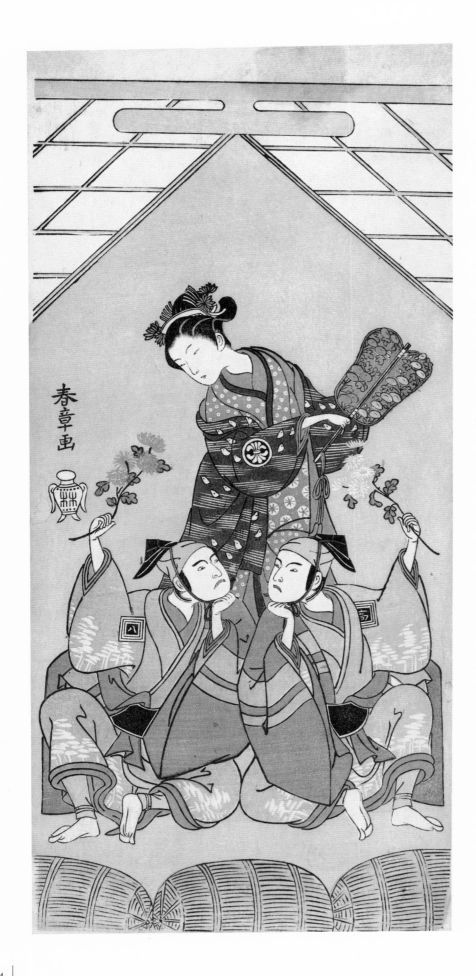

The actors Segawa Kikunojō II as the wet nurse Reizei, Ichikawa Komazō I as Suruga no Hachirō in the guise of the *shamisen* player Kichiroku (right), and Ichikawa Yaozō II as Tada no Kurando in the guise of the palanquin bearer Kichinai (left), in the scene "Kiku-zumō" (Chrysanthemum Sumo) from the play *Ima o Sakari Suehiro Genji* (The Genji Clan Now at Its Zenith), performed at the Nakamura Theater in the eleventh month, 1768

Hosoban; 32.6 x 15.2 cm
The Clarence Buckingham Collection 1930.394

This print relates to the same play as Number 31, and again we must rely on comments from actor critiques (*yakusha hyōbanki*) to interpret the scene depicted.[1]

Kichiroku the *shamisen* player and Kichinai the palanquin bearer are rivals for the affections of Reizei, wet nurse to Lady Jōruri. She declares she will give her love to whichever of them wins a mock sumo wrestling bout, with herself as judge. And this is no ordinary wrestling, for they fight with stems of red and white chrysanthemums! *Kabuki Nendaiki* mentions that the actors made their entrance via a trapdoor (*seri*) set in the stage (a piece of business known as *seridashi*),[2] and we also know that the bout was accompanied by onstage chanting with *shamisen* accompaniment (*jōruri*) of the *Ōzatsuma* school.

Rice bales laid end to end bound the wrestling ring, which is sheltered by a pointed roof whose shape echoes the triangular tableau of figures. Kikunojō II, as Reizei, stands decorously over the two contenders, displaying an umpire's ceremonial fan. Like all of Shunshō's early female figures, her features are small and impassive (cf. No. 29). Komazō I and Yaozō II, in matching costumes, squat before her and attempt to stare each other out of countenance. But the delicately flourished chrysanthemums travesty the drama of male rivalry: this was surely an interlude of high comedy. Komazō I must have won, because the wrestling bout was followed by an intimate scene between Reizei and himself. The ever resourceful plot then moved on to a version of the famous love encounter between Lady Jōruri and Ushiwakamaru (the young Minamoto no Yoshitsune).

Bunchō designed a *hosoban* triptych depicting the same fanciful sumo match, only two sheets of which are presently known (fig. 32.1). The colors of the Shunshō print— purple, red, green, pink, yellow, and indigo— are miraculously pristine.

1 *Kabuki Nempyō*, vol. 4 (1959), p. 78.
2 *Kabuki Nendaiki* (1926), p. 317.

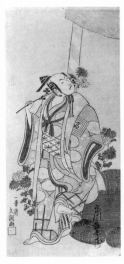
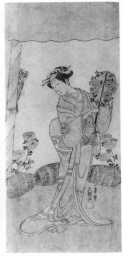

32.1 Ippitsusai Bunchō. *The actors Segawa Kikunojō II as Reizei* (right) *and Ichikawa Komazō I as Suruga no Hachirō* (left). Tsubouchi Memorial Theater Museum, Waseda University, Tokyo

SIGNATURE *Shunshō ga*
ARTIST'S SEAL *Hayashi* in jar-shaped outline
PROVENANCE Baron Fujita collection
REFERENCE Gookin (1931), no. CBAI 68

33 KATSUKAWA SHUNSHŌ
(1726–1792)

The actor Nakamura Nakazō I as Osada no Tarō
in the play *Ima o Sakari Suehiro Genji* (The Genji
Clan Now at Its Zenith), performed at the Naka-
mura Theater from the first day of the eleventh
month, 1768

Hosoban; 30.5 x 14.4 cm
The Clarence Buckingham Collection 1938.479

In a further scene from the play treated in the two
previous entries, Nakamura Nakazō I as Osada no
Tarō gains the confidence of Kasahari Hokkyō, an
Umbrella Maker (played by Sakata Tōjūrō III), only to
steal from him a mirror, presumably an important
heirloom.[1] Here Nakazō I is shown holding the mirror
by its purple silk wrapper. Does his pose suggest
surprise at discovering the precious treasure inside the
cloth? Or is he perhaps directing the mirror's magic
beam against some enemy? His assassin's eyes glare out
from under bushy eyebrows, and the grimace of his
down-turned mouth is accentuated by blue makeup,
always associated with evil roles. Nakazō I's ability to
portray villainy with a new and gripping realism seems
to have inspired Shunshō, a new realist in his own right,
to create startlingly arresting designs (see also No. 26).

Legend has it that Nakazō I was determined to become
one of the three most celebrated Kabuki actors of his
day, and as a kind of sympathetic magic he chose as his
"alternative crest" (*kaemon*) an emblem consisting of the
character for "man" (*hito*) written three times in a row.[2]
This is the large white pattern that here decorates his
long ceremonial trousers (*naga-bakama*). The reddish
orange lead pigment (*tan*) used to print these trousers
has oxidized to a mottled brown. Red kimono, purple
wrapper, orange trousers, sky blue background, and
white accents must have formed a brilliant color
scheme.[3] Here it serves to accentuate further the
boldness of the figure.

1 *Kabuki Nempyō*, vol. 4 (1959), p. 79.
2 Ihara (1913), p. 159. Ihara quotes the legend that Nakazō would
draw the character for "man" three times on the palm of his
hand before going on stage.
3 The still vivid blue of the background was created by a pig-
ment as yet untested; it does not appear to be indigo, which is
exceedingly prone to fading to a buff or tan hue.

SIGNATURE *Shunshō ga*
ARTIST'S SEAL *Hayashi* in jar-shaped outline
PROVENANCE Frederick W. Gookin collection
REFERENCE Gookin (1931), no. 37

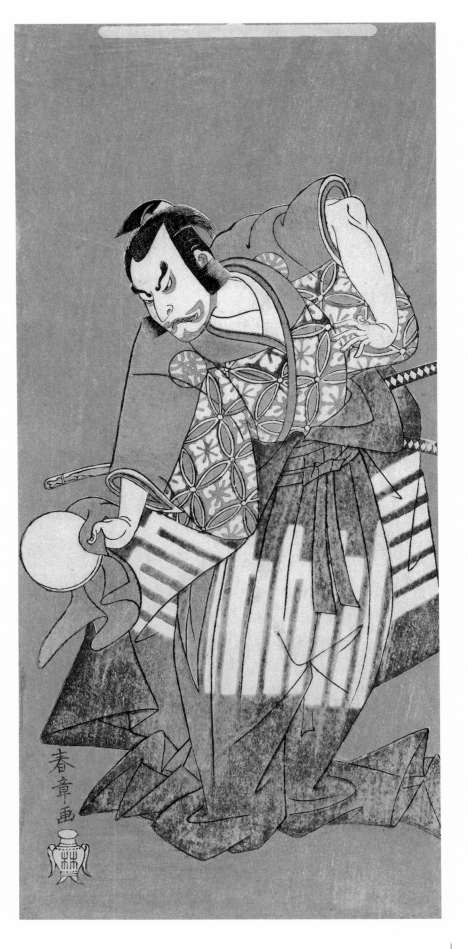

34 KATSUKAWA SHUNSHŌ

(1726–1792)

The actors Nakamura Nakazō I and Ichikawa Komazō I in the dance scene "Shakkyō" (The Stone Bridge), from the play *Ima o Sakari Suehiro Genji* (The Genji Clan Now at Its Zenith), performed at the Nakamura Theater from the first day of the eleventh month, 1768

Hosoban; 29.9 x 14.0 cm
Frederick W. Gookin Collection 1939.673

Shakkyō (The Stone Bridge) is an ancient Buddhist fable telling of Priest Jakushō's pilgrimage to Mt. Wutai (J: Godai) in Shanxi Province, China. This site, one of the chief holy places of East Asian Buddhism and a magnet for Japanese pilgrim-monks, was associated with the paradise of the bodhisattva Manjuśrī (J: Monju).

At a stone bridge crossing a deep ravine on the slopes of the holy mountain,[1] Jakushō is greeted by a *shishi*, a kind of mythical lion, auspicious messenger of the bodhisattva, who frolics and dances among blooming peonies. A version of the story appears in *Konjaku Monogatari*, an early twelfth-century collection of tales, and is also the theme of several medieval Nō plays.[2] Colorful Kabuki adaptions of what is essentially a "lion dance" were popular from the seventeenth century onward.

In the mid-eighteenth century it became customary to conclude a day's Kabuki performance with a dance sequence accompanied by onstage musicians (*jōruri shosagoto*); this served particularly as a vehicle to display the dancing skills of leading female impersonators (*onnagata*) such as Segawa Kikunojō I and Nakamura Tomijūrō I.[3] Kikunojō I, in particular, was a great success in *Shakkyō*, the lion dance, and *Sagi Musume*, the white heron dance. The next development was to include one of the male leads as a foil to the *onnagata* dancer, an innovation that may well have been introduced by Nakazō I, who was himself a fine dancer.

We know from *Kabuki Nempyō* that in this 1768 performance the *onnagata* dancer was to have been Segawa Kikunojō II (as Reizei), whose predecessor, Kikunojō I, had specialized in the role, and that Nakazō I (as Mikuni no Kurō) was to have appeared with him. As lions, the two were supposed to fight over the White Banner of the War God Hachiman (tutelary deity of the Genji clan) that Reizei had received from Suruga no Hachirō (played by Komazō I). For the first four days of the run, however, Kikunojō II was indisposed and Komazō I had to substitute for him in the dance.[4] This must have given rise to some inconsistencies in the plot, doubtless papered over by last-minute changes in action or dialogue. Presumably the print publisher was warned in time of Kikunojō II's illness, for Shunshō's design records Komazō I in the part. At present no print is known showing Kikunojō II in the lion dance of this production.

In any event, Komazō I and Nakazō I are caught in a powerful "dramatic pose" (*mie*), disputing possession of the White Banner. Komazō I brandishes his peony stem as a weapon, and Nakazō I has his branch clenched, lion-like, between his teeth. The carved lion masks worn on their heads— which were actually adapted from hand puppets— seem incongruously small.

Nakazō I's kimono and the background of the print are both faded, the former from a darker and the latter from a lighter shade of indigo blue.

1 The stone bridge seems to have been transposed into this legend from another of the holy places of Chinese Buddhism, Mt. Tiantai (J: Tendai) in Zhejiang Province, home of the Tiantai (J: Tendai) sect of Buddhism. At Mt. Tiantai a natural stone bridge spanning a waterfall very early acquired an aura of legend as the approach to a Buddhist paradise other than Manjuśrī's.
2 *Kabuki Saiken* (1926), pp. 437–45, seems to locate the Nō plays— mistakenly— on Mt. Tiantai rather than Mt. Wutai.
3 *Kabuki Jiten* (1983), s.v. *shosagoto*.
4 *Kabuki Nempyō* (1959), p. 78.

SIGNATURE *Shunshō ga*
ARTIST'S SEAL *Hayashi* in jar-shaped outline
PROVENANCE Kobayashi Bunshichi (square *Hōsūkaku* seal on reverse)
REFERENCE Gookin (1931), no. 39, text pp. 100–101

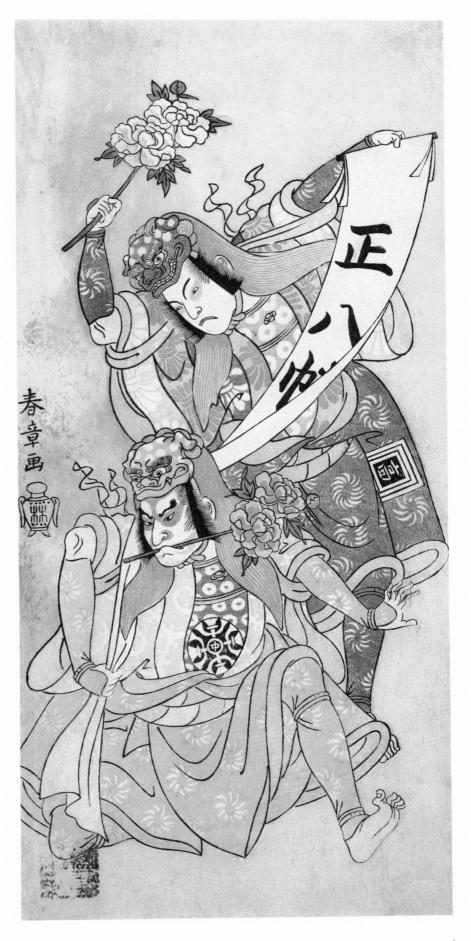

35 KATSUKAWA SHUNSHŌ

(1726–1792)

The actor Ichikawa Danjūrō IV in a "Shibaraku" role, possibly from the play *Ima o Sakari Suehiro Genji* (The Genji Clan Now at Its Zenith), performed at the Nakamura Theater from the first day of the eleventh month, 1768

Ōban; 38.3 x 26.0 cm
The Clarence Buckingham Collection 1925.2365

With repeated cries of "*Shibaraku!*" (Stop right there!) the hero stalks down the *hanamichi* walkway toward the stage, where murder is about to be done. He is wearing an exaggerated persimmon red costume, consisting of a *suō* jacket with huge, square sleeves, very long trousers (*naga-bakama*), and folded white paper "strength" adornments extending from his head. Much of the hero's time is spent declaiming (*tsurane*) and posturing (*mie*) on the *hanamichi*; when he finally steps onto the stage, all wrongs are forthwith righted. A moment later, attacked by a swarm of armed dastards, he unsheathes his massive sword and the villains' heads roll. From the early eighteenth century it became obligatory to include the "Shibaraku" scene in all opening-of-the-season (*kaomise*) productions, somehow weaving it into the plot of whatever play was being performed. Details of the scene are described more fully in Number 44.

The great revolution that Shunshō brought about in actor prints was to make them into portraiture: the actors were now recognizable in prints by their actual facial features or, more precisely, by their actual facial features as interpreted by Shunshō. In this respect it is interesting to note the subtle distinctions Shunshō conveys between the faces of Danjūrō IV and V, father and son, both blessed as they were with the pronounced Ichikawa nose and both having small, closely spaced eyes. The greater age of the senior Danjūrō is clearly signified in this print by a certain heaviness to the jowl, emphasized by several closely spaced wrinkles or folds of skin. Like contemporary Western designers of coins and medals, Shunshō had to find a way to allude to the monarch's advancing years without detracting from the royal dignity.

Given that this is a portrait of Danjūrō IV, and given the form of the signature and the artist's seal, it has been suggested that the print relates to a "Shibaraku" scene forming part of the play *Ima o Sakari Suehiro Genji*, performed at the Nakamura Theater in the eleventh month of 1768.[1] Alternatively the portrait may have been intended as some form of memorial, perhaps of the actor's last performance of the "Shibaraku" role before his son succeeded to the title Danjūrō V in the eleventh month of 1770 (see No. 44). Perhaps the print was designed in the unusually large *ōban* size to accommodate the voluminous sleeves and *naga-bakama* trousers of the "Shibaraku" costume, which are displayed to the full by Danjūrō IV's threatening pose. It is pertinent to note that Harunobu also began to use the larger *ōban* format at about this time, 1769–1770.

The print bears the seal of the publisher, Maruya Jimpachi (which appears on other works by Shunshō from this period). There is no question, therefore, of the design being a private commission for limited circulation; it must have enjoyed wide public sale. At present, however, only two impressions are known to have survived— a paucity which highlights the heavy attrition rate of eighteenth-century prints. The Chicago impression is not in the best of condition, with a crease down the middle, repairs, toning of the paper, and fading in the blue-and-red areas of the under-costume and makeup.

1 *Genshoku Ukiyo-e Daihyakka Jiten*, vol. 7 (1980), p. 24, pl. 47.

SIGNATURE *Katsukawa Shunshō ga*
ARTIST'S SEAL *Hayashi* in jar-shaped outline
PUBLISHER Maruya Jimpachi
REFERENCE Gookin (1931), no. CBAI 60
OTHER IMPRESSIONS Irma E. Grabhorn-Leisinger collection, San Francisco

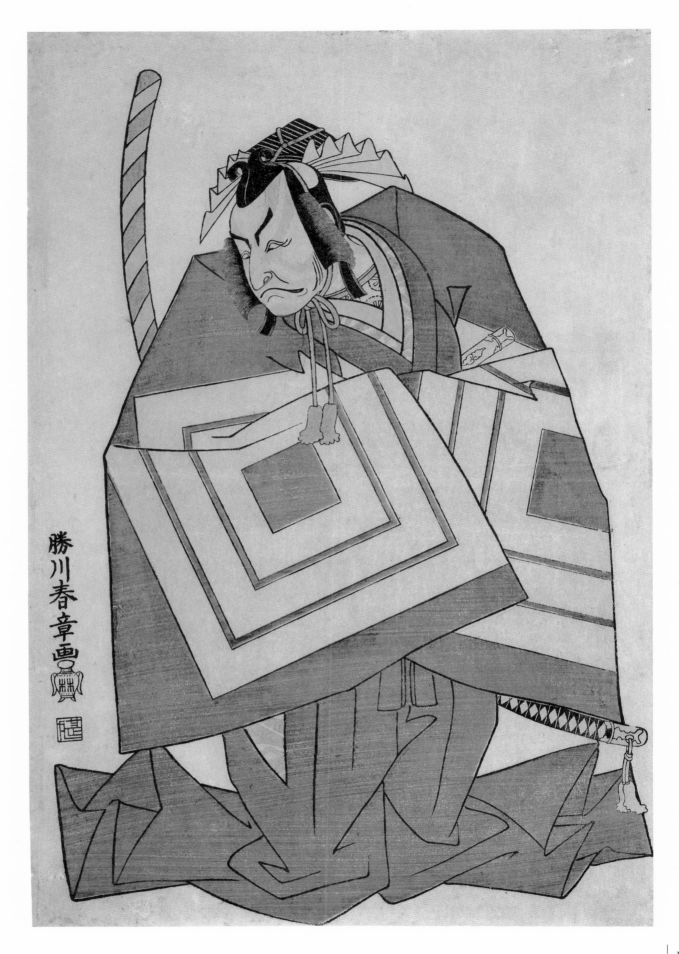

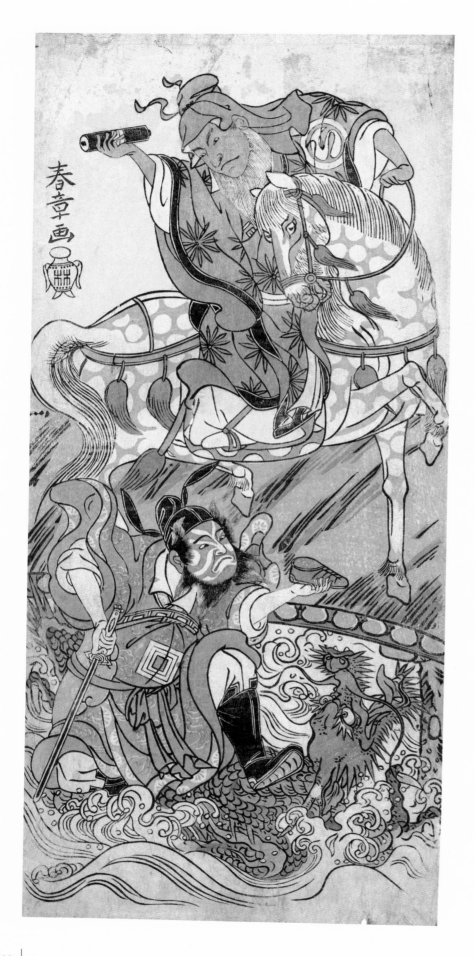

The actors Sawamura Sōjūrō II as the Chinese sage Huangshi Gong (on horseback), and Ichikawa Danzō III as the Chinese warrior Zhang Liang (mounted on a dragon), in the finale of the play *Otokoyama Yunzei Kurabe* (At Mt. Otoko, a Trial of Strength in Drawing the Bow), performed at the Ichimura Theater from the first day of the eleventh month, 1768

Hosoban; 32.5 x 14.9 cm
The Clarence Buckingham Collection 1925.2411

After his failed attempt to assassinate the Qin dynasty emperor Shi Huangdi in 218 B.C., the warrior Zhang Liang (J: Chōryō) went into hiding in Xiapei in Jiangsu Province. There he was sought out by the sage Huangshi Gong (J: Kōseki Kō) to lead a further campaign against the Qin tyrant. The meeting between the two became immortalized in legend. Huangshi Gong, travelling incognito as an old man on horseback, contrived to test Zhang Liang's character by dropping his shoe into the water as he crossed a small bridge. Zhang, sitting on the river bank, returned the shoe with such perfect courtesy that Huangshi presented him with a precious handscroll of secret military strategies. Zhang Liang became an early supporter of Liu Bang, instrumental in the overthrow of the Qin, and a general of great repute in the Han dynasty founded by Liu Bang.

In Japan the story of Chōryō and Kōseki Kō became current at all cultural levels; aristocratic audiences knew it as the Nō play *Chōryō*, popular audiences in various *jōruri* versions. In the more popular (and more colorful) theatrical versions Chōryō has first to subdue a dragon living in the river. Kabuki stagings of the story seem to have been rare, indeed possibly limited to the 1768 production illustrated here by Shunshō; this was presented as the grand finale of the opening-of-the-season (*kaomise*) production at the Ichimura Theater.[1] Horses were often played by two strong men in an equine suit, but one wonders how on earth the management contrived to get a dragon on stage!

Just as the legend's popularity gained for it a variety of dramatic forms, so it became a common subject for visual artists of different schools during the Edo period. *Ukiyo-e* versions include an impressive diptych of large *kakemono*-sized prints, attributed to Torii Kiyonobu I (act. ca. 1664–1729), depicting the famous meeting in a more or less historical manner.[2] Later Harunobu parodied the lofty subject in a *chūban* diptych of about the same date as our Shunshō print, showing a youth and a girl exchanging a love-letter for a dropped fan.[3]

Since legend immortalized Chōryō as the embodiment of military virtue, his meeting with Kōseki Kō made an apt and frequent subject for painters of the Kanō school, whose chief patrons were the samurai aristocracy. It is interesting to compare Shunshō's print with an album leaf showing Chōryō and Kōseki Kō by Kanō Tsunenobu (1636–1713), from a presentational album of many similar subjects painted by Tsunenobu and pupils in about 1681 (fig. 36.1). Tsunenobu's album leaf exhibits a highly polished handling of gold washes and rich ink tonalities, and the action takes place at a discrete remove, amid a considerable expanse of swirling clouds and frothing waves. The result is an elegant rendering of classical figures-in-a-landscape. How much more vivid is Shunshō's dynamic, concentrated design, which conveys the reality of flesh-and-blood actors as powerfully as it does the illusion of historical personages.

The blue, purple, and pink pigments of this impression have faded somewhat.

1 *Kabuki Nempyō*, vol. 4 (1959), pp. 80–84.
2 Hillier (Vever) (1976), no. 13.
3 *Ukiyo-e Shūka*, vol. 11 (1979), nos. 84, 85.

SIGNATURE *Shunshō ga*
ARTIST'S SEAL *Hayashi* in jar-shaped outline
REFERENCE
Gookin (1931), no. CBAI 40; *Ukiyo-e Shūka*, vol. 5 (1980), no. 18

36.1 Kanō Tsunenobu. *Chōryō and Kōseki Kō.* Album leaf. Arthur M. Sackler Museum, Harvard University Art Museums, Cambridge, Mass.

37 KATSUKAWA SHUNSHŌ

(1726–1792)

Memorial portrait of Ichikawa Ebizō II (Danjūrō II) as a peddler of the panacea *uirō*
Ca. 1768–1770

Hosoban; 31.2 x 14.2 cm
Frederick W. Gookin Collection 1939.686

Ichikawa Ebizō II appears in the role of a peddler of *uirō*— a kind of panacea used as an expectorant, deodorant, and mouthwash (among other things). Under the weight of the large black lacquer chest that holds his wares he stands with legs braced and back bowed, scowling. His face is flat, the nose long and pointed.[1] Clearly visible at the top of the chest is the place-name Odawara, where the medicine was made; at the bottom of the chest, nearly hidden behind the actor's left sleeve, is the word *uirō*. His kimono is colorfully decorated with the "assorted lucky treasures" (*takara-zukushi*) pattern and the actor's lobster (*ebi*) emblem. On his sleeveless jacket is a bold design of paper streamers hanging from ropes (a Shintō emblem called *shimenawa*). Ebizō II had first created the role of *uirō* seller in 1718 (when he still used the name Danjūrō II), scoring a great comic hit with a rush of words "like a waterfall" advertising the miraculous powers of his cure-all.[2]

Since Ebizō II died on the twenty-fourth day of the ninth month, 1758, and full-color prints (*nishiki-e*, of which this is one) only began to appear about 1765, there is no doubt that this was issued as a posthumous portrait. Probably for this reason Shunshō felt obliged to jog the memory of the fickle populace by adding the name of the actor to the print; for an actor currently in the public eye, the accuracy of the portrait was sufficient identification. *Kabuki Nendaiki* reproduces a portrait of Danjūrō II as an *uirō* seller in the first performance of the role, in 1718 (though of course these illustrations were redrawn by Katsukawa Shuntei [1770–1820] when *Nendaiki* was published in 1811–1815), and it is likely that Shunshō based this likeness on some such earlier portrait (fig. 37.1). Gookin (1931, p. 94) mentions a *surimono* by Shunshō showing Ebizō II as an *uirō* seller (not reproduced, present location unknown), with the words *ji sha* ("drawn by himself") in the signature, which he suggests may have been made from life.

The difficult question to answer is when the print might have been issued. The form of the signature, along with the seal composed of *Hayashi* in a jar-shaped outline, suggests a date between 1767 and 1770. There were memorial performances for Ebizō II in the ninth months of 1764 and 1770, the seventh and thirteenth anniversaries of his death. On neither occasion does there seem to have been a performance of the "*uirō* seller" scene, though publishers may have marked the 1770 anniversary by issuing this print of Ebizō II in his most famous role. The unabbreviated form of the character *ga* ("drawn by") in the signature (similar to the signature on No. 30, published in the tenth month of 1768), and the generally simple style of the drawing, however, suggest a date later than 1764 and earlier than 1770— closer to 1768.

The indigo blue background of the Chicago impression has faded to a pale shade of sand.

37.1 Katsukawa Shuntei.
*The actor Ichikawa Danjūrō II
as an* uirō *seller.*
From *Kabuki Nendaiki*.
The Art Institute of Chicago

1 Roger Keyes (*Ukiyo-e Shūka*, vol. 13 [1981], no. 60) has identified this as a portrait of Ichikawa Danzō III performing in memory of Danjūrō II. But though the faces are superficially similar in shape, the nose seems much more pointed in this print than in the portrait of Danzō III (No. 25).
2 *Kabuki Nendaiki* (1926), p. 48, where the text of the soliloquy is reproduced in full.

SIGNATURE *Shunshō ga*
ARTIST'S SEAL *Hayashi* in jar-shaped outline
REFERENCE Gookin (1931), no. 32, text pp. 93–95
OTHER IMPRESSIONS
Museum of Fine Arts, Boston; Musées Royaux d'Art et d'Histoire, Brussels;
Watanabe Tadasu collection, Tokyo

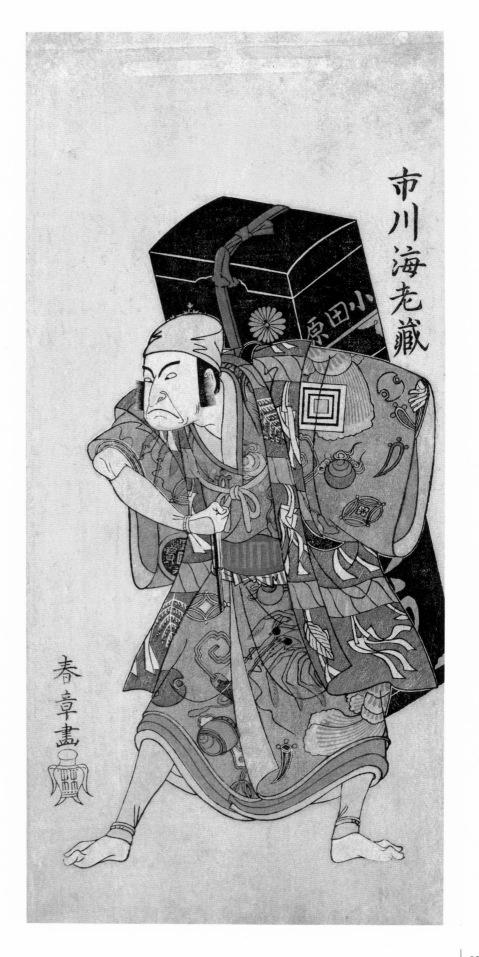

市川海老蔵

春章畫

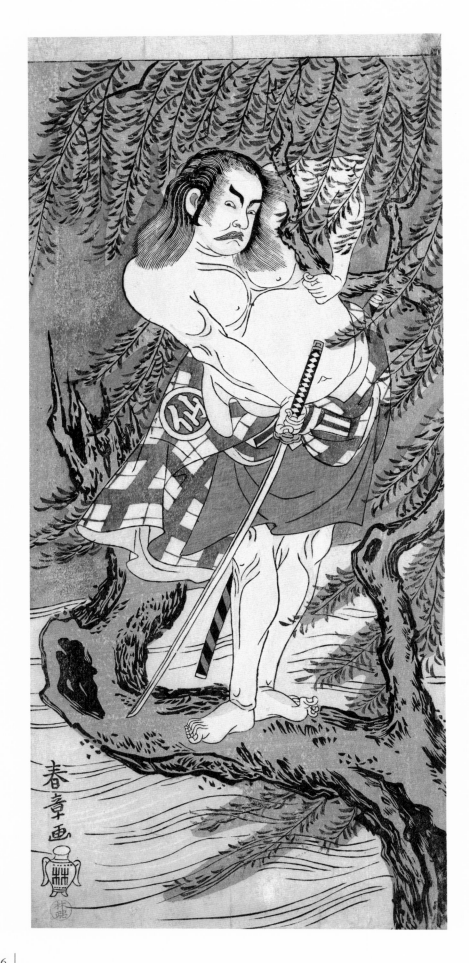

38 KATSUKAWA SHUNSHŌ
(1726–1792)

The actor Nakamura Sukegorō II in the role of a chivalrous commoner (*otokodate*)
Ca. 1768–1770

Hosoban; 32.3 x 14.5 cm
Frederick W. Gookin Collection 1939.580

Stripped to the waist and brandishing his sword, Sukegorō II has clambered up among the fresh green tresses of a willow overhanging a river. His kimono is still tied around his waist, but he has pushed it behind him for greater mobility. Grasping a branch for balance, he manages a fierce stage pose (*mie*) in what is presumably a scene of nighttime ambush (implied by the dark blue of the sky and the fact that such attacks generally occurred at night).

The complexity of the style and the combination of this particular form of Shunshō's signature with the jar-shaped *Hayashi* seal suggest that the print was issued between 1768 and 1770. Suzuki has suggested that the nearly bare body and cooling river setting imply a summer performance, but he is unable to identify the scene with any role recorded for Sukegorō II in the summers of these years.[1] A similar pose is depicted in the illustrated program (*ehon banzuke*) for the play *Kagami-ga-ike Omokage Soga* (Mirror Pond: Vestiges of Soga), performed at the Nakamura Theater at the New Year in 1770, in which Sukegorō II (as Dōzaburō) is set upon by two ruffians played by Nakamura Konozō and Bandō Zenji I (fig. 38.1). The settings, however, are very different, and as Suzuki has further pointed out, this pose was part of Sukegorō II's acting style and was employed by him in many different roles. A picture book of actors in characteristic *mie*, *Himo Kagami*, published in 1771, describes it as follows: "... a stage pose in which he half raises his hips, bends his elbow, and twists his body"[2]— precisely the attitude we see here.

The contrast between the gracefully curving willow fronds and the assertive angularity of Sukegorō II's posture makes this a particularly satisfying design, even further enhanced by the sharp clarity and fresh, unfaded colors of this impression.

1 See the essay by Suzuki Jūzō in *Ukiyo-e Shūka*, vol. 5 (1980), no. 20.
2 Quoted in ibid.

38.1 *The actor Nakamura Sukegorō II as Dōzaburō set upon by two ruffians, played by Nakamura Konozō and Bandō Zenji I. From the illustrated program of the play Kagami-ga-ike Omokage Soga*. Tsubouchi Memorial Theater Museum, Waseda University, Tokyo

SIGNATURE *Shunshō ga*
ARTIST'S SEAL *Hayashi* in jar-shaped outline
PROVENANCE Hayashi Tadamasa (seal)
REFERENCE
Gookin (1931), no. G86; *Ukiyo-e Shūka*, vol. 5 (1980), no. 20

(1726–1792)

The actors Nakamura Utaemon I as the old hag Karashi Baba, wife of Sanshōdayū, and Yoshizawa Sakinosuke III as Shirotae, wife of Sano Genzaemon, in a scene from part two of the play *Kawaranu Hanasakae Hachi no Ki* (The Ever-Blooming Potted Tree), performed at the Nakamura Theater from the first day of the eleventh month, 1769

Hosoban; 30.6 x 14.6 cm
The Clarence Buckingham Collection 1925.2413

Kabuki Nempyō describes how Shirotae, attempting to flee with Prince Tsunehito, is intercepted and murdered by the old hag Karashi Baba.[1] Shunshō's print shows Karashi Baba about to plunge a large cleaver into Shirotae, who is kneeling at her feet with one hand raised in futile supplication. In her awful eagerness to strike, the old hag has shrugged off the sleeves of her over-kimono (*uchikake*) and is almost toppling forward over the defenseless Shirotae. Cold white snow swirling against a pitch black sky intensifies the ineluctable menace of the scene.

Because of the shogunal government's ban on treating contemporary political events in Kabuki plays, playwrights frequently set current or recent events in the distant Kamakura period (1185–1333). Some of the most popular of these "Kamakura-period" plays purported to be versions of the medieval Nō play *Hachi no Ki*. In the Nō text the powerful regent Hōjō Tokiyori (1227–1263) has taken holy orders and embarked on an ostensible pilgrimage, which is in fact a reconnaissance of his vassals' military forces. At Sano in Kōzuke Province he is overtaken by a fierce snowstorm and seeks shelter in a humble cottage. His samurai host, Sano Genzaemon, has been impoverished through the machinations of enemies; having no other fuel, he chops up his three cherished potted trees for a fire to warm his noble guest. Later, a call to arms in the nation's defense brings Genzaemon to Tokiyori's headquarters, where the regent recognizes him and rewards his loyalty and generosity with three estates— one for each potted tree. In the Kabuki play Shirotae is the wife of this Sano Genzaemon.[2]

Hachi no Ki's winter setting made it a common choice for the "snow scene" that formed an obligatory part of the opening-of-the-season (*kaomise*) productions, which began in the eleventh month of each year. The plot of the version performed at the Nakamura Theater in 1769 was complicated by the interpolation of elements from a quite different story, that of Sanshōdayū; such creative mingling of plots was a very common practice among Kabuki playwrights. Many details of the performance remain obscure: it is not known, for instance, which actor played Prince Tsunehito, nor what function the prince served in the plot. In any event, the production seems to have been a great success, as Shunshō devoted three more prints to it and scenes from it appear in at least twelve *hosoban* prints by Bunchō (see No. 8).[3]

1 *Kabuki Nempyō*, vol. 4 (1959), pp. 119–21.
2 *Kabuki Saiken* (1926), sect. no. 24, pp. 164–67.
3 The other Bunchō designs are reproduced in Hayashi (1981), nos. 9, 10, 23, 58, 59, 74, 75, 163, 248, 249, 274; and the Shunshō designs in Gookin (1931), no. 57, and *Ukiyo-e Shūka*, vol. 13 (1981), nos. 61, 62.

SIGNATURE *Shunshō ga*
ARTIST'S SEAL *Hayashi* in jar-shaped outline
PROVENANCE Frederick May collection
REFERENCE Gookin (1931), no. 56
OTHER IMPRESSIONS
Tokyo National Museum; ex-collection M. Bing (present location unknown)

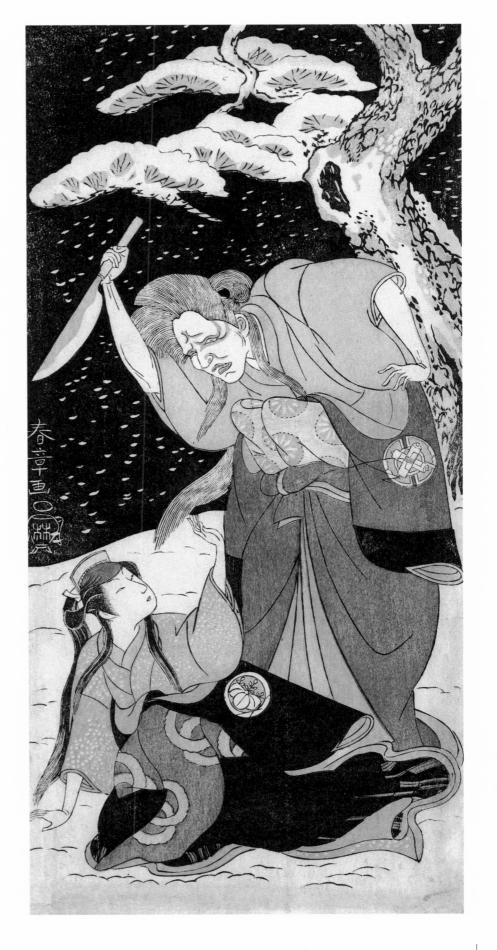

40 KATSUKAWA SHUNSHŌ
(1726–1792)

The actor Bandō Matatarō IV as Gempachibyōe
in the play *Mutsu no Hana Ume no Kaomise* (Snow-
flakes: Plum Blossom *Kaomise*), performed at the
Ichimura Theater from the first day of the eleventh
month, 1769

Hosoban; 31.6 x 14.2 cm
The Clarence Buckingham Collection 1932.1008

The short verse in white reserve against the faded blue
background reads:

Korede yabo nara	I may look boorish
shōkoto ga nai	but it can't be helped.

According to Kabuki records, Gempachibyōe seems
to have been a supporting character who appeared in
at least three different guises: an official at a Shintō
ceremony, a runner for a messenger service (*hikyaku*),
and a servant (*yakko*) who fights another servant with
bales of rice straw.[1] The costume does not establish
which of these guises Shunshō is depicting, but the
poem seems to signify, "This may not be a very stylish
disguise, but I will triumph in the end."

Whatever the exact persona, this is surely one of
Shunshō's most powerful early designs, full of barely
controlled dynamism. All of the energy of the figure
pours into the right arm, which is locked in a defiant,
downward-pointing gesture— a gesture echoed and
reinforced by the lines of the right leg, the scabbard,
and the *soku mie* pose of the legs. Even the face, with its
bright red "streaked" (*sujiguma*) makeup, is turned to
scowl down the rigid line of the arm. A regular pattern
of brilliant yellow spots is dazzling against the black
costume, and the printed white pigment of the kimono
lining would have stood out much more prominently
against the original unfaded blue background.

Shunshō seems to have favored this strong pose of body
and head turned in almost opposite directions, since it
appears in several of his early prints (see, for example,
No. 30). It seems also to have been a conventional stage
pose of the time.

1 *Kabuki Nempyō*, vol. 4 (1959), p. 122.

UNSIGNED
ARTIST'S SEAL *Hayashi* in jar-shaped outline
PROVENANCE Frederick W. Gookin collection
REFERENCE Gookin (1931), no. 55, text p. 105
OTHER IMPRESSIONS
Minneapolis Institute of Arts (ex-coll. Louis V. Ledoux)

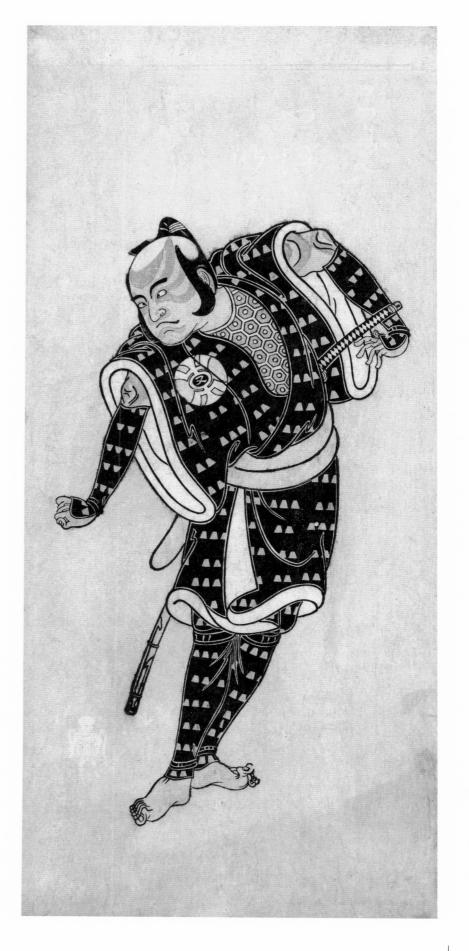

41 KATSUKAWA SHUNSHŌ
(1726–1792)

The actor Ōtani Hiroji III in a stage pose (*mie*) before a
shrine gateway
Ca. 1769–1770

Hosoban; 31.1 x 14.4 cm
Frederick W. Gookin Collection 1939.690

Standing before a stone fence and the pillar of a shrine gate-
way (torii), Hiroji III is shown in *soku mie* pose (legs straight
and heels together) at some climactic moment in the plot.
His right hand lifts the hem of his kimono; his left arm is
outflung in a resolute gesture. The conspicuous purple check
of the kimono and red makeup around the eyes suggest that
this may be the role of a chivalrous commoner (*otokodate*),
though a definite identification has not yet been possible.[1]
Preparing for action, Hiroji III has slipped his right arm out
of the kimono, revealing the foaming wave pattern on the
under-kimono beneath.

Ōtani Hiroji III (1746–1802) was a large, muscular man,
strong of voice and imposing rather than graceful in appear-
ance and manner, suited for such roles as able-bodied and
faithful servants, wrestlers, chivalrous commoners, and the
like— roles in which Shunshō often depicted him. It is
recorded that during his youth in the 1760s and 1770s his
admiring patrons included several women.[2]

Though the role remains unidentified, the forms of the sig-
nature and seal together suggest that the print was issued
at the end of the 1760s. During this time Shunshō was grad-
ually replacing the simple, often monochrome backgrounds
of his earliest designs with more complex settings.

1 Shunshō also designed a bust portrait of Hiroji III, similarly cos-
 tumed, in a fan-shaped cartouche. The role depicted has been tenta-
 tively identified as Kawazu no Saburō in the play *Myōto-giku
 Izu no Kisewata* (Cotton Wadding of Izu Protecting the Matrimonial
 Chrysanthemums), performed at the Ichimura Theater in the eleventh
 month of 1770. See Kobori Sakae, "Butai Ōgi no Chimpin," *Ukiyo-e
 Kai* (Aug. 1939), pp. 34–35.
2 Quoted in Ihara (1913), p. 216.

SIGNATURE *Shunshō ga*
ARTIST'S SEAL *Hayashi* in jar-shaped outline
REFERENCE Gookin (1931), no. 50, text p. 104
OTHER IMPRESSIONS
Ukiyo-e Taisei, vol. 5 (1931), pl. 37; *Shibai Nishiki-e Shūsei* (1919),
no. 134 (present location unknown)

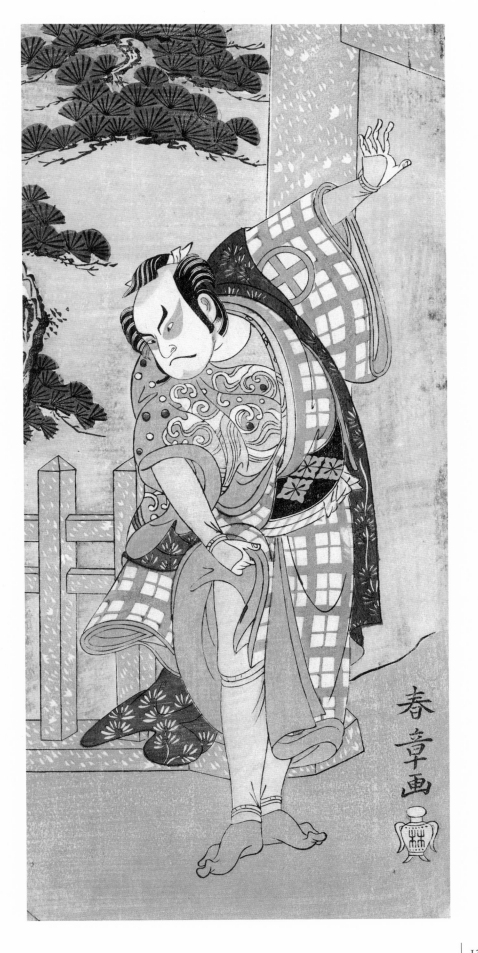

42 KATSUKAWA SHUNSHŌ
(1726–1792)

The actor Ōtani Hiroji III, possibly as Akaneya Hanshichi in the play *Fuji no Yuki Kaikei Soga* (Snow on Mt. Fuji: The Soga Vendetta), performed at the Ichimura Theater from the fifteenth day of the first month, 1770

Hosoban; 31.5 x 15.2 cm
Frederick W. Gookin Collection 1939.692

By slicing through a bamboo drainpipe with his sword, Hiroji III has discovered the hiding place of a tiny statue of the bodhisattva Kannon— doubtless a precious relic eagerly sought by both sides in a vendetta. Wearing nothing more than a loincloth bearing his acting crest, the muscular hero now poses holding it proudly, oblivious to the torrent of water cascading down the back of his neck from the severed drain. Perhaps this was intended by the playwrights as a parody of the monk Mongaku doing penance under a waterfall, or some such well-known story from classical literature.

A handwritten inscription on another impression of this print, illustrated in *Ukiyo-e Taisei*, identifies the role as that of Akaneya Hanshichi in the play *Fuji no Yuki Kaikei Soga*, performed at the Ichimura Theater in the spring of Meiwa 7 (1770). *Kabuki Nendaiki* describes a scene in that play involving a fight over a small statue of Kannon: "Akeneya Hanshichi was played by Hiroji; Imaichi Zen'emon by Tomoemon. He [Tomoemon] swallowed a statue of Kannon about two inches tall. There was a fight between the two in the mud and Hanshichi cut open Zen'emon's stomach. This was a particularly good scene and a great hit with the audience."[1] We can imagine, then, the following scenario: after Hiroji III recovered the statue, as shown in Shunshō's print, Ōtani Tomoemon I somehow got it away from him and managed to swallow it. A fight in the mud created by the water gushing from the drainpipe ended with Hiroji III cutting open Tomoemon I's stomach to recover the statue once more.

1 Quoted by Suzuki Jūzō in *Ukiyo-e Shūka*, vol. 5 (1980), no. 85. Suzuki expresses reservations about this identification, on the grounds that (i) the mud-wrestling scene is not mentioned in *Kabuki Nempyō*, and (ii) actors were unlikely to be subjected to a drenching during the cold of winter.

UNSIGNED
ARTIST'S SEAL *Hayashi* in jar-shaped outline
REFERENCE
Gookin (1931), no. 51, text p. 104; Riccar (1973), no. 103; *Ukiyo-e Shūka*, vol. 5 (1980), no. 85
OTHER IMPRESSIONS
Ukiyo-e Taisei, vol. 5 (1931), pl. 74 (present location unknown)

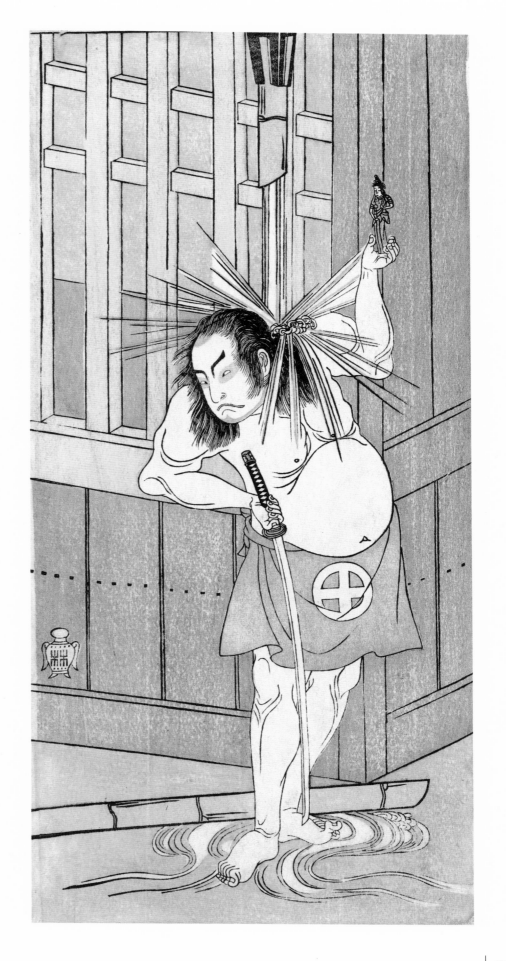

43 KATSUKAWA SHUNSHŌ
(1726–1792)

The actor Ōtani Hiroji III, probably as Ukishima Dai-
hachi in the play *Shinasadame Sōma no Mombi*
(Comparing Merits: Festival Day at Sōma), performed
at the Ichimura Theater from the twenty-third day of
the seventh month, 1770

Hosoban; 31.4 x 14.0 cm
The Clarence Buckingham Collection 1925.2415

Hiroji III stands with legs braced wide apart, impassive
in the battering storm. The fierce wind that drives the
night rain slantwise against him has turned his large paper
umbrella inside out. He wears the twin swords of a sam-
urai, an over-kimono decorated with an auspicious inter-
locking circle pattern (*shippō tsunagi*), and high wooden
clogs (*geta*). The identification of the role as Ukishima
Daihachi in the play performed at the Ichimura Theater in
the fall of 1770 comes from the handwritten inscription
along the right-hand side of this impression of the print.
It is exceedingly rare for the name or role of an actor to
be printed on a Katsukawa school *hosoban* print of about
1765–1795, and perhaps for that reason later scholars and
collectors often added handwritten inscriptions of this
kind. We do not know who made the identification here.

Kabuki Nempyō's brief description of Ukishima Daihachi
suggests an action-filled role involving fights for pos-
session of a secret scroll belonging to the Tsumagoi Shrine,
but mentions neither a rainstorm nor an umbrella.[1] The
only supporting evidence for the identification is a *chūban*
print by Bunchō, showing Hiroji III in this role (iden-
tifiable by his *mon* and from information in theatrical
records) with the same unusually long hanks of hair behind
his ears.[2] In general, however, the form of Shunshō's
signature and seal and the simple, vigorous figure style are
consistent with a date of 1770.

The positioning of signature and seal in the middle of the
sheet suggests that this may well be the center sheet of a
hosoban triptych. The colors of the print are strong and
relatively unfaded.

1 *Kabuki Nempyō*, vol. 4 (1959), p. 141.
2 Illustrated in color in Riccar (1978), no. 117.

SIGNATURE *Shunshō ga*
ARTIST'S SEAL *Hayashi* in jar-shaped outline
REFERENCE Gookin (1931), no. CBAI 41
OTHER IMPRESSIONS Honolulu Academy of Arts

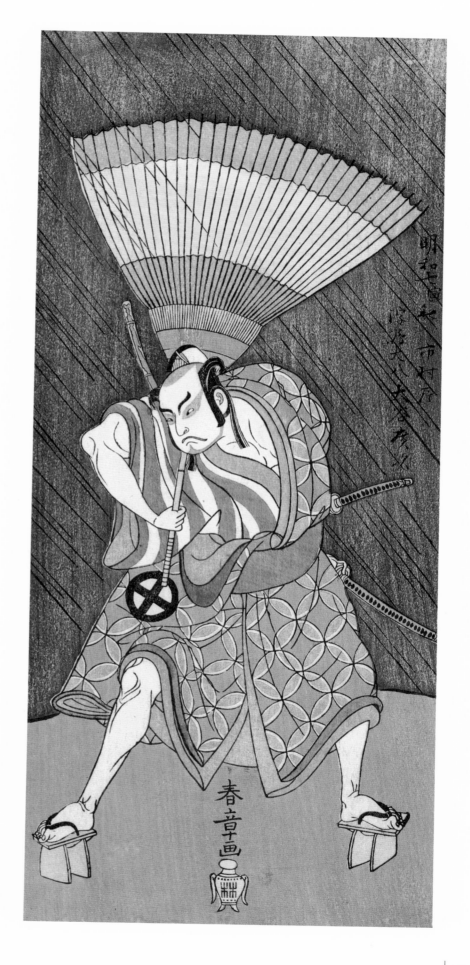

44 KATSUKAWA SHUNSHŌ

(1726–1792)

The actors Ichikawa Danjūrō V as Watanabe Kiou Takiguchi (bottom), and Nakamura Nakazō I as Taira no Kiyomori (top), in the "Shibaraku" scene from the play *Nue no Mori Ichiyō no Mato* (Forest of the *Nue* Monster: Target of the Eleventh Month), performed at the Nakamura Theater from the first day of the eleventh month, 1770

Hosoban; 32.2 x 14.3 cm
Frederick W. Gookin Collection 1939.596

An evil courtier is about to order the execution of some hapless victim onstage when cries of "*Shibaraku!*" (Stop right there!) are heard from the back of the theater, and a hero dressed in a distinctive persimmon-colored costume with fantastically large square sleeves enters down the *hanamichi* walkway to save the day.[1] The "Shibaraku" scene is the ultimate confrontation between good and evil in Kabuki, and the most perfect display of the bombastic, stylized *aragoto* (rough stuff) acting style associated with the Ichikawa Danjūrō line of actors. First performed by Danjūrō I in 1697, it became obligatory from the early eighteenth century to include the scene in the opening-of-the-season (*kaomise*) productions held at every theater in the eleventh month of each year. The excitement attending the performance at the Nakamura Theater in the eleventh month of 1770 must have been particularly intense, for it was on this occasion that twenty-nine-year-old Matsumoto Kōshirō III, acting the "Shibaraku" role for the first time, had to prove himself a worthy successor to his father as the new Danjūrō V.

In Shunshō's print we see Danjūrō V half-kneeling in his voluminous "Shibaraku" costume decorated with the large white "triple square" (*mimasu*) crest of the Ichikawa family, towered over by Nakamura Nakazō I in the "receiving" (*uke*) role of the evil courtier Taira no Kiyomori. For more complete depictions of the scene we can turn to a page in the illustrated play program (*ehon banzuke*; fig. 44.1) as well as to an illustration from the book *Yakusha Kuni no Hana* (Prominent Actors of Japan; fig. 44.2). Yorimasa, played by Ichikawa Komazō II, has been commanded by Kiyomori to commit suicide for losing the sword of the Lion King (Shishi Ō); Nakamura Denkurō II as Seno'o Tarō stands behind Yorimasa, sword at the ready, to ensure compliance. Standing on the steps leading up to the palace, dressed in white court robes and *kammuri* headdress, Nakazō I as Kiyomori dominates the scene, but Danjūrō V as the hero Kiou Takiguchi has just entered to the left. *Kabuki Nempyō* describes Danjūrō V pulling out a brocade banner from a protective tube,[2] the moment shown in the illustration from *Yakusha Kuni no Hana*.

Though the more detailed book illustrations give us a much better idea of the complete stage tableau, they also demonstrate (by comparison) the purer compositional power of the *hosoban* print, from which all extraneous elements have been eliminated to present the two protagonists in a confrontation fraught with physical and psychological tension.

1 Cf. No. 35.
2 *Kabuki Nempyō*, vol. 4 (1959), p. 145.

SIGNATURE *Shunshō ga*
ARTIST'S SEAL *Hayashi* in jar-shaped outline
REFERENCE Gookin (1931), no. G32
OTHER IMPRESSIONS
Honolulu Academy of Arts; *Ukiyo-e Taisei*, vol. 5 (1931), pl. 40; ex-collection Henri Vever (ex-coll. Manzi; present location unknown); Musées Royaux d'Art et d'Histoire, Brussels; *Shibai Nishiki-e Shūsei* (1919), no. 128

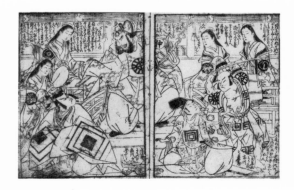

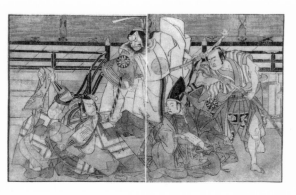

44.1 Left: *The actors Ichikawa Danjūrō V, Nakamura Nakazō I, and others in a "Shibaraku" scene.* From the illustrated program. Kaga Bunko, Tokyo Municipal Central Library

44.2 Right: Katsukawa Shunshō. *The actors Nakamura Denkurō IV, Ichikawa Komazō II, Nakamura Nakazō I, and Ichikawa Danjūrō V in a "Shibaraku" scene.* From *Yakusha Kuni no Hana.* The Art Institute of Chicago

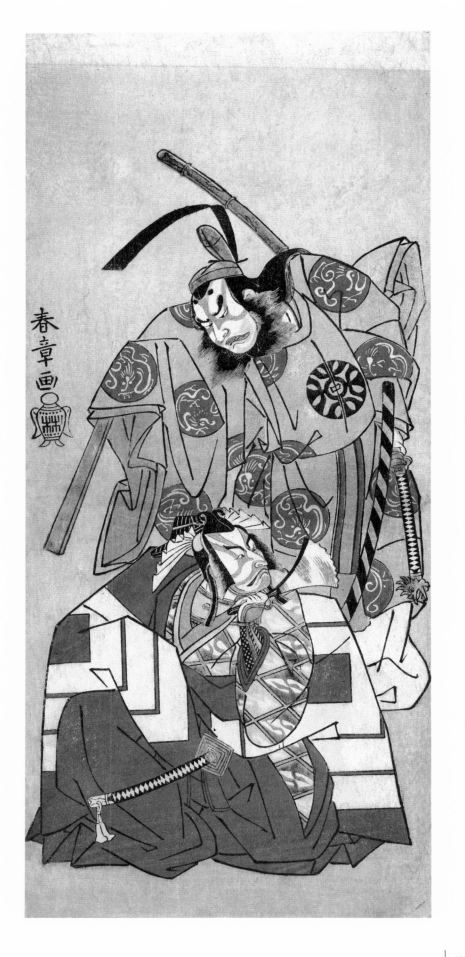

(1726–1792)

The actor Matsumoto Kōshirō II as Osada no Tarō Kagemune disguised as the woodcutter Gankutsu no Gorozō, in act four(?) of the play *Nue no Mori Ichiyō no Mato* (Forest of the *Nue* Monster: Target of the Eleventh Month), performed at the Nakamura Theater from the first day of the eleventh month, 1770

Chūban; 25.6 x 17.7 cm
The Clarence Buckingham Collection 1928.986

SIGNATURE *Katsukawa Shunshō ga*
ARTIST'S SEAL *Hayashi* in jar-shaped outline
PUBLISHER Urokogataya Magobei, Edo
PROVENANCE Alexander G. Mosle collection
REFERENCE Gookin (1931), no. CBAI 58, text p. 117

45.1 Katsukawa Shunshō. *The actors Matsumoto Kōshirō II and Ichikawa Danzō III*. From *Yakusha Kuni no Hana*. The Art Institute of Chicago

As with most eighteenth-century Kabuki plays, the libretto does not survive for *Nue no Mori Ichiyō no Mato*, the opening-of-the-season (*kaomise*) production at the Nakamura Theater in the eleventh month of 1770. Fortunately, however, the existence of a cluster of color prints[1] and some book illustrations depicting various scenes, together with the fragmentary descriptions contained in actor critiques (*yakusha hyōbanki*), allows us— if we add a measure of creative imagination— to reconstruct at least the outlines of the first part. Number 44 shows the twenty-nine-year-old Matsumoto Kōshirō III, newly succeeded to the name Danjūrō V, making his debut in the "Shibaraku" scene; the following scenes of the play featured Danjūrō V's father, Danjūrō IV, who from this performance onward resumed the name Matsumoto Kōshirō II.

An illustration from the rare color-printed book *Yakusha Kuni no Hana* (Prominent Actors of Japan) shows the third (or perhaps fourth) act of the first part (fig. 45.1). This is described in *Kabuki Nendaiki* as follows: "The third act of the first part. The woodcutter Gorozō of the cave of Mt. Iwakura, real name Osada no Tarō Kagemune [played by] Matsumoto Kōshirō [II]. A straw head cover, wide-sleeved kimono, carrying an axe. At a place where there was a large gingko tree with a hollow [in the trunk], [he is joined by] I no Hayata Tadazumi [played by] Danzō [III], wearing a lime green patchwork kimono and a persimmon *kamishimo* [surcoat and trousers], and with red *sujiguma* makeup. He comes up through a trapdoor, striking a *mie* and carrying inside his kimono a child who had fallen into the valley. The scene was gorgeous beyond words."[2] Though the writer fails to mention it, we see in the book illustration (fig. 45.1) that Tadazumi also hoists a massive rock calmly into the air— presumably to impress Gorozō with his strength.

In the *chūban* color print Kōshirō as the woodcutter is shown in a pose virtually identical with that in the book illustration: legs straight and heels close together (*soku mie*), a fist clenched under his chin, and the massive axe over his shoulder. He is staring down at a baby in a basket (who later turns out to be Prince Takakura). The question is, does this scene come before or after the meeting with Tadazumi? The account in *Kabuki Nempyō* mentions that both men made their entrance together through the trapdoor;[3] but the unusual inclusion of the mountain landscape in the background of this print suggests that Gorozō has just come down out of the mountains and discovered the baby abandoned in the basket. Then would follow the meeting with Tadazumi (shown in fig. 45.1), when Tadazumi takes charge of the child. Number 46 probably illustrates a slightly later tableau in the same scene.

It is rare to find a publisher's mark on an early Shunshō print, and it is perhaps no coincidence that the mark of the long-established Edo firm of Urokogataya Magobei appears on this unusual *chūban* format. It was precisely at this time (ca. 1770) that Urokogataya was issuing the forty-eight *chūban* prints of the *Ise Monogatari* series designed by Shunshō, which also feature figures in landscape settings (No. 63).

1 Gookin (1931) includes illustrations of two more *hosoban* prints relating to this scene, nos. 65 and 66, which appear in the present volume as cat. nos. 115 and 121. Cat. no. 122 is a key-block impression of 121, not illustrated by Gookin.
2 *Kabuki Nendaiki* (1926), p. 324.
3 *Kabuki Nempyō*, vol. 4 (1959), p. 144.

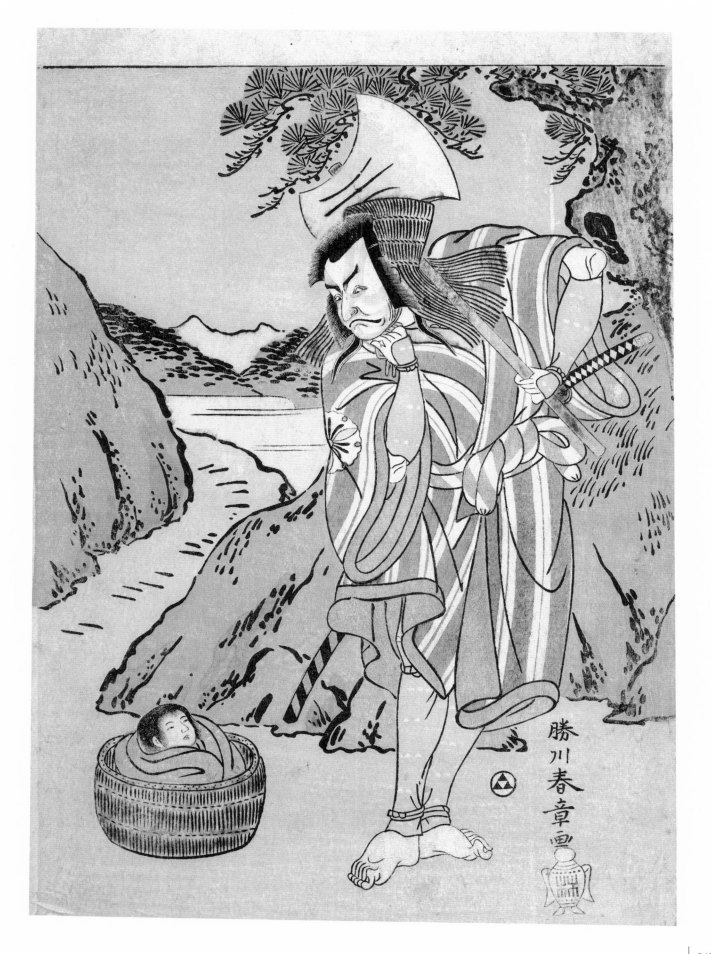

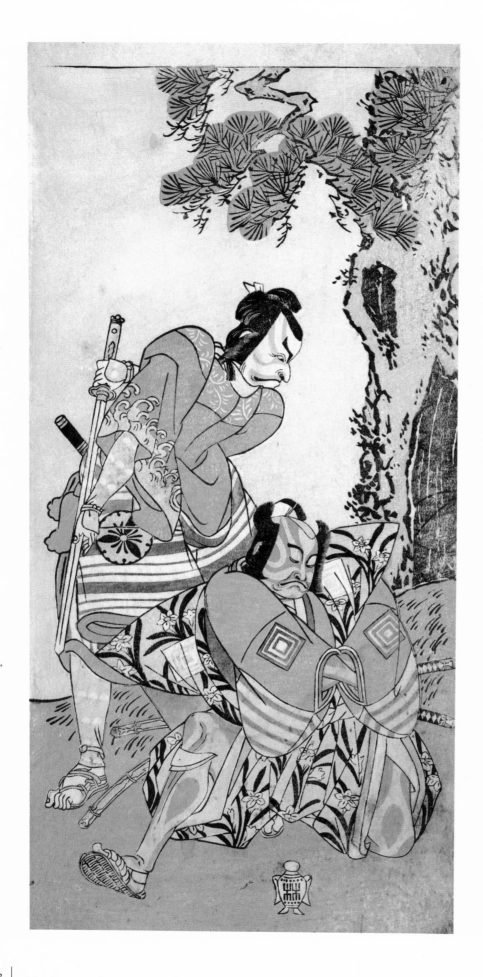

(1726–1792)

The actors Matsumoto Kōshirō II as Osada no Tarō Kagemune disguised as Yatsurugi Zaemon (left), and Ichikawa Danzō III as I no Hayata Tadazumi (right), in part one, act four(?) of the play *Nue no Mori Ichiyō no Mato* (Forest of the *Nue* Monster: Target of the Eleventh Month), performed at the Nakamura Theater from the first day of the eleventh month, 1770

Hosoban; 32.1 x 15.3 cm
Frederick W. Gookin Collection 1939.668

UNSIGNED
ARTIST'S SEAL *Hayashi* in jar-shaped outline
REFERENCE
Gookin (1931), no. 67; *Ukiyo-e Shūka*, vol. 5 (1980), no. 19
OTHER IMPRESSIONS
The Art Institute of Chicago, 1939.695 (dark background); H. R. W. Kühne collection, Zurich (light background)

46.1 Katsukawa Shunshō. *The actors Ichikawa Danzō III as I no Hayata Tadazumi and Matsumoto Kōshirō II as Osada no Tarō Kagemune*. The Art Institute of Chicago

Continuing on with its synopsis of part one (see No. 45), *Kabuki Nempyō* relates that Gankutsu no Gorozō the woodcutter and I no Hayata Tadazumi get drunk together, and Gorozō lets slip that he chased away some evil foxes using the sword of the Lion King (Shishi Ō).[1] Possession of this famous heirloom seems to be central to the plot of *Nue no Mori Ichiyō no Mato*, and Tadazumi invites Gorozō to become a retainer of Yorimasa, so that he (Tadazumi) can get close to the sword. Gorozō accepts the invitation and takes the name Yatsurugi Zaemon.

It is probably the Lion King's long, straight sword that we see Yatsurugi Zaemon (played by Kōshirō II, left) wielding in this print. He has discarded the straw headgear and shrugged off his striped over-kimono to reveal a red kimono with a pattern of foaming breakers bordering the sleeves. At his shoulders we can see the lining of the over-kimono, lime green with a scrolling-vine pattern. The tree behind the figures has a hollow in the trunk, as described in the account in *Kabuki Nendaiki* (translated in No. 45), but is a pine rather than a gingko. A further illustration from the book *Yakusha Kuni no Hana* (Prominent Actors of Japan; fig. 46.2) shows the final confrontation scene in this act, when all of the characters reveal their true identities. The current print probably shows Gorozō/Zaemon and Tadazumi sizing one another up soon after meeting.

This is perhaps the most powerful and complexly three-dimensional composition among the works of Shunshō so far described, auguring the mastery of figures in space which distinguishes his later works, particularly the paintings. Kōshirō II's extraordinary twisting pose— he is seen from behind with his head turned to the right— forms a curve in the composition into which the half-kneeling Danzō III forcefully juts his shoulder. The streaked red makeup on Danzō III's face, arms, and legs makes them too appear three-dimensional and solid. Overlying the solidity and volume of the figures, and at odds with the violence of the action, are two-dimensional grace notes of decoration, such as the wave patterns on Kōshirō II's sleeves and the curving leaves of narcissus on Danzō III's *kamishimo*.

Another state of this design, also represented in the Art Institute collection (fig. 46.1); shows an emphatic dark gray background, but the example illustrated here is a superior impression, untrimmed, with almost pristine, unfaded colors.

1 *Kabuki Nempyō*, vol. 4 (1959), p. 144.

46.2 Katsukawa Shunshō. *The actors Ichikawa Komazō I, Matsumoto Kōshirō II, and Ichikawa Danzō III*. From *Yakusha Kuni no Hana*. The Art Institute of Chicago

47 KATSUKAWA SHUNSHŌ

(1726–1792)

The actor Nakamura Nakazō I as a monk, Raigō Ajari, in the play *Nue no Mori Ichiyō no Mato* (Forest of the *Nue* Monster: Target of the Eleventh Month), performed at the Nakamura Theater from the first day of the eleventh month, 1770[1]

Hosoban; 31.0 x 14.6 cm
The Clarence Buckingham Collection 1932.1012

Nakazō I is shown in the role of Raigō (1004–1084), a Buddhist monk of the Tendai temple Onjō-ji (also known as Mii-dera) near Lake Biwa. Raigō is sometimes called simply by his ecclesiastical title, Ajari (S: *ācārya*, monk, especially of one of the Esoteric schools such as Tendai). Various chronicles relate that by virtue of Raigō's prayers a son was born to the retired emperor Shirakawa (1053–1129), in return for which Shirakawa offered to grant the priest any wish. When Raigō requested the establishment of an ordination platform at Onjō-ji, however, the retired emperor reneged on his promise, for fear of the armed monks of the rival Tendai temple Enryaku-ji on Mt. Hiei, who enjoyed a monopoly on ordination. Casting a curse on Shirakawa, Raigō shut himself in the Buddha Hall of the temple and began a fast in protest.[2]

It is at this point that the Kabuki playwrights began to elaborate on the historical accounts. In the play of 1770, according to *Kabuki Nempyō*, Raigō fasted for one hundred days. He then trampled a serving table underfoot, and when it burst into flames took this as an omen that his prayers had been answered.[3] This is the scene depicted in Shunshō's print: Raigō is shown with his tonsure grown out into an unkempt mop of hair, wearing tattered priest's robes and with a rope wrapped around his waist— perhaps to ease the pangs of hunger in his belly. In one hand he holds a rosary and in the other a ritual bell (*kongō rei*). At his feet flames engulf the smashed table.

Raigō lived a century before Minamoto no Yorimasa (1104–1180), the central character in *Nue no Mori*. Kabuki playwrights, however, characteristically and enthusiastically conflated the most disparate events and stories, in order to thicken their plots or perhaps to provide a showcase role for a particular actor's talents. Shunshō has responded to a powerful actor in an impassioned role with a gripping design in an austere color scheme: the skin of the emaciated monk is rendered in pale gray, with darker gray tracing the protruding rib cage. Raigō's body leans in the direction of his distant gaze, and his grim, set expression creates a sense of foreboding.

An illustration in the program (*ehon banzuke*) for the production shows Nakazō I in identical costume standing under the same ivy-covered pine tree (fig. 47.1). In the color print Shunshō has wisely eliminated the two subsidiary characters shown in the program— Raigō's follower Kamada Gon-no-kami Masayori and a child actor in an unidentified role— so as to concentrate on the dramatic figure of Nakazō I alone. Number 48 shows another portrait of Nakazō I as Raigō in the same scene.

1 The handwritten inscription reads: "Meiwa shichi, tora, kaomise, Nakamura-za, Raigō Ajari, Nakamura Nakazō" (Nakamura Nakazō [I in the role of] Raigō Ajari in the *kaomise* production, Nakamura Theater, in the year of the tiger, Meiwa 7 [1770]).
2 *Nihon Denki Densetsu Daijiten* (1986), s.v. *Raigō*.
3 *Kabuki Nempyō*, vol. 4 (1959), p. 146.

SIGNATURE *Shunshō ga*
ARTIST'S SEAL *Hayashi* in jar-shaped outline
PROVENANCE Frederick W. Gookin collection
REFERENCE Gookin (1931), no. 69, text pp. 117–19
OTHER IMPRESSIONS
H. George Mann collection, Chicago (ex-coll. Henri Vever)

47.1 *The actor Nakamura Nakazō I as Raigō Ajari.*
From the illustrated program.
Kaga Bunko,
Tokyo Municipal Central Library

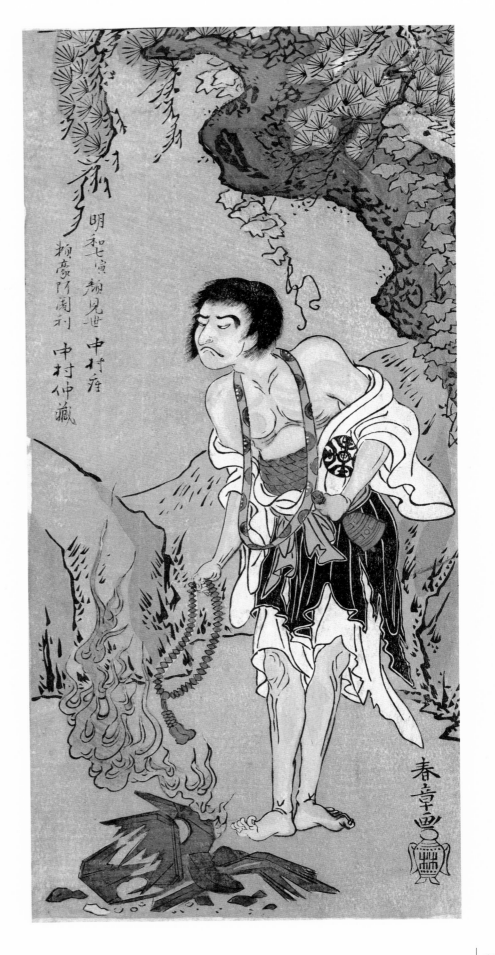

The actor Nakamura Nakazō I as a monk, Raigō Ajari, from the play *Nue no Mori Ichiyō no Mato* (Forest of the *Nue* Monster: Target of the Eleventh Month), performed at the Nakamura Theater from the first day of the eleventh month, 1770

Hosoban; 32.3 x 15.2 cm
The Clarence Buckingham Collection 1938.480

The role of the monk Raigō Ajari, performed by Nakamura Nakazō I in the play *Nue no Mori* in 1770, has been described in the preceding entry. In this yet more poignant and somberly colored composition Raigō's emaciated body resembles the crucified Christ of a German Renaissance sculptor, and he seems all but overwhelmed by gloom and fatigue. His expression is now more downcast than grim, and his gait is slow and feeble. Compared with the preceding print, his skin is an even more ashen gray against a darker gray background. Only the soft, fresh green of the mossy bank on which he stands somewhat mitigates the baleful atmosphere. For Frederick Gookin, writing in 1931, the design "in its merit as a work of art... is not surpassed by any other print in the whole range of Ukiyo–e."[1]

Another Shunshō design involving Raigō appears in the color-printed illustrated book *Yakusha Kuni no Hana* (Prominent Actors of Japan) (fig. 48.1). *Kabuki Nempyō* relates how Raigō and his follower Kamada Gon-no-kami Masayori go to the mansion of Minamoto no Yorimasa to plead for the establishment of a monastic ordination platform at Raigō's temple, Onjō-ji (Mii-dera). Yorimasa refuses the request, and somehow Raigō is made to drink poisoned sake. He dies in agony and is transformed into a horde of rats.[2] (Here the playwrights are again weaving in accounts of Raigō's death taken from such historical tales as *Heike Monogatari* [*Enkyō* version], which tell how Raigō's spirit turned into a large rat that ate the Buddhist statues

and sutra scrolls of the rival temple, Enryaku-ji.)[3] Shunshō's illustration in *Yakusha Kuni no Hana* shows Raigō standing in the center, holding the bottle of poisoned sake, rats scampering at his feet amid the broken fragments of the wine cup. He leans for support on the shoulder of his follower Kamada Gon-no-kami Masayori, played by Sakata Tōjūrō III. The other two characters, with their hands raised like forepaws, are male and female foxes, Sakon-gitsune and Otatsu-gitsune (played by Ichikawa Yaozō II and Iwai Hanshirō IV), who have taken on human guise to aid their hunt for the precious sword of the Lion King. In the background is a large box of sutras, presumably about to be devoured by the rats.

1 Gookin (1931), p. 118.
2 *Kabuki Nempyō*, vol. 4 (1959), p. 146.
3 *Nihon Denki Densetsu Daijiten* (1986), s.v. *Raigō*.

SIGNATURE *Shunshō ga*
ARTIST'S SEAL *Hayashi* in jar-shaped outline
PUBLISHER Maruya Jimpachi
PROVENANCE Frederick W. Gookin collection
REFERENCE Gookin (1931), no. 68, text p. 118
OTHER IMPRESSIONS
Arthur M. Sackler Museum, Harvard University, Cambridge, Mass.; *Ukiyo-e Taisei*, vol. 5 (1931), pl. 35 (present location unknown); Vignier and Inada (1910), pl. LIV (present location unknown); *Shibai Nishiki-e Shūsei* (1919), no. 122 (present location unknown)

48.1 Katsukawa Shunshō. *The actors Iwai Hanshirō IV, Nakamura Nakazō I, Sakata Tōjūrō III, and Ichikawa Yaozō II.* From *Yakusha Kuni no Hana*. The Art Institute of Chicago

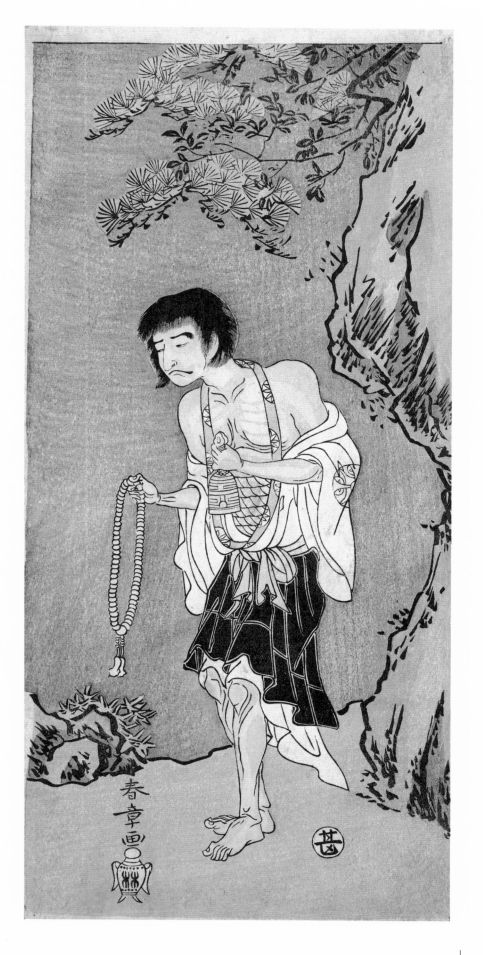

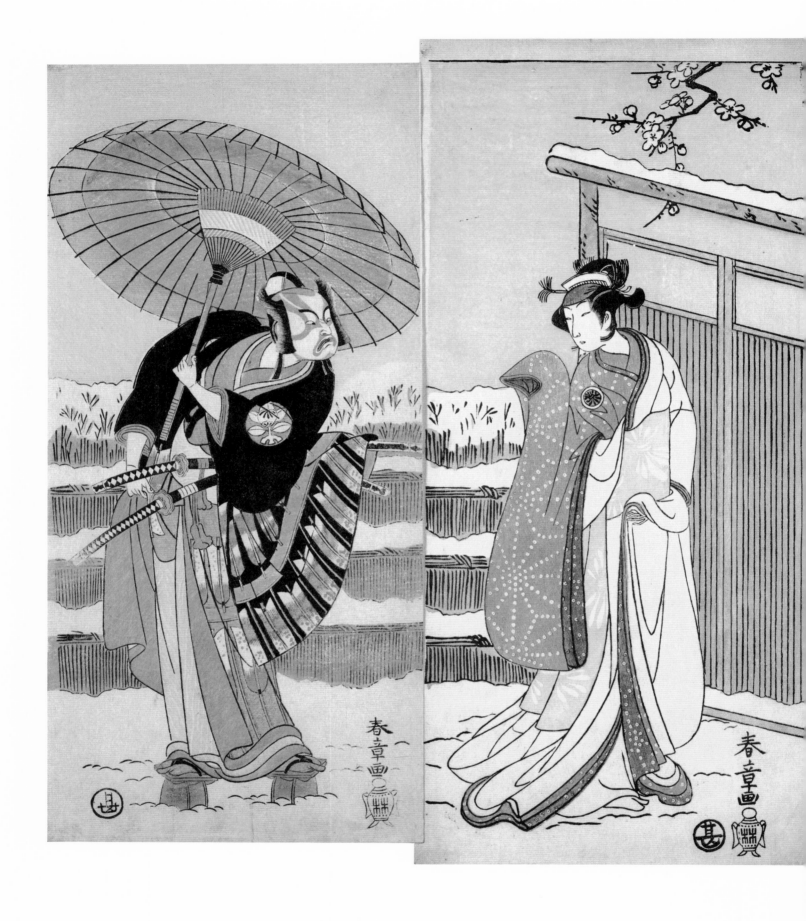

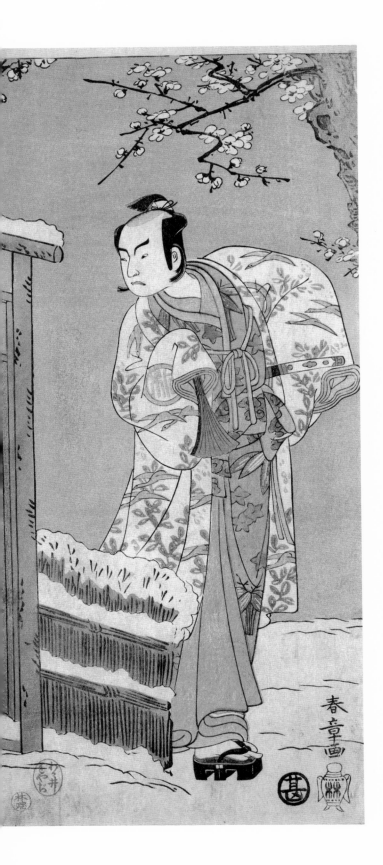

The actors Arashi Sangorō II as Minamoto no Yoritomo (right), Segawa Kikunojō II as Yuki Onna (the Snow Woman, center), and Ichimura Uzaemon IX as Kajiwara Genta no Kagetoki (left), in a dance interlude in scene two of the *jōruri* "Oyama Beni Yuki no Sugao" (Courtesan's Rouge on a Snow White Face), from the play *Myōto-giku Izu no Kisewata* (Cotton Wadding of Izu Protecting the Matrimonial Chrysanthemums), performed at the Ichimura Theater from the first day of the eleventh month, 1770

Hosoban triptych; (right) 30.8 x 14.0 cm; (center) 32.5 x 15.0 cm; (left) 30.6 x 14.3 cm
The Clarence Buckingham Collection (right) 1949.73; (center) 1942.112; (left) 1925.2419

SIGNATURE *Shunshō ga*
ARTIST'S SEAL *Hayashi* in jar-shaped outline
PUBLISHER Maruya Jimpachi
PROVENANCE
(right) Wakai Hayashi, Louis V. Ledoux collections;
(center) Charles H. Chandler collection
REFERENCE
Gookin (1931), nos. 71–73, text pp. 119–20;
(right) Ledoux (1945), no. 44
OTHER IMPRESSIONS
(right and center) Irma E. Grabhorn-Leisinger collection, San Francisco; (right and center) Yale University Art Gallery, New Haven; (left) Tokyo National Museum

49.1 Katsukawa Shunshō. *The actors Arashi Sangorō II, Segawa Kikunojō II, and Ichimura Uzaemon IX. From Yakusha Kuni no Hana.* The Art Institute of Chicago

In the eleventh month of 1770, while the Nakamura Theater was staging the popular *Nue no Mori Ichiyō no Mato* (Forest of the *Nue* Monster: Target of the Eleventh Month) as an opening-of-the-season (*kaomise*) production (Nos. 44–48), the Ichimura Theater countered with an even more successful program ending with a dance interlude, to Tomimoto school *jōruri* chanting, called "Oyama Beni Yuki no Sugao." Wearing a pure white kimono over one of persimmon red, Kikunojō II, the unchallenged superstar of female roles during the 1760s, danced the role of the Snow Woman (Yuki Onna). Her lover Yoritomo, the young Minamoto (Genji) lord, was played by Arashi Sangorō II, a promising newcomer to Edo, praised for his "manly good looks and fine voice, unusual in a Kyoto actor."[1] The third member of the trio, Ichimura Uzaemon IX, acted the role of Kajiwara Genta, carrying an umbrella and wearing a black *haori* jacket decorated with a striking arrow-feather pattern. In the play *Hiragana Seisuiki* (*Hiragana* Version of the Rise and Fall of the Taira Clan) Genta was a valiant young warrior in love with the maiden Chidori; it is not clear how he is associated with the Snow Woman in this plot. Shunshō has made the expressions of the three actors a study in contrasts.

The costume for the Snow Woman was very similar to that for the Heron Maiden (Sagi Musume; see also No. 34), a dance created by Kikunojō II to enormous acclaim in 1762. A review of the 1770 performance, published the following spring, relates that the actor performed the solo Heron Maiden dance immediately following the Snow Woman scene.[2] At least four extant prints by Bunchō— three *hosoban* and one *chūban*— also show Kikunojō II in these roles.[3]

The three sheets of the Chicago triptych must have come from three separate printings, as witnessed by the different sizes of the sheets and the different tonalities of the three backgrounds. This is, however, the only complete version of this grand design known to have survived. Shunshō began his career in 1764 with a *hosoban* diptych of the confrontation between Sukeroku and Ikyū (No. 23), and he went on to create a sensation in 1768 with a five-sheet print of actors as the Five Chivalrous Commoners (*Gonin Otoko*; No. 27). Each of his designs survives in so few impressions that it is highly likely that many of the single-sheet prints we come across today were created as parts of larger compositions. A single standing figure on each sheet of a multisheet print remained characteristic of Shunshō's compositional technique throughout his career.

The present composition has a rudimentary setting of stage props— the snow-covered gateway and brushwood fence and the flowering branches of a white plum tree. An illustration from the color woodblock-printed book *Yakusha Kuni no Hana* (Prominent Actors of Japan) shows the three actors in almost identical poses, save that Kikunojō II is seated and Sangorō II holds a lantern (fig. 49.1). The ground plane has also been tilted higher to reveal stepping stones behind the garden gate.

1 From the actor critique *Yakusha Saitan Jō*, published in the spring of 1771. Quoted by Suzuki Jūzō in his essay in *Ukiyo-e Shūka*, vol. 5 (1980), no. 1.
2 From *Yakusha Saitan Jō*, quoted by Suzuki in *Ukiyo-e Shūka*, vol. 5 (1980), no. 1.
3 Riccar (1978), no. 71; Hayashi (1981), nos. 165, 166, 242.

50 KATSUKAWA SHUNSHŌ
(1726–1792)

Lovers dressed as *komusō* monks in an autumn landscape
Ca. 1770

Chūban; 26.2 x 19.3 cm
The Clarence Buckingham Collection 1938.481

A pair of lovers— he in black and she in white— are shown
walking together in an autumn landscape of bush clover, wild
chrysanthemums, and tangled grasses. They are in the guise of
wandering mendicant monks (*komusō*), with basket-shaped
woven rush hats (*tengai*), monk's stoles (*kesa*), and bamboo
curved flutes (*shakuhachi*). Hanging from the young man's waist
and set off stylishly against the black of his kimono are a pair of
rich brocade bags for the flutes. Very similar compositions of
lovers as *komusō* were designed as *ōban* and pillar prints by
Suzuki Harunobu (ca. 1724–1770) during the last year or so of
his career, and it seems likely that Shunshō took his inspiration
from such Harunobu designs.[1] Shunshō's faces are, however,
proportionately smaller than Harunobu's, and show the particular
delicate cast of features perfected by him and seen also in his *Ise
Monogatari* series of about 1770 (No. 63). Early Western critics of
ukiyo-e championed prints by Harunobu, the *komusō* designs
above almost all others; Laurence Binyon's judgment that in this
print "Shunshō rivals Harunobu" was intended as the highest
accolade.[2]

In the past the lovers have been identified as Shirai Gompachi
and Komurasaki, but it has recently been suggested that the
vogue for *komusō* prints about 1770 relates to a dance sequence,
"Komusō," incorporated in the play *Sono Sugata Shichi-mai Kishō*
(Her Lovely Form: A Seven-Page Written Pledge), performed
at the Ichimura Theater in the first month of 1770.[3] In the dance
Ichimura Uzaemon VII took the role of Karigane Bunshichi
disguised as a *komusō*, while Onoe Tamizō I appeared as the
courtesan Seigawa.

Except for the indigo blue sky, which has faded to a pale buff,
the colors of the print are pristine and unfaded. Its decorative
richness is enhanced by elaborate blind-printing (*karazuri*), used
for the diamond pattern on the woman's kimono and for the
textured weave of the greenish rush hats. There appear to be no
other recorded impressions of the design.

1 See *Ukiyo-e Shūka*, suppl. vol. 2 (1982), pl. 406.
2 Binyon and Sexton (1923), p. 68; quoted in Gookin (1931), p. 127.
3 Suggested by David Waterhouse in *Ukiyo-e Shūka*, suppl. vol. 2 (1982),
 pl. 406.

SIGNATURE *Shunshō ga*
PROVENANCE Frederick W. Gookin collection
REFERENCE
Gookin (1931), no. 94, text pp. 126–27;
Ukiyo-e Shūka, vol. 5 (1980), no. 14 (black and white)

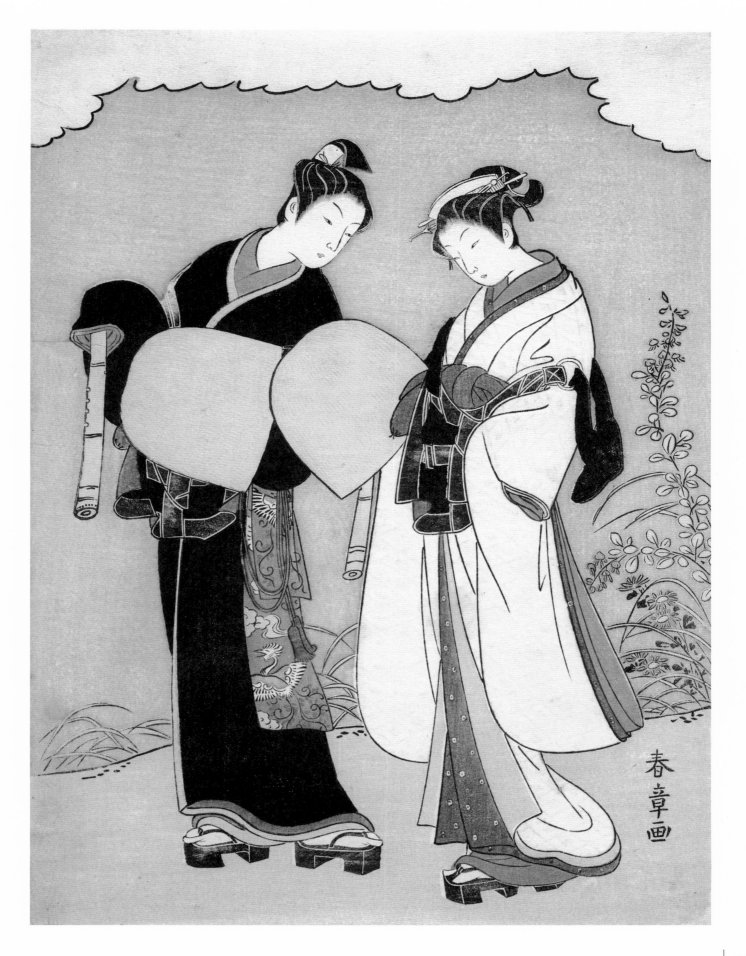

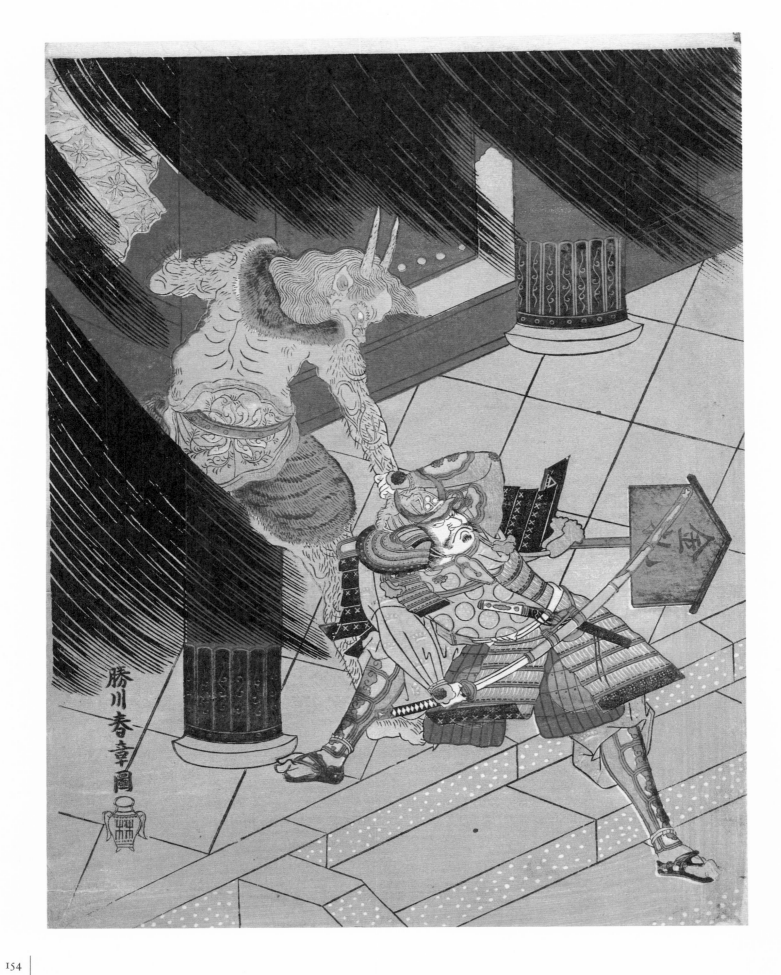

51 KATSUKAWA SHUNSHŌ
(1726–1792)

The warrior Watanabe no Tsuna fighting the demon
at Rashōmon
Ca. 1770

Chūban; 28.0 x 21.3 cm
Gift of Mr. and Mrs. Harold G. Henderson 1967.642

As one of the valiant retainers of Minamoto no Yorimitsu (Raikō),
the warrior Watanabe no Tsuna (953–1025) assisted in such legendary
exploits as the subjugation of Shuten Dōji, a hideous ogre who was
terrorizing the Kyoto area. Watanabe no Tsuna's most famous single
combat, however, was with a demon who appeared initially as a
beautiful woman and waylaid him (depending on the version of the
tale) either at Modoribashi (Modori Bridge) or Rashōmon (Rashō
Gate) in the imperial capital of Kyoto. The version of the incident
depicted here takes place at Rashōmon— the great southern entrance
to the city and frequent site of supernatural goings-on— and had
first been dramatized in the fifteenth-century Nō play *Rashōmon*.[1]

After an argument with Hirai Yasumasa as to whether or not a demon
haunted the gate at night, Watanabe no Tsuna decides to settle the
matter by visiting the spot in person. As he mounts the stone steps of
the gateway to set up a warning signboard, he suddenly feels a grasp
at his helmet. Drawing the famous sword Hige-kiri (Beard Cutter),
given him by Yorimitsu, the warrior severs the demon's arm with a
single slash, and the monster flies off with a terrible scream.[2]

The demon coiling round the gate pillar has been depicted by Shunshō
with the traditional green skin, horns, and tigerskin garment. The
cascades of black lines sweeping down from the top of the print serve
both to suggest night and to heighten the sense of action, and the
curious piece of brocade in the top left-hand corner may be an edge
of the feminine costume shed by the demon as it pounces on Watanabe
no Tsuna.

Warrior subjects were a constant but minor genre within *ukiyo-e*
during the eighteenth century, but about 1770 a rash of such prints
appeared by leading artists such as Shunshō, Kitao Shigemasa (1739–
1820), Isoda Koryūsai (act. ca. 1766–1788), and Suzuki Harunobu
(ca. 1724–1770, proving that the vogue began before Harunobu's
death in 1770). Shunshō himself is known to have designed more than
twenty warrior prints in the *chūban* format at this time.[3] The reason
for the sudden vogue is difficult to determine; perhaps artists were sim-
ply keen to explore the possibilities of the warrior print genre using
the new full-color print technology.

1 *Nihon Denki Densetsu Daijiten* (1986), s.v. *Watanabe no Tsuna*.
2 Ibid.
3 Gookin (1931), pp. 81–83.

SIGNATURE *Katsukawa Shunshō zu*
ARTIST'S SEAL *Hayashi* in jar-shaped outline
REFERENCE Gookin (1931), p. 81
OTHER IMPRESSIONS New York Public Library

52 KATSUKAWA SHUNSHŌ
(1726–1792)

Taira no Atsumori riding a horse into the sea
Ca. 1770

Chūban; 24.8 x 19.6 cm
Frederick W. Gookin Collection 1939.777

One of the most famous and affecting episodes in the medieval war tale *Heike Monogatari* (Tale of the Heike, bk. 9) tells of the death of Taira no Atsumori, a handsome and innocent young nobleman, at the hands of the Minamoto warrior Kumagai no Jirō Naozane during the battle of Ichinotani in 1184. Realizing that the battle was lost, Atsumori was spurring his horse into the sea toward the safety of the Taira ships, when Kumagai's challenge from the shore forced him, in honor, to turn back. Only when Atsumori lay helmetless and helpless on the ground did Kumagai realize that he held at mercy a mere lad of sixteen or seventeen— no older than his own son Naoie. His instant impulse to spare the boy was foiled by the appearance of other Minamoto troops, who would have killed him without a moment's hesitation or remorse. Nearly paralyzed by grief, and promising to pray for Atsumori's soul, Kumagai struck off Atsumori's head, then wept frantically. Compounding the tragedy, the grief-stricken Kumagai then discovered an antique flute in a brocade bag tucked into Atsumori's sash, and realized that this was the youth who had enchanted both camps with his flute playing at dawn, before the battle.

The episode poignantly symbolizes the overthrow of the cultivated nobility of Kyoto by the rough warriors of the provinces. Though one of those same rude warriors, Kumagai himself reflects, "Among the hundred thousand warriors on our side, there is no one who has carried with him a flute to the battlefield. What a gentle life these nobles and courtiers have led!"[1]

Shunshō depicts the moment when Atsumori turns his horse in response to Kumagai's challenge from the shore— a scene he also drew in pillar print (*hashira-e*) format.[2] The cloth (*horo*) billowing from Atsumori's shoulders provided some protection against arrows. The placement of the signature on the far right, Atsumori's gaze out of the picture toward the left, and the small waves entering the composition from the left all suggest that this may be the right-hand sheet of a diptych whose other sheet must have shown Kumagai on horseback on the beach. Another single-sheet *chūban* print by Shunshō depicts the moment when Kumagai has wrestled Atsumori to the ground, pulled off his helmet, and realized with horror that his opponent is just a boy (fig. 52.1).

Though warrior prints by all leading *ukiyo-e* artists were in vogue about 1770, the particularly large number of designs showing Atsumori and Kumagai may relate in some way to the performance of a well-received Kabuki play on the theme of the battle of Ichinotani, *Ichinotani Futaba Gunki* (Young Sprigs of Ichinotani: A War Tale), at the Ichimura Theater in the sixth (or eighth?) month of 1770.[3]

The colors of this print have faded: the horse trappings would originally have been bright red and the sea indigo blue.

1 Hiroshi Kitagawa and Bruce T. Tsuchida, trans., *The Tale of the Heike* (Tokyo: University of Tokyo Press, 1975), p. 562.
2 TNM, vol. 1 (1960), no. 956.
3 *Kabuki Nempyō*, vol. 4 (1959), p. 139.

SIGNATURE *Katsukawa Shunshō zu*

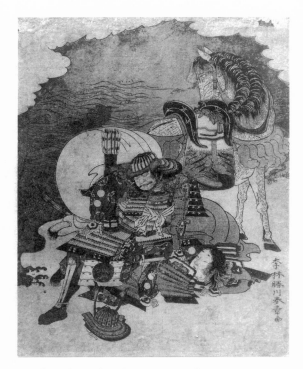

52.1 Katsukawa Shunshō. *Atsumori and Kumagai.* Tokyo National Museum

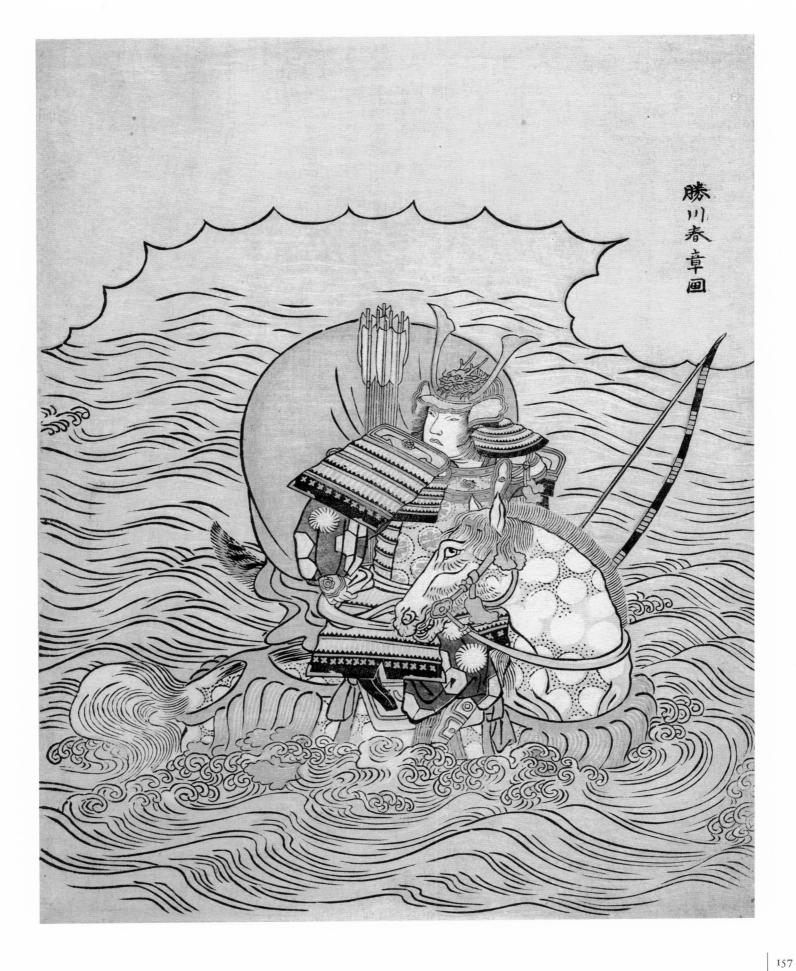

勝川春章画

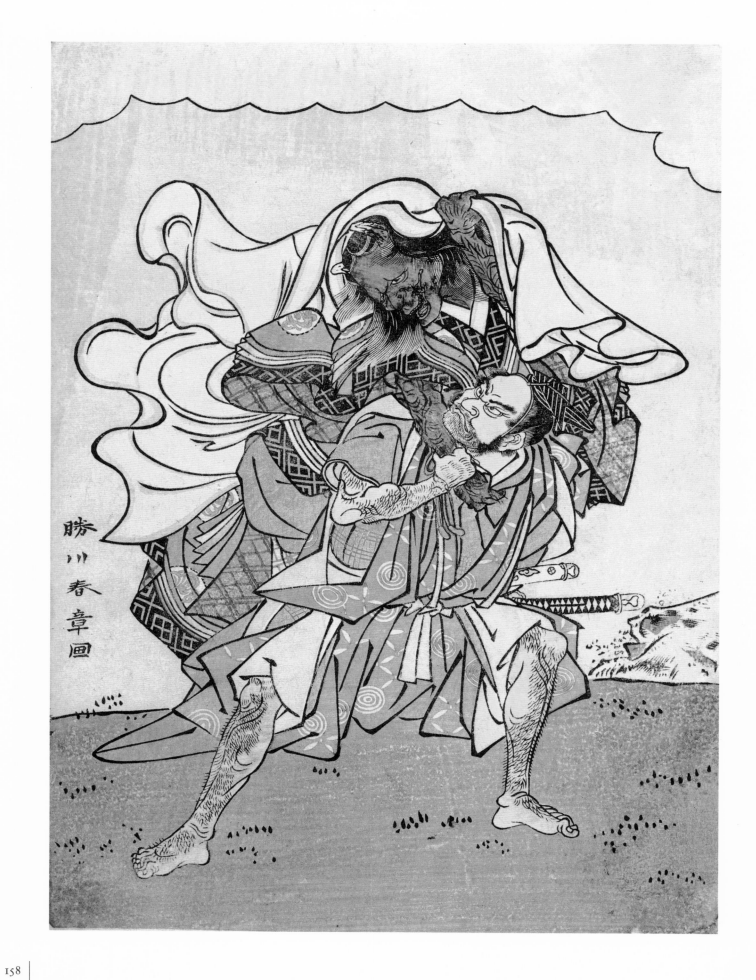

The warrior Ōmori Hikoshichi carrying a female
demon on his back
Ca. 1772

Chūban; 26.3 x 19.2 cm
Frederick W. Gookin Collection 1939.593

Like many of Shunshō's warrior prints, this one takes its
subject from a dramatic incident in one of the historical
chronicles: the tale of the warrior Ōmori Hikoshichi
and the female demon is included in book 23 of the
fourteenth-century war tale *Taiheiki* (Chronicle of the
Great Pacification).[1]

At the battle of Minatogawa in 1336 Ōmori Hikoshichi,
a vassal of the warlord (later shogun) Ashikaga Takauji,
defeated the general of the imperial forces, Kusunoki
Masashige (1294–1336), who thereupon committed
suicide. In reward, Hikoshichi was granted lordship over
the province of Iyo. On his way to a celebratory per-
formance of *sarugaku* (a precursor of Nō drama and
Kyōgen) in Iyo, Hikoshichi met a beautiful woman on the
road at night who said she was travelling to the same
place. Hikoshichi's gallant offer to carry her on his back
was gratefully accepted, but as they approached the
mountains the woman suddenly turned into a fearful
demon— the vengeful spirit of his defeated enemy
Kusunoki Masashige— which tried to carry him off into
the sky. Though he was able to resist the spirit of Masa-
shige on this occasion, Hikoshichi continued to be
haunted by the demon until Buddhist monks read the
Daihannya Sutra in pacification.

Appropriately, Shunshō's demon resembles the *hannya*
mask— sharp horns, burning eyes, and toothy grimace—
which would have been worn by an actor portraying this
female devil in the Nō version of the tale. The rough,
burly warrior is also brought vividly to life, showing that
the "new realism" of Shunshō's art was not confined to
actor portraiture.

The purple and blue pigments used in the print have
faded considerably, giving it a deceptively autumnal color
scheme, and the bright orange lead pigment of the
demon's skin has become tarnished with oxidation.

1 See *Nihon Denki Densetsu Daijiten* (1986), s.v. *Ōmori Hikoshichi.*

SIGNATURE *Katsukawa Shunshō ga*
REFERENCE Gookin (1931), no. G300

(1726–1792)

The actor Iwai Hanshirō IV in the "Sangai-gasa" (Triple-Umbrella) dance interlude of the *jōruri* "Yukashii wa Miyako no Naredoko" (Yearning After One's Own Bedchamber in the Capital), from part two of the play *Kuni no Hana Ono no Itsumoji* (Flower of Japan: Ono no Komachi's Five Characters), performed at the Nakamura Theater from the first day of the eleventh month, 1771

Hosoban; 30.8 x 14.5 cm
The Clarence Buckingham Collection 1925.2427

Hanshirō IV is shown in animated dance, one knee lifted high and long tasselled sleeves and skirts flying. Across his shoulder he rests a long pole topped with three umbrellas (*sangai-gasa*) hung with flounces and bells. His kimono with long hanging sleeves (*furisode*) is decorated with a pattern of fans around the skirts and zigzags edging the sleeves.

The Triple-Umbrella dance is thought to have been a dance interlude in the *jōruri* scene "Yukashii wa Miyako no Naredoko," composed by the master Tokiwazu school chanter Tokiwazu Mojitayū. Its story was based on the famous love affair between the young courtier-poet Ariwara no Yukihira (818–893) and the lowly sisters Matsukaze and Murasame, who carried sea brine to the local salt works in the neighborhood of Yukihira's exile at Suma. This tale was dramatized in the Nō play *Matsukaze* and subsequently modified into dramatic narratives (*jōruri*) on the one hand and Kabuki dances such as "Shiokumi" (The Salt Maidens) on the other. In the 1771 performance Hanshirō IV as Murasame was joined by Nakamura Nakazō I as Matsukaze and Ichikawa Komazō II as Yukihira, and the large number of extant *hosoban* prints by Shunshō and Bunchō— six have been identified so far— that relate to this one scene attest to its popularity at the time.[1] One of these, by Shunshō, shows Hanshirō IV similarly posed but wearing a different kimono and dancing with two tasselled spears (*yari*) in place of the triple umbrella (fig. 54.1). The "Triple-Umbrella" dance was a standard part of the "Salt Maidens" sequence, but clearly the "Spear Dance" ("Yari Odori") was also incorporated on this occasion.

The Chicago impression still retains a largely unfaded purple pigment on the *furisode*, and a delicate printed gray background.

1 The collection of the Ashmolean Museum, Oxford, contains an album of twenty-eight *hosoban* prints by Shunshō and Bunchō, formerly in the collection of the Meiji period Kabuki historian Sekine Shisei (1825–1893), relating to performances in 1771 and 1772. This album contains twelve prints relating to the *kaomise* performance at the Nakamura Theater in 1771, six of which show scenes from the *jōruri* "Yukashii wa Miyako no Naredoko."

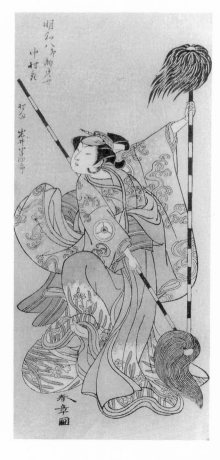

54.1 Katsukawa Shunshō. *The actor Iwai Hanshirō IV as Murasame.* Ashmolean Museum, Oxford

SIGNATURE *Shunshō ga*
REFERENCE Gookin (1931), no. CBAI 31

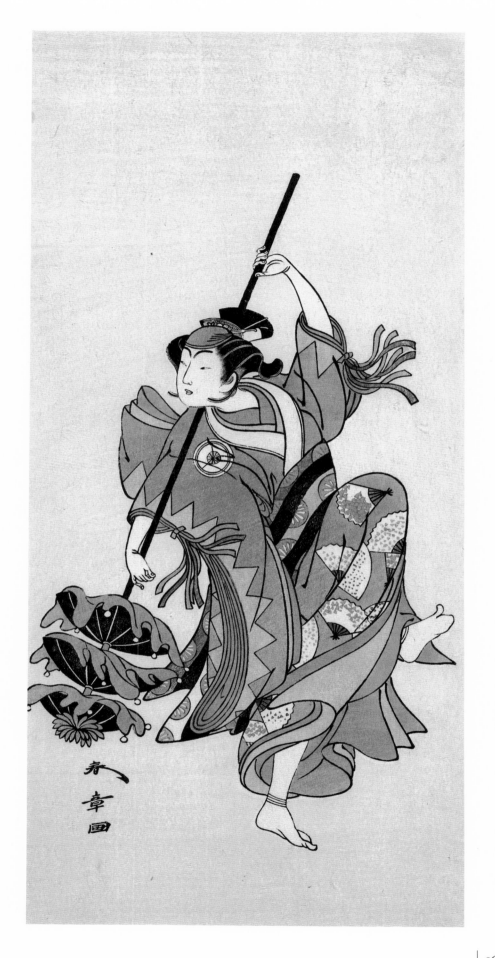

55 *Attributed to* KATSUKAWA SHUNSHŌ
(1726–1792)

The actor Ichikawa Danjūrō V as the Buddhist deity Fudō in the final scene
from part one of the play *Fuki Kaete Tsuki mo Yoshiwara* (Rethatched Roof:
The Moon also Shines Over the Yoshiwara Pleasure District), performed at
the Morita Theater from the first day of the eleventh month, 1771

Hosoban; 31.2 x 14.8 cm
Frederick W. Gookin Collection 1939.699

Danjūrō V is shown in the awesome aspect of the Esoteric Buddhist deity Fudō
(the "Immovable One"), one of the fierce Wisdom Kings (*Myō-ō*) who were
emanations of the Buddha Dainichi. The presentation is iconographically orthodox:
Fudō stands on a rock surrounded by an aureole of angry red flames, holding in
one hand a demon-quelling sword (*riken*) and in the other a five-colored rope with
which he checks iniquity (*kensaku*). Fearsome of aspect, Fudō is the implacable
enemy of evil and the protector of those engaged in Buddhist ascetic practices.

An illustration (No. 56C) from *Yakusha Kuni no Hana* (Prominent Actors of Japan)
shows the spectacular tableau of actor-deities that composed the finale of the first
part of the opening-of-the-season (*kaomise*) production at the Morita Theater in
1771: Danjūrō V, on the central cloud, is accompanied by his child-attendants Kon-
gara Dōji (right, played by Bandō Mitsugorō I) and Seitaka Dōji (left, played by
Nakamura Sukegorō II). The evil courtier they have come to punish is Ikazuchi
Shinnō, Prince of Thunder, played by Sawamura Kijūrō I (far left). This suggests
that the present *hosoban* print of Danjūrō V as Fudō may originally have formed part
of a multisheet composition, perhaps flanked by Kongara and Seitaka in a triptych.

We today may experience a slight sense of disjunction at seeing a familiar Buddhist
deity, posed and accoutered like a thirteenth-century temple statue, but bearing
Danjūrō V's utterly distinctive features, familiar from so many other stage portray-
als. But to theater-goers of the eighteenth century this would not have seemed
anomalous. The association between the Danjūrō acting line and Fudō is said to
have originated with a pledge to serve the deity made by Danjūrō I at the Fudō
temple in Narita, upon the birth of his son Danjūrō II in 1688.[1] Danjūrō I indeed
regarded himself as a *living embodiment* of Fudō Myō-ō; furthermore, this deity
provided a perfect vehicle for the *aragoto* (rough stuff) acting techniques that were
the specialty of the Ichikawa family. The role was performed by all subsequent
generations of Danjūrō actors, and the play *Fudō* was selected as one of the Eighteen
Great Plays of the Danjūrō lineage (*Kabuki Jūhachiban*) by Danjūrō VII in 1832.

The performance at the Morita Theater in the eleventh month of 1771 marked
Danjūrō V's first appearance after his promotion to head of the theater troupe
(*za-gashira*), and *Kabuki Nempyō* records that the occasion was celebrated by the
rhythmic hand-clapping of groups of Danjūrō's fans in different parts of the theater.[2]

The orange lead pigment (*tan*) of the rock and Danjūrō V's hair and jewels has
tarnished, but otherwise the colors are relatively fresh and unfaded.

1 *Zusetsu Nihon no Koten 20: Kabuki Jūhachiban* (1979), p. 66.
2 *Kabuki Nempyō*, vol. 4 (1959), p. 185.

UNSIGNED
REFERENCE Gookin (1931), no. 83, text pp. 123–24
OTHER IMPRESSIONS ex-collection Werner Schindler

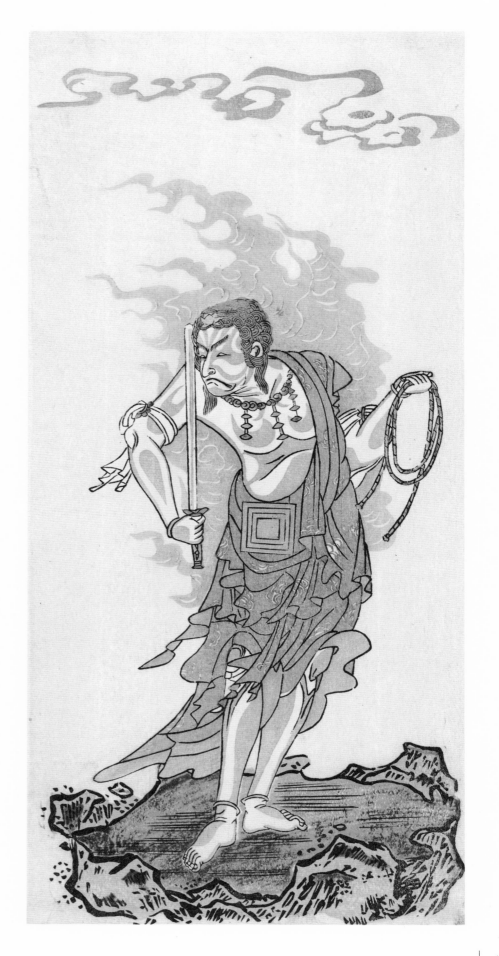

(1726–1792)

Four pages from the illustrated book
Yakusha Kuni no Hana (Prominent Actors of Japan)
Ca. 1771–1772

Size: 16.8 x 13.7 cm
Frederick W. Gookin Collection 1939.799

In The Art Institute of Chicago collection is a group of separately mounted pages from a book of stage scenes by Shunshō, bearing the manuscript title *Yakusha Kuni no Hana* (Prominent Actors of Japan, cat. nos. 152–82). No printed title, colophon, or other publishing data survive. This rare color-printed work illustrates scenes from the opening-of-the-season (*kaomise*) productions held in the eleventh month of the years 1770 and 1771. The opening play at the Nakamura Theater in the eleventh month of 1771 was *Kuni no Hana Ono no Itsumoji* (Flower of Japan: Ono no Komachi's Five Characters), and it is doubtless from the name of this play that the book title *Yakusha Kuni no Hana* was derived. Publication of the book may have been timed to coincide with the opening of the season in the eleventh month of 1771, or with the New Year of 1772. Judging from the format of the surviving sheets, it seems that the work originally consisted of four volumes, each containing six double-page illustrations with one single-page illustration at front and back. The only other known copy of this work is in the collection of the Museum of Fine Arts, Boston, and has been described by Hillier as comprising three volumes.[1] These bear the handwritten title *Shibai Mukashi Nishiki* (Old Brocade Prints of the Stage). The extreme rarity of this book, like that of the complete series of Shunshō's *Ise Monogatari* (No. 63), might be owing to the great fire in Edo on the twenty-ninth day of the second month, 1772, which must have destroyed many printing blocks and stocks of finished prints and books.

The double-page illustrations show groups of actors in stage tableaux similar to but generally more integrated than Shunshō's *hosoban* triptychs, in which the breaks between the sheets necessarily interrupt the composition. In fact many scenes in the book were also issued in slightly modified form as *hosoban* single-sheet or triptych designs (No. 49). This type of color-printed picture-book (*ehon*) of stage scenes never developed into a separate genre, possibly because in function it fell between the already existing genres of single-sheet color prints and black-and-white illustrated programs (*ehon banzuke*).

Selected for reproduction here are four pages depicting scenes from the play *Fuki Kaete Tsuki mo Yoshiwara* (Rethatched Roof: The Moon also Shines Over the Yoshiwara Pleasure District), performed at the Morita Theater in the eleventh month of 1771.

In the opening (third) act, at the order of evil Prince Ikazuchi, his henchman Shinagawa Ōkaminosuke (played by Ōtani Hiroemon III, right) is about to cast down a stone basin planted with peonies. Because peonies were regarded as the "King of Flowers," this gesture symbolizes Ikazuchi's machinations to seize power in the realm. Entering via the *hanamichi* walkway, Ichikawa Danjūrō V in the role of the hero Arashishi Otokonosuke, dressed in the extravagant costume of the "Shibaraku" (Stop right there!) role (left), reaches the stage in time to effect what must be one of the oddest rescues in Kabuki— the saving of the peonies.

1 Hillier (1988), vol. 1, p. 337.

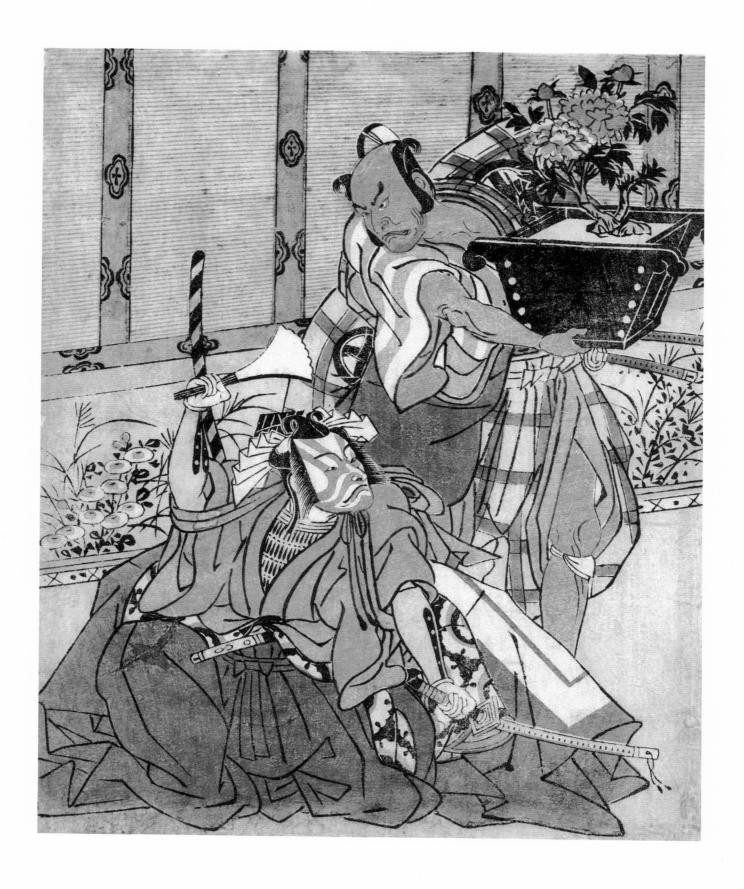

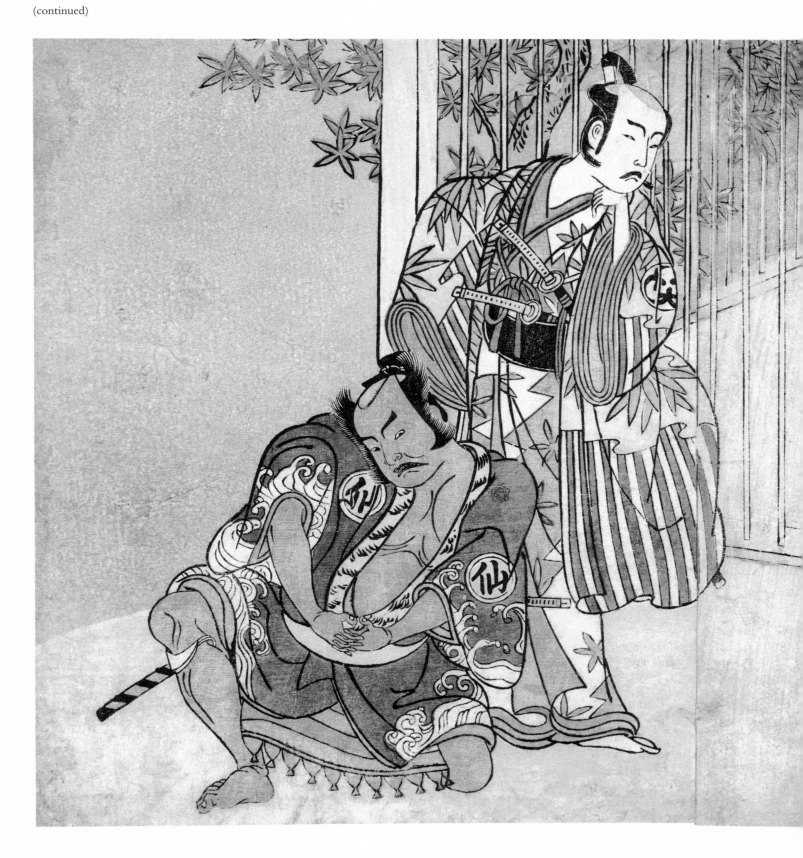

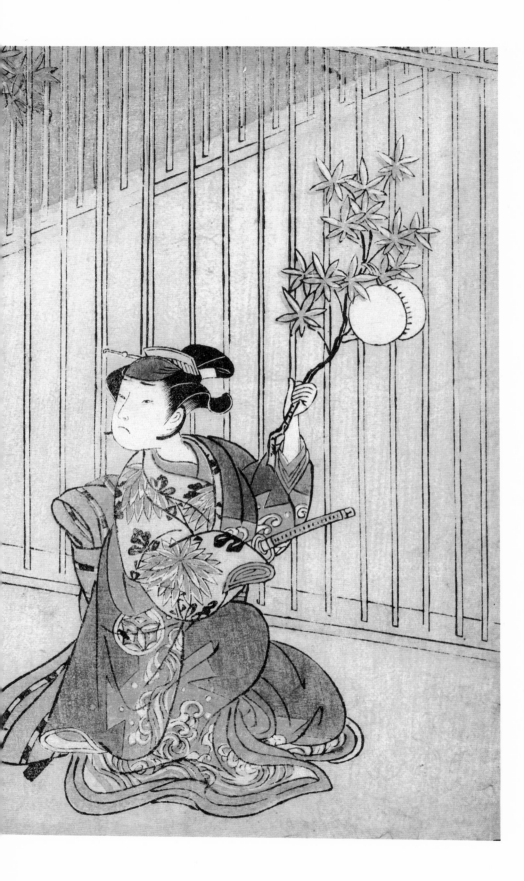

Size: 17.0 x 27.2 cm
The Clarence Buckingham Collection 1938.525

This scene, set before the bamboo-pole enclosure of a playing ground for court football (*kemari*), is based loosely on the events of "New Herbs: Part One" (*Wakana no Jō*), chapter 34 of the *Tale of Genji*. Yamashita Kinsaku II (right) plays the part of Mutsuhana, a daughter of Regent Michinaga. Mutsuhana serves as lady-in-waiting to the Third Princess (Nyosan no Miya) and as go-between in the love affair between the Third Princess and the young courtier Kashiwagi no Emon (played by Bandō Mitsugorō I, standing center). Here she is holding a branch of maple from which is hanging one of the deerskin footballs used in the game of *kemari*. At Kashiwagi's feet kneels the muscular manservant Akamatsu Mushanosuke (played by Nakamura Sukegorō II in allover red body makeup).

Kabuki Nempyō relates that Ichikawa Danjūrō V as Mumezu no Kamon made his entrance together with Kinsaku II and Sukegorō II via a trapdoor in the stage. He demanded that Kashiwagi give up the Third Princess to him and hit Kashiwagi on the head with a *kemari* boot when the latter refused, in a parody of the famous dispute over a woman between Fuwa Banzaemon and Nagoya Sanza (see No. 30).[2]

2 *Kabuki Nempyō*, vol. 4 (1959), pp. 185–88.

56C

Size: 17.0 x 27.4 cm
The Clarence Buckingham Collection 1938.524

In the spectacular finale of the first part Dan-jūrō V appears as the Buddhist deity Fudō, descending on a cloud flanked by his child attendants Kongara Dōji (played by Bandō Mitsugorō I, right) and Seitaka Dōji (Naka-mura Sukegorō II, left), to thwart the evil plans of Ikazuchi Shinnō, Prince of Thunder (Sawamura Kijūrō I, far left). Danjūrō V as the deity Fudō was also portrayed by Shunshō in a *hosoban* print (No. 55).

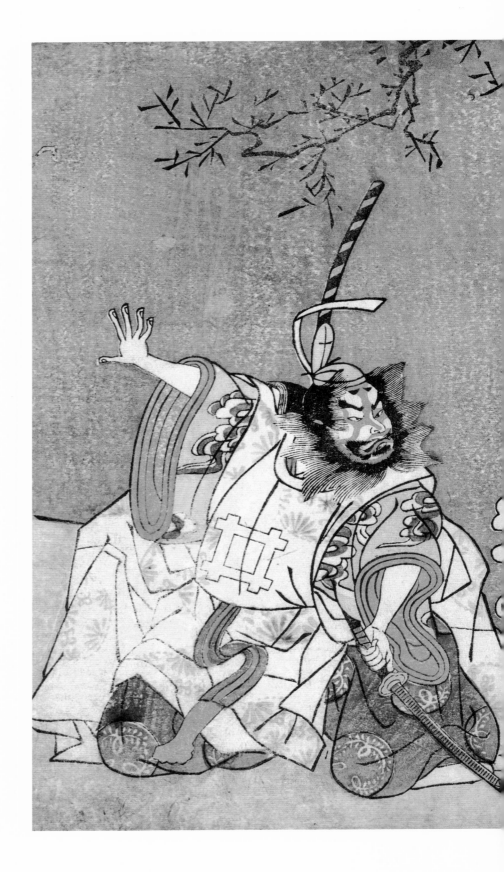

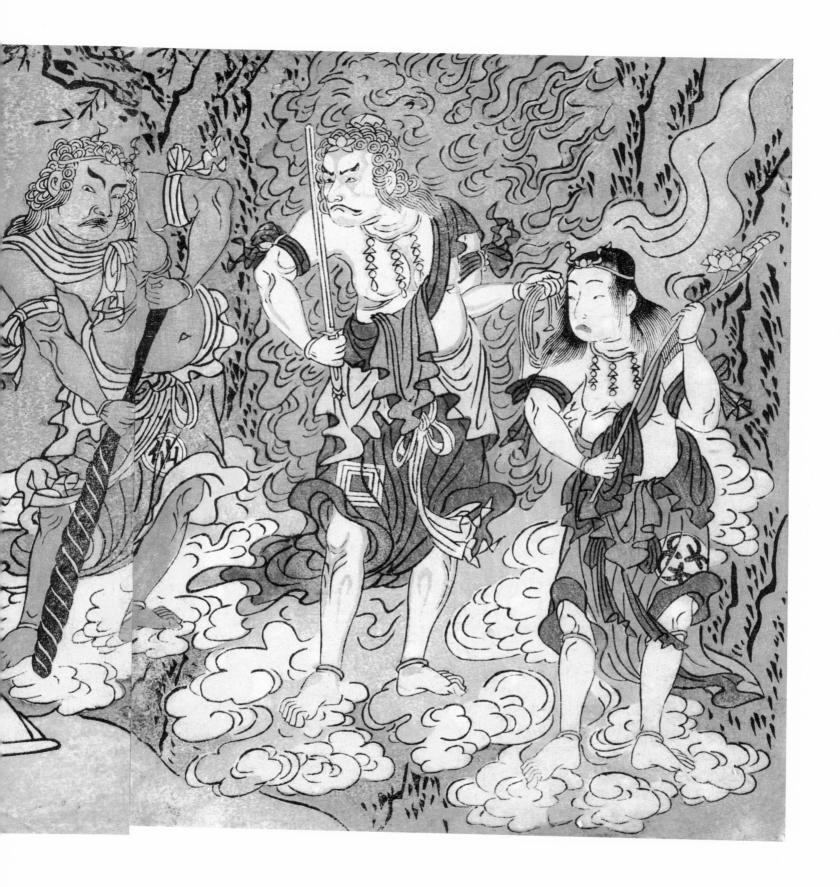

56D

Size: 16.7 x 13.5 cm
Frederick W. Gookin Collection 1939.795

In the second part Nakamura Tomijūrō I appears as
Nagoya Osan, who seeks to avenge the murder of
her father, Nagoya Saburōzaemon. She spends every
evening cormorant fishing in the Gifu River, and is
overjoyed when her father's precious sword Naratarō
is brought up from the river in the beak of one of the
cormorants.[3] Here Tomijūrō I poses triumphantly on
the bank of the Gifu River, holding up a torch as the
cormorant fishermen did to attract their catch. Thrust
through the actor's sash is the sought-for sword.

3 *Kabuki Nempyō,* vol. 4 (1959), p. 188.

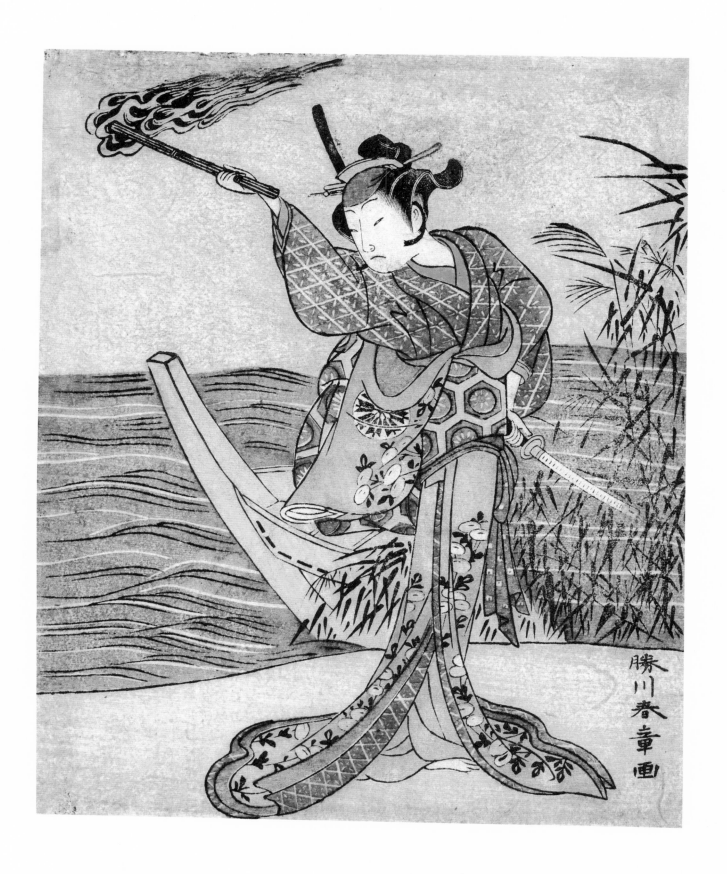

勝川春章画

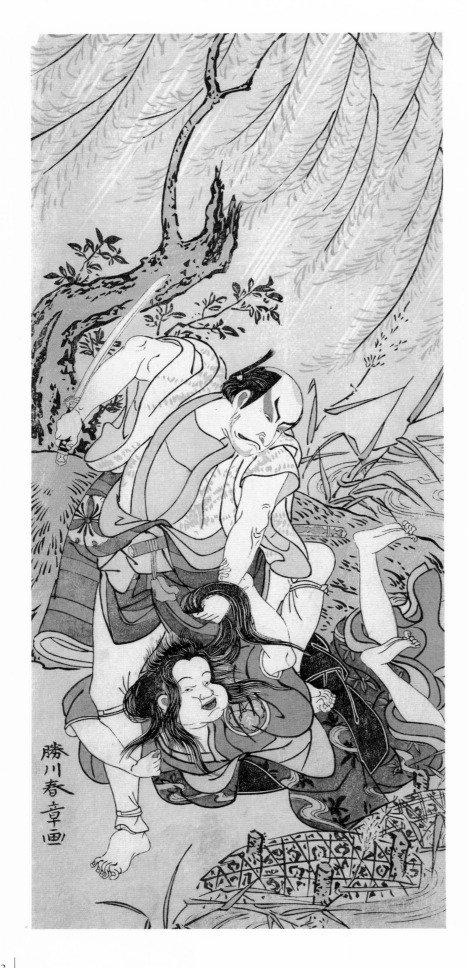

57 KATSUKAWA SHUNSHŌ
(1726–1792)

The actors Matsumoto Kōshirō II as Yoemon
and Yoshizawa Sakinosuke III as Kasane, his wife
Ca. 1771

Hosoban; 30.8 x 13.8 cm
Frederick W. Gookin Collection 1939.578

The various versions of the "Kasane" story are based on an incident that took place at the village of Hanyū in Shimōsa Province some time in the second half of the seventeenth century. An ugly and madly jealous woman named Kasane was murdered and her body thrown into the Kinu River by her husband, Yoemon. Her vengeful spirit, which haunted Yoemon and the other villagers, was laid to rest only by the prayers of the monk Yūten Shōnin.[1]

In 1778 the story of Kasane was interwoven with incidents and characters derived from internecine struggles in the powerful Date clan of Sendai, whose name had also become a byword for high living and ostentation. The resulting play was called *Date Kurabe Okuni Kabuki* (A Competition in Ostentation: Okuni's Kabuki). In its plot the beautiful Kasane is first disfigured and then entirely possessed by the vengeful spirit of her murdered elder sister, Takao. Though he still loves Kasane loyally despite her new-made ugliness, Yoemon is forced to murder her in order to safeguard his feudal lord. To contemporary audiences, such an action would have seemed the heroically appropriate and satisfyingly tragic resolution of the classic dilemma between the dictates of feudal duty (*giri*) and personal feelings (*ninjō*).[2] We cannot determine how closely the earlier version of Kasane's story, depicted here, relates to the plot of *Date Kurabe Okuni Kabuki*.

Shunshō spares us none of the brutality of the gruesome scene: Yoemon traps Kasane face-down on the ground with a foot planted in the small of her back, yanks up her head by its long hair (thereby showing us her bloated, ugly face), and raises his sword to strike. Kasane grasps his leg and arm and kicks wildly, but to no avail. Despite the tangle of white limbs, the image is immediately intelligible— a tribute to Shunshō's growing skill at handling complex three-dimensional forms. The rain-swept branches of the willow tree intensify the agitated rhythms of the composition, yet in themselves they simply form delicate, lovely curves.

In trying to identify the performance depicted, we face a quite common problem: the information given by the print does not tally with written theatrical records. Yoshizawa Sakinosuke III played Kasane twice, in 1770 and 1771, but on neither occasion (according to *Kabuki Nendaiki* and *Kabuki Nempyō*) did he play opposite Matsumoto Kōshirō II as Yoemon. Of the two performances, the second, in the play *Tamuramaro Nanae no Kasane* (Tamuramaro in the Seven-Layered Robe), performed at the Nakamura Theater from the twenty-first day of the seventh month of 1771, tallies more closely with the style of the print,[3] though in that play Yoemon is recorded as having been played by Ichikawa Danzō III. Perhaps the discrepancy reflects a last-minute cast change.

1. *Kabuki Jiten* (1983), s.v. *Kasane-mono*.
2. The plot of *Date Kurabe Okuni Kabuki* is given in Halford (1956), pp. 16–22. A slightly different version appears in *Kabuki Saiken* (1926), pp. 535–40.
3. Yoshizawa Sakinosuke III also played the role of Kasane in the play *Katakiuchi Chūkō Kagami*, performed at the Nakamura Theater in the sixth month, 1770.

SIGNATURE *Katsukawa Shunshō ga*
REFERENCE Gookin (1931), no. G83
OTHER IMPRESSIONS
Ukiyo-e Taisei, vol. 5 (1931), p. 95 (present location unknown)

Courtesan and her attendant at the Yagurashita unlicensed pleasure
district in Fukagawa
Print title: *Yagurashita no Banshō* (Evening Bell at Yagurashita)
Series title: *Fukagawa Hakkei* (Eight Views of Fukagawa)
Ca. 1771

Chūban; 25.2 x 19.0 cm
Frederick W. Gookin Collection 1961.118

In the Fukagawa district, on the east bank of the Sumida River, were
located many of the thriving "unlicensed" pleasure quarters (*okabasho*)
of the city of Edo. Unlicensed districts, which had grown up during the
eighteenth century, provided a cheaper, more down-to-earth harlotry
than the elaborate courting rituals that were de rigueur at Yoshiwara,
Edo's single licensed district. This series of eight prints shows women of
Fukagawa along with small distant views of well-known landmarks of
the district, parodying the famous "Eight Views of the Xiao and Xiang
Rivers" or "Eight Views of Lake Biwa" (themes of classical Chinese and
Japanese painting, respectively).[1]

One of the Eight Views of Lake Biwa, "Evening Bell at Mii-dera"
(Mii Temple), provides the pretext for this view of Yagurashita (literally,
"Under the Tower"), named after the fire watchtower with its warning
bell at the top. At the foot of the tower begins a canal, Abura-bori,
beyond which are the buildings of the block known as Susotsugi, one
of the "Seven Pleasure Districts of Fukagawa." Behind this district the
wooded temple precincts of Eitai-ji can just be seen.[2] Thus the women
shown in the foreground perhaps work out of the Susotsugi district.

The Fukagawa unlicensed brothels were dubbed "child houses" (*kodo-
moya*), and operated according to the "summoning" (*yobidashi*) system,
whereby the women were called out to entertain at particular restaurants
and riverside hostelries (*funayado*).[3] The building behind the courtesan
and her attendant— with a verandah overlooking a small garden contain-
ing a white plum tree— may thus be either the brothel where the woman
lives or the establishment where she has gone to entertain.

The petite, delicate figures show the strong influence of the recently
deceased Suzuki Harunobu (ca. 1724–1770), though the faces are unmis-
takably in Shunshō style, suggesting a date for the series of about 1771.

1 The other designs in the series are: *Dobashi no Seiran* (Clearing Storm at Dobashi
[Do Bridge]); *Nikenjaya no Bosetsu* (Lingering Snow at Nikenjaya [Niken Teahouse])
[British Museum]; *Shiohama no Shūgetsu* (Autumn Moon at Shiohama [Shio Beach])
[ex-coll. Theodor Scheiwe]; *Nakachō no Yau* (Night Rain at Nakachō [Naka Street]);
Tsukudajima no Rakugan (Descending Geese at Tsukudajima [Tsukuda Island]);
Sanjūsangendō Sekishō (Evening Glow at Sanjūsangendō [Sanjūsangen Hall] [Ger-
hard Pulver collection]); *Susaki no Kihan* (Returning Sails at Susaki [Su Point]).
2 Isobe (1962), pp. 5–6.
3 *Edogaku Jiten* (1984), pp. 560–61.

SIGNATURE *Katsukawa Shunshō ga*
REFERENCE *Ukiyo-e Shūka*, vol. 5 (1980), no. 21
OTHER IMPRESSIONS British Museum, London

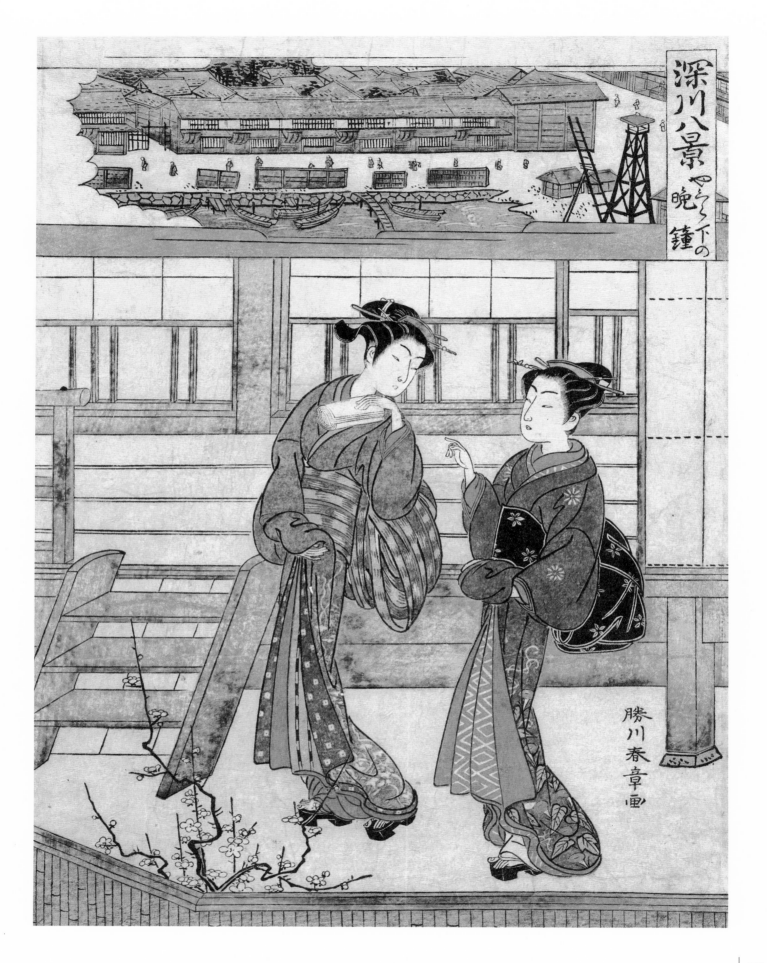

深川八景やらく下の晩鐘

勝川春章画

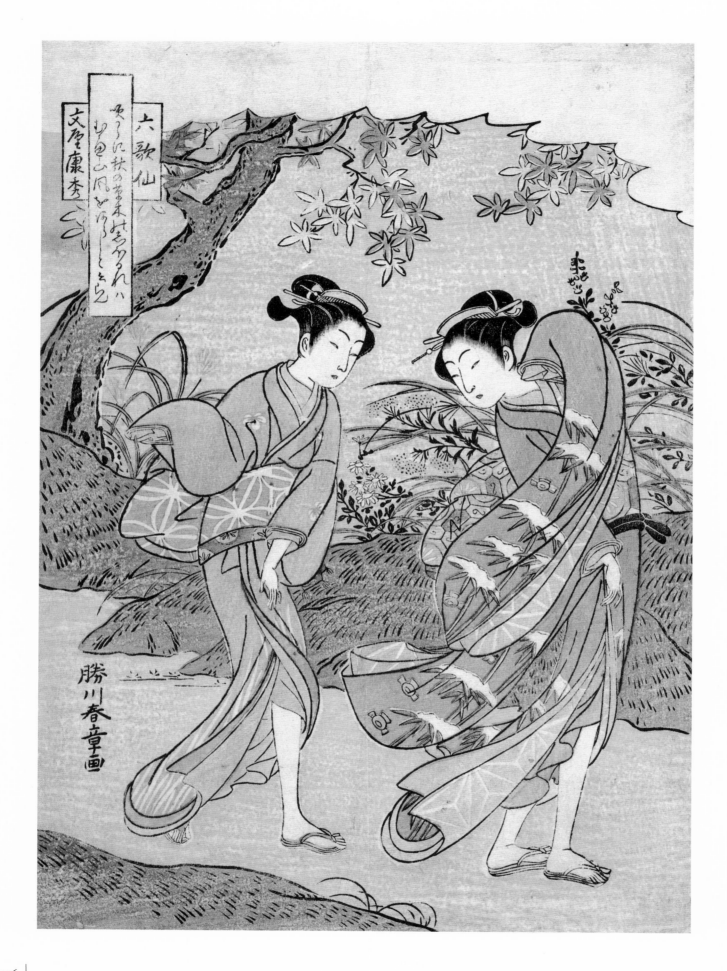

59 KATSUKAWA SHUNSHŌ
(1726–1792)

Two women in a gusty autumn landscape
Print title: *Funya no Yasuhide*
Series title: *Rokkasen* (The Six Immortal Poets)
Ca. 1771

Chūban: 25.5 x 18.2 cm
Gift of Mr. and Mrs. Harold G. Henderson 1967.641

This design is from a series of six prints showing beautiful women representing the themes of poems by the Six Immortal Poets (*Rokkasen*) of the Early Heian period.[1] Funya no Yasuhide (dates unknown) was a courtier who served the emperors Seiwa (r. 858–876) and Yōzei (r. 876–884), and five of his poems are included in the imperial anthologies *Kokin Wakashū* (Anthology of Ancient and Modern Japanese Verse) and *Gosen Wakashū* (Later Anthology of Ancient and Modern Japanese Verse). The poem quoted on Shunshō's print appeared originally in the second Autumn section of the *Kokin Wakashū* (poem no. 249), under the heading "A poem from the contest at Prince Koresada's house." It was later included in the *Hyakunin Isshu* (One Hundred Poems by One Hundred Poets), known to every educated Japanese of the Edo period through the card game played at the New Year, which involved matching the two halves of each of these famous poems. It reads:

Fuku kara ni	The plants of autumn
aki no kusaki no	Droop and wither at its touch—
shiorureba	That explains, of course,
mube yamakaze o	Why a wind from the mountains
arashi to iuramu	Has come to be called a storm.[2]

In Shunshō's print we see the storm wind tangling the long autumn grasses and shaking the branches of the maple. It fills the long hanging sleeves (*furisode*) of the woman at the right, and threatens to blow open the skirts of her companion. Cultured Japanese of the late eighteenth century combined an affectionate acquaintance with their classical heritage with an irreverent spirit and contemporary point of view. Shunshō expresses this temper with a light-hearted and stylish, yet congenial, modern image for an ancient court poem.

Though the print now has an appropriately brownish, autumnal hue, in its pristine state the color scheme of the women's robes would have included bright purple, red, and blue.

1 Only two more of the six designs are currently known: *Ono no Komachi* [ex-coll. Theodor Scheiwe; Hillier (1976), no. 256]; *Kisen Hōshi* [Victoria and Albert Museum, London].
2 Translated by Helen C. McCullough, *Kokin Wakashū* (Stanford: Stanford University Press, 1985), p. 63. Professor McCullough also notes that "the poem is based on a graph play. When the graphs for *yama* ('mountain') and *kaze* ('wind') are combined, the result is the graph for *arashi* ('storm')."

SIGNATURE *Katsukawa Shunshō ga*
OTHER IMPRESSIONS Tokyo National Museum

The actors Ichikawa Danjūrō V as the Spirit of
Monk Seigen (right), and Nakamura Noshio I as the
Spirit of the Courtesan Takao (left), in the *shosagoto*
dance sequence "Sono Utsushi-e Matsu ni Kaede"
(A Shadow-Picture of Pine and Maple), the last scene
of part two of the play *Keisei Momiji no Uchikake*
(Courtesan in an Over-Kimono of Maple Leaf
Pattern), performed at the Morita Theater from the
ninth day of the ninth month, 1772

Hosoban diptych; (right) 29.1 x 14.4 cm; (left) 32.3 x 15.0 cm
The Clarence Buckingham Collection (right) 1932.996; (left)
1932.997

SIGNATURE *Shunshō ga*
PROVENANCE Frederick W. Gookin collection
REFERENCE
Gookin (1931), nos. 100a, 100b, text p. 131; *Ukiyo-e Shūka*,
vol. 5 (1980), nos. 4, 5 (black-and-white)
OTHER IMPRESSIONS
(right) Yale University Art Gallery, New Haven;
(right) Ledoux (1945), no. 47 (present location unknown);
(right) *Ukiyo-e Taika Shūsei*, vol. 8 (1932), no. 8

60.1 Publicity handbill for the play *Keisei Momiji no Uchikake*.
Bigelow collection, Museum of Fine Arts, Boston

Dressed in matching courtesans' robes and arched into mirror-image con-
trapposti, Danjūrō V and Noshio I enact the spirits of Takao and Seigen which
have emanated from the incense burners (*kōro*) on red lacquer stands at their
feet. A publicity handbill (*tsuji banzuke*) for the performance shows similar
figures actually levitating in the trails of smoke from the two burners and also
depicts the third (male) character of the *shosagoto* dance sequence, Ashikaga
Yorikane (fig. 60.1). The contrast between Noshio I's delicate, thoroughly
feminine mien and Danjūrō V's long, aquiline nose and somewhat awkward
stance may seem inadvertently comic but is in fact appropriate, for Danjūrō V
is playing a transvestite role as Monk Seigen of the Kyoto temple Kiyomizu-
dera in female guise. Besides the heroic or villainous swashbucklers that made
him famous, Danjūrō V did occasionally play female roles— though these were
usually rather virile or spirited females such as Kasane, Yamauba, Iwafuji,
Tomoe Gozen, and the like.[1]

The pigments of these impressions are considerably faded, but originally the
kimono were probably bright red and purple and the obi perhaps blue.[2] The
white over-kimono (*uchikake*), embossed with a diamond pattern, are suitable
to the ghostly status of their wearers, and the maple leaves that decorate them
were used as a crest by generations of courtesans inheriting the prestigious
name Takao (Mt. Takao is a scenic spot famed for its brilliant autumn foliage).

The spirits of dead lovers would seem to be the underlying theme of this
dance sequence with recitation chanted by Fujioka Waka-tayū, and indeed the
device of a courtesan's spirit appearing out of an incense burner had been used
to good effect in a succession of dance sequences known as *Asama-mono* (Mt.
Asama is a still active volcano). In 1698 the original *Asama-mono*, "Keisei
Asamagatake" (A Courtesan's Mt. Asama) had embroidered upon a real-life
scandal within the Suwa family, and included a scene in which the young
aristocrat Kozasa Tomonosuke burns in an incense burner the love-letters
written him by the courtesan Oshū, only to have her apparition appear in the
smoke and engage him in a spirited lovers' quarrel. A 1757 version featured
two spirits— the courtesan Yatsuhashi, who had been murdered by a jealous
client, and Monk Seigen, also murdered, who had abandoned his vows out of
a mad passion for Princess Sakura. The 1772 version depicted here introduces
Seigen again (in female guise), together with the ghost of the courtesan Takao,
who was supposed to have been strangled by the Lord of Sendai in a boat off
Mitsumata on the Sumida River sometime in the 1660s.[3] Mention of Takao
plunges us into the world of the *Date Sōdō*, the notorious feud in the Date
daimyo clan of Sendai, and evokes Takao's lover, Ashikaga Yorikane (alias the
Lord of Sendai), played in 1772 by Bandō Mitsugorō II.

The Kabuki historian Ihara Toshirō records that in the 1772 performance
Danjūrō V also danced as the skeleton of the courtesan Yatsuhashi, thus
reviving elements of the 1757 version.[4] Kabuki playwrights were almost
limitless in the ingenuity with which they could repeatedly alter a proven
crowd-pleaser, making it into a vehicle for a particular actor's skills while
retaining its familiar and richly evocative aura.

1 Ihara (1913), p. 184.
2 These are not the colors reproduced in *Ukiyo-e Taika Shūsei*, vol. 8 (1932), no. 8 (Danjūrō
 V as Seigen in courtesan's robes), which shows a red-and-green kimono and a bright
 yellow obi. This illustration must represent a different edition of the print.
3 Information concerning *Asama-mono*, Yatsuhashi, Seigen, Takao, and *Date Sōdō* plays can
 be found in section nos. 108, 238, 110, 148, and 74, respectively, of *Kabuki Saiken* (1926).
4 Ihara (1913), p. 177.

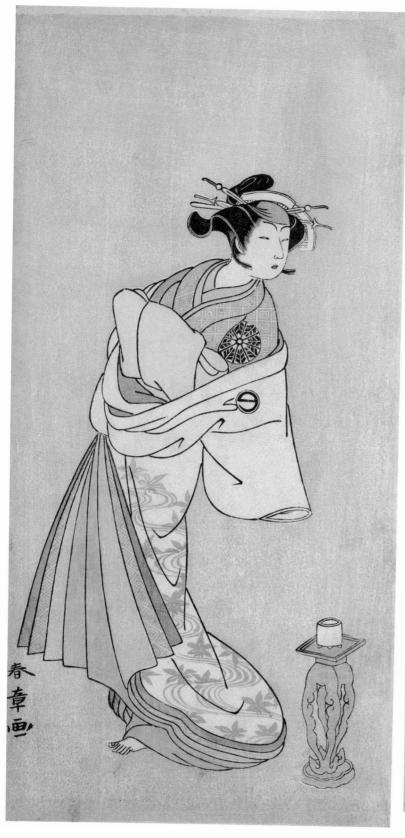
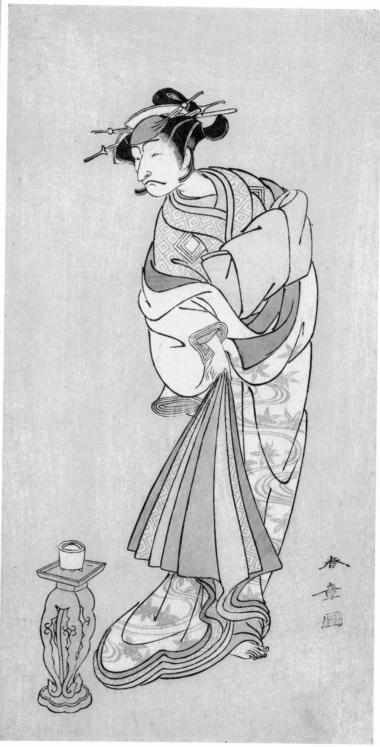

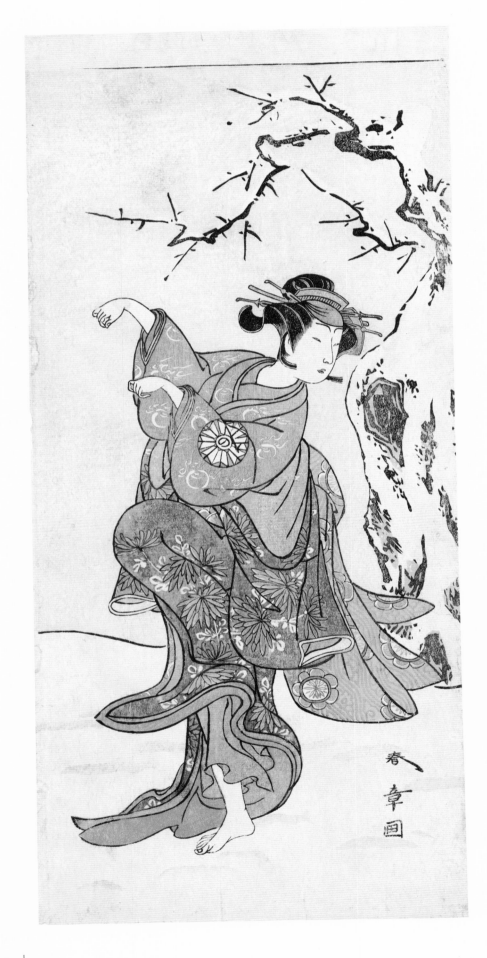

61 KATSUKAWA SHUNSHŌ

(1726–1792)

The actor Nakamura Noshio I as the Fox-Wife from Furui, in a dance sequence (*shosagoto*) in part two of the play *Izu-goyomi Shibai no Ganjitsu* (First Performance Day of the Izu Calendar), performed at the Morita Theater from the first day of the eleventh month, 1772

Hosoban; 32.5 x 15.0 cm
The Clarence Buckingham Collection 1932.1023

Hands raised and curled over like the forepaws of a fox, Nakamura Noshio I is shown bounding in a lively dance in the snow before an old plum tree. His brilliant over-kimono, decorated with red and green chrysanthemums, has been thrown back to reveal a red under-kimono patterned with the flaming jewel (*yakara no tama*) that seems to be an object of dispute in the play (see below). The trailing robes and the long brocade sash fly upward and outward to the rhythm of the dance. Japanese folklore endows foxes with the magical power to assume human form and so trick and seduce human beings. Sometimes, however, in their human guise they betray their true animal nature with such gestures as the hands raised like paws. Notice also that the fox-woman thinks nothing of dancing barefoot in the snow.

Kabuki Nempyō simply records, without further description, that Noshio I played the role of a female fox on this occasion.[1] The illustrated program (*ehon banzuke*) for the performance, however, shows us a little more of what went on (fig. 61.1). Noshio I is shown in a similar fox pose, dancing around the *yakara no tama* jewel, which is placed on the ground. He is joined by Nakamura Daitarō, in the role of a manservant, Tochihei, doing a handstand. This is likely a comic part of the dance, with the fox-woman using her magic to put Tochihei through his paces. The theme of a fox-woman seeking to recover a famous jewel in a snow scene at Mt. Yoshino was later standardized into the dance sequence (*shosagoto*) "Meoto-gitsune" (Fox-Husband and Fox-Wife).[2]

This print may relate to another of the same play, showing Nakamura Jūzō II as Kajiwara Genta no Kagetoki standing in the snow under an umbrella, holding a spool of thread (cat. no. 209). *Kabuki Nempyō* records that Jūzō II made his entrance following Noshio I as the fox-wife by means of a cord attached to her skirts.[3] Perhaps he was out to trap the fox.

1 *Kabuki Nempyō*, vol. 4 (1959), p. 200.
2 *Kabuki Saiken* (1926), sect. 16.16 (pp. 115–16).
3 *Kabuki Nempyō*, vol. 4 (1959), p. 201.

SIGNATURE *Shunshō ga*
PROVENANCE Frederick W. Gookin collection
REFERENCE Gookin (1931), no. 104

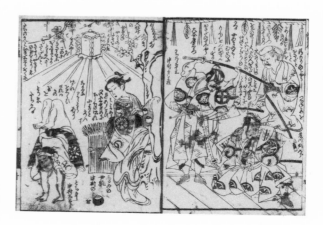

61.1 *The actor Nakamura Noshio I as the Fox-Wife from Furui.*
From the illustrated program. Tōyō Bunko Library, Tokyo

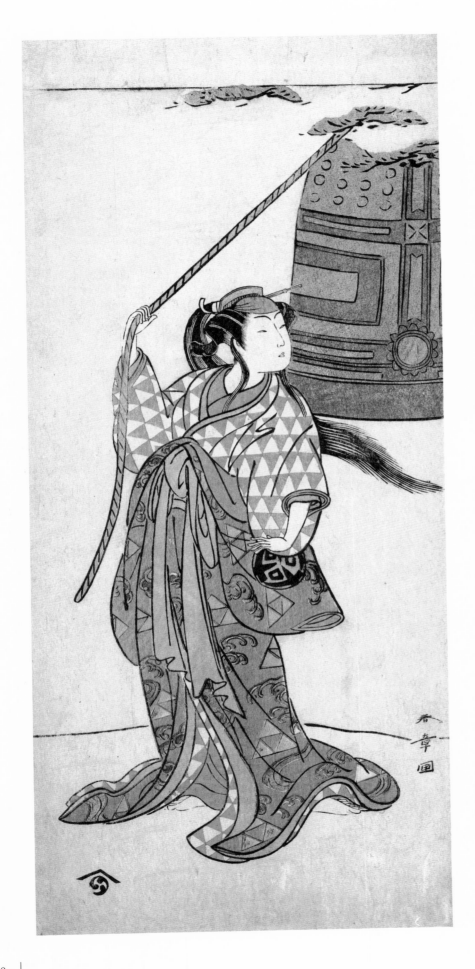

62 KATSUKAWA SHUNSHŌ
(1726–1792)

The actor Arashi Hinaji I dancing "Musume Dōjō-ji"
(The Maiden at Dōjō Temple)
Ca. 1772

Hosoban; 31.5 x 14.3 cm
The Clarence Buckingham Collection 1925.2390

The various versions of the "Dōjō-ji" legend, in such medieval collections as *Konjaku Monogatari* and in later dramatizations for the Nō and Kabuki theaters, all have as their central theme the terrible powers unleashed in a woman driven mad by unrequited love— transmuted into a kind of she-devil. Kiyohime, a young woman living in a village near the temple Dōjō-ji in Kii Province, develops an all-consuming passion for the young monk Anchin, who chances to stop at her house. Faithful to his vow of celibacy, he rejects her advances and flees to the temple, whereupon she turns into a huge snake and pursues him there. The abbot orders the giant bronze temple bell to be lowered over Anchin in protection, but the snake thereupon coils itself around the bell. Its flaming breath melts the bell and incinerates Anchin.

Kabuki versions of the story were performed from at least the 1670s onward, but took definitive form as a sequence of dramatic dances with chanted *nagauta* accompaniment in "Kyōganoko Musume Dōjō-ji," performed by Nakamura Tomijūrō I at the Nakamura Theater from the third month of 1753 for an astounding run of 125 days. That version is similar to the Nō play. In it the action takes place long after Anchin's death, on the occasion of the dedication of a new bell at Dōjō-ji. A young woman pilgrim appears in the costume of a *shirabyōshi* dancer.[1] She pleads to be admitted to the dedication, offering to dance in honor of the new bell. Since Anchin's fiery death, women have been stringently barred from the temple precincts, but this time the monks relent, and the appealing pilgrim, who is actually the spirit of Kiyohime in disguise, enters. Slowly she dances closer and closer to the bell, finally disappearing under it. When a large crowd of monks raise the bell, there beneath it is the serpentine she-devil. The snake is finally subdued by the local governor, Saba Gorō.[2]

Arashi Hinaji I as Musume Dōjō-ji is shown holding the rope of the large bronze bell which hangs from the branch of a snow-covered pine. She has shrugged her over-kimono (*uchikake*) off her shoulders to reveal the triangular snake-scale pattern (*uroko-gata*) of the kimono, and her long hair hangs down in a wild ponytail that will whip through the air like a snake as she dances. The form of Shunshō's signature suggests that the print dates from the early 1770s, but no theatrical records survive describing Hinaji I in such a role during this period. The snow-laden pine suggests that on this occasion "Dōjō-ji" had been adapted to serve as a dance sequence (*shosagoto*) in the snow, such a sequence having become obligatory in opening-of-the-season (*kaomise*) productions, which began about the eleventh month each year and ran for about six weeks.

1 *Shirabyōshi* were itinerant prostitutes who entertained by dancing in a characteristic "masculine" costume of court robes and hat.
2 *Kabuki Saiken* (1926), sect. 93, pp. 459–66.

SIGNATURE *Shunshō ga*
PUBLISHER Nishimuraya Yohachi
REFERENCE Gookin (1931), no. CBAI 49

The *Ise Monogatari* series
Ca. 1772–1773

Color-printed wrapper for *Ise Monogatari*

The original *Ise Monogatari* (Tales of Ise) is a collection of something over one hundred brief narrative episodes, each serving to frame one or more classical poems. It is generally believed to have been composed in the tenth century, though many of the poems are somewhat older, and its nameless protagonist is generally assumed to be, or to have been modelled after, the courtier-poet Ariwara no Narihira (825–880), author of many of the poems and known recipient of others. From the latter part of the Heian period (794–1185) onward the *Ise Monogatari*— its poems and surrounding prose vignettes— became part of the "classical" literature of Japan, that body of works with which every cultured person was intimately familiar. Scenes from *Ise Monogatari* became a common subject for later painters, particularly those of the Tosa school, who painted for the imperial family and court patrons from the fifteenth century onward.

In the early 1770s Shunshō illustrated forty-eight of the most famous episodes from *Ise Monogatari*, each identified in the top right-hand corner with one of the forty-eight symbols of the Japanese phonetic syllabary (arranged in *i-ro-ha* order— the equivalent of A, B, C). At the top of each print a border in the shape of a stylized cloud encloses the poem from the episode depicted. Though *Ise Monogatari* had been issued in many black-and-white illustrated versions during the Edo period, beginning with the luxurious *Saga-bon* woodblock-printed edition of 1608, Shunshō was the first artist to design *Ise* prints using the new full-color print technology adopted by commercial publishers after 1765. His designs are courtly in mood and clearly influenced by earlier Tosa painting styles but have a vigor and charm uniquely his own, which point toward his later great achievements as a book illustrator and painter of women. Though some of the women are anachronistically shown in eighteenth-century dress, most of the male figures have the dress and demeanor appropriate to the *yoki hito* (good people, i.e., aristocrats) of the Heian court. In general the designs betray scarcely any contemporary *mitate* (parody) feeling. Asano Shūgō has recently demonstrated that Shunshō took some of the designs from an edition of *Ise Monogatari* illustrated in black and white by the Kyoto artist Nishikawa Sukenobu (1671–1750) in 1748.[1]

Considerable uncertainty clouds the date and format in which the series was issued. A color-printed wrapper with a design of red peonies in the collection of The Art Institute of Chicago (No. 63A), bearing the title *Fūryū Nishiki-e Ise Monogatari— nijūyommai* (Fashionable Brocade Pictures of the *Tales of Ise*— twenty-four sheets), suggests that at least the first half of the series was issued as twenty-four single-sheet prints in the small *koban* size, contained in a decorative wrapper. In his *Ehon Nempyō* (Chronological List of Illustrated Books) of 1983, however, Urushiyama Matashirō gives a firm publication date of New Year 1773 for *Ehon Ise Monogatari*, which he describes as a half-size *book* of color prints by Shunshō, published by Urokogataya Magobei of Edo. He also comments, "Why does one often come across incomplete copies comprising [the first] twelve sheets [i.e., twenty-four designs]?" The only known complete series of forty-eight prints is in the collection of the British Museum, mounted in album format;[2] they appear to have been so mounted, however, a considerable time after publication. It is not impossible that at least some of the designs were first issued as single-sheet prints and the blocks later adapted for reissue in illustrated book format.

The complex publishing history and scarcity of the second half of the series may be linked to the disastrous fire that swept Edo at the end of the second month of 1772. If the series was being published in two halves, or over a period of time, the second half may have been printed just before the fire destroyed printing blocks and stocks of the newly published prints.

1 An incomplete copy of *Fūryū Nishiki-e Ise Monogatari*, containing the first twenty-four designs in the set (Hirahata Terumasa collection), is discussed by Asano Shūgō in *Ukiyo-e Geijutsu*, vol. 96 (1988), pp. 32–44.

2 Department of Japanese Antiquities, British Museum, 1988.8-6.01-048 [ex-coll. Mrs. Sayers-Lloyd; Sotheby's sale of 3 November 1970, lot 170; ex-coll. Richard Illing]. These are relatively late impressions and entered the museum collection mounted as album leaves. Two prints in the series, *ru* and *wo* (nos. 11 and 12), occur in two states, printed from different key-blocks (one of the *wo* prints bears the mark of the publisher Urokogataya hidden in the circular tile at the end of the roof). Since the prints in the series were clearly cut two to a block, side by side on a single block, the existence of the two states of these two designs implies nothing more than that one printing block in the series was damaged and had to be replaced. See Tim Clark, "Shunshō's 'Fūryū Nishiki-e Ise Monogatari' (Tales of Ise)," *Ukiyo-e Geijutsu*, vol. 100 (1991), pp. 72–81.

風流　錦繪
錦繪　伊勢物語　いせものかたり　二拾四枚

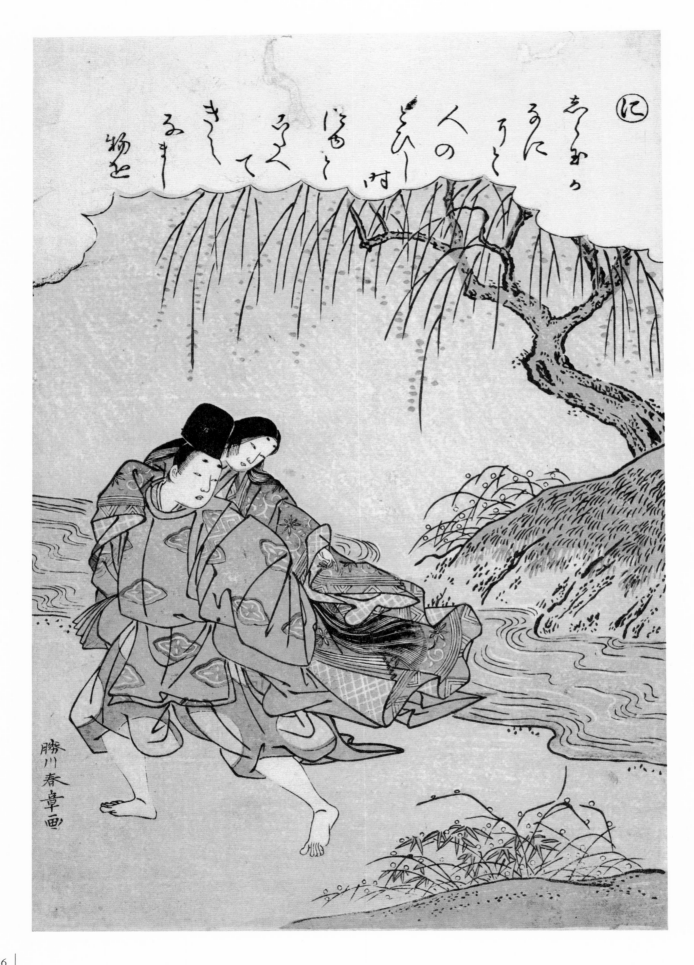

63B

"Akutagawa." Episode 6 of *Ise Monogatari*; no. 4 (*ni*) in Shun-shō's series of illustrations

Koban; 23.0 x 15.6 cm
The Clarence Buckingham Collection 1928.984–4

"A certain man" runs off with a court lady one dark night. As they pass the stream called Akutagawa, she sees dewdrops on the grass and asks him what they are. The hour grows late and rain begins to fall in torrents, so the man shelters his lady-love in a ruined store-house while he stands guard at its entrance. But the storehouse is inhabited by demons, who devour the lady while thunder drowns her screams. In the morning when he finds her gone and surmises her gruesome fate, the distraught lover composes this poem:

Shiratama ka	When my beloved asked,
nani zo to hito no	"Is it a clear gem,
toishi toki	Or what might it be?"
tsuyu to kotaete	Would that I had replied,
kienamashi mono o	"A dewdrop!" and perished.[3]

Shunshō dresses the eloping couple in ancient court costume— the woman in the many-layered brocade robes and the man in black lacquered hat (*eboshi*) and hunting cloak (*kariginu*)— with no obvious anachronisms of eighteenth-century dress. The lover carries his lady on his back as they flee, and both look earnestly at the drops of dew drawn prominently on each curved blade of grass. The graceful green willow withes overhead add to the lyricism of the scene. In this sense Shunshō's *Ise Monogatari* illustrations appear generally faithful to the spirit and world of the original Heian-period novel; they do not belong to the category of parodies (*mitate-e*) of ancient themes that were so common in eighteenth-century *ukiyo-e*.

Asano Shūgō has shown that Shunshō took the composition of this print from the *Ise Monogatari* published in 1748 with black-and-white woodblock-printed illustrations by Nishikawa Sukenobu (1671–1750).[4]

3 McCullough (1968), p. 73.
4 Asano, vol. 96 (1988), p. 43.

SIGNATURE *Katsukawa Shunshō ga*
PROVENANCE Alexander Mosle collection
OTHER IMPRESSIONS
Honolulu Academy of Arts; Musée Guimet, Paris;
British Museum, London; Allen Memorial Art Museum,
Oberlin College; Hirahata Terumasa collection, Chōshi

63C

"Musashi Plain." Episode 12 of *Ise Monogatari*; no. 8 (*chi*) in
Shunshō's series of illustrations

Koban; 22.8 x 16.0 cm
The Clarence Buckingham Collection 1928.984–8

A man abducts a young woman and flees with her to Musashi Plain
(Musashino). Pursued by provincial officials, he hides her in a
clump of bushes and runs off. When the officials threaten to set fire
to the grass to smoke them out, the girl recites this poem, and the
two are discovered, arrested, and taken away:

Musashino wa	Do not set fire today
kyō wa no yaki so	To Musashi Plain,
wakakusa no	For my beloved husband
tsuma mo komoreri	Is hidden here,
ware mo komoreri	And so am I.[5]

The lovers are shown in not very deep hiding before a tangle of
long grasses, wild chrysanthemums, and bush clover, while their
pursuers chase across a low bank in the background, waving blazing
torches. In this illustration the men are dressed in Heian costume
but the woman wears a kimono with long hanging sleeves (*furisode*)
of late eighteenth-century fashion. Despite this anachronistic note,
the delicacy of the figures and the Tosa style perspective imbue the
design with a nostalgic, courtly flavor.

5 McCullough (1968), p. 78.

SIGNATURE (trimmed) *Shunshō ga*
PROVENANCE Alexander Mosle collection
OTHER IMPRESSIONS
Honolulu Academy of Arts; British Museum, London (2 impressions);
Allen Memorial Art Museum, Oberlin College;
Hirahata Terumasa collection, Chōshi

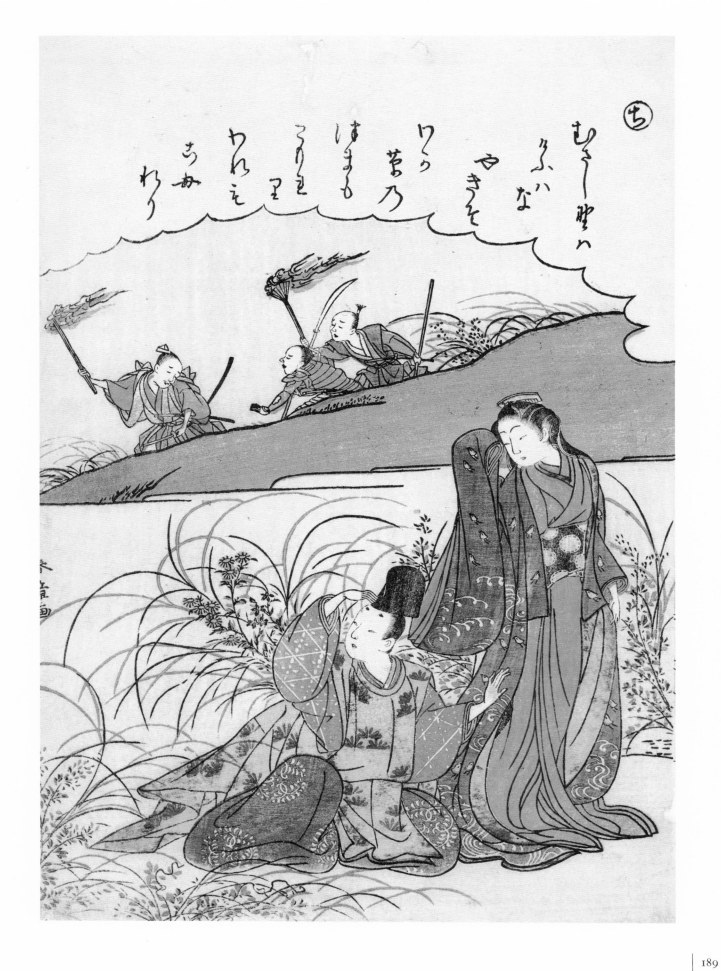

63D

"Narihira in the snow at Ono." Episode 83 of *Ise Monogatari*,
no. 19 (*tsu*) in Shunshō's series of illustrations

Koban; 22.6 x 15.9 cm
The Clarence Buckingham Collection 1928.984–19

At court Ariwara no Narihira was not only a retainer but a valued
member of the literary-minded Prince Koretaka's entourage. But
the prince has taken monastic vows and lives a life of seclusion in
Ono at the foot of Mt. Hiei. "An elderly Commander of the Right
Horse Bureau" (presumably Narihira) resolves to pay his respects to
the prince and makes his way through deep snow to the hermitage
at Ono. After considerable nostalgic reminiscence he feels obliged
to end his visit and return to his official responsibilities. As he sets
out, he recites:

Wasurete wa	When for an instant I forget,
yume ka to zo omou	How like a dream it seems....
omoiki ya	Never could I have imagined
yuki fumiwakete	That I would plod through snow drifts
kimi o minu to wa	To see my lord.[6]

In the print Narihira is shown making his way through the snow to
Ono, accompanied by two older servants, one of whom shelters
him beneath a large umbrella, and a page boy carrying a sword.
A strong contrast is drawn between the lively, individualized faces
of the chatting servants and the impassive, idealized features of
Narihira, a "man of breeding" (*yoki hito*) of courtly rank and status.
Such a distinction was an integral element in the courtly *yamato-e*
(later Tosa school) painting tradition which would have been
well known to Shunshō. This composition too was taken from
Sukenobu's black-and-white illustrated *Ise Monogatari* of 1748.[7]

6 McCullough (1968), pp. 127–28.
7 Asano (1988), p. 44.

SIGNATURE *Shunshō ga*
PROVENANCE Alexander Mosle collection
OTHER IMPRESSIONS
Honolulu Academy of Arts; British Museum, London;
Hirahata Terumasa collection, Chōshi

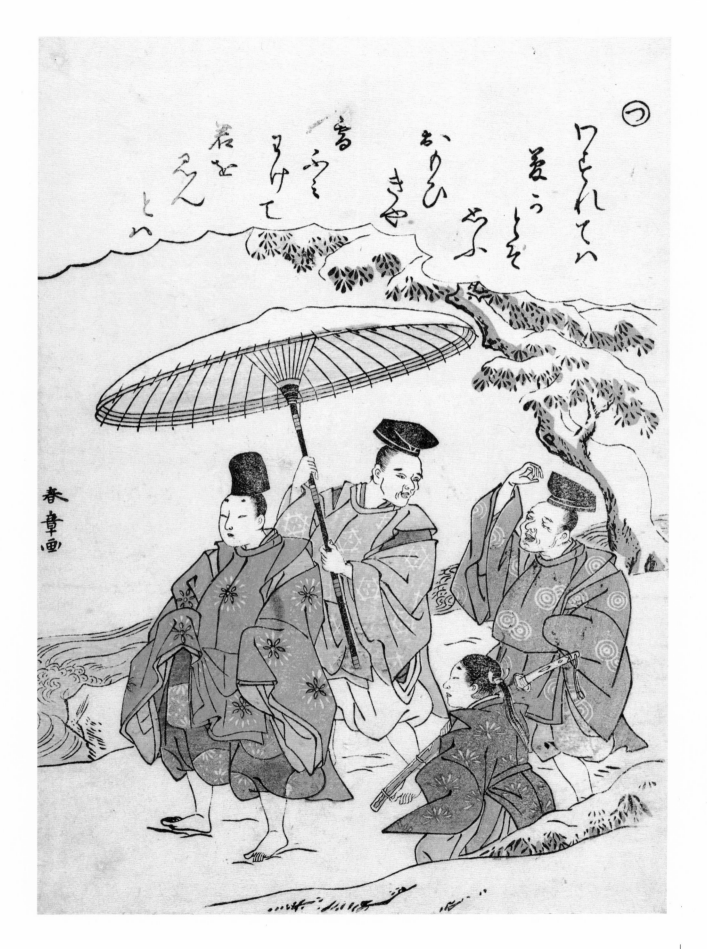

64 KATSUKAWA SHUNSHŌ

(1726–1792)

The Chinese Immortal Seiōbo (C: Xi Wang Mu)
Ca. 1770s

Chūban; 25.4 x 17.7 cm
Frederick W. Gookin Collection 1939.574

Seiōbo (C: Xi Wang Mu, Queen of the West) was a female Immortal (J: *sennin*) who, according to Daoist lore, lived in a palace by Jewel (or Turquoise) Pond in the Konron (C: Kunlun) Mountains, where she cultivated a peach tree which bore fruit every three thousand years. To eat of this fruit was to gain immortality, and there are many early accounts of her visiting or being visited by Chinese rulers— from legendary emperors such as Shun and Yu to eminently historical ones such as Han Wu Di (156–87 BC)— and presenting them with peaches from her tree.

Shunshō has meticulously created an atmosphere of exotic chinoiserie: Seiōbo is shown wearing a fanciful approximation of Tang dynasty (618–906) court costume, standing on a terrace surrounded with a Chinese style railing beside Jewel Pond. One young attendant carries the Peaches of Immortality in a bowl, another a Chinese style fan on a long pole. Even the rock and tree in the background are rendered in the highly inflected ink-painting style of the Kanō school, a style based originally on Chinese prototypes.

Shunshō designed a series of such prints illustrating legends of Chinese Immortals, all seen through a circular window set in a black ground, with a Chinese poem in white reserve above the window.[1] This distances the scene appropriately in both space and time: it suggests a view into a Chinese garden through the round window of a typical Chinese pavilion, and at the same time a view into the immeasurably distant past through a kind of telescope. The meticulously rendered figure of Seiōbo is perfectly framed by this circular surround, her sleeve raised to her chin in that appealingly feminine gesture so often seen in Shunshō's paintings of women.

The four-character couplets written above are part of a poem said to have been composed by Seiōbo when she visited Emperor Mu (ca. 1000 BC) of the Zhou dynasty:

Hakuun ten ni ari	White clouds are in the heavens,
michinori haruka ni tōku	The journey is long and far,
sansen kore o hedachi	Mountains and rivers come between.
masa ni mata shisuru koto nashi	Surely you will not die.[2]

Shunshō and his contemporaries Kitao Shigemasa (1739–1820) and Torii Kiyonaga (1752–1815) each produced several series of *chūban* prints featuring round or fan-shaped landscapes set in black surrounds— often sets of "Eight Views of Lake Biwa" (*Ōmi Hakkei*) or scenes of Edo. The two Kiyonaga series of this type have been dated to 1780 and 1781 (without supporting evidence),[3] and the dating of the Shunshō series here to "about the 1770s" is tentative.

1 Gookin (1931), p. 78 lists three other designs from the series: *Ryūjo* (Liu Nü) flying on a white goose (illustrated in Boller, 1953); *Kikujidō* (C: Ju Citong), the Chrysanthemum Boy; and *Chikurin Shichi Kenjin*, the Seven Sages of the Bamboo Grove. I do not know of illustrations of the last two.

2 The poem as it appears in *Boku Tenshi Den* (Biography of Emperor Mu) includes a second line, *kyūryō onozu to izu* ("hills emerge in their turn"), and a last line, *nao mata yoku kitare* ("and yet come more often"). *Boku Tenshi Den* (Biography of Emperor Mu). 6 vols. Author unknown. Said to have been discovered in grave of King Xiang of the Wei dynasty in AD 281. Text of poem is quoted in Kanai Shiun (Taizaburō), ed., *Tōyō Gadai Sōran* (Tokyo: Rekishi Tosho Sha, 1975), p. 489.

3 Hirano (1939), nos. 289–95, 309–16.

SIGNATURE *Shunshō ga*

白雲在天
道里
悠
山川
間之
將又
無
死
遠

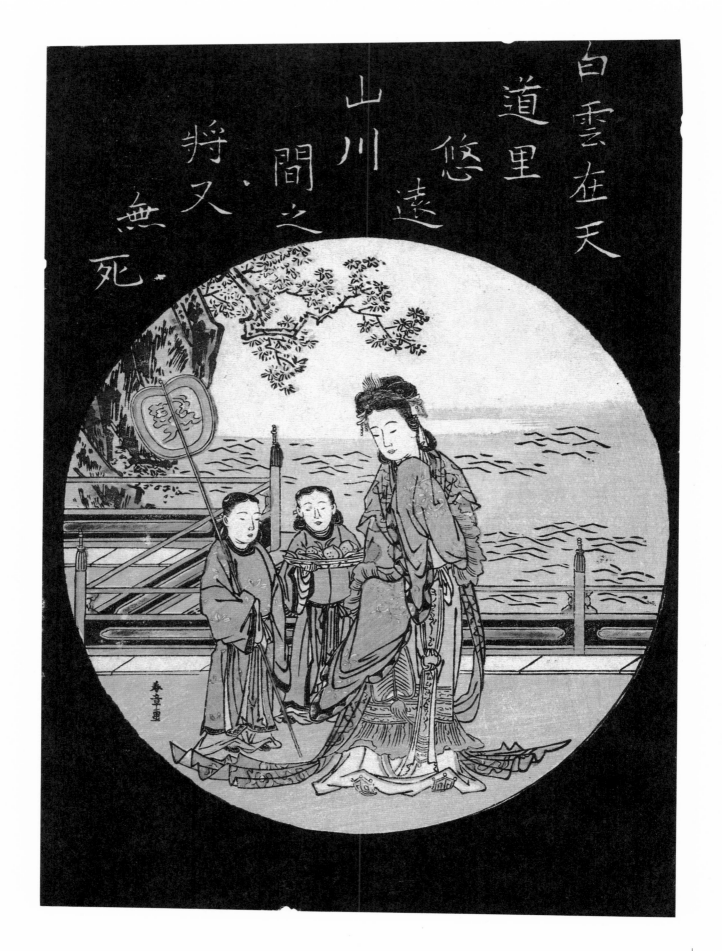

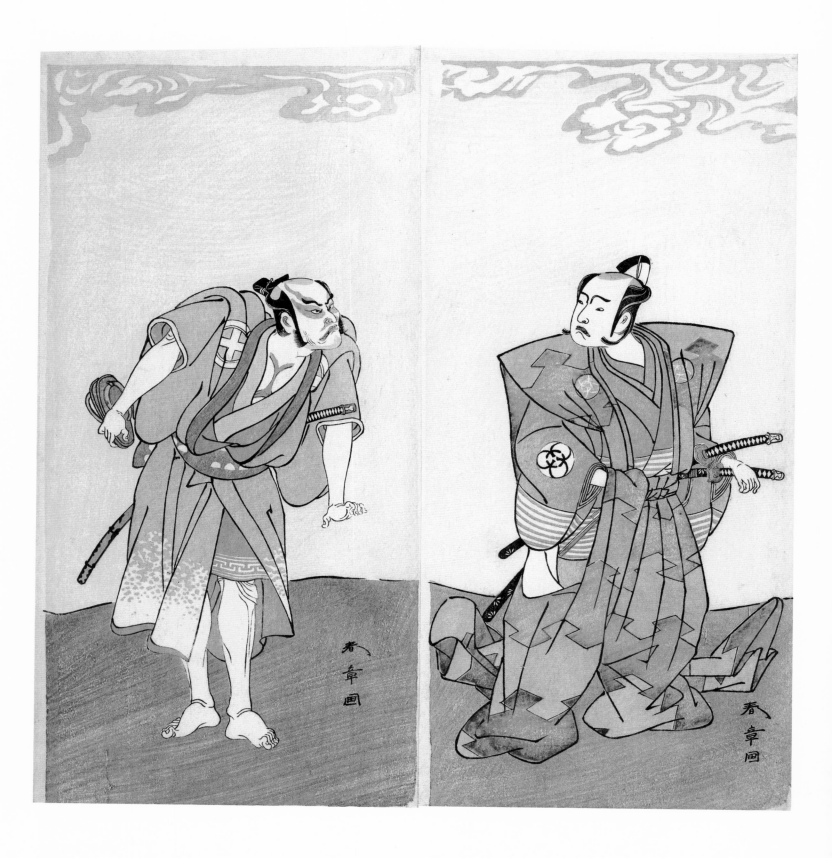

The actors Bandō Mitsugorō I as Hata no Kawakatsu (right), and Ōtani Hiroemon III as the manservant (*yakko*) Gansuke (left), in the play *Miya-bashira Iwao no Butai* (Shrine Pillars on a Stone Base), performed at the Morita Theater from the fifteenth day of the seventh month, 1773

Hosoban diptych; (right) 31.2 x 15.5 cm; (left) 31.5 x 15.3 cm
The Clarence Buckingham Collection 1932.999

A confrontation appears to be in the making between Bandō Mitsugorō I as Hata no Kawakatsu, a high-ranking samurai dressed in formal *kamishimo* (wide-shouldered surcoat and extra-long *naga-bakama* trousers), and Ōtani Hiroemon III as the muscular manservant Gansuke, bare-legged and holding his sandals behind his back. Above their heads swirl baroque clouds, suggesting some turbulent heavenly goings-on. Though the plot of the play has not yet been ascertained from actor critiques (*yakusha hyōbanki*), the identification is confirmed by a publicity handbill (*tsuji banzuke*) preserved in the collection of the Museum of Fine Arts, Boston.

The present autumnal color scheme is deceptive, the dull buff in both men's costumes having faded from its original bright purple.

Five further *hosoban* prints by Shunshō relating to this performance have been identified.[1]

1 Cat. nos. 255–58 and Ōta Museum (1983), no. 7.

SIGNATURE *Shunshō ga*
PROVENANCE Frederick W. Gookin collection
REFERENCE Gookin (1931), no. CBAI 80
OTHER IMPRESSIONS
(left) Museum of Fine Arts, Boston

(1726–1792)

The actor Nakamura Nakazō I as Prince Koreakira, younger brother of Emperor Go-Toba, in the play *Gohiiki Kanjinchō* (Your Favorite Play *Kanjinchō* [The Subscription List]), performed at the Nakamura Theater from the first day of the eleventh month, 1773

Hosoban; 32.5 x 14.9 cm
The Clarence Buckingham Collection 1925.2440

Nakamura Nakazō I (1736–1790) was much in demand to play various evil courtiers (*aku kuge*), the "receiving" (*uke*) role opposite the hero in the ever popular "Shibaraku" (Stop right there!) scene that was obligatory in every opening-of-the-season (*kaomise*) production (see No. 44). Ironically, contemporary commentators remarked that he was by nature a compassionate man, incapable of sufficient venom to portray a true villain.[1]

Though the names of the evil courtiers in Kabuki may differ from one play to the next, their intention is always the same: with the help of thuggish followers to usurp the throne and establish their tyranny over the country. Similarly, the costume is always of a type (see No. 44): white court robes, gold *kammuri* headdress, long, unkempt wig, and a huge sword to symbolize monstrous ambition. The "Shibaraku" scene generally takes place on the stone steps at the entrance to a shrine, with the evil courtier standing in the center shaded by a large umbrella carried by an attendant. In the nick of time his followers are prevented from murdering innocent victims by the electrifying arrival of the hero, shouting "Shibaraku!" (Stop right there!) as he makes his entrance.

In the opening-of-the-season play at the Nakamura Theater in the eleventh month, 1773, Nakazō played the evil Prince Koreakira, younger brother of Emperor Go-Toba (r. 1185–1198), who occupied the throne during the turbulent period following the establishment of the Minamoto shogunate in 1185. The hero of this "Shibaraku" scene was Kumai no Tarō, played by Ichikawa Danjūrō V. As we have seen (No. 44), this was not the first time the two had confronted one another in such roles.

1 Ihara (1913), p. 151.

SIGNATURE *Shunshō ga*
PROVENANCE Frank Lloyd Wright collection
REFERENCE Gookin (1931), no. CBAI 15
OTHER IMPRESSIONS H. R. W. Kühne collection

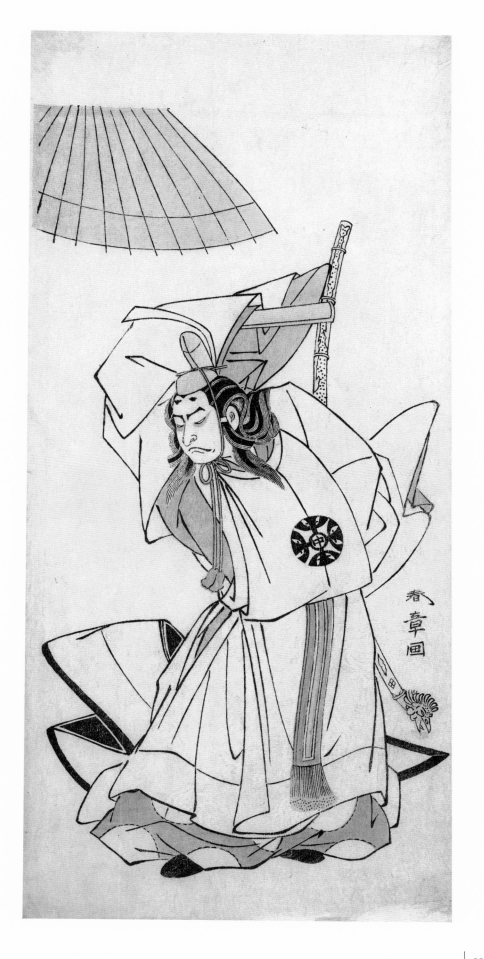

(1726–1792)

The actors Ichikawa Monnosuke II as Shimokōbe Shōji Yukihira (right), and Segawa Yūjirō I as Matsukaze, sister of Togashi no Saemon, in the play *Gohiiki Kanjinchō* (Your Favorite Play *Kanjinchō* [The Subscription List]), performed at the Nakamura Theater from the first day of the eleventh month, 1773

Hosoban, possibly the left and center sheets of a triptych; (right) 30.2 x 14.3 cm; (left) 29.9 x 14.6 cm
The Clarence Buckingham Collection (right) 1925.2431; (left) 1925.2429

The opening-of-the-season (*kaomise*) production at the Nakamura Theater in 1773 was an unusually broad medley of famous scenes, with something for everyone. As the title of the play suggests, its centerpiece was *Kanjinchō*, the famous story of Minamoto no Yoshitsune and his devoted retainer Benkei at the Ataka Barrier. Also included, of course, was the obligatory "Shibaraku" scene (see No. 44).

For the dance sequence (*shosagoto*) we see illustrated here, two well-known legends were creatively combined: the characters of the exiled young nobleman Yukihira and the lowly sisters Matsukaze and Murasame, whom he loves, were transposed into the setting of a quite different tale, *Momiji-gari* (Maple Viewing). *Momiji-gari* is an ancient legend from the collection *Konjaku Monogatari*, in which the warrior Taira no Koremochi is sent by the emperor to quell a demon that is haunting Mt. Togakushi. Stopping to enjoy the brilliant autumn foliage on the mountain slopes, Koremochi is accosted, beguiled, and plied with sake by a mysterious beauty who is none other than the mountain demon in disguise. Lulled by the sake and the mountain air, he falls asleep, but in his dream the tutelary deity of the mountain reveals the identity of the mysterious beauty and presents him with a sword to use against her. Koremochi wakes in time to drive off the demon.[1]

The costumes in Shunshō's prints reflect the mixing of the two legends. Segawa Yūjirō I is holding up the devil (*hannya*) mask worn by the demon in the Kabuki dance version of *Momiji-gari*, but wearing a kimono decorated with the plover-and-waves pattern associated with Matsukaze, who, after all, lived by the seashore at Suma. Similarly, Ichikawa Monnosuke II has half shrugged off Koremochi's hunting cloak (*kariginu*) and is holding up the court hat (*eboshi*) left as a token at Suma by Yukihira when he is recalled to court. Presumably spectators of the 1773 performance derived much of their enjoyment from the ingenuity with which the two legends had been interwoven.

Shunshō has composed the figures in mirrored poses, perfectly though not pedantically balanced, which must have been the climax of the dance sequence. Yukihira's cloak hangs down at the back to echo Matsukaze's trailing skirts, but he holds up his fan in a gesture not matched on her side. The composition seems so complete that it is hard to credit Gookin's suggestion that there would have been a third sheet on the right, showing Segawa Kichiji as Murasame;[2] furthermore, *Momiji-gari* as originally written called for a confrontation between just two characters, Koremochi and the female demon.

The original colors of the costumes have modified considerably, fading from bright purple and blue to russet and sand.

1 *Kabuki Saiken* (1926), sect. 124.2, pp. 569–70.
2 Gookin (1931), p. 137A.

SIGNATURE *Shunshō ga*
REFERENCE
Gookin (1931), nos. 116, 117, text pp. 136–37A

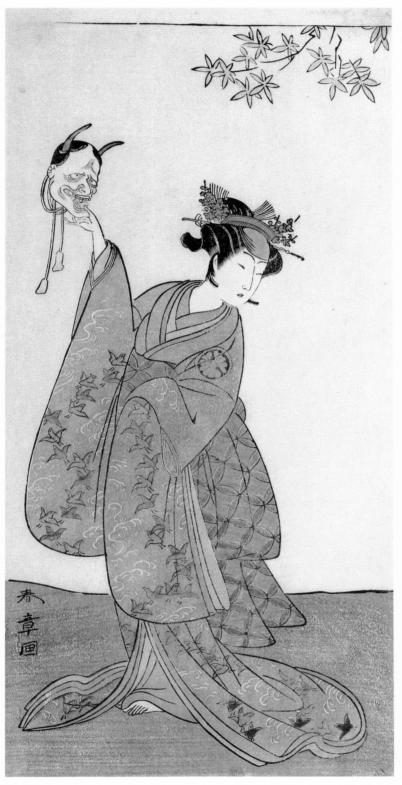
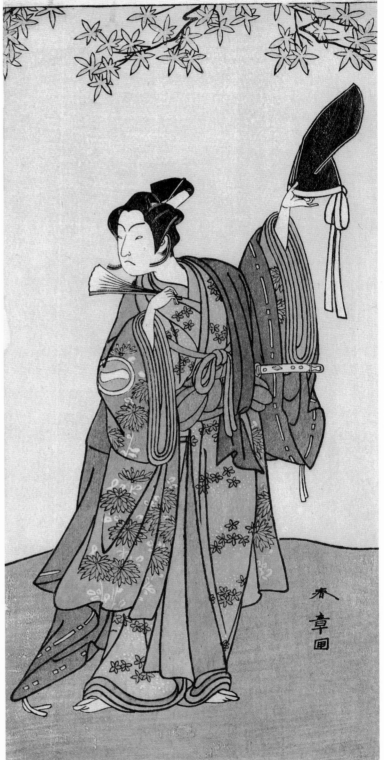

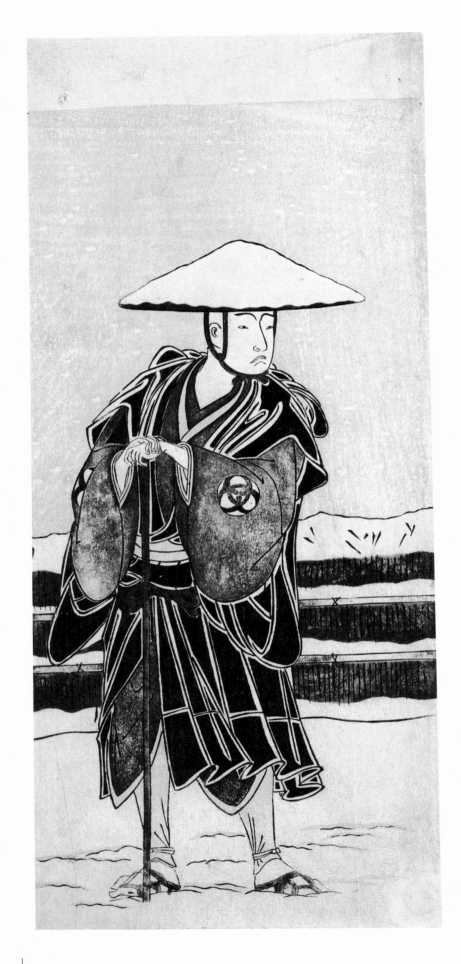

"Hachi no Ki" (The Potted Trees) was a popular *jōruri* for inclusion in opening-of-the-season productions because it provided the snow scene obligatory for the *kaomise*: in this case, the famous episode in which the regent Tokiyori, disguised as an itinerant monk, seeks shelter from the snow at the cottage of Sano Genzaemon; Genzaemon, having no other firewood, chops up his beloved potted trees to make a fire for his guest. A more detailed plot synopsis occurs in the commentary to Number 39, but the novelty of the 1773 performance lay in Tokiyori's reception not by Sano Genzaemon but by his wife Shirotae and her sister Tamazusa— hence the title "Onna Hachi no Ki" (A Female Version of "The Potted Trees"). The dramatist Chikamatsu had similarly switched the sexes in a puppet play written in 1699, and by 1707 the idea had already been taken over into Kabuki.[1]

The illustrated program (*ehon banzuke*) for the performance of 1773 shows Bandō Mitsugorō I as Tokiyori outside the gate to the farmhouse, Nakamura Tomijūrō I as Shirotae wearing a straw cape against the snow and carrying a basket of vegetables, and Nakamura Noshio I as Tamazusa in the famous pose of sweeping the snow from the eaves with a broom (fig. 68.1).

This is one of the first plays mentioned by Lord Yanagisawa Nobutoki in his theater diary, *Enyū Nikki Betsuroku*, which he began writing in 1773. Of the socially varied crowd that attended the performance on the thirteenth day of the eleventh month he writes, "Two women who looked like geisha came [and sat in the box] next door. In five boxes on the opposite side were customers of the Onoya [theater teahouse]— the wives of various lords wearing wraparound cotton headscarves to disguise their features."[2]

The sense of seriousness, even *gravitas*, with which Shunshō has imbued his portrait of Tokiyori confutes the misguided notion that Kabuki was (and is) nothing more than a colorful popular spectacle devoid of emotional content. Regent Tokiyori's purpose in disguising himself as a humble itinerant monk was to learn firsthand the condition of the people and the distribution of enemy forces throughout the nation; his sober expression and firm stance amid the thickly falling snow convey both the arduousness of the mission he has set himself and his unswerving resolution in pursuing it.

Clearly Shunshō intended a somber color scheme to match this serious theme: Tokiyori's monastic robes were rendered in white, gray, and black, with the folds of his black cotton rain jacket (*kappa*) left in stark white reserve. The orange-red lead pigment (*tan*) of the brushwood fence and of Tokiyori's staff, hat, and straw sandals has taken on a deep purple-black tarnish, and the white lead of his kimono has dulled to a heavy gray. It remains an intriguing question whether these rich patinas on the surface of the lead pigments were intended by the artist and his printer, perhaps even artificially induced. In any event, to have abandoned the glorious full color of the new "brocade print" technology in favor of a grisaille color scheme is surely a mark of unusual artistic sophistication.

1 *Kabuki Jiten* (1983), s.v. *Hachi no Ki-mono*.
2 *Enyū Nikki* (1977), p. 818.

The actor Bandō Mitsugorō I as Abbot Saimyō-ji Tokiyori, disguised as a monk, in the *jōruri* "Onna Hachi no Ki" (A Female Version of "The Potted Trees") from part two of the play *Onna Aruji Hatsuyuki no Sekai* (A Woman as Master: the World of the First Snow), performed at the Morita Theater from the first day of the eleventh month, 1773

Hosoban; 31.2 x 13.5 cm
Frederick W. Gookin Collection 1939.679

SIGNATURE *Shunshō ga* (trimmed from bottom left)
REFERENCE Gookin (1931), no. 119, text pp. 137–38
OTHER IMPRESSIONS
Ledoux (1945), no. 38 (Minneapolis Institute of Arts);
ex-collection Shugyō

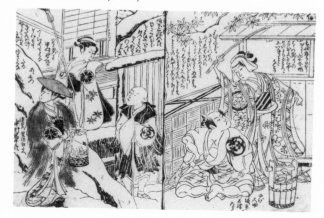

68.1 *The actors Bandō Mitsugorō I as Saimyō-ji Tokiyori, Nakamura Noshio I as Tamazusa, and Nakamura Tomijūrō I as Shirotae.* From the illustrated program. Tōyō Bunko Library, Tokyo

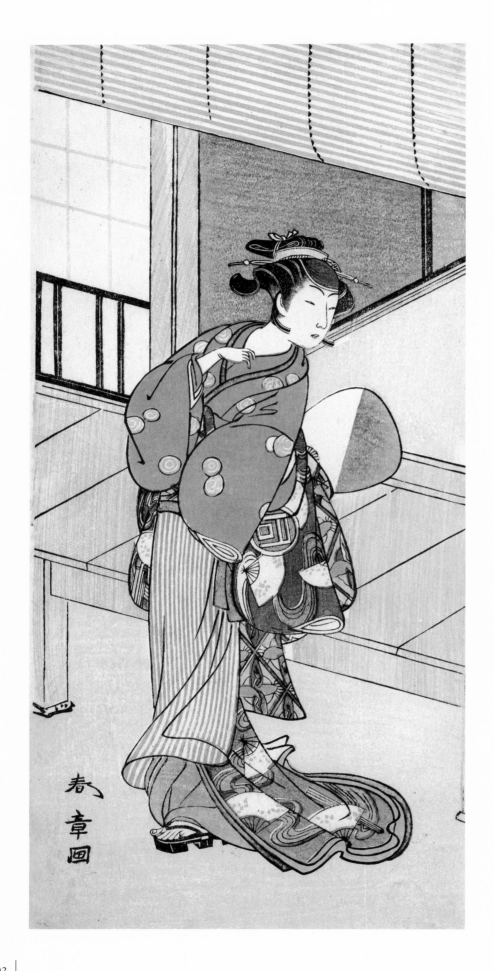

The actor Sanogawa Ichimatsu II in an unidentified role
Ca. 1773–1774

Hosoban, possibly the left-hand sheet of a diptych; 31.0 x 14.8 cm
The Clarence Buckingham Collection 1925.2426

Wearing a red striped apron and sporting a summer fan
(nonfolding, called *uchiwa*) tucked into the sash at the
back, Ichimatsu II seems to be playing a teahouse waitress
or proprietress. Given the luxurious appearance of the
over-kimono with its pattern of scattered fans floating on
a stream, it is perhaps more likely that this is a well-to-do
wife than a simple serving girl. The top part of the over-
kimono has been slipped off the shoulders in preparation
for work, to reveal a bright red under-kimono beneath,
and the sash is a rich brocade of stylized sparrows or
plover. Behind the woman a reed blind has been raised,
revealing a room opening out onto a verandah, an
arrangement typical of a restaurant, teahouse, or similar
establishment.

About the years 1772–1774 Shunshō's signature on actor
prints acquired certain distinctive formal characteristics:
the downward diagonal stroke on the right-hand side of
the first character (*shun*) developed an ever more pro-
nounced hook, and the final character (*ga*, "painted by")
was written as a large square enclosing a smaller square
that was bisected horizontally and vertically. During this
period Ichimatsu II, who specialized in playing women
and delicate-looking young men, appeared in many a
domestic drama (*sewamono*) as "the wife of so-and-so,"
making it difficult to identify precisely the role depicted
here. The print is quite possibly the left-hand sheet of a
diptych; discovery of the missing right-hand sheet would
assist in pinpointing the scene depicted.

Like so many of Shunshō's figures, this dainty lady is
caught in arrested movement, walking forward while
turning to look back— a pose that curves the body into a
slight, elegant arch. Her tiny hand is raised to her neck in
a delicate, coquettish gesture.

The colors remain virtually as fresh as on the day the
picture was printed.

SIGNATURE *Shunshō ga*
PROVENANCE Colonel H. Appleton collection
REFERENCE
Gookin (1931), no. CBAI 33; *Ukiyo-e Shūka*, vol. 5 (1980), no. 92

The actors Nakamura Nakazō I as Ōmi no
Kotōda (right), and Ōtani Hiroji III as Bamba no
Chūda (left), in the *jōruri* "Sono Chidori Yowa
no Kamisuki" (The Plovers: Combing Hair at
Midnight), from part two of the play *O-atsurae-
zome Soga no Hinagata* (A Soga Pattern Dyed to
Order), performed at the Nakamura Theater from
the tenth day of the third month, 1774

Hosoban diptych; each sheet approx. 28.2 x 13.3 cm
The Clarence Buckingham Collection 1939.2169

SIGNATURE *Shunshō ga*
OTHER IMPRESSIONS
(both sheets) H. George Mann collection, Chicago;
(right) Tokyo National Museum

70.1 Katsukawa Shunshō.
*The actors
Nakamura Nakazō I
as Ōmi no Kotōda
and Ōtani Hiroji III
as Bamba no Chūda.*
Japan Ukiyo-e Museum,
Matsumoto

Nakazō I as Ōmi no Kotōda (right), and Hiroji III as Bamba
no Chūda (left), retainers of the rival factions in the Soga
story, confront one another in the rice fields at dead of night,
their long swords drawn. They are similarly clad in cream-
colored (perhaps faded from blue?) kimono, with their sleeves
tied back and their topknots untied in preparation for the
fight, the hair held out of their faces by headbands (*hachimaki*).
Nakazō I draws himself up to his full height, legs straight and
heels together in *soku mie* pose, in preparation for a two-
handed lunge; Hiroji III, by contrast, stands half-crouched, his
legs braced wide apart. In actual swordplay the fighters would
rarely come in so close, but this, after all, is choreography,
not combat. The intense black of the night sky (obtained by
repeated printings of the background block, a technique
known as *ji-tsubushi*) sets off the fierce battle grimaces to
striking effect. By positioning the standing figures at the very
bottom of the sheet and extending the landscape far behind
them, Shunshō brings the action dramatically close to the
viewer.

Judging from the title and the brief mention in *Kabuki
Nempyō*, the *jōruri* "Sono Chidori Yowa no Kamisuki,"
chanted onstage by the singer Edo Handayū at the Nakamura
Theater in the New Year performance of 1774, must have
consisted of two parts. The first was the ever popular "hair-
combing" (*kamisuki*) scene, in which the courtesan Ōiso no
Tora (played by Nakamura Rikō I) combs the hair of her lover
Soga no Jūrō Sukenari (played by Matsumoto Kōshirō IV);
the second was the specially choreographed sword-fight scene
illustrated in this diptych.[1] The fight scene was apparently
"very well performed and enthusiastically received" (*ōdeki
daihyōban*),[2] and it forms the subject of another single-sheet
print by Shunshō, showing the warriors in similar costumes
fighting at close quarters beneath a pine tree (fig. 70.1). In
this single-sheet version Ōmi no Kotōda has abandoned a
large lantern bearing the crest of his lord, Kudō Suketsune,
villain of all "Soga" plays. Lord Yanagisawa Nobutoki, an
important patron of Nakazō I, attended a performance in the
second month of 1774 and recorded in his diary that the fight
scene was "very cleverly done."[3]

Shunshō used the diptych and triptych format increasingly
during the 1770s— generally placing a single standing figure
on each sheet— but many of these "sets" have been broken up.
Even if the separate sheets have all survived, the relationship
among them may go unrecognized. Though the individual
sheets are in themselves fine, often striking, designs, only
the original ensemble, of course, can fully reveal the overall
conception and the complementary poses of the figures.

1 *Kabuki Nempyō*, vol. 4 (1959), pp. 234–35. A stylized plover was the
 emblem of Soga no Jūrō and always appeared as the pattern on his
 costume.
2 *Kabuki Nendaiki* (1926), p. 344.
3 *Enyū Nikki* (1977), pp. 821–22. See No. 68.

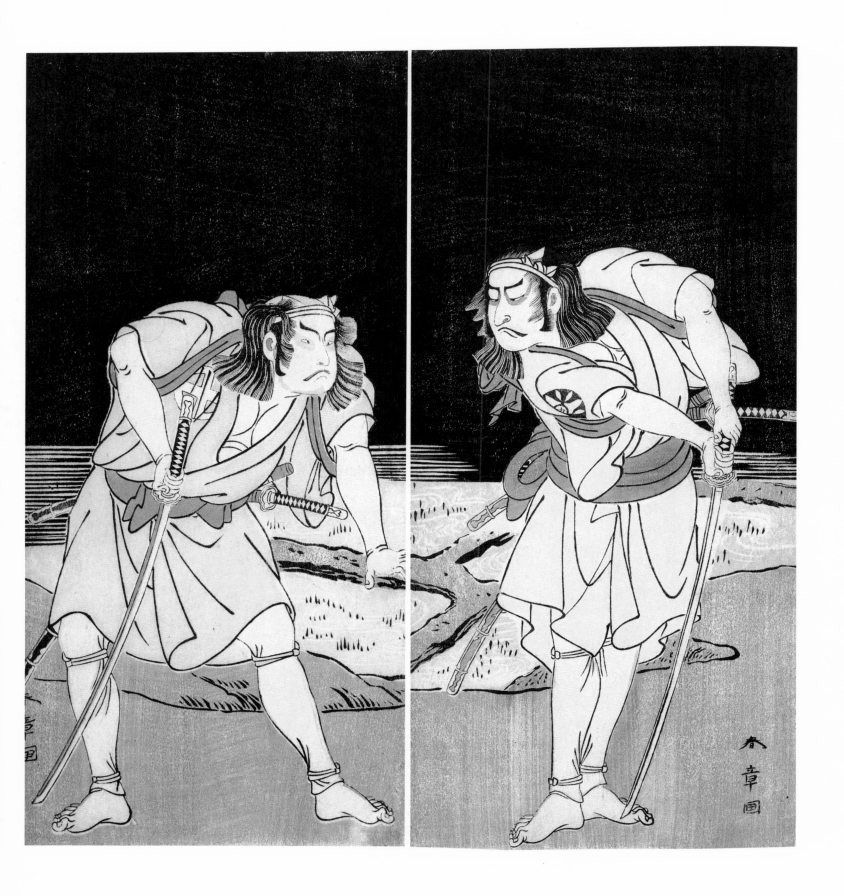

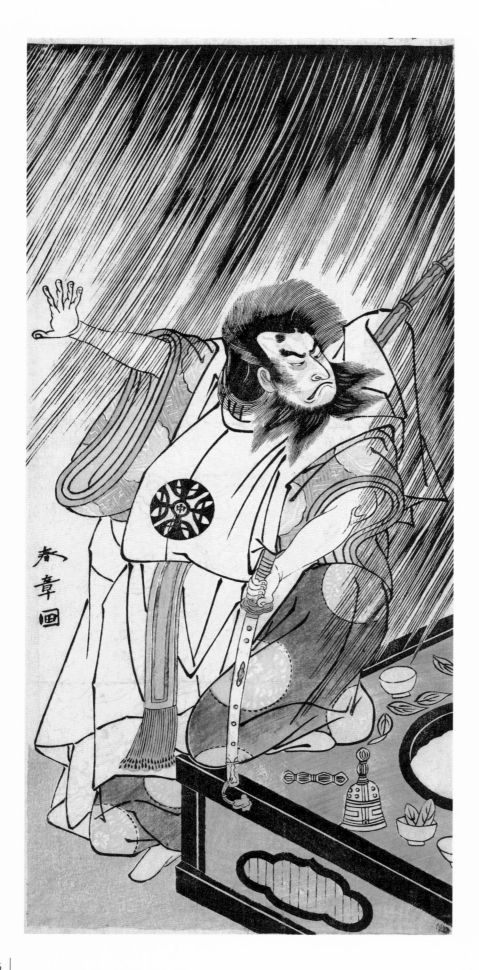

71 KATSUKAWA SHUNSHŌ

(1726–1792)

The actor Nakamura Nakazō I in the role of an evil courtier, probably Prince Takahito, illegitimate son of Emperor Takakura, disguised as Asō no Matsuwaka, in part one of the play *Iro Moyō Aoyagi Soga* (Green Willow Soga of Erotic Design), performed at the Nakamura Theater from the thirteenth day of the second month, 1775

Hosoban; 31.8 x 14.8 cm
The Clarence Buckingham Collection 1932.1013

Nakazō I once more appears in the costume and makeup of an evil courtier: white court robes, a great long sword, unkempt hair, and blue striped makeup (*kuge are*), with an aristocrat's black "stars of rank" (*kurai-boshi*, used only in Kabuki to denote courtly rank) painted on his forehead. Amid lashing rain (which discreetly does not obscure his person), the courtier strikes a menacing pose, with one arm outflung, the other hand fiercely gripping his sword, and one foot planted on a ceremonial altar platform (*goma dan*) used in Esoteric Buddhist rites. The *goma dan* is a lacquered wood platform enclosing a sunken brazier in which slips of aromatic wood inscribed with prayers were burnt in front of icons. On the platform, surrounding the brazier, are various ritual implements, including a bronze thunderbolt (*kongōsho*) and a thunderbolt-handled bronze bell (*kongōrei* or *gokorei*) as well as bowls of (mulberry?) leaves to be burned.

The researches of Suzuki Jūzō and Kimura Yaeko have suggested convincingly that this is a scene from part one of the play *Iro Moyō Aoyagi Soga*, performed at the Nakamura Theater from the second month of 1775.[1] Asō no Matsuwaka, a robber (the role played here by Nakamura Nakazō I), discovers that he was born Prince Takahito, illegitimate son of Emperor Takakura. Following the common Kabuki convention, this discovery immediately implants in him an overweening ambition to usurp the throne, and to that end he begins to practice magic Brahmanic rituals (*haramon no hō*). Matsui no Gengo (played by Ichikawa Danzō IV), a retainer who tries to dissuade him, falls victim to the magic and is made to commit suicide. At this point Matsuwaka's wife Ubatama (played by Yamashita Kinsaku II) realizes it is up to her to foil his evil ambitions. Enlisting the aid of the faithful retainer Oniō (Ōtani Hiroji III), she first murders Mibu no Kozaru (played by Nakamura Tsutaemon) and then commits suicide, for she has learned that only by the mingled blood of a man and woman born in the same year of the sixty-year zodiacal cycle can Matsuwaka's magic be counteracted. Matsuwaka is tricked into drinking the blood, and his evil powers falter. Suzuki suggests that Shunshō's print shows Matsuwaka's despair at the moment when he realizes that his ambitions have been thwarted. Not entirely beaten, however, Matsuwaka passes on his powers to the evil Kudō Suketsune (also played by Nakazō I), whereupon the plot transforms into the familiar story of the revenge of the Soga brothers.

After a dispute with the management brought about the defection from the Nakamura Theater, in the fifth month of 1774, of Ichikawa Danjūrō IV and V, Yoshizawa Sakinosuke III, Matsumoto Kōshirō IV, Ichikawa Monnosuke II, Iwai Hanshirō IV, and Ichikawa Danzaburō II, Nakazō I remained as the virtual mainstay of the Nakamura troupe.[2] In the spring of 1775 he played no fewer than five major roles, some of which were recorded by Shunshō: Asō no Matsuwaka (this print), Kudō Suketsune (cat. no. 300), Honda no Jirō, the monk Dainichibō, and a new hit role as a female seller of hare's-foot fern (*shinobu uri*).[3]

1 *Ukiyo-e Shūka*, vol. 5 (1980), pl. 89, text p. 185; also *Kabuki Nempyō*, vol. 4 (1959), pp. 255–58.
2 Described in Gookin (1931), pp. 141–43; see also *Kabuki Nempyō*, vol. 4 (1959), p. 235.
3 It is regrettable that no print has yet been identified showing Nakazō I in the role of the female *shinobu uri* in the spring play of 1775, a plagiarism of "Musume Dōjō-ji," which was the jealously guarded preserve of Nakamura Tomijūrō I and Segawa Kikunojō III. It was the *shinobu uri* role that brought about Nakazō I's elevation to the coveted *jōjōkichi* (upper, upper, felicitous) rank in the actor critiques of 1775.

SIGNATURE *Shunshō ga*
PROVENANCE Frederick W. Gookin collection
REFERENCE Gookin (1931), no. 217; *Ukiyo-e Shūka*, vol. 5 (1980), no. 89

AZUMA ŌGI

(FANS OF THE EAST): 72 and 73.

"*Note*: In order to make this folding fan, please cut out the fan shape from the sheet and make the folds along the lines shown. Then tap it [flat] with a mallet, line up the top and bottom and trim to a length of six *sun* [approx. 6″]. Take the old ribs of a fan which you have to hand and stick them one by one onto one side of the paper. In no time at all you will have a folding fan for your personal use. We will keep publishing many different designs. Of course, they are also suitable for sticking onto your folding screens and sliding doors in scattered arrangements. Please request yours now!"

— Iwatoya Gempachi, *Publisher*

This instruction/advertisement printed on every sheet of the series *Azuma Ōgi* (Fans of the East, i.e., Edo) makes it clear that the half-length portraits of actors drawn by Shunshō inside fan-shaped borders were actually intended to be cut out and used to create folding fans. And the extreme rarity of surviving prints from the series implies that the public followed these instructions enthusiastically. In an entry in his diary *Hannichi Kanwa* (A Half-Day's Idle Chat), dating from the fifth month of 1776, the celebrated man of letters Ōta Nampo is surely referring to "Fans of the East" when he records: "Recently, color-printed portraits of Kabuki actors on fan-shaped papers have been coming out. You make the folds, stick them to the ribs from an old fan, and [thus] make a new one."[1] At present twenty-three designs from the series are known, including one by Utagawa Toyoharu (1735–1814) and two by Isoda Koryūsai (act. ca. 1766–1788).[2] Some of these have survived only in single impressions, so it is likely the range of designs was originally more extensive. Preliminary investigation of the dates when the roles were performed suggests that the series was issued over a period of years, about 1775–1782 (which would accord well with the date of Nampo's diary entry above).[3] The possibility remains, however, given the practical use intended for the fans, that some of the designs may be retrospective—i.e., recalling a role made famous by an actor in earlier years.

Fans bearing portraits of actors seem to have been something of a vogue in the late 1760s. A well-known print by Harunobu from about 1767–1768 shows a young man selling fans of the nonfolding (*uchiwa*) type from a portable stall, and prominent at the top of his display is one decorated with a bust portrait of an actor, perhaps in a Soga role (fig. 72.1).

Half-length portraits of actors enclosed in fan shapes had occurred to Shunshō virtually from the beginning of his career. This form was most extensively developed in the color-printed illustrated book *Ehon Butai Ōgi* (A Picture-Book of Stage Fans), designed by Shunshō in collaboration with Bunchō and issued by the publisher Kariganeya Ihei in 1770 (fig. 72.2). But even before this Shunshō designed a number of single-sheet prints, each of which contains several fan-shaped portraits of actors within the narrow confines of the *hosoban* format (fig. 72.3). Given Shunshō's revolutionary interest in capturing something of the actual facial features of the actors (*nigao-e*), this focus on the half- or bust-length portrait (albeit within a fan-shaped frame) should come as no surprise.[4] Not until 1780, however, would Shunshō design an *ōban* half-

72 KATSUKAWA SHUNSHŌ

(1726–1792)

The actor Ōtani Hiroji III as a chivalrous commoner (*otokodate*), possibly Satsuma Gengobei in the play *Iro Moyō Aoyagi Soga* (Green Willow Soga of Erotic Design), performed at the Nakamura Theater from the thirteenth day of the second month, 1775

Series title: *Azuma Ōgi* (Fans of the East)
Bai aiban (double *aiban*); 42.0 x 31.0 cm
The Clarence Buckingham Collection 1928.987

SIGNATURE *Shunshō ga*
PUBLISHER Iwatoya Gempachi
PROVENANCE Hayashi Tadamasa; Alexander G. Mosle collection
REFERENCE
Gookin (1931), no. CBAI 5; *Ukiyo-e Shūka*, vol. 5 (1980), no. 27

length portrait without a fan-shaped or decorative border (fig. 112.2), a lead which was quickly followed by Shunkō (Nos. 112, 113).

1 Quoted by Suzuki Jūzō in *Ukiyo-e Shūka*, vol. 5 (1980), no. 27.
2 The designs from the series currently known are: 1. Ichikawa Danjūrō V as Sukeroku (ex-coll. Aihara); 2. Ichikawa Danjūrō V as a *shakkyō* dancer (ex-coll. Aihara); 3. Ichikawa Danjūrō V as an *uirō* seller (ex-coll. Aihara; *Ukiyo-e Taikei*, vol. 3 [1976], no. 127); 4. Ichikawa Danjūrō V as Kudō Suketsune (Tokyo National Museum [1960], no. 984); 5. Ichikawa Monnosuke II as Soga no Jūrō Sukenari (ex-coll. Aihara; *Ukiyo-e Taikei*, vol. 3 [1976], no. 128); 6. Ichikawa Monnosuke II in an unidentified role (ex-coll. Aihara; *Ukiyo-e Taikei*, vol. 3 [1976], no. 129); 7. Matsumoto Kōshirō IV in an unidentified role (ex-coll. Aihara; *Ukiyo-e Taikei*, vol. 3 [1976], no. 130); 8. Ōtani Hiroji III, probably as Satsuma Gengobei (The Art Institute of Chicago, Buckingham Collection, 1928.987, No. 72); 9. Ōtani Hiroemon III in an unidentified role (Hayashi [1902], pl. 536); 10. Nakamura Matsue I as Oyamada Tarō (ex-coll. Aihara); 11. Nakamura Nakazō I as Ono Sadakurō (Tokyo National Museum [1960], no. 985; The Art Institute of Chicago, Buckingham Collection, 1932.1004, No. 73); 12. Nakamura Nakazō I brandishing a sword (*Genshoku Ukiyo-e Daihyakka Jiten*, vol. 7 [1980], p. 183); 13. Onoe Matsusuke I as an *otokodate* (*Ukiyo-e Geijutsu*, vol. 97 [1989], cover); 14. Segawa Kikunojō III as Kuzunoha (ex-coll. Aihara; *Ukiyo-e Taikei*, vol. 3 [1976], no. 135); 15. Segawa Kikunojō III in an unidentified role (ex-coll. Aihara; *Ukiyo-e Taikei*, vol. 3 [1976], no. 133); 16. Segawa Kikunojō III as Shirokiya Okoma (*Ukiyo-e Taikei*, vol. 3 [1976], no. 134); 17. Iwai Hanshirō IV as Agemaki (ex-coll. Aihara; *Ukiyo-e Taikei*, vol. 3 [1976], no. 131); 18. Nakamura Rikō I as Katsushika no Ojū (Tokyo National Museum [1960], no. 983); 19. Nakamura Rikō I in an unidentified role (*Ukiyo-e Taikei*, vol. 3 [1976], no. 132); 20. Yamashita Kinsaku II in an unidentified role (ex-coll. Schindler); 21. [Utagawa Toyoharu] Gurnard and flatfish (present location unknown); 22. [Isoda Koryūsai] Plum blossoms and long-tailed bird (present location unknown); 23. [Isoda Koryūsai] The courtesan Hanaōgi of the Ōgiya (The Art Institute of Chicago, Buckingham Collection, 1949.33).
3 These dates for the series are suggested in *Genshoku Ukiyo-e Daihyakka Jiten*, vol. 7 (1980), p. 27. Some scholars believe the series to have been begun somewhat earlier, about 1773.
4 Richard Lane illustrates a fan painting by Shunshō with a portrait of the actor Nakamura Sukegorō II as a *yakko*, in *Images from the Floating World* (1978), pl. 113, p. 118. The form of the signature and written seal (*kaō*) would suggest a date in the 1780s.

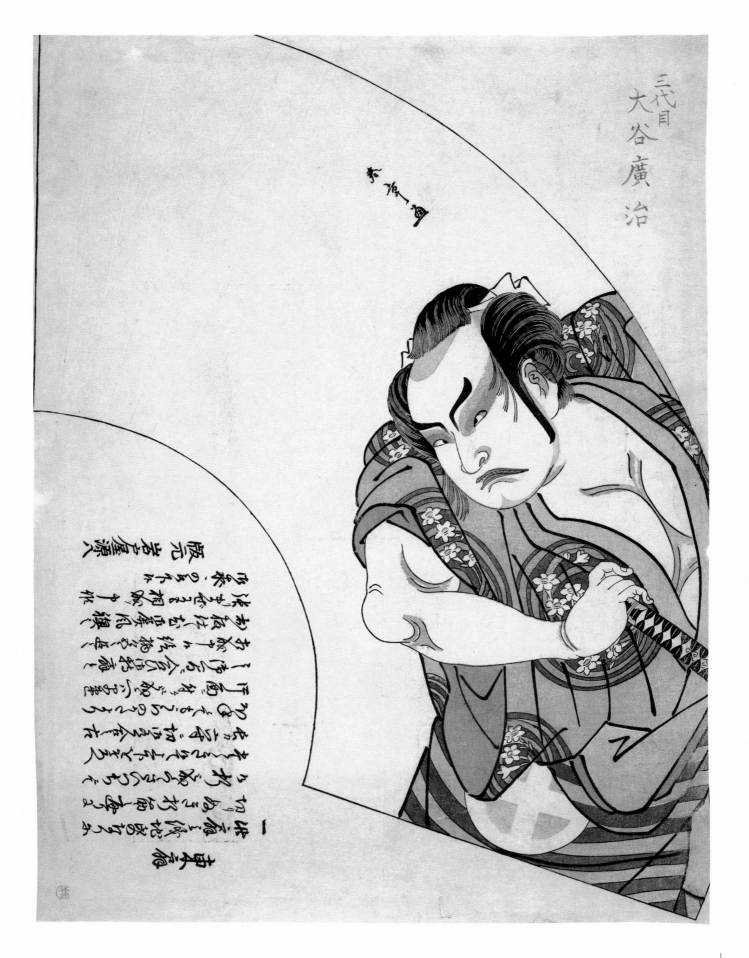

Ōtani Hiroji III is here cast in his customary role as a muscular champion of the oppressed (*otokodate*), hand on the hilt of his sword, his crossed eyes indicating, as was the usage in Kabuki, the most resolute determination. The pale crimson under-kimono is decorated with the narcissus roundel pattern that was made famous by his predecessor, Ōtani Hiroji II, while the striped kimono bears the Ōtani lineage's standard crest (*jōmon*) of a cross within a circle. As in the print of Nakazō I from the same series (No. 73), the figure of the actor curves to the shape of the fan, and the unusually large scale of the face (proportionately much larger than in a *hosoban*) allows us to enjoy fine details of the design, cutting, and printing: the improbably large mouth, which droops in opposition to the up-curving eyebrow; the two shades of pink used for the bands of makeup around the eyes; and the sensitive engraving of the wig, with one sidelock recurving in front of the ear. The print is in near perfect condition, with even the indigo blue relatively unfaded.

The identification of the role as the *otokodate* Satsuma Gengobei (actually Yamada no Saburō in disguise) must remain tentative. It is based on the affinities between this print and another in the series, showing Nakamura Rikō I sporting the sword and hand towel of a "female champion of the oppressed" (*onnadate*) (fig. 72.4). In the past this was identified by Yoshida Teruji, without supporting evidence, as the role of Katsushika no Ojū (actually the wife of Yamada no Saburō in disguise) played by Rikō I opposite Hiroji III in *Iro Moyō Aoyagi Soga* at the Nakamura Theater in the second month of 1775.[1] The signatures on the two prints are very similar, but definite identification must await more evidence.

The Chicago impression bears the name of the actor hand-written in red ink at the top right-hand corner of the print. Similar inscriptions are seen on the three prints from this series in the collection of the Tokyo National Museum, and all these must once have belonged to the same collector.[2]

1 Yoshida Teruji, *Ukiyo-e Zenshū*, vol. 5, *Yakusha-e* (1957), pl. no. 4; mentioned by Suzuki Jūzō in *Ukiyo-e Shūka*, vol. 5 (1980), no. 27.
2 Tokyo National Museum (1984), nos. 222–24.

72.1. Suzuki Harunobu.
A Fan Peddler.
Museum für Ostasiatische Kunst, Berlin

72.2. Ippitsusai Bunchō and Katsukawa Shunshō.
*Half-length portraits of the actors Nakajima Mihoemon II
and Nakamura Nakazō I.* From *Ehon Butai Ōgi.* Chester
Beatty Library, Dublin

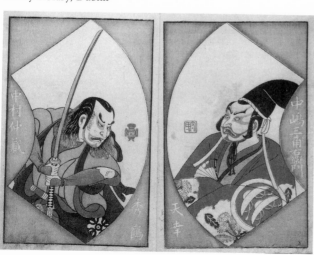

72.3. Katsukawa Shunshō. *Half-
length portraits of the actors Ichikawa
Danzō III, Nakamura Nakazō I,
Matsumoto Kōshirō III, and
Ōtani Hiroemon III.* Museum für
Ostasiatische Kunst, Berlin

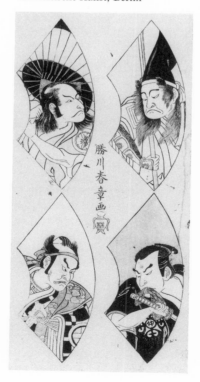

72.4. Katsukawa Shunshō. *The actor
Nakamura Rikō I as an onnadate. From the series
Azuma Ōgi.* Tokyo National Museum

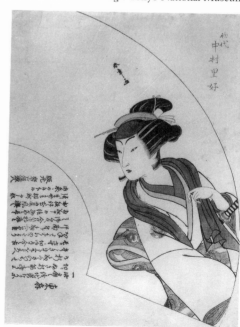

73 KATSUKAWA SHUNSHŌ

(1726–1792)

The actor Nakamura Nakazō I as Ono Sadakurō in act five of *Kanadehon Chūshingura* (Model for *Kana* Calligraphy: Treasury of the Forty-seven Loyal Retainers), performed at the Nakamura Theater from the fifth day of the fifth month, 1776

Series title: *Azuma Ōgi* (Fans of the East)
Bai aiban (double *aiban*); 45.4 x 32.8 cm
The Clarence Buckingham Collection 1930.391

In the ninth month of 1766 a production of *Chūshingura* at the Ichimura Theater marked the return of Onoe Kikugorō I from Kansai (the Osaka-Kyoto region). In this production of the famous revenge tale Nakamura Nakazō I scored a sensation with a completely new interpretation of the role of the robber Ono Sadakurō in act five. The occasion proved to be a turning point in his career: from that time on he became the leading interpreter of cruel and villainous roles.

Until Nakazō I's reinterpretation, Sadakurō— who murders and robs the old man Yoichibei at a lonely mountain pass on the Yamazaki highway— had been played in the manner (and costume) of a mountain bandit. But Sadakurō, though thoroughly vicious, had been born into a high-ranking samurai household, and Nakazō I therefore portrayed him as a scruffy *rōnin* (masterless samurai), bearing all the signs of once-honorable estate fallen to baseness and slovenry. This is the guise we see depicted here on Shunshō's fan-print: a wig with the hair grown out on what should be a shaved pate; a tattered short-sleeved kimono in black *habutae* silk still bearing his clan's falcon-feather crest (this worn as if an unlined summer kimono); a brown *kokura* (hard-woven cotton) obi; a pair of swords with red lacquer sheaths; rolled-up sleeves; kimono skirt tucked out of the way into the back of the obi; rush sandals likewise thrust into the back of the obi; white makeup on his face, arms, and legs. Since the scene takes place on a stormy night, Nakazō I doused himself with a bucket of water before coming on, and he carried a battered umbrella with a snake's-eye pattern. He called out to Yoichibei from the *hana-michi* walkway, then wrung out his sleeves and wiped the water from his hair as he reached the stage.[1] The audience loved it.

No illustration is known of this interpretation as performed in 1766, but when Nakazō I played Sadakurō for the second time, in the summer of 1768, Shunshō designed a full-length *hosoban* portrait (fig. 73.1). Given the tentative period of publication (ca. 1775–1782) for the series *Azuma Ōgi*, it is likely that the fan print illustrated as Number 73 relates to the fourth time Nakazō I played the role, in the fifth month of 1776.

Sadakurō is shown in the act of drawing his sword to murder old Yoichibei for the tragically gotten purse he is carrying. The fabric of his kimono has bunched into a formidable mass of intense black, and against this his face has been printed in a sickly pinkish white, with gray half-circles under the slitted eyes. Perhaps the most impressive aspects of the print are the way in which the figure looms suddenly, startlingly into view from one corner of the fan, and the subtle conformation between the menacing bulk of the body and the fan-shaped outline.

1 The description of Sadakurō's costume and actions is taken from Ihara (1913), pp. 134–35.

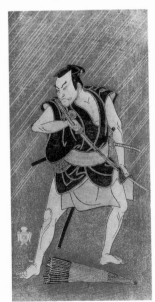

73.1. Katsukawa Shunshō.
The actor Nakamura Nakazō I as Ono Sadakurō.
Irma E. Grabhorn-Leisinger collection, San Francisco

SIGNATURE *Shunshō ga*
PUBLISHER Iwatoya Gempachi
PROVENANCE Baron Fujita collection
REFERENCE
Ukiyo-e Taikei, vol. 3 (1976), no. 39; *Ukiyo-e Shūka*, vol. 5 (1980), black-and-white no. 10
OTHER IMPRESSIONS Tokyo National Museum

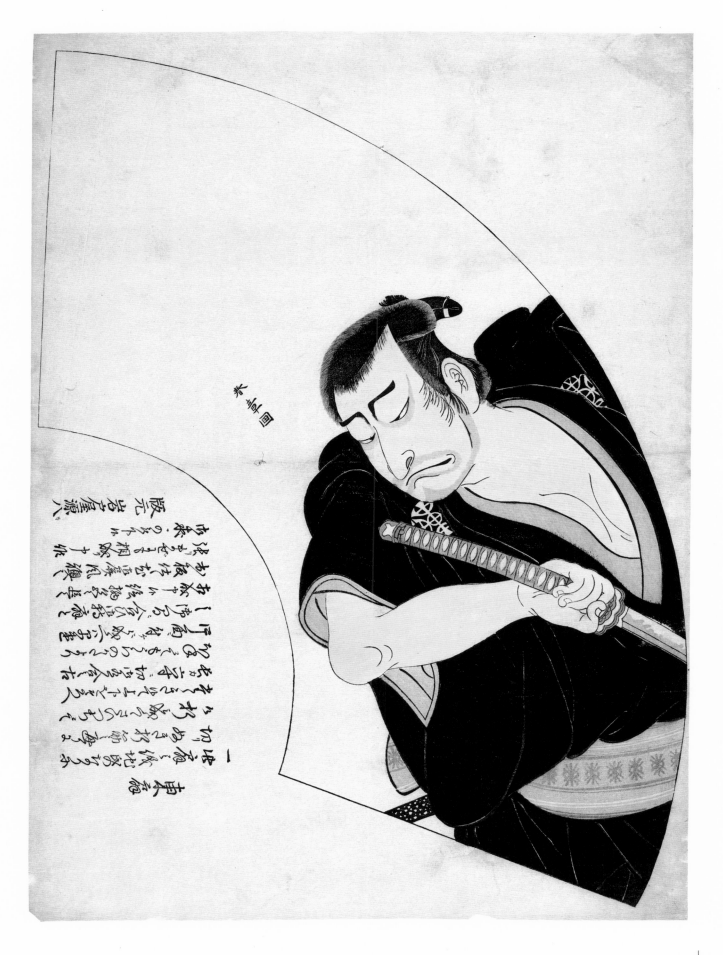

74 KATSUKAWA SHUNSHŌ

(1726–1792)

The actor Segawa Kikunojō III in private life, standing in a snow-covered garden
Ca. 1775

Large *hosoban*; 38.5 x 17.5 cm
The Clarence Buckingham Collection 1949.39

This special portrait of Segawa Kikunojō III must have been issued shortly after the young actor succeeded to this prestigious name at the opening-of-the-season (*kaomise*) performance in the eleventh month of 1774, in his mid-twenties and doubtless at the height of his beauty. As Ichiyama Tomisaburō, he had arrived from Osaka the previous year with sufficiently high reputation to be named by Kikunojō II as his successor when the latter lay dying in the third month of 1773. Kikunojō III danced "Musume Dōjō-ji" (The Maiden at Dōjō-ji), one of Kikunojō II's best-loved roles, in memory of his predecessor, and quickly won over Edo fans with his good looks and charm in female roles.[1] Together with Nakamura Tomijūrō I, he would dominate "young woman" (*waka-onnagata*) roles during the 1770s and '80s and on into the nineteenth century.

The actor is shown not in costume but in the height of offstage good taste, elegantly posed in a snowy garden. By showing Kikunojō's hand tucked inside his long hanging sleeve and raised in a gesture of aesthetic delight, Shunshō simultaneously reveals the beauty of the garment and calls our attention to the beauty of the scene. In his other hand Kikunojō III holds a furled umbrella. Scattered chrysanthemum blossoms decorate the skirt of the pale blue kimono, and the actor's formal crest (*jōmon*), a bundle of floss silk (*yuiwata*), is just visible at the breast. The fashionably long purple jacket (*haori*) has a pattern of decorated New Year balls and also bears Kikunojō III's informal crest (*kaemon*) of a chrysanthemum-and-butterfly (*kiku-chō*). About this time a new hair style called lantern locks (*tōrōbin*), in which the side locks were combed outward to resemble the silhouette of a paper lantern, had just become the rage. Kikunojō III, whose stage persona made him a leader of female fashion, was of course to be seen in the latest style.

The larger-than-normal size of this *hosoban* print, together with the careful cutting and printing, suggests that it might have been specially commissioned by some wealthy theater patron keen to promote the career of the attractive young man. Kikunojō II and III are both known, in fact, to have enjoyed the special support and patronage of Lord Matsudaira Munenobu (Nankai; 1729–1782), daimyo of Matsue. The possibility that it was a special commission is further borne out by the haiku poem printed above the figure, which was composed by Kikunojō III and signed with his pen name, Rokō:

Hatsuyuki ya	The first snow!
monomi e hakobu	Move the foot-warmer
okigotatsu	To the balcony with the view.

A similar print is known, showing Yamashita Kinsaku II holding a fan and with a poem referring to summer planting. Suzuki Jūzō suggests that these two may originally have formed half of a set of four portraits of popular female impersonators in settings relating to the four seasons.[2]

1 For an account of Kikunojō III's career, see Ihara (1913), pp. 254–65.
2 *Ukiyo-e Shūka*, vol. 5 (1980), no. 29.

SIGNATURE *Shunshō ga*
PROVENANCE Louisa Langdon Kane collection; Louis V. Ledoux collection
REFERENCE
Gookin (1931), no. 148; Ledoux (1945), no. 50; *Ukiyo-e Taikei*, vol. 3 (1976), no. 25;
Ukiyo-e Shūka, vol. 5 (1980), no. 29
OTHER IMPRESSIONS Japan Ukiyo-e Museum, Matsumoto

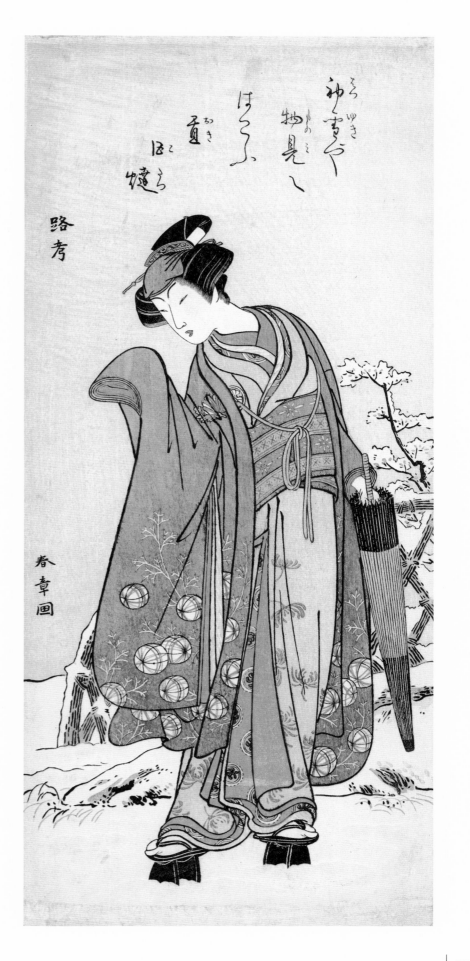

そら行き
神(かみ)むまや
物(もの)見(み)し
ほとふ

夏(なつ)
ほと
き

路考

春
章
画

Illustrations from the book *Seirō Bijin Awase Sugata Kagami* (Comparison of
Beauties of the Green Houses: A Mirror of their Lovely Forms)
New Year, 1776

Double-page illustrations cut from a book; each approx. 21.8 x 30.2 cm
Frederick W. Gookin Collection 1939.815, –817, –820, –843

The book *Seirō Bijin Awase Sugata Kagami* (Comparison of
Beauties of the Green Houses [i.e., houses of pleasure]: A Mirror
of Their Lovely Forms), illustrated jointly by Shunshō and Shige-
masa, has long been appreciated not only as a superb example of
color printing but also as a kind of celebration of the ever more
extravagant cult of the Yoshiwara courtesan in the late eighteenth
century.

It is true that an earlier book of over one hundred portraits of
Yoshiwara courtesans, the *Seirō Bijin Awase* (Comparison of
Beauties of the Green Houses) of 1770 by Suzuki Harunobu (ca.
1724–1770), had for its day been equally ambitious (fig. 75.1).
Yet *Seirō Bijin Awase Sugata Kagami*, by incorporating and ex-
panding on the title of the earlier work, seems to proclaim that
its creators had matched and surpassed the achievement of their
predecessor. Harunobu's delicate women appear against a plain
background with a haiku poem written above; in Shigemasa and
Shunshō's double-page designs the lavishly bedecked courtesans
inhabit richly detailed and brightly colored indoor and outdoor
settings, with the poems relegated to a separate section at the
back of the last volume. This reflects the ever more sumptuous
tenor of *ukiyo-e* prints of beautiful women in the later 1770s
and 1780s.

The work is divided into three volumes: volume one contains a
three-page preface by Kōshodō Shujin ("Owner of the Kōshodō,"
the business appellation of the publisher Tsutaya Jūzaburō), ten
double-page illustrations of beauties in spring and eight double
pages of others in summer, each introduced by an illustration
of appropriate seasonal flowers. Volume two contains twelve
double pages of autumn charmers and ten double pages of
winter, each section also introduced by seasonal flowers. Volume
three begins with a single page showing the *ōmon-guchi*, main
gate of the Yoshiwara, and then guides us around the pleasure
district with three double pages of courtesans seated in the
assignation teahouses and making progresses along the street.
On the remaining fourteen sheets are haiku poems by each of the
women, in the same order in which the women are illustrated
and therefore in seasonal order as well. The final page gives the
names of the artists, engraver, and publishers, and the date as
recorded above.[1]

The preface by Tsutaya may be translated as follows:

"The analects of Confucius say that to perfect oneself requires
not only a fine basic nature but also the cultivation of one's moral
character. One can compare it to adding the finishing white
touches to a painting. It is, however, also true that masterpieces
of Chinese painting and artistic refinement are judged differently
at different times. Even famous Japanese *yamato-e* masters in
the three capitals must follow the changes in fashion and culture
by showing the latest hairpins and kimono patterns; all people
must also go through changes by maturing from childhood to
adulthood.

"The successful print artists Kitao [Shigemasa] and Katsukawa
[Shunshō] have now depicted graceful courtesans in the various
seasons, showing their manners and customs within elegant
surroundings at the brothels. The book is entitled *Bijin Awase
Sugata Kagami* and consists of three volumes, namely *Moon*,
Snow, and *Flowers*. To assure its success and the prosperity of my
publishing business, the designs have been carved onto cherry-
wood blocks. Moreover I asked the ladies to contribute their
occasional, seasonal verses to imbue their portraits with spirit.
I wish that these ladies will be inspired to compose new poems
and recite them, smiling sweetly, when they see their portraits."[2]

The phrase "to assure . . . the prosperity of my publishing house"
can be interpreted quite literally. It was only in the autumn of the
previous year that Tsutaya had established himself as a major
publisher by securing the monopoly on publication of the semi-
annual guides to the Yoshiwara (*Yoshiwara Saiken*). Indeed it has
been suggested that Tsutaya collaborated in this project with the
long-established firm of Yamazakiya Kimbei in order to engage
leading artists and engravers who would otherwise have been
unavailable to him.[3] That Tsutaya should have contributed the
preface himself surely indicates a closely proprietary interest in
the successful outcome of the venture, and the exhortation to the
courtesans to "be inspired to compose new poems" suggests that
this ambitious newcomer on the publishing scene was already
planning a sequel.

Each illustration is opulent with the many-layered robes of the
courtesans, predominantly in shades of pink, scarlet, and purple.
To these are added many closely observed luxurious accessories
and accoutrements, creating an overall visual effect of sheer
material lavishness. Great stress is laid on the refined and culti-

vated daytime pursuits of the grand courtesans, with not a vulgar hint of their principal profession. During this period the official monopoly of the Yoshiwara as the only licensed pleasure district was threatened by less expensive unlicensed districts (*okabasho*) dotted about the city. Books such as these can be seen in part as a counter-maneuver by the brothel owners and publishers to emphasize the exclusivity— and hence justify the high prices— of the Yoshiwara. It is no coincidence that many of the women are shown pursuing the refined courtly pastimes of the Late Heian period (984–1185) as described in the *Tale of Genji*; unquestionably these contemporary courtesans were meant as latter-day versions of the exquisite, ethereal yet passionate court ladies of the distant past. The phrase *bijin awase* (comparison of beauties) in the title of the book was definitely intended to evoke such ancient courtly pastimes as *uta awase* (poem competition) and *kō awase* (incense matching).

True to the artistic conventions of *ukiyo-e* during this period, these pictures are in no way intended as physiognomically accurate portraits of each woman. Rather, they conform to the unified ideal of female beauty evolved by the two artists concerned; a stereotype, if you will, that is so pervasive as to make it well-nigh impossible to differentiate the designs by the two different hands.[4] This has the happy result, however, of concentrating attention on the inventiveness of the compositions and on the details of the paraphernalia for the pastimes portrayed.

1 Black-and-white photographs of the complete *Seirō Bijin Awase Sugata Kagami* may be found in Ōta Kinen Bijutsukan, eds., *Tsutaya Jūzaburō to Temmei Kansei no Ukiyoeshi-tachi* (Tokyo, 1985), pp. 61–94.
2 Translation by Osamu Ueda.
3 Ōta Kinen Bijutsukan, *Tsutaya Jūzaburō*, p. 20.
4 Gookin, after consulting "Japanese experts," proposed that the spring and autumn designs be assigned to Shigemasa and the summer and winter ones to Shunshō (Gookin [1931], p. 154).

SIGNATURES *Katsukawa Yūji Shunshō*; *Kitao Karan Shigemasa*
ARTISTS' SEALS
Katsukawa and *Shunshō*; *Kitao* and *Shigemasa no in*
ENGRAVER Inoue Shinshichi
PUBLISHERS Yamazakiya Kimbei and Tsutaya Jūzaburō
REFERENCE Gookin (1931), no. 145, text pp. 150–54

75.1. Suzuki Harunobu.
Portraits of Yoshiwara courtesans.
From *Seirō Bijin Awase.*
Chester Beatty Library, Dublin

75A Women of the Chōjiya House of Pleasure (early summer)

Karauta stands at the center of the balcony watching Hinazuru,
who is playing a hand drum (*tsuzumi*). Meizan sits listening to
the call of the cuckoo in flight. Volume one, sheets 14 and 15.
(1939.815)

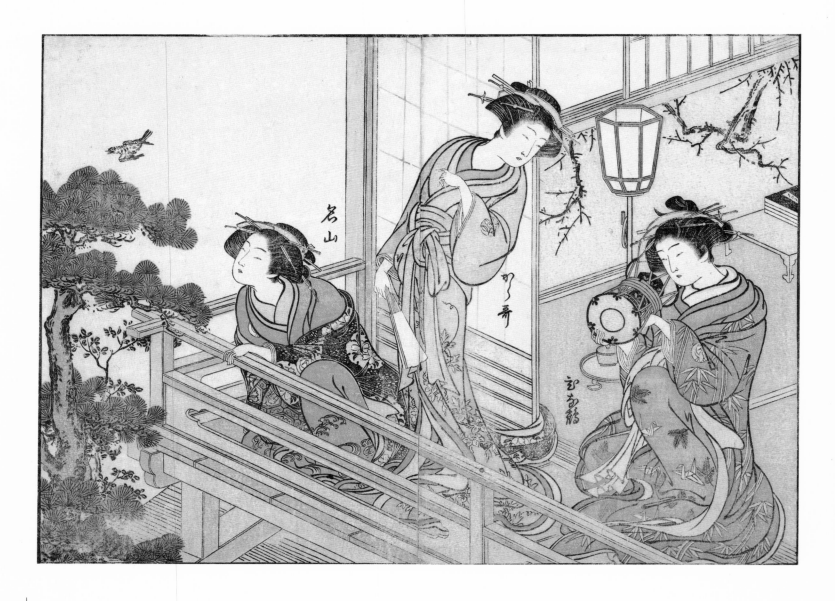

75B Women of the Yadaya House of Pleasure (summer)

Tamazusa reclines and Konoharu is seated on a summer platform
covered with a red carpet. Shiratama stands holding a fan. The
women are watching some miniature fireworks sparking in the
small brazier from a smoking set. Volume one, sheets 16 and 17.
(1939.817)

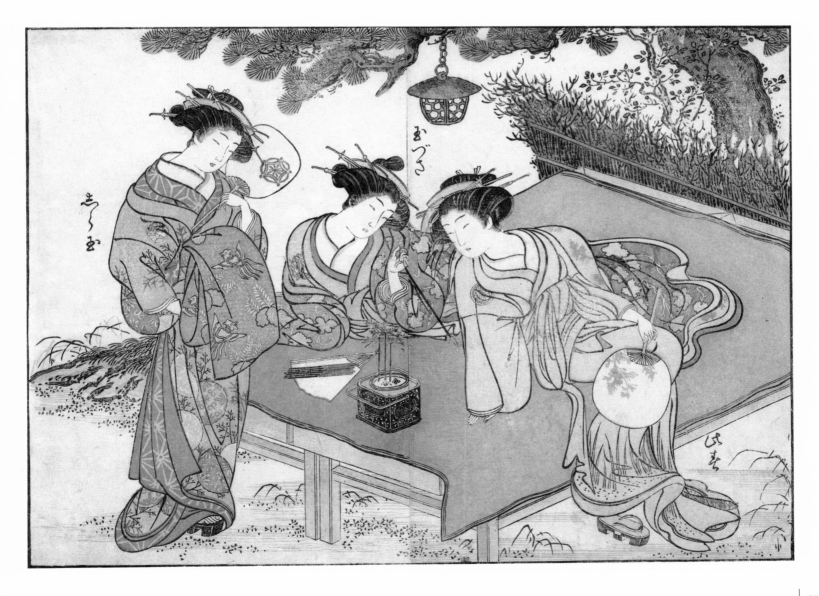

75C Women of the Kadotsutaya House of Pleasure (summer)

Shioginu is seated before the tokonoma alcove arranging tiger
lilies, while Hitomachi (smoking a pipe) and Michiharu look on.
Volume one, sheets 19 and 20. (1939.820)

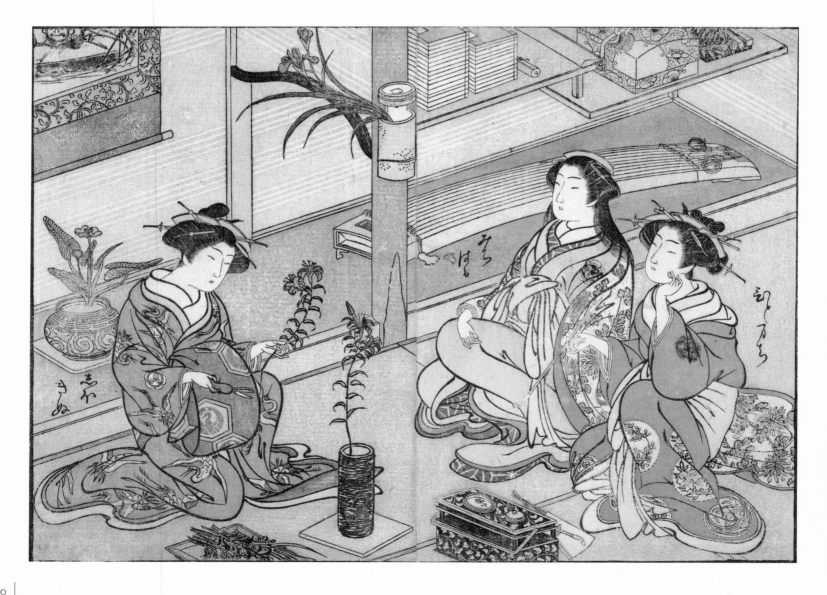

75D Women of the Ōbishiya House of Pleasure (winter)

Isawa, Kisakata, Mitsunoho, and Mitsuhana (right to left) are
gathered on a balcony, looking across snow–covered fields at
distant Mt. Fuji through a spyglass. Volume two, sheets 22 and 23.
(1939.843)

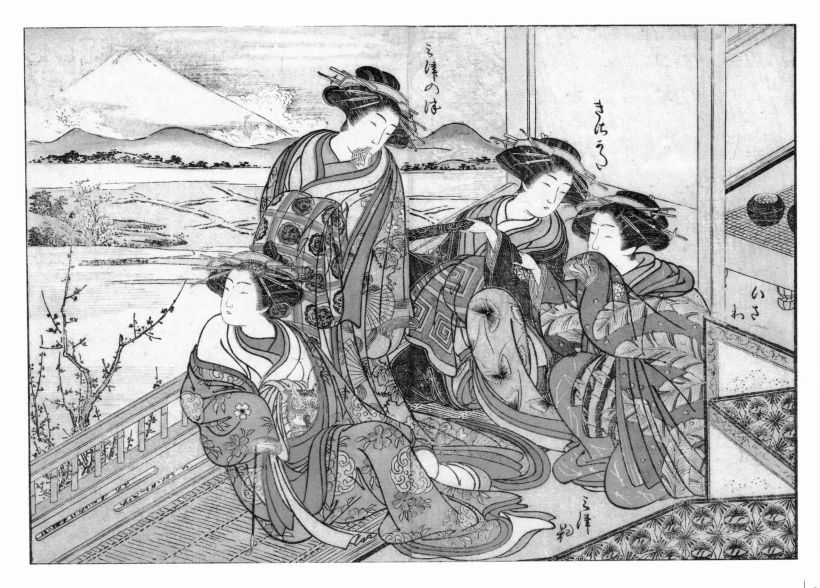

76 KATSUKAWA SHUNSHŌ
(1726–1792)

Young woman with a caged monkey
(calendar print for New Year 1776)

Chūban; 25.7 x 17.0 cm
The Clarence Buckingham Collection 1929.75

As a young woman wearing a kimono with long hanging sleeves
(*furisode*) walks past, her pet monkey mischievously reaches
through the bars of its cage and grasps the end of her sash. Rais-
ing her long sleeve, the young woman looks around with an
expression of affectionate surprise. This charming scene is in fact
encoded with a series of visual messages relating to the New
Year of 1776. The potted miniature white plum tree and *fukujusō*
(*adonis vernalis*) plants on top of the cage are auspicious deco-
rations and presents for the New Year holiday; 1776 was the year
of the monkey; the monkey's gesture calls attention to the hem
of the woman's sash, which is decorated with the characters for
"An'ei 5" (fifth year of the An'ei era = 1776); and the roundels on
the sash contain the numbers for the "long" months of the lunar
calendar for that year— 1, 3, 5, 7, 9, 10, 11.

This is a calendar print (*egoyomi*, literally "picture calendar"), and
the custom of distributing calendar prints as New Year gifts had
existed since at least the beginning of the eighteenth century.
Some of the illustrations were privately commissioned from
professional *ukiyo-e* artists by amateur poets, as settings for their
New Year verses. This example bears a poem signed with the
nom de plume Fuyōsō (Hibiscus Window) and sealed Kozan
(Lake Mountain):

Ume ga ka ya	Fragrance of the plum!
abura mo nurumu	And the oil warms
hitai-gami	In the hair at the brow.

In other words, the fragrance locked in the plum blossoms and
the scent of the oil that sets the woman's elaborate coiffure
(*tōrōbin*, "lantern locks") are both released by the gentle warmth
of the early spring sun.

Shunshō's signature is followed by a rare early form of his writ-
ten seal (*kaō* or *kakihan*), which he came to use commonly on his
paintings in the 1780s (when the use of such a seal became
generally customary). It has been suggested that this early *kaō* is
an abbreviation of the character *yū* from Yūji, one of Shunshō's
art names (*gō*).[1] The color of the woman's *furisode* has faded
from pale blue to a light sand.

1 Naitō Masato, "Katsukawa Shunshō no Nikuhitsu Bijinga ni tsuite,"
 Bijutsushi, no. 125 (March 1989), p. 80.

SIGNATURE *Shunshō ga*
ARTIST'S WRITTEN SEAL (*kaō*) *Yū* (?)
ENGRAVER Okamoto Shōgyo
REFERENCE
Gookin (1931), no. 151, text p. 162; *Ukiyo-e Shūka*, vol. 5 (1980), no. 30

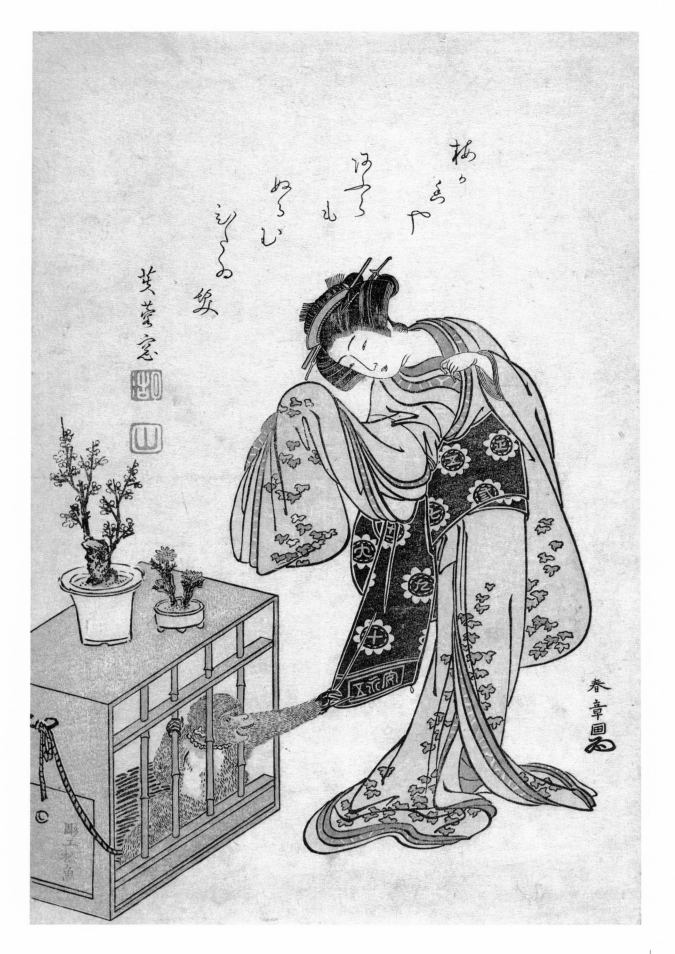

77 KATSUKAWA SHUNSHŌ
(1726–1792)

Woman on a verandah about to open a love-letter
Mid–late 1770s

Wide *hashira-e*; 69.0 x 16.7 cm
The Clarence Buckingham Collection 1942.129

A woman has come out onto the corner of a verandah under the eaves, away from prying eyes, to open a love-letter. From her coiffure she pulls a hairpin with which to break the seal on the letter. Her kimono, now faded but originally perhaps pale blue, is patterned with vine-grasses (*tsuru kusa*) around the hem and tied with a heavy obi brocaded with a design of interlocking circles. A red plum tree in blossom around the corner of the verandah shows that the season is early spring.

Shunshō's prints of beautiful women are very rare: perhaps half a dozen designs in the "wide *hashira-e*" format are known, each showing a full-length standing figure (see Nos. 78, 79). Yet this was the format in which, during the 1780s, he would execute a large number of autograph paintings, of which more than one hundred now survive. Like the Kaigetsudō school of artists at the beginning of the eighteenth century, Shunshō seems to have designed prints of beautiful women as something of a sideline to the more prestigious and profitable work of painting hanging scrolls for wealthy clients. A popular novel published in 1775 offers the passing comment, "A hanging scroll by Shunshō is worth one thousand gold pieces,"[1] and even allowing for a bit of hyperbole, paintings must have been expensive. For those who wanted a picture of a beauty in Shunshō style but could not afford to commission a painting, a handsome print such as this, in a format suggestive of a hanging scroll, would have served as a welcome substitute.

Several later Shunshō paintings echo the woman's pose in this print: a long, perfect curve, with shoulders back, stomach forward, and knees slightly bent, long skirts fanning out around the feet. Her head is tilted down, the neck forming a right angle with the shoulder, so that she can open or read a letter, cradle her pet cat, glance down at the puppy playing at her feet. These combinations of attitude and action make the women seem simultaneously reticent and intensely appealing.

1 This comment, "Shunshō ippuku senkin," appears in *Tōsei Onna Fūzoku Tsū*, with text by Hōseidō Kisanji and illustrations by Shunshō, published in 1775.

SIGNATURE *Shunshō ga*
PROVENANCE
Arthur Davison Ficke collection; Charles H. Chandler collection
OTHER IMPRESSIONS
The Art Institute of Chicago (Kate S. Buckingham Fund, 1952.382)

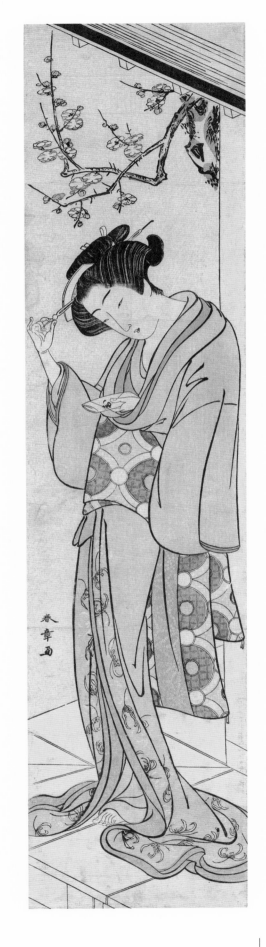

78 KATSUKAWA SHUNSHŌ

(1726–1792)

A courtesan of the Matsubaya House of Pleasure
Mid–late 1770s

Wide *hashira-e*; 67.0 x 16.0 cm
Gift of Mr. and Mrs. Gaylord Donnelley 1969.688

A grand courtesan from the Yoshiwara pleasure district is shown dressed
in lavish New Year costume, perhaps parading in the afternoon along Naka
no Chō, the main street of the district. She wears a pale gray kimono with
a complex pattern of white floral arabesques, under three layers of heavy
brocade outer garment (*uchikake*) decorated with cherry flowers and styl-
ized waves (*seigaiha*) in roundels against a purple background. The linings
of the outer garment and the innermost undergarment are a (now faded)
scarlet. Like all Yoshiwara courtesans, she wears her brocade obi tied in
front; its pattern is of paulownia blooms and flying phoenixes, a standard
decorative combination. The crest (*mon*) on her sleeve, three oak leaves in-
side a crenellated white lozenge shape, indicates that this is one of the high-
ranking women of the Matsubaya (Pine Needle House), possibly even
the great Segawa.

In the spring of 1776 the picture book *Seirō Bijin Awase Sugata Kagami*
(A Comparison of Beauties of the Green Houses: A Mirror of Their Lovely
Forms) was published jointly by Yamazakiya Kimbei and Tsutaya Jūzaburō
(No. 75). Its illustrations, by Shunshō and his younger contemporary
Kitao Shigemasa (1739–1820), show leading courtesans of the Yoshiwara
engaged in elegant pastimes amid opulent settings. In the first illustration
four splendid women (identified by name) from the Matsubaya, the most
prestigious house, sit writing the ceremonial first calligraphy of the New
Year (fig. 78.1). Segawa, seated on the right, is quoting from an anthology
of poems, and it is interesting to note that she— and none of the others—
has the oak leaf crest on her sleeve.

Her coiffure is so similarly shaped in the book illustration and the print—
the "lantern locks" (*tōrōbin*) curving directly outward from the bottom of
the ear— that the two were most likely issued at about the same time.
Indeed the popularity of the book perhaps stimulated demand for single-
sheet prints of beautiful women by Shunshō, like this example in the
unusual wide pillar-print format.

It was not uncommon for a beautiful and high-ranking courtesan to be
bought out of her house of prostitution by a wealthy samurai or even
a feudal lord (daimyo), who would make her his mistress; about this time
Segawa was thus ransomed by the samurai Toriyama Kenkō.[1]

1 This piece of gossip is recorded by Ōta Nampo in *Hannichi Kanwa*; see *Nihon Zuihitsu
Taisei*, vol. 4 (1927), p. 490.

SIGNATURE *Shunshō ga*
REFERENCE Gookin (1931), no. 146B, text p. 155;
Ukiyo-e Shūka, vol. 5 (1980), no. 113
OTHER IMPRESSIONS
Wadsworth Atheneum, Hartford; Riccar Art Museum, Tokyo;
The Art Institute of Chicago (The Clarence Buckingham Collection, 1925.2262)

78.1. Katsukawa Shunshō and Kitao Shigemasa.
Courtesans of the Matsubaya House of Pleasure.
From *Seirō Bijin Awase Sugata Kagami.*
The Art Institute of Chicago

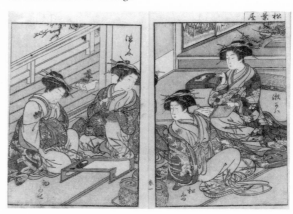

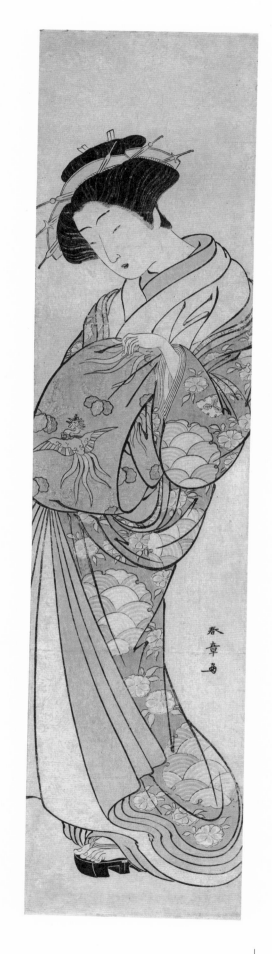

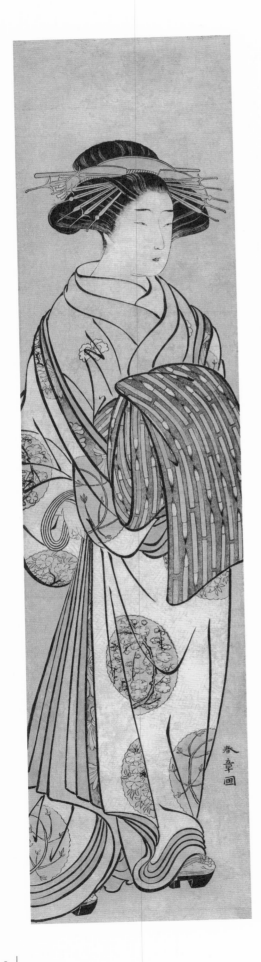

Walking courtesan, possibly Sugawara of the
Tsuruya House of Pleasure
Mid–late 1770s

Wide *hashira-e*; 69.0 x 16.6 cm
The Clarence Buckingham Collection 1925.2261

Over a plain pink kimono this courtesan wears
a white over-kimono (*uchikake*) decorated with
roundels of white and red plum blossom and bud-
ding tree branches. Her black lacquer clogs sug-
gest that she is probably parading in the colorful
procession that took place each afternoon along
the central street (Naka no Chō) of the Yoshiwara
pleasure district.

On the sleeve of her pink kimono is a crest (*mon*)
consisting of a double-bordered ivy leaf, which is
known to have been used by the high-ranking
courtesan Sugawara of the Tsuruya (Crane House).[1]
If the woman is indeed Sugawara, this would explain
the highly original and striking pattern of orange and
green writing brushes against a purple background
on her sash: the Heian-period courtier and statesman
Sugawara Michizane (845–903)—after whom she
was named—is regarded as one of the great calligra-
phers of Japan.

As with the previous print (No. 78), the "lantern
locks" (*tōrōbin*) fanning outward directly from the
bottom of the ears suggests that the print was issued
soon after this new coiffure became popular in Edo
in 1775.[2] In its ample proportions and general stance
the figure resembles one of the few Shunshō paint-
ings of beautiful women known to date from the
mid-1770s (fig. 79.1).[3] The print also resembles the
painting in that the face and the *uchikake* are *printed*
white, not merely left in reserve as the cream color
of the paper. The two differ markedly, however, in
the arresting—and characteristic—cropping of the
composition in the pillar print format, which creates
the impression that one is catching a fleeting glimpse
of the grand beauty as she parades by.

1 This crest is recorded as being used by Sugawara of the
 Tsuruya in the guide to courtesans' apparel *Keiseikei*, by
 Santō Kyōden, published in 1788.
2 The *tōrōbin* hair style had originated in the Kansai.
3 The signature on this painting is followed by an unusual
 form of Shunshō's written seal (*kaō*), which is also seen on a
 calendar print for 1776 (No. 76). The painting was formerly
 in the Bigelow collection, auctioned in Tokyo in 1933,
 present location unknown.

79.1. Katsukawa Shunshō.
Painting of a Yoshiwara courtesan.
Ex-collection William Sturgis Bigelow

SIGNATURE *Shunshō ga*
REFERENCE Gookin (1931), no. 146C

80 KATSUKAWA SHUNSHŌ

(1726–1792)

The actors Nakajima Mihoemon II as Fujiwara no Shihei, Minister of the Left (center, in the carriage), Ichikawa Ebizō III as Matsuō-maru (center, kneeling on the ground), Ichikawa Yaozō II as Sakura-maru (right), and Ichimura Uzaemon IX as Umeō-maru (left), in the "Carriage Stopping" (*Kuruma-biki*) scene from the play *Sugawara Denju Tenarai Kagami* (Sugawara's Secrets of Calligraphy), performed at the Ichimura Theater from the sixteenth day of the seventh month, 1776

Hosoban triptych; (right) 31.1 x 14.4 cm;
(center) 31.0 x 14.7 cm; (left) 31.1 x 14.2 cm
The Clarence Buckingham Collection 1938.498

SIGNATURE *Shunshō ga* (left and right sheets)
PROVENANCE Frederick W. Gookin collection
REFERENCE Gookin (1931), no. 158, text pp. 163–64
OTHER IMPRESSIONS
(complete triptych) Japan Ukiyo-e Museum, Matsumoto
(*Ukiyo-e Taikei*, vol. 3 [1976], nos. 30–32); (right)
Museum Rietberg, Zurich; (center) H. R. W. Kühne
collection, Switzerland; (left) Elvehjem Museum of Art,
University of Wisconsin, Madison; (left) Edoardo
Chiossone Museum of Oriental Art, Genoa

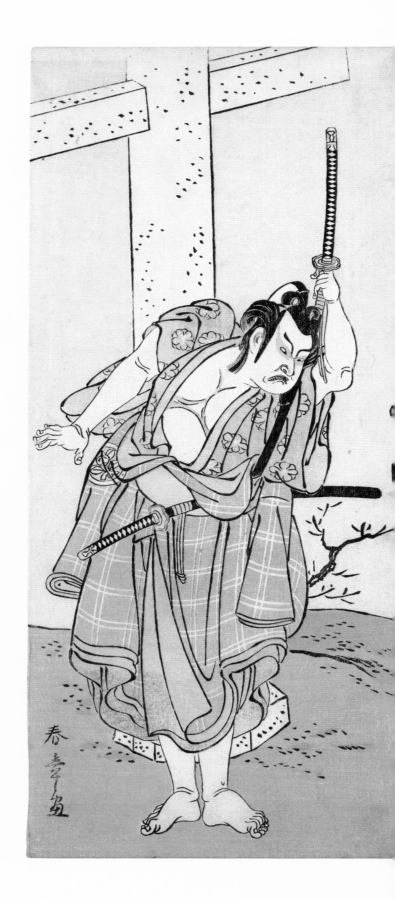

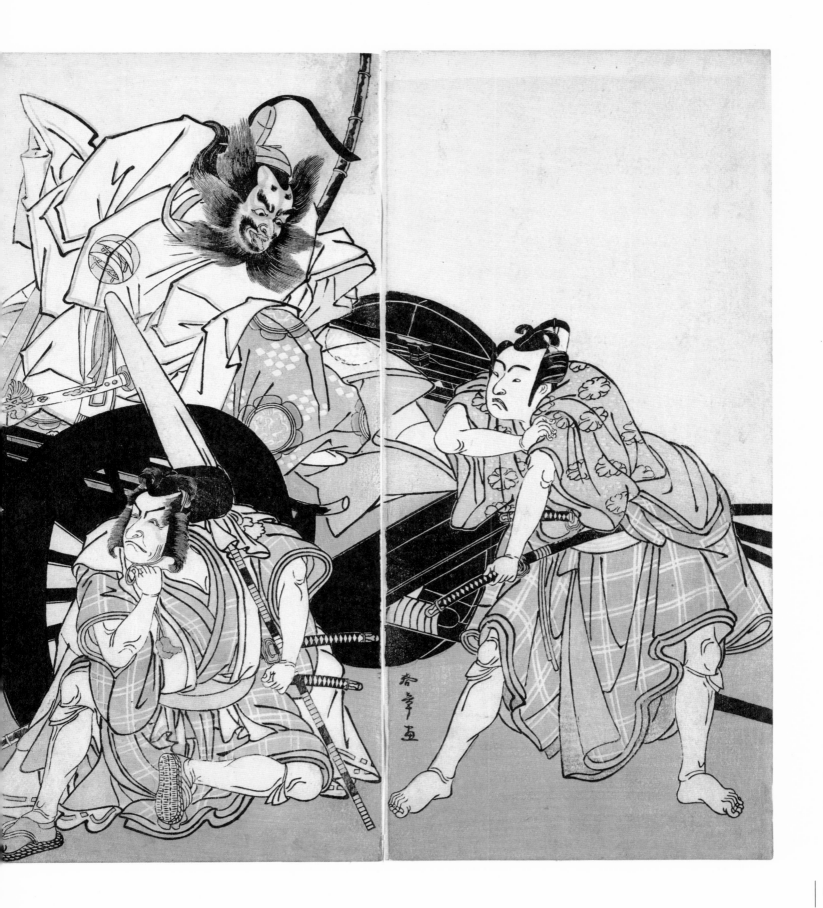

80.1. Katsukawa Shunshō, copied by Katsukawa Shuntei. The "Carriage Stopping" scene from *Sugawara Denju Tenarai Kagami*. From *Kabuki Nendaiki*. The Art Institute of Chicago

Sugawara Denju Tenarai Kagami, written as a puppet play in 1746 and quickly adapted for Kabuki, interweaves historical accounts of the rivalry between Sugawara Michizane and Fujiwara Shihei, ministers serving the emperor Daigo in the late ninth century, with the local sensation caused by male triplets born in Osaka at the time the play was written. In the play Michizane stands sponsor to these brothers, who when grown become the retainers Matsuō-maru (Pine), Umeō-maru (Plum), and Sakura-maru (Cherry)— named after Sugawara's three favorite trees— serving Fujiwara Shihei, Sugawara Michizane, and Prince Tokiyo respectively. The theme of the play is the conflict between family and feudal loyalties.[1]

The "Carriage-Stopping" (*Kuruma-biki*) scene seems to have been an invention for the Kabuki version of the play; a vehicle (pun intended) for the Edo *aragoto* (rough stuff) acting style, as well as an excuse to bring the three brothers on stage together. The political machinations of Fujiwara Shihei have resulted in the banishment of the noble Michizane to Dazaifu in Kyushu. Umeō and Sakura wait outside the Yoshida Shrine in Kyoto for Shihei and his retinue to appear, intending to upbraid Matsuō for serving an enemy of their family. Matsuō comes on bearing the standard of his master and replies to his brothers' taunts that Shihei is his master, to whom he owes fidelity come what may. A fierce quarrel is interrupted by the arrival of Shihei's carriage, and in their rage the two younger brothers rip the sides from the vehicle. When the august (and furious) figure of the Minister of the Left is revealed, however, they are overawed and must bear his taunts. This is the climactic scene portrayed in Shunshō's triptych.

Shihei appears in the costume of a power-crazed courtier so familiar from "Shibaraku" scenes (e.g., No. 66): white court robes, gold *kammuri* headdress, wild wig, and *sujiguma* makeup in the indigo hues that denote villainy. He sticks out his tongue in a famous expression of derision that was the invention of this actor, Nakajima Mihoemon II. Beneath him kneels Ichikawa Ebizō III (formerly Danjūrō IV), with the standard over one shoulder and an elbow resting resolutely on his raised knee. This was Ebizō III's retirement performance, and Shunshō indicates his advanced age with a cluster of discreet wrinkles on the jowl. To the left is Umeō, the muscular middle brother, in an under-kimono patterned with plum blossoms, and to the right Sakura, the delicate younger brother, in an under-kimono patterned with cherry blossoms and the white makeup of a young man.

For this most famous of scenes Shunshō has composed one of his most sculptural designs, the figures arranged into a strong diamond shape. Though Shihei presides over the group from the carriage, it is the immovable figure of Matsuō seated on the ground who most commands our eyes; this focus was doubtless a tribute to the retiring superstar Ebizō III. The lines of drapery and patterns of the kimono masterfully enhance the powerful stances and suggest the differing temperaments of the four characters. This design, one of the most successful of Shunshō's middle period, was copied by his pupil Shuntei (1770–1820) for an illustration in *Kabuki Nendaiki*, published in 1811–1815 (fig. 80.1).

The colors of the Chicago triptych have faded considerably, losing the bright red and purple still visible in the impression from the Sakai collection in the Japan Ukiyo-e Museum.

1 For a full synopsis of the play, see Halford (1956), pp. 306–21.

81 KATSUKAWA SHUNSHŌ

(1726–1792)

The actors Ōtani Hiroji III as Yokambei (right),
Nakamura Tomijūrō I as Kuzunoha (center), and
Bandō Mitsugorō I as Yakambei (left), in the last
scene from the play *Shinodazuma* (The Wife from
Shinoda Forest), performed as a supplement to the
play *Kikyō-zome Onna Urakata* (Female Diviner in
Deep Violet), at the Morita Theater from the ninth
day of the ninth month, 1776

Hosoban triptych; (right) 31.1 x 14.6 cm; (center) 31.3 x 14.9
cm; (left) 31.1 x 14.3 cm
The Clarence Buckingham Collection 1938.499

SIGNATURE *Shunshō ga*
PROVENANCE Frederick W. Gookin collection
REFERENCE
Riccar (1973), no. 108; *Ukiyo-e Taikei*, vol. 3 (1976),
nos. 108–10; *Ukiyo-e Shūka*, vol. 5 (1980), nos. 22–24
OTHER IMPRESSIONS
(complete triptych) Watanabe Tadasu collection, Tokyo

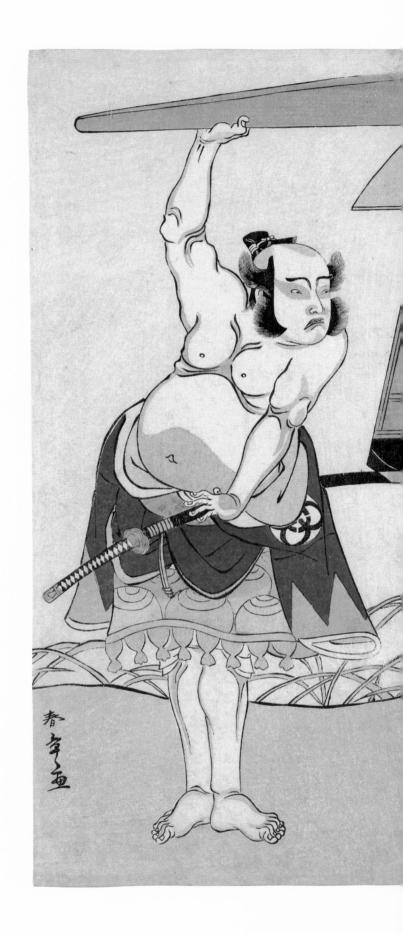

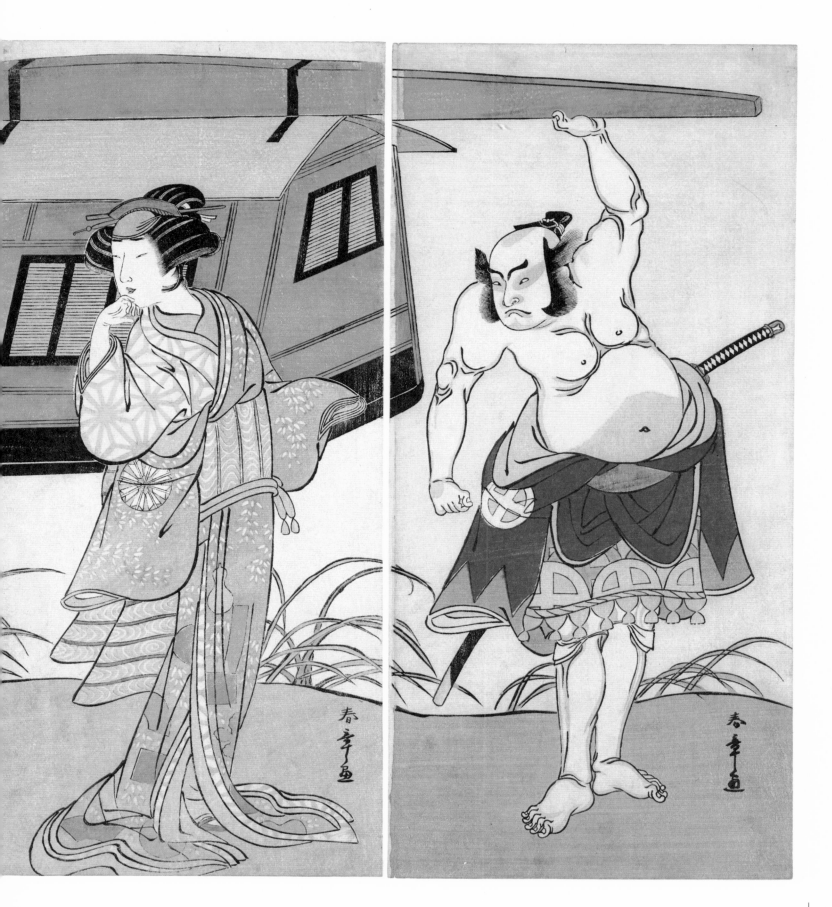

The play *Kikyō-zome Onna Urakata*, performed at
the Morita Theater in the fall of 1776, was a version
of the famous *Ashiya Dōman Ōuchi Kagami* (Mirror
of Ashiya Dōman and Ōuchi). In the story Abe no
Yasuna, hunting in Shinoda Forest, saves the life of
a vixen who in gratitude takes on the form of his
betrothed, the beautiful Princess Kuzunoha. The fox-
princess becomes Yasuna's wife and bears him a child.
When the real human Princess Kuzunoha comes to
visit, however, the fox must return to the forest, and in
a well-known, touching scene she holds the child in her
arms and writes a farewell poem on the *shōji* (sliding
screen panel), using a brush held in her teeth. In Kabuki
foxes often perform such astounding feats.

The human Kuzunoha, learning of the fox's sacrifice,
sets off for Shinoda Forest with the child to visit her. En
route their palanquin (*kago*) is set upon by the villain
Ishikawa Akuemon, whose amorous advances she had
once rejected, and mother and child seem about to be
abducted. Suddenly, deus ex machina, a muscular
"chivalrous commoner" (*otokodate*) called Yokambei
appears on the scene and drives off the villains. No
sooner rescued, however, than they are set on by
another band of ruffians; upon which another muscular
hero, Yakambei, appears and defeats the second gang.
The two champions then hoist up the palanquin out of
harm's way in a famous tableau known as "*Sashi-kago*"
(Lifting the Palanquin).[1]

As a publicity broadsheet (*tsuji banzuke*) shows, in the
play the palanquin was lifted up with Kuzunoha and the
child inside (fig. 81.1). But perhaps to meet composi-
tional conventions, the *hosoban* triptych depicts Kuzu-
noha standing coquettishly between the men, casually
interrupting the symmetry of their *soku mie* poses. One
actor critique of the time likened the heroes to a pair
of *niō*, the fierce guardian deities whose statues flank
Buddhist temple entrances, one vehemently open-
mouthed, the other with his mouth grimly closed.[2]

1 The synopsis of the plot is derived from Suzuki Jūzō's com-
 mentary in *Ukiyo-e Shūka*, vol. 5 (1980), nos. 22–24, and
 Kabuki Saiken (1926), sect. 126, pp. 573–76.
2 *Ukiyo-e Shūka*, vol. 5 (1980), nos. 22–24.

81.1. Publicity handbill for the play *Kikyō-zome Onna Urakata*. Babcock collection, Museum of Fine Arts, Boston

82 KATSUKAWA SHUNSHŌ

(1726–1792)

The actors Nakamura Nakazō I as Hata Rokurōzaemon disguised as the samurai's manservant (*yakko*) Igaguri Hanehei (left), and Nakamura Noshio I as the lady-in-waiting Kōtō no Naishi (right), in the dance sequence "Sodegasa Momiji no Tekuda" (Umbrella Sleeves: Coquettish Tricks at Maple Time), from the fourth act of the play *Hikitsurete Yagoe Taiheiki* (The War Tale Taiheiki: With Din and Clamor of Battle), performed at the Morita Theater in the eleventh month of 1776

Aiban; 30.3 x 20.4 cm
The Clarence Buckingham Collection 1938.485

The dance interlude to *jōruri* accompaniment "Sodegasa Momiji no Tekuda" is briefly described by Lord Yanagisawa Nobutoki in his theater diary, *Enyū Nikki Betsuroku*. It began with Nakamura Nakazō I and Nakamura Noshio I emerging onto the stage through a trapdoor (*seridashi*), Nakazō I in the guise of a manservant with red body makeup and Noshio I as the lady-in-waiting Kōtō no Naishi, dressed in a long over-kimono with sleeves left unsewn down the front. These two danced together for a while (as shown in this print), then were joined by Matsumoto Kōshirō IV and Iwai Hanshirō IV, both in the guise of travelling peddlers.[1]

The poses in this print seem obviously comic: Noshio I is clearly playing the role of a strong-woman. Hands braced together and legs planted firmly apart, Nakazō I pushes against her with all his might, but Noshio I, far from giving way, just leans her elbow nonchalantly on his shoulder. She is wearing a pair of swords tucked into her sash in the manner of a female champion of the oppressed (*onnadate*), and Nakazō is dressed in a padded kimono decorated with large stylized versions of his acting crest. Perhaps Shunshō designed an accompanying sheet showing Kōshirō IV and Hanshirō IV in their respective roles.

This is the first of a succession of *aiban* prints designed by Shunshō during the late 1770s and early 1780s featuring two actors in contrasting poses during a *shosagoto* dance sequence. Entering upon his most prolific period as a designer of actor prints, Shunshō was simultaneously breaking away from the standard composition— a single standing figure on each sheet of a *hosoban* triptych— to develop figural groupings suggesting a sense of space.

The colors of the Chicago print have faded considerably. At present only one other impression of the design is known.

1 *Enyū Nikki* (1977), p. 850.

SIGNATURE *Katsu Shunshō ga*
PROVENANCE Frederick W. Gookin collection
REFERENCE Gookin (1931), no. 166, text p. 165
OTHER IMPRESSIONS Museum Rietberg, Zurich

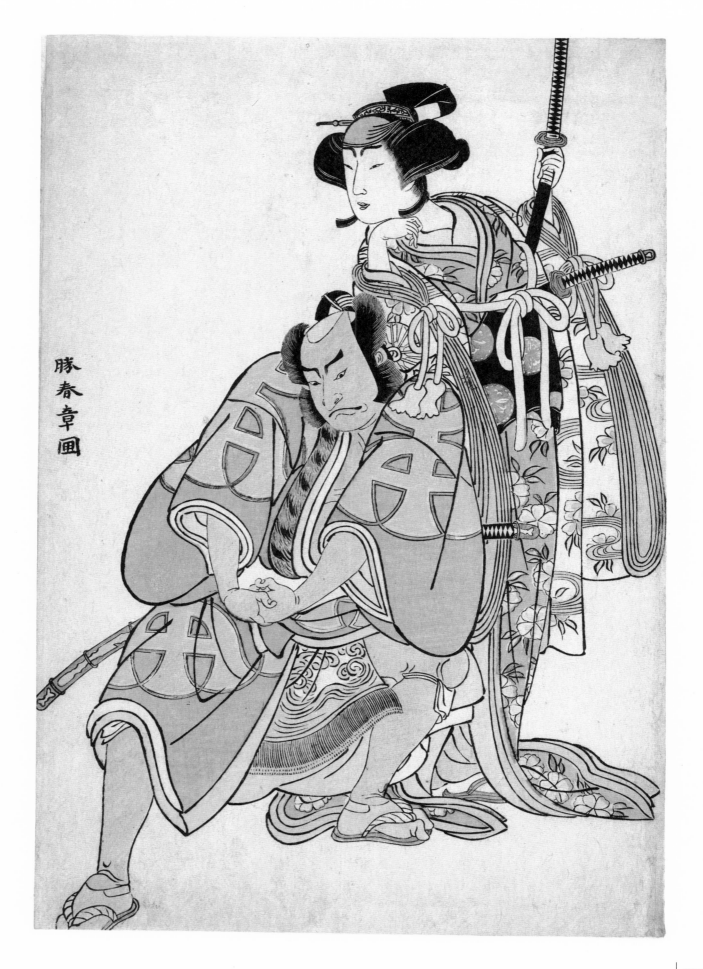

勝春章圖

83 KATSUKAWA SHUNSHŌ

(1726–1792)

The actor Nakamura Tomijūrō I as Hangaku Gozen breaking down the gate in the play *Wada-gassen Onna Maizuru* (The Wada Conflict: A Woman's "Maizuru"), performed at the Nakamura Theater from the twenty-fifth day of the seventh month, 1777

Hosoban; 30.5 x 14.4 cm
Frederick W. Gookin Collection 1939.620

The Wada Conflict is based on historical events of the power struggle between the Hōjō and Wada families for control of the Kamakura shogunal government in the early years of the thirteenth century, after the death of the first Kamakura shogun, Minamoto no Yoritomo (1147–1199). The play was written for the puppet stage in 1736, adapted for Kabuki in Osaka in 1763, and first performed in Edo on the occasion depicted in this print, at the Nakamura Theater during the seventh month of 1777.

Egara no Heita is sent by both the Wada and Hōjō families as an envoy to the shogunal court of Minamoto no Sanetomo, to bid for the hand of the shogun's daughter, Princess Itsuki. Heita himself has amorous designs on the princess, and when these are repulsed he murders her in an access of rage and makes his escape. The vassal Asari no Yoichi rushes to the shogun's assistance, but because his wife, Hangaku Gozen, is a cousin of the murderer Heita, the gates of the castle are barred to him. On the spot, Yoichi divorces Hangaku. To demonstrate her sterling loyalty toward her husband, Hangaku Gozen undertakes to break down the gates of the castle single-handed.[1] This is the climactic scene we see depicted in Shunshō's print.

Nakamura Tomijūrō I, whose occasional interpretations of "martial women" (*onna budō*) roles were much appreciated, is shown in the classic "gate-breaking" (*mon yaburi*) pose. In order to express the Herculean effort necessary for Hangaku— as a woman— to accomplish such a feat, Tomijūrō I braces a halberd (*naginata*) tightly under his arm. Planting his feet wide apart, he pushes against the door with all his might with the other hand. The ties that hold the kimono sleeves out of the way are fluttering wildly— Shunshō's device to express the force being unleashed. The unusual frontal angle of the face also has the effect of confronting the viewer with Hangaku's rock-solid determination. Vibrant colors predominate, including an orange lead pigment (*tan*) used for the gate frame.

"A Woman's Maizuru" (*Onna Maizuru*), the subtitle of the play, alludes to the actual historical event being parodied in this scene: the breaking down of a gate during the Wada conflict by the warrior Kobayashi no Asahina (the common name of Wada Saburō Yoshihide). As a character in the "Soga" plays performed every New Year, Asahina is well known to Kabuki audiences. Since one of Asahina's crests is the stylized dancing crane (*maizuru*), "A Woman's Maizuru" signifies "A Woman's Version of Asahina Breaking Down the Gate." In fact Hangaku's pink outer kimono is decorated with one more of Asahina's crests— three white bars across a circle— in yet another visual clue to the parallel being drawn with the exploits of the famous warrior.[2]

1 See *Kabuki Saiken* (1926), sect. 22, pp. 153–55 ("Wada-gassen").
2 Noted by Suzuki Jūzō in *Ukiyo-e Shūka*, vol. 5 (1980), no. 111, p. 189.

SIGNATURE *Shunshō ga*
REFERENCE Gookin (1931), no. 175, text pp. 170–71; *Ukiyo-e Shūka*, vol. 5 (1980), no. 111
OTHER IMPRESSIONS Riccar Art Museum, Tokyo

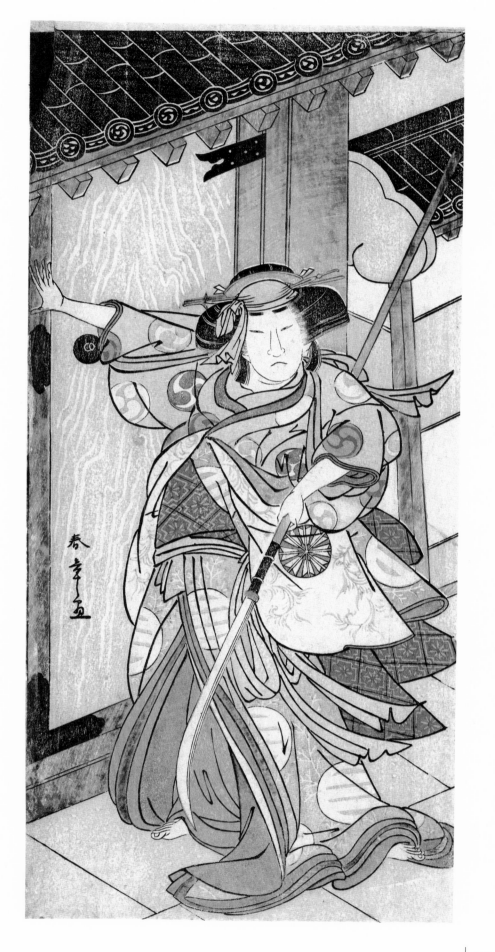

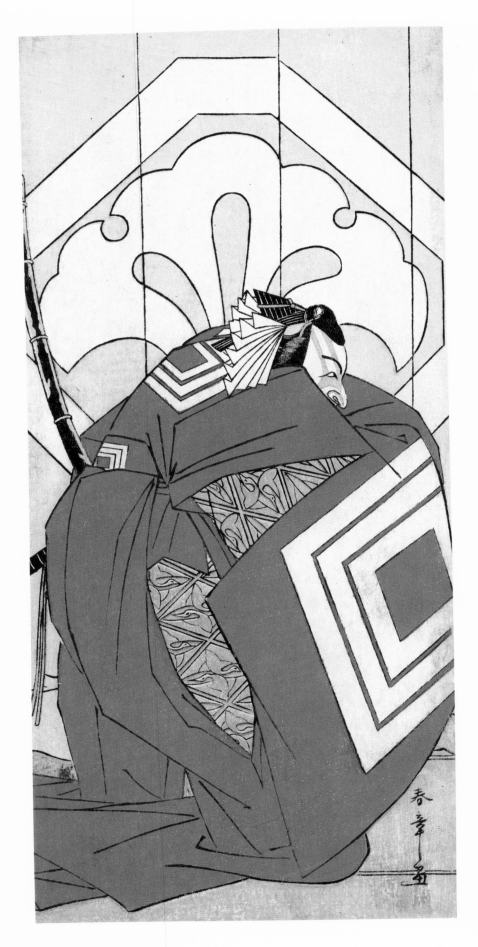

The actor Ichikawa Danjūrō V in a "Shibaraku"
role, probably as Katō Hyōeisa Shigemitsu, in the
third scene of the play *Masakado Kammuri no
Hatsuyuki* (The First Snow on Taira no Masakado's
Court Headdress), performed at the Nakamura
Theater in the eleventh month, 1777 (the so-called
Red Danjūrō)

Hosoban; 29.0 x 13.4 cm
The Clarence Buckingham Collection 1938.487

SIGNATURE *Shunshō ga*
PROVENANCE Frederick W. Gookin collection
REFERENCE
Gookin (1931), no. 204, text pp. 184–85; *Ukiyo-e Shūka*,
vol. 5 (1980), no. 109
OTHER IMPRESSIONS
Succo (1922), p. 33; *Ukiyo-e Taisei*, vol. 5 (1931), pl. 89;
Shibai Nishiki-e Shūsei (1919), pl. 164; ex-collection Louis
V. Ledoux; Grunwald Center for the Graphic Arts,
University of California, Los Angeles

All but submerged in the voluminous sleeves of his persimmon red "Shibaraku" (Stop right there!) costume, Danjūrō V crouches like some fantastic predator about to strike.[1] Shunshō must have drawn actors in this famous role every year of his working life, but for this celebrated design he chose a deliberately unconventional viewpoint— Danjūrō motionless at the start of the *hanamichi* walkway, silhouetted before the divided curtain bearing the large gingko-leaf crest of the Nakamura Theater. The octagonal border of the crest on the curtain serves to echo and amplify Danjūrō's hunched silhouette, reflecting an inspired, even playful, sense of design.

This print seems to belong to a set of three showing leading actors in opening-of-the-season (*kaomise*) productions of the years 1777 and 1778, each standing before a curtain bearing the crest of one of the three Kabuki theaters of Edo. The second print of this putative series shows Ichimura Uzaemon IX in a formidable frontal pose, in a "Shibaraku" role at the Ichimura Theater in 1778 (fig. 84.1); the third shows Ichikawa Danzō IV as Mashiba Tōkichirō, in formal *kamishimo* (surcoat and long trousers) and holding a mirror, at the Morita Theater in 1777 (fig. 84.2). The complementary poses of the figures even suggest that the three prints might be viewable as a triptych, with Danjūrō V on the left, Uzaemon IX in the center, and Danzō IV on the right. It was typical of Shunshō's ever inventive approach to print making that he produced such compositionally striking designs, designs which managed, moreover, to glorify the actors and advertise the theaters at one and the same time.

Danjūrō V played the "Shibaraku" role in *kaomise* productions in both 1777 and 1779. It has been suggested that the form of Shunshō's signature makes the earlier date more likely for this print,[2] and this would seem to be confirmed by the dating of the other two designs in the set. An illustrated program (*ehon banzuke*) for the 1777 performance shows Danjūrō V in a similar hunched pose, though not in strict profile (fig. 84.3).

The Chicago impression has been trimmed, particularly at the top, where the stitched loops of the curtain are no longer visible. The blue of the curtain has faded to pale buff.

1 For a discussion of the "Shibaraku" role, see No. 44.
2 The opinion expressed by Suzuki Jūzō in *Ukiyo-e Shūka*, vol. 5 (1980), no. 109.

84.1

84.2

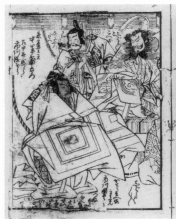 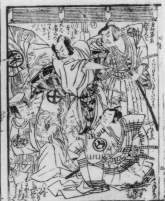

84.1. Katsukawa Shunshō. *The actor Ichimura Uzaemon IX in a "Shibaraku" role.* Ōta Memorial Museum, Tokyo

84.2. Katsukawa Shunshō. *The actor Ichikawa Danzō IV as Mashiba Tōkichirō.* Ex-collection Friedrich Succo

84.3. *Ichikawa Danjūrō V and others in a "Shibaraku" scene.* From the illustrated program. Tokyo University Library

84.3

The actors Nakamura Nakazō I as Onmaya Kisanda dressed as Kakubei the Lion Dancer (Kakubei-jishi) and Segawa Kikunojō III as Shizuka Gozen (No. 85, right), with Ichimura Uzaemon IX as a male fox disguised as the sake seller Iseya and Nakamura Tomijūrō I as a female fox disguised as the beancake peddler Hyūgaya (No. 86, left), in the dance sequence "Myōto-zake Kawaranu Nakanaka" (Everlasting Harmony of the Marital Cup), from the second part of the play *Chigo Torii Tobiiri Kitsune* (Heavenly Child— The Fox Leaps Through the Shrine Gate), performed at the Ichimura Theater in the eleventh month, 1777

Aiban; (right) 32.8 x 23.0 cm; (left) 32.4 x 23.1 cm
Frederick W. Gookin Collection 1939.708 (right)
Gift of Mr. and Mrs. James Michener 1958.154 (left)

Though they entered the Art Institute collections some twenty years apart, it is certain that these two splendid *aiban* prints by Shunshō— each showing two Kabuki actors against a plain background— are very closely related. They are reunited here for the first time.

The right-hand print shows Kikunojō III as Shizuka Gozen, a halberd (*naginata*) braced against her shoulder with a kimono slung over it, and Nakazō I dressed as Kakubei the Lion Dancer kneeling resolutely at her feet, with a lion mask on his head and a portable drum hung around his neck. In the left sheet Tomijūrō I as a bun seller, Hyūgaya, balances two boxes of beancakes on a carrying pole, while Uzaemon IX as the sake seller Iseya has set down his load of sake to fan himself.

The related illustrated program (*ehon banzuke*) by Kiyonaga (fig. 85.1) confirms that all four actors appeared together in these roles in the dance sequence (*shosagato*) "Kakubei-jishi" (Kakubei the Lion Dancer), written to conclude the second part of the play *Chigo Torii Tobiiri Kitsune* for the Ichimura Theater's new season in the eleventh month of 1777. It was the custom in the 1770s and 1780s to end the second part with a dance sequence, thus concluding the day's performance with an opulent and gorgeous spectacle that showed off the skills of the principal players. Chanters and *shamisen* players came on stage to provide accompaniment and take up the dialogue while the actors were dancing. For this particular performance the musicians were led by Tomimoto Buzendayū II (1754–1822), undoubtedly the most talented chanter in Edo at the time. Such dance sequences often left the complex, convoluted plots completely unresolved; but in Kabuki theater spectacle is often more important than plot.

Though the original libretto does not survive in its entirety, we can reconstruct the outlines of the scene illustrated. Shizuka Gozen is distraught because she has heard rumors that her warrior lover Yoshitsune has been killed. The *ehon banzuke* notes, "she becomes crazed and there is a wild dance" (...*kyōki to nari kurui ari*...). She meets Onmaya Kisanda, a retainer of Yoshitsune, who is disguised as a lion dancer, and the two join forces and set out toward Mt. Kurama, where Yoshitsune had been hiding. Meanwhile, onto the scene come a sake seller and a bun seller, a humble husband-and-wife duo. They advertise their respective wares, in what must have been a comic interlude (the likely subject of the left sheet here). Awed by a magic mirror suddenly produced by Kisanda and touched by Shizuka's plight, however, they reveal their true identities as male and female foxes and exchange for the mirror the young Genji child they have reared in secret. Swearing to assist the Genji cause, they then disappear.

We may find such fantastic elements— fox-fairies, magic mirrors, and lion dances— implausible, and the juxtaposition of high drama and domestic farce disconcerting, but it was just such a rich, contrived mixture that most delighted eighteenth-century audiences in Edo.

Shunshō has skillfully captured many of these contrasts in his two designs. Shizuka's poignant plight is emphasized by the vulnerable gesture of lifting her sleeve to her mouth, Kisanda's determination and valor by his firmly braced arm and leg. In contrast the fox-humans seem almost perversely nonchalant: her back is gracefully arched and her hand hangs limply over the carrying pole; he has one arm pulled snugly into his kimono and is idly fanning himself.

Two *hosoban* prints by Shunshō showing Tomijūrō I as the bun seller are known, both perhaps from now separated diptychs or triptychs;[1] also extant is a *hosoban* diptych showing Shizuka dancing with Kakubei's lion mask, while he kneels looking on (fig. 85.2). It is interesting to see that Shunshō was designing both *aiban* and *hosoban* prints concurrently for performances in 1777.

1 See Gookin (1933), no. CBAI 63 (cat. no. 382), and *Ukiyo-e Daihyakka Jiten*, vol. 7 (1980), no. 55 (Irma E. Grabhorn-Leisinger coll.).

SIGNATURE *Shunshō ga*
REFERENCE
(right) Gookin (1933), no. G275; (left) *Ukiyo-e Shūka*, vol. 5 (1980), no. 25
OTHER IMPRESSIONS
(both) *Shibai Nishiki-e Shūsei* (1919), nos. 156, 157; (right) ex-collection Werner Schindler (present location unknown); (left) Tokyo National Museum

85.2. Katsukawa Shunshō. *The actors Segawa Kikunojō III as Shizuka and Nakamura Nakazō I as Kakubei the Lion Dancer.* British Museum, London

85.1. Torii Kiyonaga. *The dance interlude "Kakubei-jishi."* From the illustrated program.
H. R. W. Kühne collection, Switzerland. Photo courtesy of Sotheby's London

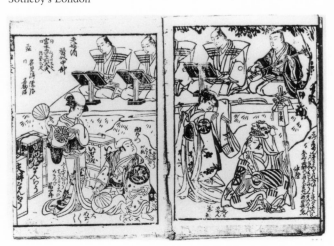

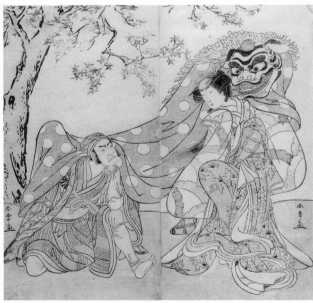

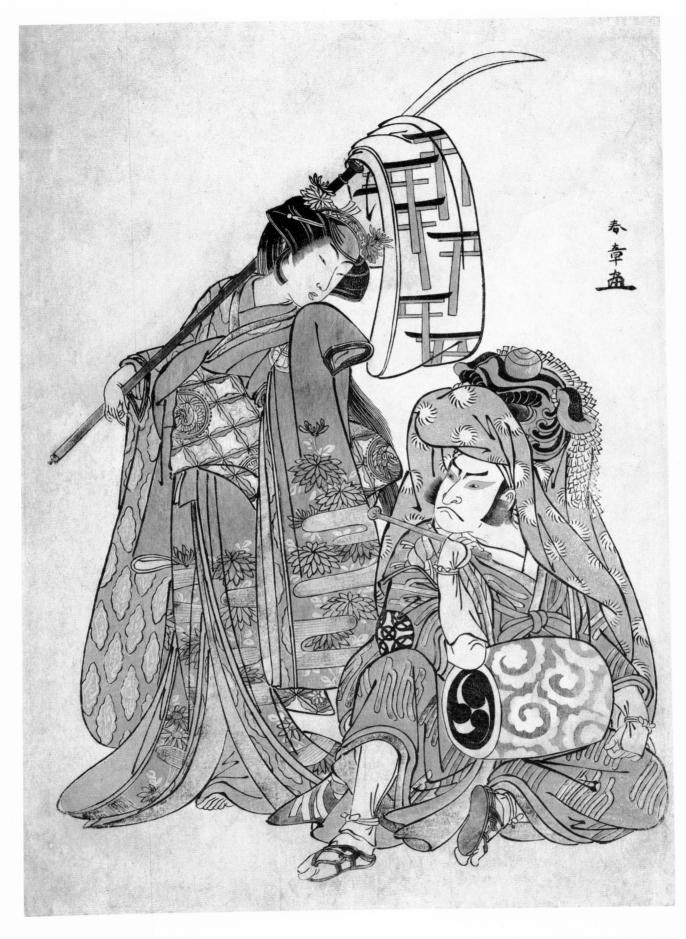

86

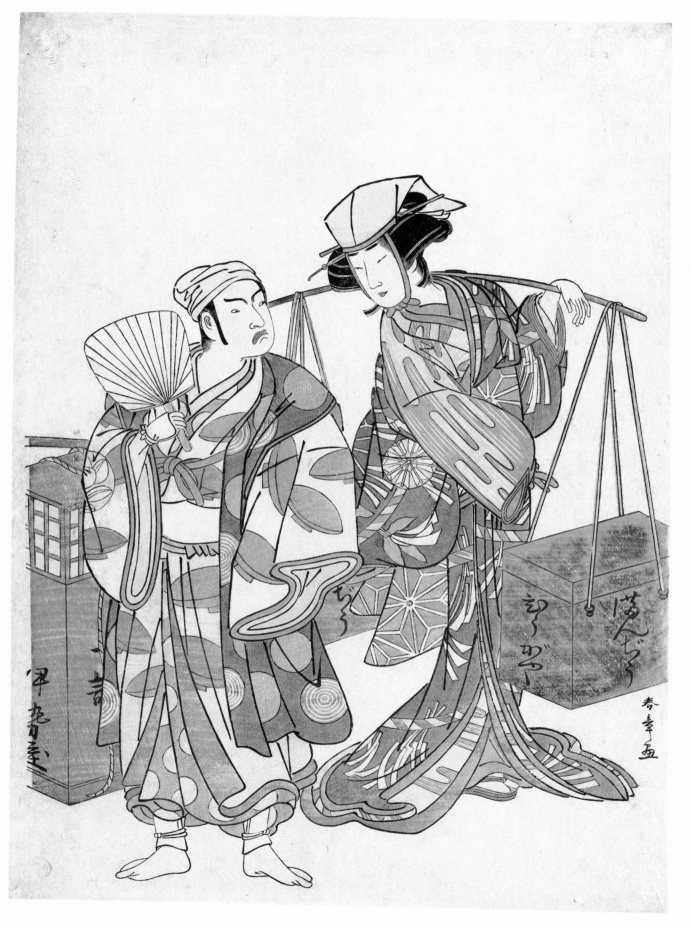

247

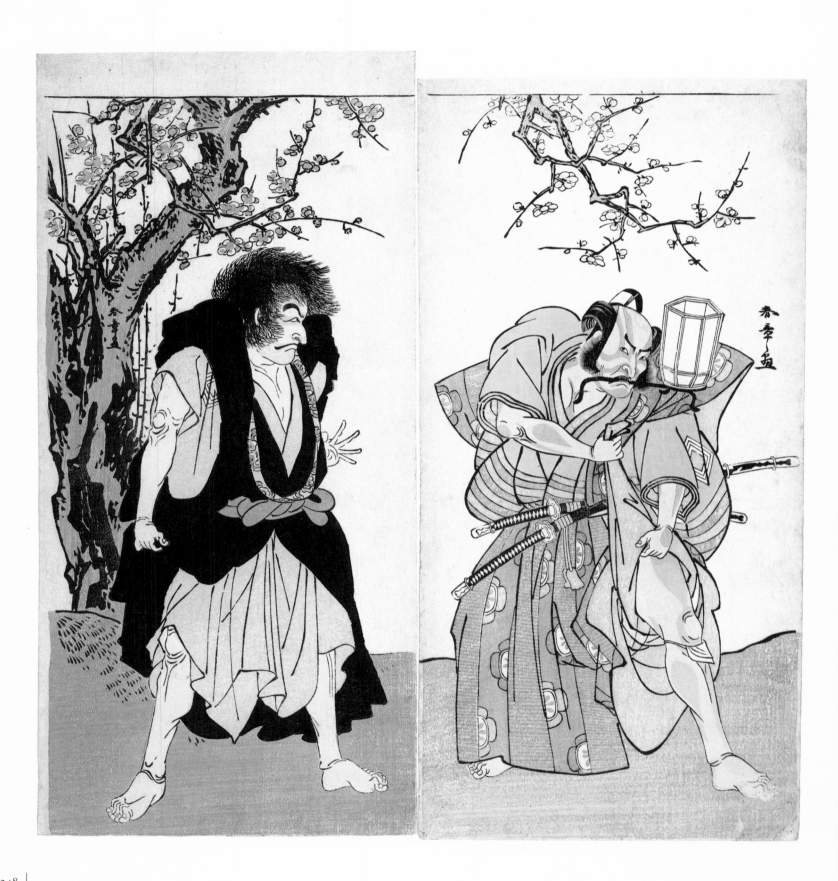

The actors Ichikawa Danjūrō V as the renegade Buddhist monk Wantetsu from Ōkamidani (left), and Ichikawa Danzō IV as Kamakura no Gongorō Kagemasa (right), in the fifth scene of the play *Date Nishiki Tsui no Yumitori* (A Dandyish Brocade: Opposing Warriors), performed at the Morita Theater in the eleventh month, 1778

Hosoban diptych (or two sheets of a triptych); (right) 31.5 x 15.6 cm; (left) 32.5 x 15.1 cm
Frederick W. Gookin Collection 1939.621 (right)
The Clarence Buckingham Collection 1938.500 (left)

Ichikawa Danjūrō V left the Nakamura Theater after a dispute with Matsumoto Kōshirō IV and appeared in the opening-of-the-season (*kaomise*) production at the Morita Theater in the eleventh month of 1778. The impressive cast included Ichikawa Danzō IV and Nakamura Nakazō I.

In the fifth scene Danjūrō V played the despicable renegade Buddhist monk Wantetsu from Ōkamidani (Wolf Valley). *Kabuki Nempyō* describes his monastic tonsure grown out into a wild "chestnut burr" mop of hair (*igaguri atama*). After extorting money from Hagiwara, wife of Hachiman Tarō Yoshiie, by falsely claiming to be her brother, Wantetsu steals the heirloom sword known as Hige-kiri (Beard Cutter) and sets out to murder Yoshiie. He is challenged and thwarted, however, by the hero Kamakura no Gongorō Kagemasa, played by Danzō IV. Danzō IV appeared in persimmon-colored formal *kamishimo* (surcoat and long trousers). He struck an impressive dramatic pose (*mie*), grasping the hilt of his sword while holding a hand-lantern in his teeth.[1] Shunshō's print shows the initial moment of confrontation between the two, as Kagemasa hastily pulls up one leg of his long trousers (*hakama*) in preparation for a fight.

Danjūrō V has his tattered black monk's robes bunched up around his shoulders, the fingers of one hand splayed out in surprise, and eyebrows contorted in a furious frown at the unexpected interference in his plans. Danzō IV, for his part, looks directly out at us; the red lines of the heroic *sujiguma* makeup seem to concentrate all the angry force of his body in the angular face and particularly in the down-turned mouth which grips the handle of the lantern. He tucks back his encumbering *kamishimo* sleeves and trousers, revealing the muscular body of a fighting man, also caked in red makeup.

As we have seen in Numbers 82 and 85–86, in the later 1770s Shunshō began to design compositions of two actors on a single sheet in the wider *aiban* format, in addition to the more conventional *hosoban* diptychs and triptychs (which generally have one figure to a sheet). An *aiban* composition survives showing Danjūrō V and Danzō IV in a scene almost identical to this one (fig. 87.1). In the *aiban* print the background has changed to a hanging reed blind and Danjūrō carries a mysterious sealed jar, but Danzō IV's *mie*, particularly appreciated in *Kabuki Nempyō*, is almost the same. It is as if the action has moved ahead one frame, and Danzō IV is now kneeling to pull up the other leg of his *hakama* trousers. This kneeling posture does seem somewhat impoverished and constrained, however, in comparison with the powerful standing version.

1 *Kabuki Nempyō*, vol. 4 (1959), pp. 350–51.

SIGNATURE (right) *Shunshō ga*
PROVENANCE (right) Frederick W. Gookin collection
REFERENCE Gookin (1931); (right) no. 171; (left) no. G283
OTHER IMPRESSIONS (right) Tokyo National Museum; (left) Minneapolis Institute of Arts

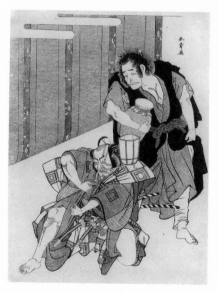

87.1. Katsukawa Shunshō. *The actors Ichikawa Danjūrō V as Wantetsu, a renegade monk, and Ichikawa Danzō IV as Kamakura no Gongorō Kagemasa.* Arthur M. Sackler Museum, Harvard University Art Museums, Cambridge, Mass.

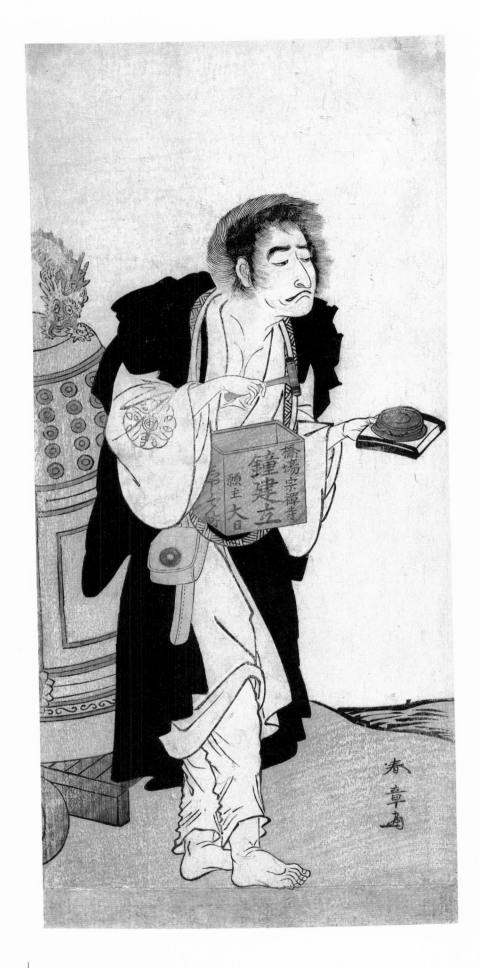

The actor Nakamura Nakazō I as the renegade monk Dainichibō soliciting alms in the play *Edo Meisho Midori Soga* (Famous Places in Edo: A Green Soga), performed at the Morita Theater from the fifteenth day of the first month, 1779

Hosoban; 30.2 x 14.0 cm (repaired at base)
The Clarence Buckingham Collection 1932.1003

Popular accounts tell of a monk called Hōkaibō from Jōbon-ji, a temple in Ōmi Province, who came to Edo in the 1760s seeking donations for temple repairs. He is said to have preached Buddhist salvation to none other than the grand courtesan Hanaōgi of the Yoshiwara pleasure district, who gave him in return a beautiful bronze bell, which he pulled back to the temple along the Tōkaidō (Eastern Sea Road) on a cart.[1]

The character of Hōkaibō was quickly introduced by the actor Nakamura Nakazō I into a Kabuki play on the theme of the Sumida River, *Edo Meisho Miyako no Tori-oi* (Famous Places in Edo: Hunting the Capital-Bird), performed in 1765. In 1775 and 1779 Nakazō I again played the role in Sumida River plays, but by this time the monk had been transformed into a worldly, scheming villain, known by the name Dainichibō.

We have already seen the characteristic stage aspect of a wicked monk in Number 87: shaven head grown out into a wild mop, ragged black robes worn over a white kimono. Here Dainichibō stands before a large bronze temple bell on a cart, soliciting donations by striking a small gong with a hammer. Suspended by a cord round his neck is an alms box inscribed: "Hashiba Sōzen-ji kane konryū/negainushi Dainichi Shōden-chō" (Dainichi of Shōden-chō soliciting to set up a bell at Sōzen Temple in Hashiba).[2] Shunshō has captured the penetrating characterization which Nakazō undoubtedly brought to the role, in the manner in which the head is bent forward, mouth downturned and eyebrows arched. The slight yellow pigment in the eyes adds a hint of menace.

Kabuki Nempyō records that later in the play Dainichibō was murdered by the manservant Gunsuke (played by Ichikawa Danzō IV). As Gunsuke was about to leave the stage, the ghost of Dainichibō appeared and dragged him back by the topknot of his hair. Gunsuke drew his sword, cut himself free, and did three backward somersaults with the sword over his shoulder![3] Audiences loved it.

1 *Kabuki Saiken* (1926), p. 487.
2 Shōden-chō and Hashiba were neighboring districts of Edo along the Sumida River (present-day Daitō ward in Tokyo). "Sōzen-ji" may be a stage-name for Sōsen-ji, one of the "three great temples of Edo," located in Hashiba.
3 *Kabuki Nempyō*, vol. 4 (1959), p. 357.

SIGNATURE *Shunshō ga*
PROVENANCE Frederick W. Gookin collection
REFERENCE Gookin (1931), no. 139, text p. 193
OTHER IMPRESSIONS
Riccar Art Museum, Tokyo; Tokyo National Museum; Museum of Fine Arts, Boston

89 KATSUKAWA SHUNSHŌ
(1726–1792)

Scene at the Tsurugaoka Hachiman Shrine, from act one of *Chūshingura*
(Treasury of the Forty-seven Loyal Retainers)
Series title: *Chūshingura Jūichimai-Tsuzuki* (Set of Eleven Sheets
Illustrating *Chūshingura*)
Ca. late 1770s

Chūban; 25.1 x 18.4 cm
Frederick W. Gookin Collection 1939.649

On the snowy night of the fourteenth day of the twelfth month, 1702, loyal
samurai of the disbanded Akō clan attacked the mansion of Kira Kōzuke-no-
suke Yoshinaka, who had villainously brought about the death of their lord
Asano Takumi-no-kami Naganori, and Yoshinaka was killed. Though their
actions aroused much public sympathy, all forty-seven samurai who took
part in the attack were ordered to commit ritual suicide by the authorities on
the fourth day of the second month, 1703.

The events of this vendetta were quickly elaborated into plays for both
puppet and Kabuki theaters, known by the title *Chūshingura* (Treasury of the
Forty-seven Loyal Retainers). In compliance with the shogunal government's
ban on treating contemporary events in literature or the theater, the story
was set in the fourteenth century and the names of the protagonists were
changed. The version that became most popular was *Kanadehon Chūshingura*
(Model for *Kana* Calligraphy: Treasury of the Forty-seven Loyal Retainers),
its punning title alluding to the *kana* calligraphy primers, which offered
models for all forty-seven *kana* syllables, just as the forty-seven loyal samurai
offered models of heroic behavior. This was first performed at the Takemoto
Puppet Theater, Osaka, in the eighth month of 1748, and contained eleven
acts.[1] The play quickly became one of the most popular and most often
performed in the repertory.

In the late 1770s Shunshō designed a series of eleven *chūban* prints showing a
famous scene from each act of *Chūshingura*. In the illustration to act one,
depicted here, the setting is the entrance to the Tsurugaoka Hachiman Shrine
in Kamakura. The villain Kō no Moronao is trying to force a love-letter on
Lady Kaoyo, wife of Enya Hangan, threatening that he will destroy her
husband's career if she does not yield to his passion. He is disturbed in this
clumsy wooing, however, by Momonoi Wakasanosuke, shown here ob-
serving from beyond the stone pillar of the shrine gateway. This serves to
worsen the already hostile relations between the two men, which by a chain
of events will ultimately result in the forced suicide of Enya Hangan.

Shunshō draws the characters in *Chūshingura* as semihistorical figures, rather
than as Kabuki actors in a specific stage performance. The male characters
wear standard formal robes of the military class of the Edo period, and the
women appear in the fashions and hair styles of the 1770s. The Art Institute
collection includes five more designs from the series (cat. nos. 425–29).

1 For a synopsis in English of the eleven acts of *Kanadehon Chūshingura*, see Halford
(1956), pp. 138–65.

SIGNATURE *Shunshō ga*

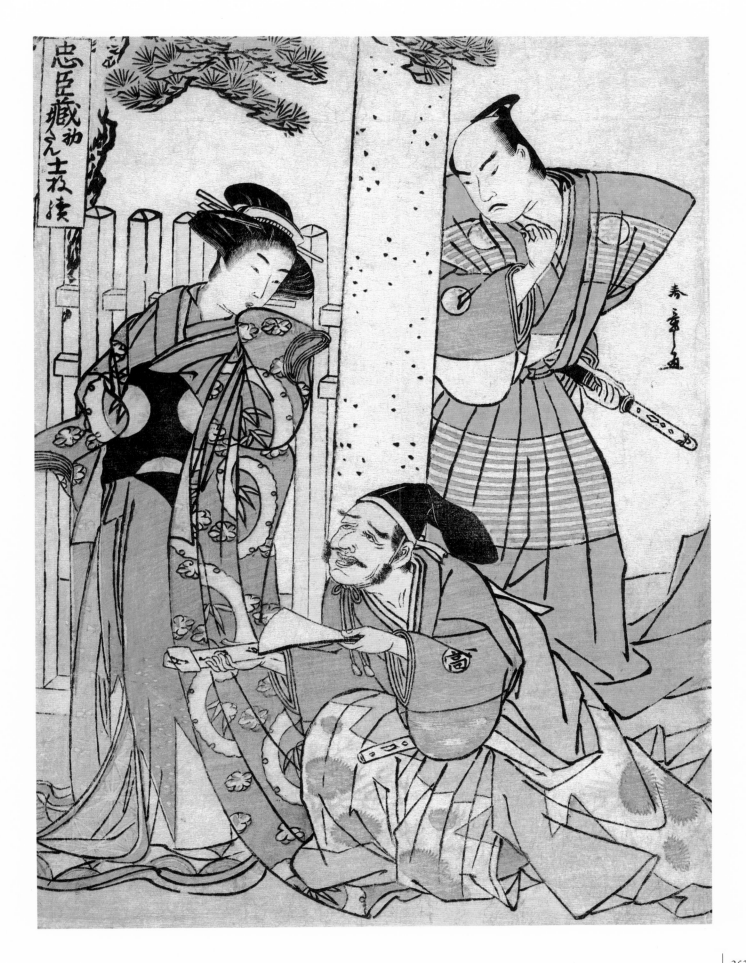

(1726–1792)

"Gonin Otoko" (Five Chivalrous Commoners), an interlude in part two of the play *Hatsumombi Kuruwa Soga* (A Soga Drama on the First Festival Day in the Pleasure District), performed at the Nakamura Theater from the first day of the second month, 1780. The actors and their roles are (from right to left): Ichikawa Monnosuke II as Karigane Bunshichi, Bandō Mitsugorō I as An no Heibei, Ichikawa Danjūrō V as Gokuin Sen'emon, Nakamura Sukegorō II as Kaminari Shōkurō, and Sakata Hangorō II as Hotei Ichiemon

Hosoban pentaptych; (from right to left) 31.3 x 14.5, 31.3 x 14.1, 31.3 x 14.5, 31.3 x 14.8, 31.3 x 14.1 cm
Gift of Mr. and Mrs. Gaylord Donnelley 1970.492

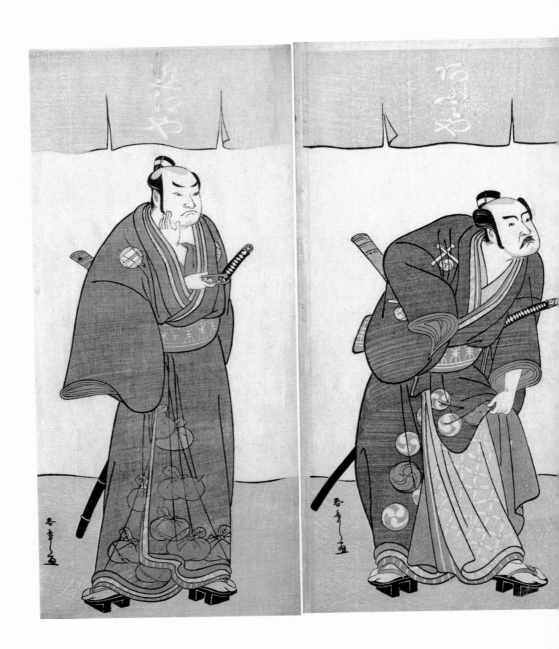

SIGNATURE *Shunshō ga*
PROVENANCE George T. Smith collection
OTHER IMPRESSIONS
(complete pentaptych) School of Oriental and African
Studies, University of London; (two sheets at far left)
British Museum, London

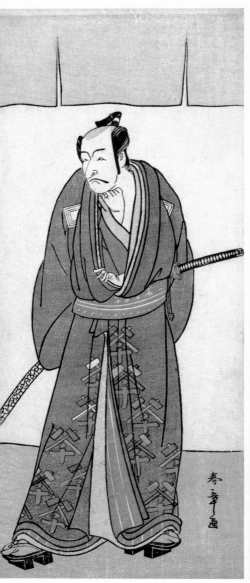

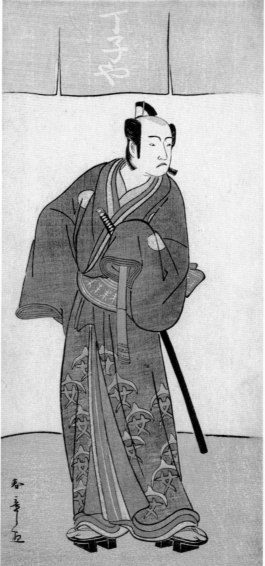

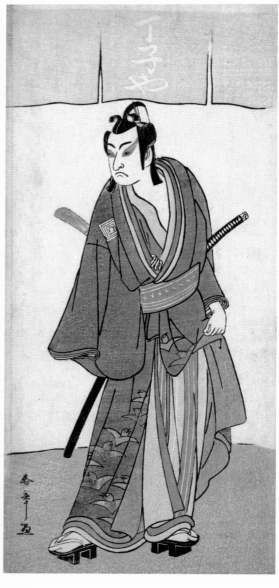

Five famous actors, headed by Ichikawa Danjūrō V, are shown dressed as *otokodate* (chivalrous commoners), standing before the entrance curtains to the Chōjiya and Ōmiya Houses of Pleasure in the Yoshiwara.

Otokodate were fearless young street toughs who (more often in popular literature than in life) protected ordinary townspeople against the frequent ill-treatment, even violence, inflicted upon them by lawless *hatamoto yakko*, theoretically samurai in direct service to the shogunate, but in actuality men-at-arms with too little income and too much free time. Street fights between the two groups were common. Forced to live beyond the law, *otokodate* made a living from the proceeds of gambling, becoming as wild and reckless as their enemies. They nevertheless enjoyed widespread support and affection among most townspeople, who regarded them as their only protection from ruffians against whom there was no redress in law. It is not surprising, then, that *otokodate* quickly became heroes in Kabuki as well as real life, and such *otokodate* as Sukeroku, Banzui Chōbei, and Karigane Bunshichi and his gang were among the most popular of stage champions.

Karigane Bunshichi and his four accomplices were Osaka swashbucklers sentenced to death by the authorities in the eighth month of 1702. The following month their exploits, real and imaginary, were already featured in a puppet play, and many more versions followed. In the first Kabuki *Five Chivalrous Commoners*, performed in Edo at the Nakamura Theater in 1730, each of the heroes delivered a comic version of the high-declamatory soliloquy (*tsurane*) on a different theme.[1]

The early biographical account of *ukiyo-e* artists, *Ukiyo-e Ruikō* (Thoughts About *Ukiyo-e*), mentions that Shunshō was the originator of the five-sheet *hosoban* composition presenting one *otokodate* per sheet.[2] This was designed for the *Gonin Otoko* interlude performed at the Nakamura Theater in the summer of 1768. No single complete set of these prints seems to have survived, but The Art Institute of Chicago collection does include the sheet showing Nakamura Sukegorō II as Kaminari Shōkurō, standing against an opaque blue background (No. 27), and the complete set can be pieced together from various sources.

90.1. Katsukawa Shunshō. *Five actors as the Five Chivalrous Commoners*. Tokyo National Museum

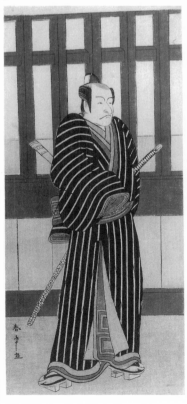 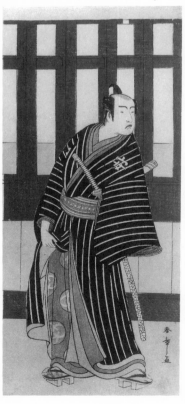 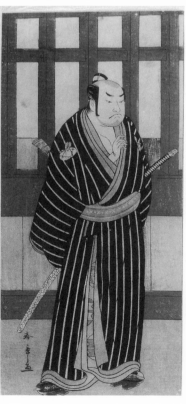 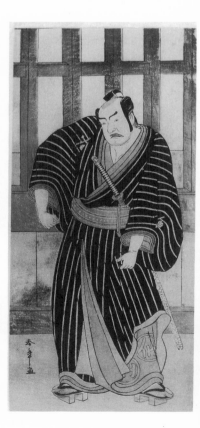

It was a feature of the "Gonin Otoko" plays that the five heroes were always identically costumed for a particular production. In the 1780 performance as depicted here, each man wears a green kimono decorated with the emblem of his particular character around the hem.[3] And yet Shunshō designed another five-sheet print for the same performance in which each man wears a black-striped kimono (fig. 90.1). In this second version the actors are standing in front of the slatted "display window" (*harimise*) of a brothel, so this must also be a scene in the Yoshiwara pleasure district. Two further pentaptychs by Shunshō relating to this performance are known, giving a total of four— each showing the *Gonin* in yet a different costume.[4] In so clearly differentiating the five identically costumed heroes, Shunshō's "Gonin Otoko" designs strikingly reveal the artist's gift for individual characterization.

The advance publicity handbill for the performance (*tsuji banzuke*) shows the five men dressed in yet another costume, with a bold sawtooth pattern around the sleeve opening (fig. 90.2). All this evidence suggests that prints were designed *before* the performance, with appropriate but not necessarily accurate costumes, so as to be ready for sale immediately after the play opened. Compared with the rather stiff, "posed" lineups in the five-sheet prints, this handbill gives a much better idea of the lively antics of the *otokodate*, as they brandish the flutes they characteristically carried (evidence of their cultivation) over the heads of troublesome samurai.

1 *Kabuki Saiken* (1926), pp. 694–95.
2 Yura Tetsuji, ed., *Sōkō Nihon Ukiyo-e Ruikō* (Tokyo: Gabundō, 1979), pp. 117–18.
3 The emblems are (right to left): flying geese for Karigane Bunshichi (the *kari* part of his name means "goose"), the stylized character *an* for An no Heibei, the stylized character *sen* under crossed hammers for Gokuin Sen'emon, the drumhead of the Thunder God for Kaminari Shōkurō (*kaminari* means "thunder"), and the lucky treasure sack of the god Hotei for Hotei Ichiemon.
4 One of the other two pentaptychs shows the five men with clouds behind (The Art Institute of Chicago, cat. no. 435); in the other they are standing by a river (Arthur M. Sackler Museum, Harvard University; School of Oriental and African Studies, University of London).

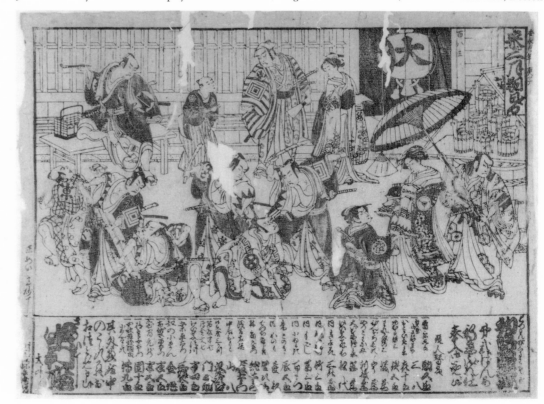

90.2. Publicity handbill for the play *Hatsumombi Kuruwa Soga*. Babcock collection, Museum of Fine Arts, Boston

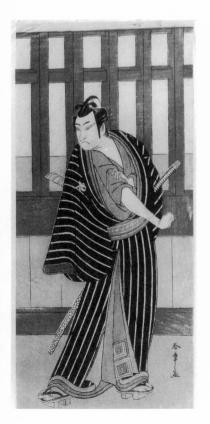

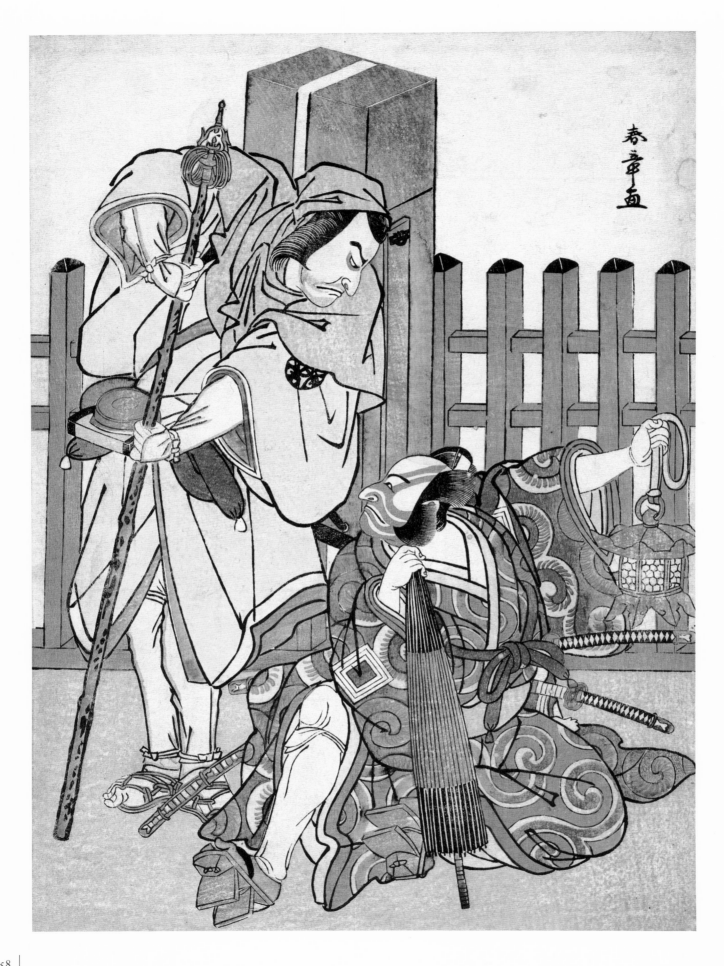

91 KATSUKAWA SHUNSHŌ
(1726–1792)

The actors Nakamura Nakazō I as Chinzei Hachirō Tametomo disguised as a pilgrim (left), and Ichikawa Danjūrō V as Kazusa no Gorobei Tadamitsu (right), in the "Silent Encounter" scene (*dammari*) from the end of part one of the play *Kitekaeru Nishiki no Wakayaka* (Returning Home in Splendor), performed at the Nakamura Theater from the first day of the eleventh month, 1780

Chūban; 26.4 x 19.0 cm
The Clarence Buckingham Collection 1925.2361

"Next he [Nakazō I] came on as Chinzei Hachirō Tametomo in the guise of a pilgrim, and at this point there was a confrontation with Danjūrō. The audience were beside themselves with delight and anticipation at this great scene." So ran the appreciative account of Nakazō I's performance in this role in an actor critique (*yakusha hyōbanki*) of the following year.[1] For it had been two years since the two great men had appeared on stage together, and there must have been more than a little friendly rivalry to add spice to the performance. "Silent encounter" scenes (*dammari*), such as depicted here, were a recent innovation in Kabuki at the time, strongly associated with— possibly even invented by— Nakazō I. They generally took place in some lonely mountain shrine at night (the red railing here marks the entrance to the Mishima Myōjin Shrine), with the actors engaging in a slow, stylized struggle for possession of some precious object. In this play the disputed object was a sacred bow, which is shown in the illustrated program (*ehon banzuke*) (fig. 91.1).

Nakazō I is wearing the disguise of a pilgrim who visits the sixty-six holy sites associated with the Lotus Sutra: gray robes, white leggings and arm covers, a portable shrine on his back, and carrying a staff with jingles (*shakujō*) and a brass gong, which the pilgrims struck to gain merit. Danjūrō V copied his costume from that of the old shrine attendant in the Nō play (and painting subject) *Aridōshi*: a "snake's eye" umbrella, high wooden clogs (*geta*), and a bronze lantern. Both thus had ample "weapons" to deploy in the silent fight scene.

Shunshō's composition is bristling with tension as the villain (?) Nakazō I towers over Danjūrō V, who in turn strikes a defiant stance (*mie*). Multisheet *hosoban* compositions too often slip into the isolating convention of one actor per sheet, but in his *chūban* designs Shunshō frequently devised powerful groupings of related figures: Danjūrō V's leg seems almost to thrust toward us out of the two-dimensional confines of the print. Very few impressions seem to have survived, and its pristine, unfaded colors make this one a particularly choice specimen.

At least five other designs are known that relate to the same performance: two magnificent half-length portraits by Shunkō (Nos. 112, 113), two *hosoban* prints by Shunshō showing Nakazō I in the pilgrim's garb, and an early *hosoban* triptych by Shunkō showing Danjūrō V, Ichikawa Yaozō III, and Onoe Matsusuke I in another scene.[2] The play was so extremely popular that the theater management even considered petitioning the city magistrate (*machi bugyō*) to allow them to extend the run an extra ten days after the official end of the theatrical season on the seventh day of the twelfth month.[3]

91.1. *The actors Nakamura Nakazō I and Ichikawa Danjūrō V in a "silent encounter" scene.* From the illustrated program. Nippon University Library, Tokyo

1 From the actor critique *Yakusha Sange no Tsuno-moji* (1781), quoted by Suzuki Jūzō in his notes on this print in *Ukiyo-e Shūka*, vol. 5 (1980), no. 4.
2 See Gookin (1931), no. 22; *Zusetsu Nihon no Koten*, vol. 20 (1979), pl. 326; and Ōta Memorial Museum (1983), no. 49, respectively.
3 *Kabuki Nempyō*, vol. 4 (1959), p. 407.

SIGNATURE *Shunshō ga*
PROVENANCE Baron Sumitomo collection
REFERENCE
Gookin (1931), no. 224; Riccar (1973), no. 106; *Ukiyo-e Taikei*, vol. 3 (1976), no. 11;
Ukiyo-e Shūka, vol. 5 (1980), no. 4
OTHER IMPRESSIONS *Shibai Nishiki-e Shūsei* (1919), no. 160

The actor Arashi Hinasuke I as Watanabe Chōshichi Tonau in the play *Tokimekuya O-Edo no Hatsuyuki* (Thriving Now: The First Snow of Edo), performed at the Morita Theater from the first day of the eleventh month, 1780

Chūban; 26.3 x 19.5 cm
Gift of Chester W. Wright 1961.196

The leading Osaka actor Arashi Hinasuke I (1741–1796) arrived in Edo in the eleventh month of 1780 and starred as Watanabe Chōshichi Tonau in the opening-of-the-season (*kaomise*) production at the Morita Theater.

Hinasuke I's father, Arashi Shōroku I, noted also as an author of witty haiku, had received the pen name Sūjo (also read Hinasuke) from Ichikawa Danjūrō II during a visit to Edo in the 1740s, and thereafter relations between the two acting families had been cordial. Later, Hinasuke I as a boy attended calligraphy classes alongside the future Danjūrō V, and when he returned to Edo in 1780 Danjūrō V, in a speech from the stage (*kōjō*), in the most affectionate terms introduced him to the Edo public as his "younger brother." Hinasuke I even adapted his personal crest—the character *kanau*—to resemble the "triple-rice-measure" (*mimasu*) crest of the Ichikawa family.[1] This print records not only Hinasuke I's performance but also the witty haiku poems (*senryū*) exchanged between the two men during his visit. On the right is Hinasuke I's tribute to Danjūrō V (whose earliest acting name was Ume-maru, "Young Plum") and an expression of his pleasure at being in Edo. Hinasuke I uses the pen name Minshi (Sleepy Lion):

> Arikata no
> Edo-e ni sakuya
> fuyu no ume
> — Minshi

> Glad to be in Edo!
> How the 'Winter Plum'
> blossoms on every print!

Danjūrō V (pen name Sanshō, "Triple Rice Measure") repays the compliment with a verse that plays on Hinasuke I's family name, Arashi, which means "storm":

> Kaomise ya
> tokaku arashi wa
> ateru mono
> — Sanshō

> At the *kaomise* performance
> The storm is bound
> To strike [a hit!]

92.1. *The actor Arashi Hinasuke I performing the "Dōjō-ji" dance.* From the illustrated program. Akiba Bunko, University of Tokyo Library

Hinasuke I is shown posing under the great temple bell in the famous "Dōjō-ji" dance interlude, with which he had scored a great success at the *kaomise* in Osaka in 1775.[2] In contrast to the standard version of "Dōjō-ji," in which the dancer impersonates a lovelorn young woman (No. 62), Hinasuke I is here seen performing as an exceedingly muscular male. Apparently this displeased Edo audiences, for the dance was lengthened to include a sequence in female costume. Even then, some members of the Edo audience complained that his costume was too large and that his voice lacked modulation.[3] The differences in acting styles between Edo and the cities of Osaka and Kyoto in western Japan were extensive and profound, and local audiences were partisan in their preferences.

The illustrated program (*ehon banzuke*) for the performance shows Hinasuke I striking a similarly determined pose under the bell (fig. 92.1).

1 *Kabuki Nendaiki* (1926), p. 382.
2 *Kabuki Nempyō*, vol. 4 (1959), p. 415.
3 Ibid.

SIGNATURE *Shunshō ga*
OTHER IMPRESSIONS Ōta Memorial Museum, Tokyo

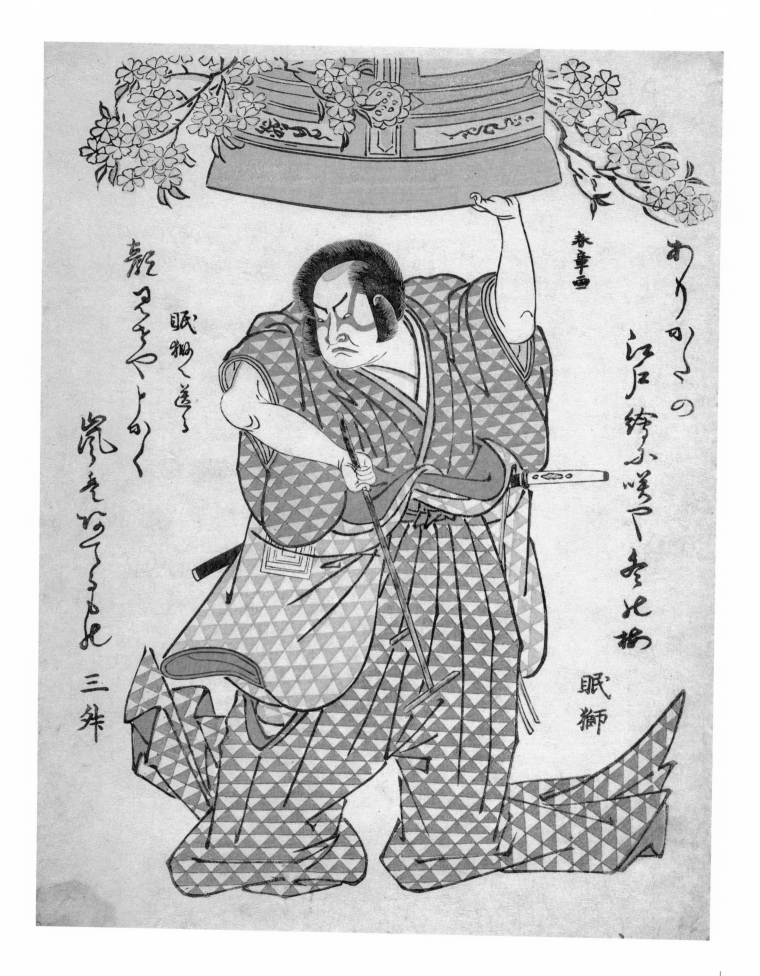

All spectators, but especially women, many of whom were passionate Kabuki fans, were forbidden entry to the all-male world backstage at the Kabuki theater. Fierce notices were posted warning women and other intruders not to venture up to the dressing rooms on the second and third floors, and in the unlikely event that a woman did penetrate these defenses, the areas sullied by their presence were supposed to be purified afterward with salt.[1] Backstage was (almost) sacrosanct.

How great the appeal, then, of prints that offered a glimpse of this out-of-bounds world and showed the stars at their ease— applying or removing makeup, waiting in their dressing rooms to go on stage, chatting in the corridors dressed in fashionable street clothes. Having established a new realism for images of actors in character, Shunshō went on to pioneer depictions of the stars offstage as well. Doubtless he was responding to a certain extent to the ever more sumptuous tenor of popular culture in the An'ei/Temmei eras (1770s and 1780s), with its enthusiasm for larger-than-life icons, be they superbly exclusive courtesans of the Yoshiwara pleasure district or Kabuki superstars.

An important indicator of the public's growing fascination with the lives of actors offstage was the book *Yakusha Natsu no Fuji* (Actors: Mt. Fuji in Summer), illustrated by Shunshō and datable from its preface to the winter of An'ei 9 (1780). The conceit behind the title and the main intent of the book was to show leading actors as they looked without their makeup, like Mt. Fuji in summer without its mantle of snow. Starting with a New Year scene of the three theater managers exchanging compliments of the season in the street (fig. 93.1), the book contains thirteen double-page black-and-white illustrations of groups of famous stars enjoying various seasonal activities.[2] A promised sequel, showing actors "down to the child stars" inside the three theaters, was never published. Perhaps this intention was diverted into the present series of *ōban* color prints, untitled in Japanese (but here given the working title *Actors Backstage*), thought to have been issued about 1780–1783 (see below).

In his preface to *Yakusha Natsu no Fuji* Shunshō makes the following somewhat diffident confession: "I am fond of the theater and it is my habit to see plays performed, but as I am not personally acquainted with the actors, I know nothing of their private lives.... but finally I acceded to Tsūshō's [author of a preface and a few passages of text] earnest request, hoping that the things which are not accurately portrayed may yet be entertaining."[3] It is hard to believe that the supreme portraitist of actors on stage might never have had social contact with his subjects, and perhaps Shunshō's comment simply reflects the modesty customarily required of authors in their prefaces. And yet there is certainly something contrived about scenes such as two famous stars meeting by chance at the entrance to the public bathhouse (fig. 93.2). All the color prints of the *Actors Backstage* series share this somewhat studied quality: the figures and settings are instantly recognizable and the activities are thoroughly plausible, but the whole effect of the compositions seems more posed than spontaneous.

Eight designs from the series are presently known.[4] Roger Keyes has suggested that the design of Ichikawa Danjūrō V in the costume of the "Shibaraku" role was intended as a souvenir of the production opening in the eleventh month of 1783 (which was cancelled because the Nakamura Theater burned down); Keyes has also pointed out that the print of Ichikawa Danzō IV must have been issued before he went to Osaka at the end of that year.[5] Whether all the prints were issued toward the end of 1783 is open to question. Japanese scholars have divided the designs into those with signatures in the formal script (*kaisho*) style and those with signatures in the semicursive script (*gyōsho*) style; the implication being that the former group was issued earlier than the latter.[6] One clue to an approximate date for the series may lie in the fact that Torii Kiyonaga (1752–1815) began to issue his first *ōban* theatrical prints, showing onstage musicians as well as actors (*degatari-zu*), in the spring of 1782.[7] Shunshō's *Actors Backstage— his* first series of *ōban* theatrical prints— may have been prompted by competition with Kiyonaga (or vice versa). Like the *Azuma Ōgi* (Fans of the East) series (Nos. 72, 73), the *Actors Backstage* could well have been issued over a number of years, and a tentative date of 1780–1783 is proposed.

1 See the quotation from *Gekijō Shinwa* in Koike (1979), p. 122.
2 For a complete modern reproduction of *Yakusha Natsu no Fuji*, including a transliteration of the text, see Kurokawa Mamichi, *Nihon Fūzoku Zu-e*, vol. 11 (Tokyo: Kashiwa Shobō, 1983), pp. 73–118, 209–11.
3 Translated in Gookin (1931), p. 194.
4 These are: Ichikawa Danjūrō V in his dressing room consulting with the program announcer (Tokyo National Museum; Museum of Fine Arts, Boston; The Art Institute of Chicago [cat. no. 464]); Onoe Matsusuke I in the costume room examining a costume

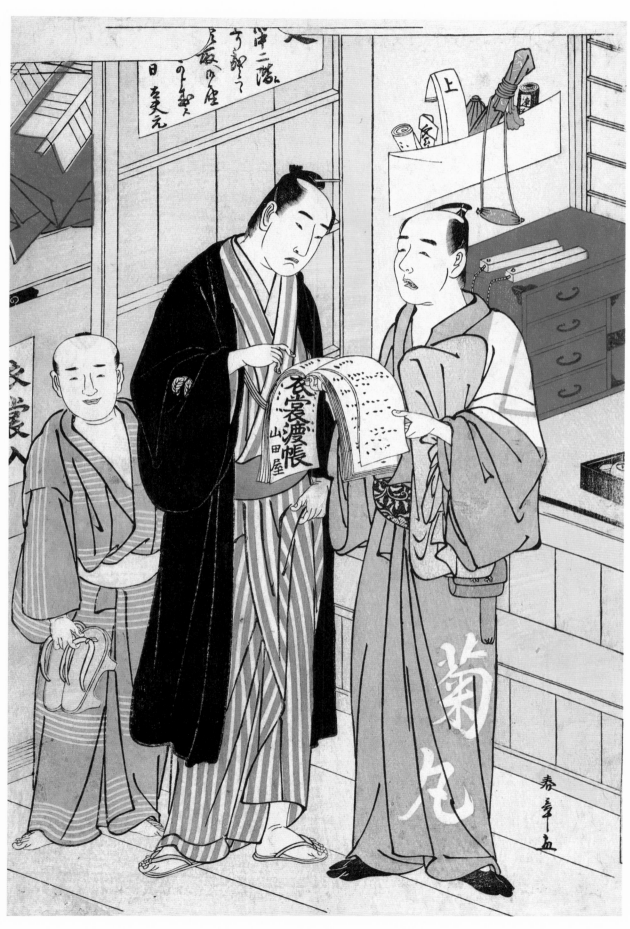

The actor Onoe Matsusuke I in the wardrobe room of a theater
Ca. 1780–1783

Ōban; 38.3 x 25.5 cm
The Clarence Buckingham Collection 1925.2363

delivery notebook held by Ichikawa Kikumaru (Musée Guimet, Paris; The Art Institute of Chicago [No. 93]); Ōtani Hiroji III in his dressing room with Ōtani Tokuji I and probably Nakamura Nakazō I (Musées Royaux d'Art et d'Histoire, Brussels; The Art Institute of Chicago [cat. no. 462]); Sawamura Sōjūrō III in his dressing room with Segawa Kikunojō III (H. R. W. Kühne collection, Switzerland; Kashiwabara Magozaemon collection; ex-coll. Vever [present location unknown]; Tokyo National Museum; The Art Institute of Chicago [No. 94]); Iwai Hanshirō IV, Ichikawa Monnosuke II, and probably Iwai Karumo backstage (Museum of Fine Arts, Boston; The Art Institute of Chicago [No. 95]); Nakamura Nakazō I in his dressing room with Nakamura Rikō I and a wig maker (Tokyo National Museum; ex-coll. Vever [present location unknown]); Matsumoto Kōshirō IV in his dressing room with Ichikawa Komazō III and a hairdresser (Musée Guimet, Paris; Watanabe Tadasu collection, Tokyo); Ichikawa Danzō IV in his dressing room with Segawa Kikunojō III (Musée Guimet, Paris).

5 *Ukiyo-e Shūka*, vol. 13 (1981), no. 21.
6 *Genshoku Ukiyo-e Daihyakka Jiten*, vol. 7 (1980), p. 138.
7 See the table in Yoshida Teruji, "Torii Kiyonaga no Ōban Yakusha-e," *Ukiyo-e Bisan* (Tokyo: Kitamitsu Shobō, 1943), pp. 170–76.

Next to the room of the dressing-room manager, by the stairs leading up to the principal actors' dressing rooms on the third floor, was the wardrobe room (*ishō-beya*) or costume storeroom (*ishō-gura*).[1] As a rule actors were expected to provide their own costumes, either buying them or soliciting them as gifts from patrons.[2] For those who could not so equip themselves, however, theaters maintained a considerable wardrobe from which items could be borrowed. In addition, special costumes could be rented from hire firms. The shogunal government regularly passed sumptuary laws limiting the opulence of stage costumes, and wardrobe rooms were subject to inspection by officials.[3]

Onoe Matsusuke I, dressed in a simple striped kimono and long black *haori* jacket, stands examining a "record book of costumes issued" (*ishō watashi-chō*). This bears the name Yamadaya, suggesting that it is a record of costumes rented from that company. The figure holding the record book wears a blue cotton kimono dyed with the Ichikawa family crest and the name Kikumaru; on his feet are black *tabi* socks, such as would normally be worn backstage. He may be either an employee of the Yamadaya company whose job was to look after the costumes,[4] or else a minor actor (Ichikawa Kikumaru?) performing the same function for the theater. He carries a bundle wrapped in a yellow cloth, presumably to be delivered somewhere, since the boy assistant is holding a pair of sandals for street wear. Shunshō draws an amusing contrast between the good-looking actor with his strong, regular features and the snub-nosed, weak-chinned costume assistant.

Through the doorway at the back can be seen a large chest marked "costume box" (*ishō ire*), on top of which is piled a persimmon-colored costume with an emblem of arrow shafts, such as might be used in a "Shibaraku" scene. Pasted on the sliding door is a list of regulations from the theater manager, and in the alcove are stored a variety of small stage props: various types of letters, a small sword and an amulet in brocade bags, and a rolled scroll. On top of the small chest is a pair of wooden stage clappers (*hyōshigi*), used for sound effects such as running feet and clashing swords.

Onoe Matsusuke I (1744–1815) was born in Osaka and became a pupil of Onoe Kikugorō I. He was later known for his ghost roles in plays written by Tsuruya Namboku IV (1755–1829).

1 Koike (1979), p. 142, quoted from *Gekijō Shinwa*.
2 Ihara (1913), p. 716.
3 Ibid., pp. 713–15.
4 The person in charge of the costumes, the *ishō-gakari*, was expected to clean makeup from clothes and mend them after each use. See *Kabuki Jiten* (1983), s.v. "*ishō-beya*."

SIGNATURE *Shunshō ga*
PROVENANCE Ernest F. Fenollosa collection
REFERENCE Gookin (1931), no. CBAI 1
OTHER IMPRESSIONS Musée Guimet, Paris

93.1. Katsukawa Shunshō.
Managers of the three Edo Kabuki theaters
exchanging New Year greetings.
From *Yakusha Natsu no Fuji*.
British Museum, London

93.2. Katsukawa Shunshō.
Two famous actors meeting
at the entrance to the public bathhouse.
From *Yakusha Natsu no Fuji*.
British Museum, London

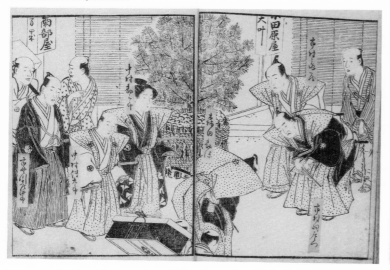

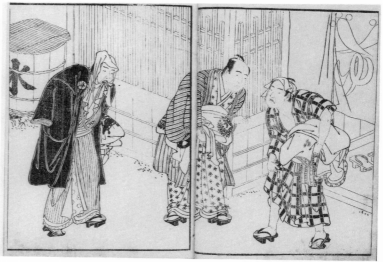

94 KATSUKAWA SHUNSHŌ
(1726–1792)

Sawamura Sōjūrō III (right), in his dressing room in
conversation with Segawa Kikunojō III (left)
Ca. 1780–1783

Ōban; 36.0 x 24.6 cm
The Clarence Buckingham Collection 1938.496

Sawamura Sōjūrō III stands wearing a *yukata* (informal cotton
kimono, often worn as a bathrobe) decorated with his alternate
crest (*kaemon*) of "chrysanthemum in a circle" (*kan-giku*).
The gesture of wiping the ear with the end of the sleeve is a
common pictorial convention for showing that a person has
just returned from the bath. Squatting on the floor is the great
female impersonator (*onnagata*) Segawa Kikunojō III, dressed
in a purple-and-black striped kimono and black *haori* jacket,
with his alternate crest (*kaemon*) of a butterfly just visible on
the sleeve. The black jacket has been embossed to suggest the
folds of the fabric, using a technique known as *kimedashi*.

Female impersonators were expected to dress and behave as
women both on and off stage, and the superstars among them
often became leaders of female fashion. A print such as this
would excite viewers not merely because it shows two super-
stars casually chatting after the show in a dressing room,
normally terra incognita to outsiders (particularly females):
surely many women would go on to imagine themselves as
Kikunojō III in casual proximity to Sōjūrō III clad only in his
bathrobe. For Sōjūrō III, in his late twenties in the early 1780s,
was perhaps the most attractive romantic hero of the day.

Surrounding the two actors is the usual furniture of the
dressing room: a cosmetic stand bearing a hand-mirror draped
with a towel, a bucket of water for washing the face, a wig
box, a smoking set. The large storage chest (*nagamochi*) behind
them is for clothes, and on top of this is an open costume box
in which three lavish brocade kimono have been neatly folded.
It was the actor's responsibility to provide his own costumes,
and performances were judged in part by the suitability— or
chic— of the ensemble. Resting on the costume box are a pair
of stage swords in sharkskin scabbards. The name-board
hanging on the wall reads "Sōjūrō."

The colors of the Chicago impression are still remarkably fresh,
only the pale blue on Sōjūrō III's *yukata* having faded slightly.
The considerable amount of pink in the print— in Japan as in
the West a "feminine" hue— may have been selected as appro-
priate to Kikunojō III.

SIGNATURE *Shunshō ga*
PROVENANCE Frederick W. Gookin collection
REFERENCE Gookin (1931), no. G255
OTHER IMPRESSIONS
Tokyo National Museum; Kashiwabara Magozaemon collection,
Kyoto; H. R. W. Kühne collection, Switzerland; ex-collection Vever
(present location unknown)

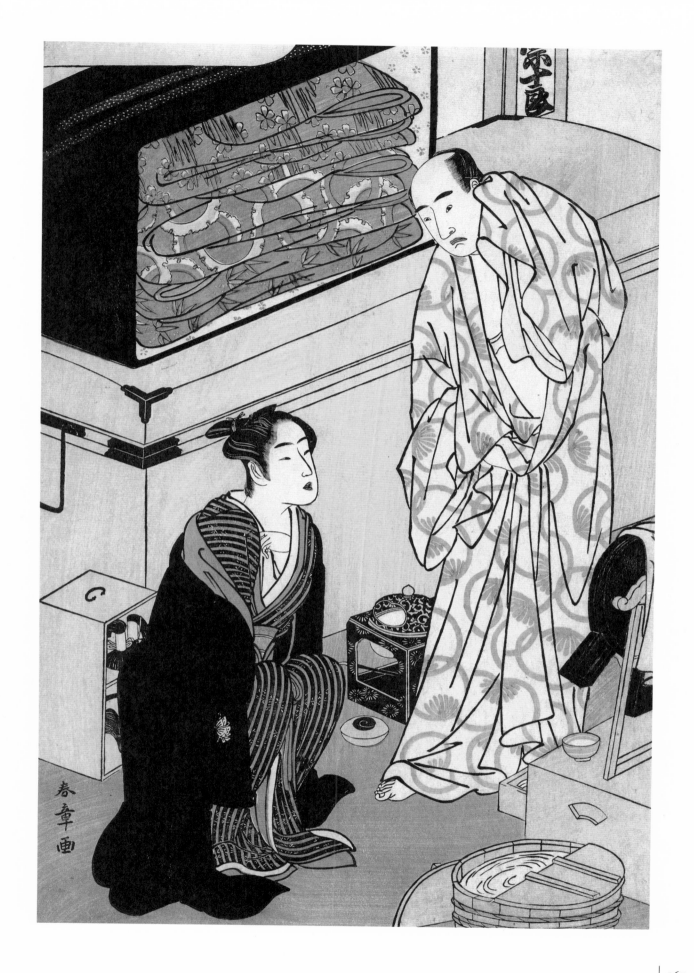

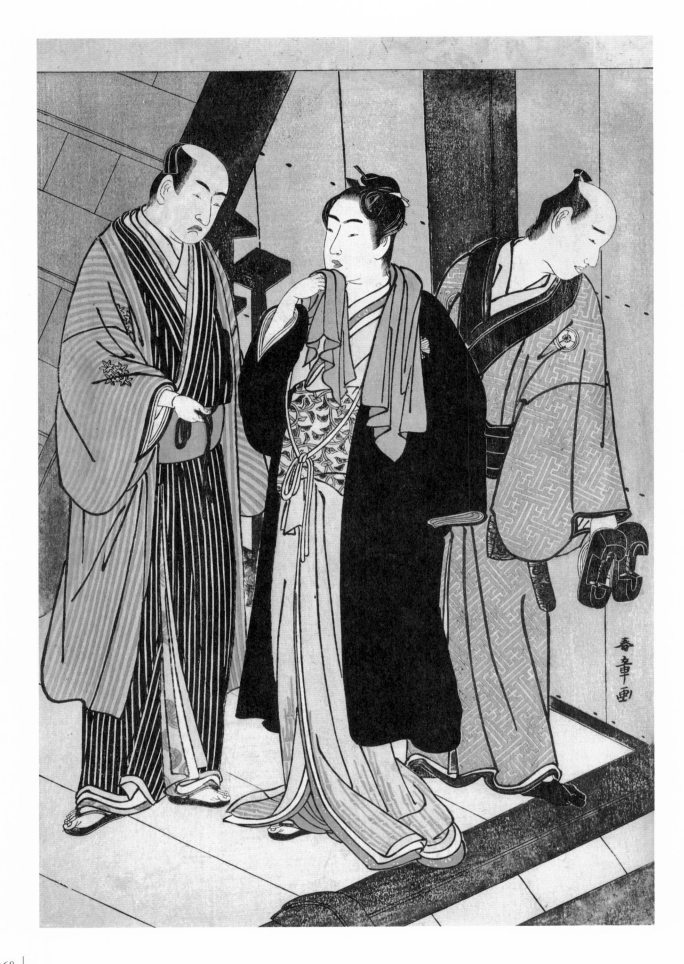

95 KATSUKAWA SHUNSHŌ
(1726–1792)

The actors Ichikawa Monnosuke II (left), Iwai Hanshirō IV
(center), and Iwai Karumo (?) (right), on a landing backstage
Ca. 1780–1783

Ōban; 37.5 x 26.2 cm
The Clarence Buckingham Collection 1925.2364

Three actors, stylishly but informally clad, are gathered on a
staircase landing backstage. When the Nakamura and Ichimura
theaters were rebuilt in 1781, the shared dressing rooms for the
male leads were on the third floor (*sangai*) and individual dressing
rooms for the female impersonators (*onnagata*) on the second-
floor mezzanine level (*chū nikai*).[1] The staircase behind Mon-
nosuke II is perhaps the one leading up to the dressing rooms on
the third floor. Stored behind it are a stack of lamps on stands.

Given pride of place in the center of the group is Iwai Hanshirō IV
(1747–1800), who shared top ranking among female imperson-
ators with Segawa Kikunojō III during the 1770s and '80s. Off-
stage he is said to have had a fiery temper, but the public seems
to have been fond of his plump, round face and called him by the
affectionate nickname Otafuku Hanshirō (Otafuku was the
archetypal chubby woman of popular folklore). Here he wears a
pink (therefore feminine) kimono, its trailing skirts decorated
with bamboo canes: the long black *haori* jacket was fashionable
with entertainers of both sexes. His hair is wound informally
around a single hairpin, feminine style. Draped around Hanshirō
IV's shoulders is a purple hand towel which he holds up to his
half-open mouth in a gesture of surprise.

His conversation partner is Ichikawa Monnosuke II (1743–1794),
whose good looks and splendid stage presence made him one
of the most popular male leads of his generation, excelling
in both swashbuckling (*aragoto*) and tender (*wagoto*) roles. He
is dressed in a black-striped kimono and brown-striped jacket,
with his informal crest (*kaemon*) of "maple leaves in a loz-
enge shape" (*momiji-bishi*) on the sleeve. In a casual, comic
touch, his topknot has slipped lopsidedly off-center.

The identity of the third figure is uncertain, though his discreet
downward gaze and lack of participation in the conversation
make it clear that he is an altogether lesser light than the two
stars. On his sleeve is the "three fans in a circle" crest of the
Iwai family, suggesting that he is a pupil (and attendant) of
Hanshirō IV, perhaps Iwai Karumo (future Iwai Kiyotarō II).[2]

1 Koike (1979), p. 132.
2 Iwai Karumo is recorded as having been apprenticed to Hanshirō IV
between 1782 and 1787. See *Kabuki Jimmei Jiten* (1988), p. 116.

SIGNATURE *Shunshō ga*
PROVENANCE Bernard Welby collection
REFERENCE Gookin (1931), no. CBAI 2
OTHER IMPRESSIONS
Museum of Fine Arts, Boston; Allen Memorial Art Museum,
Oberlin College

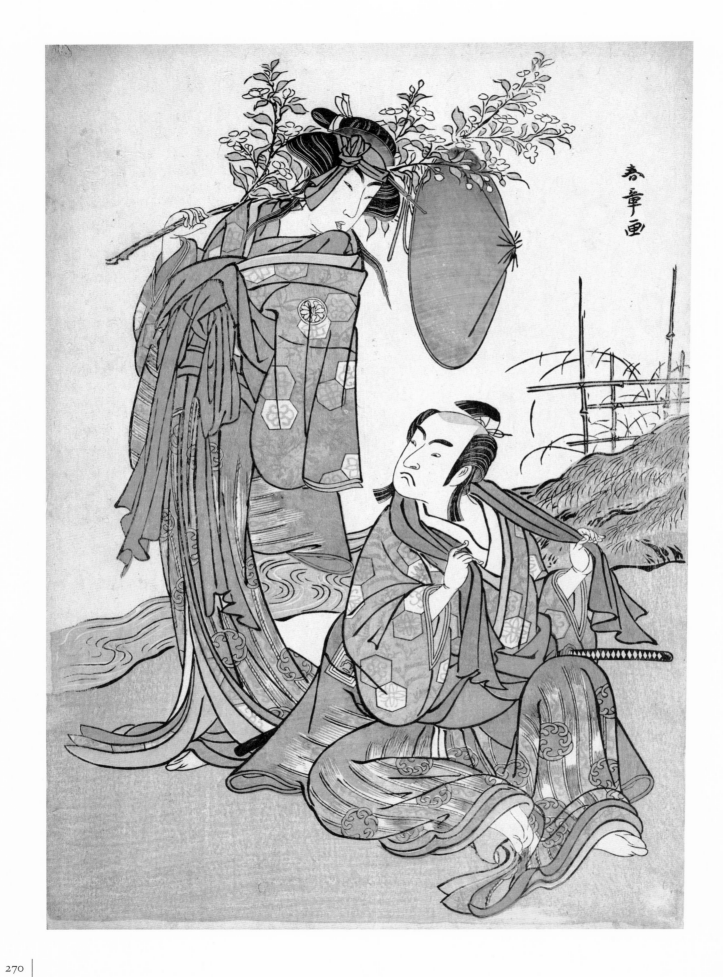

The actors Ichikawa Monnosuke II and
Segawa Kikunojō III as the lovers Seijūrō
(right) and Onatsu (left) in the elopement
scene "Michiyuki Hiyoku no Kiku-chō"
(An Elopement: Chrysanthemum-and-But-
terfly[1] Lovebirds), a dance interlude from part
two of the play *Kabuki no Hana Bandai Soga*
(Flower of Kabuki: The Eternal Soga), per-
formed at the Ichimura Theater from the
twenty-fifth day of the fourth month, 1781

Aiban; 32.5 x 28.0 cm
The Clarence Buckingham Collection 1927.605

On the night of the eighth day of the first month,
1781, a great fire broke out in Edo which utterly
destroyed both the Nakamura and Ichimura
theaters. Not until the end of the fourth month
did performances of the customary New Year
"Soga" plays recommence in the newly recon-
structed theaters.[2] The second part of the program
at the Ichimura Theater consisted of a dance
sequence on the theme of star-crossed lovers— in
fact three variant dance sequences, performed on
consecutive days and then repeated— each starring
Segawa Kikunojō III, a leading female imper-
sonator (*onnagata*) of the day. "The hit of the
century,"[3] the dance sequences were performed
through the summer and into the autumn.

Each dance sequence (*shosagoto*) enacted a
famous love tragedy, accompanied by onstage
jōruri musicians led by Tomimoto Buzen-
dayū II (1754–1822). Kikunojō III depicted all
three tragic ingenues, with a different male
partner in each of the three sequences. The first
of the dance sequences, illustrated here, was
"Michiyuki Hiyoku no Kiku-chō," with Kiku-
nojō III as Onatsu and Ichikawa Monnosuke II as
her lover, Seijūrō. The story is said to be based
on actual events occurring in 1662: Seijūrō, an
employee of the Tajimaya, a shop in Himeji, was
discovered to be the secret lover of the owner's
daughter Onatsu and was therefore dismissed and
sent packing. Onatsu fled after her lover, but the
two were captured. Seijūrō was convicted of
abducting Onatsu and executed. Onatsu lived
out her days unmarried and in sorrow.[4] In some
versions of the play, however, Onatsu goes mad
after Seijūrō's death; she wanders from place to
place seeking him and perpetually thinking she
sees him among the crowds of Ise pilgrims
wearing similar hats.

As we have seen, Shunshō began to use the
medium-sized oblong *aiban* format to depict pairs
of actors in the mid-1770s (Nos. 82, 85, 86, 91).
Here too he has drawn a highly satisfying compo-
sition in which the figures suggest the space they
occupy, with Monnosuke II (as Seijūrō) resting
near a river bank and looking up at Kikunojō III
(as Onatsu), who stands with his back arched
into a graceful curve. The lovers wear matching
costumes, with their over-kimono shrugged
off to the waist, suggesting the exertions of the
flight. Over her shoulder Onatsu carries Seijūrō's
travelling hat attached to a branch of white
mountain cherry.

An illustration by Shunshō's pupil Shunjō
(d. 1787) in the program for the performance
(*ehon banzuke*) shows the lovers (standing)
attended by Bandō Mitsugorō I as Zaigō no
Genjū (seated, right) and an unidentified female
character seated at left (fig. 96.1). The advance
publicity handbill (*tsuji banzuke*) shows vignettes
of all three elopement scenes, beginning with
Onatsu and Seijūrō on the right (fig. 96.2).

1 "Chrysanthemum and Butterfly" (*kiku-chō*) refers to the
 alternative acting crest (*kaemon*) of Segawa Kikunojō III.
2 *Kabuki Nempyō*, vol. 4 (1959), pp. 450–51.
3 "Kono kyōgen hyakunen irai no ō-atari no yoshi." *Enyū
 Nikki* (1977), p. 915. Lord Yanagisawa did not see the
 play because his wife, Oryū, was indisposed.
4 *Kabuki Saiken* (1926), "Onatsu Seijūrō," pp. 841–45.

SIGNATURE *Shunshō ga*
REFERENCE Gookin (1931), no. CBAI 45

96.1. Katsukawa Shunjō. *The actors Bandō Mitsugorō I as Zaigō no
Genjū, Segawa Kikunojō III as Onatsu, and Ichikawa Monnosuke II
as Seijūrō.* From the illustrated program. Nippon University Library, Tokyo

96.2. Publicity handbill for the play *Kabuki no Hana Bandai Soga*.
Bigelow collection, Museum of Fine Arts, Boston

273

(1726–1792)

The actors Matsumoto Kōshirō IV and Segawa Kikunojō III as the lovers Chōemon (right) and Ohan (left) in the elopement scene "Michiyuki Segawa no Adanami" (An Elopement: Treacherous Waves in the Shallow River),[1] a dance interlude from part two of the play *Kabuki no Hana Bandai Soga* (Flower of Kabuki: The Eternal Soga), performed at the Ichimura Theater from the twenty-fifth day of the fourth month, 1781

Aiban; 32.5 x 21.6 cm
The Clarence Buckingham Collection 1937.179

SIGNATURE *Shunshō ga*
PROVENANCE Spaulding collection
REFERENCE
Gookin (1931), no. 233, text pp. 202–3;
Riccar (1973), no. 109
OTHER IMPRESSIONS
Museum of Fine Arts, Boston; British Museum, London

97.1. Katsukawa Shunshō.
*The actors Segawa Kikunojō III
as Ochiyo and
Bandō Mitsugorō I
as Hambei.*
Baur collection, Geneva

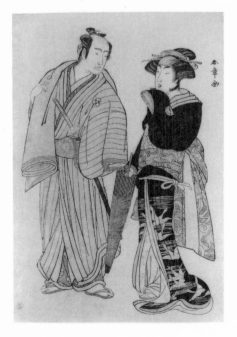

As described in Number 96, through the summer of 1781 the Ichimura Theater staged a phenomenally successful series of three dance sequences on three consecutive days, each on the theme of a famous love tragedy and starring Segawa Kikunojō III as the female protagonist. The first day featured the doomed elopement of the lovers Seijūrō and Onatsu from Himeji (No. 96); the second presented the suicide of the husband and wife Hambei and Ochiyo (fig. 97.1). The third performance, illustrated here, depicted the ill-fated affair between Chōemon, a middle-aged obi merchant, and Ohan, fourteen-year-old daughter of the shopkeeper of the Shinanoya, whose bodies were found floating in the Katsura River in Kyoto. Caught between their love for each other and Chōemon's duty to his wife and family, Chōemon and the pregnant Ohan committed love-suicide by drowning.[2] Kabuki audiences had no taste for happy endings where love-affairs were concerned; the more heartrending the outcome, the more satisfying the drama.

At the time of the performance Kikunojō III would have been just thirty and at the height of his beauty and theatrical powers. Shunshō captures the tremulous shyness in the actor's portrayal of a teenage girl in love, as she hides her face in the collar of her kimono and toys with a hairpin. Kōshirō IV, as her mature lover, stands protectively to the fore. Though the two do not look at one another, their intimacy is well conveyed by that gently curving line along which her black kimono meets the vivid check of his jacket. They seem unconsciously to lean together.

For an eye-witness account of the performance, we can look to the memoirs of the writer Santō Kyōzan (1769–1858), entitled *Kumo no Itomaki* (The Spider's Web). Though written in 1846, in his old age, the events of considerably more than a half century before are still vivid in his mind's eye:

"In the second act they had plays representing Edo, Kyoto, and Osaka, which were performed on three consecutive days. It was a huge success the like of which has never been seen, and it ran until the autumn. At this time I was thirteen years old and went to see the play about Ohan and Chōemon. I can still picture how beautiful Ohan was. As for Kōshirō, well, he wasn't much of a dancer. So while Ohan was doing the dancing he just stood there with his arms folded. People said it was truly amazing how he managed to show his inner feelings of despair at the horror of having to kill Ohan. You don't see things like that today. Really, that was the golden age of the theater...."[3]

In addition to the three *aiban* prints showing the pairs of lovers, Shunshō also designed a *hosoban* diptych of the elopement performed on the second day, "Michiyuki Kakine no Yuiwata" (An Elopement: Bundle of Floss Silk[4] at the Brushwood Fence) (cat. no. 469). Bandō Mitsugorō I as Hambei and Kikunojō III as Ochiyo walk sadly under a single umbrella (symbol of true love), carrying the blanket upon which they will commit love-suicide and watched over by Ōtani Tomoemon I as Otsuma, widow of the grocer Kamakuraya. Scenes from all three elopements are shown on the advance publicity handbill (*tsuji banzuke*) for the performance (fig. 96.2), as well as on the covers of the libretti of the Tomimoto school narrative songs (*jōruri seihon*) published at the time.[5]

1 A pun on Kikunojō III's family name, Segawa, which literally means "shallow river."
2 In the true-life drowning on which this play is based, the principals were victims of a robber and did not even know each other.
3 Quoted in *Kabuki Nempyō*, vol. 4 (1959), p. 452.
4 Another reference to Kikunojō III, this time to his formal crest, the *yuiwata* (bundle of floss silk).
5 *Shibai Nishiki-e Shūsei* (1919), no. 175.

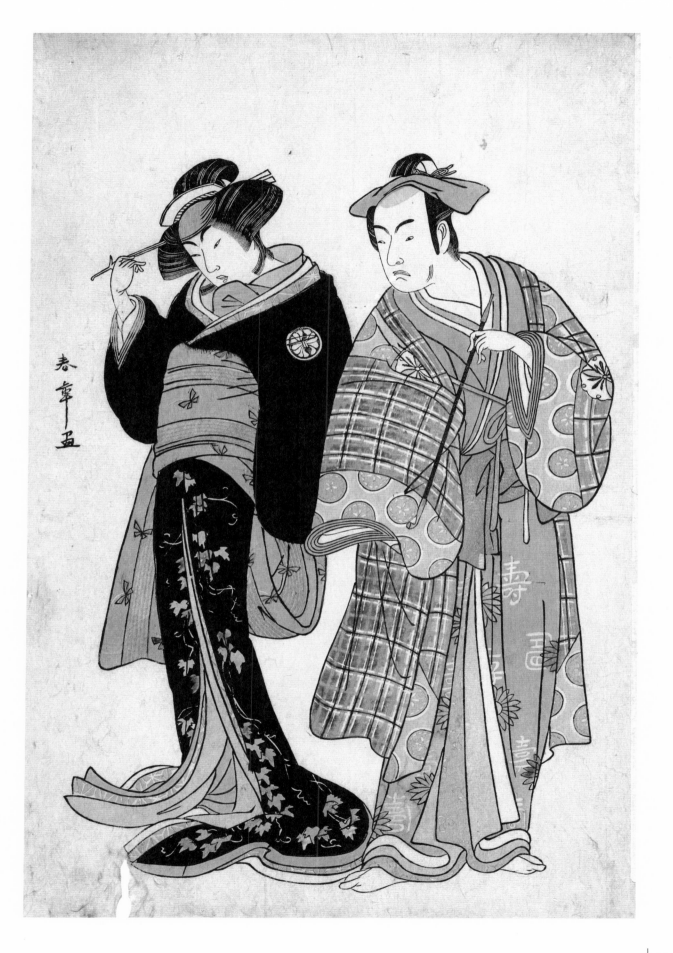

The actor Ichikawa Danjūrō V as Sakata Hyōgonosuke Kintoki in the play *Shitennō Tonoi no Kisewata* (Raikō's Four Intrepid Retainers in the Costume of the Night Watch), performed at the Nakamura Theater from the first day of the eleventh month, 1781

Hosoban; 32.0 x 14.8 cm
The Clarence Buckingham Collection 1949.38

The opening-of-the-season (*kaomise*) play at the Nakamura Theater in the eleventh month of 1781 was set in the tenth-century "world" (*sekai*) of the warrior Minamoto no Yorimitsu (better known as Raikō, d. 1021) and his four dauntless retainers, whose intrepidity earned them the collective sobriquet "Four Heavenly Kings" (*Shitennō*): Watanabe no Tsuna, Sakata no Kintoki, Usui no Sadamitsu, and Urabe no Suetake. Ichikawa Danjūrō V appears here as Kintoki, a massive, lowering presence in voluminous black robes with sleeves like great kites, on which the character *kin* is writ large in white.

Raikō and his retainers were common characters in opening-of-the season productions, which also traditionally offered a "Shibaraku" (Stop right there!) interlude in part one, act three (see No. 44). The novelty of this production was to play the "Shibaraku" role not as a male hero but as an evil woman (acted by Segawa Kikunojō III).[1]

The drama presented a version of the legend in which Raikō and his followers subdue the monster Earth Spider (*Tsuchi-gumo*). The spirit of this monster spider of Mt. Katsuragi appears here in the form of a beautiful woman, *Jorō-gumo* (Harlot Spider), first wearing the large robes and court hat of the "Shibaraku" role, then shedding these to reveal the costume of a voluptuous *maiko* (young geisha in training), Tsumagiku, who wishes to dance for the entertainment of Lord Raikō.[2] This is the scene depicted in the program. Segawa Kikunojō III, who kneels in the bottom left-hand corner holding a decoration on a stand, wears a kimono with long hanging sleeves (*furisode*) decorated with the "crane rhombus" (*tsuru-bishi*) pattern normally found on a man's "Shibaraku" costume. Her approach is challenged by Raikō's four retainers, each wearing a wide-shouldered *suō* jacket decorated with his large crest (*mon*). Danjūrō V as Kintoki stands foremost, posed very much as in our print. Though he is accoutered with the fan and hair decorations of the male "Shibaraku" role, in this production the action of the role is performed by his female foe.

At the top of the stair sits Lord Raikō (played by Sawamura Sōjūrō III), clearly bewitched by the dancing of the lovely Tsumagiku and reciprocating her gesture with his sake cup. Above the sake cup, however, as yet unnoticed by the warriors, hangs a spider. This reminds the audience that the true identity of the dancer will be revealed, and her plans thwarted, when Raikō sees her reflected in the sake cup — in her true form of an evil spider![3]

A comparison between the program illustration and the print of Danjūrō V demonstrates forcefully Shunshō's genius for refining a complex stage tableau into a design of enormous graphic power. Indeed the black robes, with folds picked out in white reserve, not only fill the composition but virtually take on a life of their own. Only the challenging stance, and Danjūrō V's angular features appearing out of the kimono like a blade half drawn from its sheath, remind us of the redoubtable warrior within the robes. Louis Ledoux named the print, quite simply, *The Black Danjūrō*.[4]

Shunshō's pupil Shunjō designed a magnificent five-sheet *hosoban* showing Segawa Kikunojō III as Tsumagiku flanked by Raikō's four retainers in this performance, very close in style to Shunshō's own work.[5]

1 *Kabuki Nempyō*, vol. 4 (1959), pp. 455–59.
2 *Kabuki Saiken* (1926), pp. 590–91.
3 *Kabuki Nempyō*, vol. 4 (1959), p. 456.
4 Ledoux (1945), no. 46.
5 *Ukiyo-e Taikei*, vol. 3 (1976), nos. 57–61 (Japan Ukiyo-e Museum, Matsumoto).

SIGNATURE *Shunshō ga*
PROVENANCE Louis V. Ledoux collection
REFERENCE
Gookin (1931), no. 239, pp. 206–7; Ledoux (1945), no. 46
OTHER IMPRESSIONS
British Museum, London; *Shibai Nishiki-e Shūsei* (1919), no. 170 (present location unknown)

98.1. Torii Kiyonaga. *Ichikawa Danjūrō V and other actors in the "Onna Shibaraku" scene.*
From the illustrated program.
Tōyō Bunko Library, Tokyo

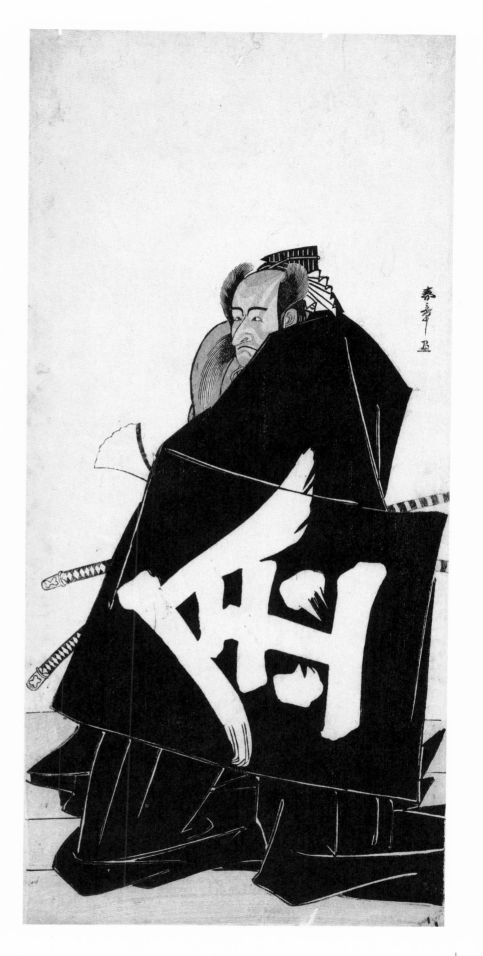

Sumo wrestlers of the Eastern Group: (right) Nijigadake
Somaemon of *sekiwake* rank from Awa Province, and (left)
Fudenoumi Kin'emon of *maegashira* rank from Kokura
Ca. 1782–1783

Ōban; 38.2 x 26.0 cm
Frederick W. Gookin Collection 1949.44

As Asano Shūgō has recently written, Shunshō was probably the
originator of sumo prints as a distinctive category of *ukiyo-e*.
Until his time individual wrestlers had been regarded as curi-
osities, worthy of occasional depiction in color prints; it was
Shunshō who, from about 1782, made the illustration of sumo
champions into a genre in its own right, with its own stylistic
conventions.[1] As in his actor portraits, Shunshō was closely
attentive to the wrestlers' facial features, though of course an air
of comeliness was neither necessary nor even desirable. And yet,
though their bloated bodies and heavy features could be shown
without flattery, Shunshō's wrestlers are always drawn sympa-
thetically, imbued with a sense of dignity and self-respect few
later artists could match. He simultaneously established and
perfected the genre.

Sumo tournaments were generally held for "ten fine days" (*seiten
tōka*) in temporary arenas set up in the large open spaces around
temples and shrines, which received part of the proceeds of
the matches. Hence tournaments were normally described as
"Subscription Sumo" (*kanjin sumō*). From the 1780s the regular
location came to be the Ekō-in, a temple at Honjo, across the
Sumida River from the main part of Edo.[2] Shunshō designed a
large horizontal "perspective" print (*uki-e*) of wrestlers crossing
a bridge over the Sumida River on their way to a tournament,
accompanied by an enthusiastic crowd,[3] and another showing a
match in progress (fig. 99.1).

The burgeoning interest among *ukiyo-e* artists in designing
wrestler prints occurred at least in part because Edo had, by the

late eighteenth century, supplanted Osaka as the main center of
the sport. Shunshō's immediate incentive to design a group of
sumo prints in 1782–1783, however, seems to have been the
unexpected defeat of Tanikaze by Onogawa from Osaka, after an
unbroken run of sixty-three victories, in the second month of
1782. This upset roused public interest in sumo to fever pitch.[4]

In the present print the two wrestlers stand naked save for boldly
patterned aprons, waiting for one to be called into the ring. As
always, Shunshō appears to relish the contrasting features of the
two men. Nijigadake from Awa Province in Shikoku, on the
right, is clearly the elder of the two and of higher rank (*sekiwake*
is the second of the top three ranks). His drooping eyes and
broad (maybe broken) nose suggest melancholy, accentuated by
the way in which the head seems sunk in the massive shoulders.
He holds his hands open, as if anxious to get on with the fight.
Fudenoumi, on the left, from Kokura in Kyushu and of *mae-
gashira* (fourth) rank, has smooth, round, untroubled features.
Nijigadake only held the *sekiwake* rank between the second
month of 1782 and the eleventh month of 1783, so the print must
have been issued between these dates.[5]

The strange mottled patina covering the men's flesh and the
background was caused by oxidation of a lead pigment— prob-
ably lead white— which was mixed with red for flesh tones and
blue(?) for the background. It was not present when the print
was new.

1 Asano Shūgō, in *Hizō Ukiyo-e Taikan*, vol. 9 (1989), no. 98, pp. 238–39.
2 *Edogaku Jiten* (1984), pp. 521–22.
3 Vignier and Inada (1910), no. 509.
4 Asano, in *Hizō Ukiyo-e Taikan*, vol. 9 (1989), no. 98, pp. 238–39.
5 *Nihon Sumō-shi*, vol. 1 (1956), pp. 146, 171.

SIGNATURE *Shunshō ga*
PUBLISHER Matsumura Yahei
PROVENANCE Louis V. Ledoux collection
REFERENCE
Ledoux (1945), no. 34; *Ukiyo-e Taikei*, vol. 3 (1976), no. 41
OTHER IMPRESSIONS
Museum für Ostasiatische Kunst, Berlin; Museum of Fine Arts, Boston;
Allen Memorial Art Museum, Oberlin College

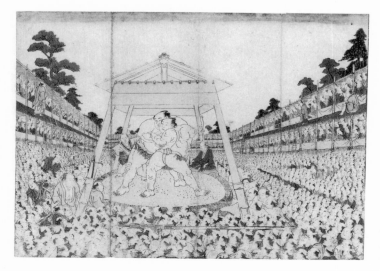

99.1. Katsukawa Shunshō.
A perspective view of the subscription sumo in Edo.
British Museum, London

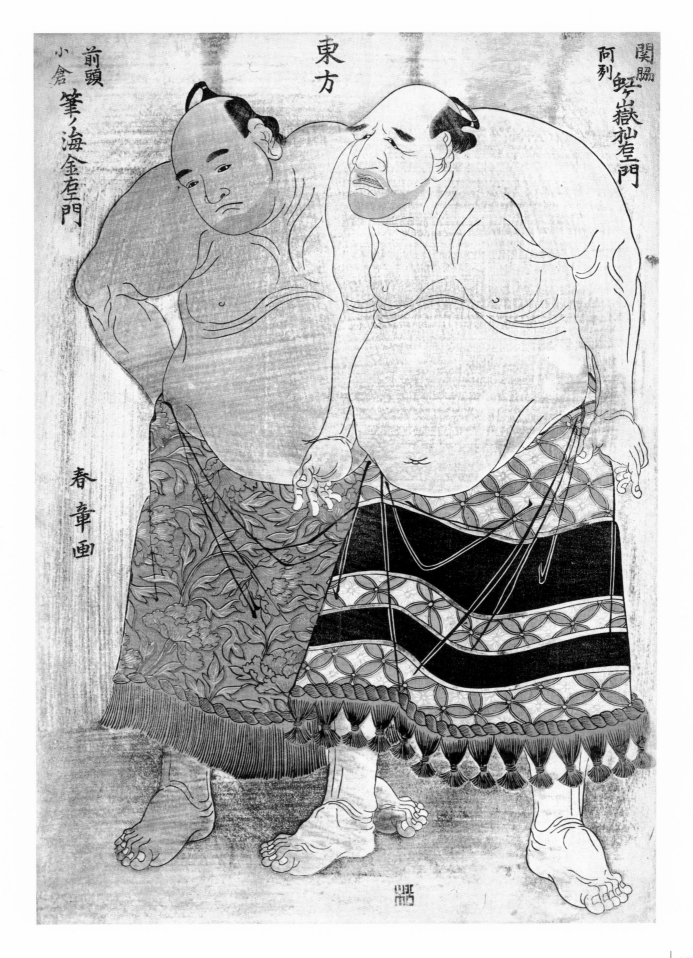

100 KATSUKAWA SHUNSHŌ

(1726–1792)

The sumo wrestler Onogawa Kisaburō of the Eastern Group,
with an attendant
Ca. 1782–1786

Ōban; 39.0 x 26.0 cm (untrimmed)
The Clarence Buckingham Collection 1942.103

Onogawa Kisaburō was the young wrestler from Osaka who caused a
sensation in Edo with his upset victory over the champion Tanikaze
Kajinosuke in the second month of 1782, ending dramatically the latter's
unbroken run of sixty-three victories. It was this event more than any
other that made the Edo public sumo-mad in the late eighteenth century;
it may also have prompted Shunshō to begin designing wrestler prints
in that same year.[1]

Onogawa ranked in the lowly fifth grade of the junior division when he
arrived from Osaka, but once in Edo his rise was meteoric: third grade of
maegashira rank in 1781; second grade *maegashira* in the fall of 1783;
sekiwake (the second to highest) rank in 1786; finally achieving the top
rank of *ōzeki* in 1789 and retaining this until his retirement in 1798.[2] Since
this portrait does not give Onogawa's rank, it cannot be more closely
dated than about 1782–1786, the period during which Shunshō designed
wrestler prints.

Onogawa is dressed in street clothes— a purple-striped cotton kimono
and long black *haori* jacket— and is accompanied by an attendant carrying
a bundle. In his hand is a folding fan, suggesting that it is summer, and
the towel around his shoulders may indicate that the pair are returning
from a tournament. Showing a wrestler in street clothes was perhaps
analogous to showing actors backstage (Nos. 93–95). The difference in
height between the two figures emphasizes Onogawa's imposing size, and
in comparison with the attendant's coarse features (the beard seems to be
painted in by hand), the wrestler's broad, smooth face looks positively
handsome. Indeed Onogawa seems to have attracted the romantic
attentions of many female fans by his resemblance to the contemporary
Kabuki heartthrob Ichikawa Monnosuke II. A year after his defeat of
Tanikaze, Onogawa married a geisha called Yae from the Yoshiwara
pleasure district. He was even featured as a character in a Kabuki play.[3]

The indigo blue background is still largely unfaded and— unusual among
eighteenth-century prints— the borders remain untrimmed on all sides.

1 Asano Shūgō, in *Hizō Ukiyo-e Taikan*, vol. 9 (1989), no. 98, pp. 238–39.
2 *Nihon Sumō-shi*, vol. 1 (1956), pp. 141, 144, 165, 196.
3 *Kabuki Nempyō*, vol. 4 (1959), pp. 496–97.

SIGNATURE *Shunshō ga*
PROVENANCE Charles H. Chandler collection
REFERENCE
Gookin (1931), no. 161, text p. 164; *Ukiyo-e Taikei*, vol. 3 (1976), no. 141
(black-and-white); *Ukiyo-e Shūka*, vol. 5 (1980), no. 15
OTHER IMPRESSIONS
Musée Guimet, Paris; ex-collection Theodor Scheiwe (present location
unknown)

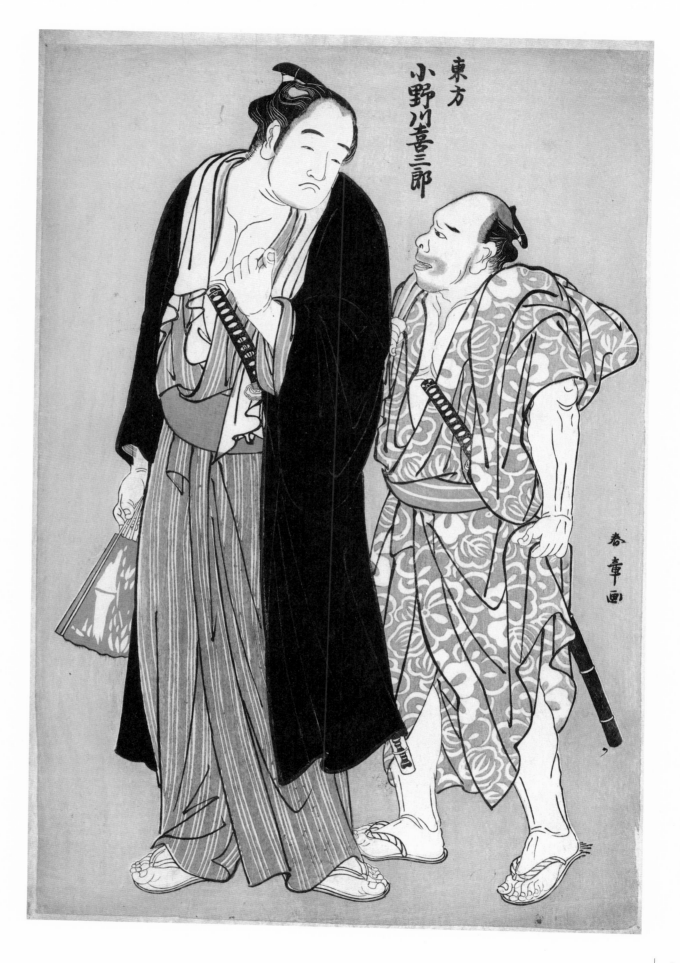

東方
小野川喜三郎

春章画

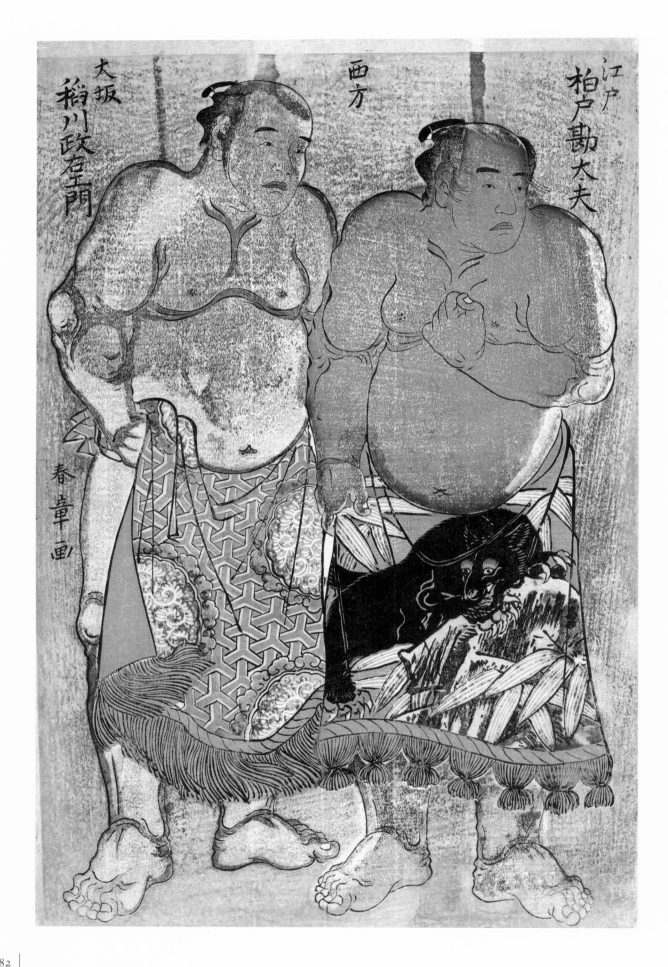

IOI KATSUKAWA SHUNSHŌ
(1726–1792)

Sumo wrestlers of the Western Group: (right) Kashi-
wado Kandayū from Edo, and (left) Inagawa
Masaemon from Osaka
Ca. 1784

Ōban; 39.0 x 25.7 cm
The Clarence Buckingham Collection 1942.102

The present appearance of the print is misleading: lead
white pigment mixed with other colors to print the
bodies of the wrestlers and the background has heavily
tarnished after two centuries of exposure to oxygen in
the air. Originally the skin of the two men was different
shades of pink, with the musculature emphasized in
darker tones. The background was probably blue.

The massive bulk of the wrestlers fills the page from top
to bottom. They are clearly engrossed in what is hap-
pening in the ring, and rearrange their ceremonial aprons
with absent-minded gestures. Shunshō appreciated that
such immediacy of expression and gesture conveyed the
essence of his subject better than stiff, formal portraits,
and he drew the faces of the men with empathy and
sensitivity. Kashiwado's apron is decorated with a
suitably ferocious image of a black bear clambering
on a rock.

Kashiwado changed his name from Yukariyama in the
spring of 1784, and Inagawa retired in the spring of 1786.
Since the tournaments in Edo were cancelled in 1785,
the print must relate to the matches of either the third or
the eleventh month of 1784.[1] During the 1780s Shunshō
designed more than twenty sumo prints of three types:
large horizontal double *ōban* compositions of wrestlers
grappling in the ring; *hosoban* prints of single standing
wrestlers; and *ōban* prints such as this featuring two men
waiting to enter the ring.[2]

1 *Nihon Sumō-shi*, vol. 1 (1956), pp. 153, 161.
2 Asano Shūgō, in *Hizō Ukiyo-e Taikan*, vol. 9 (1989), no. 98,
 pp. 238–39.

SIGNATURE *Shunshō ga*
PROVENANCE Charles H. Chandler collection

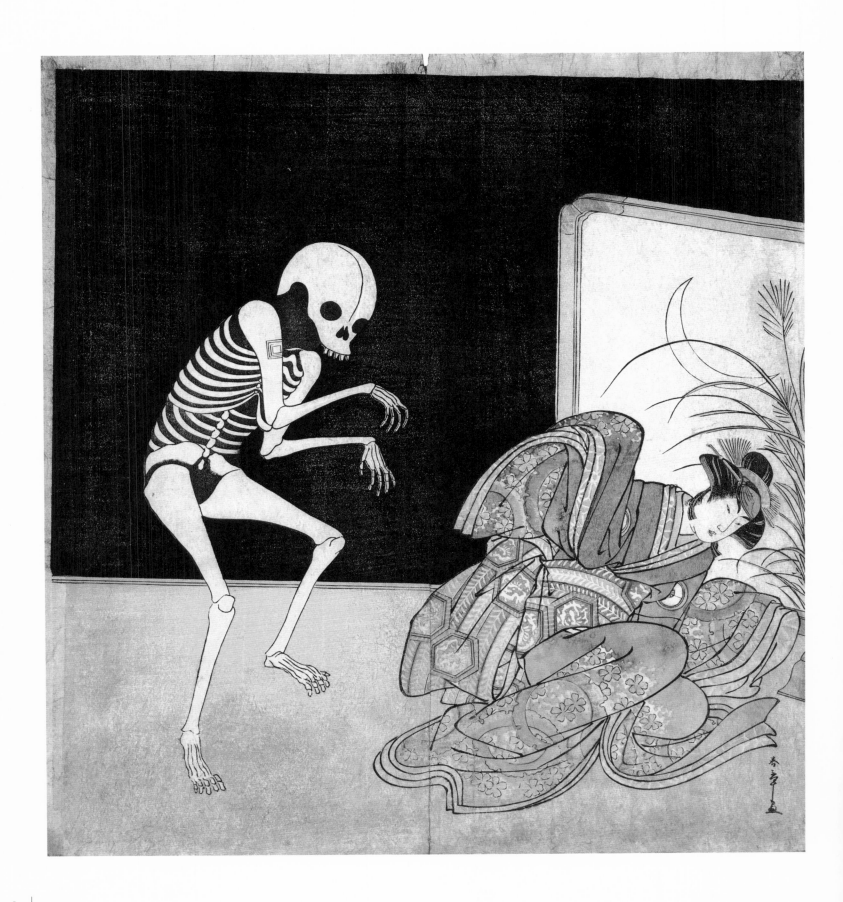

102 KATSUKAWA SHUNSHŌ
(1726–1792)

The actors Ichikawa Danjūrō V as a skeleton, spirit of the renegade monk Seigen (left), and Iwai Hanshirō IV as Princess Sakura (right) in the *jōruri* "Sono Omokage Matsu ni Sakura" (Vestiges of Pine and Cherry), from part two of the play *Edo no Hana Mimasu Soga* (Flower of Edo: An Ichikawa Soga), performed at the Nakamura Theater from the first day of the second month, 1783

Hosoban diptych; (right) 32.9 x 15.0 cm; (left) 32.9 x 15.2 cm
The Clarence Buckingham Collection 1938.491

A staple of the Kabuki repertory, surviving in many versions (see No. 60), is the story of the fatal attraction of Monk Seigen to the lovely Cherry Princess (Sakura Hime). In the grip of this mad passion Seigen breaks his monastic vows, is driven from Kiyomizu-dera (his temple in Kyoto), and ends his life in bitter poverty in a lonely country hut. Even after he is murdered, his ghost continues to haunt Sakura Hime, as in the scene we see depicted here.

Sakura Hime, played by Iwai Hanshirō IV, cowers in terror, menaced by the preying skeleton. Her kimono forms a vortex of swirling lines as she lifts one cherry-petalled sleeve in pathetic defense against her macabre suitor. Danjūrō V is wearing a close-fitting black suit painted with the skull and bones of the ghost, and the jet black background, which probably also was used on stage, would have enhanced the fearful illusion. A screen painted with autumn grasses and crescent moon suggests some lonely, desolate moor. Only the *mimasu* (triple-rice-measure) crest of the Ichikawa family, appearing on the skeleton's arm, lends a note of whimsy to the fearful scene. There is a sense of flowing movement across the composition unusual in Shunshō's multisheet prints, which so often have a single standing figure planted firmly in the center of each page.

An advance publicity handbill (*tsuji banzuke*) confirms that the actors played these particular roles in the production of 1783.[1] According to *Kabuki Nempyō*, the dance sequence "Sono Omokage Matsu ni Sakura" was performed to commemorate the third anniversary of the death of the *jōruri* chanter Tokiwazu Moji-tayū (1709–1781).[2] The performance began with a sequence from the "Mt. Asama" lineage (*Asama-mono*) of dances, in which Danjūrō V played the spirit of dead Seigen and Segawa Kikunojō III the spirit of the murdered courtesan Yatsuhashi, both emanating from a single incense burner (see No. 60). This was followed by the present scene, with Danjūrō V as the *skeleton* (rather than the spirit) of Seigen. The "dancing skeleton" (*gaikotsu odori*) had been a specialty of the Ichikawa family since first performed by Danjūrō II in 1742,[3] and Danjūrō V had already appeared as the skeleton of the courtesan Yatsuhashi in a play in 1772.[4] Thus the idea of Danjūrō V dancing as a skeleton in a "Seigen" play found an accustomed and eager public: for novelty's sake, the playwrights might change the identity of the skeleton.

1 *Kabuki Zusetsu* (1934), pl. 163.
2 *Kabuki Nempyō*, vol. 4 (1959), p. 496.
3 Danjūrō II appeared as a skeleton in a dream to Princess Taema in the play *Narukami Fudō Kitayama-zakura* (Saint Narukami and the God Fudō: Cherry Blossoms at Mt. Kitayama), performed at the Ōnishi theater in Osaka in the first month of 1742. See Suzuki Jūzō, *Ukiyo-e Shūka*, vol. 5 (1980), no. 28, p. 58.
4 The dance sequence "Sono Utsushi-e Matsu ni Kaede" (A Shadow-Picture of Pine and Maple) in the play *Keisei Momiji no Uchikake* (Courtesan in an Over-Kimono of Maple Leaf Pattern), performed at the Morita Theater in the ninth month of 1772. See No. 60.

SIGNATURE *Shunshō ga*
PROVENANCE Frederick W. Gookin collection
REFERENCE
Gookin (1931), no. 242, text p. 209; *Ukiyo-e Shūka*, vol. 5 (1980), no. 28
OTHER IMPRESSIONS
(both sheets) Musée Guimet, Paris; (both sheets) *Kabuki Zusetsu* (1934), no. 469 (present location unknown)

103 *Attributed to* KATSUKAWA SHUNSHŌ

(1726–1792)

The actor Nakayama Kojūrō VI as Osada no Tarō Kagemune (in reality Hatchō Tsubute no Kiheiji) in the guise of a lamplighter of Gion Shrine, in act three from part one of the play *Yukimotsu Take Furisode Genji* (Snow-Covered Bamboo: Genji in Long Sleeves), performed at the Nakamura Theater from the first day of the eleventh month, 1785

Hosoban; 31.6 x 15.2 cm
The Clarence Buckingham Collection 1932.1005

Nakayama Kojūrō VI (an alternative name used by Nakamura Nakazō I) appears dressed in the robes of a pilgrim to Izu, wearing a bundle of straw as a headdress and carrying a jar of oil to light the lanterns at Gion Shrine. With one hand grasping the straw, the other arm thrust rigidly in front of him, legs straight and heels pressed together, Kojūrō VI strikes the *soku mie* stage pose. Cross-eyed with concentration, his scowling features framed by an aureole of straw, Kojūrō VI confronts us directly. A breeze sweeps the skirts of his kimono to one side, adding to the sense of agitation. He has adopted the guise of a lamplighter in order to search for a precious heirloom banner of the Genji clan, which has been hidden in one of the stone lanterns at the shrine. Another *hosoban* print attributed to Shunshō shows him in almost identical pose, but viewed from a different angle and with a stone lantern behind (fig. 103.1).

The opening-of-the-season (*kaomise*) production *Yukimotsu Take Furisode Genji*, in the eleventh month of 1785, was a desperate attempt by Nakamura Nakazō I to restore the flagging fortunes of the Nakamura Theater and, incidentally, his personal fortunes as well. At the pleading of Okiku and Otomi, daughters of Nakamura Kanzaburō VIII, former owner of the theater, and out of loyalty to the memory of his old teacher Nakamura Denkurō II, Nakazō I broke his contract with the rival Kiri Theater and contributed his own savings to form a troupe at the Nakamura with himself as leading actor (*za-gashira*).[1] His nominal salary was 1,000 *ryō*, a considerable but unrealistic sum, given the perilous financial condition of the theater.

Nakazō I also took the occasion to honor the memory of his adoptive father, the famous *nagauta* singer Nakayama Kojūrō V, by changing his own acting name to Nakayama Kojūrō VI. The whole venture ended in failure, however, for not only was the *kaomise* production a flop, but the theater burned down in the first month of the following year, 1786. By the end of that year Kojūrō VI's own finances were so low that he decided to take up a long-standing invitation to perform in Osaka. Reasoning that the Osaka audience would not be familiar with the name Kojūrō VI, however, he reverted to Nakazō I for the *kaomise* production in the eleventh month of 1786, shortly before his departure. Thus Nakazō I used the name Nakayama Kojūrō VI for barely one year.

Though unsigned, this print bears a seal consisting of the character *Hayashi* within a jar-shaped (*tsubo*) outline. The seal is similar to that used by Shunshō approximately between 1764 and 1770, except that the mouth of the jar is wider and the base and neck more elaborately decorated. Though this later, more elaborate form of the *Hayashi* seal is never corroborated by a signature, it appears on works of such combined sensitivity and power that these are now generally accepted as Shunshō's. The use of the seal seems to fall between the eleventh month of 1785 and the eleventh month of 1786, and marks a final flowering of Shunshō's work in the actor print genre.[2] Might there be some link between Nakazō I's use of the name Kojūrō VI and Shunshō's reversion to the jar-shaped seal?

1 Ihara (1913), p. 142.
2 See H. R. W. Kühne, "The Tsubo-seals of the Katsukawa Masters" (1971); and *Genshoku Ukiyo-e Daihyakka Jiten*, vol. 7 (1980), p. 28.

UNSIGNED
ARTIST'S SEAL *Hayashi* in jar-shaped outline
PROVENANCE Frederick W. Gookin collection
OTHER IMPRESSIONS H. R. W. Kühne collection, Switzerland

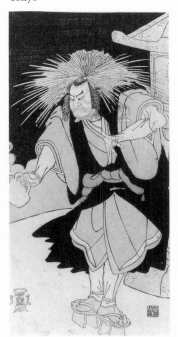

103.1. Attrib. Katsukawa Shunshō. *The actor Nakayama Kojūrō VI as a lamplighter of Gion Shrine.* Ōta Memorial Museum, Tokyo

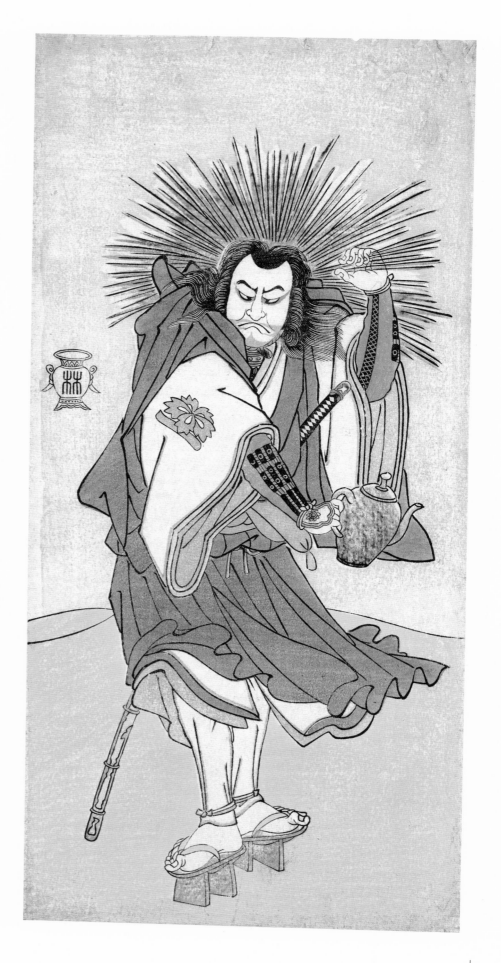

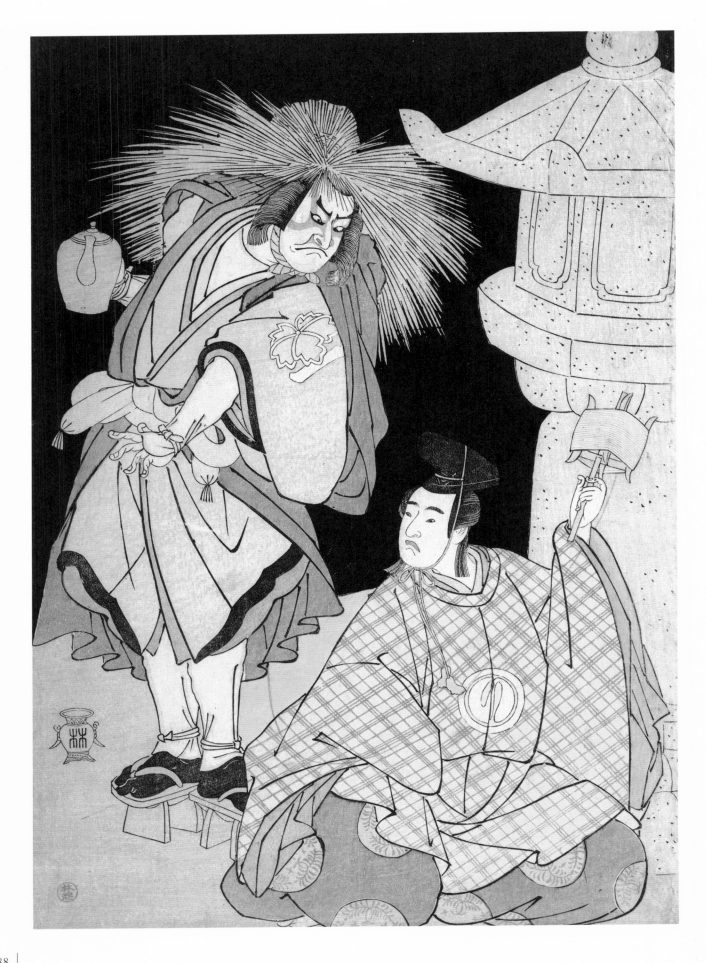

104 *Attributed to* KATSUKAWA SHUNSHŌ
(1726–1792)

The actors Nakayama Kojūrō VI as Osada Tarō Kagemune (in reality Hatchō Tsubute no Kiheiji) in the guise of a lamplighter of Gion Shrine (left), and Sawamura Sōjūrō III as Komatsu no Shigemori (right), in act three from part one of the play *Yukimotsu Take Furisode Genji* (Snow-Covered Bamboo: Genji in Long Sleeves), performed at the Nakamura Theater from the first day of the eleventh month, 1785

Aiban; 34.6 x 24.2 cm
The Clarence Buckingham Collection 1942.104

The opening-of-the-season (*kaomise*) production at the Naka-mura Theater in the eleventh month of 1785, *Yukimotsu Take Furisode Genji*, was set in the "world" (*sekai*) of the twelfth-century rivalry between the Taira and Minamoto (Genji) clans. Act three began with the three stars, Nakayama Kojūrō VI, Ichikawa Yaozō III, and Sawamura Sōjūrō III coming up through trapdoors dressed as pilgrims from Izu, Kamakura, and Kumano, respectively. The stage then revolved to reveal the precincts of Gion Shrine at night. Kojūrō VI reappeared wearing a straw headdress and carrying the oil jar of a lamplighter, the costume we see here. In reality he is Hatchō Tsubute no Kiheiji, in search of the precious white banner of the Genji, which has been hidden in one of the stone temple lanterns.[1]

The other character on stage is Komatsu no Shigemori, played by Sawamura Sōjūrō III, dressed in court robes and a black lacquered court hat (*eboshi*). He kneels holding a spool of red thread, whose end he has surreptitiously attached to the hem of the kimono worn by the suspicious-looking lamplighter in order to be able to follow him through the dark.[2] Shunshō's print shows the actors' pose at the moment when Kiheiji realizes, to his fury, that he has been overtaken. Towering on high clogs

over the kneeling courtier, he seems almost to be brandishing the oil jar as a weapon. Even the yellow straw of his headdress bristles angrily against the jet black sky.

As described in *Kabuki Nendaiki*, the two were then joined on stage by Yaozō III as Evil Genta in an assassin's black kimono, and Ōtani Hiroji III as Namba no Jirō Tsunetō, wearing red body makeup and formal *kamishimo* robes.[3] The four-way "silent fight" (*dammari*) in the dark which ensued is shown in an illustration from the program (*ehon banzuke*) (fig. 104.1). Shunshō also designed two further *hosoban* prints showing Kojūrō VI as the lamplighter (No. 103).

The Chicago impression is slightly faded and has been trimmed on all sides.[4]

1 A synopsis of the scene is given by Hattori Yukio in *Hizō Ukiyo-e Taikan*, vol. 2 (1987), no. 89, p. 247. See also *Kabuki Nempyō*, vol. 5 (1960), pp. 10–14.
2 This is a parody of a scene in the play "Imoseyama Onna Teikin" (Mt. Imo and Mt. Se: An Example of Noble Womanhood), first performed in Edo in 1778, in which Omiwa attaches a thread to the kimono of Motome, with whom she has fallen in love. See *Kabuki Saiken* (1926), sect. 2.5, p. 10.
3 *Kabuki Nendaiki* (1926), p. 410.
4 Compare with the pristine impression in the collection of the Japan Ukiyo-e Museum, Matsumoto, illustrated in *Ukiyo-e Taikei*, vol. 3 (1976), no. 24.

UNSIGNED
ARTIST'S SEAL *Hayashi* in jar-shaped outline
PROVENANCE
Hayashi Tadamasa (seal); Carl Schraubstadter collection; Charles H. Chandler collection
OTHER IMPRESSIONS
Japan Ukiyo-e Museum, Matsumoto; Museum of Fine Arts, Boston; British Museum, London

104.1. *The actor Nakayama Kojūrō VI and others in a four-way "silent encounter" scene.* From the illustrated program. Tōyō Bunko Library, Tokyo

105 KATSUKAWA SHUNSHŌ
(1726–1792)

Plants, porcelain bowl, and glass goblet
Ca. 1789

Long *surimono*; 19.0 x 53.0 cm
The Clarence Buckingham Collection 1925.2366

Unusual among Shunshō's prints is this elegant still life of autumn plants in a porcelain bowl with an imported Western glass goblet. Though more usually considered a summer flower, here the morning glory twines around *susuki*, a kind of pampas grass and one of the "seven plants of autumn" (*aki no nanakusa*). The bowl is of brightly enamelled Imari porcelain, with a design of fanciful "Chinese lions" (*shishi*) and red peonies in alternating cartouches. On the surface of the water floats a red lacquer sake cup decorated with the character *kotobuki* (long and happy life). The printing was done with extraordinary delicacy and care to suggest the stems of the plants seen through the water in the bowl and the edges of the leaves seen through the glass goblet. Still life is an uncommon subject for prints of this period, but of course Shunshō's paintings of beautiful women contain many minutely rendered objects and accessories.

Surimono were prints privately published in small editions for distribution among friends or artistic or intellectual coteries. They were intended as festive (often New Year) greetings, invitations to private concerts or other performances, or mementos of some special occasion. Professional artists were commissioned to supply a design appropriate to a text, often a poem, and the whole was printed on luxuriously thick paper using the most refined color-printing techniques. For long *surimono*, the text was printed on the top half of the sheet— which is missing from this print.[1] Quite possibly, however, the print was issued to commemorate an early autumn gathering organized by some cultivated person of advanced years (hence the "felicitous long life" on the sake cup).

Though there is no text, it is possible to date the print fairly exactly from the form of the signature and seal. Only in 1789 did Shunshō combine a signature in wide "Teika" style (which he used from the New Year of 1789 until his death) with the dramatically curving *kaō* seal (which he abandoned by the New Year of 1790).[2] Long *surimono* from the 1780s— by Shunshō, Torii Kiyonaga, and Kitagawa Utamaro— have survived in very small numbers, and this is the only impression of the design currently known.

1 For a discussion of the origins and nature of *surimono*, see Roger S. Keyes, *The Art of Surimono* (London: Sotheby's, 1985), pp. 13–40.
2 Naitō, "Katsukawa Shunshō no Nikuhitsu Bijinga ni Tsuite," pp. 63–64.
3 Shunshō's distinctive "handwritten" seal (*kaō*), which appears on many paintings, has been interpreted as an abbreviation of the character *yū* from his art name (*gō*) Yūji. See Naitō, ibid., p. 80.

SIGNATURE *Shunshō ga*
ARTIST'S WRITTEN SEAL (*kaō*), here printed: *Yū* (?)[3]
ENGRAVER Shumpūdō Ryūkotsu
PROVENANCE H. B. Wrenn collection

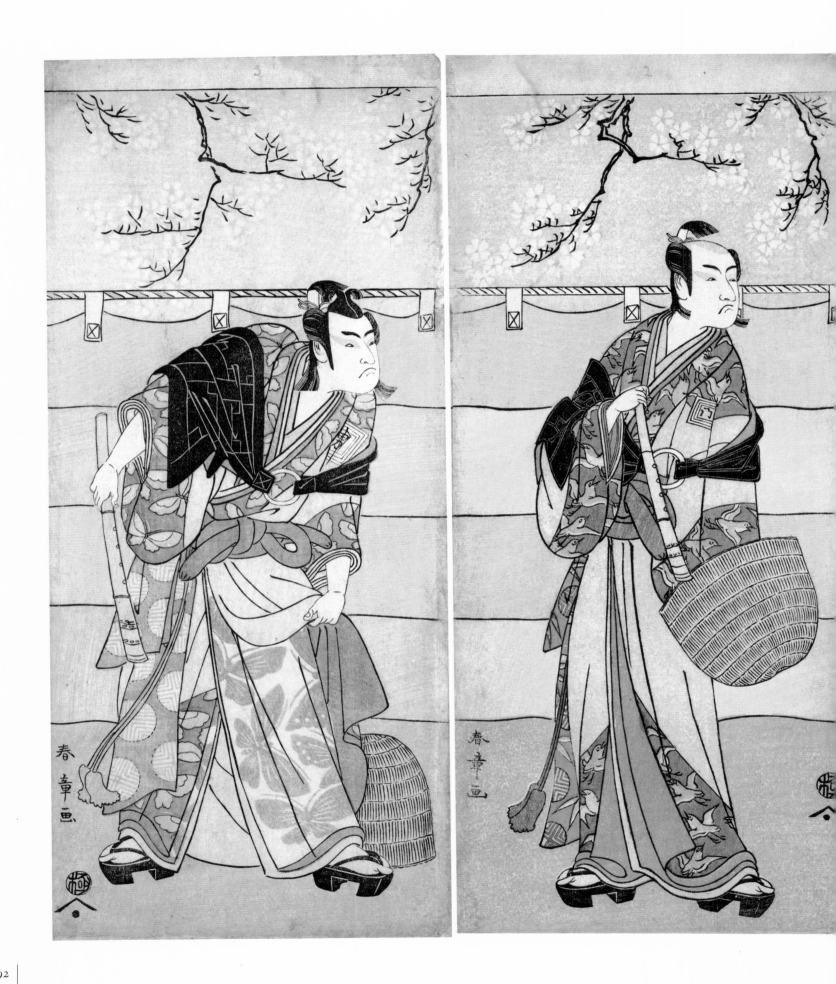

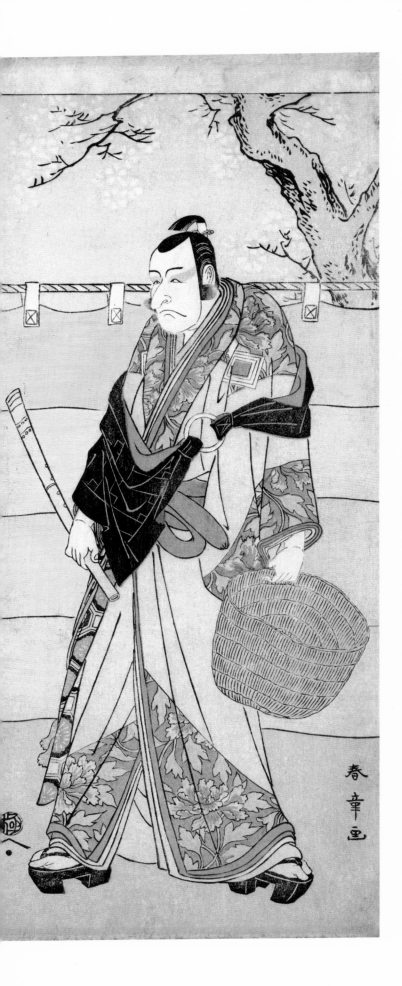

Three *komusō* monks: the actors Ichikawa Ebizō (Danjūrō V) as Kudō Suketsune (right), Ichikawa Monnosuke II as Soga no Jūrō Sukenari (center), and Ichikawa Omezō I as Soga no Gorō Tokimune (left), in act six of the play *Waka Murasaki Edokko Soga* (Pale Purple Soga, Edo Style), performed at the Ichimura Theater from the twenty-third day of the first month, 1792

Hosoban triptych; (right) 32.8 x 14.4 cm; (center) 36.2 x 14.7 cm; (left) 32.7 x 14.3 cm
Gift of Mr. and Mrs. Gaylord Donnelley 1969.689

The New Year production at the Ichimura Theater was the customary Soga play, including a scene in which the two Soga brothers, Gorō (played by Ichikawa Omezō I) and Jūrō (played by Ichikawa Monnosuke II), came on dressed as mendicant monks (*komusō*), characteristically accoutered with basket-shaped woven rush hats (*tengai*), black monastic stoles (*kesa*), and bamboo curved flutes (*shakuhachi*). They paused on the *hanamichi* walkway to deliver alternate lines of a declamatory speech (*tsurane*) full of witty repartee and wordplay.[1] Arriving on stage, they were joined by their enemy Kudō Suketsune (played by the venerable Ichikawa Ebizō, formerly Danjūrō V), similarly attired. This is the scene we see depicted here: the three men meeting in front of a curtain strung between blossoming cherry trees to make a flower-viewing enclosure. Under his monastic stole each character wears a kimono decorated with his crest: peonies for Kudō Suketsune, plover for Jūrō, butterflies for Gorō.

An illustration in the theater program (*ehon banzuke*) also shows the three as *komusō* (fig. 106.1). Behind them in a room opening onto a verandah is Kobayashi no Asahina (also called Wada Saburō Yoshihide, and here played by Bandō Hikosaburō III), seated before a makeup mirror on a stand, with Kewaizaka no Shōshō (played by Iwai Kiyotarō II) combing his hair; this parodies the famous scene in which, in standard versions of the play, Jūrō's hair is combed by his mistress Ōiso no Tora ("Kamisuki Jūrō").[2]

The very composition of the triptych expresses confrontation between heroes and villain: both brothers— Gorō most threateningly— seem to start toward Kudō, who seems to shrink back in alarm. The figure style— elongated bodies with narrow, sloping shoulders, and long, elegant lines to the drapery— would come to dominate prints of the 1790s, particularly the work of Shunshō's pupil Shun'ei (see, for example, No. 126).

Some viewers, indeed, might maintain that this triptych was in fact designed by Shun'ei and a false signature of Shunshō added afterward (as seems to be true of No. 130). Such an assumption fits the hypothesis that Shunshō ceased to design actor prints after the eleventh month of 1786 and became exclusively a painter of hanging scrolls, many of which bear the "Teika style" signature of his last few years. The present catalogue, however, includes quite a number of works that can be dated after the eleventh month of 1786. Even if Shunshō severely curtailed his print designing after this date, he did not necessarily abandon print making altogether. Rather, prints such as the present triptych demonstrate that he may have helped create the new figure style of the 1790s.

The last datable print by Shunshō in the collection of The Art Institute of Chicago is a five-sheet design from the play *Gonin Onna* ("Five Chivalrous Women," a parody of *Gonin Otoko*, or "Five Chivalrous Commoners" [see Nos. 27, 49, 90]). *Gonin Onna* followed the present Soga play into the Ichimura Theater on the sixteenth day of the second month, 1792 (cat. no. 542). Shunshō died at the end of that year, on the eighth day of the twelfth month.

1 The text of the speech is reproduced in *Kabuki Nendaiki* (1926), pp. 476–77.
2 This is described in *Kabuki Nendaiki* (1926), p. 477.

SIGNATURE *Shunshō ga*
PUBLISHER Harimaya Shinshichi
CENSOR'S SEAL *Kiwame*
PROVENANCE Mrs. George T. Smith collection
OTHER IMPRESSIONS
(center) Tokyo National Museum

106.1. *The actors Ichikawa Ebizō, Ichikawa Monnosuke II, and Ichikawa Omezō I as komusō.*
From the illustrated program. Tokyo University Library

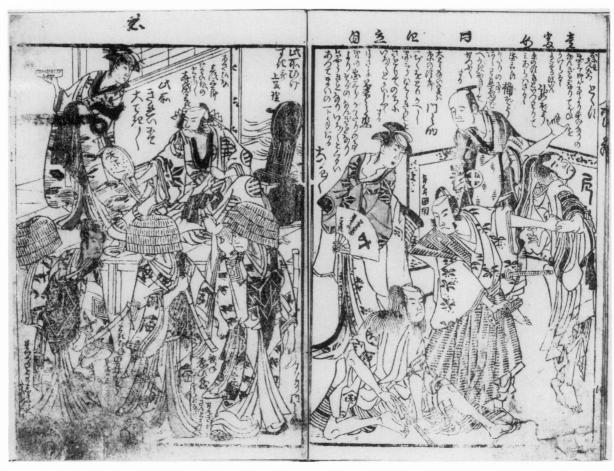

(1743–1812)

The actor Ōtani Hiroemon III as Osada no Zenjō Kagemune in the play *Izu-goyomi Shibai no Ganjitsu* (First Performance Day of the Izu Calendar), performed at the Morita Theater from the first day of the eleventh month, 1772

Hosoban; 30.5 x 14.4 cm
Frederick W. Gookin Collection 1939.873

We have already seen Shunshō's print of Nakamura Noshio I as a dancing fox-woman in the play *Izu-goyomi Shibai no Ganjitsu* (No. 61). In the illustration of that scene from the program (*ehon banzuke*), the fox-woman is shown dancing around a mysterious glowing jewel, the *yakara no tama* (fig. 61.1). In the present print, by Shunkō, Ōtani Hiroemon III as the villain Osada no Zenjō Kagemune is searching for the jewel.[1] Beneath a pine tree at night Hiroemon III stands in the classic *soku mie* pose, legs stiffly straight and heels together. His sharp features scowl, and one arm, freed from the surcoat of his formal *kamishimo* robes, brandishes a sickle ominously. A further illustration in the program shows him kneeling, holding the same sickle and wearing a straw raincoat over his kimono (fig. 107.1).

This is one of the earliest known theatrical prints by Shunkō, one of a small number bearing beneath the signature a jar-shaped seal containing the character *ki* (tree), in imitation of Shunshō's *hayashi* (two trees) seal.[2] Not until 1776 does Shunkō appear to have designed theatrical prints regularly.[3] It is not surprising that at this early point in his career he should imitate his teacher Shunshō's style so closely. It *is* remarkable that he is in this print so nearly his teacher's artistic equal, as attested by comparison with Shunshō's similar portrait of Hiroemon III from the following year (No. 65).

1 As described in *Kabuki Nempyō*, vol. 4 (1959), p. 202.
2 The earliest theatrical print by Shunkō mentioned by Japanese authorities is a *hosoban* design showing Ichimura Uzaemon IX as Gorō and Nakajima Mihoemon II as Asahina, in an "Anchor-Tugging" (*Ikari-biki*) scene from the play *Wada Sakamori Osame no Mitsugumi* (Wada's Carousal: The Last Drink with a Set of Three Cups), performed at the Ichimura Theater from the ninth day of the second month, 1771. This print also bears the jar-shaped *ki* seal. See *Genshoku Ukiyo-e Daihyakka Jiten*, vol. 7 (1980), p. 76.
3 See Tanaka Tatsuya, "Katsukawa Shunkō I," *Azabu Bijutsukan Dayori*, no. 15 (Dec. 1986), [p. 5].

SIGNATURE *Shunkō ga*
ARTIST'S SEAL *Ki* in jar-shaped outline

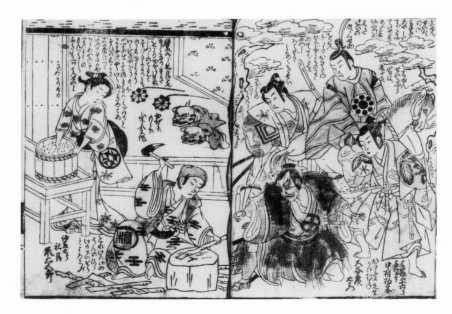

107.1. *The actor Ōtani Hiroemon III as Osada no Zenjō Kagemune.* From the illustrated program. Tōyō Bunko Library, Tokyo

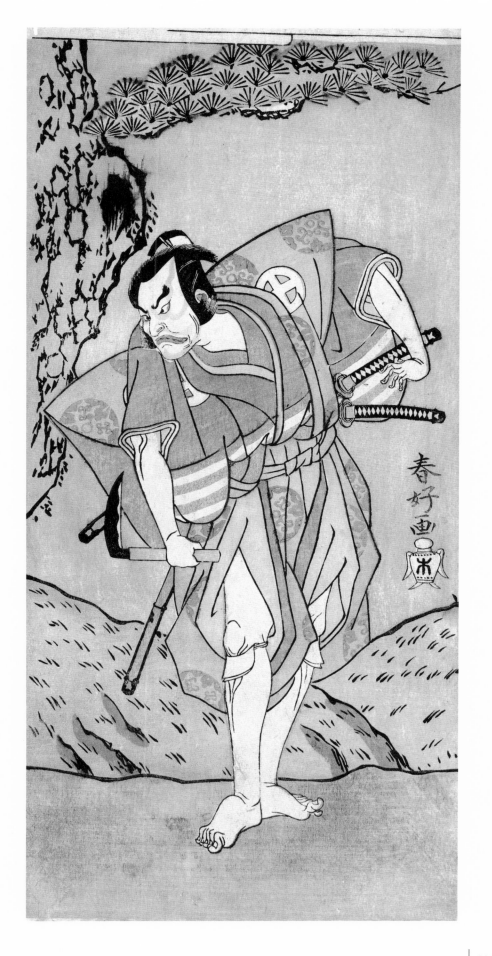

108 KATSUKAWA SHUNKŌ

(1743–1812)

(Right) The actor Nakamura Tomijūrō I as a courtesan
(Left) The actor Sawamura Sōjūrō III, possibly as Oyamada Tarō
disguised as the farmer Tarosaku of Oyamada village, in the play
Azuma no Mori: Sakae Kusunoki (Azuma Forest: The Flourishing
Kusunoki Family) (?), performed at the Ichimura Theater from the
first day of the eleventh month, 1779
Ca. 1777–1779

Narrow *ai-tanzakuban*; (right) 32.3 x 7.3 cm; (left) 32.3 x 8.0 cm
The Clarence Buckingham Collection (right) 1939.2203a; (left) 1939.2203b

We are uncertain of the original format of these two small prints, and of
which production (or productions) they commemorate. The design of
Sawamura Sōjūrō III in a male role (left) has an untrimmed border on the
left-hand side and the signature on the right, so it would appear to be
close to the original size. The design of Nakamura Tomijūrō I as a cour-
tesan (right) has been trimmed on the left side along a hand-drawn black
line. It would seem that both were designed in an unusually narrow
tanzaku format (about half the width of the standard *hosoban*). No other
impressions are known, however, to corroborate this. It is also possible
that both were cut from larger sheets containing several such designs of
actors of the day in various roles.

Both must have been issued sometime in the later 1770s. Sōjūrō III
returned to the Morita Theater for the opening-of-the-season (*kaomise*)
production in the eleventh month of 1777, after an absence of nine years
in Osaka.[1] Tomijūrō I left Edo for Osaka after a farewell performance at
the Ichimura Theater in the ninth month of 1778 and died there in 1786,
without ever returning. His Edo farewell performance included seven
changes of costume, but in none of these did he appear as a courtesan.[2]
The two actors do not seem to have performed together during the time
they were both in Edo, and there is therefore no reason to assume that the
two prints show roles from the same play.

Tomijūrō I is dressed in the gorgeous robes of a high-ranking courtesan.
The over-kimono is decorated with a pattern of cherry blossom and court
fans, a pattern normally associated with the courtesan Hanaōgi (whose
name means "Flower-fan") of the Ōgiya (Fan) house of pleasure. Kabuki
records, however, do not mention Tomijūrō I in this role.

Sōjūrō III's costume somewhat resembles that shown in the illustrated
program (*ehon banzuke*) for the play *Azuma no Mori Sakae Kusunoki*,
performed at the Ichimura Theater in the eleventh month of 1779, in
which he played Oyamada Tarō disguised as the farmer Tarosaku of
Oyamada village (fig. 108.1). If this is the role depicted in the left-hand
print, then the right-hand print is either an earlier design or a memento
issued after Tomijūrō I had left Edo for Osaka.

Whatever the roles portrayed, both figures have been stylishly arranged in
the cropped, narrow format, in the manner of pillar prints (*hashira-e*). The
colors of both prints are bright and unfaded.

1 *Kabuki Nempyō*, vol. 4 (1959), p. 324.
2 The seven roles are listed in *Kabuki Nempyō*, vol. 4 (1959), p. 343.

SIGNATURE (right) unsigned; (left) *Katsukawa Shunkō ga*

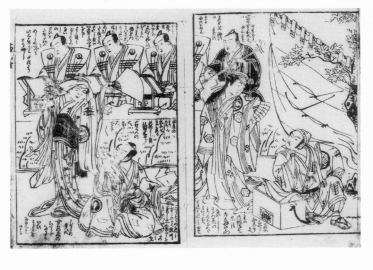

108.1. *The actor Sawamura Sōjūrō III as Oyamada Tarō.*
From the illustrated program. Tokyo University Library

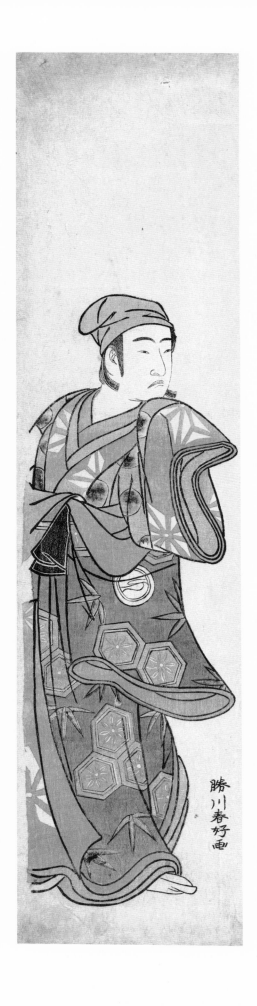

勝川春好画

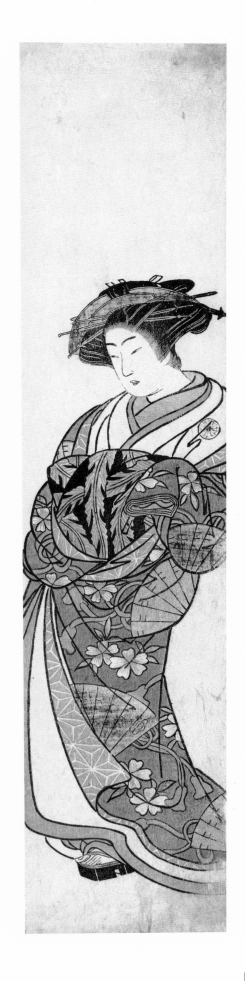

109 KATSUKAWA SHUNKŌ

(1743–1812)

The actor Nakamura Nakazō I as Monk Shunkan in *Hime Komatsu Ne no Hi Asobi* (Outing to Pick Pine Seedlings on the Rat-Day of the New Year), performed as the last act of part two at the Ichimura Theater in the seventh month, 1778

Hosoban, probably the right sheet of a diptych; 32.5 x 14.7 cm
The Clarence Buckingham Collection 1939.2121

The plot of the play *Hime Komatsu Ne no Hi Asobi*— Monk Shunkan's secret mission to guard the birth of the emperor's child by his concubine Kogō no Tsubone at remote Horagadake— has already been summarized (see No. 29). Like Shunshō's print relating to the 1768 production, this design by Shunkō shows Shunkan attempting to forestall Oyasu, the village girl whom he has enlisted as midwife, from obtaining his story by swearing secrecy on a pair of metal handmirrors. But at the sight of his aged, care-worn features in one of the mirrors, Shunkan drops his guard and lets slip to Oyasu his true identity and the tale of his lonely exile on the island of Kikaigajima, the penalty of a failed plot against the Taira clan's domination of the imperial court. From the direction of Shunkan's movement and gaze we can infer that this is the right-hand sheet of a diptych, whose other sheet would probably show Nakamura Rikō I as Oyasu, holding the other mirror.

As in Shunshō's print, the monk is shown with long, straggly hair, and Shunkō has depicted him bearded as well. He leans on his long sword as if for support, pondering, perhaps, the aged features reflected in the mirror. His kimono has a pattern of wild chrysanthemums and, near the hem at the right, a "Genji emblem" (*Genji kō*), which indicates his secret loyalty to this clan. Nakazō I's grim features are familiar to us from many of Shunshō's prints (Nos. 26, 33, 34, etc.), and Shunkō has produced a design as powerfully concentrated as any done by his teacher.

The dark blue pigment of the over-kimono and lighter blue streaked face makeup (*sujiguma*) have both faded in this impression.

SIGNATURE *Shunkō ga*
PROVENANCE R. T. Crane collection
REFERENCE *Ukiyo-e Shūka*, vol. 5 (1980), no. 120

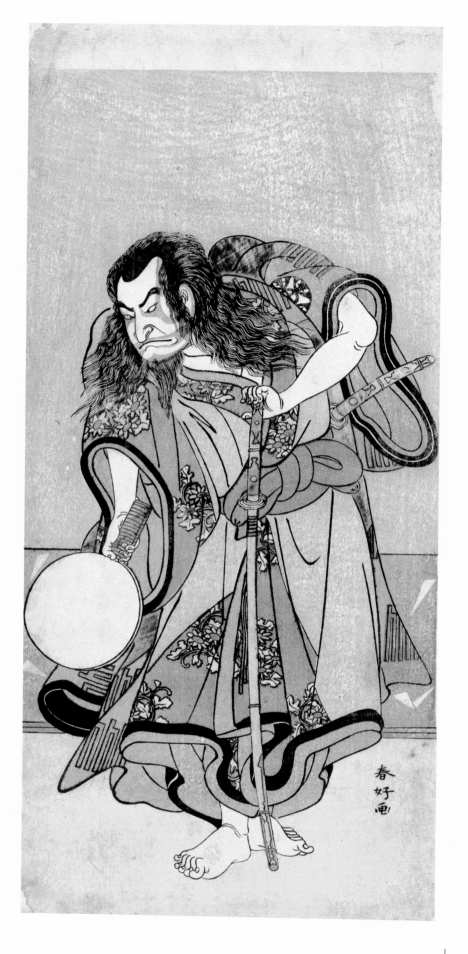

The actor Yoshizawa Ayame IV as Yadorigi, the sister of Nikaidō Shinanosuke, disguised as Orie, the wife of Aoto Magosaburō, in part two of the play *Motomishi Yuki Sakae Hachi no Ki* (Looking up at Falling Snow: Thriving Potted Trees), performed at the Nakamura Theater from the first day of the eleventh month, 1778

Hosoban, probably the right sheet of a diptych; 30.5 x 15.0 cm
The Clarence Buckingham Collection 1925.2478

Though quite severely faded— Ayame IV's purple kimono and the iris on the *haori* jacket have paled to a light sand color— this robust design shows Shunkō's figure drawing at its most accomplished. As in the preceding print (No. 109), the costumed figure of the actor fills the narrow *hosoban* sheet almost to its edges in a composition of broad, sweeping curves. Yadorigi's skirts fan out into an immaculate half-circle over the snow, and her snow-covered travelling hat forms a generous three-quarter-moon shape over her head.

Snow scenes were de rigueur in opening–of-the-season (*kaomise*) productions, and this particular play was a variation on the ever popular *Hachi no Ki* (The Potted Trees). The plot of *Hachi no Ki* has already been described (see No. 39). In Shunkō's design Ayame IV as Orie is clearly

leading something into the picture, and reference to the illustrated program (*ehon banzuke*) shows that this was an ox on which was seated her husband, Aoto Magosaburō Fujitsuna (played by Matsumoto Kōshirō IV) (fig. 110.1). *Kabuki Nempyō* mentions that once on stage the couple had an amusing domestic quarrel.[1] Possibly this was intended as a parody of the (serious) scene in *Hachi no Ki* in which Hōjō Tokiyori, who has taken holy orders, is rebuked on religious grounds by a man with a horse. The horse is tired, but Tokiyori wants nevertheless to ride it through the snow to the village of Sano, where they will find lodgings. The horse's owner refuses, however, saying that a monk should have more compassion for an animal and should furthermore willingly undergo the austerity of walking through the snow himself.[2]

Whether or not this was the intended reference, the scene as played in 1778 was clearly colorful and comic. We can only regret that the left sheet of what was obviously a diptych, showing Kōshirō IV on the ox, has yet to be discovered.

1 *Kabuki Nempyō*, vol. 4 (1959), pp. 344–45.
2 See *Kabuki Saiken* (1926), pp. 166–67.

SIGNATURE *Katsukawa Shunkō ga*
PROVENANCE Ernest F. Fenollosa collection

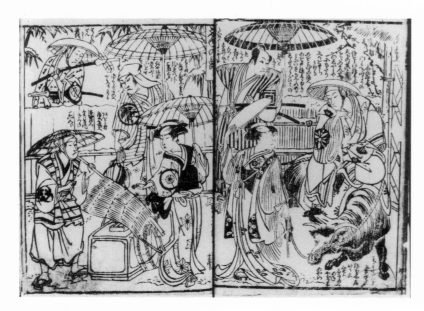

110.1. *The actors Yoshizawa Ayame IV as Yadorigi and Matsumoto Kōshirō IV as her husband, Aoto Magosaburō Fujitsuna, seated on an ox.* From the illustrated program. National Diet Library, Tokyo

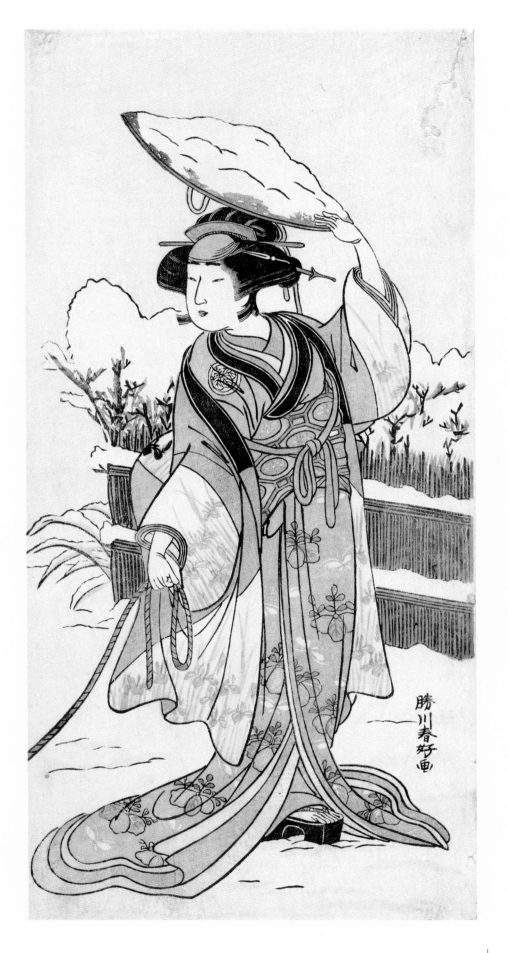

III KATSUKAWA SHUNKŌ

(1743–1812)

The actors Nakamura Nakazō I as Danshichi Kurobei (right), and Ichikawa Danjūrō V as Issun Tokubei (left), in act eight of the play *Natsu Matsuri Naniwa Kagami* (Mirror of Osaka in the Summer Festival), performed at the Morita Theater from the seventeenth day of the seventh month, 1779

Hosoban diptych; (right) 31.6 x 14.2 cm; (left) 31.4 x 14.5 cm
The Clarence Buckingham Collection (right) 1942.113; (left) 1928.311

Natsu Matsuri Naniwa Kagami was a popular "contemporary drama" (*sewamono*) in nine acts, set in Osaka and featuring the exploits of the hero Danshichi Kurobei, one of the "five chivalrous commoners" (*gonin otoko*). We have already seen an early *chūban* print by Shunshō, showing the scene in act seven— which took place in the back streets of the city during the summer festival— in which Danshichi, goaded beyond endurance and beyond filial piety, murders his wicked and abusive father-in-law (No. 26). The present diptych by Shunkō shows the scene in act eight, set on the roof of the house where Danshichi has been hiding, when his friend Issun Tokubei helps him to escape.

With Danshichi about to be arrested for killing Giheiji, Tokubei persuaded the officers of the law that all would be safer if he, who had Danshichi's trust, persuaded this dangerous armed criminal to surrender. In Shunkō's design Tokubei (played by Ichikawa Danjūrō V) kneels on the roof brandishing the metal baton of an arresting officer so that it can be seen from below, but in his other hand— in place of a rope with which to bind the criminal— he carries a string of coins. He and Danshichi will escape together to their native village, where the son of the headman is bound to them in an oath of friendship and mutual loyalty.[1] Along the edge of the roof is a row of sharpened bamboo stakes, intended to deter intruders. Danshichi, played by Nakamura Nakazō I, stands wielding a long sword, ready to take on all attackers. The taut curve of his body echoes the pure line of the sword. Both men wear the bold striped and checkered summer kimono of the "chivalrous commoners," with the ends of their scarlet loincloths visible beneath the kimono hems.

A composition in which the figures of two fighting men are brought close to the picture plane and set against a jet black background had already been devised by Shunshō in 1774 (No. 70).

1 The plot of the modern, condensed version of *Natsu Matsuri Naniwa Kagami* is given in Halford (1956), pp. 231–40.

SIGNATURE (right) *Katsukawa Shunkō ga*
PROVENANCE
(right) H. Jackson collection; (left) Charles H. Chandler collection
REFERENCE *Ukiyo-e Shūka*, vol. 5 (1980), nos. 32, 33.
OTHER IMPRESSIONS
(both sheets) Museum of Fine Arts, Boston;
(left) Honolulu Academy of Arts; (left) Altkunst, Berlin

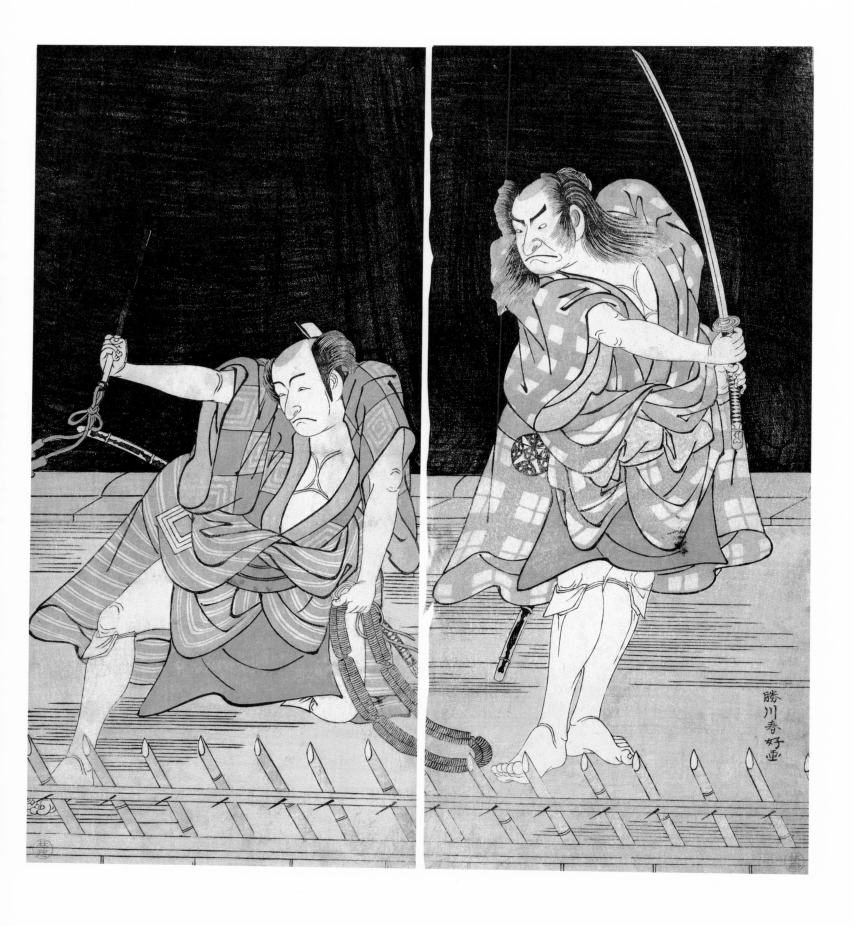

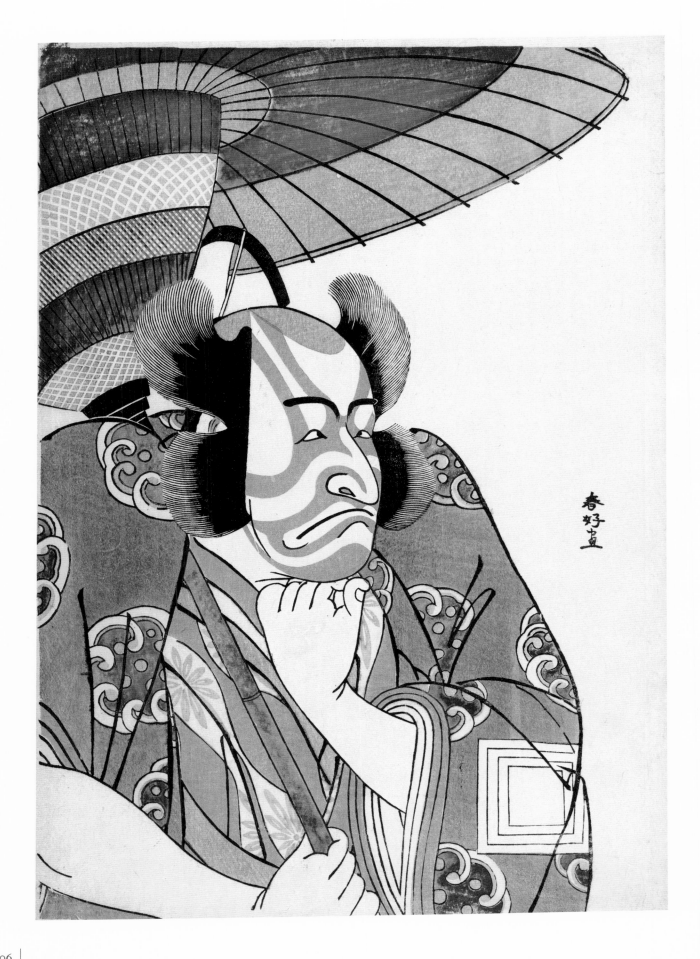

112 KATSUKAWA SHUNKŌ

(1743–1812)

Half-length portrait of the actor Ichikawa Danjūrō V as Kazusa no Gorobei Tadamitsu in act three of the play *Kitekaeru Nishiki no Wakayaka* (Returning Home in Splendor), performed at the Nakamura Theater from the first day of the eleventh month, 1780

Aiban; 32.2 x 22.5 cm (untrimmed)
The Clarence Buckingham Collection 1925.2369

In this print Ichikawa Danjūrō V appears alone in the role of Kazusa no Gorobei Tadamitsu, but his open "snake's eye" umbrella suggests the nighttime "silent encounter" scene (*dammari*) at the entrance to the Mishima Myōjin Shrine. In that scene, as the illustrated program (*ehon banzuke*) shows, Danjūrō V struggles for possession of a sacred bow with Nakamura Nakazō I, playing Chinzei Hachirō Tametomo disguised as a pilgrim (fig. 112.1). A *chūban* print by Shunshō also depicts the two men together (No. 91). In his diary, *Shūkaku Nikki*,[1] Nakazō I described Danjūrō V's costume: a long *haori* jacket, red *sujiguma* makeup, an umbrella, and a lantern.[2] This was adapted from the costume of the old keeper of the Aridōshi Shrine, a character whose canonical dress and accoutrements were established in classical literature and paintings.[3]

Shunkō's half-length portrait shows Danjūrō V in a grand dramatic pose (*mie*): staring out from under his umbrella, chin on fist and eyes crossed in the traditional expression of intense resolution. His purple kimono is decorated with wave roundels and bears the square "triple-rice-measure" (*mimasu*) crest of the Ichikawa family on the sleeve. The wig is arranged in bristling wings that continue the red "strength" lines of the *sujiguma* makeup, so that the hero, though motionless, fairly pulses with energy.

Although designed in the *aiban* format— slightly smaller than the *ōban* that would later be the norm— this print marks the inception of the half-length and bust portraits of actors that are counted among the glories of *ukiyo-e* in the 1790s and throughout the nineteenth century. It appeared during the same time that Shunshō was issuing his series of half-length portraits in fan-shaped borders (*Azuma Ōgi*, Nos. 72, 73) and at least one print in standard rectangular format, showing Danjūrō V as Kudō Suketsune in *kamishimo* dress and holding a sword hilt, which is thought to date from the first month of 1780 (fig. 112.2).[4] Surprisingly, Shunshō designed no more such portraits, and it would be another eight years before Shunkō began to design half-length portraits with considerable frequency.[5]

This print and Number 113, which depicts Onoe Matsusuke I as Retired Emperor Sutoku in the same production, are the only impressions of these designs known, and it is marvelous that they should be in such fine, unfaded condition. Most likely Shunkō also designed a half-length portrait of Nakazō I as Tametomo; one hopes that an impression still exists, awaiting rediscovery.

1 Shūkaku was Nakazō I's pen name (poetry name), and his diary is simply entitled "Shūkaku's Diary."
2 Quoted in *Kabuki Nempyō*, vol. 4 (1959), p. 407.
3 Paintings of the Aridōshi Shrine legend are discussed in Kobayashi Tadashi, *Edo no Gakatachi* (Tokyo: Perikansha, 1987), pp. 150–57.
4 Waterhouse (1975), no. 144. Based on similarities with a *hosoban* triptych in the Tokyo National Museum (TNM [1960], no. 1053), this bust portrait is thought to show Danjūrō V as Kudō Suketsune in the play *Hatsumombi Kuruwa Soga*, performed at the Nakamura Theater in the first month, 1780. The similarity of the signatures on the two prints would seem to confirm this.
5 See text of No. 128.

SIGNATURE *Shunkō ga*
PROVENANCE Hamilton E. Field collection
REFERENCE
Riccar (1973), no. 111; *Ukiyo-e Taikei*, vol. 3 (1976), no. 163 (black-and-white); *Ukiyo-e Shūka*, vol. 5 (1980), no. 118

112.1. *The actors Nakamura Nakazō I and Ichikawa Danjūrō V in a "silent encounter" scene.* From the illustrated program. Nippon University Library, Tokyo

112.2. Katsukawa Shunshō. *Half-length portrait of the actor Ichikawa Danjūrō V as Kudō Suketsune.* Royal Ontario Museum, Toronto

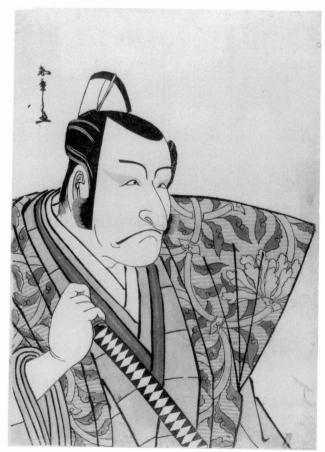

II3 KATSUKAWA SHUNKŌ

(1743–1812)

Half-length portrait of the actor Onoe Matsusuke I
as Retired Emperor Sutoku in act three of the play
Kitekaeru Nishiki no Wakayaka (Returning Home in
Splendor), performed at the Nakamura Theater from
the first day of the eleventh month, 1780

Aiban; 32.1 x 23.5 cm (untrimmed)
The Clarence Buckingham Collection 1925.2370

In another half-length portrait relating to the same play as
Number 112, Shunkō depicts Onoe Matsusuke I in the role
of Retired Emperor Sutoku. *Kabuki Nempyō* records that
he made his entrance on a kind of elevator platform which
rose through a trapdoor in the stage floor, while musicians
chanted in *Ōzatsuma* style.[1]

Sutoku was born in 1119 and reigned from 1123 to 1141.
In the Hōgen Incident of 1156 he schemed to have his son
assume the throne, but powerful forces among the war-
rior clans as well as at court supported the candidacy of
Sutoku's brother-in-law, Go-Shirakawa. The issue was in
fact decided by fighting between the rival Minamoto and
Taira warrior clans, and Sutoku, whose partisans were
defeated, was exiled to Sanuki Province on the island of
Shikoku, where he died in 1164.

The full plot of the 1780 play is not known, but the
illustrated program (*ehon banzuke*) shows Matsusuke I as
the exiled Sutoku, standing on the beach in Sanuki holding
aloft a handscroll, with a warrior retainer kneeling at his
feet (fig. 113.1). His hair hangs loose, and the top part of
his kimono has been thrown back (*bukkaeri*) to reveal a
pattern of angry flames, just as in Shunkō's portrait. Pos-
sibly both designs depict that climactic moment in which
the retired emperor suddenly reveals his evil ambition to
reclaim the throne, perhaps with the assistance of magic
incantations contained in the scroll.

Shunkō composed the portrait so that the flames flicker
upward toward the face, which looms down upon the
viewer. The narrowed eyes, with pupils crossed, express
sinister calculation. Particularly fine and sensitive engrav-
ing renders Sutoku's glossy mane of hair, which cascades
down to meet the leaping flames on the robe. Over
each shoulder are the purple brocade straps of a monk's
stole (*kesa*), indicating that Sutoku had, as was the
custom, taken holy orders and nominally retired from
worldly affairs.

1 *Kabuki Nempyō*, vol. 4 (1959), p. 408.

SIGNATURE *Shunkō ga*
REFERENCE
Riccar (1973), no. 112; *Ukiyo-e Taikei*, vol. 3 (1976), no. 162
(black-and-white); *Ukiyo-e Shūka*, vol. 5 (1980), no. 16 (black-
and-white)

113.1. *The actor Onoe Matsusuke I as Retired
Emperor Sutoku with a retainer.* From the
illustrated program. Nippon University
Library, Tokyo

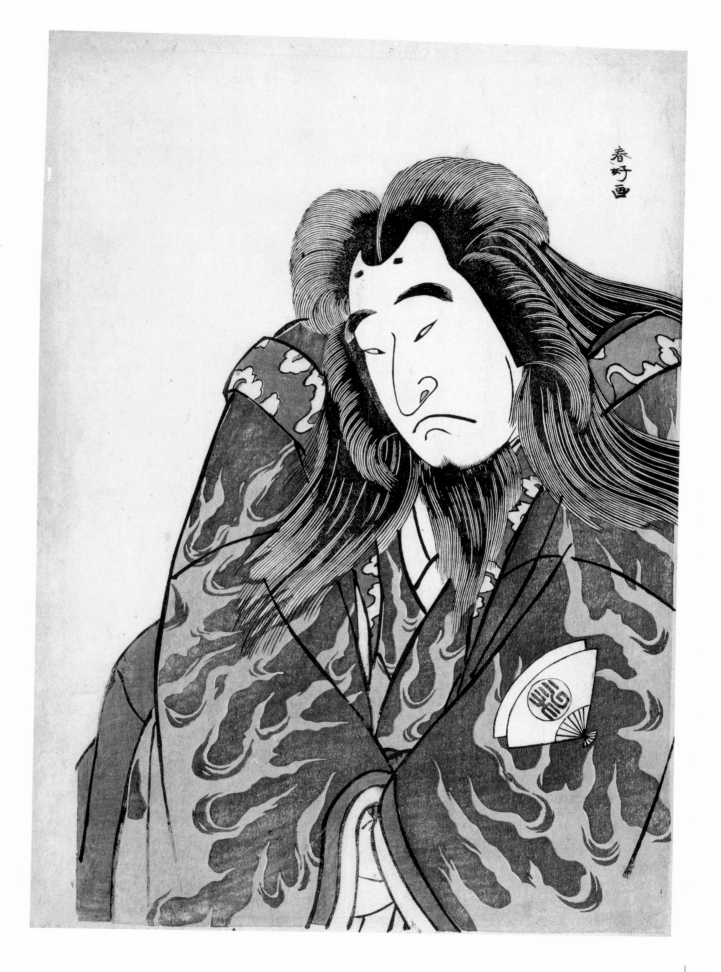

The actor Ichikawa Danjūrō V as Sukeroku in the *jōruri* "Sukeroku Kuruwa no Natori-gusa" (Sukeroku: Peony of the Pleasure Quarters), from the last act of part two of the play *Nanakusa Yosooi Soga* (The Seven Guises of Soga), performed at the Nakamura Theater from the fifth day of the fifth month, 1782

Hosoban, center sheet of a triptych; 32.5 x 15.1 cm
Frederick W. Gookin Collection 1939.2245

SIGNATURE *Katsukawa Shunkō ga*
OTHER IMPRESSIONS
(complete triptych) Japan Ukiyo-e Museum, Matsumoto

The character of the playboy-dandy Hanakawado no Sukeroku, created by Ichikawa Danjūrō II in 1713, combined the up-to-the-minute chic of the Yoshiwara pleasure district with the historical-romance valor of early warrior tales, for in the world of Kabuki, Sukeroku is the hero Soga no Gorō in disguise. Gorō, alias Sukeroku, has a secret mission to recover the Minamoto clan's stolen heirloom sword, known as Tomokiri-maru; to this end he picks fights with samurai in the pleasure district, in order to get a glimpse of their swords as they draw. In Shunkō's print the cursive white characters on his black kimono proclaim: "If you're buying a fight, I'll sell you one; if you're selling one, I'll buy it!" Love-interest enters the plot through the rivalry between Sukeroku and the rich, vile, and elderly samurai Hige no Ikyū for the affections of the courtesan Agemaki. It is of course the evil Ikyū who has the stolen sword, and few scenes in Kabuki are more popular than that of the villain refusing to draw— and thereby reveal— the stolen sword, preferring to submit tamely to the utter humiliation of having one of Sukeroku's sandals placed on his head. This scene must have had the Edo townsmen positively tingling with delight, for real life afforded them few such opportunities to turn the tables on their samurai "betters."[1]

Shunkō's portrait shows Danjūrō V as Sukeroku in the classic pose of defiance, his right leg slightly advanced so that the skirts of the black kimono curve elegantly to the ground. Sukeroku's accessories consisted of a bamboo flute (*shakuhachi*), "snake's eye" pattern umbrella (both potential weapons) and, most famous of all, the foppish purple headband (unfortunately faded in this impression). The complete triptych (fig. 114.1), of which this is the center sheet, shows him threatened by Nakamura Nakazō I as Ikyū (?) (right) and Onoe Matsusuke I as Kampera Mombei (left).[2] The composition is linked by two angled benches, marking the front of the Miuraya house of pleasure, where the scene was set.

As commonly occurred, the rival Ichimura Theater also staged a production of "Sukeroku" opening on the same day. The Ichimura production, as recorded in *Kabuki Nempyō*, marked the retirement of the ailing actor-proprietor Ichimura Uzaemon IX, and was sponsored by the owners of the Daikokuya and Tamaya houses in the Yoshiwara pleasure district. On the eleventh day of the fifth month the performance at the Ichimura was attended by fifty *kamuro* (child attendants to the courtesans) on an outing from Yoshiwara. So well loved was this play that even two competing productions seem to have had no trouble attracting full houses.[3]

1 For a synopsis of "Sukeroku" in English, see Halford (1956), pp. 321–28. For a synopsis in Japanese, see *Zusetsu Nihon no Koten*, vol. 20, *Kabuki Jūhachiban* (1979), pp. 52–61.
2 These are the roles named in *Kabuki Nempyō*, vol. 4 (1959), p. 472.
3 *Kabuki Nendaiki* (1926), p. 391, records that the "Sukeroku" at the Nakamura Theater was "*ō-iri ō-atari*" (full house, great hit).

114.1. Katsukawa Shunkō. *The actor Ichikawa Danjūrō V as Sukeroku, standing between Nakamura Nakazō I and Onoe Matsusuke I.* Japan Ukiyo-e Museum, Matsumoto

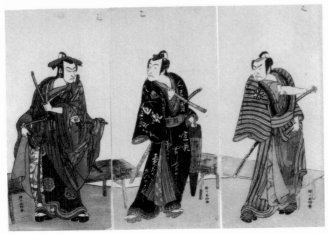

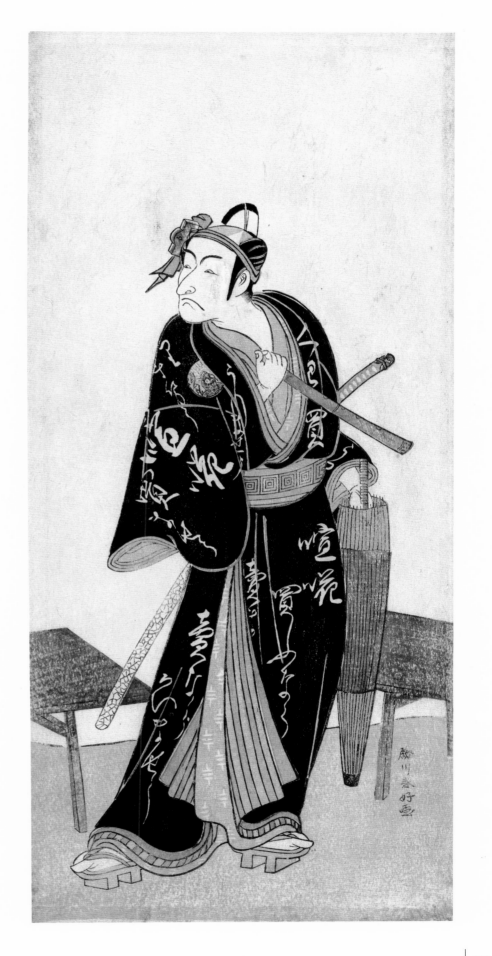

115 KATSUKAWA SHUNKŌ
(1743–1812)

The actor Ichikawa Danjūrō V, probably as Ise no Saburō disguised as Sanjō Uemon, leader of a robber gang, in part two of the play *Fude-hajime Kanjinchō* (First Calligraphy of the New Year: *Kanjinchō* [The Subscription List]), performed at the Nakamura Theater from the fifteenth day of the first month, 1784

Hosoban, possibly right sheet of a triptych; 29.0 x 13.2 cm
The Clarence Buckingham Collection 1925.2470

Because the Nakamura Theater had burned to the ground in the tenth month of the previous year, the production in the reconstructed theater in the first month of 1784 was treated as the opening of the season (*kaomise*), and the New Year plays were postponed until the following month.[1] The play *Fude-hajime Kanjinchō* seems to have been a complex melange of characters and scenes from various historical plays, including the Ataka Barrier scene (*Kanjinchō*), a parody of Narihira's Journey to the East (*Azuma Kudari*), and the tale of the rival warriors Nasu no Yoichi and Ise no Saburō at the Battle of Yashima in 1185.

Danjūrō V probably appears here as Ise no Saburō disguised as Sanjō Uemon, leader of a robber gang. Typically for Shunkō's *hosoban* designs of the 1780s, the figure is close to the picture plane and bulky, filling the page. Over a suit of armor Ise no Saburō wears the black kimono and hood of a thief or "shadow warrior" (*ninja*)—a character who wants to escape undetected into the night. Under one arm is a richly decorated chest, presumably containing treasure, and with the other hand he grips his unsheathed sword, holding the blade straight up. The identical costume and pose, with the sword pointing directly upward, appear in the illustrated program (*ehon banzuke*) (fig. 115.1).

Kabuki Nendaiki relates that part two opened with a scene at the Mieidō Fan Shop featuring three leading actors of female roles (*onnagata*): Iwai Hanshirō IV as Otsugi, in reality Ise no Saburō's sister Hamaōgi; Nakamura Rikō I as the fan maker Okaji, in reality the court lady Tamamushi; and Segawa Kikunojō III as the fan maker Otatsu, in reality Hanazono, daughter of the warrior Kamada Shōji. The illustration in the program (fig. 115.1) shows Danjūrō V with Hanshirō IV and and Rikō I, suggesting that Shunkō's *hosoban* print may have come from a multisheet composition showing Danjūrō V with one or more of these female characters.

1 *Kabuki Nempyō*, vol. 4 (1959), p. 523.

115.1. *The actors Nakamura Rikō I, Ichikawa Danjūrō V, and Iwai Hanshirō IV.* From the illustrated program. Tsubouchi Memorial Theater Museum, Waseda University, Tokyo

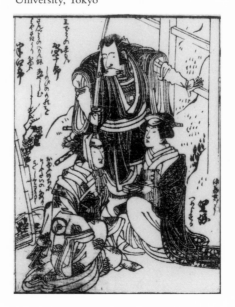

SIGNATURE *Shunkō ga*
PROVENANCE Hayashi Tadamasa (red seal)

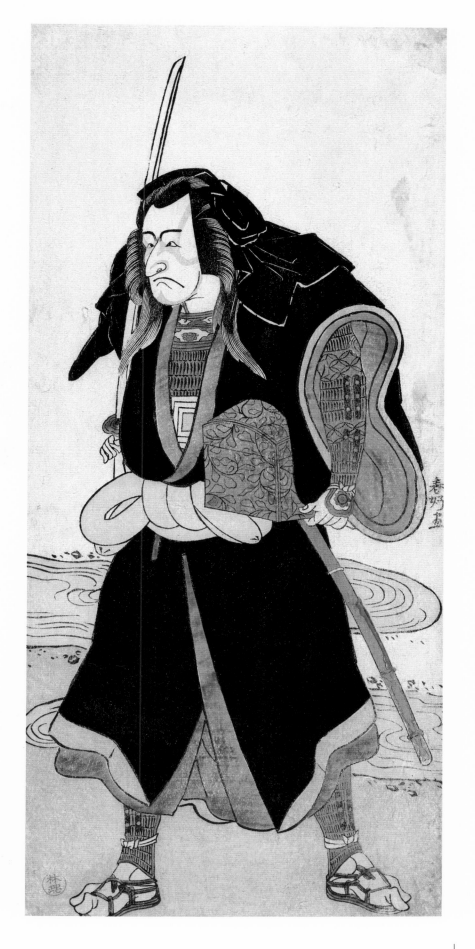

(1743–1812)

The actors Osagawa Tsuneyo II (right), Ichikawa Monnosuke II (center), and Segawa Kikunojō III (left), possibly as Misao Gozen, Matsuya Sōshichi, and the courtesan Kojorō of Hakata, in the play *Chiyo no Hajime Ondo no Seto* (Beginnings of Eternity: The Ondo Straits in the Seto Inland Sea) (?), performed at the Kiri Theater from the twenty-seventh day of the seventh month, 1785

Hosoban triptych; each sheet approx. 32.0 x 14.2 cm
The Clarence Buckingham Collection (right) 1952.368; (center) 1952.367; (left) 1952.366

Before sliding doors decorated with a frieze of bush clover, the three actors pose in summer costumes. Tsuneyo II, on the right, wears a thin black kimono with the Japanese "well-head" pattern (*igeta-gasuri*) in white reserve over a brilliant red under-kimono mostly covered by a white apron, in the manner of a waitress. The actor's obi is tied at the front, and he carries a round fan (*uchiwa*), the kind customarily used in summer. Monnosuke II also wears a thin resist-dyed black summer kimono; he has slipped one arm out of its sleeve, revealing a striped under-robe. Kikunojō III appears as a courtesan tying the simple sash of her nightgown. The two *onnagata* (actors of female roles) incline slightly toward Monnosuke II, who stands stiffly erect and impassive between them.

It is uncertain to which production this print relates. The costumes suggest a summer play, and these three actors seem to have appeared together only in the summers of 1785 and 1790. This may be a scene set in the pleasure district of Hakata, from the play *Chiyo no Hajime Ondo no Seto*, performed at the Kiri Theater in the seventh month (i.e., early autumn) of 1785. This was a version of the play *Kezori* (The Barber's Apprentice) written by Chikamatsu Monzaemon, based on the story of a pirate captured in Nagasaki.[1] In the 1785 production the role of the pirate— known as Kuemon, the Barber's Apprentice— was played by Nakamura Nakazō I, the Kyoto merchant Matsuya Sōshichi by Monnosuke II, the Hakata courtesan Kojorō by Segawa Kikunojō III, and the role of Misao Gozen by Tsuneyo II. "Gozen," however, is the usual appellation of a court lady, and such a one is unlikely to have worn an apron. Perhaps the court lady is shown here disguised as a waitress, or perhaps Tsuneyo II played several roles. *Kabuki Nempyō* records that Monnosuke II's acting— in this production as in others— was completely eclipsed by the forceful stage presence of Nakamura Nakazō I.[2]

Though somewhat static, the composition has a quiet grace, and the colors are generally unfaded.

1 For a synopsis of *Kezori* (The Barber's Apprentice), see *Kabuki Saiken* (1926), pp. 760–63.
2 *Kabuki Nempyō*, vol. 5 (1960), p. 9.

SIGNATURE *Shunkō ga* (on each sheet)
PROVENANCE Colburn collection
REFERENCE Riccar (1973), no. 114

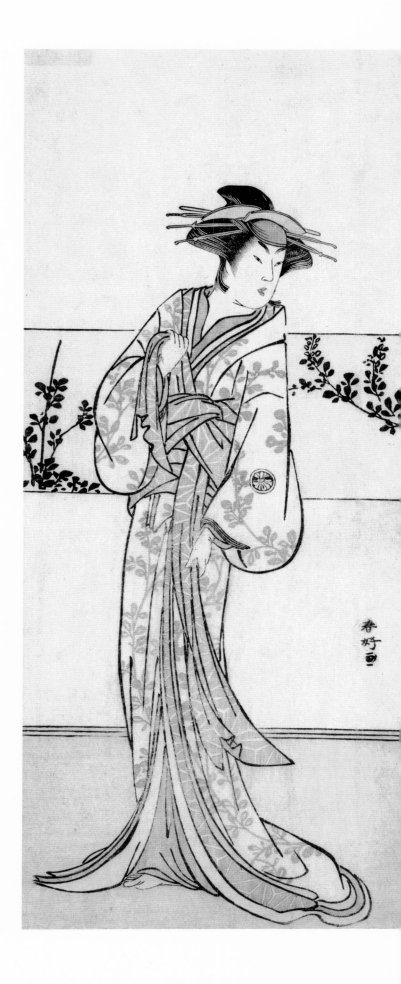

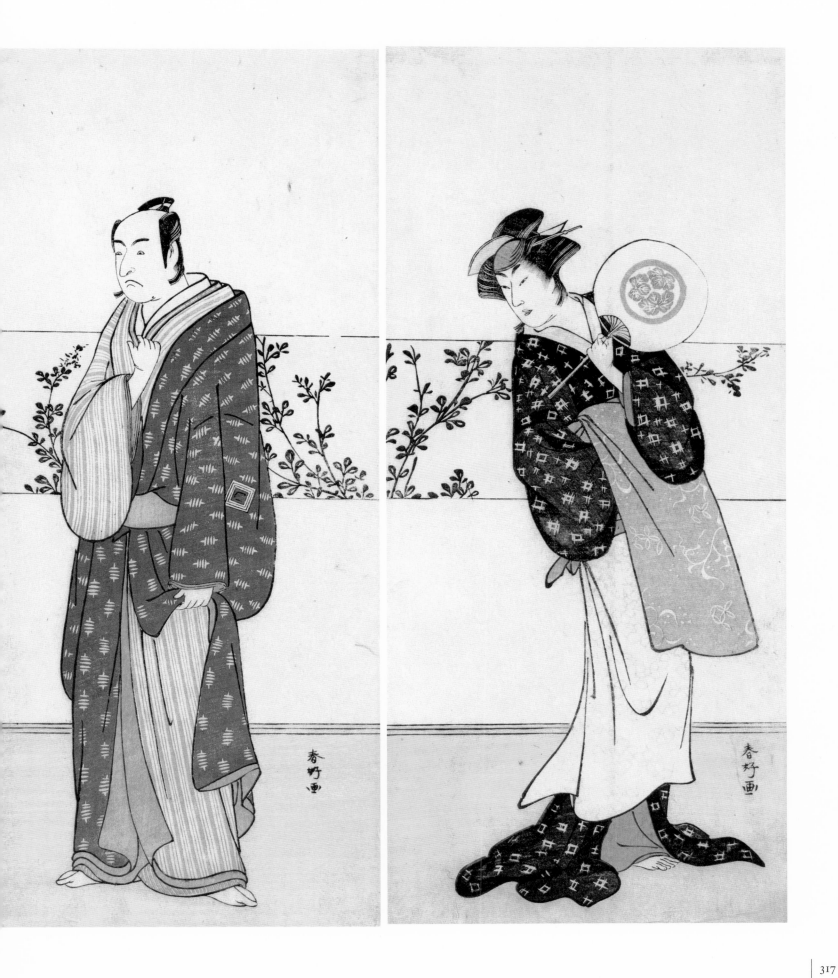

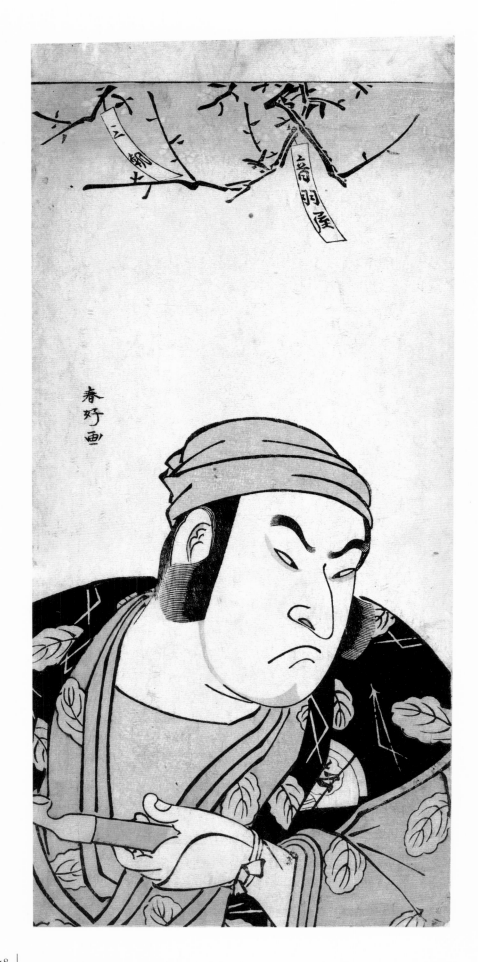

117 KATSUKAWA SHUNKŌ
(1743–1812)

Bust portrait of the actor Onoe Matsusuke I, perhaps as Yodohachi the Cowherd in the *jōruri* "Shitennō Ōeyama Iri" (The Four Great Retainers of Yorimitsu Go to Mt. Ōe), from part two of the play *Otokoyama Furisode Genji* (Genji in Long Sleeves at Mt. Otoko), performed at the Kiri Theater in the eleventh month, 1785

Hosoban; 36.3 x 14.9 cm
Gift of Mr. and Mrs. Harold G. Henderson 1962.985

Four *hosoban* bust portraits of this kind by Shunkō are known. Each shows an actor identified by two poem slips (*tanzaku*) hanging from tree branches above his head, one slip bearing his "house" name (*yagō*) and the other his pen name (*haimyō*, literally "poetry name").[1] "Otowaya" and "Sanchō," written on slips hanging from branches of a white plum, were house name and poetry name, respectively, of the actor Onoe Matsusuke I (1744–1815). He is wearing a plain cloth cap, his kimono and sleeveless jacket are both decorated with oak leaves, and he carries a short, stubby pipe. The oak-leaf pattern provides a clue to a possible identification of the role, since one of the other portraits from this group shows Ichikawa Monnosuke II as the legendary strong-boy Kintoki wearing a similar oak-leaf-patterned costume, in the *jōruri* "Shitennō Ōeyama Iri," from part two of the play *Otokoyama Furisode Genji*, performed at the Kiri Theater in the eleventh month of 1785 (fig. 117.1).[2] In this production Matsusuke I acted the role of Yodohachi the Cowherd.

The pose, with the arm pointing one way and the head turned the other, suggests arrested movement, and the bushy eyebrows are drawn into a disdainful frown. Matsusuke I is depicted with the same hooked nose and narrow eyes as in Shunkō's portrait of 1780 (No. 113), and rather differently than in Shunshō's print showing the tor backstage and out of costume (No. 93).

The purple and red of Matsusuke I's costume and cap have faded quite substantially, but no other impression is known.

1 The other three designs known are: Sawamura Sōjūrō III, whose alternative names are Sawamuraya and Tosshi (*Ukiyo-e Taisei*, vol. 8 [1931], pl. 157); Segawa Kikunojō III, whose alternative names are Hamamuraya and Rokō (*Ukiyo-e Taikei*, vol. 3 [1976], no. 155 [black-and-white]); Ichikawa Monnosuke II [as Kintoki], whose alternative names are Takinoya and Shinsha (H. R. W. Kühne collection).
2 Monnosuke II as Kintoki appears in two more prints by Shunkō: in an *ōban* together with Segawa Kikunojō III and Ichikawa Danjūrō V (*Genshoku Ukiyo-e Daihyakka Jiten*, vol. 7 [1980], no. 210), and in a *hosoban* (British Museum, London, 1915.8–23.0573).

117.1. Katsukawa Shunkō.
The actor Ichikawa Monnosuke II as Kintoki.
H. R. W. Kühne collection, Switzerland.
Photo courtesy of Sotheby's London

SIGNATURE *Shunkō ga*
REFERENCE
Ukiyo-e Taikei, vol. 3 (1976), no. 156 (black-and-white)

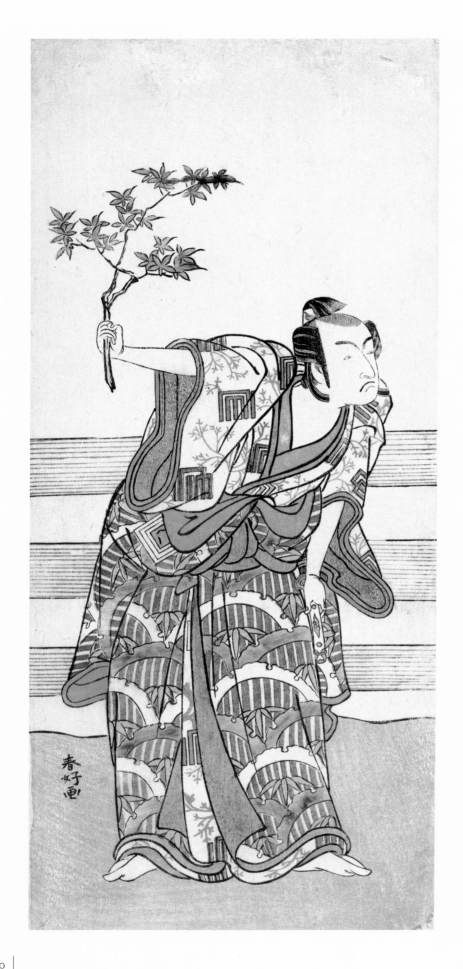

(1743–1812)

The actor Ichikawa Monnosuke II in an
unidentified role
Ca. 1785

Hosoban, part of a multisheet print; 32.7 x 14.6 cm
The Clarence Buckingham Collection 1928.310

Ichikawa Monnosuke II stands leaning forward, prob-
ably toward a figure on the next sheet of the diptych
or triptych, his right arm held straight out from the
shoulder and the hand brandishing a branch of autumn
maple. His other hand grips the hilt of his sword. The
background, patterned with bands of horizontal blue
lines, is probably a curtain drawn across the stage
between scenes.

The colors of Monnosuke II's costume are brilliant and
unfaded. His over-kimono is decorated with notched
circles (representing snow) and dwarf bamboo leaves
over a background of vertical stripes, and the actor has
shrugged off the top of that robe to reveal a white
kimono underneath, patterned with fern fronds and
"Genji emblems" (*Genji kō*).

The Genji emblem on his robes suggests that Mon-
nosuke II is enacting a member of the Genji clan in a
historical play, possibly *Otokoyama Furisode Genji* (Genji
in Long Sleeves at Mt. Otoko), performed at the Kiri
Theater in the eleventh month of 1785. In this play
Monnosuke II played the roles of Hirai no Hōshō in the
first act and Miyukinosuke Yukinari in the second,
opposite Segawa Kikunojō III in the roles of the court
lady-in-waiting Utsusemi no Naishi and Princess
Hatsune, daughter of the courtier Sano.[1] (In the final
jōruri dance sequence, as we have seen in No. 117,
Monnosuke II appeared as the strong-boy Kintoki.)
Discovery of the other sheets of the multisheet compo-
sition would assist in identifying the role and the play.

1 See *Kabuki Nempyō*, vol. 5 (1960), pp. 14–16.

SIGNATURE *Shunkō ga*
PROVENANCE H. Jackson collection

119 KATSUKAWA SHUNKŌ

(1743–1812)

The actors Iwai Hanshirō IV (right), Ichikawa Monnosuke II (center), and Sakata Hangorō III (left), possibly as Manazuru the wife of Tametomo, Hōjō Saburō Munetoki, and Kawanaya Tashirō, in the *jōruri* "Iwai-zuki Neya no Obitoki" (Inauspicious Months: Loosening the Sash in the Bedchamb'er), from part two of the play *Mutsu no Hana Izu no Hataage* (Snowflakes: Raising the Standard at Izu), performed at the Kiri Theater from the first day of the eleventh month, 1786

Ōban; 36.3 x 25.8 cm
The Clarence Buckingham Collection 1925.2368

Beginning about 1784, Shunkō designed *ōban* prints showing the grand, flamboyant dance sequences with onstage musicians (*shosagoto jōruri*) which closed each day's performance in opening-of-the-season (*kaomise*) plays, and which were such a feature of Kabuki in the Temmei era (1781–1789).[1] In this he was following the lead of Torii Kiyonaga (1752–1815), who first designed such prints several years earlier. Unlike Kiyonaga, however, Shunkō did not include the musicians in the print, nor did he necessarily depict a precise moment from the dance sequence but rather his own imagined grouping of the actors involved.

Although the libretto does not survive, making a definite identification difficult, comparison with the illustrated program (*ehon banzuke*) suggests that this print may depict the final *jōruri* "Iwai-zuki Neya no Obitoki," performed at the Kiri Theater in the eleventh month of 1786. The title of the *jōruri* contains a punning reference to the actor Iwai Hanshirō IV (*Iwai-zuki* can mean "a fan of Iwai"), who had just returned to Edo after a two-year absence in Osaka. The program illustration shows him in a female role and pose similar to that in Shunkō's print— wearing a kimono with long hanging sleeves (*furisode*) and holding a child swaddled in his own tiny costume (fig. 119.1). *Kabuki Nempyō* mentions that in this scene he played the woman Manazuru, who longs to see her child and goes to Hōjō Munetoki (played by Monnosuke II) to find him.[2]

Kabuki Nempyō also records that Hanshirō IV was joined in the dance sequence by Ichikawa Monnosuke II as Munetoki and Sakata Hangorō III as Kawanaya Tashirō, who made his entrance "half-drunk."[3] The scene was a great hit ("*ō-atari*"). The only discrepancies between the present print and the illustrated program are that the latter shows the two male characters in armor and lacks snow (fig. 119.1). As we have noted, however, Shunkō characteristically grouped characters from different stages in a dance scene; furthermore the plays themselves very commonly featured multiple disguises.

The three actors in their dazzlingly patterned costumes form a tight, self-enclosed group. Tasselled fans cascade down Hanshirō IV's scarlet kimono sleeve, surrounded by fans amid swirling waves on the over-kimono. Strong black stripes in Monnosuke II's robe contrast with the narrower black, yellow, and red bands of Hangorō III's costume. Hangorō III stands beneath a dandyish snake's eye umbrella and, inexplicably, carries two frogfish (*ankō*) suspended from a piece of string. One could not hope for a richer evocation of the colorful stage spectacle afforded by Kabuki dance sequences.

119.1. *The actor Iwai Hanshirō IV as Manazuru*. From the illustrated program. Nippon University Library, Tokyo

1 See for instance the Shunkō designs for the dance sequences in *Jūni-hitoe Komachi-zakura*, per-formed at the Kiri Theater in the eleventh month of 1784 (British Museum, London, illustrated in *Ukiyo-e Shūka*, vol. II [1979], no. 105), and *Otokoyama Furisode Genji*, performed at the Kiri Theater in the eleventh month of 1785 (illustrated in *Genshoku Ukiyo-e Daihyakka Jiten*, vol. 7 [1980], no. 210).
2 *Kabuki Nempyō*, vol. 5 (1960), p. 38.
3 Ibid., p. 37.

SIGNATURE *Shunkō ga*
PROVENANCE Frederick May collection
OTHER IMPRESSIONS Keiō University Library, Tokyo (ex-coll. Takahashi Seiichirō)

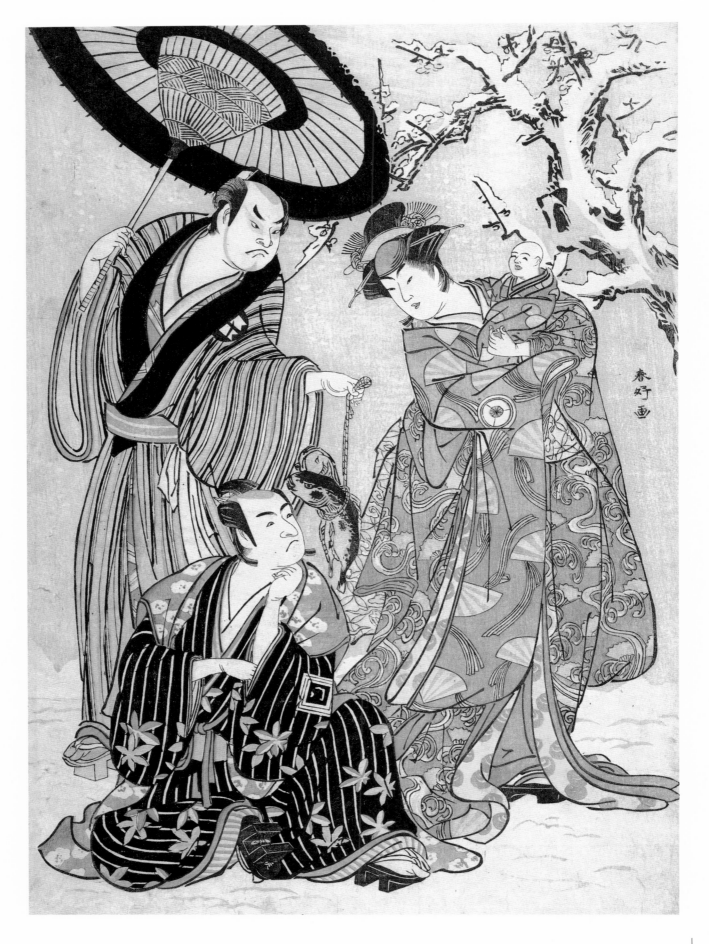

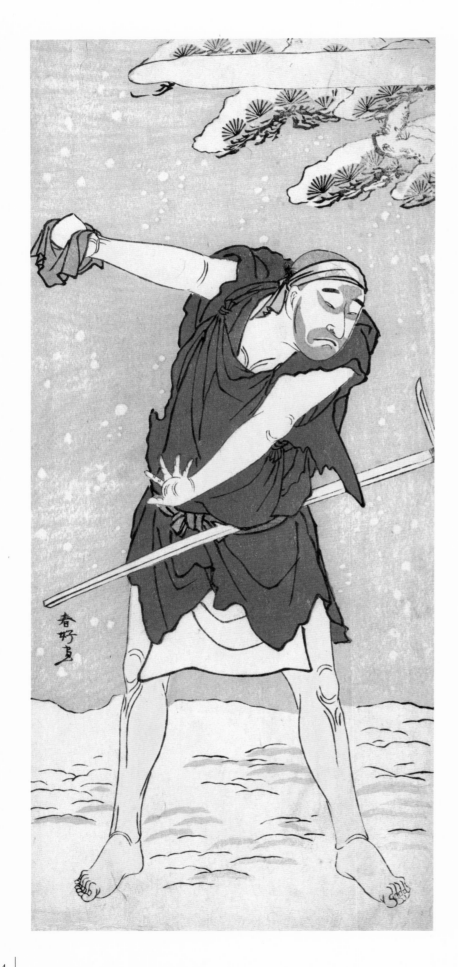

120 KATSUKAWA SHUNKŌ
(1743–1812)

The actor Onoe Matsusuke I as a mendicant monk in the *jōruri* "Midarezaki Hana no Iro-goromo" (Colorful Cloth Profusely Flowered), from part two, act six of the play *Keisei Ide no Yamabuki* (Courtesan: Kerria Roses at Ide) (?), performed at the Nakamura Theater from the sixth day of the fifth month, 1787

Hosoban, part of a multisheet print; 31.5 x 13.9 cm
The Clarence Buckingham Collection 1952.365

Onoe Matsusuke I, in the tattered brown robe and white loincloth of a mendicant monk (*gannin bōzu*), stands bare-legged in the still-falling snow beneath a pine tree. In his outstretched right hand he holds a large jewel in a cloth, while with the other splayed hand he fends off a long sword (?) that thrusts in from outside the margins of the print. This is probably the left-hand sheet of a triptych, though the other two sheets have not yet been discovered.

Similarities with the costume depicted in the illustrated program (*ehon banzuke*) suggest that this is the final (sixth) act in part two of the play *Keisei Ide no Yamabuki*, performed at the Naka-mura Theater in the fifth month of 1787 (fig. 120.1). This scene was a dance sequence (*shosagoto jōruri*), "Midarezaki Hana no Iro-goromo," with onstage chanting provided by Tokiwazu Yamato-dayū and his troupe of musicians. In this scene Matsu-suke I played three roles, including the mendicant monk, described in *Kabuki Nempyō* as "a priest of evil character" (*shōwaru oshō*).[1] Certainly his heavily stubbled face and narrowed eyes empha-sized by makeup make him look both disreputable and malevolent, and Shunkō clearly relished this opportunity to portray knavery.

The illustrated program shows that the dance scene included child actors and several female characters, and was set against a background of kerria (*yamabuki*) bushes in flower. The roles are given in *Kabuki Nendaiki*,[2] but the precise plot is not known.

1 *Kabuki Nempyō*, vol. 5 (1960), p. 49.
2 *Kabuki Nendaiki* (1926), p. 426.

120.1. *The actor Onoe Matsusuke I as a mendicant monk.*
From the illustrated program.
Tsubouchi Memorial Theater Museum, Waseda University, Tokyo

SIGNATURE *Shunkō ga*
PROVENANCE ex-collection Frederick S. Colburn

121 KATSUKAWA SHUNKŌ

(1743–1812)

The actor Sanogawa Ichimatsu III in a female role, possibly Masago Gozen in the play *Keisei Azuma Kagami* (A Courtesan's "Mirror of the East") (?), performed at the Nakamura Theater in the second month, 1788

Hosoban, right-hand sheet of a diptych or triptych;
 32.9 x 14.9 cm
Gift of Mr. and Mrs. Harold G. Henderson 1962.984

Judging by the costume, Sanogawa Ichimatsu III appears in the role of a woman of high birth, standing before an open *shōji* window through which can be seen a snow-laden clump of bamboo. Over a checkered kimono (a pattern long associated with the Ichimatsu line of actors), he wears a thick, lined purple *uchikake* robe against the cold, decorated appropriately to the season with a pattern of snow-covered dwarf bamboo leaves. The composition— with Ichimatsu III's curving pose echoed by the leaning bamboo behind him— indicates that this is the right-hand sheet of a multisheet print. In the collection of the Metropolitan Museum is the complete diptych (or possibly the right and center sheets of a triptych); the other sheet shows Sawamura Sōjūrō III in the guise of a mendicant monk (*komusō*), wearing a richly patterned kimono and monk's stole (*kesa*) and carrying the characteristic basket-shaped hat (*tengai*) and curved bamboo flute (*shakuhachi*) (fig. 121.1). In their elegant contrapposto the two figures mirror each other, with Ichimatsu III's trailing skirts matching the curve of Sōjūrō III's brocade flute bag and pointed toe.

The identification of the play is not certain. The Sanogawa Ichimatsu name fell into abeyance after 1781, and was not assumed by Ichimatsu III until the *kaomise* performance at the end of 1784.[1] Sōjūrō III may be playing the role of Shirai Gompachi and Ichimatsu III the court lady Masago Gozen in the play *Keisei Azuma Kagami*, performed at the Nakamura Theater in the second month of 1788. The casting for this production is known from an advance publicity handbill (*tsuji banzuke*) for the play in the Museum of Fine Arts, Boston.

1 *Kabuki Nempyō*, vol. 4 (1959), p. 531.

SIGNATURE *Shunkō ga*
OTHER IMPRESSIONS
(this sheet) Tokyo National Museum;
(both sheets of diptych) Metropolitan Museum of Art, New York

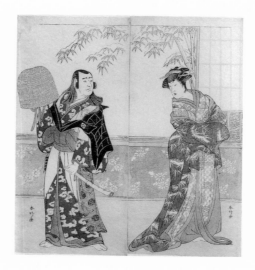

121.1. Katsukawa Shunkō. *The actors Sanogawa Ichimatsu III and Sawamura Sōjūrō III, possibly as Masago Gozen and Shirai Gompachi.* Metropolitan Museum of Art, New York

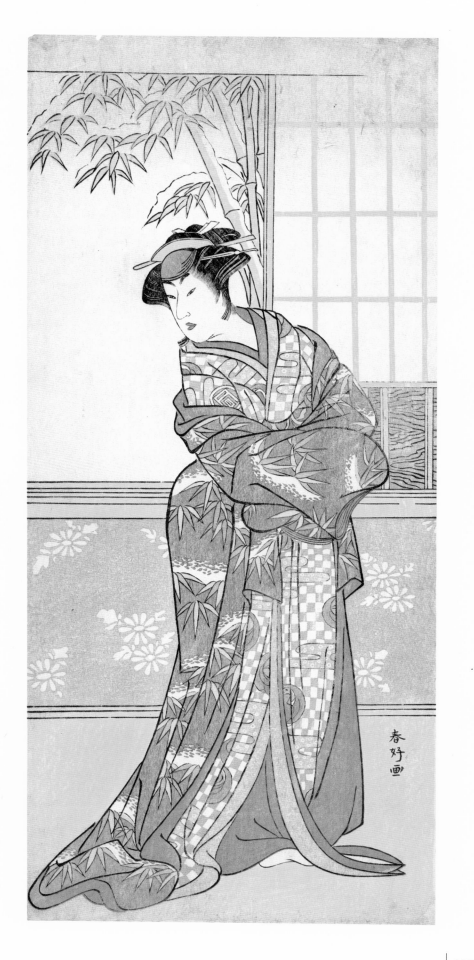

The actors Nakayama Kojūrō VI as Ono Sadakurō (right), and Mimasu Tokujirō I as Hayano Kampei (left), in act five of *Kanadehon Chūshingura* (Treasury of the Forty-seven Loyal Retainers), performed at the Nakamura Theater from the eleventh day of the fifth month, 1786

Hosoban diptych; (right) 31.6 x 14.7 cm; (left) 32.7 x 14.7 cm
Frederick W. Gookin Collection (right) 1940.1121; (left) 1939.925

Shun'ei's diptych portrays two of the principals in one of the most savagely ironic episodes of that most popular revenge drama *Chūshingura*. Young Hayano Kampei (left, played by Mimasu Tokujirō I), a retainer momentarily derelict in duty to his lord, has been living in rural isolation and poverty with his beloved wife and parents-in-law ever since his lord's enforced suicide left him a masterless samurai (*rōnin*) somewhat suspect in the eyes of his fellows. While hunting to put meat on the family table, he encounters one of his former fellow retainers, who most guardedly asks for a monetary contribution to the secret cause of avenging their dead lord. Kampei has no money but vows to get some, somehow, to reaffirm his loyalty and redeem his honor. He is unaware that his wife has arranged to sell herself into a brothel for that very purpose, and that his father-in-law has passed that way slightly earlier, bearing the brothel-keeper's down payment. Alas, the old man is never to reach home: he is intercepted by the vicious highway robber Ono Sadakurō (right, played by Nakayama Kojūrō VI), who wounds him, robs him, then stabs him to death. In the gathering darkness Kampei, following the trail of a boar he has wounded, hears Sadakurō in his hiding place, fires at the sound, and kills the robber outright. He is appalled to find that he has killed a man (whose features he cannot see for the darkness), but on discovering the purse of stolen money on the body, he takes it to donate to the cause and hurries home.

Tragically, events of the following act convince Kampei that he has inadvertently shot his father-in-law. Finding himself now apparently a parricide as well as suspect in honor, he commits ritual suicide. As the life seeps from him, the truth comes finally to light. Kampei dies peacefully, knowing that his good name is restored, inscribed in the compact of loyal retainers who have sworn to avenge their lord.[1]

In modern productions of the play Kampei and Sadakurō never confront one another directly, as they appear to do in the print; Kampei shoots Sadakurō in his hiding place and from a distance. Either the eighteenth-century plot differed slightly, or (more likely) Shun'ei simply chose to juxtapose the two characters in the composition.

As has already been described (see No. 73), the role of Sadakurō had been given a revolutionary new interpretation by Nakamura Nakazō I in 1766. In the present print we see Nakazō I as Sadakurō some twenty years on— acting now under the name Nakayama Kojūrō VI, which he employed between the eleventh month of 1785 and eleventh month of 1786[2]— with the same black robe, white body makeup, and tattered "snake's eye" umbrella that are recorded for the 1766 production. His build here, however, is noticeably more portly and elderly than that of the slick young killer depicted by Shunshō in 1768 (fig. 73.1), the second time Nakazō I appeared in the role.[3] The role of Kampei in 1786 was taken by the Osaka actor Mimasu Tokujirō I, who had been working in Edo since the New Year of 1784.

Shun'ei began to design theatrical prints with some frequency only in 1783,[4] and his early designs (such as this) rely heavily on stylistic precedents set by Shunshō and Shunkō. The two sheets of the Chicago diptych were assembled from different sources, and the left sheet is considerably faded, as comparison with the pristine impression in the collection of the Ōta Memorial Museum shows.[5]

1 For a full synopsis of *Kanadehon Chūshingura*, see Halford (1956), pp. 138–65.
2 See the commentary to No. 103.
3 Nakazō I acted the role of Sadakurō eight times: in 1766, 1768, 1771, 1776, 1779, 1783, 1786, and 1787.
4 *Genshoku Ukiyo-e Daihyakka Jiten*, vol. 8 (1981), p. 12.
5 Ōta Memorial Museum (1983), no. 73.

SIGNATURE *Shun'ei ga*
PROVENANCE (right) Judson D. Metzgar collection
OTHER IMPRESSIONS (complete diptych) Ōta Memorial Museum, Tokyo

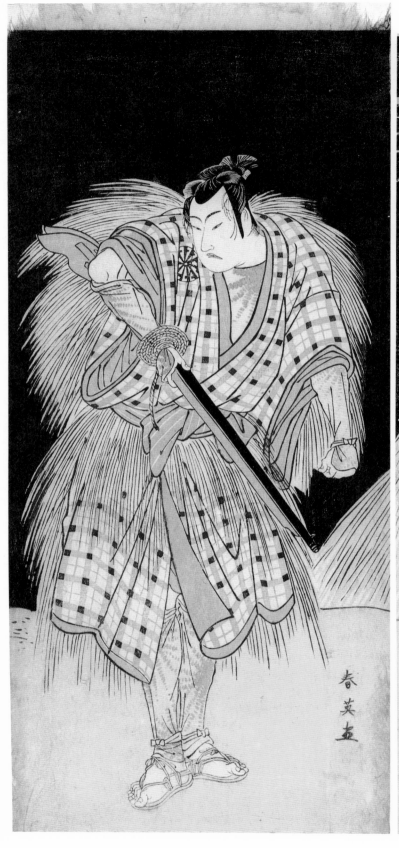
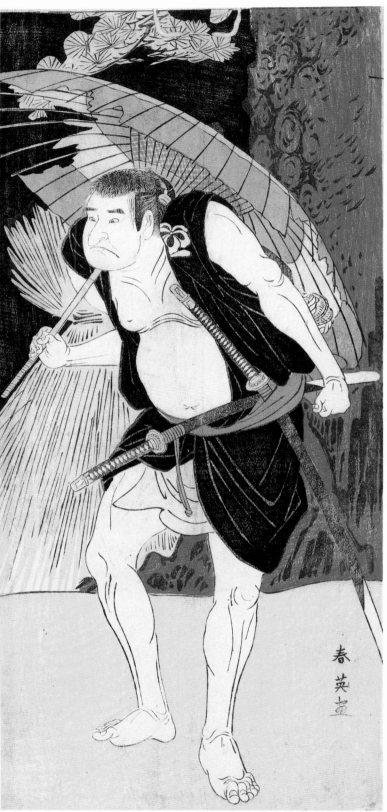

The actor Segawa Kikunojō III, possibly as Ono no Komachi in the final part of act five of the play *Komachi-mura Shibai no Shōgatsu* (Komachi Village: New Year at the Theater), performed at the Nakamura Theater from the first day of the eleventh month, 1789

Hosoban, left sheet of a diptych; 33.5 x 15.0 cm
The Clarence Buckingham Collection 1929.739

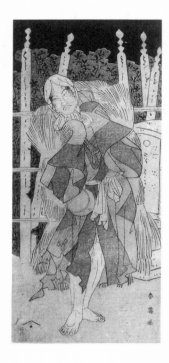

123.1. Katsukawa Shun'ei. *The actor Onoe Matsusuke I as a graveyard beggar*. Tokyo National Museum

Segawa Kikunojō III appears in the many-layered patterned robes of a court lady, her body twisting backward dramatically and one sleeve held protectively up to her head. With the other hand she holds a torch-like lantern (*gandō*) as far in front of herself as possible. The background is ominous— wooden grave markers and straggling bushes against the jet black night sky. This may be a "silent encounter" scene (*dammari*), in which the actors perform a slow, stylized confrontation in the dark, typically included in an opening-of-the-season (*kaomise*) production.

This print seems to form a diptych with a sheet showing Onoe Matsusuke I as a graveyard beggar (fig. 123.1),[1] but the roles are not clearly identifiable. The court robes suggest that Kikunojō III is playing a famous beauty of ancient times, such as Ono no Komachi, the ninth-century poet. An illustrated program (*ehon banzuke*) from the play *Komachi-mura Shibai no Shōgatsu*, performed at the Nakamura Theater in the eleventh month, 1789, does indeed show him in this role (fig. 123.2). Furthermore, the grave markers (*sotoba*) may allude to "Sotoba Komachi," one of the seven famous episodes in Komachi's life, when— old, impoverished, and unrecognized— she is upbraided by monks for sitting on such a grave marker. In the 1789 play, however, Matsusuke I played the role of Ōtomo Madori Kuronushi, a famous courtier-poet contemporary with Komachi, and one would expect to see him in court robes (as in fig. 123.2, bottom right), not in the tattered kimono and straw raincoat of a beggar. But, as always in Kabuki, he may be in disguise.[2]

123.2. *The actor Segawa Kikunojō III as Ono no Komachi*. From the illustrated program. Nippon University Library, Tokyo

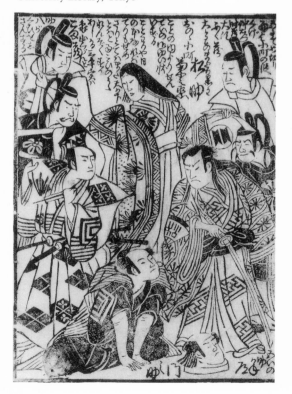

1 Suzuki Jūzō, however, suggests that these are the left- and right-hand sheets of a triptych. See *Ukiyo-e Shūka*, vol. 5 (1980), no. 125.
2 Suzuki Jūzō (*Ukiyo-e Shūka*, vol. 5 [1980], no. 125) suggests that this may be a scene from the play *Hana Yagura Tachibana Keizu*, performed at the Ichimura Theater in the eleventh month, 1798— some nine years later— but his identification is by no means definite.

SIGNATURE *Shun'ei ga*
PUBLISHER Harimaya Shinshichi
REFERENCE
Riccar (1973), no. 118; *Ukiyo-e Taikei*, vol. 3 (1976), no. 182 (black-and-white); *Ukiyo-e Shūka*, vol. 5 (1980), no. 125

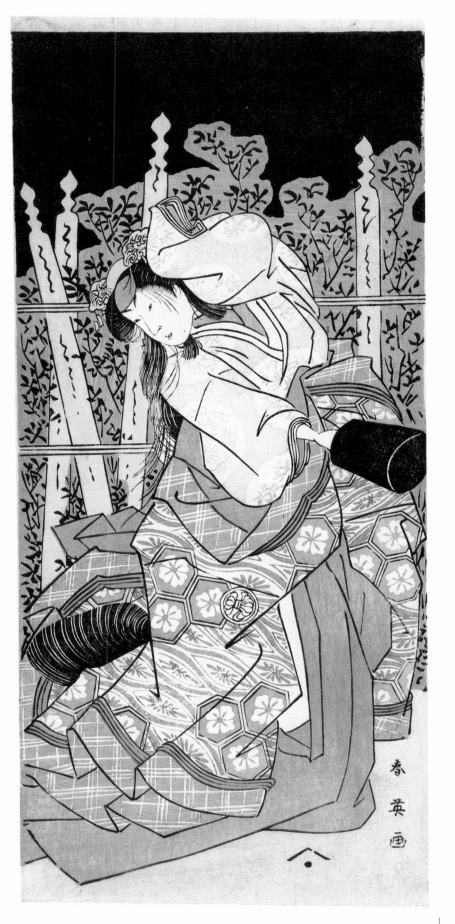

The actor Asao Tamejūrō I as Drunken Gotōbei doing a *Sambasō* dance (*Gotō Sambasō*) in act three of the play *Yoshitsune Koshigoe Jō* (Yoshitsune's Koshigoe Petition), performed at the Ichimura Theater from the ninth day of the ninth month, 1790

Hosoban; 29.4 x 13.9 cm
Frederick W. Gookin Collection 1939.912

Yoshitsune Koshigoe Jō, first performed in 1754, sailed close to the wind of political censorship by dealing with events of the Osaka campaign of 1614–1615, in which the ruling Tokugawa family had finally eradicated the rival Toyotomi clan, led by the young Toyotomi Hideyori. To circumvent censorship, however, the play was set in the "world" (*sekai*) of the twelfth-century civil wars, substituting Minamoto no Yoritomo for Tokugawa Ieyasu and Minamoto no Yoshitsune (Yoritomo's younger half-brother) for Toyotomi Hideyori.[1]

Though the two had fought together to annihilate the Taira clan, Yoshitsune's dazzling military successes and his subsequent popularity at court have aroused the vengeful ire of his elder brother, now the shogun. Driven out of Koshigoe, Yoshitsune raises the standard against Yoritomo. Izumi no Saburō recommends his vassal Gotōbei as military strategist, but Gotōbei is something of a drunkard and disgraces himself with tipsy dancing when he is presented to Lord Yoshitsune. In disgust, Gotōbei's wife Sekijo petitions to divorce him, but Izumi no Saburō has more faith in his man: Gotōbei appears to have fallen into a drunken stupor, but when Izumi no Saburō fires off a blank rifle shot Gotōbei is instantly alert and ready for action, so proving his military mettle.[2]

Gotōbei is thus not just a drunken fool, and his sudden change of character must have made for a bravura role. In the ninth month of 1790 the actor Asao Tamejūrō I scored a great success with his interpretation of Gotōbei, in a farewell performance (*nagori kyōgen*) before leaving Edo for his native Osaka.[3] In this and the following print Shun'ei depicts two of the humorous guises Tamejūrō I adopted in his drunken dance. Here Gotōbei impersonates a comic *Sambasō* dancer,[4] wearing a hand towel around his head in imitation of a court hat (*eboshi*) and about to unfasten the shoulder "wings" of his costume so that it will resemble the wide-sleeved ceremonial *suō* jacket. Shun'ei has captured brilliantly Tamejūrō's heavily intoxicated appearance, with slack, gaping mouth, comically arched eyebrows, and awkward buffoonish pose.

1 *Kabuki Saiken* (1926), p. III.
2 Ibid., p. II2.
3 *Kabuki Nempyō*, vol. 5 (1960), p. 98.
4 The *Sambasō* character comes from the Nō play *Okina* (Old Man); he performs an auspicious dance at New Year and also during the ceremonies marking the opening of the new Kabuki season (see Clark essay, p. 36).

SIGNATURE *Shun'ei ga*
OTHER IMPRESSIONS
Ex-collection Vever (present location unknown); *Ukiyo-e Taisei*, vol. 8 (1931), pl. 237; Vignier and Inada (1910), no. 521

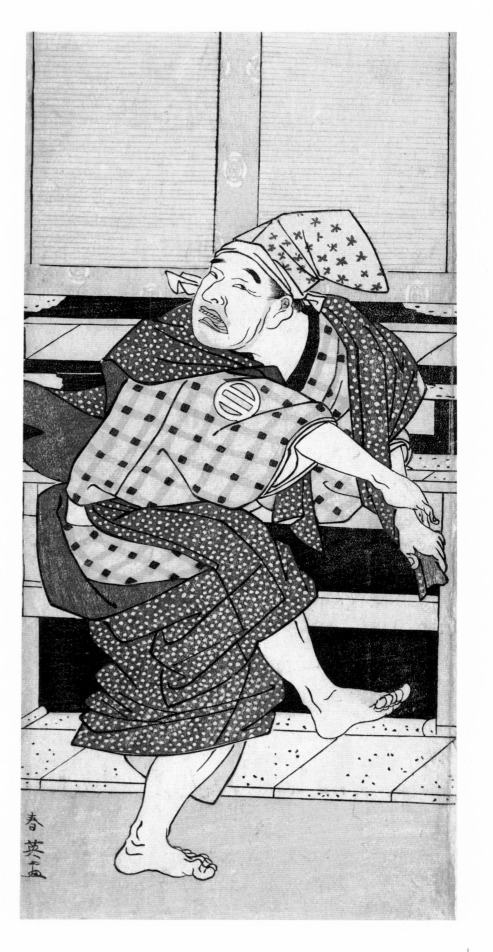

125 KATSUKAWA SHUN'EI
(1762–1819)

The actor Asao Tamejūrō I as Drunken Gotōbei
in act three of the play *Yoshitsune Koshigoe Jō*
(Yoshitsune's Koshigoe Petition), performed at
the Ichimura Theater from the ninth day of the
ninth month, 1790

Hosoban; 32.9 x 14.7 cm
Frederick W. Gookin Collection 1939.927

The Osaka actor Asao Tamejūrō I appears again as
Gotōbei, in a later moment of his drunken dance
before Lord Yoshitsune in the play *Yoshitsune Koshigoe
Jō*. In the preceding print (No. 124) he impersonated a
comic *Sambasō* dancer. Here he has hoisted a large
bucket of sake up onto his back with a broom through
the handle, perhaps in imitation of a manservant
(*yakko*) carrying a travelling case in the entourage of a
feudal lord. The red and black lacquered bucket bears
Tamejūrō I's acting crest— two parallel lines in a
circle— painted on the handle.

Once again Shun'ei has skillfully captured the actor's
depiction of drunken buffoonery: his tongue lolling in
his open mouth and his eyebrows raised in befuddle-
ment. He has also not hesitated to show Tamejūrō I's
flabby torso, in what is clearly a later part of the dance,
when Gotōbei is more deeply drunk and has discarded
more of his clothes.

SIGNATURE *Shun'ei ga*
REFERENCE *Ukiyo-e Shūka*, vol. 5 (1980), no. 127

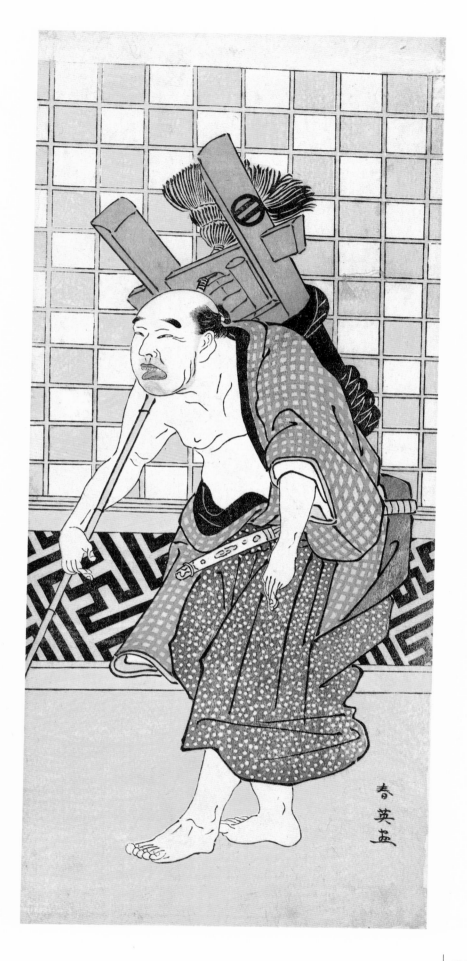

The actors Ichikawa Monnosuke II as Mori no Rammaru (right), Sawamura Sōjūrō III as Oda Kazusanosuke Harunaga (center), and Sakata Hangorō III as Takechi Mitsuhide (left), in "The Banquet," the final act in part one of the play *Kanagaki Muromachi Bundan* (Muromachi Chronicle in *Kana* Script), performed at the Ichimura Theater from the first day of the eighth month, 1791

Hosoban triptych; (right) 32.0 x 14.4 cm; (center) 32.5 x 15.0 cm; (left) 32.0 x 14.6 cm
The Clarence Buckingham Collection (right) 1939.2216; (center) 1980.276b; (left) 1980.276a

Kanagaki Muromachi Bundan was a version of *Taikōki*, the famous historical saga of the assassination in 1582 of the dictator Oda Nobunaga by his retainer Akechi Mitsuhide, who in turn was quickly destroyed by Nobunaga's general Toyotomi Hideyoshi. Since plays dealing with such relatively recent events were forbidden, the names of the characters were thinly disguised: Oda Harunaga for Oda Nobunaga and Takechi Mitsuhide for Akechi Mitsuhide. Many versions were performed during the eighteenth century, particularly on the puppet stage.

This act, near the beginning of the story, explains how Mitsuhide (played by Sakata Hangorō III, left) was driven to murder his lord. Oda Harunaga (played by Sawamura Sōjūrō III, center) has just returned from a hunting excursion to Kitayama— he is still wearing tigerskin riding leggings— accompanied by his attendant Rammaru (Ichikawa Monnosuke II, right). A banquet is to be held to welcome the imperial messenger who will promote Harunaga to the rank of prime minister. Harunaga, however, does nothing but find fault with Mitsuhide's arrangements for the festivities: Mitsuhide has hung curtains decorated with his own Chinese bellflower (*kikyō*) crest instead of Harunaga's crest, and he is wearing ceremonial robes (*kamishimo*) in the color purple, a hue officially restricted to courtiers of high rank. Mitsuhide is shown grovelling in apology before Harunaga for these evidences of insubordination, but at the end of the scene Harunaga gives his iron-ribbed fan to Rammaru and orders him to strike Mitsuhide. For this humiliation Mitsuhide resolves a terrible revenge.

The placing of a single figure on each sheet of a multisheet *hosoban* print was a pictorial convention skillfully used by Shunshō to the end of his life (see No. 106), and the conservative style employed here by Shun'ei is almost indistinguishable from that of his teacher. The triptych was reunited from different collections, and the colors of all three sheets are remarkably fresh, apart from the Chinese bellflower-patterned curtain across the top of the design, whose original pale blue has faded to light buff.

SIGNATURE *Shun'ei ga*
PUBLISHER Kawaguchiya Uhei
CENSOR'S SEAL *Kiwame*
PROVENANCE (center and left) Frank Lloyd Wright collection

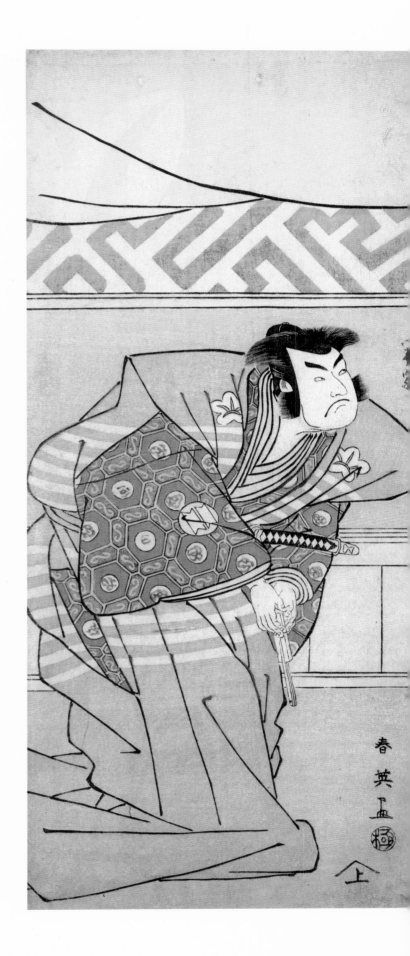

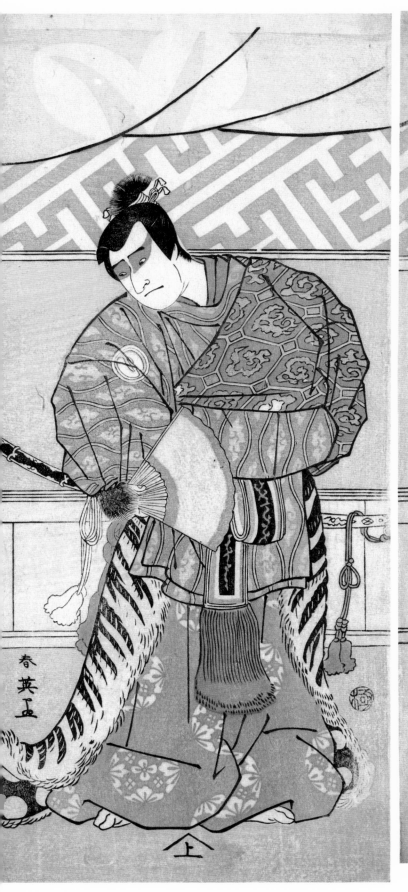
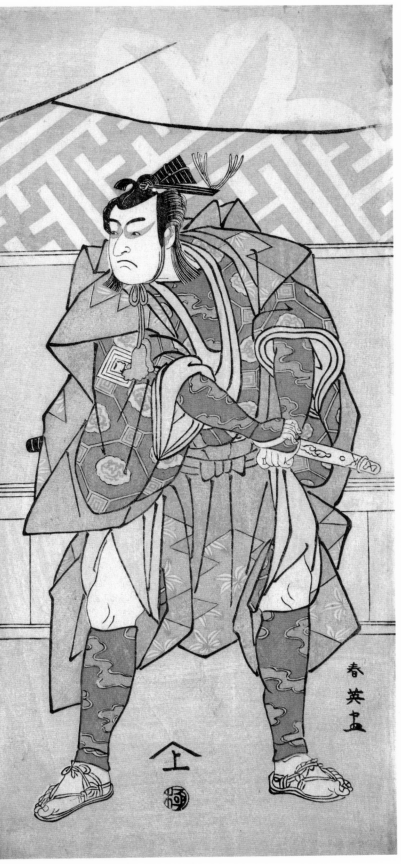

The actor Ichikawa Komazō III in three roles: Nyosan no Miya (The Third Princess), Ukare Zatō (A Blind Street Performer), and Sakata no Kaidō-maru, in the play *Zōho Natsu Matsuri* (Expanded Summer Festival), performed at the Kawarazaki Theater from the first day of the eighth month, 1791

Hosoban; 30.3 x 14.0 cm
Frederick W. Gookin Collection 1939.921

"Transformation pieces" (*hengemono*), in which a single actor played various contrasting roles in a sequence of short dances, had originated at the very end of the seventeenth century and would see their heyday in the first quarter of the nineteenth. They were often performed with onstage musicians and featured quick costume changes (*haya-gawari*).[1]

The production at the Kawarazaki Theater (the former Morita Theater, renamed in 1790) in the eighth month of 1791, *Zōho Natsu Matsuri*, included such a "transformation piece" in which Ichikawa Komazō III played five different roles (*go henge*): Issun Tokubei (one of the heroes of the main plot), Kyō Ningyō (A Kyoto Doll), and the three roles depicted here. At the top of the composition stands Nyosan no Miya, the Third Princess from *Tale of Genji*, dressed in many-layered brocade court robes and holding a large court fan.[2] Below her dances a blind street performer (*ukare zatō*), wearing gray robes and mop cap and a mournful expression on his face. Finally, kneeling at the bottom grasping a large axe, is the red-faced Sakata no Kaidō-maru (or Kintoki, see No. 98), the child of legendary strength who grew up in the wild and became one of Minamoto no Yorimitsu's four famous retainers. The point of the "transformation piece" was to display the actor's versatility.

Though he succeeded to the name in 1771, Ichikawa Komazō III was rarely portrayed as a young man during the 1770s and '80s in prints by Shunshō. During the 1790s, however, his distinctive beaked nose (which earned him the nickname Hanadaka [High Nose] Komazō) was often to be seen in the prints of Shun'ei, Tōshūsai Sharaku, and Utagawa Toyokuni. In 1801 he took the name Matsumoto Kōshirō V and went on to specialize in evil (*jitsu aku*) roles in the plays of Tsuruya Namboku IV,[3] and was celebrated as "an actor without equal, past or present" (*kokon murui*) until his death in 1838.

1 *Kabuki Jiten* (1983), s.v. *Hengemono*.
2 For the story of the Third Princess, see No. 18.
3 The handwritten inscription on this print reads "Ichikawa Komazō III, Kinshō [his poetry name, or *haimyō*], later Matsumoto Kōshirō," and so the inscription must date after 1801.

SIGNATURE *Shun'ei ga*
CENSOR'S SEAL *Kiwame*

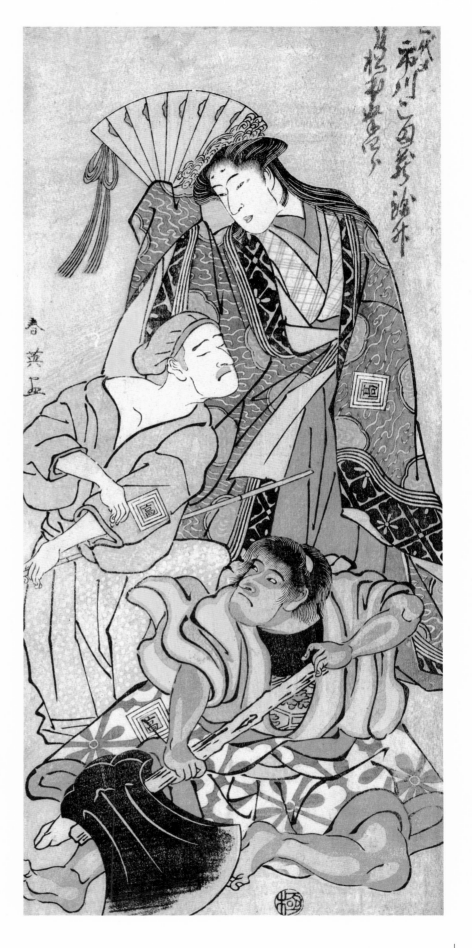

"Large head" portrait (*ōkubi-e*) of the actor Iwai Hanshirō IV as Akita Jōnosuke Yoshikage in a "Shibaraku" role, from the play *Mieikō Nori no Hachi no Ki* (Memorial Service for St. Nichiren: A Model of "The Potted Trees"), performed at the Kawarazaki Theater in the eleventh month, 1791

Aiban; 32.3 x 22.5 cm
The Clarence Buckingham Collection 1939.2206

Iwai Hanshirō IV shared honors with Segawa Kikunojō III as the leading female impersonator (*onnagata*) of the late eighteenth century, but here we see him in a rare venture into male "rough stuff" (*aragoto*) acting—as a warrior in the famous "Shibaraku" (Stop right there!) scene. His round, chubby face (which earned him the nickname Otafuku, after the legendary fat woman) is unexpectedly powerful in this most masculine of roles. He is wearing the characteristic "Shibaraku" costume: red-streaked *sujiguma* makeup, radiating "cartwheel" wig, black lacquer court headdress (*eboshi*), pleated white paper "strength" hair ornaments, and a voluminous persimmon red ceremonial jacket (*suō*) over armor. Hanshirō IV's crest of three fans arranged inside a circle appears on the breastplate.

Kabuki Nempyō records that Hanshirō IV made the normal entry down the walkway through the audience (*hanamichi*), wearing the "Shibaraku" costume decorated with the large square crests of the Ichikawa family. Just as he was about to accost evil Prince Munetaka on the main stage, his fellow actor Osagawa Tsuneyo II climbed up from the front row of the audience and interrupted, calling out, "Aren't you my younger sister Onaka?" Piece by piece the "Shibaraku" costume was removed and the makeup was washed off, to reveal a precocious young girl wearing a long hanging-sleeved kimono (*furisode*) beneath![1] This unexpected development in the hackneyed "Shibaraku" scene was well received, and is the subject of an illustration by Shuntei in *Kabuki Nendaiki* (fig. 128.1).

The signature "*Shunkō ga*" has been added by hand to the top left-hand corner of the print, and in the past this attribution has been credited by Japanese authorities.[2] Shunkō did indeed produce a series of revolutionary "large head" portraits (*ōkubi-e*) of actors against blue backgrounds during the one-year period between the eleventh month of 1788

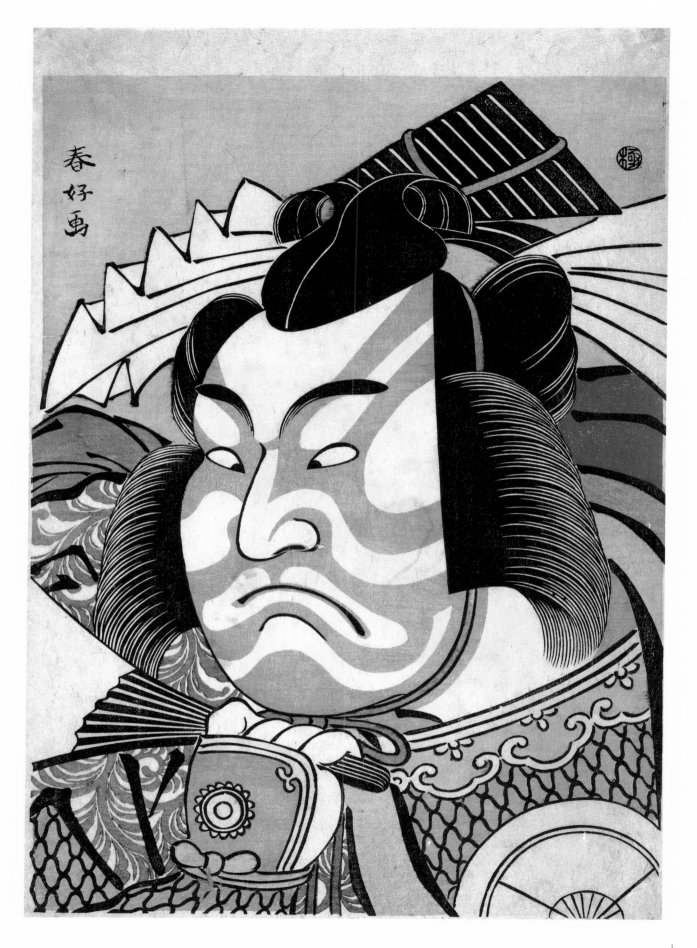

and the eleventh month of 1789. Seventeen such designs have been provisionally identified by Roger Keyes, all in the *ōban* format and all of unprecedented power.[3] Keyes also observes, however, that the last datable print designed by Shunkō, before he fell victim to a paralysis that affected his right hand, was issued to mark a performance in the third month of 1790.[4]

The present print is superficially similar to these "large head" portraits by Shunkō, but it is in the smaller *aiban* format and dates almost a year and a half after Shunkō is thought to have retired. The style is in fact closer to a *hosoban* print of Hanshirō IV in the same "Shibaraku" role signed Shun'ei (fig. 128.2), and it is likely that Shun'ei was also the artist of the present, unsigned, print. The thick black drapery lines around Hanshirō IV's face have little of the taut, sweeping power seen in Shunkō's best portraits.[5]

1 *Kabuki Nempyō*, vol. 5 (1960), p. 129.
2 See Reference below.
3 *Ukiyo-e Shūka*, vol. 13 (1981), no. 67.
4 Ibid.
5 Compare, for instance, the portraits of Nakazō I and Danjūrō V (*Ukiyo-e Shūka* 13 [1981], nos. 22 and 67).

U N S I G N E D ["*Shunkō ga*" added by hand]
C E N S O R ' S S E A L *Kiwame*
P R O V E N A N C E Leicester Harmsworth collection
R E F E R E N C E
Riccar (1973), no. 115; *Ukiyo-e Taikei*, vol. 3 (1976), no. 167 (black-and-white); *Ukiyo-e Shūka*, vol. 5 (1980), no. 21 (black-and-white)

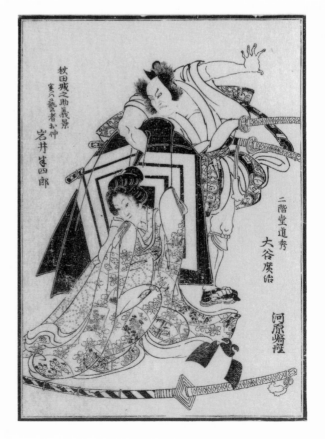

128.1. Katsukawa Shuntei. *The actors Ōtani Hiroji III and Iwai Hanshirō IV in a "Shibaraku" scene.*
From *Kabuki Nendaiki*. The Art Institute of Chicago

128.2. Katsukawa Shun'ei. *The actor Iwai Hanshirō IV in a "Shibaraku" role.*
Arthur M. Sackler Museum, Harvard University Art Museums, Cambridge, Mass.

129 KATSUKAWA SHUN'EI
(1762–1819)

The sumo wrestler Kurogumo Otozō with the teahouse waitress
Naniwaya Okita
Early 1790s

Ōban; 39.0 x 26.0 cm
Gift of Mr. and Mrs. James A. Michener 1958.159

In comparison with the scrupulous yet sympathetic objectivity of
Shunshō's portraits of sumo wrestlers some ten years earlier (Nos.
99–101), Shun'ei brings to his wrestler prints more personal qualities
of lightness and playfulness; qualities, indeed, which permeate many
of his works on all subjects during the 1790s. Also, Shun'ei's wres-
tlers are drawn with a much more "painterly," modulating line.

The early years of the '90s saw a fashion among several *ukiyo-e* artists
(Kitagawa Utamaro, Shunchō, Shun'ei) for pairing celebrated beau-
ties—Yoshiwara courtesans or pretty shop girls— with hulking wres-
tlers. Shun'ei took up this vogue with enthusiasm, showing us here
the young wrestler Otozō escorted by the waitress Okita of the
Naniwaya Teahouse, who wears a wave-patterned apron and carries a
paper lantern decorated with the vine-leaf crest of the teahouse. By
setting her figure slightly behind the wrestler, he emphasizes their
disparity in size. Okita holds up her hand to her mouth in a gesture
that might express surprise, or even admiration. For although we
may be tempted to interpret this print as a pairing of "beauty and the
beast," in fact the younger sumo wrestlers, despite their massive
bulk, were often popular heartthrobs among women. It is doubtful,
however, that Otozō and Okita would ever actually have met: their
implied relationship is an artistic conceit.

A handbill (*banzuke*) for the sumo match held in the precincts of
Kanda Myōjin Shrine in the third month of 1792 lists Otozō in the
ninth level of *maegashira* rank in the Western Group and mentions
that he came from Iyo Province.[1] The comic *kyōka* poem by Engi
Kanenari printed in the cartouche in the top left-hand corner of the
print suggests that he was very popular:

Sajiki yori	Flowers shower like
ame arare zo to	Rain and hail
hana furite	From the gallery:
hiiki mo tsuyoku	Kurogumo looks as strong
miyuru Kurogumo	As his supporters.

The colors of the print are somewhat faded.

1 *Nippon Sumō-shi*, vol. 1 (1956), p. 180.

SIGNATURE *Shun'ei ga*
PUBLISHER Tsutaya Jūzaburō
CENSOR'S SEAL *Kiwame*
OTHER IMPRESSIONS
Ex-collection Theodor Scheiwe (present location unknown); ex-collection
Count Sakai Tadamasa (Nippon Sumō Kyōkai; present location unknown)

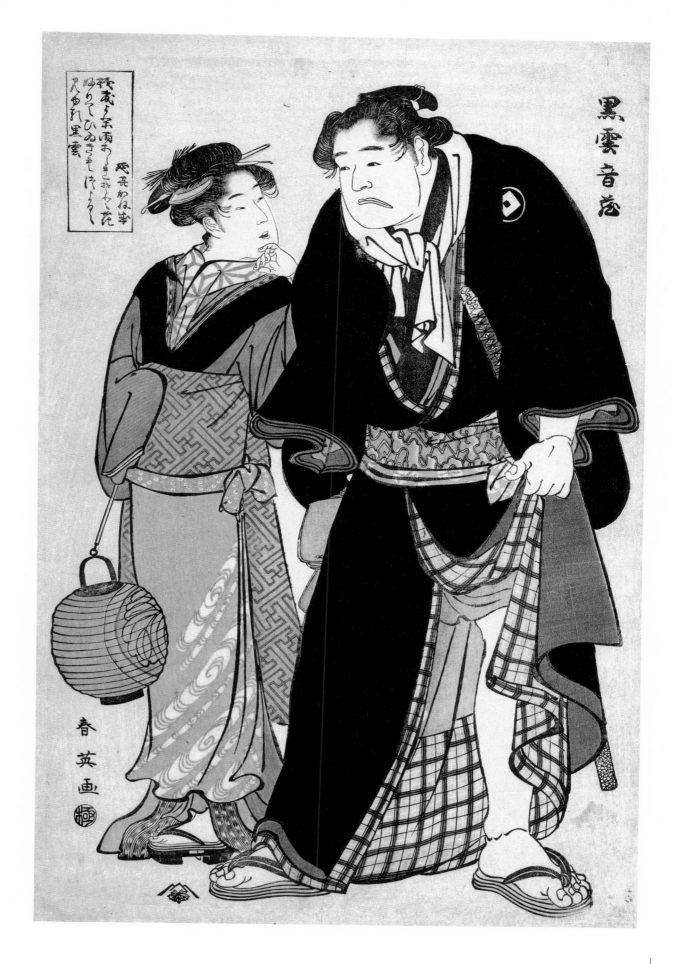

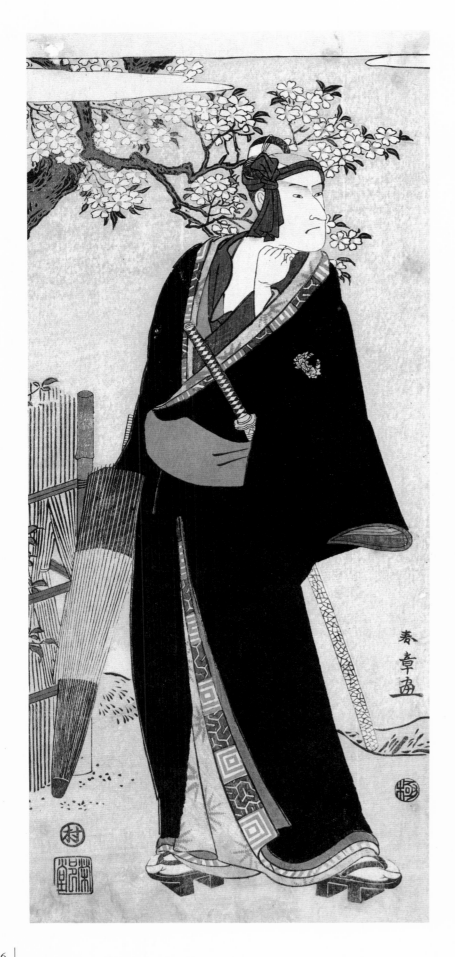

The actor Ichikawa Komazō III as Sukeroku
1793 or 1797 (?)

Hosoban, part of a multisheet composition;
35.6 x 15.6 cm
The Clarence Buckingham Collection 1937.27

The role of the heroic "champion of the oppressed" (*otokodate*) Sukeroku, with his stylish black kimono and dandified purple headband, has already been described in the commentaries to Shunshō's very first print (No. 23) and to Number 114 by Shunkō. Sukeroku is here played by Ichikawa Komazō III, who poses beneath a flowering cherry tree— probably in the main street (Naka no Chō) of the Yoshiwara pleasure district— holding a furled umbrella. This is probably the left-hand sheet of a triptych, whose other two sheets would show the courtesan Agemaki and Sukeroku's villainous rival, Ikyū.

Komazō III played the role of Sukeroku twice: Yorozuya Sukeroku (a reworking of the familiar tale in historical disguises by the playwright Sukurada Jisuke) at the Ichimura Theater in the third month of 1793, and Agemaki no Sukeroku (in a more standard version of the story) at the Kawarazaki Theater in the third month of 1797. Since the costume would have been the same in both productions, we can only know which performance this print relates to by discovering which actors were portrayed on the two missing sheets of the triptych.

The print bears the printed signature "*Shunshō ga*," but Shunshō had died on the eighth day of the twelfth month, 1792. Either the signature was added later to the impression, or— assuming the print was published in the third month of 1793— the publisher was deliberately capitalizing on the name of the recently deceased and highly esteemed artist. In any case, the elongated, elegant manner of drawing the figure and the particular style of drawing the face is typical of Shun'ei, to whom the print is attributed. An advance publicity handbill (*tsuji banzuke*) shows Komazō III as Sukeroku in the production of 1797 (fig. 130.1), holding aloft the open umbrella.

The colors of the print are unusually strong and unfaded.

UNSIGNED [printed "*Shunshō ga*" added]
PUBLISHER Murataya Jirobei (Eiyūdō)
CENSOR'S SEAL *Kiwame*
PROVENANCE Judson D. Metzgar collection

130.1. Publicity handbill for the play
Sukeroku Kuruwa no Sakurado.
Bigelow collection, Museum of
Fine Arts, Boston

131 KATSUKAWA SHUN'EI
(1762–1819)

Bust portrait of the actor Ichikawa Yaozō III as Tanabe Bunzō in the play *Hana-ayame Bunroku Soga* (Blooming Iris: Soga Vendetta of the Bunroku Era), performed at the Miyako Theater from the fifth day of the fifth month, 1794

Aiban, mica background; 31.9 x 22.0 cm
The Clarence Buckingham Collection 1942.106

In 1701 the brothers Ishii Hanzō and Ishii Genzō avenged their father's death by killing his murderer, Akabori Gengoemon. This episode so inescapably recalled the celebrated revenge of the Soga brothers in the twelfth century that it came to be known as the "Genroku Soga," after the Genroku era (1688–1704) in which it took place. In deference to censorship laws, however, the theatrical version of the story was entitled *Bunroku Soga*, after an era in the safely distant past (1592–1596), the villain was renamed Fujikawa Mizuemon, and Hanzō became Hanjirō.[1]

Tanabe Bunzō was a minor character in the drama. An illustration from the program (*ehon banzuke*) shows him rushing to the aid of Genzō and his wife Chizuka, who are under attack by the villain Mizuemon (fig. 131.2). In the ensuing fight Bunzō is wounded and crippled, but though he subsequently falls on hard times, he never abandons his support for the brothers' plan of revenge. A program illustration of a later scene shows him seated on the floor wearing a humble striped kimono, being kicked and beaten by the moneylender Kinkichi (played by Arashi Ryūzō I) (fig. 131.3). It is likely that Shun'ei's portrait shows Bunzō in the distressed circumstances of this scene: the smooth-shaven pate dictated by custom is covered by an unruly mop of hair, his shoulders are hunched as if against a blow, his eyebrows are drawn together in dismay and his mouth glumly down-turned. The kimono whose collar he pulls together with one hand is of cotton, and heavily patched. Unfortunately the pale blue pigment of Bunzō's beard and the pink of his lips have faded almost completely; the brown robe too must originally have been much brighter.

Shun'ei seems to have originated the use of a shiny mica background for actor bust portraits: his portrait (of *aiban* size) of Bandō Hikosaburō III in the role of Kudō Suketsune is thought to relate to the performance at the Kawarazaki Theater in the first month of 1794.[2] Shun'ei's mica-ground portraits have survived in very limited numbers, however, and much more widely known are the twenty-eight *ōban*-sized portraits designed by Tōshūsai Sharaku for performances in the fifth month of 1794, all of which were published by Tsutaya Jūzaburō. Presumably Tsutaya quickly appreciated the possibilities suggested by Shun'ei's designs at the New Year of 1794 and found himself an artist— Sharaku— whose daringly innovative portraits matched the bold new mica-ground format.

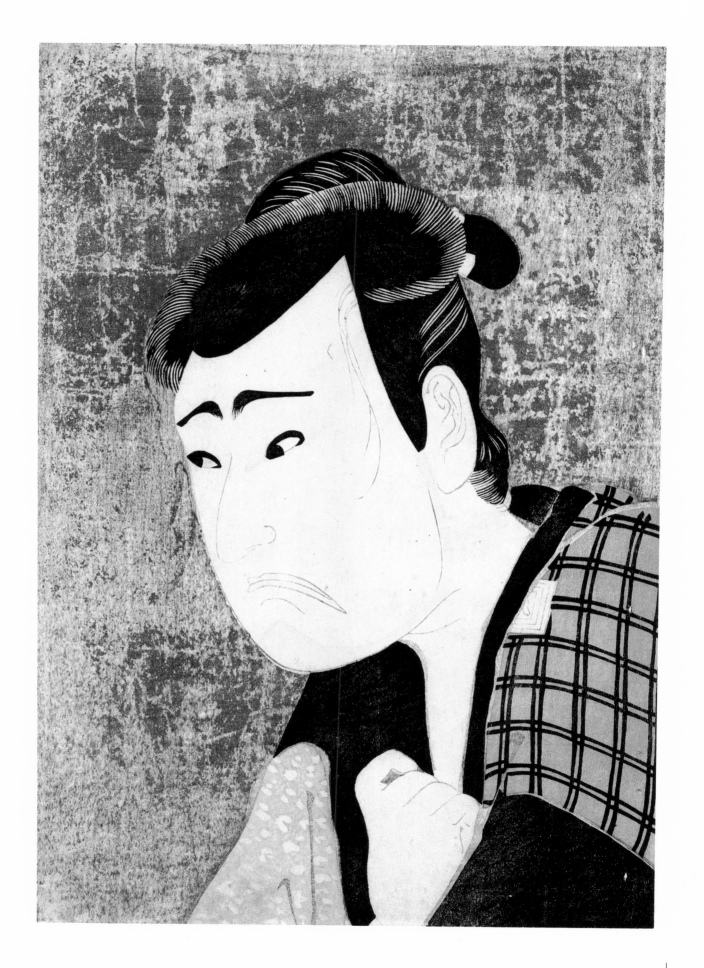

Sharaku also designed a portrait of Yaozō III as Bunzō, wearing a similar brown checkered kimono, which exhibits many of the strengths of that artist's powerful designs (fig. 131.1). First is the manner in which the eyes are opened wide to suggest shock or dismay; it was a characteristic of Sharaku's style to exaggerate each facial feature separately, to brilliant expressive effect. Secondly, notice how Sharaku's figure boldly fills the larger *ōban* sheet almost to the very top, instead of being confined rather timidly to one corner, as is generally the case in Shun'ei's mica-ground designs.

Shun'ei also designed an *aiban* mica-ground portrait of Sanogawa Ichimatsu III as the Gion prostitute Onayo in the same play (cat. no. 686), which similarly warrants comparison with the portrait of the same actor by Sharaku.

1 Harold G. Henderson and Louis V. Ledoux, *The Surviving Works of Sharaku* (New York: E. Weyhe, 1939), pp. 50–51.
2 *Ukiyo-e Shūka*, vol. 9 (1981), no. 67.

SIGNATURE *Shun'ei ga*
PUBLISHER [unread]
PROVENANCE Charles Vignier collection; Charles H. Chandler collection
REFERENCE
Riccar (1973), no. 116; *Ukiyo-e Taikei*, vol. 3 (1976), no. 204 (black-and-white); *Ukiyo-e Shūka*, vol. 5 (1980), no. 34

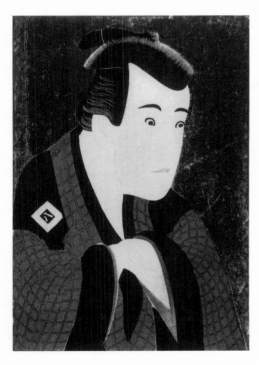

131.1. Tōshūsai Sharaku.
The actor Ichikawa Yaozō III as Tanabe Bunzō.
British Museum, London

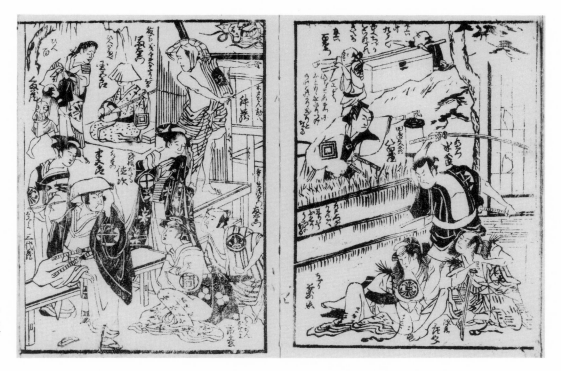

131.2. Scene from *Hana-ayame Bunroku Soga*.
From the illustrated program.
Tokyo University Library

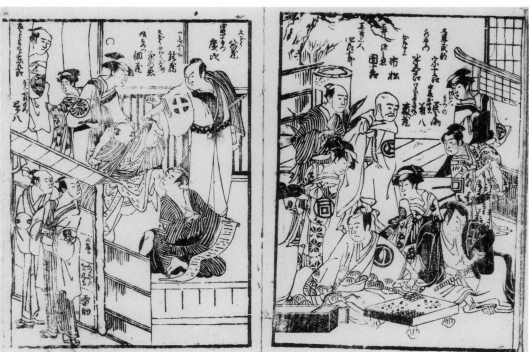

131.3. Scene from *Hana-ayame Bunroku Soga*.
From the illustrated program.
Tokyo University Library

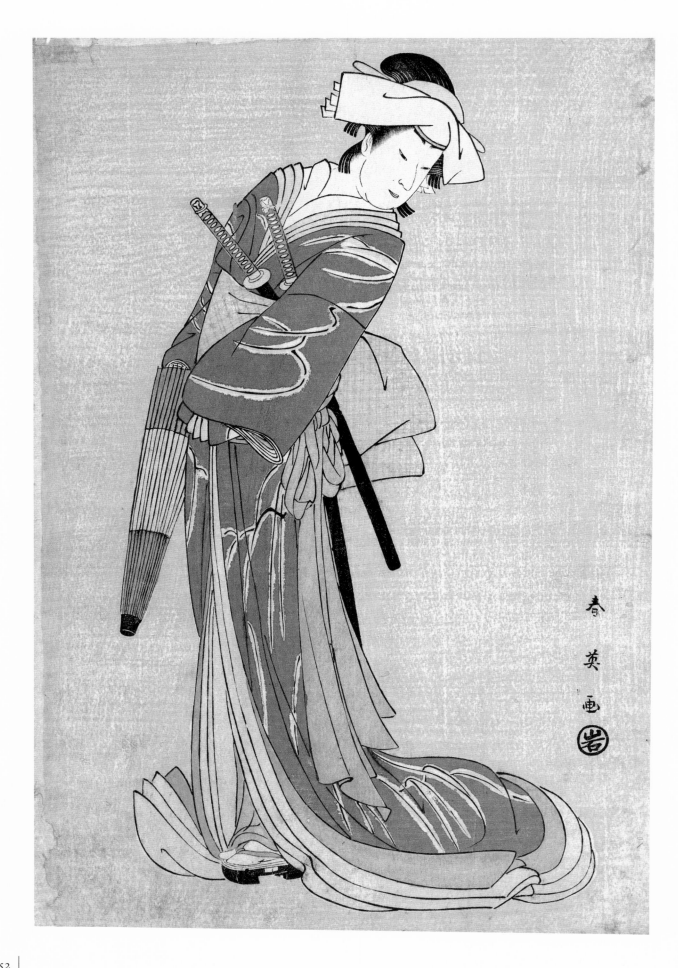

132 KATSUKAWA SHUN'EI

(1762–1819)

The actor Nakamura Noshio II as Tonase, in the bridal journey scene, act eight of the play *Kanadehon Chūshingura* (Model for *Kana* Calligraphy: Treasury of the Forty-seven Loyal Retainers), performed at the Miyako Theater from the fifth day of the fourth month, 1795

Ōban; 37.2 x 25.1 cm
The Clarence Buckingham Collection 1925.2373

After the forced suicide of their lord, Enya Hangan, which sets in motion the vendetta that is the central theme of *Chūshingura* (Treasury of the Forty-seven Loyal Retainers), Ōboshi Yuranosuke, leader of the now masterless samurai (*rōnin*), and his son Rikiya retire to Yamashina to lay their plans. Rikiya is betrothed to Konami, the daughter of Kakogawa Honzō, but Honzō is regarded as a traitor by the retainers of Enya Hangan because he held Hangan back from finishing off their enemy, Kō no Moronao. Nevertheless, Tonase, Konami's mother, determines to take her daughter to Yamashina so that the marriage to Rikiya can take place as planned. The journey is mimed to the accompaniment of onstage singers and musicians, and every place-name along the way reminds Konami of some aspect of her lover.[1]

Here we see the Kamigata (Kyoto–Osaka region) actor Nakamura Noshio II as Tonase, dressed for the bridal journey. As a woman of the samurai class, she wears a special headdress (*tsuno-kakushi*) to protect her hair from the dust of travel, and she carries a "snake's eye" umbrella (*janome-gasa*). She also wears a pair of swords thrust through her sash, since she is acting in place of her samurai husband in this important family business. Shun'ei brings all his skills as a painter of beautiful women to this lovely design, arching the figure into a broad curve that fills the page. The face, which looks modestly down, has the thick, sensual eyelashes and slightly aquiline nose seen in his paintings, and the lines of the kimono, decorated with a pattern of snow-covered willow branches, drop in long, flowing strokes. The crimson sash and kimono lining (somewhat faded in the impression) provide a shock of color against the otherwise quietly elegant green robes and matte gray background. Off-center placing of the figure has the effect of making this gray space seem to resonate in some mysterious and compelling manner.

In the summer of 1795 all three Edo theaters staged *Chūshingura* within a month of one another, an event which must have truly tested the partiality of theater fans. Print fans, too, were presented with rival portraits of the actors by Shun'ei and Utagawa Toyokuni (1769–1825), working for the publishers Iwatoya Kisaburō and Izumiya Ichibei, respectively. Credit must go to the younger Toyokuni for having devised the full-length actor portrait against a gray background on the larger *ōban* sheet, in his *Yakusha Butai no Sugata-e* (Pictures of Actors Onstage) series, begun in the New Year of 1794, of which some fifty-two designs are presently known.[2]

Shun'ei is known to have designed at least nineteen prints of this type for the *Chūshingura* plays at the Miyako and Kiri theaters in the fourth month of 1795.[3] But though similar to Toyokuni's prints in overall conception, the facial expressions in Shun'ei's designs, in particular, convey a wider range of direct emotions, transcending the customary more schematic rendering of actors' features. He was perhaps prompted to experiment in this direction by Sharaku's revolutionary bust portraits of the preceding summer.

The *Chūshingura* series is rightly considered Shun'ei's masterpiece in the genre of actor prints.

1 A full synopsis of *Kanadehon Chūshingura* (Model for *Kana* Calligraphy: Treasury of the Forty-seven Loyal Retainers) is given in Halford (1956), pp. 138–65.

2 See *Ukiyo-e Shūka*, vol. 15 (1980), pp. 204–14.

3 Of the additional eighteen *Chūshingura* prints presently known, eleven relate to the performance at the Miyako Theater, and seven to the Kiri Theater. Those relating to the performance at the Miyako Theater are: Nakamura Noshio II as Okaru (Tokyo National Museum; Honolulu Academy of Arts); Segawa Kikunojō III as Oishi (the late Aoki Tetsuo collection); Bandō Mitsugorō II as Hayano Kampei (Achenbach Foundation for Graphic Arts, San Francisco); Arashi Ryūzō I as Teraoka Heiemon (Minneapolis Institute of Arts); Kataoka Nizaemon VII as Kō no Moronao (Tokyo National Museum; Museum für Ostasiatische Kunst, Berlin; ex-coll. Henri Vever); Kataoka Nizaemon VII as Ono Sadakurō (Musée Guimet, Paris; Musées Royaux d'Art et d'Histoire, Brussels); Nakamura Nakazō II as Momonoi Wakasanosuke (Ōta Memorial Museum, Tokyo); Bandō Hikosaburō III as Ōboshi Yuranosuke (Irma E. Grabhorn–Leisinger collection, San Francisco; Otto Riese collection, Switzerland; ex-coll. Werner Schindler; Watanabe Tadasu collection, Tokyo; British Museum, London); Sawamura Sōjūrō III as Kakogawa Honzō (Otto Riese collection; ex-coll. Werner Schindler); Sawamura Sōjūrō III as Enya Hangan (British Museum, London); Nakamura Nakazō II as Ono Sadakurō (Keiō University Library, Tokyo, ex-coll. Takahashi Seiichirō). The seven designs relating to the performance at the Kiri Theater are: Ichikawa Ebizō (Danjūrō V) as Kakogawa Honzō (Honolulu Academy of Arts; The Art Institute of Chicago); Nakayama Tomisaburō I as Okaru (ex-coll. Walter Amstutz; Honolulu Academy of Arts; ex-coll. Henri Vever; British Museum, London); Ichikawa Yaozō III as Hayano Kampei (Keiō University Library, Tokyo, ex-coll. Takahashi Seiichirō); Ichikawa Yaozō III as Ōboshi Yuranosuke (present location unknown); Ichikawa Danjūrō VI as Ono Sadakurō (Minneapolis Institute of Arts; Staatsbibliothek für Ostasiatische Kunst, Berlin); Ichikawa Omezō I as Momonoi Wakasanosuke (present location unknown); Morita Kanya VIII as Teraoka Heiemon (Watanabe Tadasu collection, Tokyo; Österreichisches Museum für Angewandte Kunst, Vienna).

SIGNATURE *Shun'ei ga*
PUBLISHER Iwatoya Kisaburō
REFERENCE
Ukiyo-e Taikei, vol. 3 (1976), no. 198 (black-and-white)
OTHER IMPRESSIONS Tokyo National Museum; Otto Riese collection, Switzerland; ex-collection Werner Schindler; Ōta Memorial Museum, Tokyo; Vignier and Inada (1910), no. 554

The dance interlude (*shosagoto*) "Shinodazuma" (The Wife
from Shinoda Forest)
Series title: *Oshie-gata* (Designs for Patchwork Pictures)
Ca. 1795

Ōban; 37.5 x 24.0 cm
The Clarence Buckingham Collection 1925.2372

SIGNATURE *Shun'ei ga*
PUBLISHER Nishimuraya Yohachi (Eijudō)
CENSOR'S SEAL *Kiwame*
REFERENCE
Ukiyo-e Taikei, vol. 3 (1976), no. 219 (black-and-white)
PROVENANCE
Hayashi Tadamasa (seal); Colonel H. Appleton collection
OTHER IMPRESSIONS
Musée des Arts Décoratifs, Louvre, Paris; British Museum, London;
ex-collection Saitō (present location unknown)

The story of the fox-woman Kuzunoha from Shinoda Forest
and the huntsman Abe no Yasuna, as featured in the Kabuki play
Ashiya Dōman Ōuchi Kagami (Mirror of Ashiya Dōman and
Ōuchi), has already been described (No. 81). In gratitude for the
saving of its life, a fox takes on the form of the beautiful woman
Kuzunoha and bears a child to the hunter Abe no Yasuna. When
the real human Kuzunoha comes back, however, the fox must
tearfully take leave of husband and child and return to the forest.

Here Kuzunoha is shown dressed for the journey, with a walking
cane and black lacquer travelling hat in her hand. This is the typical
costume for a "travel scene" (*michiyuki*) in Kabuki, which required
of the actor a display of mimetic dancing (*shosagoto*). The over-
kimono is decorated with a design of autumn grasses, bush clover,
and the clappers used to scare birds away from crops; one sleeve
has been slipped off to reveal the pink kimono of sacred-jewel
pattern beneath. The black obi, tied behind, has a figured design
overprinted in mica, and is complemented by an additional bright
scarlet sash hanging down in front.

The fourteen designs presently known from the *Oshie-gata* series
all show beautiful women in dance scenes taken from Kabuki, set
against a plain, light yellow background.[1] Their light, colorful
style, and the wonderful sense of movement of certain figures
caught in mid-dance, place the series among Shun'ei's greatest
works. The "*Oshi-e*" of the title refers to a popular kind of collage
picture made by sticking scraps of colored cloth onto thick paper
and then assembling them into pictures of figures, animals, etc.
Presumably the idea was that Shun'ei's designs could serve as
models for pictures of this kind.

Though the female figures are not thought to be depictions of
particular Kabuki actors, this design of Kuzunoha was reissued
after the original edition, when the actor Nakamura Noshio I
actually performed the "Shinodazuma" dance at the Morita
Theater in the ninth month of 1795 (fig. 133.1). Printed in the top
left-hand corner were the actor's name and role and underneath
this an inscription reading, "A great performance, unrivalled past
or present" (*Kokin ō-deki ō-deki*). In place of the series title in the
red cartouche in the top right-hand corner, a recut block gives the
name of the Morita Theater. In the past the series has been dated
circa 1792–1794,[2] but the known date of Noshio I's performance
and the similarity of coloring between the two editions of the
print suggest a date close to 1795.

1 The fourteen designs are: *Hachi Tataki, Hanachi-dori, Harugoma, Kagami-
 jishi, Kikujidō, Makura-jishi, Musume Dōjō-ji, Nuno Sarashi, Sambasō,
 Shakkyō, Shinodazuma, Shiokumi, Shirabyōshi,* and *Yoshiwara Suzume.*
2 *Genshoku Ukiyo-e Daihyakka Jiten,* vol. 8 (1981), p. 16.

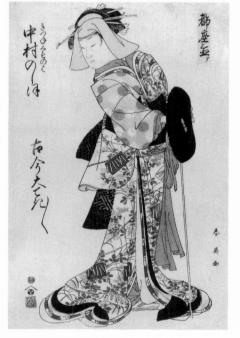

133.1. Katsukawa Shun'ei.
The actor Nakamura Noshio I as the fox-wife Kuzunoha.
British Museum, London

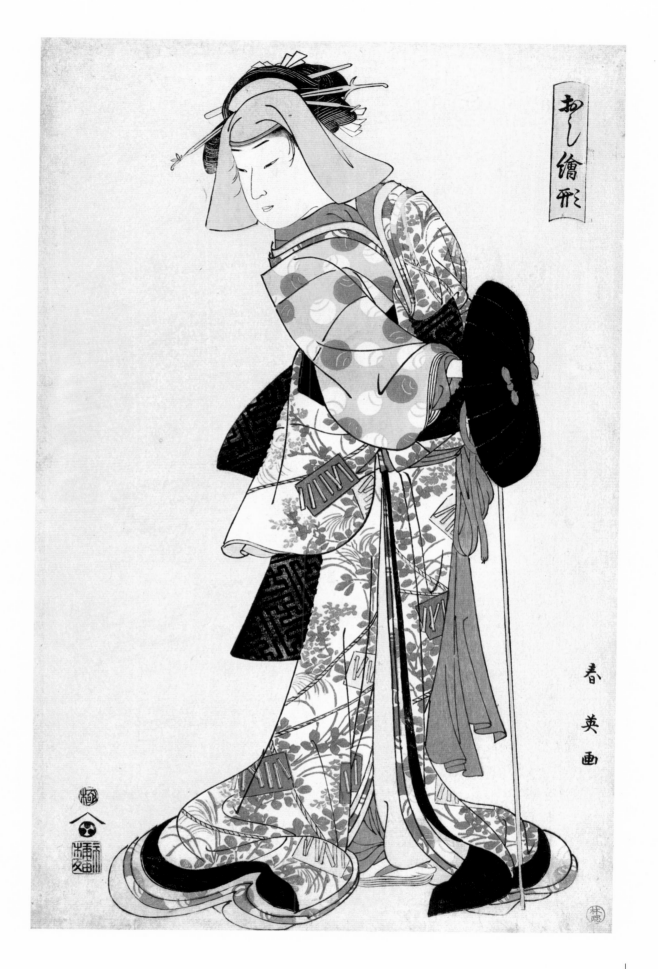

春英画

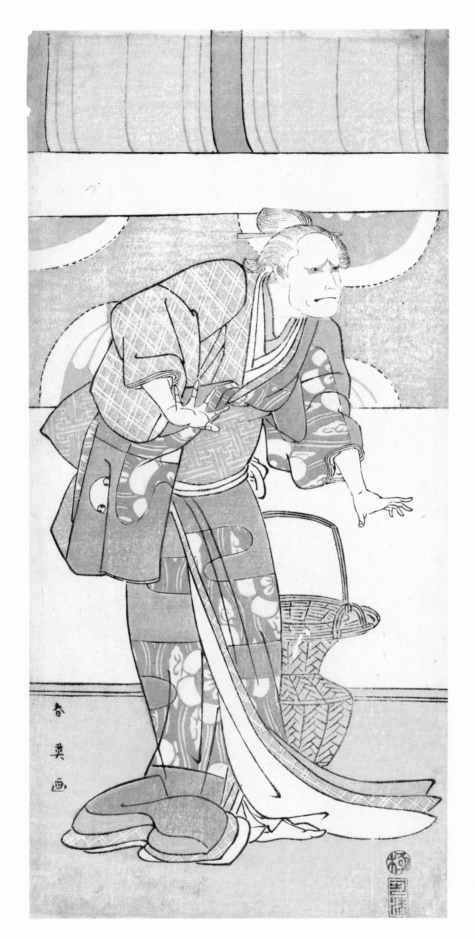

134 KATSUKAWA SHUN'EI
(1762–1819)

The actor Arashi Ryūzō II as Hachijō, Wet Nurse of Taira no Kiyomori, in act three of the play *Gempei Hashira-goyomi* (Pillar Calendar of the Genji and Heike Clans), performed at the Kiri Theater from the first day of the eleventh month, 1795

Hosoban, part of a multisheet composition; 32.2 x 14.9 cm
The Clarence Buckingham Collection 1925.2396

Arashi Ryūzō II normally played evil male characters (*jitsu aku*), but here he appears in one of his rare female roles, as Hachijō, wet nurse of the dictator Taira no Kiyomori (1118–1181), in the historical play *Gempei Hashira-goyomi*, performed at the Kiri Theater in the eleventh month of 1795. Hachijō's grim expression suggests that this was also an evil role. Her brow is furrowed, there are dark circles under her deep-set eyes, and she stands with her hands splayed tensely in front of her, one arm withdrawn from her bright orange kimono to reveal a somber gray robe beneath. Behind her stands a large wicker basket, and the background consists of hanging reed blinds and sliding doors decorated with the "ring and chrysanthemum" (*kan-giku*) crest of the actor Sawamura Sōjūrō III.

Ryūzō II's pose, facing out of the composition to the right, strongly suggests that this is a multisheet print, and in the British Museum collection is an accompanying right-hand sheet showing Sawamura Sōjūrō III as Kiyomori (fig. 134.1). He is dressed in voluminous ceremonial court robes, and wears an elaborate filigree metal crown. The illustrated program (*ehon banzuke*) shows a medley of scenes from the third act (fig. 134.2): in the top left-hand corner are the two actors attired as in the prints, and in the center is Ryūzō II again as Hachijō, carrying the same wicker basket we see in Shun'ei's print. *Kabuki Nempyō* relates that Hachijō commits suicide and her evil ambitions transfer themselves to Kiyomori.[1] This is the scene shown in the top left-hand corner of the program (fig. 134.2), where Hachijō kneels in her final death agonies, holding a blood-stained dagger, while Kiyomori towers over her malevolently. Presumably Shun'ei's diptych shows the scene just before, when she determines (or Kiyomori persuades her) that she must die for his cause. This was apparently the most popular opening-of-the-season (*kaomise*) performance for some years.[2]

1 *Kabuki Nempyō*, vol. 5 (1960), p. 200.
2 Ibid.

SIGNATURE *Shun'ei ga*
PUBLISHER Unidentified
CENSOR'S SEAL *Kiwame*
OTHER IMPRESSIONS
British Museum, London (with accompanying right-hand sheet)

134.1. Katsukawa Shun'ei.
*The actors Sawamura Sōjūrō III as Taira no Kiyomori
and Arashi Ryūzō II as Hachijō.*
British Museum, London

134.2. *The actors Sawamura Sōjūrō III as Taira no Kiyomori
and Arashi Ryūzō II as Hachijō.*
From the illustrated program.
Nippon University Library, Tokyo

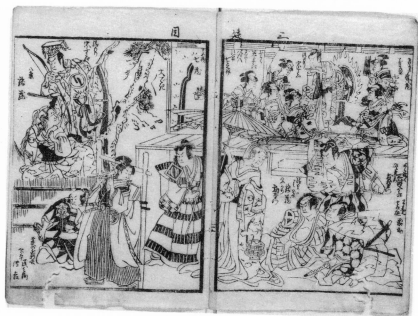

(active ca. 1770–1790)

The actors Ōtani Hiroji III as Satsuma Gengobei (right), and Nakamura Sukegorō II as Sasano Sangobei (left), in part two of the play *Iro Moyō Aoyagi Soga* (Green Willow Soga of Erotic Design), performed at the Nakamura Theater in the second month, 1775

Hosoban diptych; each approx. 32.3 x 15.0 cm
Frederick W. Gookin Collection
 (left) 1939.851; (right) 1939.852

Satsuma Gengobei (played by Ōtani Hiroji III, right) and Sasano Sangobei (played by Nakamura Sukegorō II, left) are muscular street-toughs, so-called chivalrous commoners or champions of the oppressed (*otokodate*). Their encounter takes place in front of the Sasaya riverside inn (*funayado*). This confrontation scene is mentioned in *Kabuki Nempyo*,[1] and an advance publicity handbill (*tsuji banzuke*) shows the two on a river bank engaged in a tug-of-war over a sword, Hiroji III seated by a pier and Sukegorō II standing behind (fig. 135.1). The illustration shows the Sasaya Inn beside a bridge over the river, and includes for good measure a large carp that has just come alive and leaped out of a painting into the water! The precise plot of the 1775 play is not clear, but in later versions of the story Gengobei and Sangobei were both retainers of the young lord Chidori Sentarō, who comes to Edo searching for a missing sword, a precious family heirloom. The sword is discovered in the Fukagawa pleasure district (which faced onto the Sumida River and was crisscrossed by canals).[2] Perhaps this is the setting shown on the handbill and in the prints.

Shundō seems to have been one of Shunshō's first pupils, as indicated by the early date of this print, and he designed illustrations for *kibyōshi* novels ("yellow-covered" illustrated popular fiction) and a small number of actor prints and paintings. One account even suggests that he was a fellow student with Shunshō in the studio of Miyagawa Shunsui (No. 22).[3] This handsome diptych certainly matches the level of accomplishment of Shunshō's finest designs — the squareness and open-legged stance of Sukegorō II well juxtaposed with Hiroji III's top-heavy figure. The broad, sweeping rhythms of Sukegorō II's costume and the robust coloring, moreover, suggest a strong individual style.

Shunshō's large fan-shaped bust portrait of Hiroji III, from the series *Azuma Ōgi* (Fans of the East) (No. 72), may also represent him as Satsuma Gengobei.

1 *Kabuki Nempyō*, vol. 4 (1959), pp. 256–57.
2 *Kabuki Saiken* (1926), pp. 899–900.
3 *Sōkō Nihon Ukiyo-e Ruikō* (1979), p. 127.

SIGNATURE *Rantokusai Shundō ga*
ARTIST'S SEAL *Hayashi* in jar-shaped outline
REFERENCE
Riccar (1973), nos. 121, 122; *Ukiyo-e Taikei*, vol. 3 (1976), nos. 224, 225 (black-and-white)
OTHER IMPRESSIONS
(left) Musées des Arts Décoratifs, Louvre, Paris; (diptych) Arthur M. Sackler Museum, Harvard University, Cambridge, Mass.

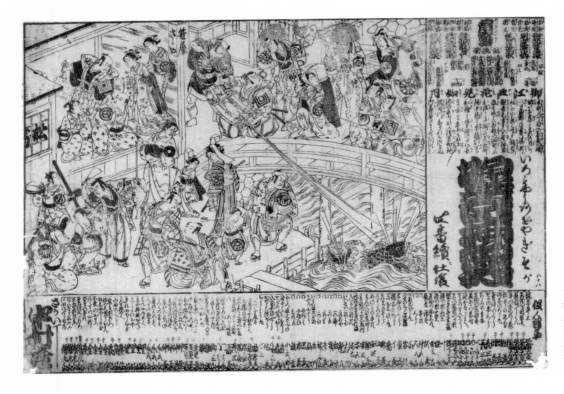

135.1. Publicity handbill for the play *Iro Moyō Aoyagi Soga.* Bigelow collection, Museum of Fine Arts, Boston

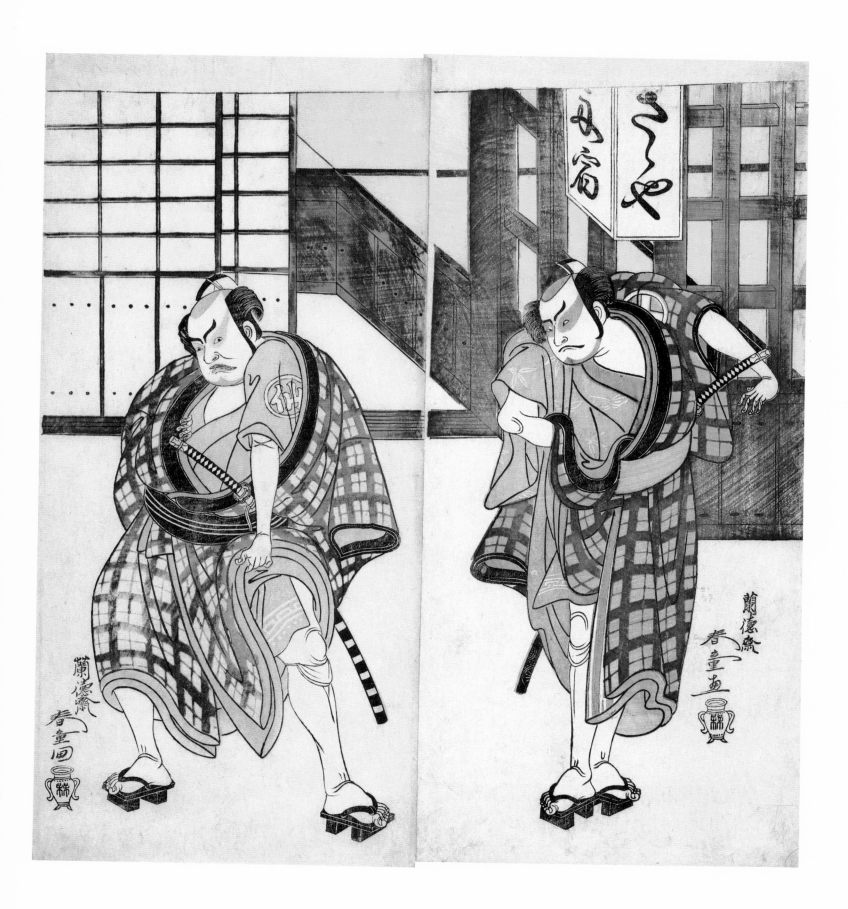

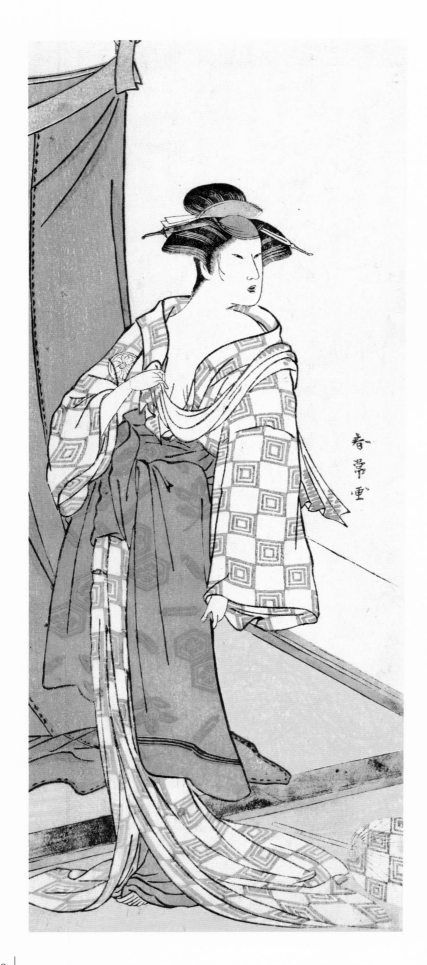

The actor Segawa Kikunojō III as a courtesan
in summer attire
Early 1780s

Hosoban; 31.0 x 12.8 cm
The Clarence Buckingham Collection 1928.1027

Segawa Kikunojō III here plays the part of a cour-
tesan just returned from the bath on a hot sum-
mer night, wearing a simple cotton kimono loosened
at the neck and with a towel draped over her shoul-
der. Her large red obi has been casually knotted in
front. To her right is a mosquito net hung over
bedding, suggesting that this may be the right sheet
of a diptych whose left sheet shows the client await-
ing her return. Both the kimono and round summer
fan (*uchiwa*, lying discarded on the floor) are deco-
rated with a checkerboard pattern of the "triple-rice-
measure" (*mimasu*) motif in indigo blue, a motif
normally associated with the Ichikawa family of
actors primarily of male roles. The precise role
depicted here has not been identified.

Shunjō, like Shundō (No. 135), was a Katsukawa
school pupil who worked faithfully in the actor-print
style devised by Shunshō. He also designed many
illustrations for comic *kibyōshi* novels ("yellow-
covered" popular fiction) in the period 1777–1785.
The present print is suave in composition and the
colors well preserved, but the angular, flat drawing
of the face is perhaps less attractive than Shunshō's
many depictions of the actor.

SIGNATURE *Shunjō ga*
PROVENANCE Alexander G. Mosle collection
REFERENCE Riccar (1973), no. 120; *Ukiyo-e Shūka*,
vol. 5 (1980), no. 129
OTHER IMPRESSIONS British Museum, London;
Vignier and Inada (1910), no. 588; Musée Guimet, Paris

Print Collections,
Publications,
and Abbreviations
Used in Catalogue Captions

See Bibliography for full citations of books

AB	Altkunst, Berlin
ADF	Ex-coll. Arthur Davison Ficke
AFGA	Achenbach Foundation for Graphic Arts, San Francisco
AIC	The Art Institute of Chicago
AM	Ashmolean Museum, Oxford
AMAM	Allen Memorial Art Museum, Oberlin College
BM	British Museum, London
BMFA	Museum of Fine Arts, Boston
BN	Bibliothèque Nationale, Paris
CM	Chiossone Museum, Genoa
CMA	Cleveland Museum of Art
CST	Ex-coll. Count Sakai Tadamasa
EMA	Elvehjem Museum of Art, Madison
EV	Ex-coll. Ernest LeVeel
FGA	Freer Gallery of Art, Smithsonian Institution, Washington D.C.
FM	Fitzwilliam Museum, Cambridge
FS	Ex-coll. Friedrich Succo
FW	Franz Winzinger collection
GFGA	Grunwald Foundation for the Graphic Arts, University of California, Los Angeles
GP	Gerhard Pulverer collection, Cologne
GUDHJ	*Genshoku Ukiyo-e Daihyakka Jiten*
HAA	Honolulu Academy of Arts
HB	Huguette Berès collection, Paris
HC	Hirahata Terumasu collection, Chōshi
HGM	H. George Mann collection, Chicago
HRWK	H.R.W. Kühne collection, Switzerland
HV	Ex-coll. Henri Vever
IEL	Irma E. Grabhorn-Leisinger collection, San Francisco
JUM	Japan Ukiyo-e Museum, Matsumoto
KK	Ex-coll. Kawaura Ken'ichi
KM	Kunstgewerbe Museum, Berlin
KUL	Keiō University Library, Tokyo
KWM	Kashiwabara Magozaemon collection, Kyoto
KZ	*Kabuki Zusetsu* (1934)
LL2	Ledoux (1945)
LL3	Ledoux (1948)
MAD	Musée des Arts Decoratifs, Paris
MAK	Museum für Angewandte Kunst, Vienna
MG	Musée Guimet, Paris
MIA	Minneapolis Institute of Arts
MMA	Metropolitan Museum of Art, New York
MOKB	Museum für Ostasiatische Kunst, Berlin
MR	Museum Rietberg, Zurich
MRAH	Musées Royaux d'Art et d'Histoire, Brussels
NAM	Nelson-Atkins Museum of Art, Kansas City
NHBZ2	*Nihon Hanga Bijutsu Zenshū*, vol. 2 (1961)
NYPL	New York Public Library
OMM	Ōta Memorial Museum, Tokyo
OR	Otto Riese collection, Switzerland
PAM	Portland Art Museum
PMA	Philadelphia Museum of Art
RAM	Riccar Art Museum, Tokyo
RMA	Rijksmuseum, Amsterdam
SA	Ex-coll. Saitō
SB	Staatsbibliothek, Berlin
SH	Ex-coll. Shugyō
SM	Arthur M. Sackler Museum, Harvard University, Cambridge
SNS	*Shibai Nishiki-e Shūsei* (1919)
SOAS	School of Oriental and African Studies, London
TMTM	Tsubouchi Memorial Theater Museum, Waseda University, Tokyo
TNM	Tokyo National Museum
TS	Ex-coll. Theodor Scheiwe
TSM	Tobacco and Salt Museum, Tokyo
UT5	*Ukiyo-e Taisei*, vol. 5 (1931)
UT6	*Ukiyo-e Taisei*, vol. 6 (1931)
UT8	*Ukiyo-e Taisei*, vol. 8 (1931)
UTS8	*Ukiyo-e Taika Shūsei*, vol. 8 (1932)
UTS13	*Ukiyo-e Taika Shūsei*, vol. 13 (1932)
VA	Victoria and Albert Museum, London
VI	Vignier and Inada (1911)
WA	Wadsworth Atheneum, Hartford
WAM	Worcester Art Museum
WB	Willy Boller collection
WS	Ex-coll. Werner Schindler
WT	Watanabe Tadasu collection, Tokyo
YUAG	Yale University Art Gallery, New Haven

Key to Catalogue Captions

(?) Possibly or probably
1) Actors and roles (or description of scene)
2) Title of play and/or series
3) Name of theater
4) Month/year of performance (or approximate date of print)
5) Artist's signature; artist's seal
6) Publisher; engraver
7) Censor's mark; date seal
8) Format and size
9) Location of other impressions (refer to list of abbreviations)
10) Credit line and registration number
*) Other remarks

Catalogue

OSAMU UEDA

A summary listing of 740 *ukiyo-e* prints by Bunchō and the Katsukawa school artists in The Art Institute of Chicago. These are referred to in the text as "catalogue number— ." The 136 prints discussed at length in the section entitled "The Prints" are referred to as "Number— ."

Scenes and interludes were often added to a production in the course of the run. That is why certain prints, while obviously illustrating the same production, differ from each other by a month or two in "date of production." The later date indicates a scene or interlude added after the play had opened. Likewise, an actor was occasionally replaced in the course of a run. Therefore prints depicting two different actors in the same role in the same production will have dates that differ by a month or two.

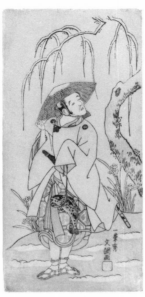

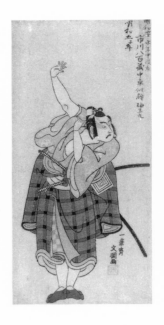

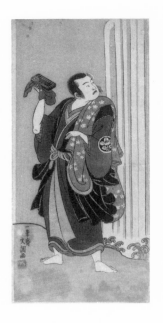

IPPITSUSAI BUNCHŌ

(active ca. 1755–1790)

1
1) Arashi Otohachi I as Numatarō, retainer of Utou Yasukata 2) *Kogane no Hana Gaijin Aramusha* 3) Nakamura 4) 11/1766 5) *Ippitsusai Bunchō ga; Mori uji* 8) hosoban; 32 x 15.4 cm 9) MMA; RAM; TMTM 10) Buckingham 1928.992
*) See No. 1

2
1) Ichikawa Yaozō II as Umeō-maru 2) *Ayatsuri Kabuki Ōgi* 3) Nakamura 4) 7/1768 5) *Ippitsusai Bunchō ga; Mori uji* 8) hosoban, left sheet of triptych; 41.3 x 29.5 cm 9) PAM; ex-coll. Mitsuno Kōshirō 10) Gift of Mr. and Mrs. Gaylord Donnelley 1970.494

3
1) Ichimura Uzaemon IX as Seigen 2) *Ise-goyomi Daidō Ninen* 3) Ichimura 4) Fall 1768 5) *Ippitsusai Bunchō ga; Mori uji* 8) hosoban; 32.1 x 14.9 cm 9) TMTM 10) Buckingham 1939.2111

4
1) Arashi Hinaji I as Lady Yuya (Yuya Gozen) (?) 2) *Ima o Sakari Suehiro Genji* (?) 3) Nakamura (?) 4) 11/1768 (?) 5) *Ippitsusai Bunchō ga; Mori uji* 8) hosoban; 31.2 x 15 cm 9) AFGA 10) Buckingham 1928.998 *) See No. 2

5
1) Segawa Kikunojō II as Princess Ayaori (Ayaori Hime) (?) 2) *Ima o Sakari Suehiro Genji* (?) 3) Nakamura 4) 11/1768 (?) 5) *Ippitsusai Bunchō ga; Mori uji* 8) hosoban; 31.5 x 14.3 cm 10) Gift of Mr. and Mrs. Gaylord Donnelley 1970.495 *) See No. 3

6
1) Sakata Sajūrō I as a *yakko* 4) ca. 1768–1770 5) *Ippitsusai Bunchō ga; Mori uji* 8) hosoban, left sheet of diptych; 31.2 x 13.9 cm 9) TNM 10) Buckingham 1928.999
*) See No. 4

7
1) Sawamura Sōjūrō II and Ichimura Kichigorō in unidentified roles 4) ca. 1768–1770 5) *Ippitsusai Bunchō ga; Mori uji* 8) hosoban; 30.9 x 14.7 cm 9) TMTM 10) Buckingham 1925.2529
*) See No. 5

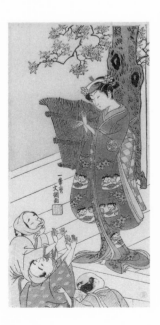

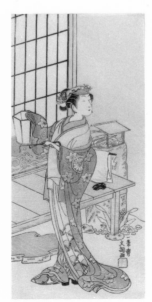

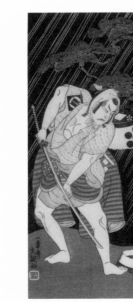

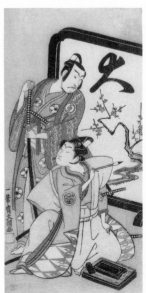

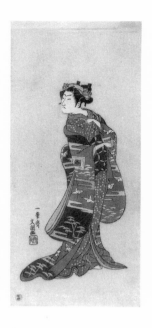

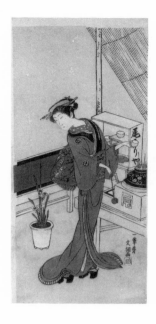

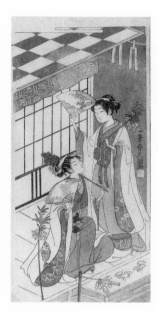

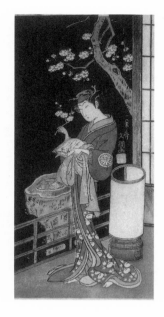

8
1) Ichikawa Benzō 4) ca. 1768
5) *Ippitsusai Bunchō ga; Mori uji*
8) *hosoban*; 31.5 x 14.5 cm 9)
TMTM 10) Buckingham 1928.994

9
1) Waitress at the Owariya Tea-
house 4) ca. 1768 5) *Ippitsusai
Bunchō ga; Mori uji* 8) *hosoban*; 32.7
x 15.5 cm 10) Gift of Mr. and Mrs.
Gaylord Donnelley 1970.496

10
1) Shrine dancers (*miko*) Ohatsu
and Onami 4) 1769 5) *Ippitsusai
Bunchō ga; Mori uji* 8) *hosoban*;
32.7 x 15.5 cm 10) Buckingham
1925.2526 *) See No. 6

11
1) Segawa Kikunojō II as Ōiso no
Tora 2) *Soga Moyō Aigo no Waka-
matsu* 3) Nakamura 4) 1/1769
5) *Ippitsusai Bunchō ga; Mori uji*
8) *hosoban*; 30.3 x 14.6 cm 9) HV
10) Buckingham 1925.2525

12
1) Segawa Kikunojō II as Princess
Hitomaru (Hitomaru Hime) (?)
2) *Soga Moyō Aigo no Wakamatsu*
(?) 3) Nakamura (?) 4) 1/1769 (?)
5) *Ippitsusai Bunchō ga; Mori uji*
6) Nishimuraya Yohachi 8) *hosoban*;
31.3 x 13.8 cm 9) UT5, pl. 236
10) Buckingham 1925.2536

13
1) Segawa Kikunojō II in *Shakkyō*
dance 2) *Soga Moyō Aigo no Waka-
matsu* 3) Nakamura 4) 2/1769
5) *Ippitsusai Bunchō ga; Mori uji*
8) *hosoban*; 31.4 x 14.3 cm 9) BM
10) Buckingham 1925.2530

14
1) Ichimura Uzaemon IX as Shume
no Hangan Morihisa (R), and
Sanogawa Ichimatsu II as Chūjō
(L) 2) *Edo no Hana Wakayagi Soga*
3) Ichimura 4) 2/1769 5) *Ippitsusai
Bunchō ga; Mori uji* 8) *hosoban*,

center and left sheets of triptych;
31.4 x 15 cm (R), 31.2 x 14.2 cm
(L) 9) AFGA; BMFA; MMA (R); BM
(L) 10) Buckingham 1928.995

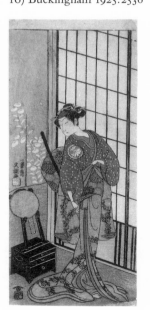

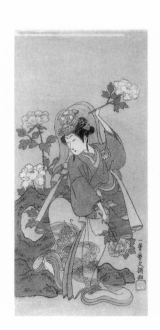

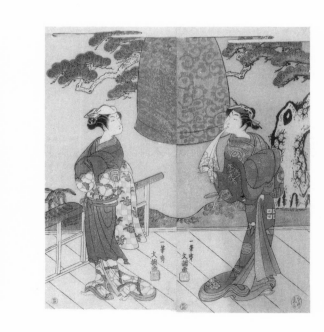

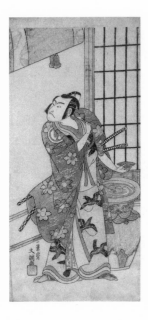

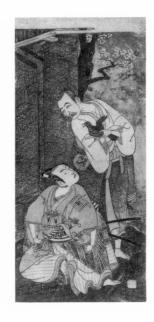

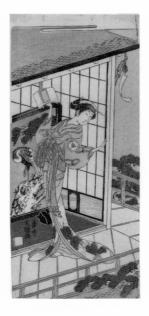

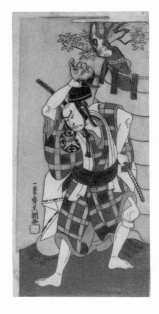

15

1) Sawamura Sōjūrō II as Kudō Suketsune (?) 2) *Edo no Hana Wakayagi Soga* (?) 3) Ichimura (?) 4) 2/1769 (?) 5) *Ippitsusai Bunchō ga; Mori uji* 8) *hosoban*; 32 x 14.5 cm 9) TMTM 10) Gookin 1939.947

16

1) Nakamura Utaemon I as Seigen (R), and Ichikawa Komazō II as Shimizu Tonoinosuke Kiyoharu (L) 2) *Soga Moyō Aigo no Wakamatsu* 3) Nakamura 4) 3/1769 5) *Ippitsusai Bunchō ga; Mori uji* 8) *hosoban*; 32.3 x 14.5 cm 9) NAM 10) Buckingham 1925.2403

17

1) Iwai Hanshirō IV as Okaru 2) *Chūshingura* 3) Morita 4) 4/1769 5) *Ippitsusai Bunchō ga; Mori uji* 8) *hosoban*; 32 x 14.3 cm 10) Buckingham 1930.930 *) See No. 7

18

1) Nakamura Nakazō I as Yamaoka no Saburō 2) *Kawaranu Hanasakae Hachi no Ki* 3) Nakamura 4) 11/1769 5) *Ippitsusai Bunchō ga; Mori uji* 8) *hosoban*; 32.7 x 15.2 cm 10) Buckingham 1925.2532 *) See No. 8

19

1) Matsumoto Kōshirō III as Akita Jōnosuke 2) *Kawaranu Hanasakae Hachi no Ki* 3) Nakamura 4) 11/1769 5) *Ippitsusai Bunchō ga; Mori uji* 6) Okumuraya 8) *hosoban*; 31.9 x 14.8 cm 10) Buckingham 1925.2535

20

1) Onoe Tamizō I as Nishikigi 2) *Mutsu no Hana Ume no Kaomise* 3) Ichimura 4) 11/1769 5) *Ippitsusai Bunchō ga; Mori uji* 6) Nishimuraya Yohachi 8) *hosoban*; 30.1 x 16.1 cm 10) Gift of Mr. and Mrs. Harold G. Henderson 1967.614

21

1) Sanogawa Ichimatsu II as a fashionable young man (*wakashu*) 4) ca. 1769 5) *Ippitsusai Bunchō ga; Mori uji* 8) *hosoban*; 31.1 x 14.6 cm 10) Buckingham 1925.2523 *) See No. 9

22

1) Ofuji of the Yanagi Shop 4) ca. 1769 5) *Ippitsusai Bunchō ga; Mori uji* 8) *hosoban*; 32.6 x 15.5 cm 10) Buckingham 1925.2533 *) See No. 10

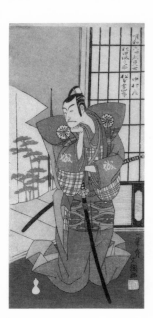

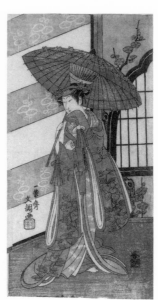

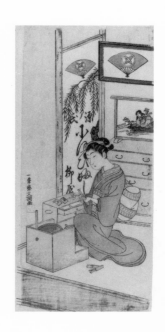

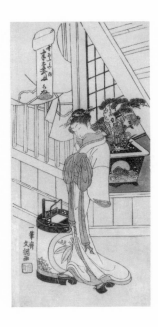

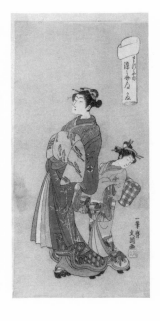

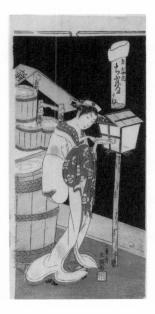

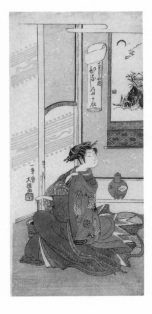

23

1) The courtesan Handayū of the Nakaōmiya house 2) *Fūji-bumi* (Folded Love-Letters) 4) ca. 1769–1770 5) *Ippitsusai Bunchō ga; Mori uji* 8) *hosoban*; 31.9 x 15.1 cm 9) MMA; TMTM 10) Buckingham 1925.2542 *) See No. 11

24

1) The courtesan Somenosuke of the Matsubaya house 2) *Fūji-bumi* (Folded Love-Letters) 4) ca. 1769–1770 5) *Ippitsusai Bunchō ga; Mori uji* 8) *hosoban*; 32.3 x 15.5 cm 10) Buckingham 1952.322

25

1) The courtesan Chibune of the Ebiya House 2) *Fūji-bumi* (Folded Love-Letters) 4) ca. 1769–1770 5) *Ippitsusai Bunchō ga; Mori uji* 8) *hosoban*; 32.3 x 15.2 cm 10) Buckingham 1952.324

26

1) Hinaji of the Chōjiya 2) *Fūji-bumi* (Folded Love-Letters) 4) ca. 1769–1770 5) *Ippitsusai Bunchō ga; Mori uji* 8) *hosoban*; 32.5 x 15.8 cm 10) Buckingham 1928.997

27

1) Waitress at the Minatoya Tea-house 4) ca. 1769 5) *Ippitsusai Bunchō ga; Mori uji* 8) *hosoban*; 31.3 x 13.8 cm 10) Buckingham 1929.726

28

1) Iwai Hanshirō IV in a female role 4) ca. 1769 5) *Ippitsusai Bunchō ga; Mori uji* 8) *hosoban*; 31.2 x 14.2 cm 10) Buckingham 1928.991

29

1) Yamashita Kyōnosuke I in a female role 4) ca. 1769 5) *Ippitsusai Bunchō ga; Mori uji* 8) *hosoban*; 30.8 x 14.4 cm 9) GUDHJ, vol. 6, pl. 305 10) Buckingham 1952.321

30

1) Ushiwaka-maru on the Gojō Bridge 4) reprint of ca. 1769 design 5) *Ippitsusai Bunchō ga; Mori uji* 8) *hosoban*; 30 x 14.2 cm 9) TMTM 10) Buckingham 1928.993

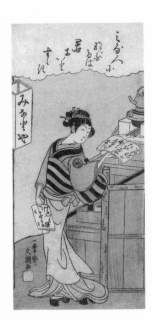

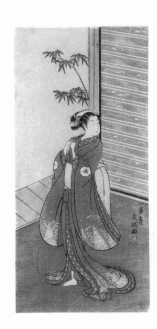

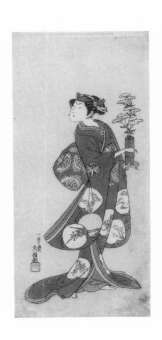

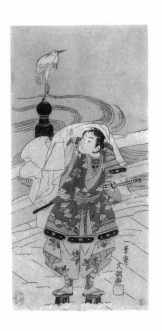

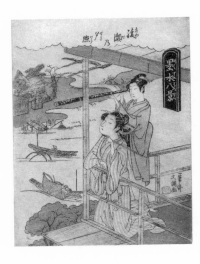

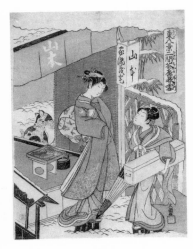

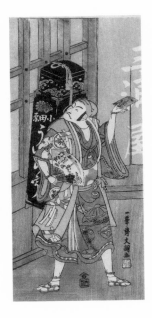

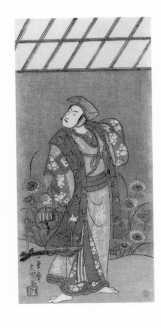

31
1) *Ayase no Yūshō* 2) *Bokusui Hak-kei* 4) ca. 1769 5) *Ippitsusai Bunchō ga; Mori uji* 8) *chūban*; 25.9 x 19.4 cm 9) BM; KK 10) Buckingham 1928.996

32
1) *Nikenjaya no Bosetsu* 2) *Azuma Hakkei* 4) ca. 1769 5) *Ippitsusai Bunchō ga; Mori uji* 8) *chūban*; 26.1 x 19.4 cm 10) Buckingham 1925.2540

33
1) Matsumoto Kōshirō III as Kyō no Jirō disguised as an *uirō* (pana-cea) peddler 2) *Kagami-ga-ike Omokage Soga* 3) Nakamura 4) 1/1770 5) *Ippitsusai Bunchō ga; Mori uji* 6) Nishimuraya Yohachi 8) *hoso-ban*; 31.4 x 14.2 cm 9) MMA; TMTM 10) Buckingham 1925.2534

34
1) Ichikawa Komazō II as Soga no Jūrō Sukenari disguised as a fox trapper 2) *Kagami-ga-ike Omokage Soga* 3) Nakamura 4) 1/1770 5) *Ippitsusai Bunchō ga; Mori uji* 8) *hosoban*; 31 x 14.4 cm 9) OMM 10) Buckingham 1928.990 *) Right sheet of diptych. Left sheet in TNM; RMA

35
1) Matsumoto Kōshirō as Kikuchi Hyōgo Narikage 2) *Katakiuchi Chūkō Kagami* 3) Nakamura 4) 6/1770 5) *Ippitsusai Bunchō ga; Mori uji* 6) Okumura Genroku 8) *hoso-ban*; 31.7 x 14.3 cm 9) TNM 10) Buckingham 1925.2402 *) See No. 12

36
1) Nakamura Matsue I as Tsuchiya Umegawa disguised as the female sumo wrestler Oyodo (?) 2) *Naniwa no Onna-zumō* (?) 3) Nakamura (?) 4) 6/1770 (?) 5) *Ippitsusai Bunchō ga; Mori uji* 6) Nishimuraya Yoha-chi 8) *hosoban*; 29.1 x 14.4 cm 9) TNM 10) Buckingham 1939.2194

37
1) Yamashita Kinsaku II as Nijō no Kisaki (?) 2) *Natsu Matsuri Naniwa Kagami* (?) 3) Morita (?) 4) 7/1770 (?) 5) *Ippitsusai Bunchō ga; Mori uji* 8) *hosoban*; 32.3 x 14.9 cm 10) Buckingham 1952.323

38
1) Iwai Hanshirō IV as Kiyohime 2) *Hidakagawa Iriai-zakura* 3) Morita 4) 9/1770 5) *Ippitsusai Bunchō ga; Mori uji* 8) *hosoban*; 29.7 x 13.8 cm 9) BM 10) Buckingham 1925.2522

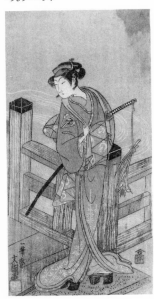

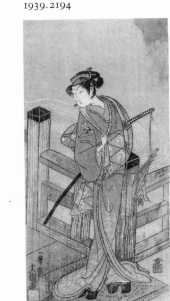

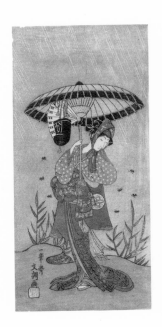

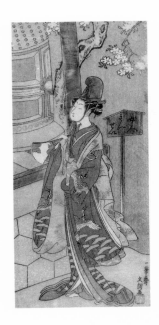

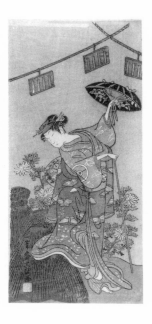

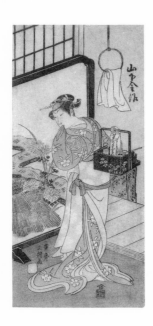

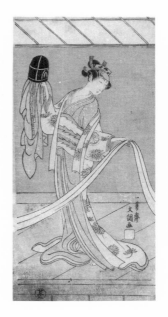

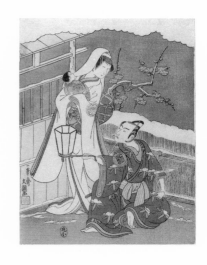

39

1) Iwai Hanshirō IV as Otatsu-gitsune 2) *Nue no Mori Ichiyō no Mato* 3) Nakamura 4) 11/1770 5) *Ippitsusai Bunchō ga; Mori uji* 8) *hosoban*; 31.5 x 14.5 cm 9) AMAM 10) Buckingham 1925.2531

40

1) Yamashita Kinsaku II as Oume, wife of Kisaku 2) *Nue no Mori Ichiyō no Mato* 3) Nakamura 4) 11/1770 5) *Ippitsusai Bunchō ga; Mori uji* 6) Nishimuraya Yohachi 8) *hosoban*; 31.2 x 14.4 cm 9) TNM 10) Buckingham 1925.2408

41

1) Segawa Kikunojō II as Princess Tatsu (Tatsu Hime) 2) *Myōto-giku Izu no Kisewata* 3) Ichimura 4) 11/1770 5) *Ippitsusai Bunchō ga; Mori uji* 6) Maruya Jimpachi 8) *hosoban*; 29.7 x 14.7 cm 9) CM 10) Buckingham 1939.2114 *) Center sheet of triptych

42

1) Arashi Sangorō II as Minamoto no Yoritomo disguised as the Hat Maker (Eboshi Ori) Daitarō, and Segawa Kikunojō II as the Snow Woman (Yuki Onna) 2) *Myōto-giku Izu no Kisewata* 3) Ichimura 4) 11/1770 5) *Ippitsusai Bunchō ga; Mori uji* 6) Maruya Kohei 8) *chūban*; 26.2 x 19.9 cm 9) SM 10) Buckingham 1925.2538 *) See No. 13

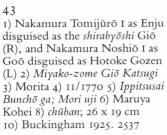

43

1) Nakamura Tomijūrō I as Enju disguised as the *shirabyōshi* Giō (R), and Nakamura Noshiō I as Goō disguised as Hotoke Gozen (L) 2) *Miyako-zome Giō Katsugi* 3) Morita 4) 11/1770 5) *Ippitsusai Bunchō ga; Mori uji* 6) Maruya Kohei 8) *chūban*; 26 x 19 cm 10) Buckingham 1925. 2537

44

1) White chrysanthemums and pinks in black vase 4) ca. 1765–1770 5) Unsigned 8) *hosoban*; 33 x 15 cm 10) Buckingham 1949.31 *) See No. 14

45

1) Flying tea ceremony kettle (*tonda chagama*) 4) ca. 1770 5) *Ippitsusai Bunchō ga; Mori uji* 6) Maruya Kohei 8) *chūban*; 27.5 x 20.3 cm 9) TMTM 10) Buckingham 1935.384 *) See No. 15

46

1) Ōtani Hiroji III 4) ca. 1770 5) *Ippitsusai Bunchō ga; Mori uji* 6) Nishimuraya Yohachi 8) *hosoban*; 31.5 x 15.2 cm 10) Buckingham 1928.312

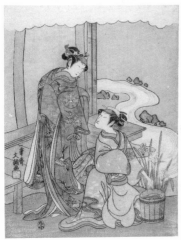

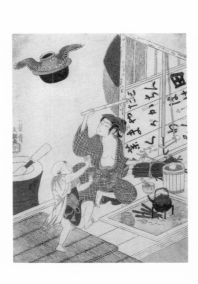

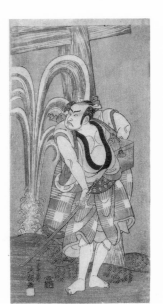

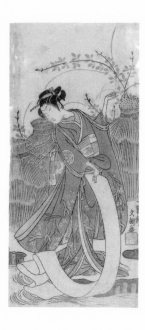

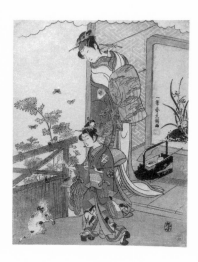

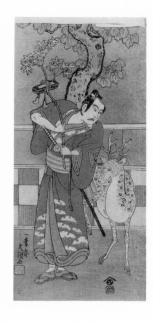

47
1) Yamashita Kinsaku II in "Nuno Sarashi" (Cloth Bleaching) dance 4) ca. 1770 5) *Ippitsusai Bunchō ga; Mori uji* 8) *hosoban*; 29.3 x 13 cm 10) Buckingham 1925.2527

48
1) Onoe Matsusuke I as Ōiso no Tora (?) (R), and Ōtani Taniji (L) 4) ca. 1770 5) *Ippitsusai Bunchō ga; Mori uji* 6) Maruya Kohei 8) *chūban*; 25.9 x 19.3 cm 10) Buckingham 1925.2539

49
1) Segawa Kikunojō II as the courtesan Hitachi 2) *Wada Sakamori Osame no Mitsugumi* 3) Ichimura 4) 2/1771 5) *Ippitsusai Bunchō ga; Mori uji* 6) Okumura Genroku 8) *hosoban*; 31.7 x 14.3 cm 9) BM 10) Buckingham 1925.2405 *) See No. 16

50
1) Ichikawa Yaozō II as Goi no Shō Munesada 2) *Kuni no Hana Ono no Itsumoji* 3) Nakamura 4) 11/1771 5) *Ippitsusai Bunchō ga; Mori uji* 6) Nishimuraya Yohachi 8) *hosoban*; 30.1 x 13.6 cm 9) TMTM 10) Buckingham 1925.2406 *) See No. 17

51
1) Ichikawa Yaozō II as Yoshimine no Munesada 2) *Kuni no Hana Ono no Itsumoji* 3) Nakamura 4) 11/1771 5) *Ippitsusai Bunchō ga; Mori uji* 8) *hosoban*; 32.5 x 14.7 cm 9) TMTM 10) Buckingham 1925.2404

52
1) Ichikawa Komazō II as Chūnagon Yukihira (R), and Iwai Hanshirō IV as Murasame (L) 2) *Kuni no Hana Ono no Itsumoji* 3) Nakamura 4) 11/1771 5) *Ippitsusai Bunchō ga; Mori uji* 8) *hosoban*; 32.3 x 14.8 cm 9) TMTM 10) Buckingham 1935.385

53
1) Nakamura Noshio I as the Third Princess (Nyosan no Miya) 2) *Fuki Kaete Tsuki mo Yoshiwara* 3) Morita 4) 11/1771 5) *Ippitsusai Bunchō ga; Mori uji* 6) Nishimuraya Yohachi 8) *hosoban*; 32.5 x 15 cm 9) TNM; TMTM; MMA 10) Buckingham 1929.735 *) See No. 18

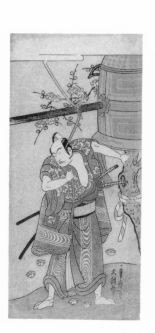

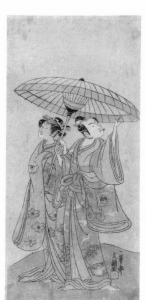

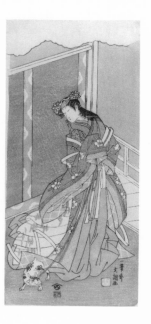

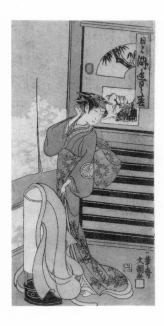 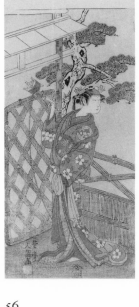 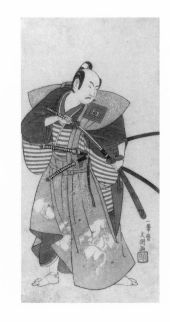

54

1) Segawa Kikunojō II 4) ca. 1771 5) *Ippitsusai Bunchō ga; Mori uji* 6) Maruya Jimpachi 8) *hosoban*; 29.1 x 14.3 cm 9) AM 10) Buckingham 1925.2528 *) An inscription added to the AM impression reads "Meiwa 8 (1771), autumn, Ichimura Theater, Segawa Kikunojō [II] as Katsuragi." But Kikunojō II was ill at that time.

55

1) Segawa Kikunojō II as the courtesan Maizuru 2) *Furisode Kisaragi Soga* 3) Ichimura 4) 2/1772 5) *Ippitsusai Bunchō ga; Mori uji* 8) *hosoban*; 30.2 x 13.8 cm 10) Buckingham 1925.2524 *) See No. 19

56

1) Yamashita Kinsaku II as Moshio, wife of Itō Sukekiyo 2) *Izu-goyomi Shibai no Ganjitsu* 3) Morita 4) 11/1772 5) *Ippitsusai Bunchō ga; Mori uji* 6) Nishimuraya Yohachi 8) *hosoban*; 31.8 x 14.5 cm 10) Gift of Mr. and Mrs. Gaylord Donnelley 1971.484

57

1) Ichikawa Komazō II as Kudō Saemon Suketsune (?) 2) *Haru wa Soga Akebono-zōshi* (?) 3) Nakamura (?) 4) 1/1772 (?) 5) *Ippitsusai Bunchō ga; Mori uji* 8) *hosoban*; 28.9 x 13.8 cm 9) TMTM; AFGA 10) Buckingham 1929.728

58

1) The lovers Ohatsu and Tokubei 2) *Chizuka no Fumi no Bosetsu; Sugata Hakkei* 4) ca. 1772 5) *Ippitsusai Bunchō ga; Mori uji* 8) *chūban*; 26.5 x 19.5 cm 9) MMA; VI, pl. XLIV; UTS, pl. 64 10) Buckingham 1929.727 *) See No. 20

59

1) The courtesan Mitsunoto of the Hishiya house 2) *Sanjūrokkasen* (Thirty-six Flowers) 4) ca. 1772 5) *Ippitsusai Bunchō ga; Mori uji* 8) *chūban*; 25.4 x 18.1 cm 10) Buckingham 1925.2541

60

1) Ichikawa Yaozō II in a pre-performance celebration 2) *Soga Monogatari* 3) Morita 4) 2/1773 5) *Ippitsusai Bunchō ga; Mori uji* 8) *hosoban*; 30.2 x 13.7 cm 9) SM 10) Buckingham 1925.2407 *) Triptych with sheets showing Matsumoto Kōshiro IV (?) and Ōtani Hiroji III (?)

61

1) Ichikawa Monnosuke II as Tsunewaka-maru 2) *Iro Moyō Ao-yagi Soga* 3) Nakamura 4) 2/1775 5) *Ippitsusai Bunchō ga; Mori uji* 8) *hosoban*; 32.8 x 15 cm 9) SM; BMFA 10) Buckingham 1952.320

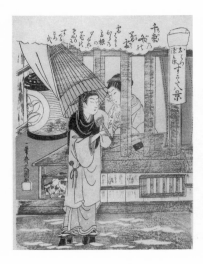 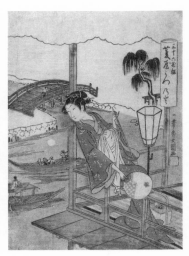 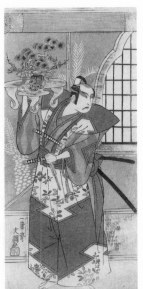 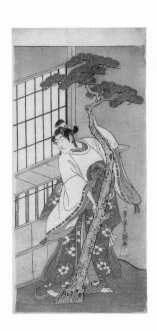

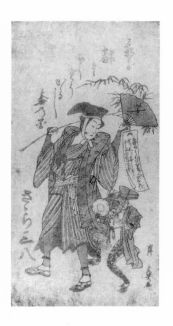

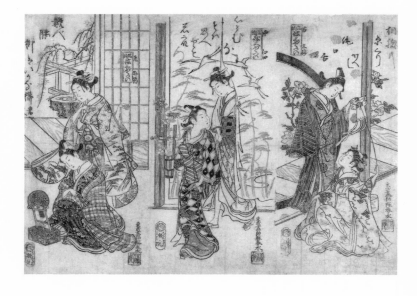

KISHI
BUNSHŌ

(1754–1796)

62

1) Monkey trainer with a monkey
at the New Year 4) ca. 1780s
5) *Kishi Bunshō ga* 8) *hosoban*;
29.3 x 14.9 cm 10) Gift of Mr.
and Mrs. Harold G. Henderson
1968.329 *) See No. 21

MIYAGAWA
SHUNSUI

(active early 1740s–early 1760s)

63

1) *Fūryū Utai Sambukutsui* 4) ca.
late 1750s 5) *Tōbu eshi Katsu Shun-
sui; Mangyo* 6) Tsuruya Kiemon of
Ōdemma-chō san-chōme 8) *beni-
zuri hosoban*, triptych (uncut);
31.1 x 47.3 cm 10) Buckingham
1925.2357 *) See No. 22

KATSUKAWA
SHUNSHŌ

(1726–1792)

64

1) Ichikawa Raizō I as Hanakawado
no Sukeroku (R), and Ōtani Hiroe-
mon III as Hige no Ikyū (L) 2)
Hitokidori Harutsuge Soga 3) Naka-
mura 4) 2/1764 5) *Hayashi* in jar-
shaped outline 8) *hosoban*, diptych
(?); 31.6 x 14.2 cm (R), 33.8 x 14.5
cm (L) 9) HAA; SNS, no. 127
10) Buckingham 1925.2358a (R),
Gookin 1939.726 (L) *) See No. 23

65

1) Ōtani Hiroji III as Oniō Shin-
zaemon (?) 2) *Bunshin Sugatami
Soga* (?) 3) Morita (?) 4) 2/1765 (?)
5) *Hayashi* in jar-shaped outline
8) *hosoban*; 32.5 x 15 cm 10) Buck-
ingham 1925.2358b

66

1) Ichikawa Danjūrō IV as Taira no
Tomomori disguised as Tokaiya
Gimpei 2) *Yoshitsune Sembon-
zakura* 3) Nakamura 4) 7/1767
5) *Shunshō ga* 8) *hosoban*; 32.2 x
15.4 cm 9) SM 10) Gookin
1939.665 *) See No. 24

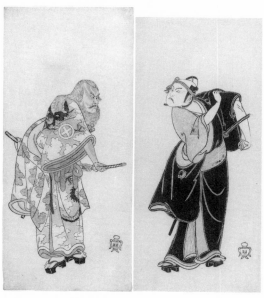

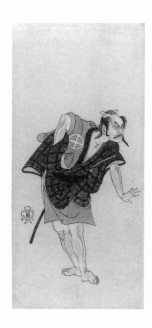

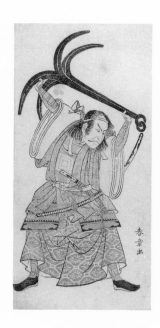

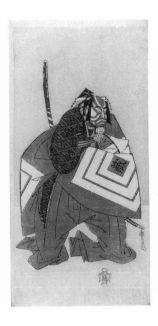
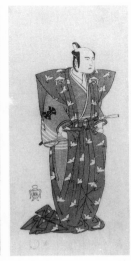
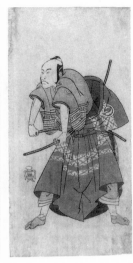
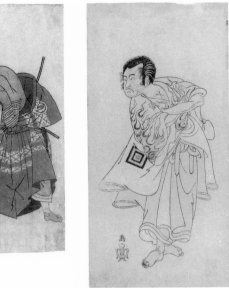

67

1) Ichikawa Danzō III as Sanada no Yoichi (?) 2) *Sanada no Yoichi Banjaku no Iezuto* (?) 3) Morita (?) 4) 11/1767 (?) 5) *Hayashi* in jar-shaped outline 8) *hosoban*; 32.4 x 15.3 cm 9) SNS, pl. 133 10) Gookin 1939.682 *) This block, with a different head plugged in, was reused; see cat. no. 90.

68

1) Sawamura Sōjūrō II (R), Bandō Mitsugorō I (C), and Bandō Sampachi I (L) as Ōmi no Kotōda (?), Soga no Jūrō Sukenari (?), and Yawata no Saburō (?) 2) *Shuen Soga Ōmugaeshi* (?) 3) Ichimura (?) 4) 2/1768 (?) 5) *Hayashi* in jar-shaped outline 8) *hosoban*; 29.6 x 14.4 cm (R), 31 x 14.1 cm (C),

32.7 x 14.3 cm (L) 9) SM, GFGA, RMA (R); OMM (C); HAA, OMM (L) 10) Gookin 1939.589 (R), 1939.694 (C), 1939.681 (L) *) Probably three sheets of a five-sheet print

69

1) Ichikawa Danzō III as the holy hermit Narukami 2) *Miyakodori Azuma Komachi* 3) Morita 4) 3/1768 5) *Hayashi* in jar-shaped outline, preceded by the printed character *ga* 8) *hosoban*; 31.1 x 15.1 cm 10) Gookin 1939.672 *) See No. 25

70

1) Matsumoto Kōshirō III as Matsuō-maru 2) *Ayatsuri Kabuki Ōgi* 3) Nakamura 4) 7/1768 5) *Hayashi* in jar-shaped outline 8) *hosoban*; 32 x 14.5 cm 10) Gookin 1939.684

71

1) Nakamura Nakazō I as Mikawaya Giheiji (R), and Nakamura Sukegorō II as Danshichi Kurobei (L) 2) *Ayatsuri Kabuki Ōgi* 3) Nakamura 4) 7/1768 5) *Shunshō zu; Hayashi* in jar-shaped outline 8) *chūban*; 24.4 x 18.9 cm 9) HGM; HAA; PAM; KUL 10) Buckingham 1925.2387 *) See No. 26

72

1) Nakamura Sukegorō II as Kaminari Shōkurō 2) *Ayatsuri Kabuki Ōgi* 3) Nakamura 4) 7/1768 5) *Hayashi* in jar-shaped outline 8) *hosoban*, one sheet of pentaptych; 31 x 14 cm 9) ADF; and see entry 10) Gookin 1939.683 *) See No. 27

73

1) Arashi Otohachi I as Hotei Ichiemon 2) *Ayatsuri Kabuki Ōgi* 3) Nakamura 4) 7/1768 5) *Hayashi* in jar-shaped outline 8) 28.6 x 13.7 cm 10) Gookin 1939.666 *) Reproduction cut from the book *Sunkin Zattetsu*, published ca. 1800

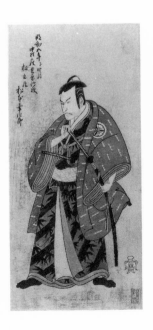
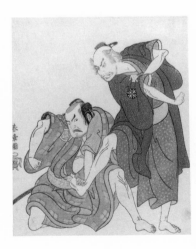
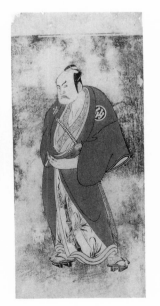
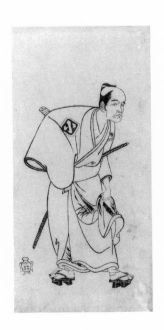

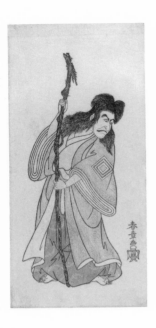

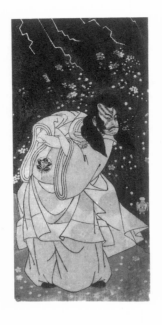

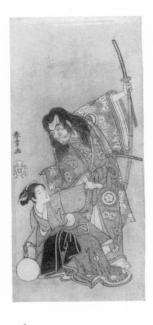

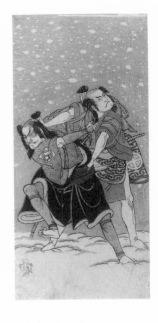

74
1) Ichikawa Danjūrō IV as *sennin* Tenjiku Tokubei (?) 2) *Tenjiku Tokubei Kokyō no Torikaji* (?) 3) Nakamura (?) 4) 8/1768 (?) 5) Shunshō ga; *Hayashi* in jar-shaped outline 8) *hosoban*; 32.8 x 15.4 cm 9) BC 1938.478; RMA; SNS, no. 124 10) Buckingham 1925.2385 *) See No. 28

75
1) Ichimura Uzaemon IX as Kan Shōjō 2) *Sugawara Denju Tenarai Kagami* 3) Ichimura 4) 8/1768 5) *Hayashi* in jar-shaped outline 8) *hosoban*; 29.4 x 13.8 cm 9) SNS, pl. 125 10) Gookin 1939.688

76
1) Sawamura Sōjūrō II as Shunkan and Azuma Tōzō II as Oyasu 2) *Hime Komatsu Ne no Hi Asobi* 3) Ichimura 4) 9/1768 5) *Shunshō ga*; *Hayashi* in jar-shaped outline 8) *hosoban*; 31.7 x 14.3 cm 10) Gookin 1925.2410 *) See No. 29

77
1) Ōtani Hiroji III as Kameō (R), and Sakata Sajūrō I as Ariō (L) 2) *Hime Komatsu Ne no Hi Asobi* 3) Ichimura 4) 9/1768 5) *Hayashi* in jar-shaped outline 8) *hosoban*; 31.2 x 14.5 cm 9) MOKB; SNS, pl. 131 10) Gookin 1939.693

78
1) Ichikawa Danzō III as Fuwa Banzaemon 2) *Date Moyō Kumo ni Inazuma* 3) Morita 4) 10/1768 5) *Hayashi* in jar-shaped outline 8) *hosoban*; 31 x 15.4 cm 9) BMFA 10) Gookin 1939.685

79
1) Ichikawa Danzō III as Shōki 2) *Date Moyō Kumo ni Inazuma* 3) Morita 4) 10/1768 5) *Shunshō ga*; *Hayashi* in jar-shaped outline 8) *hosoban*; 33.2 x 15.2 cm 10) Gookin 1939.698 *) See No. 30

80
1) Ichikawa Danzō III as Shōki 2) *Date Moyō Kumo ni Inazuma* 3) Morita 4) 10/1768 5) *Shunshō ga*; *Hayashi* in jar-shaped outline 8) *hosoban*; 31.3 x 14 cm 9) BMFA 10) Buckingham 1932.1006 *) This impression has a yellow background; see also impression with a blue background (No. 30).

81
1) Nakamura Sukegorō II as Asō no Matsuwaka 2) *Ima o Sakari Suehiro Genji* 3) Nakamura 4) 11/1768 5) *Hayashi* in jar-shaped outline 8) *hosoban*; 32.5 x 14.9 cm 9) TS 10) Buckingham 1925.2409 *) See No. 31

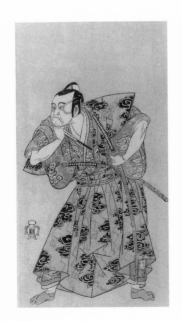

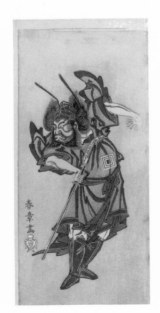

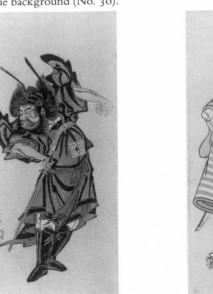

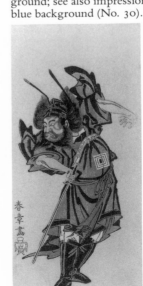

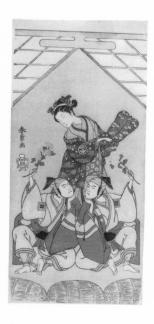
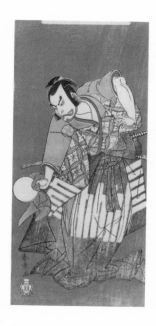
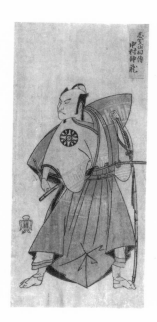
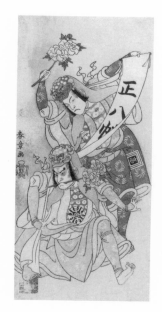

82

1) Segawa Kikunojō II as Reizei, Ichikawa Komazō I as Suruga no Hachirō in the guise of Kichiroku (R), and Ichikawa Yaozō II as Tada no Kurando in the guise of Kichinai (L) 2) *Ima o Sakari Suehiro Genji* 3) Nakamura 4) 11/1768 5) *Shunshō ga*; *Hayashi* in jar-shaped outline 8) *hosoban*; 32.6 x 15.2 cm 10) Buckingham 1930.394 *) See No. 32

83

1) Nakamura Nakazō I as Osada no Tarō 2) *Ima o Sakari Suehiro Genji* 3) Nakamura 4) 11/1768 5) *Shunshō ga*; *Hayashi* in jar-shaped outline 8) *hosoban*; 30.5 x 14.4 cm 10) Buckingham 1938.479 *) See No. 33

84

1) Nakamura Nakazō I as Osada no Tarō (?) 2) *Ima o Sakari Suehiro Genji* (?) 3) Nakamura (?) 4) 11/1768 (?) 5) *Hayashi* in jar-shaped outline 8) *hosoban*; 29.8 x 13.6 cm 10) Kate S. Buckingham Collection 1939.169 *) An alternate edition exists, printed from a slightly modified block; see UTS8, pl. 16.

85

1) Nakamura Nakazō I and Ichikawa Komazō I in dance scene 2) *Ima o Sakari Suehiro Genji* 3) Nakamura 4) 11/1768 5) *Shunshō ga*; *Hayashi* in jar-shaped outline 8) *hosoban*; 29.9 x 14 cm 10) Gookin 1939.673 *) See No. 34

86

1) Ichikawa Danjūrō IV in *Shibaraku* role 2) *Ima o Sakari Suehiro Genji* (?) 3) Nakamura (?) 4) 11/1768 (?) 5) *Katsukawa Shunshō ga*; *Hayashi* in jar-shaped outline 6) Maruya Jimpachi 8) *ōban*; 38.3 x 26 cm 9) EIG 10) Buckingham 1925.2365 *) See No. 35

87

1) Sawamura Sōjūrō II as Huang-shi Gong (R), and Ichikawa Danzō III as Zhang Liang (L) 2) *Otokoyama Yunzei Kurabe* 3) Ichimura 4) 11/1768 5) *Shunshō ga*; *Hayashi* in jar-shaped outline 8) *hosoban*; 32.5 x 14.9 cm 10) Buckingham 1925.2411 *) See No. 36

88

1) Ōtani Hiroji III as Abe no Munetō disguised as a peddler of buckwheat noodles 2) *Otokoyama Yunzei Kurabe* 3) Ichimura 4) 11/1768 5) *Shunshō ga*; *Hayashi* in jar-shaped outline 8) *hosoban*; 31.8 x 14.6 cm 10) Buckingham 1932.998

89

1) Arashi Otohachi I as Numatarō Kyūsei disguised as the burglar Ipponzaemon 2) *Otokoyama Yunzei Kurabe* 3) Ichimura 4) 11/1768 5) *Hayashi* in jar-shaped outline 8) *hosoban*; 28.5 x 13.7 cm 9) MG; UT6, pl. 78 10) Gookin 1939.689

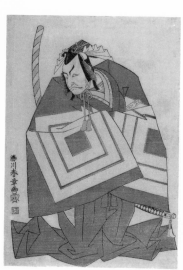
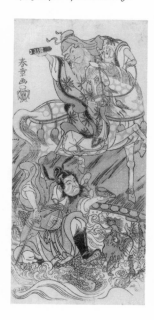
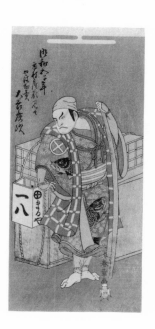
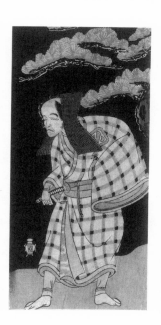

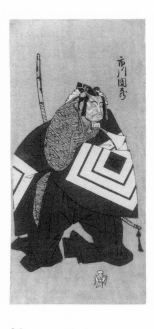

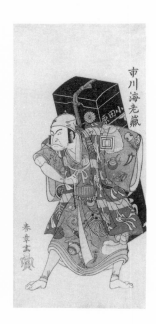

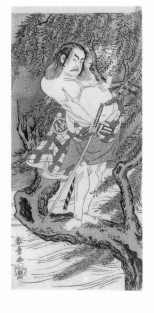

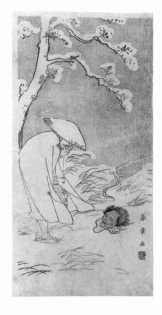

90
1) Ichikawa Danzō III as Kamakura no Gongorō Kagemasa (?)
2) *Otokoyama Yunzei Kurabe* (?)
3) Ichimura (?) 4) 11/1768 (?)
5) *Hayashi* in jar-shaped outline
8) *hosoban*; 31 x 14.3 cm 10) Buckingham 1929.74 *) Alternate editions exist from slightly modified blocks; see Succo (1922), pl. 32 and cat. no. 67.

91
1) Ichikawa Ebizō II (Danjūrō II) as an *uirō* (panacea) peddler 4) ca. 1768–1770 5) *Shunshō ga*; *Hayashi* in jar-shaped outline 8) *hosoban*; 31.2 x 14.2 cm 9) BMFA; MRAH; WT 10) Gookin 1939.686
*) See No. 37

92
1) Nakamura Sukegorō as *otokodate* 4) ca. 1768–1770 5) *Shunshō ga*; *Hayashi* in jar-shaped outline 8) *hosoban*; 32.3 x 14.5 cm 10) Gookin 1939.580 *) See No. 38

93
1) A pilgrim praying through the night to the Buddha (*kannenbutsu*) is startled by a ghostly head lying on the snow-covered ground 4) ca. 1768 5) *Shunshō ga*; [seal illegible] 8) *hosoban*; 33.1 x 16.2 cm 10) Gookin 1939.700

94
1) Nakamura Nakazō I as Tezuka no Tarō Mitsumori disguised as the monkey trainer Tonkichi Tochibei 2) *Soga Moyō Aigo no Wakamatsu* 3) Nakamura 4) 1/1769 5) *Hayashi* in jar-shaped outline 8) *hosoban*; 32.5 x 14.6 cm 9) TNM; MRAH 10) Buckingham 1939.2112

95
1) Nakamura Utaemon I as Kudō Suketsune disguised as a beggar 2) *Soga Moyō Aigo no Wakamatsu* 3) Nakamura 4) 1/1769 5) *Shunshō ga*; *Hayashi* in jar-shaped outline 8) *hosoban*; 31 x 15 cm 10) Gookin 1939.671

96
1) Ichikawa Yaozō II as Soga no Jūrō Sukenari disguised as the professional jester Senraku (?) 2) *Soga Moyō Aigo no Wakamatsu* (?) 3) Nakamura (?) 4) 2/1769 (?) 5) *Shunshō ga*; *Hayashi* in jar-shaped outline 6) Okumuraya 8) *hosoban*; 31.3 x 14.1 cm 10) Buckingham 1925.2416

97
1) Nakamura Utaemon I as Monk Seigen of Kiyomizu Temple 2) *Soga Moyō Aigo no Wakamatsu* 3) Nakamura 4) 3/1769 5) *Shunshō ga*; *Hayashi* in jar-shaped outline 8) *hosoban*; 31 x 14.9 cm 9) TNM; MMA 10) Buckingham 1925.2412

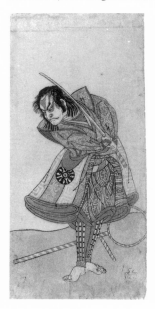

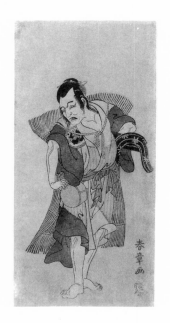

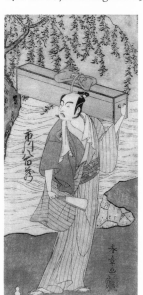

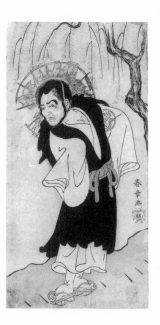

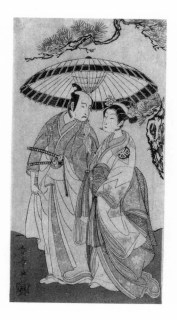
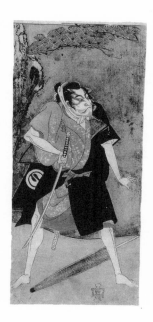
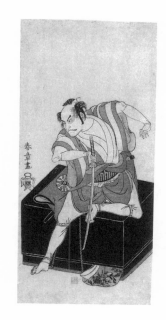
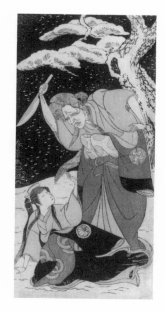

98
1) Arashi Hinaji I (R), and Ichi-kawa Komazō II (L), as Princess Sakura (Sakura Hime) (?) and Shimizu Tonoinosuke (?) 2) *Soga Moyō Aigo no Wakamatsu* (?) 3) Nakamura (?) 4) 3/1769 (?) 5) *Shunshō ga*; *Hayashi* in jar-shaped outline 8) *hosoban*; 29.1 x 15.3 cm 10) Buckingham 1925.2418

99
1) Sawamura Sōjūrō II as an out-law 4) ca. 1769 5) *Hayashi* in jar-shaped outline 8) *hosoban*; 31.8 x 14.5 cm 9) BMFA 10) Gookin 1939.691 *) Either Momi no Jinzō in *Edo no Hana Wakayagi Soga*, Ichimura Theater, 3/1769, or Ono Sadakurō in *Chūshingura*, Ichimura Theater, 5/1769. From a multi-sheet composition (?)

100
1) Nakamura Nakazō I as Izu no Jirō disguised as Kemmaku no Sabu 2) *Edo-zakura Sono Omokage* 3) Nakamura 4) 5/1769 5) *Shunshō ga*; *Hayashi* in jar-shaped outline 8) *hosoban*; 31.2 x 14.7 cm 10) Gookin 1939.584

101
1) Nakamura Utaemon I as Kara-shi Baba, and Yoshizawa Sakino-suke III as Shirotae 2) *Kawaranu Hanasakae Hachi no Ki* 3) Naka-mura 4) 11/1769 5) *Shunshō ga*; *Hayashi* in jar-shaped outline 8) *hosoban*; 30.6 x 14.6 9) TNM 10) Buckingham 1925.2413 *) See No. 39

102
1) Nakamura Utaemon I as Karashi Baba (R), and Ichikawa Danjūrō IV as Sanshōdayū (L) 2) *Kawaranu Hanasakae Hachi no Ki* 3) Nakamura 4) 11/1769 5) *Shunshō ga*; *Hayashi* in jar-shaped outline 8) *hosoban*; 32.8 x 14.9 cm 9) UT5, pl. 137 10) Buckingham 1935.413

103
1) Bandō Matatarō IV as Gempa-chibyōe 2) *Matsu no Hana Ume no Kaomise* 3) Ichimura 4) 11/1769 5) *Hayashi* in jar-shaped outline 8) *hosoban*; 31.6 x 14.2 cm 9) MIA 10) Buckingham 1932.1008 *) See No. 40

104
1) Ōtani Hiroji III in a *mie* 4) ca. 1769–1770 5) *Shunshō ga*; *Hayashi* in jar-shaped outline 8) *hosoban*; 31.1 x 14.4 cm 9) UT5, pl. 37; SNS, no. 134 10) Gookin 1939.690 *) See No. 41

105
1) Ōtani Hiroji III as Akaneya Hanshichi (?) 2) *Fuji no Yuki Kaikei Soga* (?) 3) Ichimura (?) 4) 1/1770 (?) 5) *Hayashi* in jar-shaped outline 8) *hosoban*; 31.5 x 15.2 cm 9) UT5, pl. 74 10) Gookin 1939.692 *) See No. 42

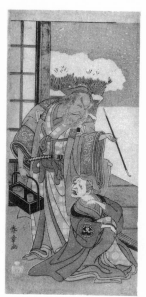
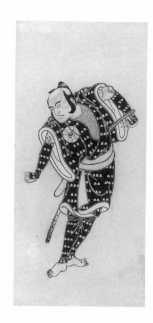
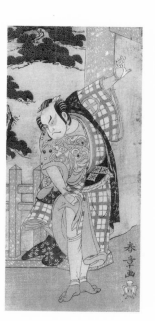
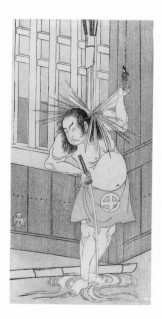

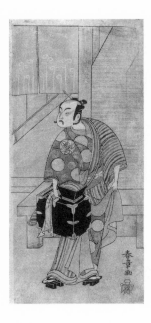

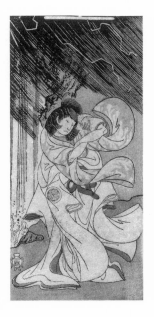

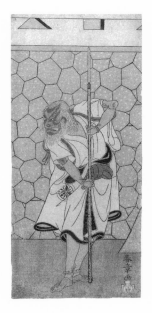

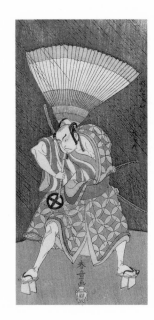

106
1) Ichimura Uzaemon IX as the hairdresser Komagata Ikkaku 2) *Fuji no Yuki Kaikei Soga* 3) Ichimura 4) 1/1770 5) *Shunshō ga; Hayashi* in jar-shaped outline 8) *hosoban*; 32.5 x 15 cm 10) Gookin 1939.579

107
1) Yamashita Kinsaku II as a Thunder Goddess 2) *Onna Narukami* 3) Morita 4) 1/1770 5) *Hayashi* in jar-shaped outline 8) *hosoban*; 31.1 x 14.2 cm 9) TNM; JUM 10) Buckingham 1932.995 *) From a multisheet composition (?)

108
1) Matsumoto Kōshirō III as Kikuchi Hyōgo Narikage 2) *Katakiuchi Chūkō Kagami* 3) Nakamura 4) 6/1770 5) *Shunshō ga; Hayashi* in jar-shaped outline 8) *hosoban*; 31.6 x 14.3 cm 9) WT (complete four-sheet print) 10) Buckingham 1932.1017 *) Second-from-left sheet in a four-sheet composition

109
1) Ōtani Hiroji III as Ukishima Daihachi (?) 2) *Shinasadame Sōma no Mombi* (?) 3) Ichimura (?) 4) 7/1770 (?) 5) *Shunshō ga; Hayashi* in jar-shaped outline 8) *hosoban*; 31.4 x 14 cm 9) HAA 10) Buckingham 1925.2415 *) See No. 43

110
1) Ōtani Hiroji III as a white fox disguised as Ukishima Daihachi 2) *Shinasadame Sōma no Mombi* 3) Ichimura 4) 7/1770 5) *Shunshō ga; Hayashi* in jar-shaped outline 8) *hosoban*; 31.7 x 14.6 cm 9) SM; UT5, pl. 135 10) Gookin 1939.670

111
1) Onoe Kikugorō I as Ukishima Danjō (?) 2) *Shinasadame Sōma no Mombi* (?) 3) Ichimura (?) 4) 7/1770 (?) 5) *Shunshō ga; Hayashi* in jar-shaped outline 8) *hosoban*; 30.4 x 14.5 cm 10) Buckingham 1930.393

112
1) Ichikawa Danjūrō V as Watanabe Kiou Takiguchi (bottom), and Nakamura Nakazō I as Taira no Kiyomori (top) 2) *Nue no Mori Ichiyō no Mato* 3) Nakamura 4) 11/1770 5) *Shunshō ga; Hayashi* in jar-shaped outline 8) *hosoban*; 32.2 x 14.3 cm 9) HAA; UT5, pl. 40; HV; MRAH; SNS, no. 128 10) Gookin 1939.596 *) See No. 44

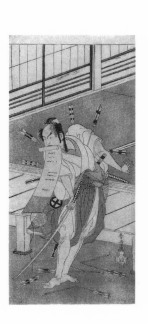

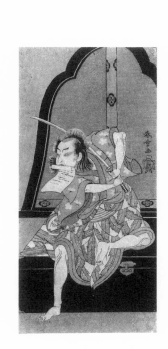

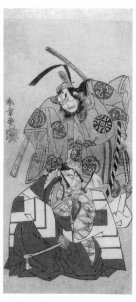

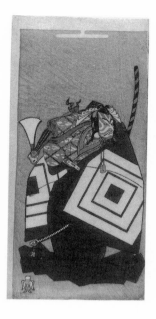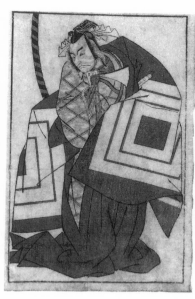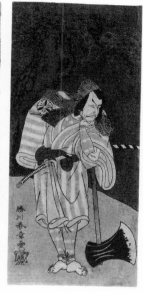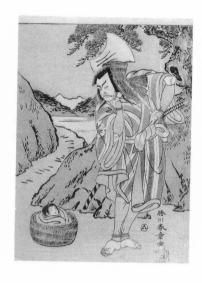

113
1) Ichikawa Danjūrō V as Watanabe
Kiou Takiguchi 2) *Nue no Mori
Ichiyō no Mato* 3) Nakamura 4) 11/
1770 5) *Hayashi* in jar-shaped out-
line 8) *hosoban*; 32.5 x 15.3 cm
10) Gookin 1939.734

114
1) Ichikawa Danjūrō V as Watanabe
Kiou Takiguchi (?) 2) *Nue no Mori
Ichiyō no Mato* (?) 3) Nakamura (?)
4) 11/1770 (?) 8) book illustration;
24.9 x 16.3 cm 9) GP 10) Gookin
1939.763 *) Illustration cut from
Ehon Zoku Butai Ōgi (1778)

115
1) Matsumoto Kōshirō II as Osada
no Tarō Kagemune disguised as
the woodcutter Gankutsu no
Gorozō 2) *Nue no Mori Ichiyō no
Mato* 3) Nakamura 4) 11/1770
5) *Katsukawa Shunshō ga*; *Hayashi*
in jar-shaped outline 8) *hosoban*; 31
x 13.8 cm 9) TNM; MMA; JUM
10) Gookin 1939.674

116
1) Matsumoto Kōshirō II as Osada
no Tarō Kagemune disguised as
Gankutsu no Gorozō 2) *Nue no
Mori Ichiyō no Mato* 3) Nakamura
4) 11/1770 5) *Katsukawa Shunshō
ga*; *Hayashi* in jar-shaped outline
6) Urokogataya Magobei,
Edo 8) *chūban*; 25.6 x 17.7 cm
10) Buckingham 1928.986
*) See No. 45

117
1) Matsumoto Kōshirō II as Osada
no Tarō Kagemune disguised as
Yatsurugi Zaemon, and Ichikawa
Danzō III as I no Hayata Tadazumi
2) *Nue no Mori Ichiyō no Mato*
3) Nakamura 4) 11/1770 5) *Hayashi*
8) *hosoban*; 32.1 x 15.3 cm 9) AIC
1939.695 (dark background); HRWK
(light background) 10) Gookin
1939.668 *) See No. 46

118
1) Ichikawa Danzō III as I no Ha-
yata Tadazumi (R), and Matsu-
moto Kōshirō II as Osada no Tarō
Kagemune (L) 2) *Nue no Mori
Ichiyō no Mato* 3) Nakamura
4) 11/1770 5) *Hayashi* in jar-shaped
outline 8) *hosoban*; 30.3 x 13.8
9) HRWK 10) Gookin 1939.695
*) See No. 46 for impression with
light background.

119
1) Nakamura Nakazō I as Raigō
Ajari 2) *Nue no Mori Ichiyō no
Mato* 3) Nakamura 4) 11/1770
5) *Shunshō ga*; *Hayashi* in jar-
shaped outline 8) *hosoban*; 31 x 14.6
cm 9) HGM 10) Buckingham
1932.1012 *) See No. 47

120
1) Nakamura Nakazō I as Raigō
Ajari 2) *Nue no Mori Ichiyō no
Mato* 3) Nakamura 4) 11/1770
5) *Shunshō ga*; *Hayashi* in jar-
shaped outline 6) Maruya Jimpachi
8) *hosoban*; 32.3 x 15.2 cm 9) SM;
UT5, pl. 35; VI, pl. LIV; SNS, no.
122 10) Buckingham 1938.480
*) See No. 48

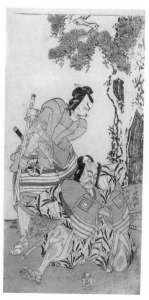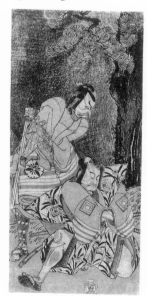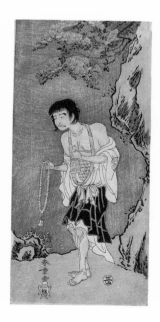

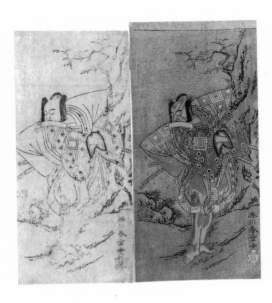
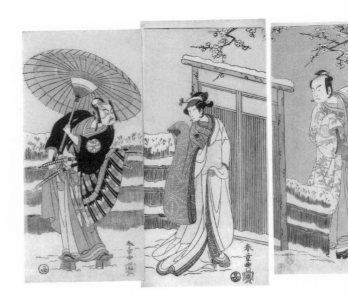

121
1) Keyblock impression of 122
8) *hosoban*; 28.8 x 13.8 cm
10) Gookin 1939.648 *) Full-color
impression, cat. no. 121

122
1) Ichikawa Danzō III as I no
Hayata Tadazumi 2) *Nue no Mori
Ichiyō no Mato* 3) Nakamura
4) 11/1770 5) *Katsukawa Shunshō
ga*; *Hayashi* in jar-shaped outline
8) *hosoban*; 30.7 x 15.1 cm
10) Gookin 1939.669 *) Key-
block impression, cat. no. 122

123
1) Arashi Sangorō II as Minamoto
no Yoritomo (R), Segawa Kikuno-
jō II as Yuki Onna (C), and Ichi-
mura Uzaemon IX as Kajiwara
Genta no Kagetoki (L) 2) *Myōto-
giku Izu no Kisewata* 3) Ichimura
4) 11/1770 5) *Shunshō ga*; *Hayashi*
in jar-shaped outline 6) Maruya

Jimpachi 8) *hosoban*, triptych; 30.8
x 14 cm (R), 32.5 x 15 cm (C),
30.6 x 14.3 cm (L) 9) IGL, YUAG
(R&C); TNM (L) 10) Buckingham
1949.73 (R), 1942.112 (C),
1925.2419 (L) *) See No. 49

124
1) Ōtani Hiroji III as Kawazu
no Saburō 2) *Myōto-giku Izu no
Kisewata* 3) Ichimura 4) 11/1770
5) *Shunshō ga* 8) *hosoban*; 32 x 15.2
cm 10) Buckingham 1932.1016
*) From a multisheet composition

125
1) Nakamura Sukegorō II as the
sumo wrestler Matano no Gorō
2) *Myōto-giku Izu no Kisewata*
3) Ichimura 4) 11/1770 5) *Katsu-
kawa Shunshō ga*; *Hayashi* in jar-
shaped outline 8) *hosoban*; 30.8 x
13.6 cm 10) Buckingham 1928.982
*) Right sheet of a triptych

126
1) Ōtani Hiroji III 4) ca. 1770
5) *Katsukawa Shunshō ga*; *Hayashi*
in jar-shaped outline 6) Maruya
Jimpachi 8) *hosoban*; 31.1 x 14.4 cm
10) Buckingham 1952.374

127
1) Black horse tethered under a
blossoming cherry tree 4) ca. 1770
5) *Katsukawa Shunshō ga*; *Hayashi*
in jar-shaped outline 8) *chūban*;
25.5 x 19.7 cm 9) SM; CM
10) Buckingham 1938.482

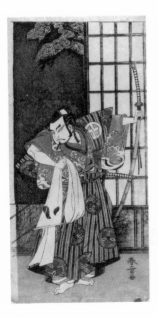
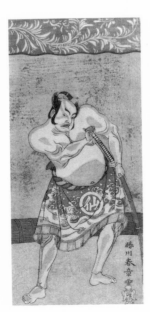
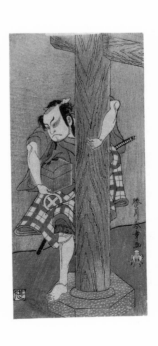

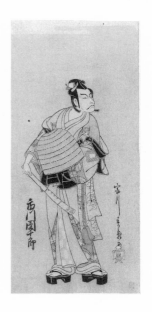

128
1) Lovers dressed as *komusō* monks in autumn landscape 4) ca. 1770 5) *Shunshō ga* 8) *chūban*; 26.2 x 19.3 cm 10) Buckingham 1938.481 *) See No. 50

129
1) Watanabe no Tsuna fighting the demon at Rashōmon 4) ca. 1770 5) *Katsukawa Shunshō zu*; *Hayashi* in jar-shaped outline 8) *chūban*; 28 x 21.3 cm 10) Gift of Mr. and Mrs. Harold G. Henderson 1967.642 *) See No. 51

130
1) Taira no Atsumori riding a horse into the sea 4) ca. 1770 5) *Katsukawa Shunshō zu* 8) *chūban*; 24.8 x 19.6 cm 10) Gookin 1939.777 *) See No. 52

131
1) Ichikawa Danjūrō V as Soga no Gorō disguised as a *komusō* 2) *Sakai-chō Soga Nendaiki* 3) Nakamura 4) 1/1771 5) *Miyagawa Shunshō ga*; *Hayashi* in jar-shaped outline 8) *hosoban*; 31.2 x 14.3 cm 10) Gookin 1939.696 *) From a multisheet composition (?)

132
1) Ichikawa Komazō II as Soga no Jūrō Sukenari (R), and Ichikawa Danjūrō V as Soga no Gorō Tokimune (L), in *komusō* attires 2) *Sakai-chō Soga Nendaiki* 3) Nakamura 4) 1/1771 5) *Shunshō ga*; *Hayashi* in jar-shaped outline 6) Maruya Jimpachi 8) *hosoban*; 32.7 x 15.5 cm 10) Gookin 1939.606

133
1) Ichikawa Danzō III as the boathouse man Kurofune Chūemon 2) *Sakai-chō Soga Nendaiki* 3) Nakamura 4) 1/1771 5) *Shunshō ga* 6) Maruya Jimpachi 8) *hosoban*; 31.6 x 14.4 cm 10) Gookin 1939.582 *) From a multisheet composition (?)

134
1) Nakamura Nakazō I as Kudō Saemon Suketsune (?) 2) *Sakai-chō Soga Nendaiki* (?) 3) Nakamura (?) 4) 1/1771 (?) 5) *Shunshō ga*; *Hayashi* in jar-shaped outline 8) *hosoban*; 30.1 x 14.6 cm 10) Gookin 1939.741 *) From a multisheet composition

135
1) Ichikawa Danjūrō V as Soga no Gorō Tokimune 2) *Sakai-chō Soga Nendaiki* 3) Nakamura 4) 1/1771 5) *Katsukawa Shunshō ga*; *Hayashi* in jar-shaped outline 8) *hosoban*; 32.7 x 14.5 cm 10) Gookin 1939.581

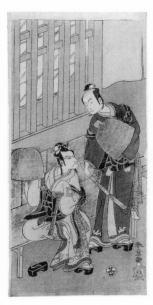
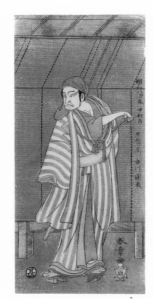
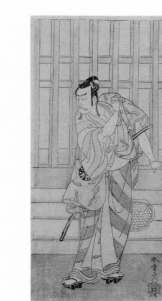
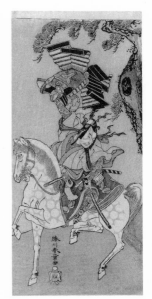

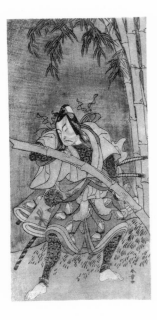

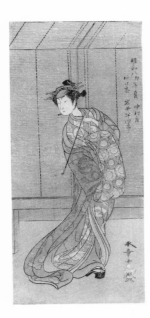

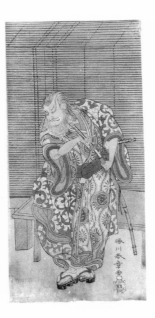

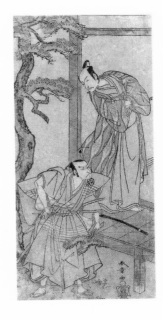

136
1) Nakamura Tomijūrō I as
Takenuki Gorō 2) *Ehō Soga Nen-
nen-goyomi* 3) Morita 4) 1/1771
5) *Shunshō ga* 8) *hosoban*; 28.7 x
13.9 cm 9) UT5, pl. 44 10) Gookin
1939.760

137
1) Nakamura Nakazō I as Hige no
Ikyū (R), and Iwai Hanshirō IV
as Agemaki (L) 2) *Sakai-chō Soga
Nendaiki* 3) Nakamura 4) 3/1771
5) *Katsukawa Shunshō ga* (R), and

Shunshō ga (L), with *Hayashi* in jar-
shaped outlines 8) *hosoban*; 32 x
15.1 cm (R), 31.7 x 14.5 cm (L)
9) AFGA (R); TNM, SM (L) 10)
Gookin 1939.667 (R), 1939.732 (L)
*) From a multisheet composition

138
1) Ichikawa Danjūrō V as Momo-
noi Wakasanosuke (R), and Naka-
mura Nakazō I as Kakogawa
Honzō (L) 2) *Kanadehon Chūshin-
gura* 3) Nakamura 4) 5/1771
5) *Shunshō ga* 8) *hosoban*; 29.8 x
14.1 cm 10) Gookin 1939.583

139
1) Ichikawa Danjūrō V as Momo-
noi Wakasanosuke Yasuchika (?)
2) *Kanadehon Chūshingura* (?)
3) Nakamura (?) 4) 5/1771 (?)
5) *Shunshō ga*; *Hayashi* in jar-
shaped outline 8) *hosoban*; 31.5 x
14.1 cm 10) Gookin 1939.577

140
1) Yamashita Kinsaku II as Oishi
(?) or Osono (?) 2) *Kanadehon Chū-
shingura* (?) 3) Nakamura (?) 4) 5/
1771 (?) 5) *Shunshō ga*; *Hayashi* in
jar-shaped outline 8) *hosoban*; 32 x
14.5 cm 9) NAM 10) Buckingham
1952.376

141
1) Ichimura Uzaemon IX as Fuwa
Banzaemon 2) *Keisei Nagoya Obi*
3) Ichimura 4) 8/1771 5) *Shunshō
ga* 8) *hosoban*; 29.2 x 13.9 cm
10) Gookin 1939.597 *) From a
multisheet composition (?)

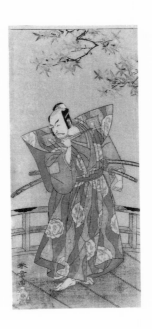

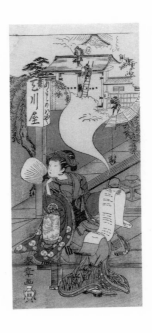

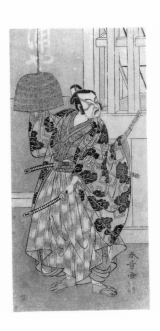

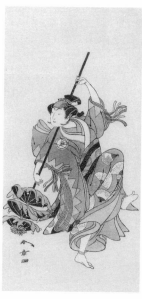
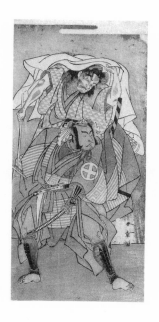

142
1) Iwai Hanshirō IV in the *Sangai-gasa* dance 2) *Kuni no Hana Ono no Itsumoji* 3) Nakamura 4) 11/1771
5) *Shunshō ga* 8) *hosoban*; 30.8 x 14.5 cm 10) Buckingham 1925.2427 *) See No. 54

143
1) Ichikawa Yaozō II as Yoshimine no Munesada 2) *Kuni no Hana Ono no Itsumoji* 3) Nakamura 4) 11/1771
5) *Shunshō ga* 8) *hosoban*; 31.4 x 14.2 cm 10) Gookin 1939.751
*) Right sheet of a diptych (?)

144
1) Ōtani Hiroji III as Kōga Saburō, and Ichimura Uzaemon IX as the Devil of Kōgakeyama, the spirit of Wakasa no Zenji Yasumura
2) *Kono Hana Yotsugi no Hachi no Ki* 3) Ichimura 4) 11/1771 5) *Shunshō ga* 8) *hosoban*; 31 x 14.3 cm
10) Buckingham 1925.2382

145
1) Ichikawa Danjūrō V as Fudō
2) *Fuki Kaete Tsuki mo Yoshiwara*
3) Morita 4) 11/1771 8) *hosoban*;
31.2 x 14.8 cm 9) WS 10) Gookin 1939.699 *) See No. 55

146
1) The courtesan Sugawara of the Tsuruya house and her *kamuro* Namiji and Kashiko 4) 1771
5) *Katsukawa Shunshō ga* 8) *chūban*; 25.5 x 17.9 cm 10) Buckingham 1925.2359

147
1) Matsumoto Kōshirō II as Yoemon (L), and Yoshizawa Sakinosuke III as Kasane (R)
4) ca. 1771 5) *Katsukawa Shunshō ga* 8) *hosoban*; 30.8 x 13.8 cm
9) UT5, pl. 95 10) Gookin 1939.578 *) See No. 57

148
1) Ichikawa Komazō II as Satsuma Gengobei (R), and Nakamura Nakazō I as Sasano Sangobei (L)
4) ca. 1771 5) *Katsukawa Shunshō ga*; *Hayashi* in jar-shaped outline 8) *hosoban*; 30.6 x 13.5 cm
10) Gookin 1939.610 *) Role names are written on print but cannot be matched with existing records

149
1) *Tōkaiji no Banshō* 2) *Shinagawa Hakkei* 4) ca. 1771 5) *Shunshō ga*
8) *chūban*; 26.4 x 19.8 cm
10) Buckingham 1939.2113

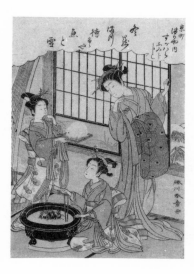
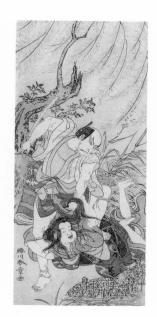
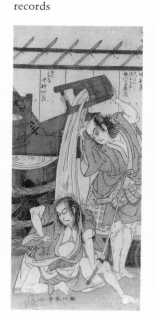

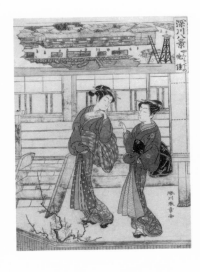 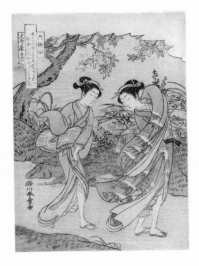 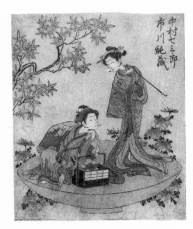 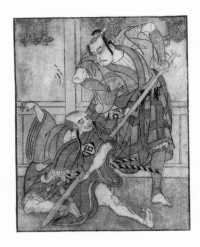

150
1) Courtesan and her attendant at the Yagurashita unlicensed pleasure district in Fukagawa 2) *Yagurashita no Banshō; Fukagawa Hakkei* 4) ca. 1771 5) *Katsukawa Shunshō ga* 8) *chūban*; 25.2 x 19 cm 9) BM 10) Gookin 1961.118 *) See No. 58

151
1) Two women in gusty autumn landscape 2) *Funya no Yasuhide; Rokkasen* 4) ca. 1771 5) *Katsukawa Shunshō ga* 8) *chūban*; 25.5 x 18.2 cm 9) TNM 10) Gift of Mr. and Mrs. Harold G. Henderson 1967.641 *) See No. 59

152
1) Nakamura Shichisaburō III (R), and Ichikawa Junzō I (L) 2) *Nue no Mori Ichiyō no Mato* 3) Nakamura 4) 11/1770 8) 16.9 x 13.8 cm 10) Gookin 1939.796 *) Page from the illustrated book *Yakusha Kuni no Hana* (ca. 1772)

153
1) Kasaya Matakurō II as Nobuyori disguised as the *yakko* Gunnai (R), and Miyazaki Hachizō as the lay monk Hambyō Nyūdō (L) 2) *Nue no Mori Ichiyō no Mato* 3) Nakamura 4) 11/1770 8) 17.7 x 13.9 cm 10) Gookin 1939.797 *) Page from the illustrated book *Yakusha Kuni no Hana* (ca. 1772)

154
1) Nakamura Denkurō II as Seno-o Tarō, Ichikawa Komazō II as Yorimasa, Nakamura Nakazō I as Taira no Kiyomori, and Ichikawa Danjūrō V as Kiou Takiguchi (R to L) 2) *Nue no Mori Ichiyō no Mato*

3) Nakamura 4) 11/1770 8) 17.6 x 27.7 cm 10) Buckingham 1938.503 *) Page from the illustrated book *Yakusha Kuni no Hana* (ca. 1772)

155
1) Nakamura Nakazō I as Taira no Kiyomori (R), and Yamashita Kinsaku II as Tokiwa Gozen (L) 2) *Nue no Mori Ichiyō no Mato* 3) Nakamura 4) 11/1770 8) 18.8 x

27.8 cm 10) Buckingham 1938.504 *) Page from the illustrated book *Yakusha Kuni no Hana* (ca. 1772)

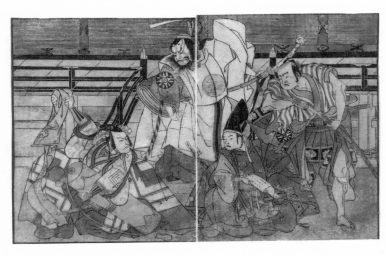 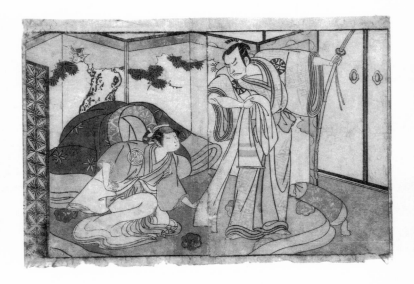

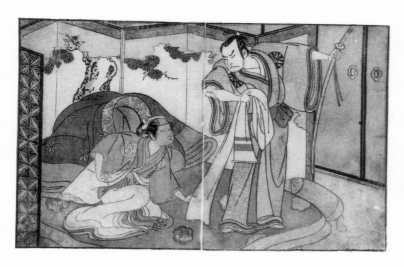

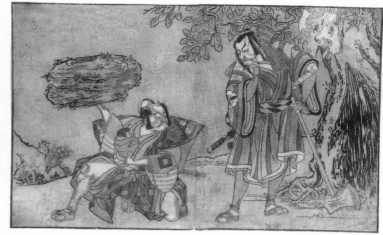

155a

1) Another impression of the above
8) 17.4 x 27.7 cm 10) Buckingham
1938.505 *) Page from the illus-
trated book *Yakusha Kuni no Hana*
(ca. 1772)

156

1) Matsumoto Kōshirō II as Osada
no Tarō Kagemune disguised as
the woodcutter Gankutsu no
Gorozō (R), and Ichikawa Danzō
III as I no Hayata Tadazumi (L)
2) *Nue no Mori Ichiyō no Mato*

3) Nakamura 4) 11/1770 8) 17.6 x
27.7 cm 10) Buckingham 1938.501
*) Page from the illustrated book
Yakusha Kuni no Hana (ca. 1772)

157

1) Ichikawa Komazō II as Mina-
moto no Yorimasa (R), Matsu-
moto Kōshirō II as Osada no Tarō
Kagemune disguised as Yatsurugi
Zaemon (C), and Ichikawa Danzō
III as I no Hayata Tadazumi (L)

2) *Nue no Mori Ichiyō no Mato*
3) Nakamura 4) 11/1770 8) 17.3 x
27.7 cm 10) Buckingham 1938.509
*) Page from the illustrated book
Yakusha Kuni no Hana (ca. 1772)

158

1) Iwai Hanshirō IV as Otatsu-
gitsune, Nakamura Nakazō I as
Raigō Ajari, Sakata Tōjūrō III as
Kamada Gon-no-kami Masayori,
and Ichikawa Yaozō II as Sakon-
gitsune (R to L) 2) *Nue no Mori*

Ichiyō no Mato 3) Nakamura
4) 11/1770 8) 17.6 x 27.7 cm
10) Buckingham 1938.502 *) Page
from the illustrated book *Yakusha
Kuni no Hana* (ca. 1772)

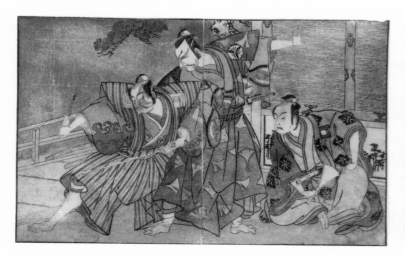

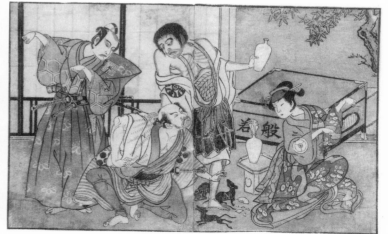

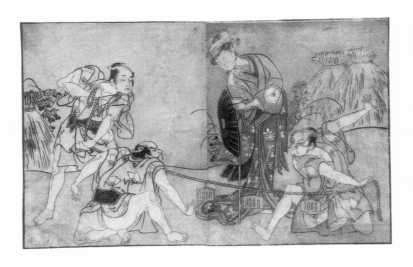 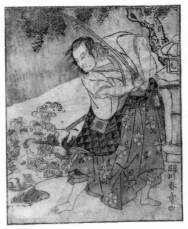 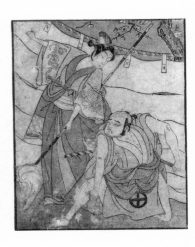

159

1) Bandō Zenji I as Nagahashi Saburō, Iwai Hanshirō IV as Otatsu-gitsune, Nakamura Kono-zō as Hagai Ujitsune, and an uni-dentified actor (R to L) 2) *Nue no Mori Ichiyō no Mato* 3) Nakamura 4) 11/1770 8) 17.6 x 27.7 cm 10) Buckingham 1938.506 *) Page from the illustrated book *Yakusha Kuni no Hana* (ca. 1772)

160

1) Ichikawa Danjūrō V as Ogata no Saburō (?) 2) *Nue no Mori Ichiyō no Mato* 3) Nakamura 4) 11/1770 5) *Katsukawa Shunshō ga* 8) 16.9 x 13.8 cm 10) Gookin 1939.1829 *) Page from the illustrated book *Yakusha Kuni no Hana* (ca. 1772)

161

1) Ōtani Tomoemon I as Emohei (R), and Sanogawa Ichimatsu II as Sanada Yoichi (L) 2) *Myōto-giku Izu no Kisewata* 3) Ichimura 4) 11/1770 8) 17.5 x 14.1 cm 10) Gookin 1939.1830 *) Page from the illus-trated book *Yakusha Kuni no Hana* (ca. 1772)

162

1) Nakamura Sukegorō II as Matano no Gorō (R), Onoe Kiku-gorō I as Soga no Tarō (C), and Ōtani Hiroji III as Kawazu no Saburō (L) 2) *Myōto-giku Izu no Kisewata* 3) Ichimura 4) 11/1770 8) 17.5 x 27.8 cm 10) Buckingham 1938.508 *) Page from the illus-trated book *Yakusha Kuni no Hana* (ca. 1772)

163

1) Ōtani Hiroji III as Kawazu no Saburō (R), Segawa Kikunojō II as Princess Tatsu (Tatsu Hime) (C), and Nakamura Sukegorō II as Matano no Gorō (L) 2) *Myōto-giku Izu no Kisewata* 3) Ichimura 4) 11/ 1770 8) 17.1 x 27.7 cm 10) Buck-ingham 1938.513 *) Page from the illustrated book *Yakusha Kuni no Hana* (ca. 1772)

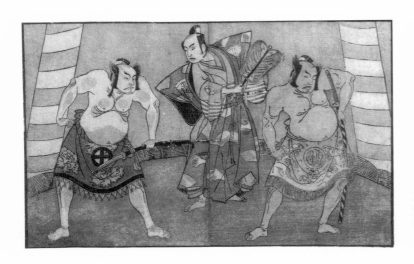 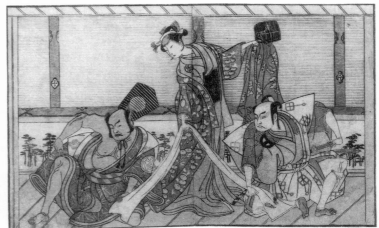

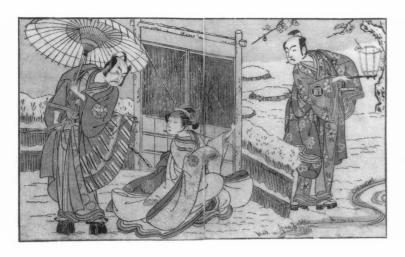

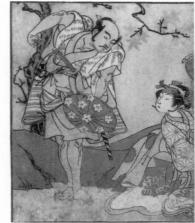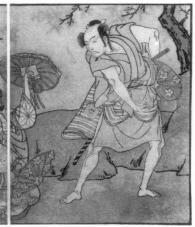

164

1) Arashi Sangorō II as Minamoto no Yoritomo (R), Segawa Kikunojō II as Yuki Onna (C), and Ichimura Uzaemon IX as Kajiwara Genta no Kagetoki (L) 2) *Myōto-giku Izu no Kisewata* 3) Ichimura

4) 11/1770 8) 17.2 x 28.1 cm 10) Buckingham 1938.507 *) Page from the illustrated book *Yakusha Kuni no Hana* (ca. 1772)

165

1) Ichikawa Somegorō (R), Segawa Kikunojō II (C), and Bandō Sampachi (L), in unidentified roles 2) *Myōto-giku Izu no Kisewata* 3) Ichimura 4) 11/1770 8) 17.4 x 27.8 cm 10) Buckingham

1938.512 *) Page from the illustrated book *Yakusha Kuni no Hana* (ca. 1772)

166

1) Ichimura Uzaemon IX as Kajiwara Genta no Kagetoki (?) 2) *Myōto-giku Izu no Kisewata* 3) Ichimura 4) 11/1770 5) *Katsukawa Shunshō ga* 8) 17.5 x 14.1 cm 10) Gookin 1939.800 *) Page from the illustrated book *Yakusha Kuni no Hana* (ca. 1772)

167

1) Nakamura Nakazō I as Matsukaze (R), Ichikawa Komazō II as Ariwara no Yukihira (C), and Iwai Hanshirō IV as Murasame (L) 2) *Kuni no Hana Ono no Itsumoji* 3) Nakamura 4) 11/1771 8) 17.2 x

27.4 cm 10) Buckingham 1938.522 *) Page from the illustrated book *Yakusha Kuni no Hana* (ca. 1772)

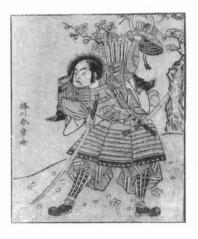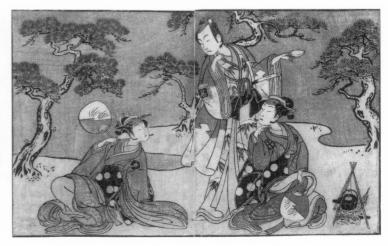

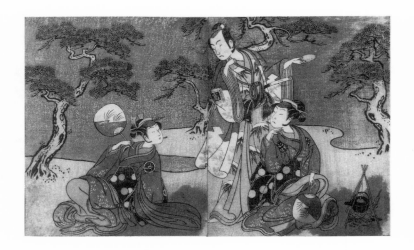

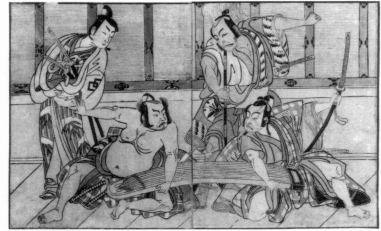

167a
Another impression of the above
10) Buckingham 1938.523

168
1) Ichikawa Yaozō II as Kujaku no Saburō, Matsumoto Kōshirō II as Hata no Daizen Taketora, Nakajima Mihoemon II as Aramaki Mimishirō, and Nakamura Shōchō I as Ki no Tsurayuki (R to L)

2) *Kuni no Hana Ono no Itsumoji*
3) Nakamura 4) 11/1771 8) 17.2 x 27.2 cm 10) Buckingham 1938.518
*) Page from the illustrated book *Yakusha Kuni no Hana* (ca. 1772)

169
1) Nakajima Mihoemon II as Aramaki Mimishirō (R), Matsumoto Kōshirō II as Ōtomo no Yamanushi (C), and Ichikawa Danzō III as Hannya no Gorō (L) 2) *Kuni no Hana Ono no Itsumoji* 3) Nakamura

4) 11/1771 8) 17.1 x 27.2 cm 10) Buckingham 1938.520 *) Page from the illustrated book *Yakusha Kuni no Hana* (ca. 1772)

170
1) Yamashita Yaozō I as Ono no Komachi (R), Matsumoto Kōshirō II as Godai Saburō (C), and Ichikawa Danzō III as Ōtomo no Kuronushi (L) 2) *Kuni no Hana Ono no Itsumoji* 3) Nakamura 4) 11/

1771 8) 17 x 27.2 cm 10) Buckingham 1938.517 *) Page from the illustrated book *Yakusha Kuni no Hana* (ca. 1772)

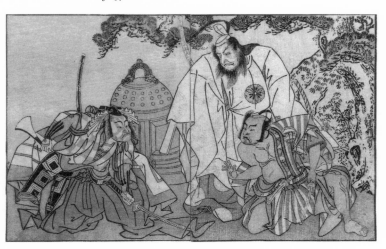

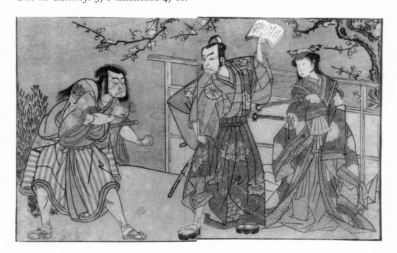

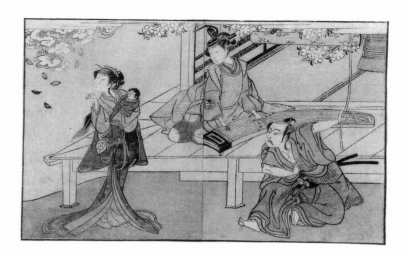

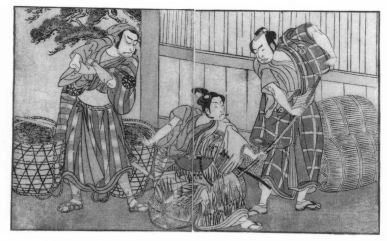

171

1) Ichikawa Yaozō II as Yoshimine no Munesada (R), Yoshizawa Saki-nosuke III as Shizuya (C), and Nakamura Matsue I as Sakuragi (L) 2) *Kuni no Hana Ono no Itsumoji* 3) Nakamura 4) 11/1771 8) 17.1 x 27.2 cm 10) Buckingham 1938.519 *) Page from the illustrated book *Yakusha Kuni no Hana* (ca. 1772)

172

1) Kasaya Matakurō II as Hagun Tarō (R), Ichikawa Monnosuke II as Izutsu no Suke Narihira (C), and Nakamura Nakazō I as Kose no Kanaoka disguised as Sōgorō the charcoal maker 2) *Kuni no Hana Ono no Itsumoji* 3) Nakamura 4) 11/1771 8) 17 x 27.2 cm 10) Buckingham 1938.521 *) Page from the illustrated book *Yakusha Kuni no Hana* (ca. 1772)

173

1) Nakamura Denkurō II as Suma no Dairyō (R), and Ichikawa Komazō II as Ariwara no Yukihira (L) 2) *Kuni no Hana Ono no Itsumoji* 3) Nakamura 4) 11/1771 5) *Shunshō ga* 8) 17.1 x 14.1 cm 10) Gookin 1939.798 *) Page from the illustrated book *Yakusha Kuni no Hana* (ca. 1772)

174

1) Onoe Matsusuke I as Akaboshi Tarō (R), and Azuma Tōzō II as Shirotae (L) 2) *Kono Hana Yotsugi no Hachi no Ki* 3) Ichimura 4) 11/1771 8) 17.5 x 27.7 cm 10) Buckingham 1938.516 *) Page from the illustrated book *Yakusha Kuni no Hana* (ca. 1772)

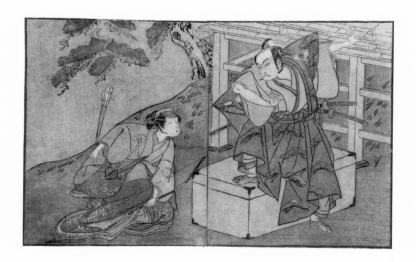

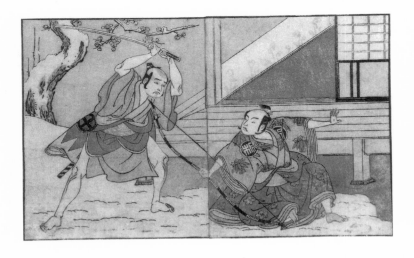

175

1) Arashi Sangorō II as Hōjō
Tokiyori (R), and Ōtani Hiroji III
as Kōga Saburō (L) 2) *Kono Hana
Yotsugi no Hachi no Ki* 3) Ichimura
4) 11/1771 8) 17.3 x 27.9 cm
10) Buckingham 1938.515 *) Page
from the illustrated book *Yakusha
Kuni no Hana* (ca. 1772)

176

1) "Shibaraku" scene 2) *Fuki Kaete
Tsuki mo Yoshiwara* 4) ca. 1771–
1772 8) 16.8 x 13.7 cm 10) Gookin
1939.799 *) Page from the illus-
trated book *Yakusha Kuni no Hana*
(ca. 1772). See No. 56A

177

1) *Kemari* (court football) scene
2) *Fuki Kaete Tsuki mo Yoshiwara*
4) ca. 1771–1772 8) 17 x 27.2 cm
10) Buckingham 1938.525 *) Page
from the illustrated book *Yakusha
Kuni no Hana* (ca. 1772). See
No. 56B

178

1) Nakamura Noshio I as Nyosan
no Miya (R), Ichikawa Danjūrō V
as the renegade monk Yōchin (C),
and Yamashita Kinsaku II as the
maid Mutsuhana (L) 2) *Fuki Kaete
Tsuki mo Yoshiwara* 3) Morita

4) 11/1771 8) 16.8 x 27.3 cm
10) Buckingham 1938.514 *) Page
from the illustrated book *Yakusha
Kuni no Hana* (ca. 1772)

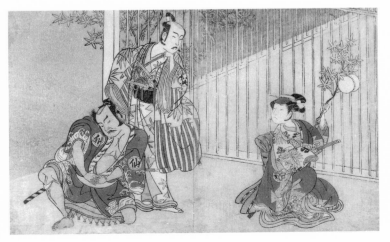

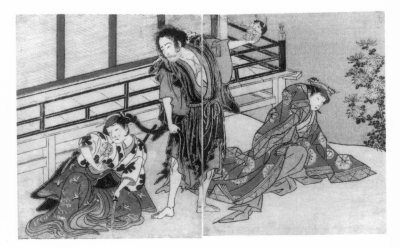

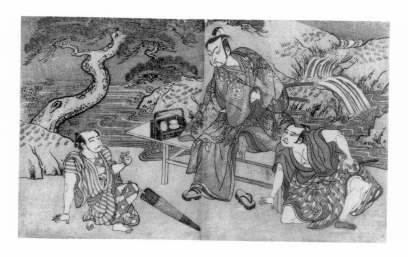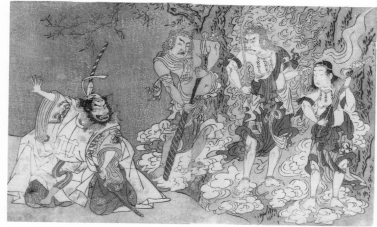

179
1) Tomizawa Hanzaburō II as Nagoya Sanzaemon (often called Sanza) (R), Nakamura Jūzō II as Fuwa Banzaemon (C), and an unidentified actor as the pickpocket Matsumoto Daishichi (L) 2) *Fuki Kaete Tsuki mo Yoshiwara* 3) Morita 4) 11/1771 8) 17 x 27.3 cm 10) Buckingham 1938.511 *) Page from the illustrated book *Yakusha Kuni no Hana* (ca. 1772)

180
1) Ichikawa Danjūrō V as Fudō, with Bandō Mitsugorō I as Kongara Dōji (R), and Nakamura Sukegorō II as Seitaka Dōji (L) 2) *Fuki Kaete Tsuki mo Yoshiwara* 4) ca. 1771–1772 8) 17 x 27.4 cm

10) Buckingham 1938.524 *) Page from the illustrated book *Yakusha Kuni no Hana* (ca. 1772). See No. 56C

181
1) Nakamura Tomijūrō I as Nagoya Osan 2) *Fuki Kaete Tsuki mo Yoshiwara* 4) ca. 1771–1772 8) 16.7 x 13.5 cm 10) Gookin 1939.795 *) Page from the illustrated book *Yakusha Kuni no Hana* (ca. 1772). See No. 56D

182
1) Nakamura Kashiwagi as a *wakashu* (2nd from R), and three unidentified actors as *yakko* 8) 16.9 x 27.3 cm 10) Buckingham 1938.510 *) Page from the illustrated book *Yakusha Kuni no Hana* (ca. 1772)

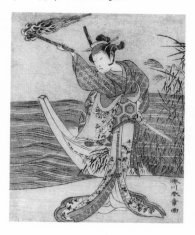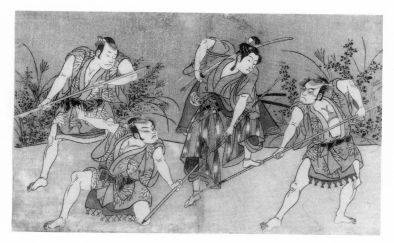

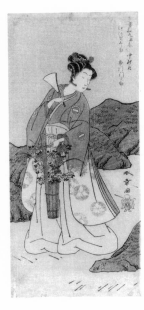

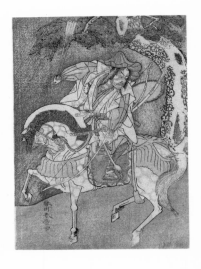

明和九壬辰

吾老

183

1) The face of Ichikawa Danjūrō V, made-up for the "Shibaraku" role, reflected in a mirror, together with the "Shibaraku" costume. Calendar print (*e-goyomi*) with numerals hid-den in design of the costume. 4) 1/1772 5) *Gorō* (attributed to Katsu-kawa Shunshō) 8) *koban*; 18 x 22.5 cm 10) Gookin 1939.575

184

1) Ichikawa Monnosuke II as Shira-giku, a temple page 2) *Haru wa Soga Akebono-zōshi* 3) Nakamura 4) 1/1772 5) *Shunshō ga*; Hayashi in jar-shaped outline 8) *hosoban*; 32 x 14.4 cm 9) CMA 10) Gookin 1939.776

185

1) Matsumoto Kōshirō II as Kage-kiyo disguised as Ōmi Yawatano-suke 2) *Haru wa Soga Akebono-zōshi* 3) Nakamura 4) 1/1772 5) *Katsukawa Shunshō ga* 8) *chūban*; 25.4 x 18.2 cm 10) Gookin 1939.761

186

1) Ichikawa Monnosuke II as Soga no Gorō Tokimune 2) *Haru wa Soga Akebono-zōshi* (?) 3) Naka-mura (?) 4) 1/1772 (?) 5) *Shunshō ga*; Hayashi in jar-shaped outline 8) *hosoban*; 30.1 x 14.6 cm 10) Buckingham 1925.2417 *) Left sheet of triptych

187

1) Arashi Sangorō II as Sakura-maru 2) *Sugawara Denju Tenarai Kagami* 3) Ichimura 4) 1/1772 5) *Shunshō ga*; Hayashi in jar-shaped outline 6) Nishimuraya Yohachi 8) *hosoban*; 31.3 x 15.5 cm 9) HAA; BMFA 10) Buckingham 1952.372

188

1) Arashi Sangorō II as Sakura-maru 2) *Sugawara Denju Tenarai Kagami* 3) Ichimura 4) 1/1772 5) *Shunshō ga* 8) *hosoban*; 30.2 x 14.2 cm 10) Gookin 1939.588 *) Right sheet of a multisheet print

189

1) Nakamura Tomijūrō I as the Chinese hero Kan'u 2) *Hatsu Akebono Niwatori Soga* 3) Morita 4) 1/1772 5) *Shunshō ga* 8) *hosoban*; 30.5 x 15 cm 10) Gookin 1939.716 *) From a multisheet composition (?)

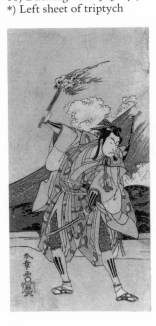

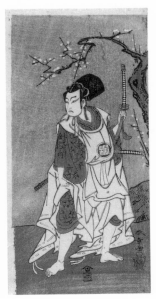

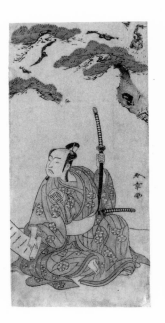

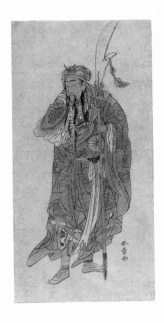

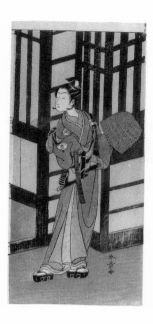 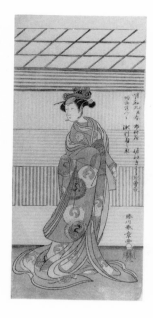 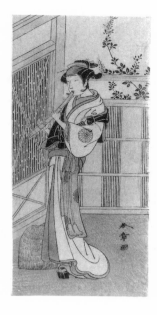 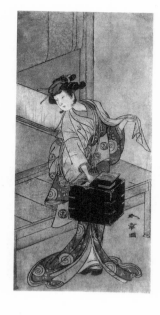

190
1) Onoe Tamizō I as Kewaizaka
no Shōshō disguised as a *komusō*
2) *Furisode Kisaragi Soga* 3) Ichi-
mura 4) 2/1772 5) *Shunshō ga*
8) *hosoban*; 31.7 x 14.6 cm
10) Buckingham 1938.483

191
1) Segawa Kikunojō II as the cour-
tesan Maizuru 2) *Furisode Kisaragi
Soga* 3) Ichimura 4) 2/1772 5) *Kat-
sukawa Shunshō ga*; *Hayashi* in jar-
shaped outline 6) Iseya 8) *hosoban*;
32 x 14.4 cm 10) Buckingham
1925.2414 *) From a multisheet
composition

192
1) Nakamura Noshio I as Misao
disguised as a *komusō* 2) *Kosode-gura
no Tekubari* 3) Morita 4) 2/1772 (?)
5) *Shunshō ga* 8) *hosoban*; 29 x 14.2
cm 10) Buckingham 1932.1025

193
1) Yamashita Kinsaku II as Miya-
gino disguised as a hairdresser
2) *Kosode-gura no Tekubari* 3) Morita
4) 2/1772 (?) 5) *Shunshō ga*
8) *hosoban*; 29.6 x 14 cm 10)
Gookin 1939.609

194
1) Ichikawa Danjūrō V as the *yakko*
Matsueda Sakinosuke 2) *Keisei
Momiji no Uchikake* 3) Morita
4 7/1772 5) *Katsukawa Shunshō
ga*; *Hayashi* in jar-shaped outline
8) *hosoban*; 32.5 x 15 cm 9) UT5,
pl. 160 10) Gookin 1939.623

195
1) Ōtani Hiroemon III as Shinoda
Jirodayū 2) *Keisei Momiji no Uchi-
kake* 3) Morita 4) 7/1772 5) *Katsu-
kawa Shunshō ga*; *Hayashi* in jar-
shaped outline 8) *hosoban*; 33 x 15.3
cm 9) NAM 10) Gift of Mr. and
Mrs. James A. Michener 1958.156

196
1) Nakamura Jūzō II as Yūshichi
(?) 2) *Keisei Momiji no Uchikake* (?)
3) Morita (?) 4) 7/1772 (?) 5) *Katsu-
kawa Shunshō ga* 6) Maruya Jimpa-
chi 8) *hosoban*; 33 x 14.6 cm
9) TNM 10) Gookin 1939.765

197
1) Nakamura Matsue I as Kasaya
Sankatsu (?) 2) *Hana no Gosho
Konegen Butai* (?) 3) Nakamura (?)
4) 8/1772 (?) 5) *Shunshō ga* 8) *hoso-
ban*; 33.5 x 15.1 cm 10) Bucking-
ham 1925.2423

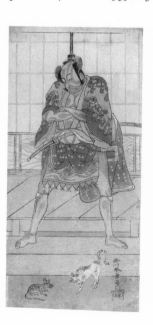 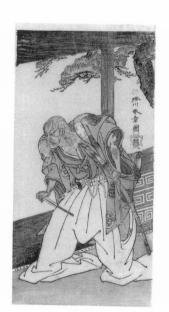 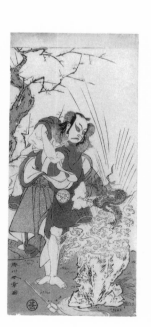 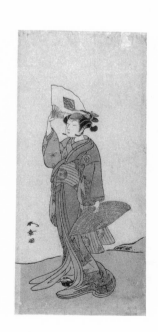

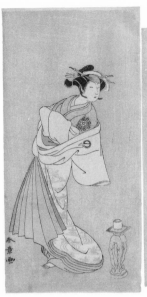

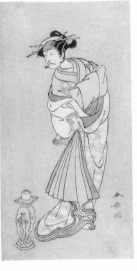

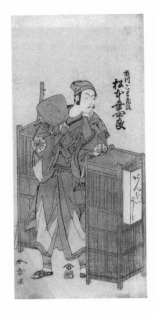

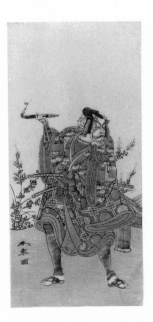

198

1) Ichikawa Danjūrō V as the Spirit of Monk Seigen (R), and Nakamura Noshio I as the Spirit of Takao (L) 2) *Keisei Momiji no Uchikake* 3) Morita 4) 9/1772 5) *Shunshō ga* 8) hosoban, diptych; 29.1 x 14.4 cm (R), 32.3 x 15 cm (L) 9) YUAG, LL2, UTS8, no. 8 (R) 10) Buckingham 1932.996 (R), 1932.997 (L)

199

1) Ōtani Tomoemon I as Kawatabiya Mombei 2) *Ōyoroi Ebidō Shinozuka* 3) Nakamura 4) 11/1772 5) *Shunshō ga* 8) hosoban; 30.7 x 13.8 cm 9) Succo (1922), pl. 4 10) Gookin 1939.702 *) See No. 60

200

1) Matsumoto Kōshirō IV as Sagami Jirō disguised as Ambaiyoshi Gorohachi 2) *Ōyoroi Ebidō Shinozuka* 3) Nakamura 4) 11/1772 5) *Shunshō ga* 6) Nishimuraya Yohachi 8) hosoban; 31.2 x 14.2 cm 10) Buckingham 1925.2425

201

1) Matsumoto Kōshirō IV as Sagami Jirō disguised as Ambaiyoshi Gorohachi 2) *Ōyoroi Ebidō Shinozuka* 3) Nakamura 4) 11/1772 5) *Shunshō ga* 8) hosoban; 32.5 x 15.4 cm 10) Gookin 1939.622

202

1) Ichikawa Yaozō II as Ashikaga Motouji disguised as Katagiri Yashichi 2) *Ōyoroi Ebidō Shinozuka* 3) Nakamura 4) 11/1772 5) *Shunshō ga* 8) hosoban; 31.6 x 14.6 cm 10) Gookin 1939.651 *) Right sheet of diptych (?)

203

1) Ichikawa Raizō II as Murakami Hikoshirō Yoshiteru 2) *Ōyoroi Ebidō Shinozuka* 3) Nakamura 4) 11/1772 5) *Shunshō ga* 8) hosoban; 29.4 x 14.2 cm 9) SNS, pl. 141 10) Gookin 1939.585

204

1) Ichikawa Danzaburō II as Usui no Sadamitsu (?) 2) *Edo Katagi Hikeya Tsunasaka* (?) 3) Ichimura (?) 4) 11/1772 (?) 5) *Shunshō ga* 8) hosoban; 32.8 x 15.1 cm 10) Buckingham 1925.2424

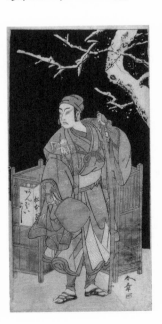

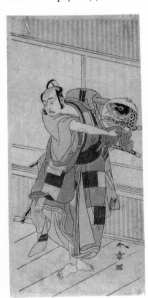

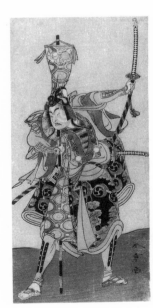

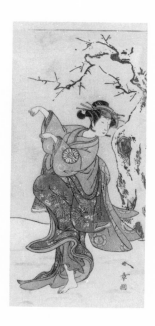

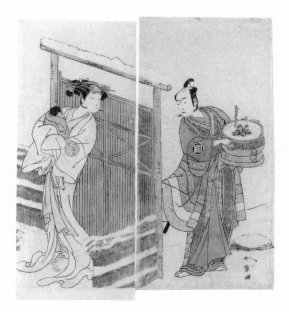

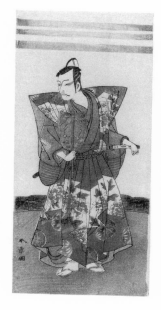

205

1) Nakamura Noshio I as the Fox-Wife from Furui 2) *Izu-goyomi Shibai no Ganjitsu* 3) Morita 4) 11/1772 5) *Shunshō ga* 8) *hosoban*; 32.5 x 15 cm 10) Buckingham 1932.1023 *) See No. 61

206

1) Arashi Sangorō II as Itō Kurō disguised as Banta (R), and Yamashita Kinsaku II as Moshio (L) 2) *Izu-goyomi Shibai no Ganjitsu* 3) Morita 4) 11/1772 5) *Shunshō ga* 8) *hosoban*; 30.1 x 14.3 cm (R), 30.7 x 12.6 cm (L) 9) MG (L) 10) Buckingham 1930.347 (R), Gookin 1939.675 (L)

207

1) Ichikawa Danjūrō V as Kudō Kanaishi 2) *Izu-goyomi Shibai no Ganjitsu* 3) Morita 4) 11/1772 5) *Shunshō ga* 8) *hosoban*; 31.8 x 15 cm 9) BMFA (complete triptych) 10) Buckingham 1925.2384 *) Center sheet of triptych

208

1) Yamashita Kinsaku II as Moshio 2) *Izu-goyomi Shibai no Ganjitsu* 3) Morita 4) 11/1772 5) *Shunshō ga* 8) *hosoban*; 29.3 x 14 cm 10) Buckingham 1925.2421

209

1) Nakamura Jūzō II as Kajiwara Genta Kagetoki 2) *Izu-goyomi Shibai no Ganjitsu* 3) Morita 4) 11/1772 5) *Shunshō ga* 8) *hosoban*; 31.2 x 14.4 cm 10) Gookin 1939.764 *) Left sheet of a multisheet composition (?)

210

1) Ichikawa Danjūrō V as Kudō Kanaishi (?) 2) *Izu-goyomi Shibai no Ganjitsu* (?) 3) Morita (?) 4) 11/1772 (?) 5) *Shunshō ga* 8) *hosoban*; 31.6 x 14.3 cm 10) Gookin 1939.607 *) Left sheet of a multisheet composition

211

1) Pl. 6 (Examining the Newly Spun Cocoons) 2) *Kaiko Yashinai-gusa* 4) ca. 1772 5) *Shunshō ga* 8) *chūban*; 25.2 x 19 cm 9) TNM, OMM, TSM, BM, NYPL 10) Gift of Chester W. Wright 1961.200

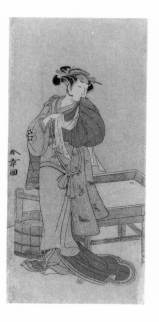

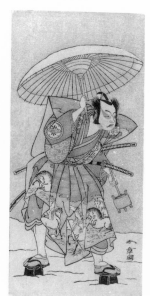

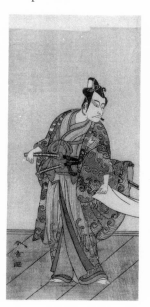

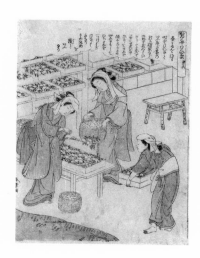

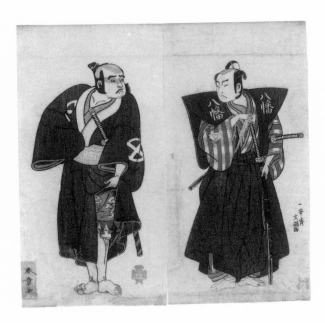
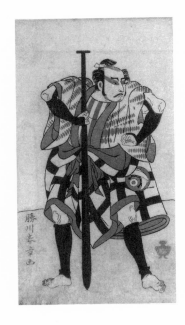
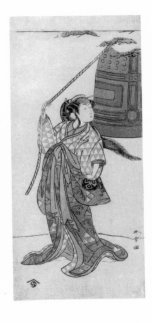

212

1) Onoe Matsusuke I as Yawata no Saburō (by Ippitsusai Bunchō) (R), and Ōtani Tomoemon I as the *yakko* Emohei (L) 2) *Myōto-giku Izu no Kisewata* 3) Ichimura 4) 11/1770 5) *Shunshō ga*; *Hayashi* in red jar-shaped outline (both later additions) 6) Kariganeya Ihei (?) 8) 27.8 x 13.8 cm (trimmed) (R), 27.8 x 14 cm (trimmed) (L) 10) Gookin 1939.590 *) Book illustrations from the later edition of *Ehon Butai Ōgi*, published ca. 1772

213

1) Kasaya Matakurō II as the boatman Rokuzō 2) play title unknown 3) Morita 4) 5/1770 5) *Katsukawa Shunshō ga*; *Hayashi* in red jar-shaped outline (both later additions) 6) Kariganeya Ihei (?) 8) 27.7 x 15 (trimmed) 10) Gookin 1939.762 *) Book illustration from the later edition of *Ehon Butai Ōgi*, published ca. 1772

214

1) Arashi Hinaji I dancing "Musume Dōjō-ji" 4) ca. 1772 5) *Shunshō ga* 6) Nishimuraya Yohachi 8) *hosoban*; 31.5 x 14.3 cm 10) Buckingham 1925.2390

215

1) The warrior Ōmori Hikoshichi carrying a female demon on his back 4) ca. 1772 5) *Katsukawa Shunshō ga* 8) *chūban*; 26.3 x 19.2 cm 10) Gookin 1939.593 *) See No. 62

216

1) Arashi Hinaji I 4) ca. 1772 5) *Shunshō ga* 3) *hosoban*; 32.5 x 14.7 cm 10) Buckingham 1952.377 *) See No. 53

217

1) Ichikawa Yaozō II as Iba no Jūzō (?) 4) ca. 1772 5) *Shunshō ga* 8) *hosoban*; 31.4 x 14.2 cm 10) Gookin 1939.601 *) Right sheet of diptych, the left panel of which shows Ōtani Tomoemon I (?)

218

1) Ichikawa Danjūrō V 4) ca. 1772 5) *Katsukawa Shunshō ga* 6) Yamahei (unrecorded elsewhere) 8) *hosoban*; 30.6 x 14.1 cm 9) TNM 10) Gookin 1939.774

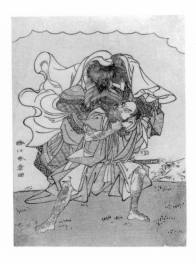
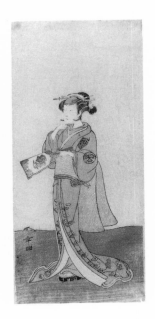
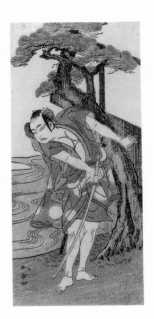
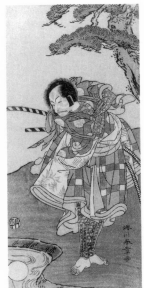

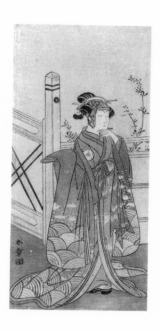

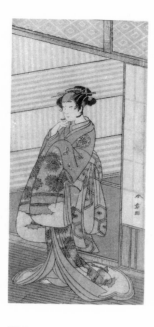

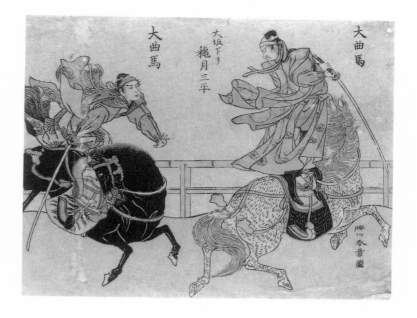

219

1) Iwai Hanshirō IV 4) ca. 1772
5) *Shunshō ga* 8) *hosoban*; 29 x 13.7
cm 10) Gookin 1939.598

220

1) Nakamura Noshio I 4) ca. 1772
5) *Shunshō ga* 8) *hosoban*; 29.5 x
13.8 cm 9) CM 10) Gookin
1939.701

221

1) Akizuki Sampei from Osaka
standing on a galloping horse
(R) 2) *Dai Kyokuba* 4) ca. 1772
5) *Katsukawa Shunshō ga* 8) *aiban*
(trimmed); 21.8 x 28 cm 10) Kate
S. Buckingham Collection

1939.170 *) Possibly a perfor-
mance in the Yagenbori moat,
which was filled in between the
sixth and eleventh month, 1771

222

1) Title page 2) *Fūryū Nishiki-e
Ise Monogatari* 4) ca. 1772–1773
5) Unsigned 8) Buckingham
1928.984–0. See No. 63A

223

1) *i*: Coming of Age 2) *Fūryū
Nishiki-e Ise Monogatari* 4) ca.
1772–1773 5) *Katsukawa Shunshō
ga* 9) HC; BM; HAA; FGA; AIC
1939.780 10) Buckingham
1928.984–1 *) McCullough
(1968), no. 1.

224

1) *ro*: Seaweed 2) *Fūryū Nishiki-e
Ise Monogatari* 4) ca. 1772–1773
5) *Shunshō ga* 9) HC; BM; HAA;
AIC 1939.781 10) Buckingham
1928.984–2 *) McCullough (1968),
no. 3

225

1) *ha*: Guards at the "Love Pas-
sage" 2) *Fūryū Nishiki-e Ise Mono-
gatari* 4) ca. 1772–1773 5) *Shunshō
ga* 9) HC; BM; HAA 10) Bucking-
ham 1928.984–3 *) McCullough
(1968), no. 5

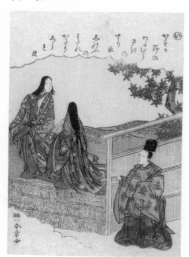

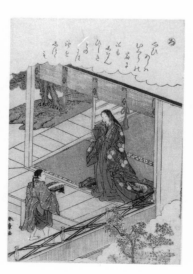

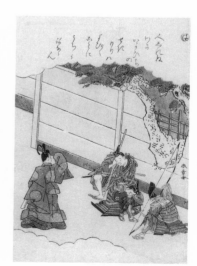

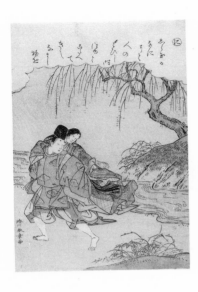
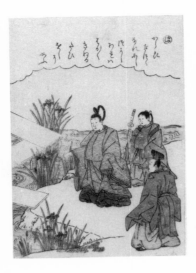
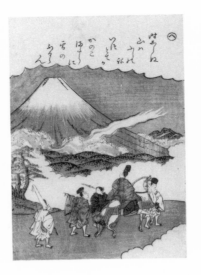
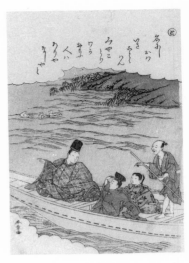

226

1) *ni*: Akutagawa 2) *Fūryū Nishiki-e Ise Monogatari* 4) ca. 1772–1773 5) *Katsukawa Shunshō ga* 8) *koban*; 23 x 15.6 cm 9) HAA; MG; BM; AMAM; HC 10) Buckingham 1928.984–4 *) McCullough (1968), no. 6. See No. 63B.

227

1) *ho*: Yatsuhashi Bridge in Mikawa Province 2) *Fūryū Nishiki-e Ise Monogatari* 4) ca. 1772–1773 9) HC; BM; HAA; AIC 1939.783 10) Buckingham 1928.984–5 *) McCullough (1968), no. 9.

228

1) *he*: Mt. Fuji, Suruga Province 2) *Fūryū Nishiki-e Ise Monogatari* 4) ca. 1772–1773 9) HC; BM 10) Buckingham 1928.984–6 *) McCullough (1968), no. 9

229

1) *to*: Sumida River, Musashi and Shimōsa provinces 2) *Fūryū Nishiki-e Ise Monogatari* 4) ca. 1772–1773 9) HC; BM; HAA 10) Buckingham 1928.984–7 *) McCullough (1968), no. 9

230

1) *chi*: Musashi Plain 2) *Fūryū Nishiki-e Ise Monogatari* 4) ca. 1772–1773 5) *Shunshō ga* 8) *koban*; 22.8 x 16 cm 9) HAA; BM; AMAM; HC 10) Buckingham 1928.984–8 *) McCullough (1968), no. 12. See No. 63C

231

1) *ri*: The Well Curb 2) *Fūryū Nishiki-e Ise Monogatari* 4) ca. 1772–1773 5) *Katsukawa Shunshō ga*; *Hayashi* in jar-shaped outline 9) HC; BM 10) Buckingham 1928.984–9 *) McCullough (1968), no. 23

232

1) *nu*: The Well Curb 2) *Fūryū Nishiki-e Ise Monogatari* 4) ca. 1772–1773 9) HC; BM 10) Buckingham 1928.984–10 *) McCullough (1968), no. 23

233

1) *ru*: Northern Province 2) *Fūryū Nishiki-e Ise Monogatari* 4) ca. 1772–1773 9) HC; BM 10) Buckingham 1928.984–11 *) McCullough (1968), no. 14

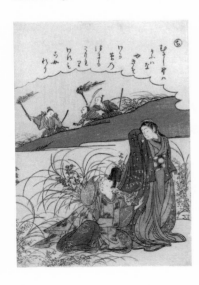
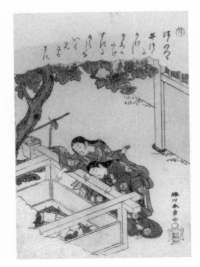
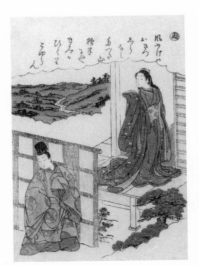
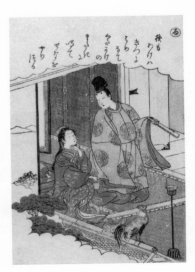

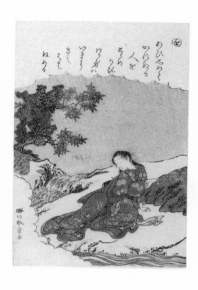

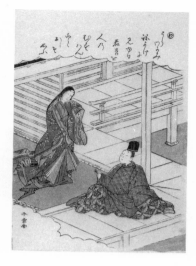

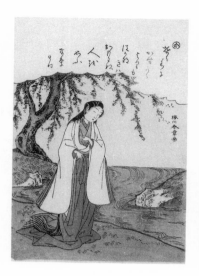

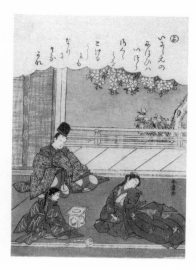

234

1) *o*: Catalpa Bow 2) *Fūryū Nishiki-e Ise Monogatari* 4) ca. 1772–1773 5) *Katsukawa Shunshō ga* 9) HC; BM; WB 10) Buckingham 1928.984–12 *) McCullough (1968), no. 24

235

1) *wa*: Young Grass 2) *Fūryū Nishiki-e Ise Monogatari* 4) ca. 1772–1773 5) *Shunshō ga* 9) HC; BM; HAA; MG; AIC 1939.784 10) Buckingham 1928.984–13 *) McCullough (1968), no. 49

236

1) *ka*: A Court Lady Thinks Disconsolately of Her Lover 2) *Fūryū Nishiki-e Ise Monogatari* 4) ca. 1772–1773 5) *Katsukawa Shunshō ga* 9) HC; BM; MG; FGA 10) Buckingham 1928.984–14 *) McCullough (1968), no. 50

237

1) *yo*: A Man Meets a Former Sweetheart, now Serving in a Provincial Household 2) *Fūryū Nishiki-e Ise Monogatari* 4) ca. 1772–1773 5) *Shunshō ga* 9) HC; BM; MG; WS 10) Buckingham 1928.984–15 *) McCullough (1968), no. 62

238

1) *ta*: Purification Ceremony to Remove the Pains of Love 2) *Fūryū Nishiki-e Ise Monogatari* 4) ca. 1772–1773 5) *Shunshō ga* 9) HC; BM 10) Buckingham 1928.984–16 *) McCullough (1968), no. 65

239

1) *re*: The Imperial Huntsman 2) *Fūryū Nishiki-e Ise Monogatari* 4) ca. 1772–1773 5) *Shunshō ga* 9) HC; BM; HAA; AIC 1939.785 10) Buckingham 1928.984–17 *) McCullough (1968), no. 69

240

1) *so*: A Coquettish Woman 2) *Fūryū Nishiki-e Ise Monogatari* 4) ca. 1772–1773 5) *Katsukawa Shunshō ga* 9) HC; BM 10) Buckingham 1928.984–18 *) McCullough (1968), no. 71

241

1) *tsu*: Narihira in the Snow at Ono 2) *Fūryū Nishiki-e Ise Monogatari* 4) ca. 1772–1773 5) *Shunshō ga* 8) *koban*; 22.6 x 15.9 cm 9) HAA; BM; HC 10) Buckingham 1928.984–19 *) McCullough (1968), no. 83. See No. 63D

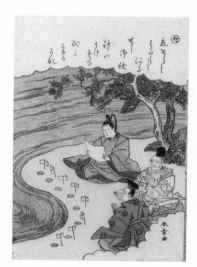

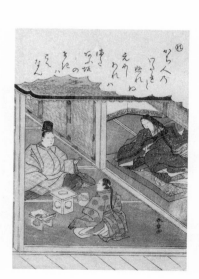

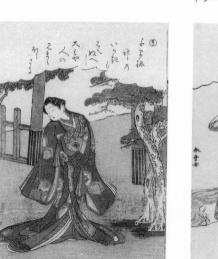

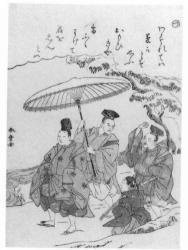

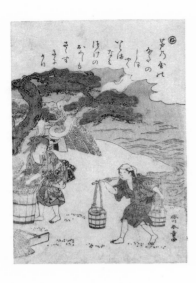

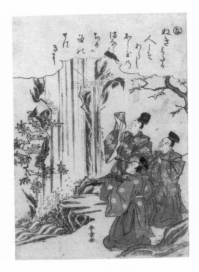

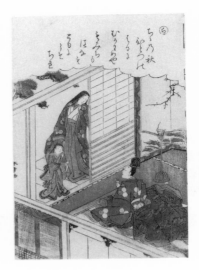

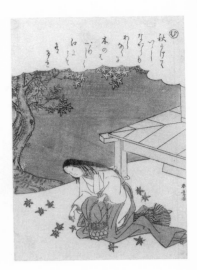

242

1) *ne*: Brine Carriers 2) *Fūryū Nishiki-e Ise Monogatari* 4) ca. 1772–1773 5) *Katsukawa Shunshō ga* 9) HC; BM; HAA; MG; TSM 10) Buckingham 1928.984–20 *) McCullough (1968), no. 87.

243

1) *na*: Nunobiki Waterfall 2) *Fūryū Nishiki-e Ise Monogatari* 4) ca. 1772–1773 5) *Shunshō ga* 9) HC; BM 10) Buckingham 1928.984–21 *) McCullough (1968), no. 87

244

1) *ra*: Narihira Requests a Painting from a Former Lover 2) *Fūryū Nishiki-e Ise Monogatari* 4) ca. 1772–1773 5) *Shunshō ga* 9) HC; BM; HAA; AIC 1939.786 10) Buckingham 1928.984–22 *) McCullough (1968), no. 94

245

1) *mu*: Clapping the Hands to Effect a Curse 2) *Fūryū Nishiki-e Ise Monogatari* 4) ca. 1772–1773 5) *Shunshō ga* 9) HC; BM; MG 10) Buckingham 1928.984–23 *) McCullough (1968), no. 96

246

1) *u*: Narihira Presents a Chancellor with a Model of a Pheasant 2) *Fūryū Nishiki-e Ise Monogatari* 4) ca. 1772–1773 5) *Shunshō ga* 9) HC; BM; HAA; FGA; AIC 1939.787 10) Buckingham 1928.984–24 *) McCullough (1968), no. 98

247

1) The Chinese Immortal Seiōbo 4) ca. 1770s 5) *Shunshō ga* 8) *chūban*; 25.4 x 17.7 cm 10) Gookin 1939.574 (See No. 64)

248

1) Arashi Sangorō II as Asahina Saburō 2) *Iro Maki-e Soga no Sakazuki* 3) Morita 4) 1/1773 5) *Shunshō ga*; *Hayashi* in jar-shaped outline 8) *hosoban*; 30.5 x 13.8 cm 10) Buckingham 1925.2420 *) From a multisheet composition (?)

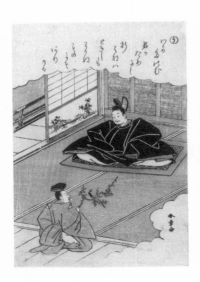

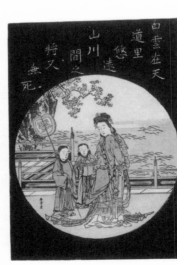

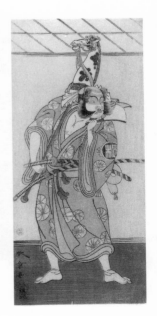

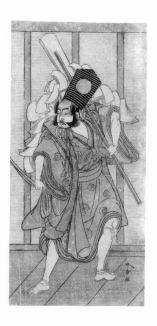
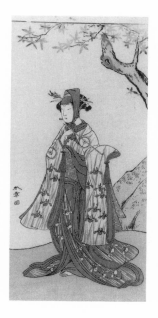
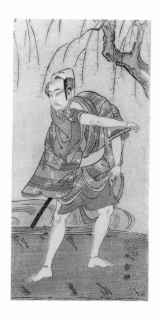
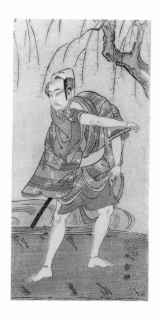

249
1) Arashi Sangorō II as Asahina Saburō 2) *Iro Maki-e Soga no Saka-zuki* 3) Morita 4) 1/1773 5) *Shun-shō ga* 8) *hosoban*; 30.4 x 14.3 cm 10) Gookin 1939.748 *) Right sheet of diptych

250
1) Iwai Hanshirō IV as Princess Sakura (Sakura Hime) 2) *Wada Sakamori Eiga Kagami* 3) Naka-mura 4) 3/1773 5) *Shunshō ga* 8) *hosoban*; 31.3 x 15 cm 10) Gift of Mr. and Mrs. Gaylord Donnel-ley 1971.481 *) Right sheet of diptych (?)

251
1) Ichikawa Ebizō III as Akushichi-byōe Kagekiyo (?) 2) *Wada Saka-mori Eiga Kagami* (?) 3) Nakamura (?) 4) 3/1773 (?) 5) *Shunshō ga*; *Hayashi* in jar-shaped outline 6) Maruya Jimpachi 8) *hosoban*; 33 x 14.7 cm 9) TNM 10) Gookin 1939.594

252
1) Ichikawa Yaozō II as Hiranoya Tokubei (?) 2) *Wada Sakamori Eiga Kagami* (?) 3) Nakamura (?) 4) 3/1773 (?) 5) *Shunshō ga* 8) *hoso-ban*; 29.7 x 14.2 cm 10) Gift of Mr. and Mrs. James A. Mitchener 1958.155 *) Right sheet of diptych (?)

253
1) Onoe Matsusuke I as Kobayashi no Asahina disguised a bird-catcher 2) *Edo no Haru Meisho Soga* 3) Ichimura 4) 3/1773 5) *Shunshō ga* 8) *hosoban*; 29.6 x 12.6 cm 10) Gookin 1939.663

254
1) Arashi Hinaji I as Hananoi 2) *Gosho-zakura Horikawa Youchi* 3) Ichimura 4) 4/1773 5) *Shunshō ga* 8) *hosoban*; 30.5 x 14.3 cm 10) Buckingham 1925.2439 *) Left sheet of diptych (?)

255
1) Bandō Mitsugorō I as Hata no Kawakatsu (R), and Ōtani Hiroe-mon III as the *yakko* Gansuke (L) 2) *Miya-bashira Iwao no Butai* 3) Morita 4) 7/1773 5) *Shunshō ga* 8) *hosoban*, diptych; 31.2 x 15.5 cm (R), 31.5 x 15.3 cm (L) 9) BMFA (L) 10) Buckingham 1932.999 *) See No. 65

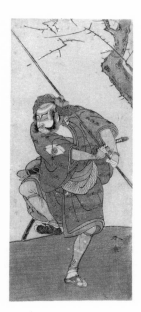
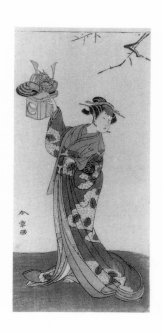
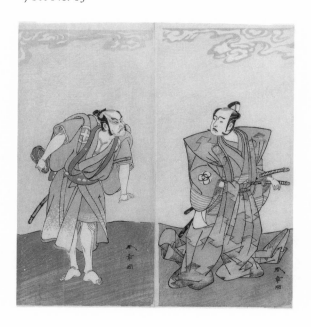

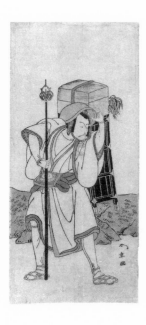

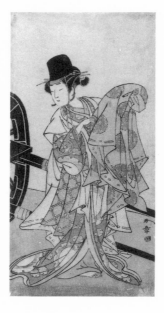

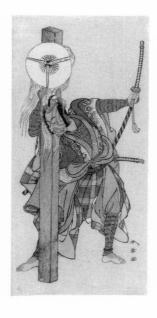

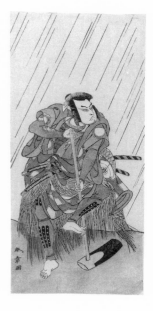

256

1) Ichikawa Danjūrō V as Moriya no Daijin disguised as Rokujū-rokubu 2) *Miya-bashira Iwao no Butai* 3) Morita 4) 7/1773 5) *Shunshō ga* 8) *hosoban*; 33 x 14.7 cm 9) HAA; SM 10) Gookin 1939.740 *) Left sheet of diptych (?)

257

1) Ichikawa Danjūrō V as Atomi no Ichii 2) *Miya-bashira Iwao no Butai* 3) Morita 4) 7/1773 5) *Shun-shō ga* 8) *hosoban*; 31.3 x 15 cm 9) HAA 10) Buckingham 1932.1001

258

1) Yamashita Kinsaku II as Tsuki-masu acting as Sakura-maru 2) *Miya-bashira Iwao no Butai* 3) Morita 4) 7/1773 5) *Shunshō ga* 8) *hosoban*; 27.7 x 13.7 cm 9) MAK, WT 10) Gift of Chester W. Wright 1961.198 *) Right sheet of triptych

259

1) Onoe Matsusuke I as Nakaōmi Katsumi disguised as the farmer Datta no Nizō 2) *Shitennō-ji Nobori Kuyō* 3) Ichimura 4) 8/1773 5) *Shunshō ga* 8) *hosoban*; 31.7 x 14.9 cm 10) Buckingham 1925.2430 *) From a multi-sheet composition (?)

260

1) Onoe Tamizō I as Shōtoku Tai-shi (?) disguised as a young build-ing worker (R), and Nakamura Rikō I as Hakata no Kojorō (?) (L) 2) *Shitennō-ji Nobori Kuyō* 3) Ichi-mura 4) 8/1773 5) *Shunshō ga*

8) *hosoban*; 29.4 x 13 cm (R), 32.3 x 14.4 cm (L) 10) Buckingham 1925.2432 (R), 1938.484 (L)

261

1) Matsumoto Kōshirō IV as Matsuō-maru 2) *Sugawara Denju Tenarai Kagami* 3) Nakamura 4) 9/1773 5) *Shunshō ga* 8) *hosoban*; 31.5 x 14.8 cm 9) UT5, pl. 80 10) Gift of Mr. and Mrs. H. George Mann 1974.464

262

1) Nakamura Nakazō I as Prince Koreakira 2) *Gohiiki Kanjinchō* 3) Nakamura 4) 11/1773 5) *Shunshō ga* 8) *hosoban*; 32.5 x 14.9 cm 9) HRWK 10) Buckingham 1925.2440 *) See No. 66

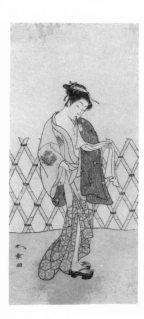

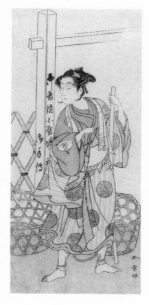

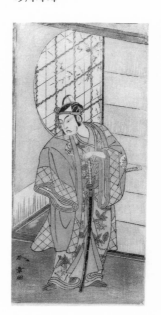

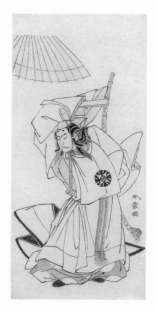

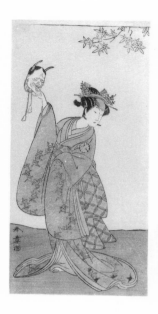
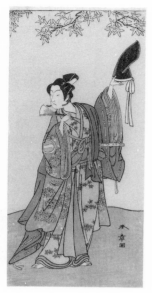
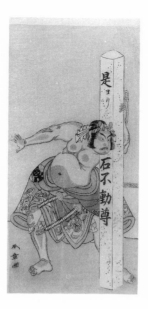
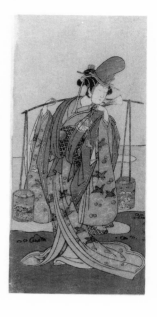

263
1) Ichikawa Monnosuke II as Shi-
mokōbe Shōji Yukihira (R), and
Segawa Yūjirō I as Matsukaze (L)
2) *Gohiiki Kanjinchō* 3) Nakamura
4) 11/1773 5) *Shunshō ga* 8) hoso-

ban, left and center sheets of a trip-
tych (?); 30.2 x 14.3 cm (C), 29.9 x
14.6 cm (L) 10) Buckingham
1925.2431 (R), 1925.2429 (L)
*) See No. 67

264
1) Bandō Matatarō IV as Bandō
Tarō 2) *Gohiiki Kanjinchō* 3) Naka-
mura 4) 11/1773 5) *Shunshō ga*
8) *hosoban*; 32.1 x 14.9 cm
10) Gookin 1939.728 *) Left
sheet of diptych (?)

265
1) Segawa Kitsuji III as Murasame
2) *Gohiiki Kanjinchō* 3) Nakamura
4) 11/1773 5) *Shunshō ga* 8) *hoso-
ban*; 29.7 x 13.7 cm 10) Gookin
1939.725 *) Left sheet of a multi-
sheet composition

266
1) Ichikawa Monnosuke II as Shi-
mokōbe Shōji Yukihira 2) *Gohiiki
Kanjinchō* 3) Nakamura 4) 11/1773
5) *Shunshō ga* 8) *hosoban*; 31 x 14.7
cm 10) Buckingham 1932.1002
*) Right sheet of diptych (?)

267
1) Segawa Kitsuji III as Murasame
2) *Gohiiki Kanjinchō* 3) Nakamura
4) 11/1773 5) *Shunshō ga* 8) *hoso-
ban*; 29.8 x 14.5 cm 9) RAM
10) Buckingham 1925.2434
*) Right sheet of triptych (?)

268
1) Nakamura Rikō I as the courte-
san Wakamatsu (?) 2) *Gohiiki Kan-
jinchō* (?) 3) Nakamura (?) 4) 11/
1773 (?) 5) *Shunshō ga* 8) *hosoban*;
32.3 x 15.1 cm 10) Gookin
1939.625

269
1) Nakamura Nakazō I as Prince
Koreakira (?) 2) *Gohiiki Kanjinchō*
3) Nakamura 4) 11/1773 5) Un-
signed 8) large *hosoban*; 36.1 x 17.2
cm 10) Gookin 1925.2448
*) Cf. No. 66

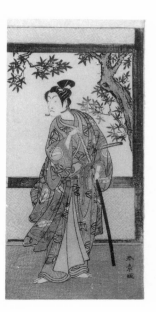
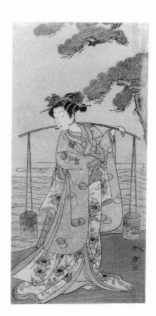
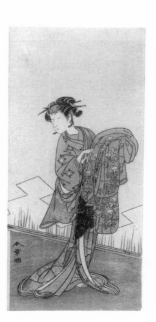
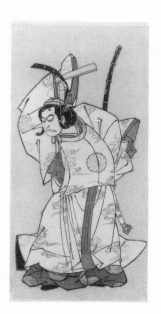

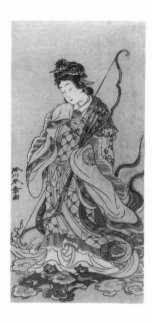

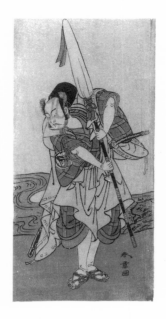

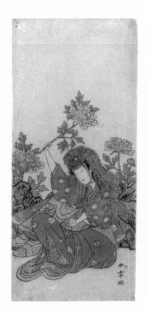

270

1) Nakamura Noshio I as the Goddess Benzaiten of Enoshima
2) *Onna Aruji Hatsuyuki no Sekai*
3) Morita 4) 11/1773 5) *Katsukawa Shunshō ga* 8) *hosoban*; 29.4 x 13.6 cm 10) Gookin 1939.709

271

1) Nakamura Jūzō II as Asahara Hachirō disguised as the servant of a princely family 2) *Onna Aruji Hatsuyuki no Sekai* 3) Morita 4) 11/1773 5) *Shunshō ga* 8) *hosoban*; 30.2 x 14.8 cm 9) AIC 1962.982 10) Gookin 1939.757

272

1) Nakamura Noshio I in a "Shakkyō Odori" (Stone Bridge Dance)
2) *Onna Aruji Hatsuyuki no Sekai*
3) Morita 4) 11/1773 5) *Shunshō ga* 8) *hosoban*; 32.7 x 14.2 cm 10) Buckingham 1925.2435

273

1) Bandō Mitsugorō I as Abbot Saimyō-ji Tokiyori disguised as a monk 2) *Onna Aruji Hatsuyuki no Sekai* 3) Morita 4) 11/1773 5) *Shunshō ga* 8) *hosoban*; 31.2 x 13.5 cm 9) LL2; SH 10) Gookin 1939.679 *) See No. 68

274

1) Nakamura Jūzō II as Akita Jōnosuke 2) *Onna Aruji Hatsuyuki no Sekai* 3) Morita 4) 11/1773 5) *Shunshō ga* 8) *hosoban*; 30 x 14.4 cm 10) Gookin 1939.749 *) Left sheet of triptych; center sheet shows Yamashita Kinsaku II as Ran no Kata disguised as a courtesan (BMFA), and right sheet shows Ichikawa Yaozō II as Aoto Magosaburō (SM)

275

1) Yamashita Kinsaku II as Osaku (?) 2) *Onna Aruji Hatsuyuki no Sekai* 3) Morita 4) 11/1773 5) *Shunshō ga* 8) *hosoban*; 31.4 x 14.9 cm 10) Buckingham 1925.2422

276

1) Ichikawa Danjūrō V as Chichibu no Shigetada 4) ca. 1773 5) *Shunshō ga* 8) *hosoban*; 28.7 x 13.8 cm 9) SM 10) Gookin 1939.599 *) From a multisheet composition (?)

277

1) Segawa Yūjirō I 4) ca. 1773 5) *Shunshō ga* 8) *hosoban*; 32.5 x 14.9 cm 9) UT5, pl. 130 10) Buckingham 1925.2433

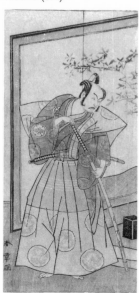

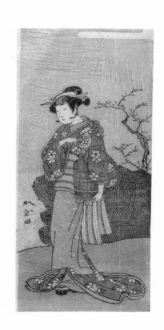

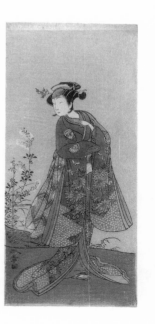

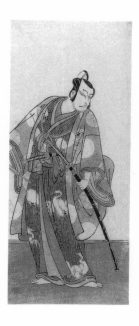

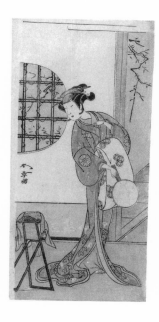

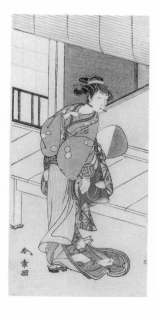

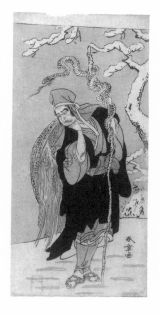

278

1) Ichikawa Danjūrō V 4) ca. 1773
5) *Shunshō ga* (trimmed) 8) *hoso-
ban*; 30.6 x 12.9 cm 9) BMFA
10) Buckingham 1925.2393

279

1) Nakamura Noshio I 4) ca. 1773
5) *Shunshō ga* 8) *hosoban*; 32 x 15.9
cm 9) SM; MG; UT5, pl. 118
10) Buckingham 1932.1027

280

1) Sanogawa Ichimatsu II in an
unidentified role 4) ca. 1773–1774
5) *Shunshō ga* 8) *hosoban*, left
sheet of dipytch (?); 31 x 14.8 cm
10) Buckingham 1925.2426
*) See No. 69

281

1) Ichimura Uzaemon IX as Aza-
maru 2) *Yui Kanoko Date-zome
Soga* 3) Ichimura 4) 1/1774
5) *Shunshō ga* 8) *hosoban*; 31 x 14.6
cm 10) Buckingham 1932.1007

282

1) Onoe Tamizō I as Ōiso no Tora
or Kewaizaka no Shōshō disguised
as a female *komusō* (?) 2) *Yui
Kanoko Date-zome Soga* (?) 3) Ichi-
mura (?) 4) 1/1774 (?) 5) *Shunshō ga*
8) *hosoban*; 31.3 x 14.3 cm 9) VI,
no. 460 10) Buckingham 1950.22
*) From a multisheet composition (?)

283

1) Nakamura Tomijūrō I as Aku-
shichibyōe Kagekiyo 2) *Kite
Hajime Hatsugai Soga* 3) Morita
4) 1/1774 5) *Shunshō ga* 6) Uroko-
gataya Magobei 8) *hosoban*;
31.3 x 14.2 cm 9) SM 10) Gookin
1939.767 *) Right sheet of
diptych (?)

284

1) Nakamura Nakazō I as Ōmi no
Kotōda (R), and Ōtani Hiroji III as
Bamba no Chūda (L) 2) *O-atsurae-
zome Soga no Hinagata* 3) Naka-
mura 4) 3/1774 5) *Shunshō ga*
8) *hosoban*, diptych; each approx.
28.2 x 13.3 cm 9) HGM (both);
TNM (R) 10) Buckingham
1939.2169 *) See No. 70

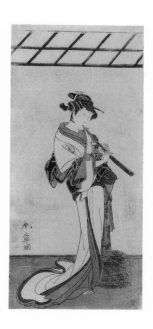

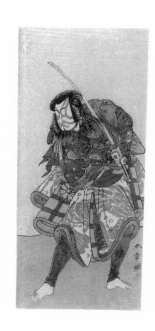

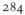

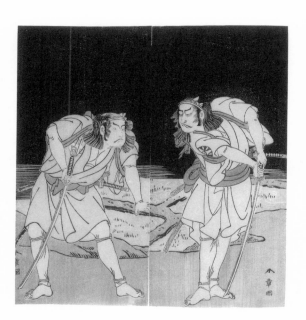

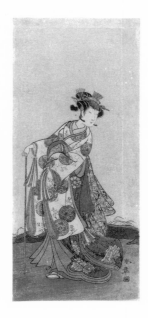
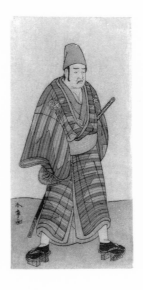
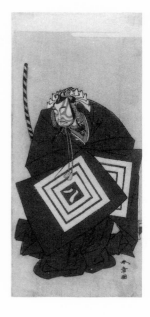

285

1) Segawa Tomisaburō I as Kiyo-
hime 2) *Hanagatami Kazaori Eboshi*
3) Ichimura 4) 3/1774 5) *Katsukawa
Shunshō ga* 8) *hashira-e*; 68.5 x 12
cm 10) Buckingham 1925.2858

286

1) Nakamura Noshio I as Princess
Usuyuki (Usuyuki Hime) 2) *Shin
Usuyuki Monogatari* 3) Morita 4) 5/
1774 5) *Shunshō ga* 8) *hosoban*; 33 x
14.6 cm 9) TNM 10) Buckingham
1928.983 *) Left sheet of diptych (?)

287

1) Ōtani Hiroemon III as Goku-
mon Shōbei 2) *Sugata no Hana
Kurofune Zukin* 3) Morita 4) 9/1774
5) *Shunshō ga* 8) *hosoban*; 29.6 x 14
cm 10) Buckingham 1925.2441
*) From a multisheet composition (?)

288

1) Ichikawa Yaozō II as Hachiō-
maru Aratora 2) *Chigo Sakura
Jūsan Kane* 3) Ichimura 4) 11/1774
5) *Shunshō ga* 8) *hosoban*; 32 x 14.5
cm 9) MIA; UT5, pl. 110 10) Buck-
ingham 1930.110

289

1) Segawa Kikunojō III as Aigo no
Waka 2) *Chigo Sakura Jūsan Kane*
3) Ichimura 4) 11/1774 5) *Shunshō
ga* 8) *hosoban*; 32.3. x 14 cm
10) Gookin 1939.608

290

1) Segawa Kikunojō III as Aigo no
Waka (R), and Ichikawa Yaozō II
as Hachiō-maru Aratora (L)
2) *Chigo Sakura Jūsan Kane* 3) Ichi-
mura 4) 11/1774 5) *Shunshō ga*
8) *hosoban*; 29.8 x 14.7 (R), 29.8 x
15 (L) 9) AFGA (L) 10) Gift of
Chester Wright 1961.197

291

1) Matsumoto Kōshirō IV as
Ogata no Saburō disguised as
Matsuura Saemon 2) *Ichi no Tomi
Tsuki no Kaomise* 3) Morita 4) 11/
1774 5) *Shunshō ga* 8) *hosoban*; 29.8
x 14.2 cm 9) KM; SM 10) Gookin
1939.737 *) From a multisheet
composition (?)

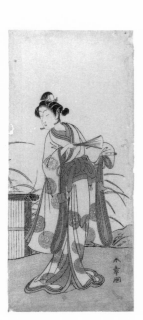
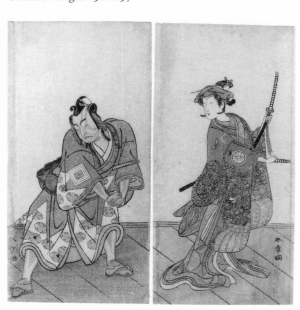
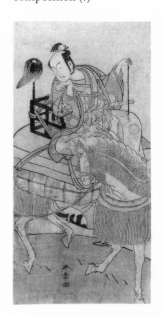

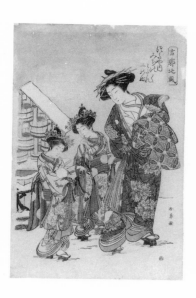
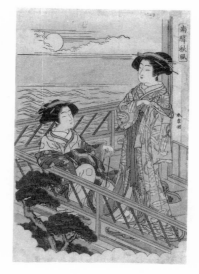
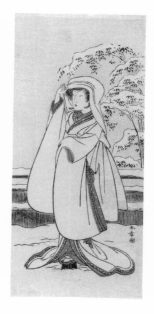
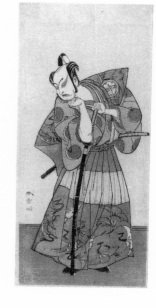

292

1) The courtesan Michinoku of the Tsutaya house with her *kamuro* Midare and Shinobu 2) *Kikkaku Hokufū* 4) ca. 1774 5) *Shunshō ga* 6) Urokogataya Magobei 8) *ōban*; 39.4 x 28.2 cm 10) Buckingham 1929.73

293

1) Two courtesans on a moonlit balcony at a house of pleasure in Shinagawa 2) *Nan'eki Shūfū* 4) ca. 1774 5) *Shunshō ga* 6) Urokogataya Magobei 8) *ōban*; 38 x 25.5 cm 9) MRAH; BN 10) Buckingham 1939.2167

294

1) Segawa Tomisaburō I as the Heron Maiden (Sagi Musume) 4) ca. 1774 5) *Shunshō ga* 8) *hoso-ban*; 32.9 x 14.9 cm 9) HAA 10) Buckingham 1925.2383

295

1) Nakamura Jūzō II 4) ca. 1774 5) *Shunshō ga* 8) large *hosoban*; 38.2 x 17.7 cm 10) Buckingham 1952.375

296

1) Segawa Yūjirō (or Segawa Kikunojō III) 4) ca. 1774 5) *Shunshō ga* 8) *hosoban*; 31.4 x 14.7 cm 10) Buckingham 1925.2428

297

1) Ichikawa Danjūrō V as Soga no Dōzaburō (?) 2) *Shida Yuzuriha Hōrai Soga* (?) 3) Morita (?) 4) 1/1775 (?) 5) *Shunshō ga* 8) *hoso-ban*; 29.8 x 13.5 cm 9) MMA 10) Gookin 1939.680

298

1) Nakamura Noshio I as Ōiso no Tora (?) 2) *Shida Yuzuriha Hōrai Soga* (?) 3) Morita (?) 4) 1/1775 (?) 5) *Katsu Shunshō ga* 8) *hosoban*; 32.4 x 14.8 cm 10) Gookin 1939.626

299

1) Nakamura Nakazō I in the role of an evil courtier, probably Prince Takahito disguised as Asō no Matsuwaka 2) *Iro Moyō Aoyagi Soga* 3) Nakamura 4) 2/1775 5) *Shunshō ga* 8) *hosoban* ; 31.8 x 14.8 cm 10) Buckingham 1932.1013 *) See No. 71

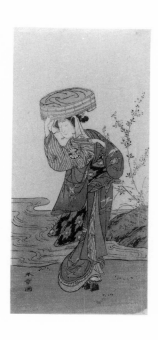
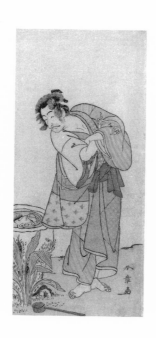
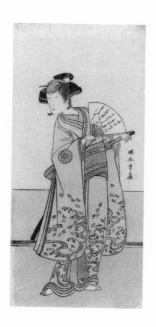
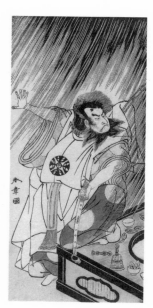

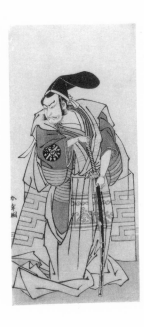

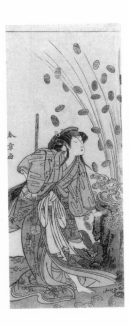

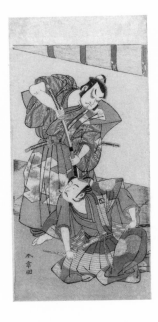

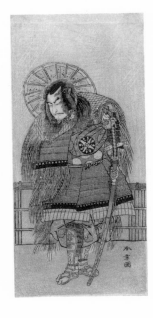

300
1) Nakamura Nakazō I as Kudō Suketsune (?) 2) *Iro Moyō Aoyagi Soga* (?) 3) Nakamura (?) 4) 2/1775 (?) 5) *Shunshō ga* 8) *hosoban*; 30.7 x 13.8 cm 10) Gookin 1939.677

301
1) Segawa Kikunojō III as Hitomaru disguised as the courtesan Chiyozaki 2) *Kuruwa no Hana Katsuragi no Kane* 3) Ichimura 4) 3/1775 5) *Shunshō ga* 8) *hosoban*; 31.4 x 12.4 cm 10) Gookin 1939.750

302
1) Ichikawa Yaozō II as Konoshita Hyōkichi (?) (R), and Sakata Hangorō II as Matsunaga Daizen Hisahide (?) (L) 2) *Gion Sairei Shinkō Ki* (?) 3) Ichimura (?) 4) 5/1775 (?) 5) *Shunshō ga* 8) *hosoban*; 32.3 x 15.3 cm 9) HRWK 10) Buckingham 1925.2436

303
1) Nakamura Nakazō I as Takechi Jūbei Mitsuhide 2) *Shusse Taiheiki* 3) Nakamura 4) 8/1775 5) *Shunshō ga* 8) *hosoban*; 32.7 x 15 cm 10) Gookin 1939.637

304
1) Onoe Tamizō I as Kureha (?) 2) *Shusse Taiheiki* (?) 3) Nakamura (?) 4) 8/1775 (?) 5) *Shunshō ga* 8) *hosoban*; 30 x 13.8 cm 10) Gookin 1939.713

305
1) Nakamura Tomijūrō I as the courtesan Tōyama of Tsuruga 2) *Keisei Tsuki no Miyako* 3) Morita 4) 8/1775 5) *Shunshō ga* 8) *hosoban*; 31.8 x 14.1 cm 10) Buckingham 1939.2189

306
1) Matsumoto Kōshirō IV as Izutsu Onnanosuke (?) 2) *Keisei Tsuki no Miyako* (?) 3) Morita (?) 4) 9/1775 (?) 5) *Shunshō ga* 8) *hosoban*; 30 x 14 cm 10) Gookin 1939.624

307
1) Nakamura Nakazō I as Chinzei Hachirō Tametomo 2) *Hana-zumō Genji Hiiki* 3) Nakamura 4) 11/1775 5) *Shunshō ga* 8) *hosoban*; 32.1 x 15.1 cm 9) BMFA 10) Gookin 1939.766 *) Right sheet of diptych; left sheet shows Arashi Sangorō II as Itō Kurō (BMFA)

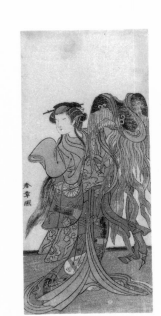

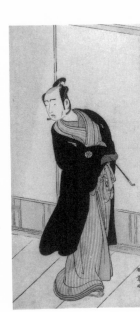

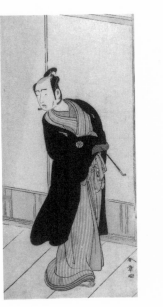

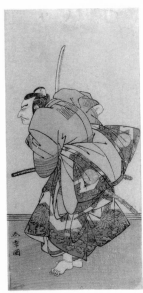

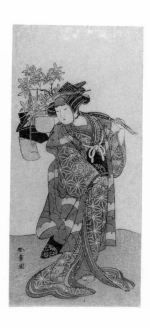
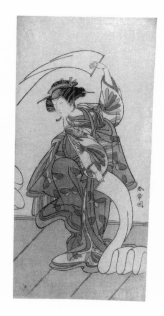
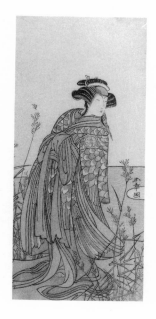

308
1) Yamashita Kinsaku II as Odai, an *eboshi* (hat) seller 2) *Hana-zumō Genji Hiiki* 3) Nakamura 4) 11/1775 5) *Shunshō ga* 8) *hosoban*; 32.8 x 14.8 cm 10) Buckingham 1925.2437

309
1) Nakamura Nakazō I as Sakon-gitsune 2) *Hana-zumō Genji Hiiki* 3) Nakamura 4) 11/1775 5) *Shunshō ga* 8) *hosoban*; 29 x 14.6 cm 9) MMA (complete triptych); SM (R) 10) Buckingham 1925.2456 *) Right sheet of triptych; center sheet shows Ichikawa Danzō IV as the monk Mongaku; left sheet shows Nakamura Rikō I as Chitose (MMA)

310
1) Segawa Kikunojō III as the courtesan Kisegawa in a "Nuno Sarashi" dance 2) *Hana-zumō Genji Hiiki* 3) Nakamura 4) 11/1775 5) *Shunshō ga* 8) *hosoban*; 32.5 x 15.5 cm 10) Buckingham 1925.2386

311
1) Segawa Kikunojō III as the spirit of a mandarin duck (*oshidori*) disguised as Tagasode 2) *Hana-zumō Genji Hiiki* 3) Nakamura 4) 11/1775 5) *Shunshō ga* 8) *hosoban*; 30.7 x 13.8 cm 9) HAA (complete diptych) 10) Buckingham 1925.2438 *) Left sheet of diptych; right sheet shows Arashi Sangorō II as the spirit of a mandarin drake disguised as Kawazu no Saburō (HAA)

312
1) Nakamura Nakazō I as Matano no Gorō 2) *Hana-zumō Genji Hiiki* 3) Nakamura 4) 11/1775 5) *Shunshō ga* 8) *hosoban*; 31.3 x 14.5 cm 9) SM 10) Buckingham 1928.306

313
1) Segawa Kikunojō III as the courtesan Kisewata (Tagasode) (?) 2) *Hana-zumō Genji Hiiki* (?) 3) Nakamura (?) 4) 11/1775 (?) 5) *Shunshō ga* 8) *hosoban*; 31.1 x 14.2 cm 9) LL2, pl. 39 10) Buckingham 1925.2444

314
1) Nakamura Noshio I as a dragon maiden disguised as Tamanami 2) *Oyafune Taiheiki* 3) Ichimura 4) 11/1775 5) *Shunshō ga* 8) *hosoban*; 29.8 x 13.3 cm 10) Gookin 1939.724

315
1) Nakajima Mihoemon II as Bōmon no Saishō Kiyotada 2) *Oyafune Taiheiki* 3) Ichimura 4) 11/1775 5) *Shunshō ga* 8) *hosoban*; 29.8 x 14.3 cm 10) Gookin 1939.747

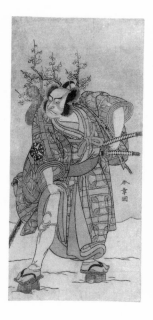
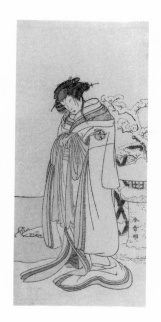
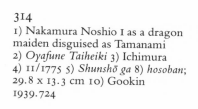
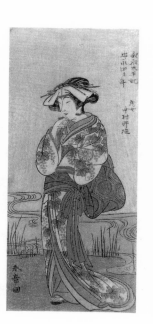
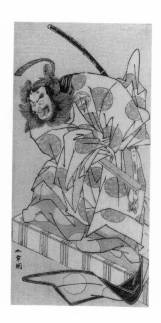

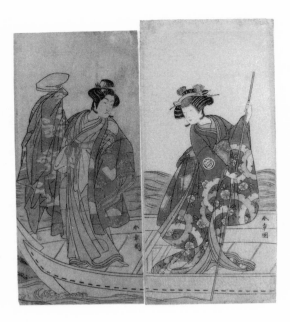
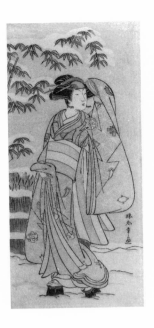
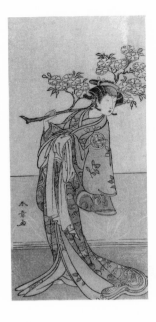

316
1) Yoshizawa Iroha I as Princess
Yosooi (Yosooi Hime) (R), and
Ichikawa Monnosuke II as Mina-
moto no Yorinobu (L) 2) *Kikujidō
Shuen no Iwaya* 3) Morita 4) 11/
1775 5) *Shunshō ga* 8) *hosoban*; 33 x
15.1 cm (R), 31.5 x 13.9 cm (L)

10) Buckingham 1932.1024 (R),
Gookin 1939.1811 (L) *) Right and
center sheets of triptych; left sheet
shows Nakamura Tomijūrō I as
Abe no Osei (Succo [1922], pl. 15)

317
1) Segawa Kikunojō III 4) ca. 1775
5) *Katsu Shunshō ga* 8) *hosoban*;
31.2 x 14.2 cm 10) Gookin
1939.733

318
1) Ichimura Uzaemon IX 4) ca.
1775 5) *Shunshō ga* 8) *hosoban*; 29.4
x 14 cm 9) BMFA (complete dip-
tych) 10) Buckingham 1925.2394
*) Left sheet of diptych

319
1) Ōtani Hiroji III as *otokodate*
Satsuma Gengobei (?) 2) *Iro Moyō
Aoyagi Soga; Azuma Ōgi* 3) Naka-
mura 4) 2/1775 5) *Shunshō ga* 6)
Iwatoya Gempachi 8) *bai aiban*; 42
x 31 cm 10) Buckingham 1928.987
*) See No. 72

320
1) Nakamura Nakazō I as Ono
Sadakurō 2) *Kanadehon Chūshin-
gura; Azuma Ōgi* 3) Nakamura
4) 5/1776 5) *Shunshō ga* 6) Iwatoya
Gempachi 8) *bai aiban*; 45.4 x 32.8
cm 9) TNM 10) Buckingham
1930.391 *) See No. 73

321
1) Segawa Kikunojō III 4) ca. 1775
5) *Shunshō ga* 8) *hosoban*; 38.5 x
17.5 cm 9) JUM 10) Buckingham
1949.39 *) See No. 74

322
1) Segawa Yūjirō I 4) ca. 1775
8) *hosoban*; 30.2 x 14 cm
10) Gookin 1939.602

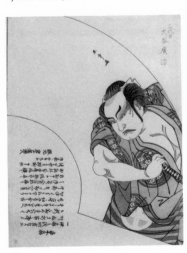
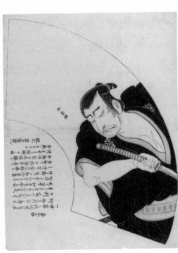
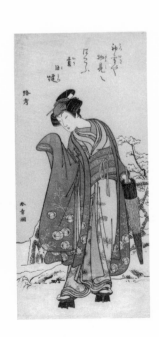
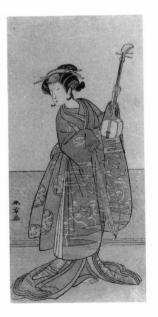

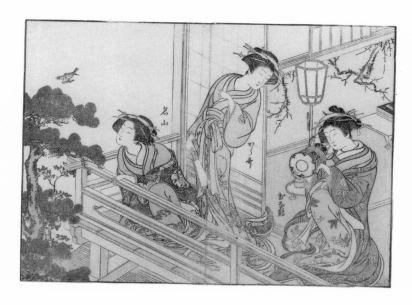
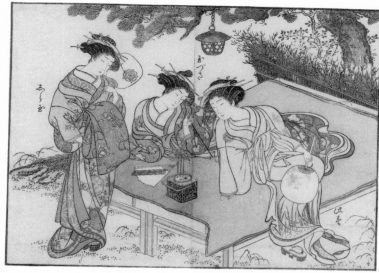

323

1) Illustrations from the book *Seirō Bijin Awase Sugata Kagami*: A. Women of the Chōjiya house (early summer); B. Women of the Yadaya house (summer); C. Women of the Kadotsutaya house (summer); D. Women of the Ōbishiya house (winter) 4) New Year, 1776 5) *Katsukawa Yūji Shunshō*; *Katsukawa* and *Shunshō*; *Kitao Karan Shigemasa*; *Kitao* and *Shigemasa no in* 6) Yamazakiya Kimbei and Tsutaya Jūzaburō; Inoue Shinshichi 8) Double-page illustrations cut from a book; each approx. 21.8 x 30.2 cm 10) Gookin 1939.815, -817, -820, -843 *) See No. 75

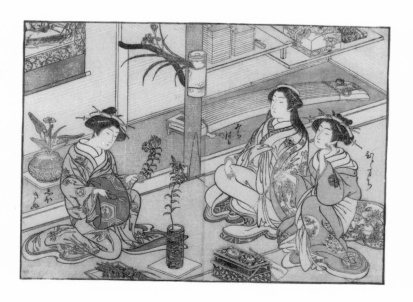
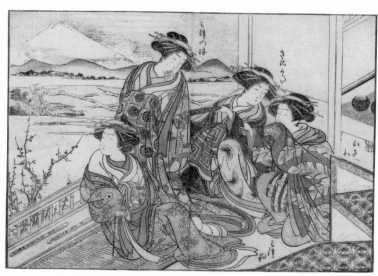

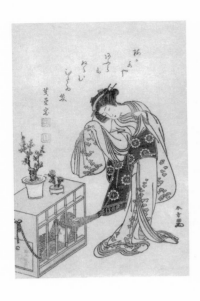

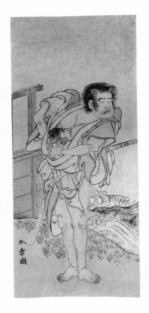

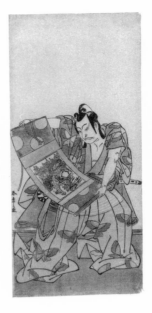

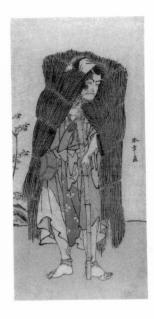

324
1) Young woman with caged monkey 4) New Year, 1776 5) *Shunshō ga*; *Yū* (?) 6) Okamoto Shōgyo 8) *chūban*; 25.7 x 17 cm 10) Buckingham 1929.75 *) See No. 76

325
1) Ōtani Tomoemon I as Kasahari Hokkyō 2) *Kazoe Uta Ta Ue Soga* 3) Nakamura 4) 1/1776 5) *Shunshō ga* 8) *hosoban*; 32.1 x 13.9 cm 9) FM 10) Gookin 1939.712 *) Left sheet of diptych; right sheet is in SM

326
1) Nakamura Nakazō I as Soga no Gorō Tokimune 2) *Kazoe Uta Ta Ue Soga* 3) Nakamura 4) 1/1776 5) *Shunshō ga* 8) *hosoban*; 33.2 x 15.3 cm 10) Buckingham 1928.305 *) Left sheet of triptych (?)

327
1) Ichikawa Ebizō III as Akushichi-byōe Kagekiyo disguised as a beggar 2) *Kamuri Kotoba Soga no Yukari* 3) Ichimura 4) 1/1776 5) *Shunshō ga* 8) *hosoban*; 29 x 13.4 cm 10) Buckingham 1932.1018

328
1) Ichikawa Ebizō III as Kudō Sae-mon Suketsune 2) *Kamuri Kotoba Soga no Yukari* 3) Ichimura 4) 1/1776 5) *Shunshō ga* 8) *hosoban*; 32.8 x 15.1 cm 10) Gookin 1939.603

329
1) Segawa Yūjirō I as Osai, a female hairdresser 2) *Kamuri Kotoba Soga no Yukari* 3) Ichimura 4) 1/1776 5) *Shunshō ga* 8) *hosoban*; 29.3 x 13.9 cm 9) HAA 10) Buck-ingham 1925.2450

330
1) Ichikawa Monnosuke II as the courtesan Kewaizaka no Shōshō 2) *Sono Kyōdai Fuji no Sugatami* 3) Morita 4) 1/1776 5) *Shunshō ga* 8) *hosoban*; 32.7 x 15 cm 9) BMFA; LL2 10) Buckingham 1932.1028

331
1) Ichikawa Monnosuke II as Kichisaburō, temple page of Kichijō-ji 2) *Sono Kyōdai Fuji no Sugatami* 3) Morita 4) 2/1776 5) *Shunshō ga* 8) *hosoban*; 32.7 x 15.1 cm 10) Gookin 1939.592

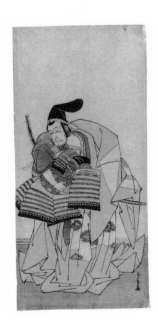

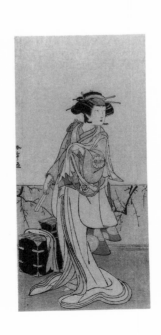

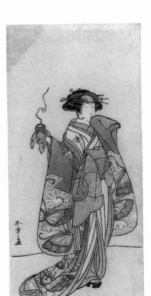

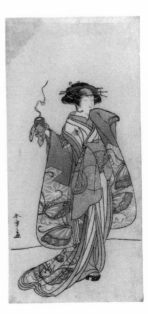

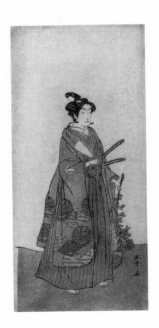

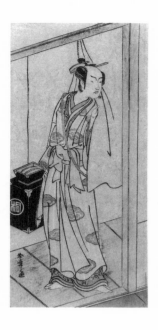

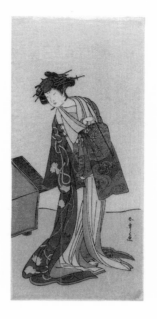

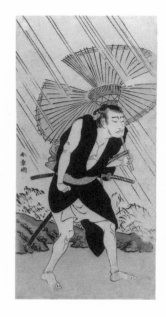

332
1) Arashi Sangorō II as the hairdresser Obana Saizaburō
2) *Koi Musume Mukashi Hachijō*
3) Nakamura 4) 3/1776 5) *Shunshō ga* 8) *hosoban*; 29.7 x 14 cm
10) Gookin 1939.768 *) Left sheet of diptych (?)

333
1) Segawa Kikunojō III as Okoma (R), and Arashi Sangorō II as the hairdresser Obana Saizaburō (L)
2) *Koi Musume Mukashi Hachijō*
3) Nakamura 4) 3/1776 5) *Shunshō ga* 8) wide *hashira-e*; 69.3 x 16.5 cm
10) Buckingham 1925.2260

334
1) Iwai Hanshirō IV as the courtesan Agemaki 2) *Sukeroku Yukari no Hatsu-zakura* 3) Ichimura 4) 3/1776
5) *Shunshō ga* 8) *hosoban*; 32.8 x 15.1 cm 9) AIC 1939.775; BMFA (complete triptych) 10) Buckingham 1942.111 *) Center sheet of triptych (BMFA)

335
1) Nakamura Nakazō I as Ono Sadakurō 2) *Kanadehon Chūshingura* 3) Nakamura 4) 5/1776
5) *Shunshō ga* 8) *hosoban*; 30.7 x 14.8 cm 10) Buckingham 1932.1004

336
1) Ichikawa Yaozō II as Sakura-maru 2) *Sugawara Denju Tenarai Kagami* 3) Ichimura 4) 7/1776
5) *Shunshō ga* 8) *hosoban*; 31.2 x 13.4 cm 9) JUM 10) Gookin 1939.722 *) Left sheet of triptych

337
1) Nakajima Mihoemon II as Fujiwara no Shihei (C), Ichikawa Ebizō III as Matsuō-maru (C), Ichikawa Yaozō II as Sakura-maru (R), and Ichimura Uzaemon IX as Umeō-maru (L) 2) *Sugawara Denju Tenarai Kagami* 3) Ichimura 4) 7/1776 5) *Shunshō ga* (L, R) 8) *hoso-*

ban, triptych; 31.1 x 14.4 cm (R), 31 x 14.7 cm (C), 31.1 x 14.2 cm (L) 9) JUM (complete triptych); UT3, nos. 30–32; MR (R); HRWK (C); EMA (L); CM (L) 10) Buckingham 1938.498 *) See No. 80

338
1) Ichikawa Ebizō III as Matsuō-maru 2) *Sugawara Denju Tenarai Kagami* 3) Ichimura 4) 7/1776
5) *Shunshō ga* 8) *hosoban*; 31.1 x 14.4 cm 9) TNM 10) Gookin 1939.703 *) Left sheet of triptych (?); right sheet shows Ichimura Uzaemon IX as Umeō-maru (?) (CMA)

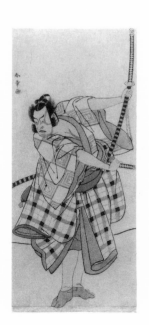

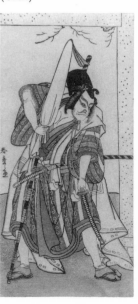

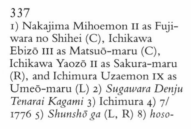

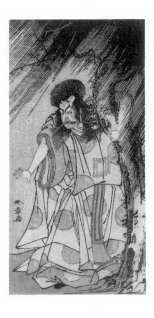

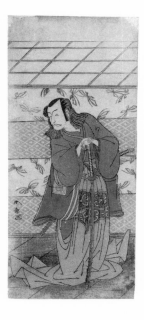

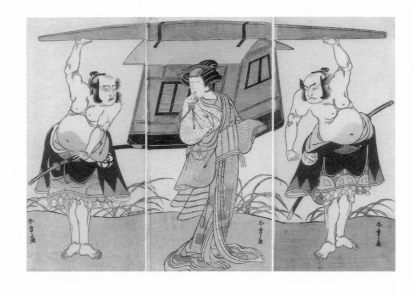

339
1) Ichikawa Ebizō III as the Thunder God, an incarnation of Sugawara Michizane 2) *Sugawara Denju Tenarai Kagami* 3) Ichimura 4) 8/1776 5) *Shunshō ga* 8) *hosoban*; 28.8 x 13.8 cm 10) Gookin 1939.730

340
1) Ichikawa Danjūrō V as Ashiya Dōman 2) *Kikyō-zome Onna Urakata* 3) Morita 4) 7/1776 5) *Shunshō ga* 8) *hosoban*; 33.4 x 14.9 cm 10) Gookin 1939.638

341
1) Ōtani Hiroji III as Yokambei (R), Nakamura Tomijūrō I as Kuzunoha (C), and Bandō Mitsugorō I as Yakambei (L) 2) *Shinodazuma* 3) Morita 4) 9/1776 5) *Shunshō ga*

8) *hosoban*, triptych; 31.1 x 14.6 cm (R), 31.1 x 14.9 cm (C), 31.1 x 14.3 cm (L) 9) WT 10) Buckingham 1938.499 *) See No. 81

342
1) Yoshizawa Iroha I as Tamamo no Mae (?) 2) *Sakuya Kono Hana no Kaomise* (?) 3) Nakamura (?) 4) 11/1776 (?) 5) *Shunshō ga* 8) *hosoban*; 31.5 x 15.1 cm 10) Gookin 1939.729 *) From a multisheet composition

343
1) Bandō Mitsugorō I as Taira no Tadamori disguised as a pottedplant seller 2) *Sakuya Kono Hana no Kaomise* 3) Nakamura 4) 11/1776 5) *Katsu Shunshō ga* 8) *hosoban*; 31.7 x 14.4 cm 10) Gookin 1939.1814

344
1) Ichikawa Danjūrō V as Hannya no Gorō 2) *Sugata no Hana Yuki no Kuronushi* 3) Ichimura 4) 11/1776 5) *Katsu Shunshō ga* 8) *hosoban*; 31.3 x 15.1 cm 9) WS 10) Gookin 1939.697

345
1) Ichikawa Yaozō II as Shii no Shōshō Okinori 2) *Sugata no Hana Yuki no Kuronushi* 3) Ichimura 4) 11/1776 5) *Katsu Shunshō ga* 8) *hosoban*; 31.3 x 14.6 cm 9) UT5, pl. 60 10) Gookin 1939.604

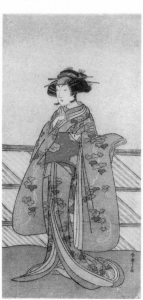

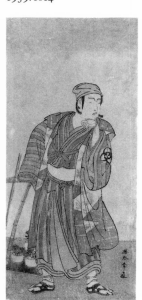

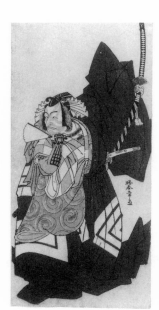

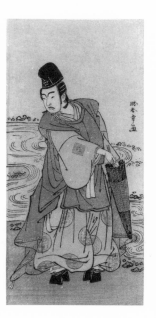

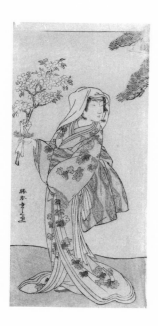

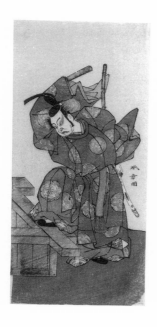

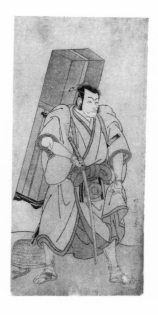

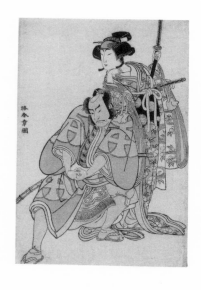

346
1) Yoshizawa Sakinosuke III as Naniwazu 2) *Sugata no Hana Yuki no Kuronushi* 3) Ichimura 4) 11/ 1776 5) *Katsu Shunshō ga* 8) *hoso-ban*; 31.2 x 14.7 cm 9) UT5, pl. 75 10) Buckingham 1925.2395

347
1) Ichimura Uzaemon IX as Ōtomo no Kuronushi 2) *Sugata no Hana Yuki no Kuronushi* 3) Ichi-mura 4) 11/1776 5) *Shunshō ga* 8) *hosoban*; 31.6 x 15 cm 10) Buckingham 1939.2188

348
1) Ichikawa Danjūrō V as Godai Saburō Masazumi disguised as Rokujū-rokubu 2) *Sugata no Hana Yuki no Kuronushi* 3) Ichimura 4) 11/1776 5) *Katsu Shunshō ga* 8) *hosoban*; 31.2 x 14.7 cm 10) Gookin 1939.612 *) Left sheet of diptych (?)

349
1) Nakamura Noshio I as Kōtō no Naishi (R), and Nakamura Nakazō I as Hata Rokurōzaemon disguised as the *yakko* Igaguro Hanehei (L) 2) *Hikitsurete Yagoe Taiheiki* 3) Morita 4) 11/1776 5) *Katsu Shunshō ga* 8) *aiban*; 30.3 x 20.4 cm 9) MR 10) Buckingham 1938.485 *) See No. 82

350
1) Nakamura Nakazō I as an itin-erant monk 2) *Hikitsurete Yagoe Taiheiki* 3) Morita 4) 11/1776 5) *Shunshō ga* 8) *hosoban*; 32 x 14.7 cm 9) UT5 10) Gookin 1939.627

351
1) Nakamura Nakazō I as Naga-saki Kageyuzaemon disguised as Gorohachi the sake seller 2) *Hiki-tsurete Yagoe Taiheiki* 3) Morita 4) 11/1776 5) *Katsu Shunshō ga* 8) *hosoban*; 31.6 x 14.9 cm 10) Gookin 1939.676

352
1) Iwai Hanshirō IV as Kojorō-gitsune of Hakata 2) *Hikitsurete Yagoe Taiheiki* 3) Morita 4) 11/1776 5) *Katsu Shunshō ga* 8) *hosoban*; 31.5 x 14.5 cm 10) Buckingham 1925.2389 *) Left sheet of diptych (?)

353
1) *Mitate* (parody) of Ono no Tōfu 2) *Geiko Zashiki Kyōgen* 4) ca. 1776 5) *Shunshō ga* 8) *aiban*; 32 x 22.4 cm 10) Buckingham 1930.348

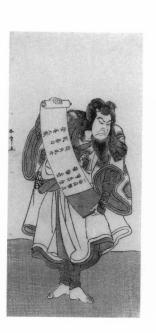

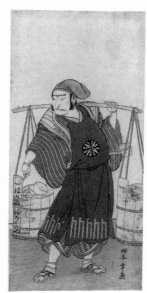

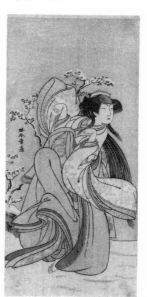

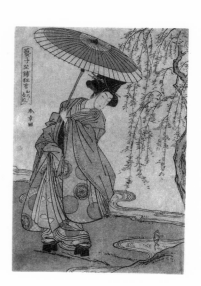

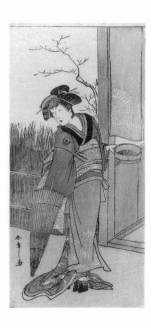

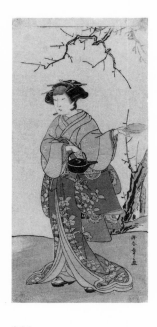

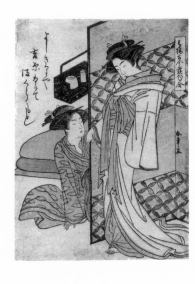

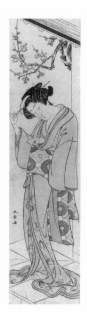

354
1) Segawa Kikunojō III 4) ca. 1776
5) *Shunshō ga* 3) *hosoban*; 32.5 x
15.2 cm 9) TNM; NAM 10) Gift of
Mr. and Mrs. Gaylord Donnelley
1971.483

355
1) Yamashita Kinsaku II 4) ca. 1776
5) *Katsu Shunshō ga* 8) *hosoban*;
32 x 14.8 cm 10) Buckingham
1952.378

356
1) Courtesans of the Yoshiwara
pleasure quarter 2) *Seirō Kokon
Hokku Awase* 4) ca. 1776 5) *Shun-
shō ga* 8) *chūban*; 25.9 x 18.1 cm
10) Gookin 1939.650

357
1) Woman on a verandah about to
open a love-letter 4) mid-late 1770s
5) *Shūnsho ga* 8) wide *hashira-e*; 69
x 16.7 cm 9) AIC, Kate S. Buck-
ingham Fund, 1952.382 10) Buck-
ingham 1942.129 *) See No. 77

358
1) A courtesan of the Matsubaya
house 4) mid-late 1770s 5) *Shunshō
ga* 8) wide *hashira-e*; 67 x 16 cm
9) WA; RAM; AIC, Buckingham
1925.2262 10) Gift of Mr. and
Mrs. Gaylord Donnelley 1969.688
*) See No. 78

359
1) Walking courtesan, possibly
Sugawara of the Tsuruya house
4) mid-late 1770s 5) *Shunshō ga*
8) wide *hashira-e*; 69 x 16.6 cm
10) Buckingham 1925.2261
*) See No. 79

360
1) Courtesan wearing a chrysan-
themum-patterned kimono 4) ca.
1776 5) *Shunshō ga*; printed imita-
tion of hand-written seal (*kaō*)
8) wide *hashira-e* ; 69 x 16.5 cm
9) AIC 1957.554 10) Buckingham
1925.2263

361
1) Nakamura Tomijūrō I as the
waitress Otake 2) *Chigo Suzuri
Aoyagi Soga* 3) Nakamura 4) 1/
1777 5) *Shunshō ga* 8) *hosoban*; 33 x
14.9 cm 9) BMFA 10) Buckingham
1925.2442

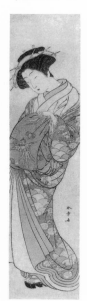

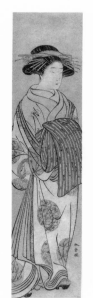

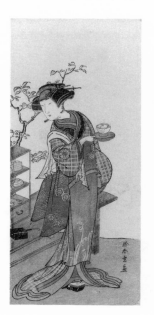

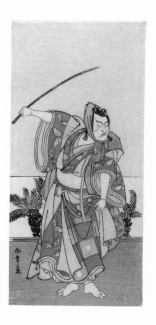

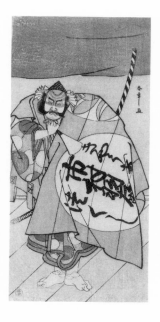

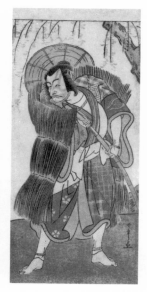

362

1) Ichikawa Danzō IV as Soga no Gorō Tokimune 2) *Chigo Suzuri Aoyagi Soga* 3) Nakamura 4) 1/1777 5) *Shunshō ga* 8) *hosoban*; 32.6 x 14.9 cm 9) FGA; TNM (complete triptych) 10) Buckingham 1925.2461 *) Left sheet of triptych

363

1) Ichimura Uzaemon IX as Asahina no Saburō 2) *Tsukisenu Haru Hagoromo Soga* 3) Ichimura 4) 1/1777 5) *Shunshō ga* 8) *hosoban*; 29.9 x 14.3 cm 10) Gookin 1939.605

364

1) Ichikawa Danjūrō V as Aku-shichibyōe Kagekiyo disguised as a beggar (R), and Ōtani Hiroemon III as the renegade monk Dainichi-bō (L) 2) *Tsukisenu Haru Hagoromo Soga* 3) Ichimura 4) 3/1777 5) *Shunshō ga* 8) *hosoban*; 31.7 x 14.4 cm (R), 30.8 x 13.8 cm (L) 9) OMM (R) 10) Gookin 1939.639 (R), 1939.715 (L)

365

1) Nakamura Nakazō I as Taira no Tomomori disguised as Tokaiya Gimpei 2) *Yoshitsune Sembon-zakura* 3) Morita 4) 4/1777 5) *Shunshō ga* 8) *hosoban*; 31.8 x 14.5 cm 9) AFGA; AM 10) Buckingham 1925.2455

366

1) Ichikawa Danjūrō V as Abe no Sadatō 2) *Ōshu Adachi ga Hara* 3) Ichimura 4) 5/1777 5) *Shunshō ga* 8) *hosoban*; 32.7 x 14.5 cm 9) BM 10) Gookin 1939.644

367

1) Nakamura Tomijūrō I as Lady Hangaku (Hangaku Gozen) 2) *Wada-gassen Onna Maizuru* 3) Nakamura 4) 7/1777 5) *Shunshō ga* 8) *hosoban*; 30.5 x 14.4 9) RAM 10) Gookin 1939.620 *) See No. 83

368

1) Nakamura Tomijūrō I as Lady Hangaku (Hangaku Gozen) 2) *Wada-gassen Onna Maizuru* 3) Nakamura 4) 7/1777 5) *Shunshō ga* 8) *hosoban*; 32 x 14.8 cm 10) Gookin 1939.611

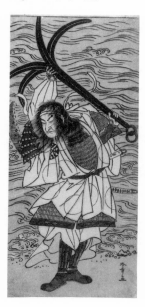

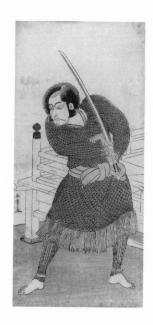

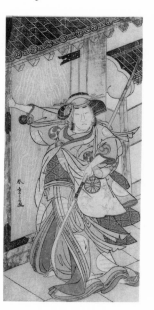

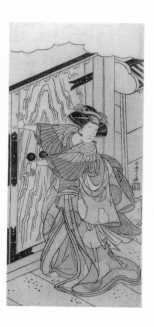

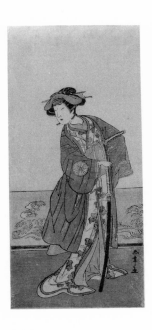
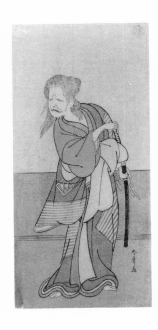
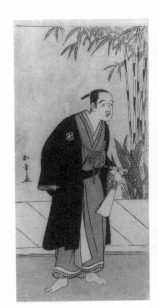
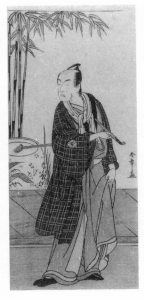

369
1) Nakamura Tomijūrō I as Lady Hangaku (Hangaku Gozen) 2) *Wada-gassen Onna Maizuru* 3) Nakamura 4) 7/1777 5) *Shunshō ga* 8) *hosoban*; 32.7 x 15.3 cm 9) UT5, pl. 134 10) Gookin 1939.678

370
1) Nakajima Kanzaemon III as Yaguchi no Karasu-baba 2) *Hōnō Nitta Daimyōjin* 3) Morita 4) 7/1777 5) *Shunshō ga* 8) *hosoban*; 31.3 x 14.7 cm 9) HB 10) Buckingham 1925.2452 *) From a multisheet composition

371
1) Matsumoto Kōshirō IV as Honchō-maru Tsunagorō (?) (R), and Ōtani Tomoemon I as Kajino Chōan (?) (L) 2) *Hōnō Nitta Daimyōjin* (?) 3) Morita (?) 4) 7/1777

(?) 5) *Shunshō ga* 8) *hosoban*; 31.9 x 14 cm (R), 32.7 x 15.2 cm (L) 9) BM (complete diptych); MG (L) 10) Buckingham 1925.2460 (R), Gookin 1939.647 (L)

372
1) Ichikawa Danzō IV as Taira no Tomomori 2) *Yoshitsune Sembonzakura* 3) Nakamura 4) 8/1777 5) *Shunshō ga* 8) *hosoban*; 29.8 x 13.5 cm 10) Gookin 1939.613

373
1) Nakamura Tomijūrō I as the courtesan Tōyama 2) *Koi Nyōbo Somewake Tazuna* 3) Nakamura 4) 9/1777 5) *Shunshō ga* 8) *hosoban*; 32.2 x 15.1 cm 9) ADF 10) Buckingham 1932.1022

374
1) Ichikawa Danjūrō V in a "Shibaraku" role as Katō Hyōeisa Shigemitsu (?) 2) *Masakado Kammuri no Hatsuyuki* 3) Nakamura 4) 11/1777 5) *Shunshō ga* 8) *hosoban*; 29 x 13.4 cm 9) FS, p. 33; UT5, pl. 89; SNS, pl. 164; LL2; GFGA 10) Buckingham 1938.487 *) See No. 84

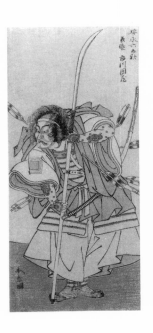
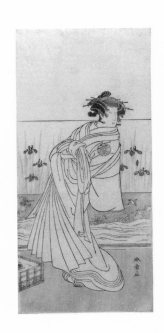
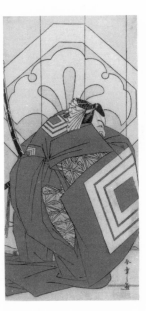

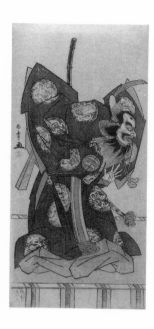

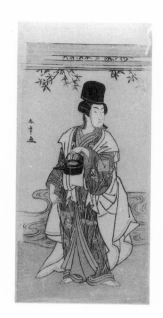

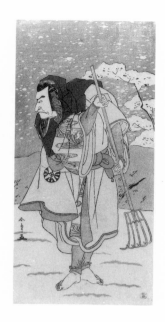

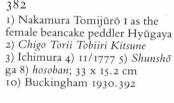

375
1) Nakajima Mihoemon II as Shujaku Tennō 2) *Masakado Kammuri no Hatsuyuki* 3) Nakamura 4) 11/1777 5) *Shunshō ga* 8) *hosoban*; 31.8 x 14.9 cm 9) TNM 10) Gookin 1932.1011 *) From a multisheet composition

376
1) Ichikawa Danjūrō V as Taira no Masakado disguised as the pilgrim Junjō 2) *Masakado Kammuri no Hatsuyuki* 3) Nakamura 4) 11/1777 5) *Shunshō ga* 8) *hosoban*; 33 x 15 cm 9) SM; BMFA (complete triptych) 10) Gookin 1939.629 *) Left sheet of triptych

377
1) Ichikawa Monnosuke II as the court servant Shōheida Sadamori 2) *Masakado Kammuri no Hatsuyuki* 3) Nakamura 4) 11/1777 5) *Shunshō ga* 8) *hosoban*; 32.8 x 15.3 cm 9) FGA (complete four-sheet print) 10) Buckingham 1939.2168 *) Second-from-right in a four-sheet print

378
1) Nakamura Nakazō I as Akugenda Yoshihira disguised as a pilgrim 2) *Chigo Torii Tobiiri Kitsune* 3) Ichimura 4) 11/1777 5) *Shunshō ga* 8) *hosoban*; 30.4 x 14.6 cm 10) Gookin Collection 1939.628 *) From a multisheet composition (?)

379
1) Segawa Kikunojō III as Lady Shizuka (Shizuka Gozen) disguised as Tamazusa 2) *Chigo Torii Tobiiri Kitsune* 3) Ichimura 4) 11/1777 5) *Shunshō ga* 8) *hosoban*; 32.6 x 15 cm 10) Buckingham 1932.1021 *) From a multisheet composition

380
1) Nakamura Nakazō I as Onmaya Kisanda dressed as the Lion Dancer Kakubei, and Segawa Kikunojō III as Lady Shizuka (Shizuka Gozen) 2) *Chigo Torii Tobiiri Kitsune* 3) Ichimura 4) 11/1777 5) *Shunshō ga* 8) *aiban*; 32.8 x 23 cm 9) SNS, no. 156; WS (L) 10) Gookin 1939.708 *) See No. 85

381
1) Ichimura Uzaemon IX as a male fox disguised as Iseya, and Nakamura Tomijūrō I as a female fox disguised as the beancake peddler Hyūgaya 2) *Chigo Torii Tobiiri Kitsune* 3) Ichimura 4) 11/1777 5) *Shunshō ga* 8) *aiban*; 32.4 x 23.1 cm 9) SNS, no. 157; TNM 10) Gift of Mr. and Mrs. James A. Michener 1958.154 *) See No. 86

382
1) Nakamura Tomijūrō I as the female beancake peddler Hyūgaya 2) *Chigo Torii Tobiiri Kitsune* 3) Ichimura 4) 11/1777 5) *Shunshō ga* 8) *hosoban*; 33 x 15.2 cm 10) Buckingham 1930.392

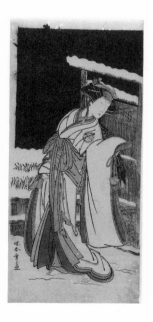

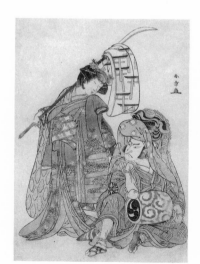

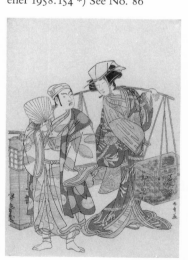

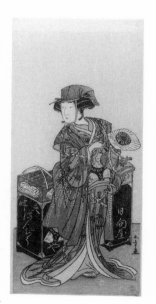

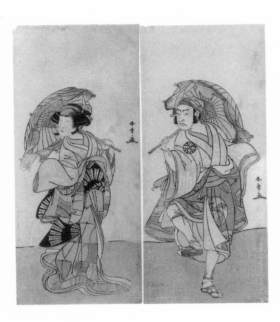

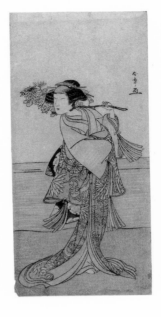

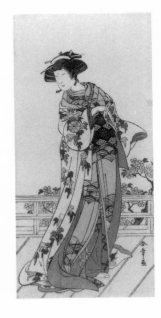

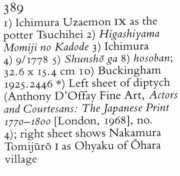

383
1) Nakamura Nakazō I as Onmaya Kisanda disguised as the Lion Dancer Kakubei (R), and Nakamura Tomijūrō I as a female fox from Mt. Ubagadake (L) 2) *Chigo Torii Tobiiri Kitsune* 3) Ichimura 4) 11/1777 5) *Shunshō ga* 8) *hosoban*; 32.8 x 14.3 cm (R), 32.7 x 14.4 cm (L) 9) AIC 1925.2391 (L) 10) Gookin 1939.739 (R), 1939.738 (L) *) Two sheets from a four-sheet composition; the other sheets show Segawa Kikunojō III (CMA) and Ichimura Uzaemon IX (Hirano, 1939, pl. 77)

384
1) Nakamura Tomijūrō I as a female fox from Mt. Ubagadake 2) *Chigo Torii Tobiiri Kitsune* 3) Ichimura 4) 11/1777 5) *Shunshō ga* 8) *hosoban*; 31.4 x 14.9 cm 10) Gookin 1939.756

385
1) Nakamura Tomijūrō I 4) ca. 1777 5) *Shunshō ga* 9) *hosoban*; 30 x 14.4 cm 10) Buckingham 1925.2453 *) From a multisheet composition

389
1) Ichimura Uzaemon IX as the potter Tsuchihei 2) *Higashiyama Momiji no Kadode* 3) Ichimura 4) 9/1778 5) *Shunshō ga* 8) *hosoban*; 32.6 x 15.4 cm 10) Buckingham 1925.2446 *) Left sheet of diptych (Anthony D'Offay Fine Art, *Actors and Courtesans: The Japanese Print 1770–1800* [London, 1968], no. 4); right sheet shows Nakamura Tomijūrō I as Ohyaku of Ōhara village

386
1) Ichikawa Danjūrō V as Kudō Suketsune 2) *Kaidō Ichi Yawaragi Soga* 3) Nakamura 4) 1/1778 5) *Shunshō ga* 8) *hosoban*; 30.5 x 13.7 cm 10) Gookin 1939.615

387
1) Nakamura Nakazō I as Kudō Suketsune (?) 2) *Kokimazete Takao Soga* (?) 3) Ichimura (?) 4) 2/1778 (?) 5) *Shunshō ga* 8) *hosoban*; 32.2 x 15.1 cm 10) Gookin 1939.711 *) From a multisheet composition

388
1) Ichikawa Monnosuke II as Ageha no Chōkichi disguised as Soga no Gorō Tokimune 2) *Kaidō Ichi Yawaragi Soga* 3) Nakamura 4) 3/1778 5) *Shunshō ga* 8) *hosoban*; 31.8 x 14.7 cm 10) Buckingham 1925.2449 *) From a multisheet composition

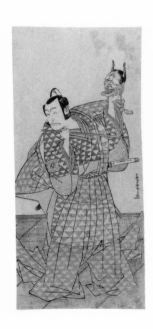

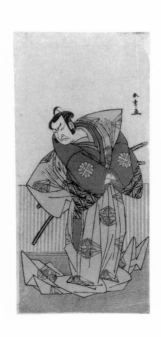

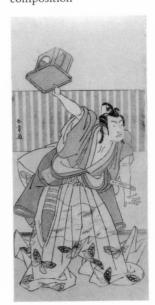

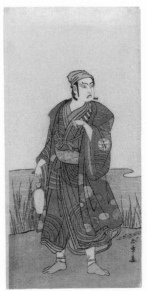

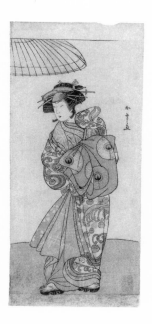

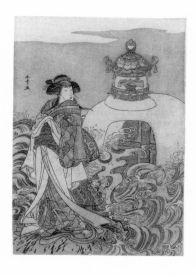

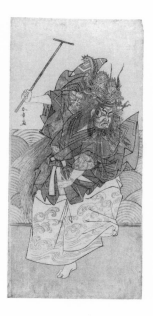

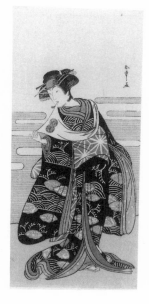

390
1) Ikushima Daikichi III as the courtesan Naniwazu 2) *Saki Masuya Ume no Kachidoki* 3) Ichimura 4) 11/1778 5) *Shunshō ga* 8) *hosoban*; 32.2 x 15 cm 10) Gookin 1939.619 *) From a multisheet composition (?)

391
1) Segawa Kikunojō III as the Dragon Princess 2) *Saki Masuya Ume no Kachidoki* 3) Ichimura 4) 11/1778 5) *Shunshō ga* 8) *ōban*; 36.6 x 25.8 cm 10) Buckingham 1925.2362

392
1) Ichimura Uzaemon IX as an incarnation of the Dragon King 2) *Saki Masuya Ume no Kachidoki* 3) Ichimura 4) 11/1778 5) *Shunshō ga* 8) *hosoban*; 32.7 x 15 cm 10) Gookin 1939.664 *) From a multisheet composition

393
1) Segawa Kikunojō III as Onami disguised as the Dragon Princess 2) *Saki Masuya Ume no Kachidoki* 3) Ichimura 4) 11/1778 5) *Shunshō ga* 8) *hosoban*; 33.7 x 14.4 cm 10) Buckingham 1929.738

394
1) Ichikawa Danjūrō V as Arakawa Tarō 2) *Date Nishiki Tsui no Yumitori* 3) Morita 4) 11/1778 5) *Shunshō ga* 8) *hosoban*; 29.9 x 14 cm 9) HRWK; WS 10) Gookin 1939.719

395
1) Nakamura Nakazō I as Prince Takahiro 2) *Date Nishiki Tsui no Yumitori* 3) Morita 4) 11/1778 5) *Shunshō ga* 8) *hosoban*; 31 x 14.8 cm 9) SM 10) Gookin 1939.587

396
1) Ichikawa Danzō IV as Kamakura no Gongorō Kagemasa (R), and Ichikawa Danjūrō V as the renegade monk Wantetsu from Ōkamidani (L) 2) *Date Nishiki Tsui no Yumitori* 3) Morita 4) 11/1778 5) *Shunshō ga* (R) 8) *hosoban*,

diptych (or two sheets of a triptych); 31.5 x 15.6 cm (R), 32.5 x 15.1 cm (L) 9) TNM (R); MIA (L) 10) Gookin 1939.621 (R), Buckingham 1938.500 (L) *) See No. 87

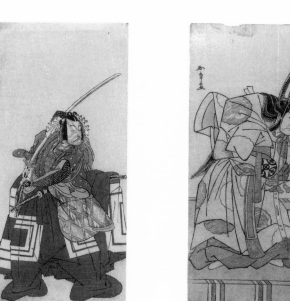

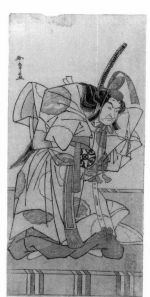

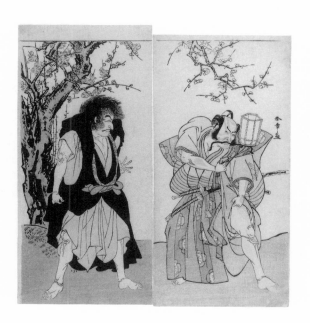

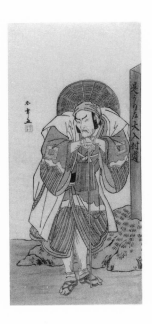
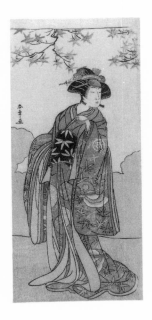
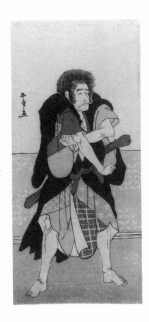
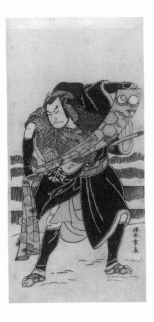

397

1) Ichikawa Danzō IV as Kunii
Kurando 2) *Date Nishiki Tsui no
Yumitori* 3) Morita 4) 11/1778
5) *Shunshō ga* 8) *hosoban*; 31.7 x
14.9 cm 9) NAM 10) Gift of Mr.
and Mrs. Harold Henderson
1967.639

398

1) Osagawa Tsuneyo II as Onoe no
Mae 2) *Date Nishiki Tsui no Yumi-
tori* 3) Morita 4) 11/1778 5) *Shun-
shō ga* 8) *hosoban*; 31.2 x 14 cm
10) Gookin 1939.614 *) From a
multisheet composition (?)

399

1) Ichikawa Danjūrō V as the rene-
gade monk Wantetsu of Ōkami-
dani 2) *Date Nishiki Tsui no
Yumitori* 3) Morita 4) 11/1778
5) *Shunshō ga* 8) *hosoban*; 30.2 x
13.4 cm 10) Buckingham
1932.1009

400

1) Nakamura Nakazō I as Abe no
Sadatō (?) 2) *Date Nishiki Tsui no
Yumitori* (?) 3) Morita (?) 4) 11/
1778 (?) 5) *Katsu Shunshō ga*
8) *hosoban*; 32.3 x 15.3 cm 9) UT5,
pl. 122 10) Gookin 1939.714

401

1) Onoe Tamizō I as Nishikigi (?)
or Otae (?) (R), Ichikawa Danjūrō V
as Miura Heidayū Kunitae (?) (C),
and Osagawa Tsuneyo II as Oyuki
(?) (L) 2) *Date Nishiki Tsui no Yu-
mitori* (?) 3) Morita (?) 4) 11/1778
(?) 5) *Shunshō ga* 8) *hosoban*; 30.4 x
14.8 cm (R), 30.5 x 15 cm (C),
30.5 x 15 cm (L) 9) HAA (C)
10) Buckingham 1925. 2360

402

1) Segawa Kikunojō III 4) ca. 1778
5) *Shunshō ga* 8) *hosoban*; 32.6 x
14.6 cm 10) Buckingham 1928.985

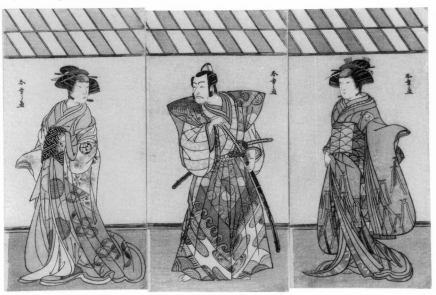

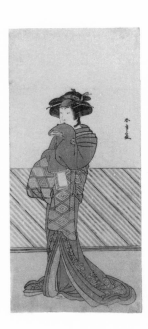

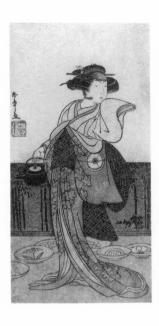

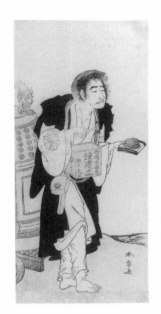

403

1) Iwai Hanshirō IV as Tsukisayo
2) *Gohiiki Nennen Soga* 3) Naka-
mura 4) 1/1779 5) *Shunshō ga*
8) *hosoban*; 29 x 14.1 cm 10) Goo-
kin 1939.643 *) Left sheet of
diptych; right sheet shows Mat-
sumoto Kōshirō IV as Kudō
Suketsune (BMFA)

404

1) Segawa Kikunojō III as the
street-walker Otsuyu 2) *Chō Chi-
dori Wakayagi Soga* 3) Ichimura
4) 2/1779 5) *Shunshō ga* 8) *hosoban*;
30 x 14.7 cm 10) Buckingham
1932.1019

405

1) Nakamura Nakazō I as the rene-
gade monk Dainichibō 2) *Edo Mei-
sho Midori Soga* 3) Morita 4) 1/1779
5) *Shunshō ga* 8) *hosoban*; 30.2 x
14 cm 9) RAM; TNM; BMFA
10) Buckingham 1932.1003
*) See No. 88

406

1) Nakamura Nakazō I as the rene-
gade monk Dainichibō 2) *Edo Mei-
sho Midori Soga* 3) Morita 4) 1/1779
5) *Shunshō ga* 8) *hosoban*; 31.5 x
14.4 cm 9) BMFA 10) Gookin
1939.652

407

1) Onoe Matsusuke I as Akoya
2) *Edo Meisho Midori Soga*
3) Morita 4) 2/1779 5) *Shunshō ga*
8) *hosoban*; 31.3 x 14.1 cm 9) TNM;
HRWK (complete diptych) *) Left
sheet of diptych; right sheet shows
Nakamura Nakazō I in the role of
a *shinobu uri* (seller of hare's-foot
fern) (HRWK) 10) Gookin
1939.640

408

1) Nakamura Nakazō I as the rene-
gade monk Dainichibō 2) *Edo Mei-
sho Midori Soga* 3) Morita 4) 2/1779
5) *Shunshō ga* 8) *hosoban*; 31.2 x
14.7 cm 9) MIA 10) Gookin
1939.717

409

1) Matsumoto Kōshirō IV as
Matsuō-maru 2) *Sugawara Denju
Tenarai Kagami* 3) Nakamura 4) 4/
1779 5) *Shunshō ga* 8) *hosoban*; 30 x
15.4 cm 9) WT (complete diptych)
10) Gookin 1939.736 *) Right
sheet of diptych; left sheet shows
Bandō Mitsugorō I as Umeō-
maru (WT)

410

1) Matsumoto Kōshirō IV as
Matsuō-maru (?) 2) *Sugawara
Denju Tenarai Kagami* (?) 3) Naka-
mura (?) 4) 4/1779 (?) 5) *Shunshō ga*
8) *hosoban*; 31.7 x 14.3 cm 9) BM
10) Gookin 1939.769

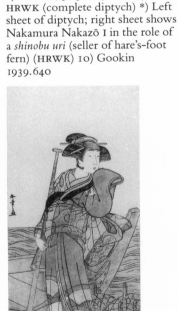

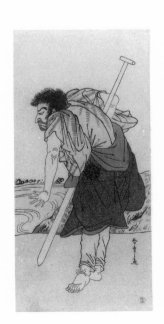

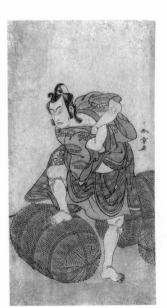

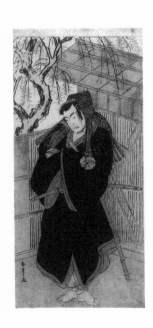

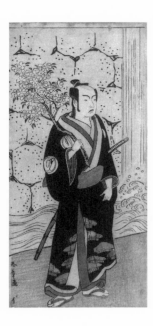

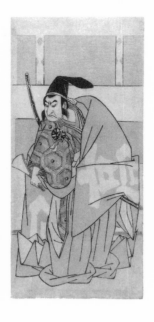

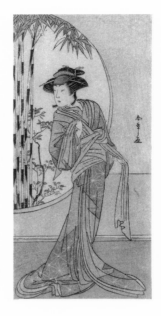

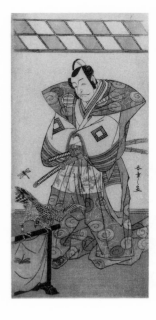

411
1) Sawamura Sōjūrō III as Sonobe Zaemon 2) *Shin Usuyuki Monogatari* 3) Ichimura 4) 8/1779 5) *Shunshō ga* 8) *hosoban*; 30.5 x 15 cm 9) BMFA (complete triptych) 10) Buckingham 1925.2392

412
1) Nakamura Nakazō I as Kō no Moronao 2) *Kanadehon Chūshingura* 3) Morita 4) 8/1779 5) unsigned 8) *hosoban*; 32.9 x 15.2 cm 10) Gookin 1939.705

413
1) Osagawa Tsuneyo II as Okaru 2) *Kanadehon Chūshingura* 3) Morita 4) 8/1779 5) *Shunshō ga* 8) *hosoban*; 30.3 x 14.4 cm 9) BMFA; SM (both have complete diptych) 10) Buckingham 1932.1026 *) Right sheet of diptych; left sheet shows Nakamura Nakazō I as Teraoka Heiemon

414
1) Ichikawa Danjūrō V as Ashikaga Takauji 2) *Kaeribana Eiyū Taiheiki* 3) Nakamura 4) 11/1779 5) *Shunshō ga* 8) *hosoban*; 32.9 x 15.1 cm 10) Buckingham 1932.994

415
1) Yamashita Kinsaku II as Lady Kikusui (Kikusui Gozen) (?) 2) *Kaeribana Eiyū Taiheiki* (?) 3) Nakamura (?) 4) 11/1779 (?) 5) *Shunshō ga* 8) *hosoban*; 32.7 x 14.6 cm 10) Buckingham 1925.2388 *) From a multisheet composition

416
1) Segawa Kikunojō III as Michichiba 2) *Azuma no Mori Sakae Kusunoki* 3) Ichimura 4) 11/1779 5) *Shunshō ga* 8) *hosoban*; 32 x 15 cm 10) Gookin 1939.645

417
1) Ōtani Hiroji III as the guard Kuriu Zaemon Yorikata 2) *Azuma no Mori Sakae Kusunoki* 3) Ichimura 4) 11/1779 5) *Shunshō ga* 8) *hosoban*; 31.9 x 14.8 cm 10) Gookin 1939.586

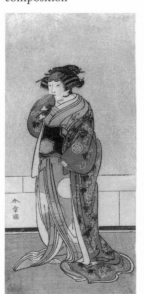

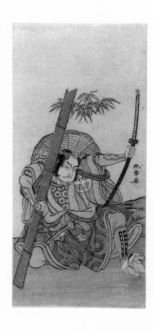

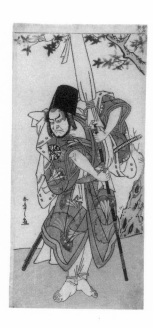

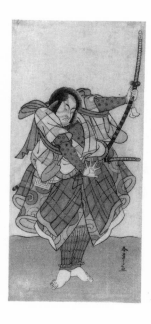

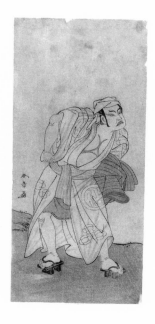

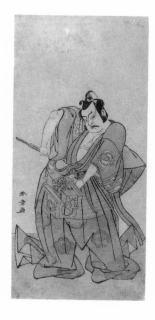

418
1) Nakamura Nakazō I as Katsu-
hei, servant of a princely family
2) *Uta Kurabe Tōsei Moyō*
3) Morita 4) 11/1779 5) *Shunshō ga*
8) *hosoban*; 32.8 x 15 cm 9) VA
10) Buckingham 1938.488 *)
From a multisheet composition

419
1) Ichikawa Monnosuke II 4) ca.
1779 5) *Shunshō ga* 8) *hosoban*; 33.2
x 15.4 cm 10) Gookin 1939.704

420
1) Nakamura Sukegorō II 4) ca.
1779 5) *Shunshō ga* 8) *hosoban*; 33 x
15 cm 10) Gookin 1939.687

421
1) Nakamura Sukegorō II 4) ca.
1779 5) *Shunshō ga* 8) *hosoban*; 32.5
x 14.9 cm 10) Gookin 1939.1816

422
1) Nakamura Sukegorō II 4) ca.
1779 5) *Shunshō ga* 8) *hosoban*; 32.5
x 15 cm 10) Gookin 1939.1817

423
1) Ichikawa Danjūrō V in formal
attire 4) ca. 1779 5) false *Sharaku*
signature 7) false *kiwame* seal
8) *hosoban*; 31.2 x 13.4 cm 9) BN
10) Gift of H.R. Warner 1932.1198

424
1) Scene at the Tsurugaoka
Hachiman Shrine 2) *Chūshingura*;
Chūshingura Jūichimai Tsuzuki
5) *Shunshō ga* 8) *chūban*; 25.1 x
18.4 cm 10) Gookin 1939.649
*) See No. 89

425
1) Act Two: The House of Kako-
gawa Honzō 2) *Chūshingura*
(Treasury of Loyal Retainers)
4) ca. 1779–1780 5) *Shunshō ga*
8) *chūban*; 26.6 x 19.5 cm
10) Gookin 1939.2119

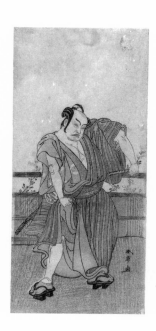

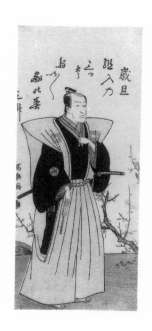

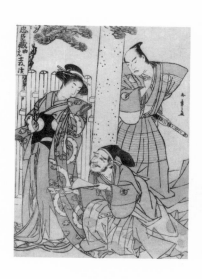

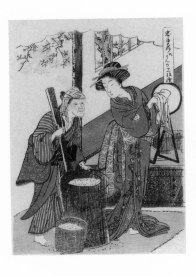
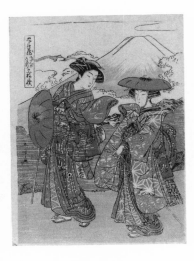
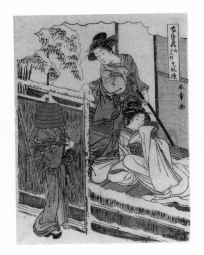
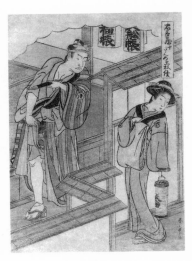

426

1) Act Six: Yoichibei's House
2) *Chūshingura* (Treasury of Loyal Retainers) 4) ca. 1779–1780
5) unsigned 8) *chūban*; 26.5 x 19 cm 9) PMA; PAM; HAA 10) Buckingham 1939.2118

427

1) Act Eight: Bridal Journey
2) *Chūshingura* (Treasury of Loyal Retainers) 4) ca. 1779–1780
5) unsigned 8) *chūban*; 26.2 x 19.5 cm 9) AIC 1961.199 10) Buckingham 1939.2117

428

1) Act Nine: Yuranosuke's House in Yamashina 2) *Chūshingura* (Treasury of Loyal Retainers) 4) ca. 1779–1780 5) *Shunshō ga* 8) *chūban*; 26.3 x 19.4 cm 10) Buckingham 1939.2191

429

1) Act Ten: The Amakawaya
2) *Chūshingura* (Treasury of Loyal Retainers) 4) ca. 1779–1780
5) *Shunshō ga* 8) *chūban*; 25.7 x 18.3 cm 9) SM; HRWK 10) Gookin 1939.653

430

1) Onoe Matsusuke I as Baramon no Kichi 2) *Hatsumombi Kuruwa Soga* 3) Nakamura 4) 1/1780
5) *Shunshō ga* 8) *hosoban*; 30.5 x 14.6 cm 9) BMFA; YUAG (both have complete diptych); SM (L)
10) Buckingham 1932.1010
*) Right sheet of diptych; left sheet shows Yamashita Kinsaku II as Hanazono

431

1) Yamashita Kinsaku II as Lady Mankō (Mankō Gozen) 2) *Hatsu-mombi Kuruwa Soga* 3) Nakamura
4) 1/1780 5) *Shunshō ga* 8) *hosoban*; 31.2 x 14.7 cm 9) TNM (complete triptych) 10) Gookin 1939.662
*) Right sheet of triptych; center sheet shows Ichikawa Danjūrō V as Kudō Suketsune, and left sheet shows Iwai Hanshirō IV as Oyuki (TNM)

432

1) Yamashita Kinsaku II as Lady Mankō (Mankō Gozen) (?)
2) *Hatsumombi Kuruwa Soga* (?)
3) Nakamura (?) 4) 1/1780 (?)
5) *Shunshō ga* 8) *hosoban*; 31.1 x 14.6 cm 10) Gookin 1939.591

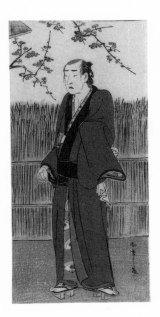
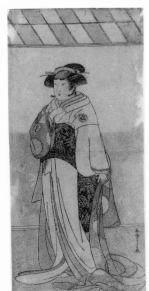
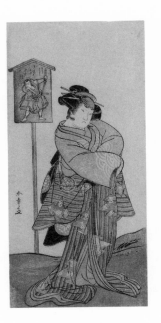

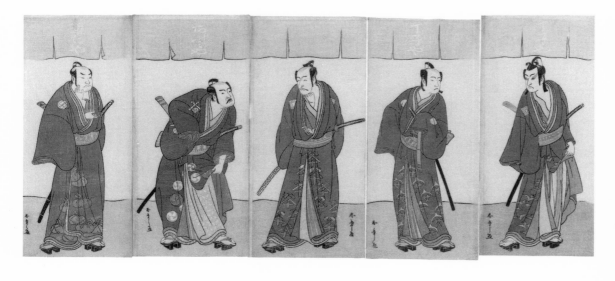

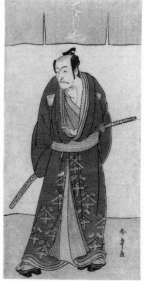

433
1) Ichikawa Monnosuke II as Kari-
gane Bunshichi, Bandō Mitsu-
gorō I as An no Heibei, Ichikawa
Danjūrō V as Gokuin Sen'emon,
Nakamura Sukegorō II as Kami-
nari Shōkurō, and Sakata Han-
gorō II as Hotei Ichiemon (R to
L) 2) *Hatsumombi Kuruwa Soga*
3) Nakamura 4) 2/1780 5) *Shunshō
ga* 8) *hosoban*, pentaptych; 31.3 x
14.5 cm, 31.3 x 14.1 cm, 31.3 x
14.5 cm, 31.1 x 14.8 cm, 31.3 x
14.1 cm (R to L) 9) SOAS (com-
plete pentaptych); BM (fourth and
fifth sheets) 10) Gift of Mr. and
Mrs. Gaylord Donnelley 1970.492
*) See No. 90

434
1) Ichikawa Danjūrō V as Gokuin
Sen'emon 2) *Hatsumombi Kuruwa
Soga* 3) Nakamura 4) 2/1780
5) *Shunshō ga* 8) *hosoban*; 30.6 x
14.5 cm 9) AIC 1970.492 (complete
pentaptych) 10) Gookin 1939.744
*) Center sheet of pentaptych (see
No. 90)

435
1) Ichikawa Danjūrō V as Gokuin
Sen'emon (R), Bandō Mitsugorō I
as An no Heibei (C), and Naka-
mura Sukegorō II as Kaminari
Shōkurō (L) 2) *Hatsumombi
Kuruwa Soga* 3) Nakamura 4) 2/
1780 5) *Shunshō ga* 8) *hosoban*; 30.3
x 14.8 cm (R), 30.4 x 15 cm (C),
30.9 x 15 cm (L) 10) Buckingham
1929.724 *) Three sheets from
pentaptych; one other sheet shows
Sakata Hangorō II as Hotei Ichie-
mon (RAM) *) See No. 90

436
1) Nakamura Sukegorō II as
Kaminari Shōkurō 2) *Hatsumombi
Kuruwa Soga* 3) Nakamura 4) 2/
1780 5) *Shunshō ga* 8) *hosoban*;
30.3 x 14.9 cm 9) SM; CM; SOAS
(all have complete pentaptych)
10) Gookin 1939.635 *) One
sheet from pentaptych

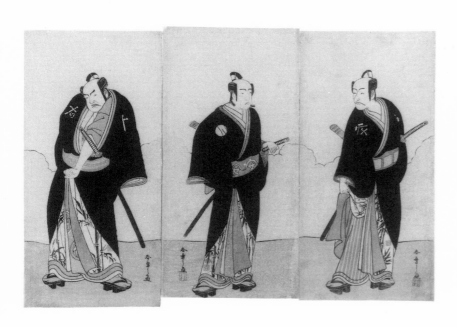

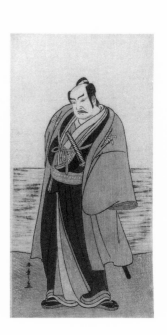

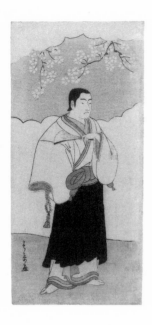
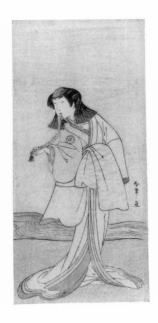
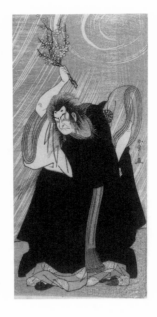
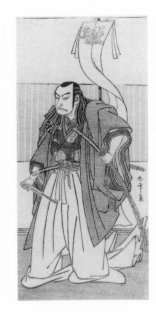

437

1) Ichikawa Monnosuke II as the monk Renseibō 2) *Hatsumombi Kuruwa Soga* 3) Nakamura 4) 3/1780 5) *Shunshō ga* 8) *hosoban*; 33.2 x 15.1 cm 9) BMFA (complete triptych); FGA; HAA (both have L sheet only) 10) Buckingham 1938.489 *) Left sheet of triptych; center sheet shows Bandō Mitsugorō I as Otatsu, and right sheet shows Ichikawa Danjūrō V as the monk Renshōbō (BMFA)

438

1) Segawa Kikunojō III as Miura no Katagai disguised as the nun Narukami 2) *Ume-goyomi Akebono Soga* 3) Ichimura 4) 2/1780 5) *Shunshō ga* 8) *hosoban*; 32.6 x 14.7 cm 9) BMFA (complete triptych); TNM; HRWK 10) Buckingham 1925.2445 *) Center sheet of triptych; right sheet shows Ichimura Uzaemon IX, and left sheet shows Sawamura Sōjūrō III as Chiba Zaemon Tsunenobu

439

1) Nakamura Nakazō I as the Thunder God, an incarnation of Kan Shōjō 2) *Sugawara Denju Tenarai Kagami* 3) Morita 4) 3/1780 5) *Shunshō ga* 8) *hosoban*; 32.8 x 14.9 cm 9) MMA; AIC 1939.2120 10) Buckingham 1952.381

440

1) Nakamura Nakazō I as Kusunoki Masayuki disguised as Uji no Jōetsu 2) *Gotaiheiki Shiraishi-banashi* 3) Morita 4) 4/1780 5) *Shunshō ga* 8) *hosoban*; 30.9 x 14 cm 10) Buckingham 1939.2190

441

1) Osagawa Tsuneyo II as the courtesan Miyagino (?) 2) *Gotaiheiki Shiraishi-banashi* (?) 3) Morita (?) 4) 4/1780 (?) 5) *Shunshō ga* 8) *hosoban*; 33 x 15.2 cm 10) Buckingham 1938.486

442

1) Yamashita Kinsaku II as Naoe 2) *Tsuma Mukae Koshiji no Fumizuki* 3) Nakamura 4) 8/1780 5) *Shunshō ga* 8) *hosoban*; 29 x 13.3 cm 10) Buckingham 1925.2443 *) Right sheet of diptych; left sheet shows Iwai Hanshirō IV as Ayaginu (?)

443

1) Yamashita Kinsaku II as Oishi (?) 2) *Kanadehon Chūshin Nagori no Kura* (?) 3) Nakamura (?) 4) 9/1780 (?) 5) *Shunshō ga* 8) *hosoban*; 29.1 x 14.6 cm 9) FW 10) Gookin 1939.633

444

1) Onoe Kikugorō I as Tonase 2) *Kanadehon Chūshin Nagori no Kura* 3) Nakamura 4) 9/1780 5) *Shunshō ga* 8) *hosoban*; 30.3 x 14.5 cm 9) TNM; HAA 10) Gookin 1939.631

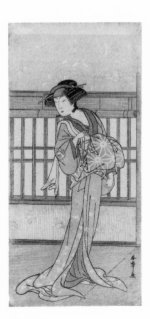
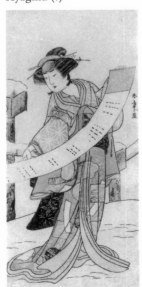
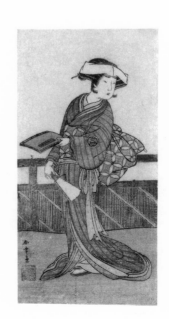
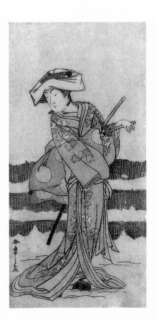

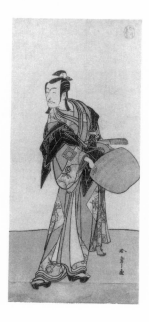

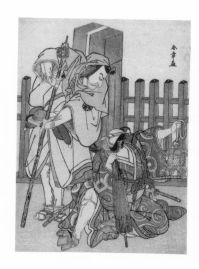

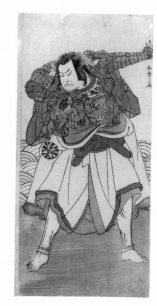

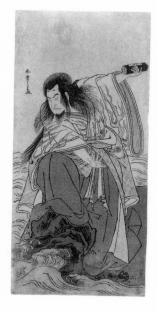

445
1) Ichikawa Danjūrō V as Kako-
gawa Honzō 2) *Kanadehon Chūshin
Nagori no Kura* 3) Nakamura 4) 9/
1780 5) *Shunshō ga* 8) hosoban; 30.2
x 14.9 cm 9) AIC 1952.373; AIC
1939.642; SM 10) Gookin 1939.641

446
1) Nakamura Nakazō I as Chinzei
Hachirō Tametomo disguised as a
pilgrim (L), and Ichikawa Danjūrō
V as Kazusa no Gorobei Tadamitsu
(R) 2) *Kitekaeru Nishiki no Waka-
yaka* 3) Nakamura 4) 11/1780 5)
Shunshō ga 8) *chūban*; 26.4 x 19 cm
9) SNS, no. 160 10) Buckingham
1925.2361 *) See No. 91

447
1) Nakamura Nakazō I as Chinzei
Hachirō Tametomo disguised as an
ascetic monk 2) *Kitekaeru Nishiki
no Wakayaka* 3) Nakamura 4) 11/
1780 5) *Shunshō ga* 8) hosoban; 31.3
x 14.6 cm 10) Gookin 1939.1813

448
1) Onoe Matsusuke I as Retired
Emperor Sutoku 2) *Kitekaeru
Nishiki no Wakayaka* 3) Nakamura
4) 11/1780 5) *Shunshō ga* 8) hoso-
ban; 32 x 14.8 cm 9) HGM
10) Gookin 1939.758

449
1) Ichikawa Danjūrō V as Kazusa
no Gorobei Tadamitsu 2) *Kitekaeru
Nishiki no Wakayaka* 3) Nakamura
4) 11/1780 5) *Shunshō ga* 8) hoso-
ban; 32.1 x 14.5 cm 9) TNM; BMFA
10) Buckingham 1952.380

450
1) Nakamura Nakazō I as Saitō
Sanemori 2) *Kitekaeru Nishiki no
Wakayaka* 3) Nakamura 4) 11/1780
5) *Shunshō ga* 8) hosoban; 30.4 x 15
cm 10) Buckingham 1928.307

451
1) Nakamura Nakazō I as Chinzei
Hachirō Tametomo disguised as an
ascetic monk 2) *Kitekaeru Nishiki
no Wakayaka* 3) Nakamura 4) 11/
1780 5) *Shunshō ga* 8) hosoban; 28.8
x 13.9 cm 9) MMA 10) Gookin
1939.753 *) Left sheet of diptych;
right sheet shows Ichikawa Dan-
jūrō V as Yaheihyōe Munekiyo

452
1) Onoe Matsusuke I as the palan-
quin bearer Gohei 2) *Kitekaeru
Nishiki no Wakayaka* 3) Nakamura
4) 11/1780 5) *Shunshō ga* 8) hoso-
ban; 32.6 x 15.2 cm 10) Gookin
1939.746 *) From a multisheet
composition

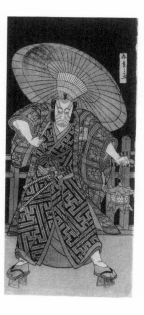

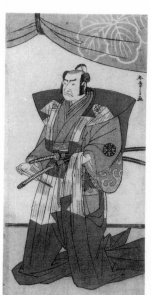

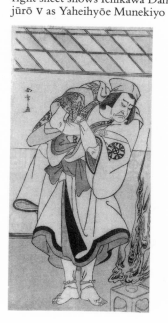

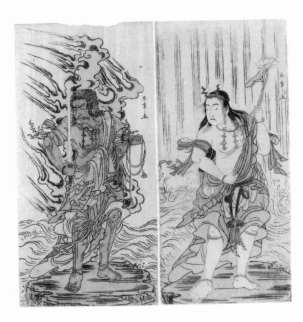

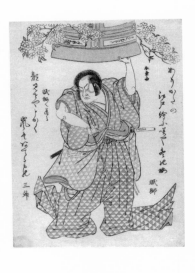

453

1) Sawamura Sōjūrō III as Kongara Dōji (R), and Ichikawa Danjūrō V as a stone image of Fudō Myōō (L) 2) *Kitekaeru Nishiki no Wakayaka* 3) Nakamura 4) 11/1780 5) *Shunshō ga* 8) *hosoban*; 31 x 14 cm (R), 31.1 x 14.8 cm (L) 9) AB; BM (both have left sheet only);

WAM (complete triptych) 10) Gookin 1939.743 (R), Buckingham 1925.2447 (L) *) Right and center sheets of triptych; left sheet shows Ichikawa Yaozō II as Seitaka Dōji (WAM)

454

1) Segawa Kikunojō III as Kojorō-gitsune disguised as the florist Okiku 2) *Mure Takamatsu Yuki no Shirahata* 3) Ichimura 4) 11/1780 5) *Shunshō ga* 8) *hosoban*; 31.5 x 14.7 cm 10) Buckingham 1925.2458

455

1) Arashi Hinasuke I as Watanabe Chōshichi Tonau 2) *Tokimekuya O-Edo no Hatsuyuki* 3) Morita 4) 11/1780 5) *Shunshō ga* 8) *chūban*; 26.3 x 19.5 cm 9) OMM 10) Gift of Chester W. Wright 1961.196 *) See No. 92

456

1) Osagawa Tsuneyo II as Itsukushima no Tennyo 2) *Tokimekuya O-Edo no Hatsuyuki* 3) Morita 4) 11/1780 5) *Shunshō ga* 8) *hosoban*; 31.5 x 15.3 cm 10) Gookin 1939. 616

457

1) Ōtani Hiroji III 4) ca. 1780 5) *Shunshō ga* 8) *hosoban*; 30.5 x 15 cm 10) Gookin 1939.656

458

1) Segawa Kikunojō III 4) ca. 1780 5) *Shunshō ga* 8) *hosoban*; 29.4 x 13.8 cm 10) Gookin 1939.634

459

1) Ōtani Hiroji III 4) ca. 1780 5) *Shunshō ga* 8) *hosoban*; 31 x 14.1 cm 10) Gookin 1939.646

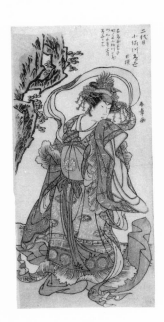

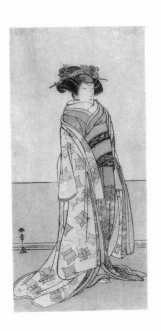

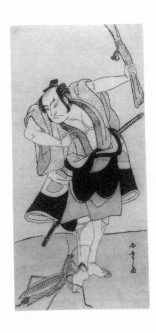

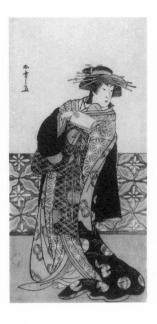

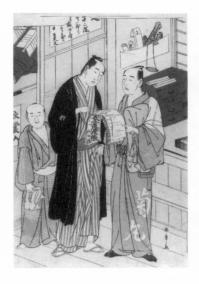

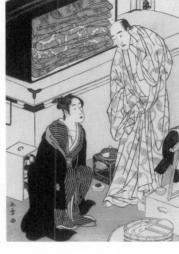

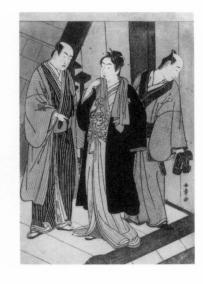

460
1) Nakamura Rikō I 4) ca. 1780
5) *Shunshō ga* 8) *hosoban*;
30.8 x 14.5 cm 9) UT5, pl. 92
10) Buckingham 1925.2457

461
1) Onoe Matsusuke I in the wardrobe room of a theater 4) ca. 1780–1783 5) *Shunshō ga* 8) *ōban*; 38.3 x 25.5 cm 9) MG 10) Buckingham 1925.2363 *) See No. 93

462
1) Sawamura Sōjūrō III (R) in his dressing room with Segawa Kikunojō III (L) 4) ca. 1780–1783 5) *Shunshō ga* 8) *ōban*; 36 x 24.6 cm 9) TNM; KWM; HRWK; HV 10) Buckingham 1938.496 *) See No. 94

463
1) Ichikawa Monnosuke II (L), Iwai Hanshirō IV (C), and Iwai Karumo (?) (R) on a landing backstage 4) ca. 1780–1783 5) *Shunshō ga* 8) *ōban*; 37.5 x 26.2 cm 9) BMFA; AMAM 10) Buckingham 1925.2364 *) See No. 95

464
1) Ichikawa Danjūrō V in his dressing room 4) ca. 1783 5) unsigned 8) *ōban*; 38.5 x 26.2 cm 9) TNM; BMFA 10) Gookin 1939.706

465
1) Ōtani Hiroji III in his dressing room assisted by Ōtani Tokuji I (?) and observed by Nakamura Nakazō I (?) 4) ca. 1783 5) *Shunshō ga* 8) *ōban*; 38.8 x 25.8 cm 10) Gookin 1939.707

466
1) Sawamura Sōjūrō III as Kobayashi no Asahina Saburō 2) *Kuruwagayoi Komachi Soga* 3) Nakamura 4) 2/1781 5) *Shunshō ga* 8) *hosoban*; 33.4 x 14.9 cm 10) Buckingham 1925.2462

467
1) Ichikawa Monnosuke II as Seijūrō (R), and Segawa Kikunojō III as Onatsu (L) 2) *Kabuki no Hana Bandai Soga* 3) Ichimura 4) 4/1781 5) *Shunshō ga* 8) *aiban*; 32.5 x 28 cm 10) Buckingham 1927.605 *) See No. 96

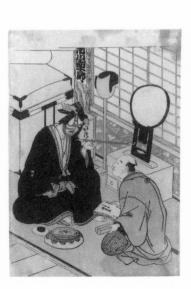

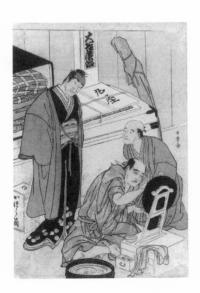

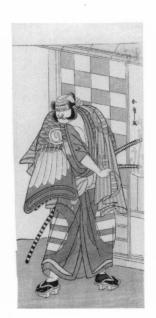

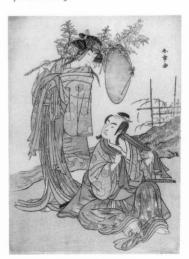

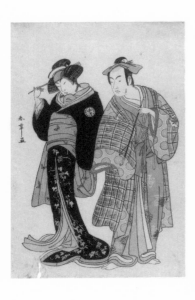

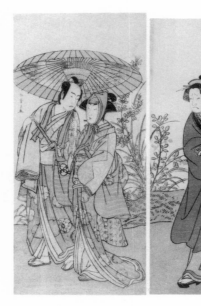

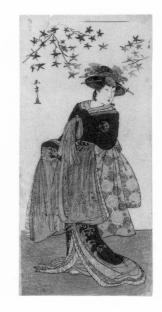

468
1) Matsumoto Kōshirō IV as
Chōemon (R), and Segawa Kiku-
nojō III as Ohan (L) 2) *Kabuki no
Hana Bandai Soga* 3) Ichimura 4) 4/
1781 5) *Shunshō ga* 8) *aiban*; 32.5 x
21.6 cm 9) BMFA; BM 10) Buck-
ingham 1937.179 *) See No. 97

469
1) Ōtani Tomoemon I as Otsuma
with Segawa Kikunojō III as
Ochiyo (R), and Bandō Mitsu-
gorō I as the greengrocer Hambei
(L) 2) *Kabuki no Hana Bandai Soga*
3) Ichimura 4) 4/1781 5) *Shunshō ga*

8) *hosoban*, diptych; 31 x 14.6 cm
(R), 31.6 x 14.5 cm (L) 10) Gookin
1939.731 (R), 1925.2454 (L)
*) Both sheets of diptych

470
1) Nakayama Tomisaburō I as the
geisha Yukino (or Oyuki?)
2) *Kabuki no Hana Bandai Soga*
3) Ichimura 4) 4/1781 5) *Shunshō
ga* 8) *hosoban*; 32.3 x 14.8 cm
10) Buckingham 1938.495

471
1) Ichikawa Danzō IV doing a
quick change between the roles of
Sadakurō and Yoichibei 2) *Kanade-
hon Chūshingura* 3) Morita 4) 3/
1781 5) *Shunshō ga* 8) *hosoban*; 32.5
x 14.8 cm 10) Gookin 1939.710

472
1) Ichikawa Danzō IV as Tonase
2) *Kanadehon Chūshingura*
3) Morita 4) 3/1781 8) *Shunshō
ga* 8) *hosoban*; 31.9 x 14.5 cm
10) Gookin 1939.771

473
1) Ichikawa Danjūrō V as Yanone
Gorō 2) *Kuruwa-gayoi Komachi
Soga* 3) Nakamura 4) 5/1781
5) *Shunshō ga* 8) *hosoban*; 32.1 x
14.9 cm 10) Gookin 1939.630

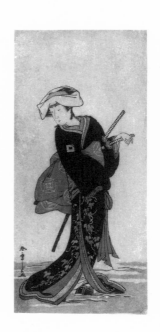

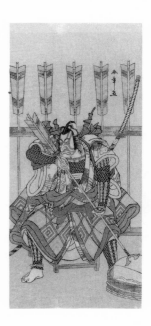

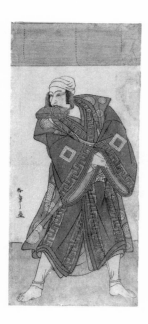

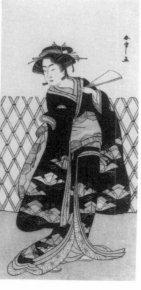

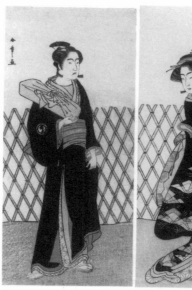

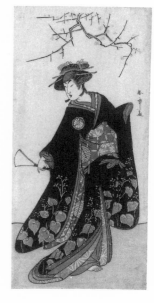

474

1) Ichikawa Danjūrō V as Prince Koretaka disguised as the courier Izutsu Chūji 2) *Yamato Kana Ariwara Keizu* 3) Nakamura 4) 5/1781 5) *Shunshō ga* 8) *hosoban*; 30.8 x 13.9 cm 9) HAA 10) Gookin 1939.660

475

1) Iwai Hanshirō IV as Mitsuōgiya Usukumo (R), and Sawamura Sōjūrō III as the hairdresser Jirokichi (L) 2) *Shida Chōja-bashira* 3) Nakamura 4) 8/1781 5) *Shunshō ga*

8) *hosoban*; 30.3 x 14.5 cm (R), 29.9 x 13.7 cm (L) 10) Buckingham 1925.2459 (R), Gookin 1939.772 (L)

476

1) Segawa Kikunojō as the spirit of Jorō-gumo (Harlot Spider) disguised as the *maiko* Tsumagiku (?) 2) *Shitennō Tonoi no Kisewata* (?) 3) Nakamura (?) 4) 11/1781 (?) 5) *Shunshō ga* 8) *hosoban*; 32.3 x 15.3 cm 10) Gift of Mr. and Mrs. Gaylord Donnelley 1971.482

477

1) Segawa Kikunojō III as the spirit of Jorō-gumo (Harlot Spider) disguised as the *maiko* Tsumagiku (R), and Ichikawa Monnosuke II as Urabe no Suetake (L) 2) *Shitennō*

Tonoi no Kisewata 3) Nakamura 4) 11/1781 5) *Shunshō ga* 8) *hosoban*; 30.9 x 14.1 cm 10) Buckingham 1938.490

478

1) Ichikawa Monnosuke II as the pilgrim Kakuzan 2) *Shitennō Tonoi no Kisewata* 3) Nakamura 4) 11/1781 5) *Shunshō ga* 8) *hosoban*; 32.1 x 14.4 cm 10) Gookin 1939.720

479

1) Ichikawa Danjūrō V as Sakata Hyōgonosuke Kintoki 2) *Shitennō Tonoi no Kisewata* 3) Nakamura 4) 11/1781 5) *Shunshō ga* 8) *hosoban*; 32 x 14.8 cm 9) BM; SNS, no. 170 10) Buckingham 1949.38 *) See No. 98

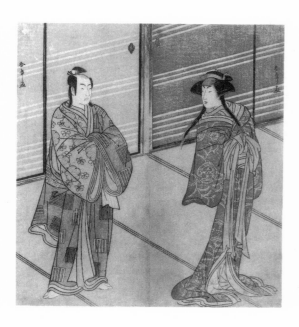

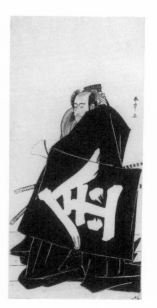

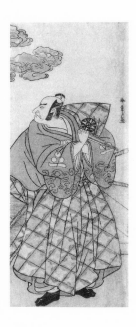

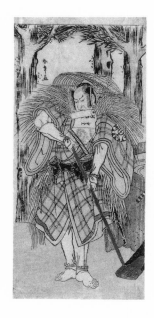

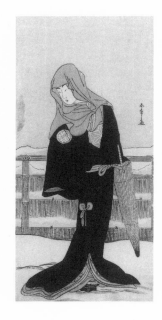

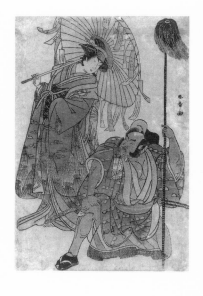

480

1) Nakamura Nakazō I as Watanabe no Tsuna 2) *Shitennō Tonoi no Kisewata* 3) Nakamura 4) 11/1781 5) *Shunshō ga* 8) *hosoban*; 31.4 x 12.5 cm 9) WT; HRWK (both have complete diptych) 10) Gookin 1939.618 *) Right sheet of diptych; left sheet shows Ichikawa Monnosuke II as the pilgrim Kakuzan

481

1) Nakamura Nakazō I as Hakamadare Yasusuke or Watanabe no Tsuna (?) 2) *Shitennō Tonoi no Kisewata* (?) 3) Nakamura (?) 4) 11/1781 (?) 5) *Shunshō ga* 8) *hosoban*; 32.7 x 14.9 cm 9) CM (complete diptych) 10) Gookin 1939.657 *) Left sheet of diptych; right sheet shows Ichikawa Danjūrō V as a woodcutter (CM)

482

1) Segawa Kikunojō III as the lady-in-waiting Suhō disguised as Tsunokuniya Tsuna 2) *Shitennō Tonoi no Kisewata* 3) Nakamura 4) 11/1781 5) *Shunshō ga* 8) *hosoban*; 31.5 x 15 cm 9) BN 10) Buckingham 1925.2451

483

1) Ichimura Uzaemon IX as Hata no Daizen Taketora disguised as the *yakko* Matahei (R), and Iwai Hanshirō IV as Umegae disguised as the poem-diviner Omatsu (L) 2) *Mukashi Otoko Yuki no Hinagata* 3) Ichimura 4) 11/1781 5) *Shunshō ga* 8) *aiban* ; 33.2 x 21.6 cm 9) BMFA 10) Gookin 1939.576

484

1) Ichimura Uzaemon IX as the *yakko* Matahei 2) *Mukashi Otoko Yuki no Hinagata* 3) Ichimura 4) 11/1781 5) *Shunshō ga* 8) *hosoban*; 30.8 x 13.8 cm 10) Gookin 1939.617

485

1) Bandō Mitsugorō I as the Shinto priest Goinosuke disguised as the spirit of a white heron 2) *Sakikaese Yuki no Miyoshino* 3) Morita 4) 11/1781 5) *Shunshō ga* 8) *hosoban*; 32.6 x 14.5 cm 9) BN; BM 10) Gookin 1939.595

486

1) Onoe Matsusuke I 4) early 1780s 5) *Shunshō ga* 8) *hosoban*; 31 x 13.3 cm 10) Gookin 1939.721

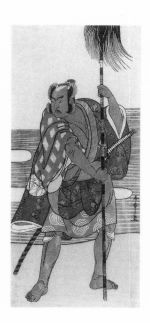

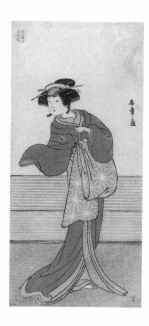

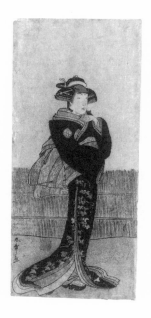

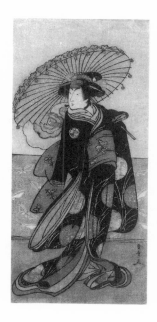

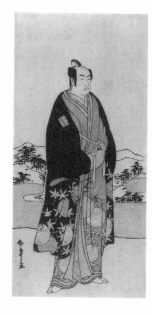

487

1) Yamashita Mangiku I 4) early 1780s 5) *Shunshō ga* 8) *hosoban*; 31.5 x 14.4 cm 10) Gookin 1939.636

488

1) Azuma Tōzō III 4) early 1780s 5) *Shunshō ga* 8) *hosoban*; 32.2 x 14.5 cm 10) Gookin 1939.735

489

1) Segawa Kikunojō III 4) early 1780s 5) *Shunshō ga* 8) *hosoban*; 31.4 x 14.3 cm 10) Buckingham 1932.1020

490

1) Ichikawa Monnosuke II 4) early 1780s 5) *Shunshō ga* 8) *hosoban*; 30.9 x 14.1 cm 10) Gift of Mr. and Mrs. Harold Henderson 1967.640

491

1) *Surimono* with chrysanthemum design 4) early 1780s 5) *Shunshō*; printed imitation of handwritten seal (*kaō*) 8) 19.8 x 37 cm (trimmed) 10) Gookin 1950.1505

492

1) Ichikawa Danjūrō V as Hanaka-wado no Sukeroku 2) *Nanakusa Yosooi Soga* 3) Nakamura 4) 5/1782 5) *Shunshō ga* 8) *hosoban*; 30.5 x 13.2 cm 9) VI, pl. L451 10) Gookin 1939.773 *) Right sheet of diptych (?)

493

1) Nakamura Nakazō I as Hige no Ikyū 2) *Nanakusa Yosooi Soga* 3) Nakamura 4) 5/1782 5) *Shunshō ga* 8) *hosoban*; 31.6 x 15.1 cm 9) SB 10) Gookin 1939.654 *) Center sheet of pentaptych; the other sheets show Nakamura Rikō I as Agemaki, Onoe Matsusuke I as Mombei, Ichikawa Danjūrō V as Sukeroku, and Sawamura Sōjūrō III as a *shirozake uri* (vendor of sweet white sake) (R to L)

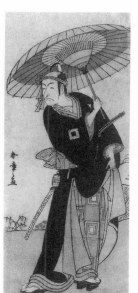

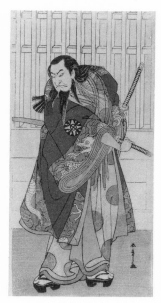

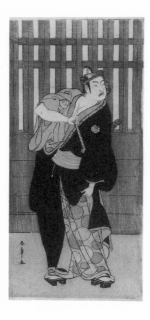

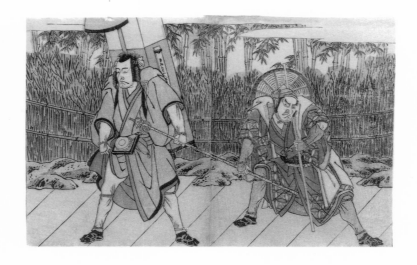

494

1) Ichimura Uzaemon IX as Soga
no Gorō Tokimune disguised as
Agemaki no Sukeroku 2) *Sukeroku
Yukari no Edo-zakura* 3) Ichimura
4) 5/1782 5) *Shunshō ga* 8) *hoso-
ban*; 32.2 x 14.8 cm 10) Gookin
1939.723 *) From a pentaptych (?)

495

1) Ichikawa Danzō IV as Arakawa
Tarō Takesada disguised as the
palanquin bearer Tarobei (R), and
Ichikawa Danjūrō V as Abe no
Sadatō disguised as the pilgrim
Kuriyagawa Jirodayū (L) 2) *Godai
Genji Mitsugi no Furisode* 3) Naka-
mura 4) 11/1782 5) unsigned
8) 17.8 x 27.4 cm 9) NHBZ2, pl.
295 10) Buckingham 1938.526
*) Double-page illustration from
unidentified theatrical picture-book

496

1) Ichikawa Danjūrō V as Miura
Kunitae (R), Segawa Kikunojō III
as Yasukata (C), and Iwai Hanshirō
IV as Utou (L) 2) *Godai Genji
Mitsugi no Furisode* 3) Nakamura

4) 11/1782 5) unsigned 8) 17.4 x
27.2 cm 10) Buckingham 1938.527
*) Double-page illustration from
unidentified theatrical picture-book

497

1) Segawa Kikunojō III as Yasu-
kata (R), and Iwai Hanshirō IV as
Utou (L) 2) *Godai Genji Mitsugi no
Furisode* 3) Nakamura 4) 11/1782
5) *Shunshō ga* 8) *hosoban*; 31.9 x
14.5 cm (each sheet) 10) Bucking-
ham 1932.1000

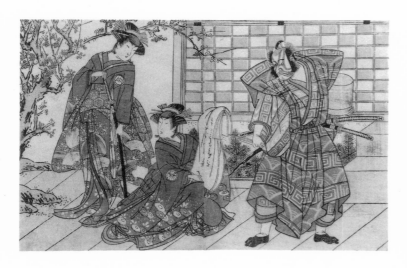

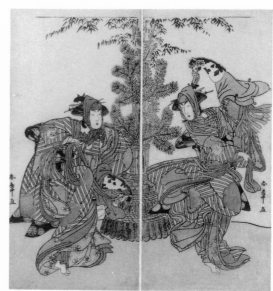

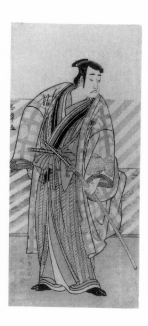

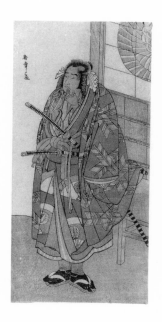

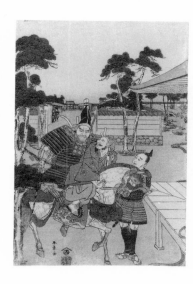

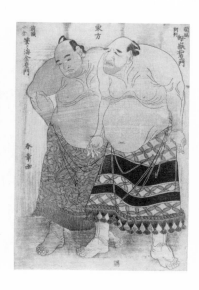

498

1) Onoe Matsusuke I 4) ca. 1782
5) *Shunshō ga* 8) *hosoban*; 31.7 x
14.2 cm 10) Gookin 1939.752

499

1) Onoe Matsusuke I 4) ca. 1782
5) *Shunshō ga* 8) *hosoban*; 31 x 14.8
cm 10) Gookin 1939.759

500

1) Musashibō Benkei brings the
captured Tosabō Shōshun to
Yoshitsune 2) *Horikawa Youchi no
Zu Uki-e Nimaitsuzuki* 4) ca. 1782
5) *Shunshō ga* 6) Nishimuraya
Yohachi 8) *ōban*; 37 x 25.3 cm
9) OMM; CM (both have complete
diptych) 10) Gookin 1939.754
*) Left sheet of diptych; title
appears on the right sheet

501

1) Sumo wrestlers of the Eastern
Group: Nijigadake Somaemon of
sekiwake rank from Awa Province
(R), and Fudenoumi Kin'emon of
maegashira rank from Kokura (L)
4) ca. 1782–1783 5) *Shunshō ga*
6) Matsumura Yahei 8) *ōban*; 38.2 x
26 cm 9) MOKB; BMFA; AMAM
10) Gookin 1949.44 *) See No. 99

502

1) Sumo wrestler Onogawa Kisa-
burō of the Eastern Group with
attendant 4) ca. 1782–1786 5) *Shun-
shō ga* 8) *ōban*; 39 x 26 cm 9) MG;
TS 10) Buckingham 1942.103
*) See No. 100

503

1) Sumo wrestlers of the Eastern
Group: Kurateyama Yadayū (R),
and Izumigawa Rin'emon (L)
4) ca. 1780 5) *Shunshō ga* 8) *ōban*;
38 x 25.3 cm 10) Restricted Gift of
the Joseph and Helen Regenstein
Foundation 1959.594

504

1) Sumo wrestlers of the Western
Group: Kashiwado Kandayū from
Edo (R), and Inagawa Masaemon
from Osaka (L) 4) ca. 1784
5) *Shunshō ga* 8) *ōban*; 39 x 25.7
cm 10) Buckingham 1942.102
*) See No. 101

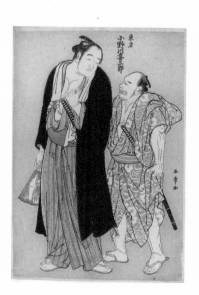

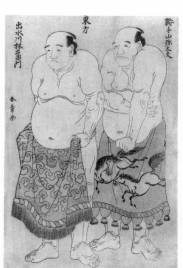

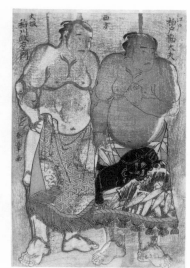

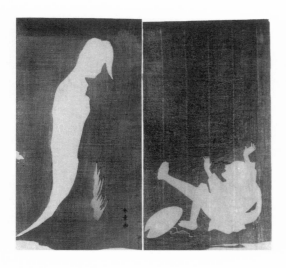

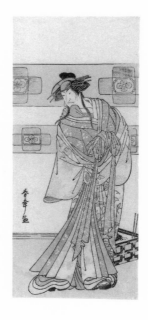

505

1) Man falling backward, startled by a woman's ghost over a river 4) ca. 1782 5) *Shunshō ga* (L) 8) *hosoban*, diptych; 31.5 x 14.2 cm (R), 31.7 x 14.2 cm (L) 9) SM (L) 10) Buckingham 1938.497

506

1) Ichikawa Monnosuke II as the ghost of the renegade monk Seigen 2) *Edo no Hana Mimasu Soga* 3) Nakamura 4) 2/1783 5) *Shunshō ga* 8) *hosoban*; 31.2 x 13.6 cm 10) Buckingham 1929.741

*) Center sheet of triptych (?); right sheet shows Sawamura Sōjūrō III as Ōtomo Hitachino-suke Yorikuni (?) (UT5, pl. 142)

508

1) Segawa Kikunojō III (?) or Segawa Otome (?) as a *shirabyōshi* dancer in *Musume Dōjō-ji* 2) *Edo no Hana Mimasu Soga* (?) or *Buke no Hana Musume no Adauchi* (?) 3) Nakamura (?) 4) 4/1783 (?) or 10/1783 (?) 5) *Shunshō ga* 8) *hoso-ban*; 33 x 15 cm 10) Buckingham 1938.492 *) Kikunojō III and his elder brother Otome used the same *yuiwata* crest, making a definite identification difficult

507

1) Iwai Hanshirō IV as Princess Sakura (Sakura Hime) (R), and Ichikawa Danjūrō V as a skeleton, spirit of the renegade monk Seigen (L) 2) *Edo no Hana Mimasu Soga* 3) Nakamura 4) 2/1783 5) *Shunshō ga* 8) *hosoban*, diptych; 32.9 x 15 cm (R), 32.9 x 15.2 cm (L) 9) MG; KZ, no. 469 10) Buckingham 1938.491 *) See No. 102

509

1) Ichikawa Monnosuke II as a Buddhist monk 2) *Edo no Hana Mimasu Soga* 3) Nakamura 4) 4/1783 5) *Shunshō ga* 8) *hosoban*; 32 x 14.2 cm 9) HV 10) Gookin 1939.655 *) Left sheet of triptych (?)

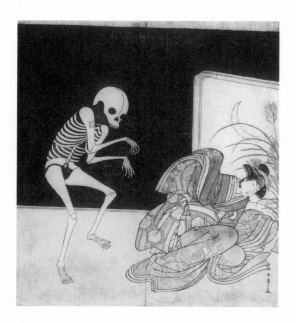

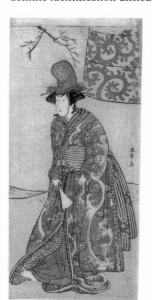

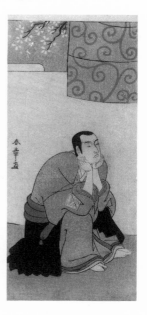

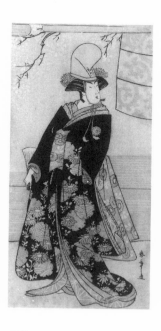

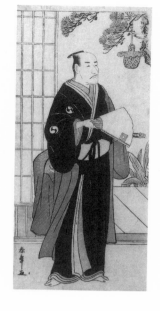

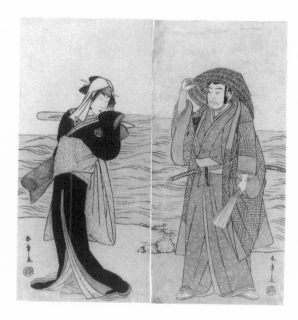

510

1) Segawa Kikunojō III as a *shira-byōshi* dancer in *Musume Dōjō-ji* 2) *Edo no Hana Mimasu Soga* 3) Nakamura 4) 4/1783 5) *Shunshō ga* 8) *hosoban*; 30.5 x 15 cm 9) MMA (complete triptych); TNM 10) Buckingham 1925.2464 *) Center sheet of triptych; right sheet shows Ichikawa Monnosuke II, and left sheet shows Sawamura Sōjūrō III, both as Buddhist monks

511

1) Ichikawa Danjūrō V as Ōboshi Yuranosuke 2) *Kanadehon Chū-shingura* 3) Nakamura 4) 5/1783 5) *Shunshō ga* 8) *hosoban*; 32.1 x 14.8 cm 9) MIA 10) Gookin 1939.778

512

1) Nakamura Nakazō I as Kume no Heinaizaemon disguised as the street fortune-teller Kōsaka Jinnai (R), and Nakamura Rikō I as Hanako, the daughter of Koshiba Kamon, disguised as a *yotaka* (low-class prostitute) (L) 2) *Koto-buki Banzei Soga* 3) Ichimura

4) 5/1783 5) *Shunshō ga* 7) *kiwame* (added later) 8) *hosoban*; 31.8 x 14.5 cm (R), 31.6 x 14.5 cm (L) 9) SM (R) 10) Buckingham 1925.2465 (R), 1925.2466 (L) *) Two sheets of triptych

513

1) Ōtani Hiroji III as Maruya Gorohachi 2) *Kotobuki Banzei Soga* 3) Ichimura 4) 5/1783 5) *Shunshō ga* 8) *hosoban*; 30.7 x 13.3 9) WT (complete triptych); TNM 10) Gookin 1939.600 *) Center sheet of triptych

514

1) Nakamura Nakazō I as Ono Sadakurō 2) *Kanadehon Chūshin-gura* 3) Ichimura 4) 6/1783 5) *Shun-shō ga* 8) *hosoban*; 32.1 x 14.4 cm 10) Buckingham 1932.1015

515

1) Nakamura Nakazō I as Kako-gawa Honzō in *komusō* attire 2) *Kanadehon Chūshingura* 3) Ichi-mura 4) 7/1783 5) *Shunshō ga* 8) *hosoban*; 33 x 14.7 cm 10) Gift of Mr. and Mrs. Gaylord Donnelley 1970.493

516

1) Ōtani Hiroji III as the monk Izayoibō 2) *Keisei Katabira ga Tsuji* 3) Ichimura 4) 7/1783 5) *Shunshō ga* 8) *hosoban*; 31 x 15 cm 10) Buck-ingham 1938.493 *) Right sheet of triptych

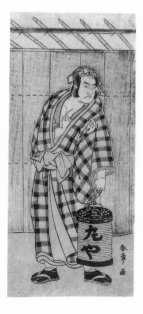

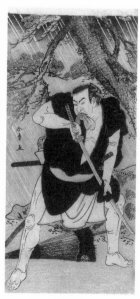

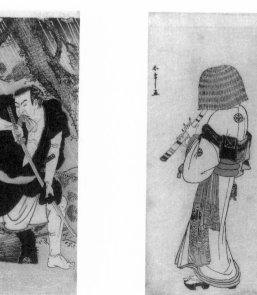

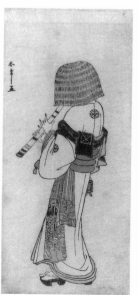

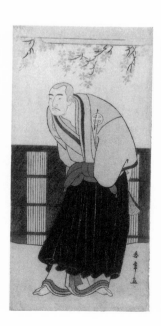

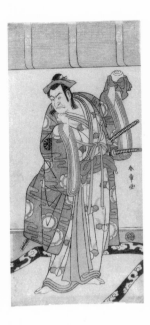

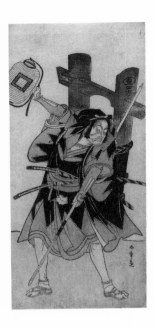

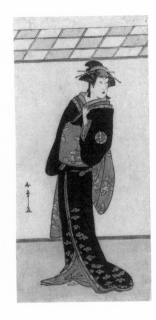

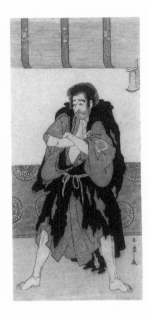

517
1) Nakamura Nakazō I as Nagao Terutora 2) *Kuruma-gakari Tekuda no Gumbai* 3) Ichimura 4) 11/1783 5) *Shunshō ga* 7) *kiwame* (added later?) 8) *hosoban*; 32.5 x 14.8 cm 10) Gookin 1939.770

518
1) Ichikawa Danjūrō V as a loyal *rōnin* 4) ca. 1783 5) *Shunshō ga* 8) *hosoban*; 31.4 x 14.6 cm 9) BMFA 10) Gift of Joseph and Helen Regenstein 1959.593

519
1) Nakamura Rikō I as Lady Mankō (Mankō Gozen) (?) 2) *Soga Musume Chōja* (?) 3) Nakamura (?) 4) 1/1784 (?) 5) *Shunshō ga* 8) *hosoban*; 32.1 x 14.7 cm 10) Gookin 1939.727

520
1) Ichikawa Danjūrō V as the monk Mongaku disguised as Seizaemon Bōzu 2) *Ōakinai Hiru ga Kojima* 3) Nakamura 4) 11/1784 5) *Shunshō ga* 8) *hosoban*; 30.9 x 13.8 cm 10) Buckingham 1938.494

521
1) Ōtani Hiroji III as Hata no Daizen Taketora disguised as Shikishima Wakahei 2) *Jūni-hitoe Komachi-zakura* 3) Kiri 4) 11/1784 5) *Shunshō ga* 8) *hosoban*; 30.8 x 13.8 cm 10) Gookin 1939.742 *) From a multisheet composition

522
1) Nakayama Kojūrō VI as Osada no Tarō Kagemune (in reality Hatchō Tsubute no Kiheiji) in the guise of a lamplighter of Gion Shrine 2) *Yukimotsu Take Furisode Genji* 3) Nakamura 4) 11/1785 5) *Hayashi* in jar-shaped outline 8) *hosoban*; 31.6 x 15.2 cm 9) HRWK 10) Buckingham 1932.1005 *) See No. 103

523
1) Sawamura Sōjūrō III as Komatsu no Shigemori (R), and Nakayama Kojūrō VI as Osada no Tarō Kagemune (in reality Hatchō Tsubute no Kiheiji) in the guise of a lamplighter of Gion Shrine (L) 2) *Yukimotsu Take Furisode Genji* 3) Nakamura 4) 11/1785 5) *Hayashi* in jar-shaped outline 8) *aiban*; 34.6 x 24.2 cm 9) JUM; BMFA; BM 10) Buckingham 1942.104 *) See No. 104

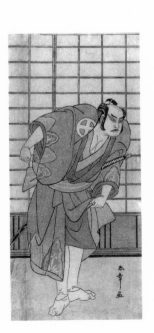

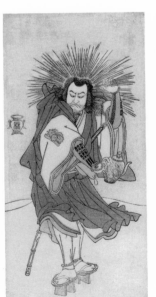

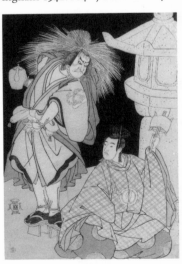

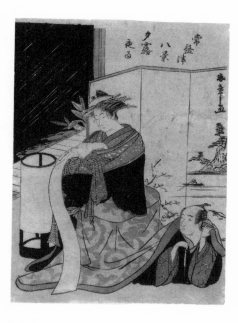

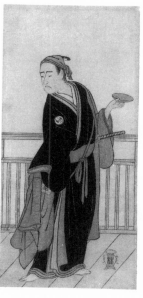

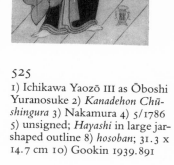

524

1) *Yūgiri Yau* (Yūgiri and Night
Rain). The courtesan Yūgiri
and her lover Fujiya Izaemon
2) *Tokiwazu Hakkei* 4) mid-1780s
5) *Shunshō ga* 8) *chūban*; 26 x 19.4
cm 10) Gift of Benjamin K. Smith
1927.697

525

1) Ichikawa Yaozō III as Ōboshi
Yuranosuke 2) *Kanadehon Chū-
shingura* 3) Nakamura 4) 5/1786
5) unsigned; *Hayashi* in large jar-
shaped outline 8) *hosoban*; 31.3 x
14.7 cm 10) Gookin 1939.891

526

1) Nakayama Kojūrō VI as Kō
no Moronao 2) *Kanadehon Chū-
shingura* 3) Nakamura 4) 5/1786
5) unsigned; *Hayashi* in large jar-
shaped outline 8) *hosoban*; 32.2 x
14.9 cm 10) Gookin 1940.1091

527

1) Nakamura Kojūrō VI in a *daishō
no mai* (sword dance) 2) *Gion
Nyōgo* 3) Nakamura 4) 10/1786
5) *Katsu Shunshō ga* 8) *hosoban*;
31.8 x 13.7 cm 10) Gookin
1939.659

528

1) Sawamura Sōjūrō III as Kusu-
noki Tatewaki Masatsura (R),
Onoe Matsusuke I as the monk
Sahei Bōzu (C), and Ichikawa
Yaozō III as the prince's servant
Kusunoki Uraminosuke (L) 2)
*Kumoi no Hana Yoshino no Waka-
musha* 3) Nakamura 4) 11/1786
5) unsigned; *Hayashi* in large jar-
shaped outline (R, C) 8) *hosoban*;

32.3 x 14.8 cm (R), 32.2 x 15.1 cm
(C), 32.1 x 14.9 cm (L) 9) UT5, BM
(L); HRWK (R, L) 10) Buckingham
1930.102 *) Three sheets of a four-
sheet composition (?); the sheet in
the BM is signed *Katsu Shunkaku*
(one of Shunshō's pupils)

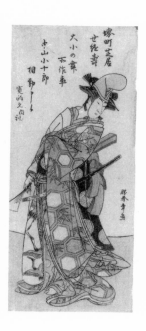

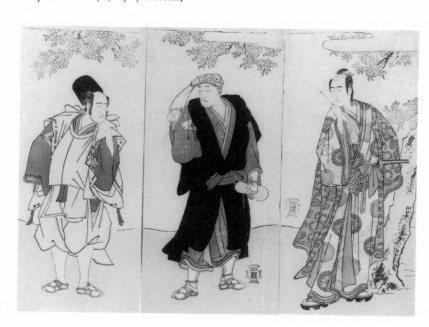

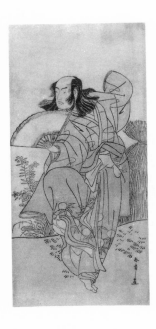

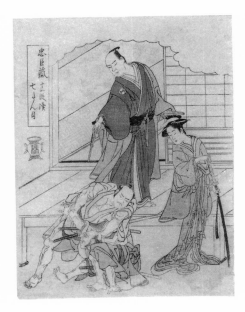

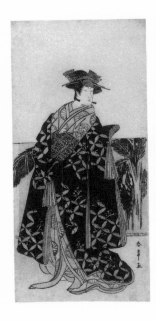

529
1) Ichikawa Yaozō III as Kusunoki Uraminosuke disguised as a male fox from Tsukamoto (?) 2) *Kumoi no Hana Yoshino no Wakamusha* (?) 3) Nakamura (?) 4) 11/1786 (?) 5) *Shunshō ga* 8) hosoban; 31 x 14.7 cm 10) Gookin 1939.755 *) Right sheet of diptych (?)

530
1) Act VII: The Ichiriki Teahouse 2) *Chūshingura Jūichidan Tsuzuki* 4) ca. 1786 5) unsigned; *Hayashi* in large jar-shaped outline 8) *chūban*; 25.6 x 19.5 cm 9) BM 10) Gookin 1939.866

531
1) Nakayama Tomisaburō I 4) ca. 1788 5) *Shunshō ga* 8) hosoban; 32.6 x 15 cm 10) Buckingham 1925.2463

532
1) Ichikawa Monnosuke II as the renegade monk Zenjibō disguised as Dainichibō 2) *Edo no Fuji Wakayagi Soga* 3) Nakamura 4) 1/1789 5) *Shunshō ga* 7) *kiwame* 8) hosoban; 31.5 x 14.2 cm 9) BM; MG 10) Buckingham 1932.1014

533
1) Nakamura Nakazō I as the sword master Takuma Genryū (?) 2) *Edo no Fuji Wakayagi Soga* (?) 3) Nakamura (?) 4) 1/1789 (?) 5) *Shunshō ga* 8) hosoban; 32.7 x 15 cm 10) Gookin 1939.661

534
1) Iwai Hanshirō IV as Osuwa 2) *Koi no Yosuga Kanagaki Soga* 3) Ichimura 4) 4/1789 5) *Shunshō ga* 8) hosoban; 32.1 x 14.7 cm 9) SM (complete diptych) 10) Buckingham 1952.379 *) Right sheet of diptych (?); left sheet shows Sawamura Sōjūrō III as Kameya Chūbei

535
1) Ōtani Hiroji III as Makino Aratarō Tokizumi 2) *Hana no O-Edo Masakado Matsuri* 3) Ichimura 4) 11/1789 5) *Shunshō ga* 6) Iwatoya Gempachi 8) hosoban; 31.8 x 14.8 cm 10) Gookin 1939.658

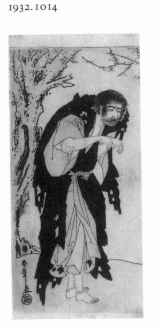

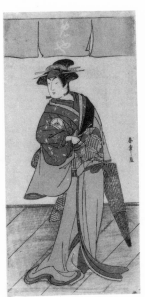

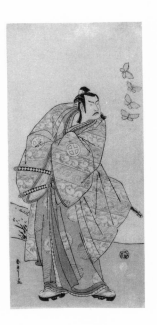

536

1) Plants, porcelain bowl, and glass
goblet 4) ca. 1789 5) *Shunshō ga*;
Yū (?; printed imitation of hand-
written seal) 6) Shumpūdō Ryū-
kotsu 8) long *surimono*; 19 x 53 cm
10) Buckingham 1925.2366
*) See No. 105

537

1) Seven Gods of Good Fortune
in a Treasure Ship 4) ca. 1789 5)
Shunshō ga 7) *kiwame* 8) *hashira-e*;
63.5 x 11.3 cm 10) Buckingham
1925.2860

538

1) The Goddess Benten holding
a *biwa* and a young man holding
a shoulder drum 2) *Fukujin Egao
Kurabe* (Comparing the Smiles of
the Lucky Gods) 4) late 1780s
5) *Shunshō ga* 8) *koban*; 22.5 x 16.7
cm 10) Gookin 1939.745

539

1) Young man dressed as an actor
of the Ichikawa family (by Shun-
shō), a maid and a geisha (by
Shunchō) 4) late 1780s 5) *Shunshō
ga, Shunchō ga* 8) *aiban*; 32.3 x 23
cm 9) HGM 10) Buckingham
1938.545

540

1) Three *komusō* monks: Ichikawa
Ebizō (Danjūrō V) as Kudō Suke-
tsune (R), Ichikawa Monnosuke II
as Soga no Jūrō Sukenari (C), and
Ichikawa Omezō I as Soga no
Gorō Tokimune (L) 2) *Waka Mura-
saki Edokko Soga* 3) Ichimura 4) I/

1792 5) *Shunshō ga* 6) Harimaya
Shinshichi 7) *kiwame* 8) *hosoban*,
triptych; 32.8 x 14.4 cm (R), 36.2
x 14.7 cm (C), 32.7 x 14.3 cm (L)
9) TNM (C) 10) Gift of Mr. and
Mrs. Gaylord Donnelley 1969.689
*) See No. 106

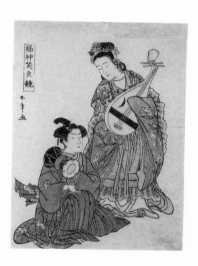
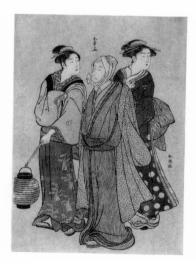
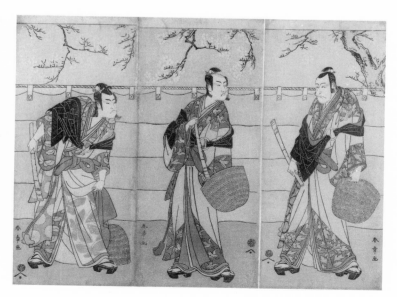

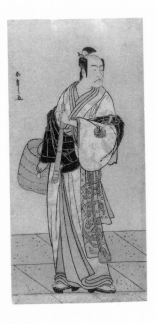

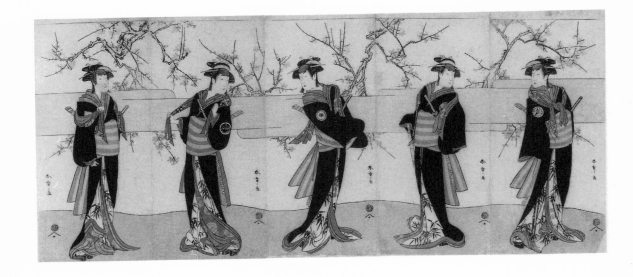

541
1) Ichikawa Ebizō as Kudō Suketsune disguised as a *komusō* 2) *Waka Murasaki Edokko Soga* 3) Ichimura 4) 1/1792 5) *Shunshō ga* 8) *hosoban*; 28.8 x 13.9 cm 9) CM 10) Gookin 1939.632 *) Center sheet of triptych

542
1) Segawa Kikunojō III as Karigane Obun, Nakayama Tomisaburō I as An no Oyasu, Iwai Kiyotarō II as Kaminari no Osha, Nakayama Tatezō I as Gokuin no Osen, and Ichikawa Monnosuke

II as Hotei no Oichi (R to L) 2) "Gonin Onna," scene one of *Waka Murasaki Edokko Soga* 3) Ichimura 4) 2/1792 5) *Shunshō ga*; *Shun* and *Shō* seals on the skirts

of each kimono 6) Harimaya Shinshichi 7) *kiwame* 8) *hosoban*; 32.3 x 14.6 cm (each sheet) 9) MMA (C); HAA (C, second from L) 10) Buckingham 1928.988

543
1) Iwai Hanshirō IV 4) ca. 1792 5) *Shunshō ga* 7) *kiwame* 8) *hosoban*; 30.7 x 15.1 cm 10) Gookin 1939.718

KATSUKAWA SHUNKŌ

(1743–1812)

544
1) Ōtani Hiroemon III as Osada no Zenjō Kagemune 2) *Izu-goyomi Shibai no Ganjitsu* 3) Morita 4) 1/1772 5) *Shunkō ga*; *ki* in jar-shaped outline 8) *hosoban*; 30.5 x 14.4 cm 10) Gookin 1939.873 *) See No. 107

545
1) Ichikawa Raizō II as Kojirō Masahira (R), and Ichikawa Danzō IV as Doi no Yatarō (L) 2) *Kaomise Ama no Iwato* 3) Nakamura 4) 11/1774 5) *Shunkō ga* 8) *hosoban*; 29.6 x 13.7 cm 9) HRWK 10) Buckingham 1925.2468

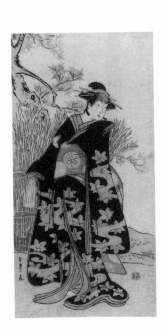

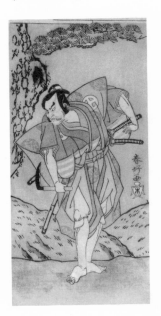

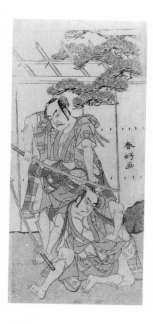

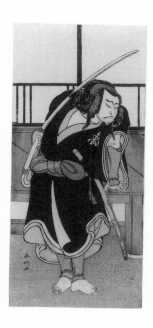

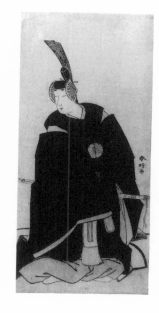

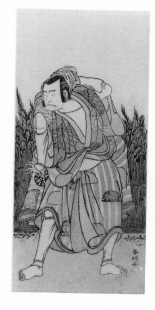

546

1) Ōtani Hiroji III as Oniō Shin-zaemon (R), and Nakamura Suke-gorō II as Wappa no Kikuō (L) 2) *Iro Moyō Aoyagi Soga* 3) Naka-mura 4) 1/1775 5) *Shunkō ga* 8) *hosoban*; 29.5 x 13.7 cm 10) Buck-ingham 1925.2467

547

1) Nakamura Nakazō I as Aso no Matsuwaka (?) 2) *Iro Moyō Aoyagi Soga* (?) 3) Nakamura (?) 4) 2/1775 (?) 5) *Shunkō ga* 8) *hosoban*; 31.1 x 14.2 cm 10) Buckingham 1938.543

548

1) Nakamura Tomijūrō I as Taira no Masakado disguised as Ōtomo no Kuronushi (?) or Sugawara Michizane (?) 2) *Shida Yuzuriha Hōrai Soga* (?) or *Sugawara Denju Tenarai Kagami* (?) 3) Morita (?) 4) 1/1775 (?) or 5/1775 (?) 5) *Shunkō ga* 8) *hosoban*; 31.5 x 14.5 cm 9) MMA 10) Gookin 1939.879

549

1) Nakamura Nakazō I as Hachi-man Tarō Yoshiie (?) 2) *Ōshū Adachi ga Hara* (?) 3) Nakamura (?) 4) 4/1775 (?) 5) *Shunkō ga* 8) *hoso-ban*; 31.1 x 14.2 cm 9) UT8, pl. 155 10) Gookin 1939.868 *) Right sheet of diptych

550

1) Ichikawa Yaozō II as the boat-man Jirosaku 2) *Oyafune Taiheiki* 3) Ichimura 4) 11/1775 5) *Shunkō ga* 8) *hosoban*; 32.7 x 14.8 cm 10) Buckingham 1928.989 *) Right sheet of diptych (?)

551

1) Ichikawa Yaozō II as Soga no Dōzaburō (?) 2) *Kamuri Kotoba Soga no Yukari* (?) 3) Ichimura (?) 4) 1/1776 (?) 5) *Shunkō ga* 8) *hoso-ban*; 29 x 13.6 cm 10) Gookin 1939.875 *) Left sheet of diptych

552

1) Ichikawa Danjūrō V as Kajiwara Heiji (?) 2) *Hiragana Seisuiki* (?) 3) Morita (?) 4) 3/1776 (?) 5) *Shunkō ga* 8) *hosoban*; 29.2 x 14.6 cm 9) TNM 10) Buckingham 1925.2481

553

1) Ichikawa Yaozō II as Sakura-maru 2) *Sugawara Denju Tenarai Kagami* 3) Ichimura 4) 7/1776 5) *Shunkō ga* 8) *hosoban*; 31.1 x 15.5 cm 10) Gookin 1939.877 *) From a multisheet composition

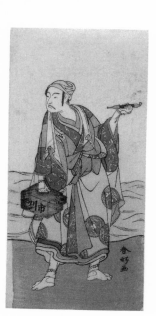

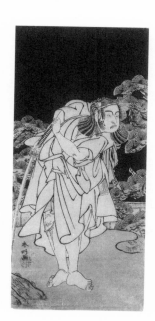

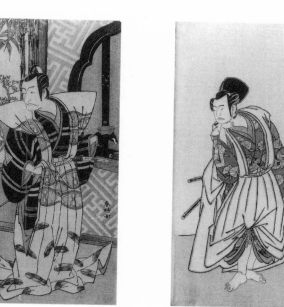

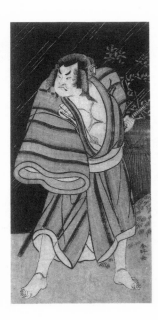

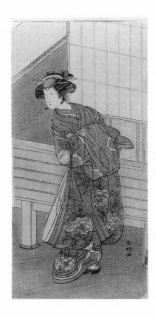

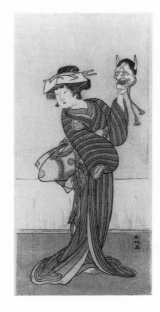

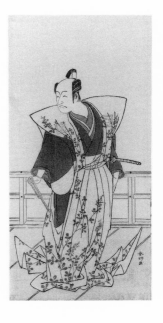

554
1) Sakata Hangorō II as the sumo wrestler Kujaku Saburō Narihira (?) 2) *Sugata no Hana Yuki no Kuronushi* (?) 3) Ichimura (?) 4) 11/1776 (?) 5) *Shunkō ga* 8) *hosoban*; 29.5 x 14.2 cm 9) EV; BMFA 10) Gookin 1939.881

555
1) Segawa Kikunojō III as the courtesan Takamura of Onoteruya (?) 2) *Sugata no Hana Yuki no Kuronushi* (?) 3) Ichimura (?) 4) 11/1776 (?) 5) *Shunkō ga* 8) *hosoban*; 31.8 x 15 cm 10) Buckingham 1925.2477
*) From a multisheet composition

556
1) Yamashita Kinsaku II 4) ca. 1776 5) *Shunkō ga* 8) *hosoban*; 31.4 x 15.1 cm 10) Buckingham 1925.2398
*) Right sheet of diptych (?)

557
1) Ichikawa Danjūrō V 4) ca. 1776 5) *Shunkō ga* 8) *hosoban*; 31 x 15.3 cm 10) Buckingham 1925.2469
*) From a multisheet composition (?)

558
1) Arashi Otohachi II as the monk Hōkaibō 2) *Edo Shitate Kosode Soga* 3) Morita 4) 1/1777 5) *Shunkō ga* 8) *hosoban*; 31.1 x 14 cm 9) UTS13, pl. 27 10) Buckingham 1925.2486

559
1) Nakamura Nakazō I as Toyose Saburozaemon Kageaki 2) *Hōnō Nitta Daimyōjin* 3) Morita 4) 7/1777 5) *Shunkō ga* 8) *hosoban*; 31.1 x 14.7 cm 10) Gookin 1939.871

560
1) Nakamura Tomijūrō I as a courtesan (R), and Sawamura Sōjūrō III as Oyamada Tarō (?) disguised as Tarosaku of Oyamada Village (L) 2) *Azuma no Mori Sakae Kusunoki* 3) Ichimura 4) 11/1779 5) *Katsukawa Shunkō ga* 8) narrow

ai-tanzakuban; 32.3 x 7.3 cm (R), 32.3 x 8 cm (L) 10) Buckingham 1939.2203a (R), 1939.2203b (L)
*) See No. 108

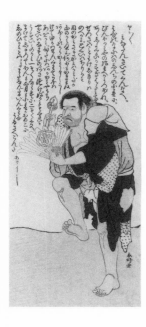

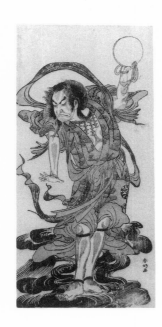

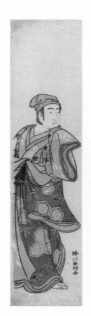

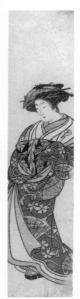

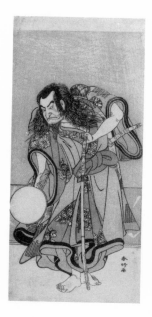

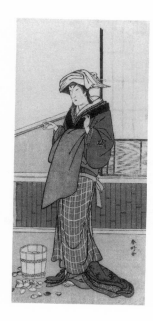

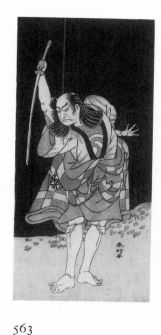

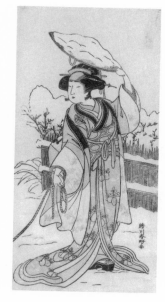

561

1) Nakamura Nakazō I as the
monk Shunkan 2) *Hime Komatsu
Ne no Hi Asobi* 3) Ichimura 4) 7/
1778 5) *Shunkō ga* 8) *hosoban*, right
sheet of diptych; 32.5 x 14.7 cm
10) Buckingham 1939.2121
*) See No. 109

562

1) Nakamura Rikō I as Moshio (?)
2) *Honda Yayoi Meoto Junrei* (?)
3) Ichimura (?) 4) 7/1778 (?)
5) *Shunkō ga* 8) *hosoban*; 31.9 x 14.8
cm 10) Buckingham 1925.2483

563

1) Nakamura Nakazō I as Ippei (?)
2) *Koi Nyōbō Somewake Tazuna* (?)
3) Ichimura (?) 4) 8/1778 (?)
5) *Shunkō ga* 8) *hosoban*; 32.7 x 15
cm 10) Buckingham 1939.2204
*) Right sheet of diptych

564

1) Yoshizawa Ayame IV as
Yadorigi disguised as Orie
2) *Motomishi Yuki Sakae Hachi
no Ki* 3) Nakamura 4) 11/1778
5) *Katsukawa Shunkō ga* 8) *hoso-
ban*, right sheet of diptych (?);
30.5 x 15 cm 10) Buckingham
1925.2478 *) See No. 110

565

1) Ichimura Uzaemon IX as
Araoka Hachirō 2) *Sakimasu ya
Ume no Kachidoki* 3) Ichimura
4) 11/1778 5) *Katsukawa Shunkō
ga* 8) *hosoban*; 32.2 x 14.8 cm
10) Gookin 1939.872 *) The
blocks were modified and reused
in 11/1779; see GUDHJ7, pl. 207

566

1) Ichikawa Monnosuke II 4) ca.
1778 5) *Shunkō ga* 8) *hosoban*; 32.2
x 14.4 cm 10) Gookin 1939.867
*) From a multisheet composition (?)

567

1) Segawa Kikunojō III as Oshichi
2) *Junshoku Edo Murasaki* 3) Ichi-
mura 4) 1/1779 5) *Shunkō ga*
8) *hosoban*; 32.6 x 14.9 cm
10) Buckingham 1925.2489
*) Right sheet of diptych (?)

568

1) Ichikawa Danjūrō V as Kazusa
no Akushichibyōe Kagekiyo dis-
guised as a blind court musician
(*kengyō*) 2) *Edo Meisho Midori Soga*
3) Morita 4) 4/1779 5) *Katsukawa
Shunkō ga* 8) *hosoban*; 28.6 x 13.7
cm 10) Gookin 1939.882

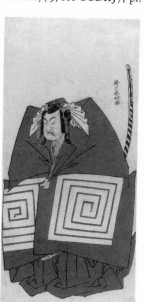

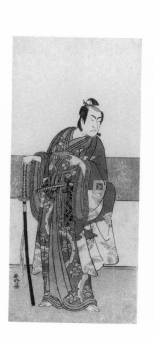

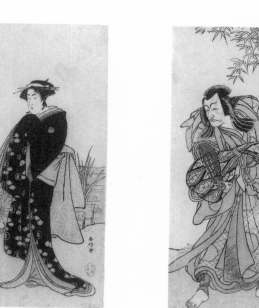

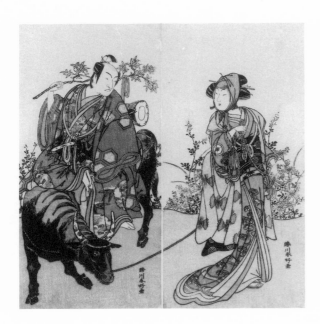

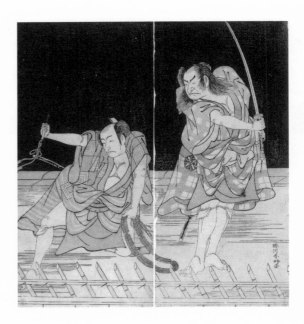

569
1) Iwai Hanshirō IV as Okume (R), and Ichikawa Monnosuke II as Koshiba Yukienojō disguised as the *eboshi* seller Rokusaburō (L)

2) *Katakiuchi Adana Kashiku* 3) Nakamura 4) 7/1779 5) *Katsukawa Shunkō ga* 8) *hosoban*; 30.4 x 14.8 cm (R), 30.4 x 15.2 cm (L) 9) PAM (R) 10) Buckingham 1925.2371

570
1) Nakamura Nakazō I as Danshichi Kurobei (R), and Ichikawa Danjūrō V as Issun Tokubei (L) 2) *Natsu Matsuri Naniwa Kagami* 3) Morita 4) 7/1779 5) *Katsukawa*

Shunkō ga (R) 8) *hosoban*, diptych; 31.6 x 14.2 cm (R), 31.4 x 14.5 cm (L) 9) BMFA (both); HAA (L); AB (L) 10) Buckingham 1942.113 (R), 1928.311 (L) *) See No. 111

571
1) Yamashita Kinsaku II as Lady Kikusui (Kikusui Gozen) 2) *Kaeribana Eiyū Taiheiki* 3) Nakamura 4) 11/1779 5) *Katsukawa Shunkō ga* 8) *hosoban*; 30 x 14.8 cm 9) UT8, pl. 173; BMFA; MMA; Hayashi (1902), pl. 588 10) Buckingham 1925.2475 *) Right sheet of diptych (?)

572
1) Nakamura Sukegorō II 4) ca. 1779 5) *Katsukawa Shunkō ga* 8) *hosoban*; 30.3 x 14.8 cm 10) Gookin 1939.883

573
1) Segawa Kikunojō III 4) ca. 1779 5) *Katsukawa Shunkō ga* 8) *hosoban*; 30.7 x 14.7 cm 9) MOKB 10) Buckingham 1925.2476

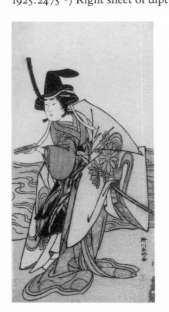

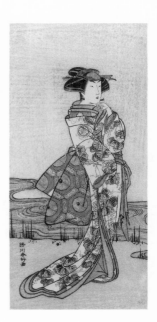

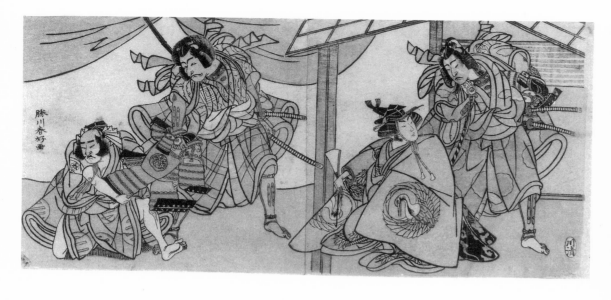
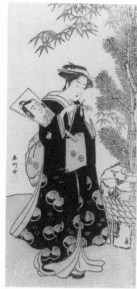

574

Right-hand page: 1) Bandō Hiko-saburō III as Soga no Gorō (R), and Segawa Kikunojō IV as Onna Asahina (L) 2) *Ume-goyomi Ake-bono Soga* 3) Ichimura 4) 1/1780

Left-hand page: 1) Onoe Matsu-suke I as Furugōri Shinzaemon (L), and Ichikawa Danjūrō V as Kagekiyo (R) 2) *Hatsumombi Kuruwa Soga* 3) Nakamura 4) 1/

1780 5) *Katsukawa Shunkō ga* 8) 15 x 32.3 cm 10) Gift of Mr. and Mrs. Harold G. Henderson 1968.359 *) Double-page illustration from a theatrical picture-book

575

1) Segawa Kikunojō III as Otora
2) *Ume-goyomi Akebono Soga*
3) Ichimura 4) 3/1780 5) *Shunkō ga*
8) *hosoban*; 33 x 14 cm 10) Buck-ingham 1925.2488 *) Left sheet of diptych (?)

576

1) Nakamura Nakazō I as Matsuō-maru 2) *Sugawara Denju Tenarai Kagami* 3) Morita 4) 3/1780
5) *Katsukawa Shunkō ga*
8) *hosoban*; 30.3 x 14.7 cm
9) FGA 10) Gookin 1939.884

577

1) Ichikawa Monnosuke II as Hayano Kampei 2) *Kanadehon Chūshin Nagori no Kura* 3) Naka-mura 4) 9/1780 5) *Shunkō ga*
8) *hosoban*; 32.8 x 15.2 cm
10) Buckingham 1939.2202

578

1) Ichikawa Danjūrō V as Enya Hangan (?) 2) *Kanadehon Chūshin Nagori no Kura* (?) 3) Nakamura (?)
4) 9/1780 (?) 5) *Shunkō ga* 8) *hoso-ban*; 32.2 x 15 cm 10) Gookin 1939.878

579

1) Yamashita Mangiku I as Osan
2) *Kitekaeru Nishiki no Wakayaka*
3) Nakamura 4) 11/1780 5) *Shunkō ga* 8) *hosoban*; 29.5 x 14 cm 9) BMFA
10) Buckingham 1925.2474

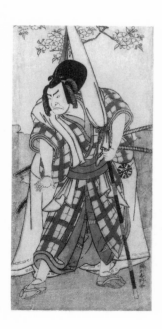
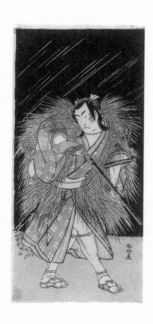
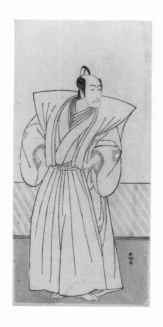
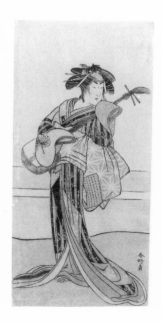

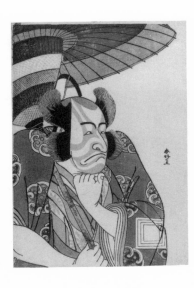 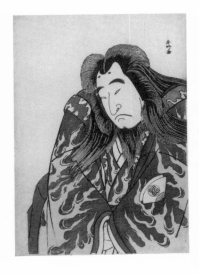 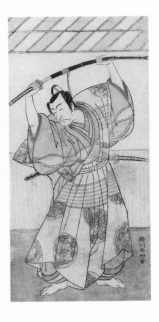 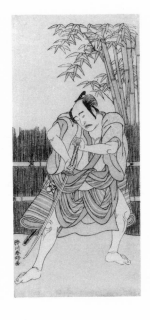

580
1) Ichikawa Danjūrō V as Kazusa no Gorobei Tadamitsu 2) *Kitekaeru Nishiki no Wakayaka* 3) Nakamura 4) 11/1780 5) *Shunkō ga* 8) *aiban*; 32.2 x 22.5 cm (untrimmed) 10) Buckingham 1925.2369 *) See No. 112

581
1) Onoe Matsusuke I as Retired Emperor Sutoku 2) *Kitekaeru Nishiki no Wakayaka* 3) Nakamura 4) 11/1780 5) *Shunkō ga* 8) *aiban*; 32.1 x 23.5 cm (untrimmed) 10) Buckingham 1925.2370 *) See No. 113

582
1) Ichikawa Danjūrō V as Taira no Munekiyo (?) 2) *Kitekaeru Nishiki no Wakayaka* (?) 3) Nakamura (?) 4) 11/1780 (?) 5) *Katsukawa Shunkō ga* 8) *hosoban*; 30.5 x 14.6 cm 9) HAA 10) Gookin 1939.885 *) From a triptych (?)

583
1) Bandō Mitsugorō I as Ogata no Saburō disguised as Yōrōya Takiemon 2) *Mure Takamatsu Yuki no Shirahata* 3) Ichimura 4) 11/1780 5) *Katsukawa Shunkō ga* 8) *hosoban*; 32.2 x 14.4 cm 10) Buckingham 1925.2473 *) Right sheet of diptych (?)

584
1) Ichikawa Danzō IV as Shutokuin 2) *Tokimekuya O-Edo no Hatsuyuki* 3) Morita 4) 11/1780 5) *Shunkō ga* 8) *hosoban*; 32 x 14.7 cm 10) Gift of Mr. and Mrs. Harold G. Henderson 1967.644

585
1) Iwai Hanshirō IV as Umegae disguised as the female fortune-teller Omatsu 2) *Mukashi Otoko Yuki no Hinagata* 3) Ichimura 4) 11/1781 5) *Shunkō ga* 8) *hosoban*; 33 x 14.9 cm 10) Buckingham 1925.2484

586
1) Sawamura Sōjūrō III 4) ca. 1781 5) *Shunkō ga* 3) *hosoban*; 29 x 14.2 cm 10) Buckingham 1928.308 *) From a multisheet composition (?)

587
1) Ichikawa Danjūrō V as Sukeroku 2) *Nanakusa Yosooi Soga* 3) Nakamura 4) 5/1782 5) *Katsukawa Shunkō ga* 8) *hosoban*, center sheet of triptych; 32.5 x 15.1 cm 9) JUM 10) Gookin 1939.2245 *) See No. 114

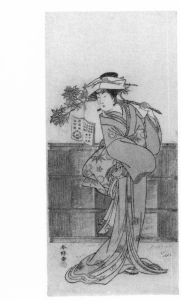 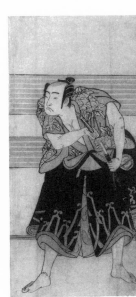 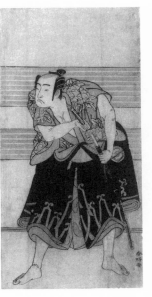 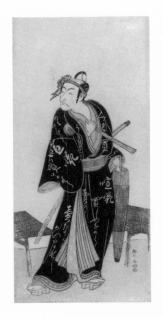

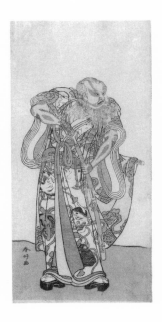

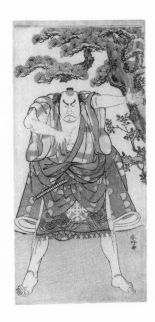

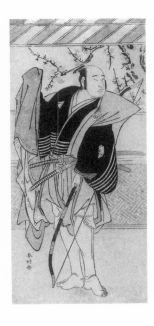

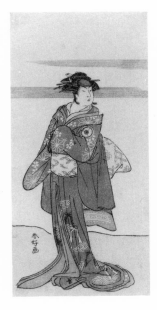

588

1) Sakata Hangorō II as Hige no Ikyū 2) *Shida Yakata Yotsugi no Hikibune* 3) Ichimura 4) 5/1782 5) *Shunkō ga* 8) *hosoban*; 31 x 15.1 cm 10) Gookin 1939.876 *) From a multisheet composition

589

1) Nakamura Nakazō I as the *yakko* Nakahei disguised as Miura Arajirō (?) 2) *Ise Heishi Eiga no Koyomi* (?) 3) Ichimura (?) 4) 11/1782 (?) 5) *Shunkō ga* 8) *hosoban*; 32.6 x 15.1 cm 10) Buckingham 1925.2482

590

1) Onoe Matsusuke I as Yawata no Saburō (?) 2) *Edo no Hana Mimasu Soga* (?) 3) Nakamura (?) 4) 1/1783 (?) 5) *Shunkō ga* 8) *hosoban*; 31.3 x 14.6 cm 10) Gookin 1939.887 *) From a multisheet composition

591

1) Iwai Hanshirō IV as Hitomaru disguised as the geisha Oshun 2) *Edo no Hana Mimasu Soga* 3) Nakamura 4) 3/1783 5) *Shunkō ga* 8) *hosoban*; 30.6 x 14.4 cm 10) Buckingham 1939.2205 *) Left sheet of diptych; right sheet is in SM

592

1) Nakamura Nakazō I as Kagekiyo dressed as a beggar (R), and Ōtani Hiroji III as Oniō Shinzaemon (L) 2) *Kotobuki Banzei Soga* 3) Ichimura 4) 3/1783 5) *Shunkō ga* 8) *hosoban*; 31 x 15 cm 10) Gookin 1939.888

593

1) Ichikawa Danjūrō V as Ise no Saburō disguised as Sanjo Uemon (?) 2) *Fude-hajime Kanjinchō* 3) Nakamura 4) 1/1784 5) *Shunkō ga* 8) *hosoban*, right sheet of triptych (?); 29 x 13.2 cm 10) Buckingham 1925.2470 *) See No. 115

594

1) Nakamura Nakazō I in a *shakkyō* dance 2) *Aioi Jishi* 3) Ichimura 4) 4/1784 5) *Shunkō ga* 8) *hosoban*; 32.1 x 14.8 cm 10) Gookin 1939.880

595

1) Nakamura Rikō I as Kiyotaki 2) *Ōakinai Hiru ga Kojima* 3) Nakamura 4) 11/1784 5) *Shunkō ga* 8) *hosoban*; 32.3 x 15 cm 10) Gift of Mr. and Mrs. James A. Michener 1958.152 *) Left sheet of diptych

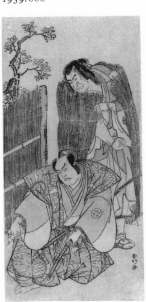

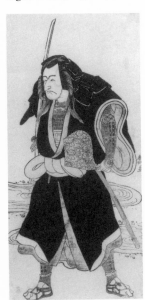

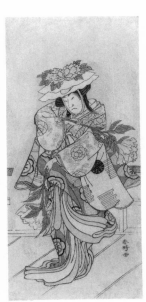

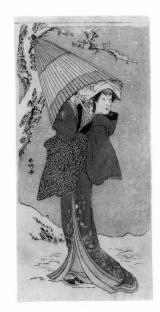

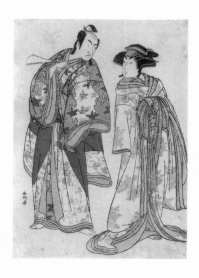

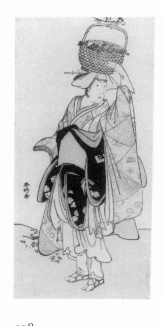

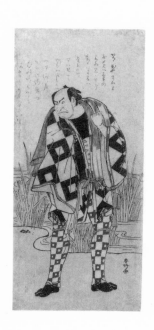

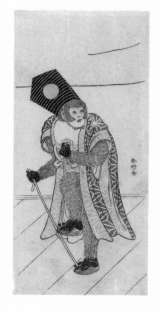

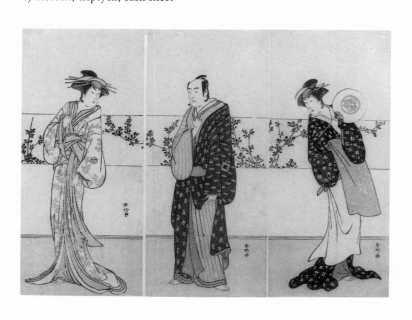

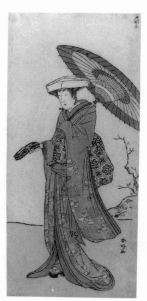

596
1) Segawa Kikunojō III as the courtesan Sumizome (R), and Ichikawa Monnosuke II as Goinosuke Yoshimine (L) 2) *Jūni-hitoe Komachi-zakura* 3) Kiri 4) 11/1784 5) *Shunkō ga* 8) *aiban*; 29.7 x 21.2 cm 9) HAA 10) Gookin 1939.865

597
1) Iwai Hanshirō IV 4) ca. 1784 5) *Shunkō ga* 8) *hosoban*; 30.9 x 14.2 cm 10) Buckingham 1939.2166

598
1) Ichikawa Yaozō III as Shiragiku in the dance sequence "Shinobu Uri" 2) *Hatsuhana Mimasu Soga* 3) Nakamura 4) 1/1785 5) *Shunkō ga* 8) *hosoban*; 29.7 x 14.2 cm 9) HAA 10) Buckingham 1925.2479

599
1) Ichimura Uzaemon IX as a monkey 2) *Mitsu Ningyō Yayoi no Hinagata* 3) Nakamura 4) 2/1785 5) *Shunkō ga* 8) *hosoban*; 31.8 x 14.9 cm 10) Gookin 1939.874

600
1) Nakamura Nakazō I as Dozaemon Denkichi 2) *Yaoya Oshichi* 3) Kiri 4) 4/1785 5) *Shunkō ga* 8) *hosoban*; 32.7 x 14.7 cm 10) Gookin 1939.890

601
1) Osagawa Tsuneyo II (R), Ichikawa Monnosuke II (C), and Segawa Kikunojō III (L) as Misao Gozen, Matsuya Sōshichi, and the courtesan Kojorō of Hakata (?) 2) *Chiyo no Hajime Ondo no Seto* 3) Kiri 4) 7/1785 5) *Shunkō ga* 8) *hosoban*, triptych; each sheet approx. 32 x 14.2 cm 10) Buckingham 1952.368 (R), 1952.367 (C), 1952.366 (L) *) See No. 116

602
1) Nakayama Kojūrō VI as Chinzei Hachirō Tametomo disguised as Lady Hotoke (Hotoke Gozen) 2) *Yukimotsu Take Furisode Genji* 3) Nakamura 4) 11/1785 5) *Shunkō ga* 8) *hosoban*; 32.4 x 14.8 cm 10) Buckingham 1928.309

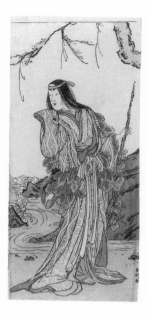

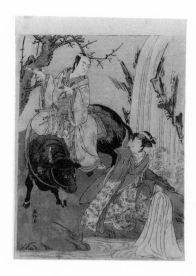

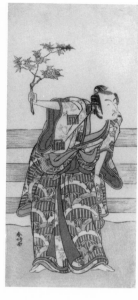

603

1) Segawa Kikunojō III as Yamauba 2) *Otokoyama Furisode Genji* 3) Kiri 4) 11/1785 5) *Shunkō ga* 8) *hosoban*; 31.1 x 14 cm 9) TNM 10) Gookin 1939.870

604

1) Segawa Kikunojō III as Princess Hatsune (Hatsune Hime) (R), and Ichikawa Monnosuke II as Miyuki-nosuke Yukinari (L) 2) *Otokoyama Furisode Genji* 3) Kiri 4) 11/1785 5) *Shunkō ga* 8) *ōban*; 38.3 x 25.6 cm 10) Buckingham 1925.2367

605

1) Onoe Matsusuke I as Yodohachi the Cowherd (?) 2) *Otokoyama Furisode Genji* 3) Kiri 4) 11/1785 5) *Shunkō ga* 8) *hosoban*; 36.3 x 14.9 cm 10) Gift of Mr. and Mrs. Harold G. Henderson 1962.985 *) See No. 117

606

1) Ichikawa Monnosuke II 4) ca. 1785 5) *Shunkō ga* 8) *hosoban*, part of multisheet print; 32.7 x 14.6 cm 10) Buckingham 1928.310 *) See No. 118

607

1) Iwai Hanshirō IV (R), Ichikawa Monnosuke II (C), and Sakata Hangorō III (L) as Manazuru, Hōjō Saburō Munetoki, and Kawanaya Tashirō (?) 2) *Mitsu no Hana Izu no Hataage* 3) Kiri 4) 11/1786 5) *Shunkō ga* 8) *ōban*; 36.3 x 25.8 cm 9) KUL 10) Buckingham 1925.2368 *) See No. 119

608

1) Segawa Kikunojō III 4) ca. 1786–1787 5) *Shunkō ga* 8) *hosoban*; 31.7 x 14.8 cm 10) Gookin 1939.869

609

1) Ichikawa Danjūrō V as Kajiwara Genta Kagesue 2) *Yuki Nazuna Saiwai Soga* 3) Kiri 4) 1/1787 5) *Shunkō ga* 8) *hosoban*; 32.7 x 14.9 cm 10) Buckingham 1925.2399

610

1) Iwai Hanshirō IV as Kitsune ga Saki Otama (?) 2) *Miyakodori Yayoi no Watashi* (?) 3) Kiri (?) 4) 3/1787 (?) 5) *Shunkō ga* 8) *hosoban*; 31.1 x 14.5 cm 10) Gookin 1939.886

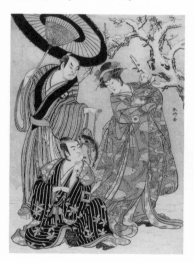

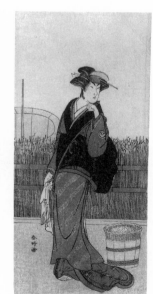

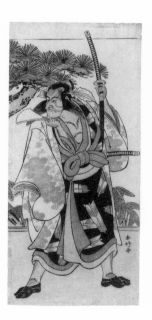

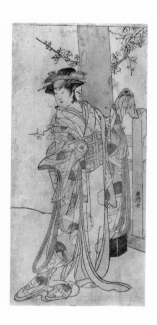

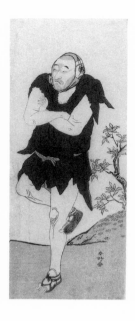

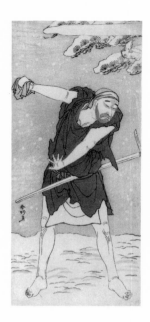

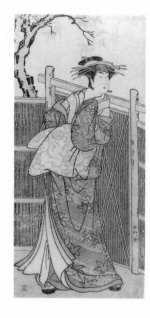

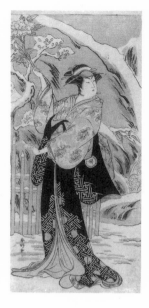

611

1) Onoe Matsusuke I as a mendicant monk (*gannin bōzu*) 2) *Keisei Ide no Yamabuki* 3) Nakamura 4) 5/ 1787 5) *Shunkō ga* 8) *hosoban*; 29.2 x 11.9 cm 9) BMFA 10) Buckingham 1925.2485

612

1) Onoe Matsusuke I as a mendicant monk (*gannin bōzu*) 2) *Keisei Ide no Yamabuki* 3) Nakamura 4) 5/ 1787 5) *Shunkō ga* 8) *hosoban*, part of a multisheet print; 31.5 x 13.9 cm 10) Buckingham 1952.365 *) See No. 120

613

1) Sawamura Sōjūrō III as the spirit of the courtesan Takao 2) *Takao Daimyōjin Momiji no Tamagaki* 3) Nakamura 4) 7/1787 5) *Shunkō ga* 8) *hosoban*; 31.6 x 14.2 cm 10) Buckingham 1925.2480

614

1) Iwai Hanshirō IV as Lady Yaehata 2) *Sanga no Shō Haru no Hanayome* 3) Kiri 4) 11/1787 5) *Shunkō ga* 8) *hosoban*; 31.8 x 14.4 cm 10) Buckingham 1925.2492 *) Left sheet of diptych

615

1) Sanogawa Ichimatsu III as Lady Masago (Masago Gozen) (?) 2) *Keisei Azuma Kagami* 3) Nakamura 4) 2/1788 5) *Shunkō ga* 8) *hosoban*, right-hand sheet of diptych or triptych; 32.9 x 14.9 cm 9) TNM; MMA (both sheets of diptych) 10) Gift of Mr. and Mrs. Harold G. Henderson 1962.984 *) See No. 121

616

1) Segawa Kikunojō III as Kumenosuke 2) *Keisei Natori Soga* 3) Kiri 4) 2/1788 5) *Shunkō ga* 8) *hosoban*; 33 x 14.8 cm 10) Buckingham 1925.2490 *) Right sheet of diptych (?)

617

1) Nakamura Nakazō I greeting the audience on his return from Osaka 3) Nakamura 4) 1788 5) *Shunkō ga* 8) *hosoban*; 31.7 x 14.1 cm 9) UTS13, pl. 25 10) Gookin 1939.892

618

1) Segawa Tomisaburō II as Lady Masago (Masago Gozen) (?) 2) *Genji Saikō Kogane no Tachibana* (?) 3) Ichimura (?) 4) 11/1788 (?) 5) *Shunkō ga* 8) *hosoban*; 32.1 x 14.5 cm 9) TNM 10) Buckingham 1925.2491 *) From a multisheet composition (?)

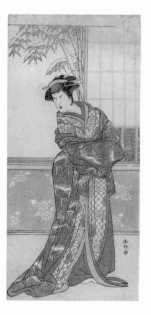

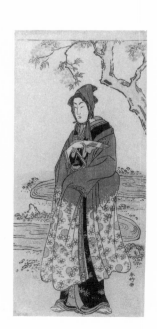

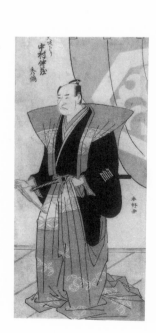

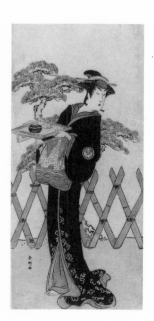

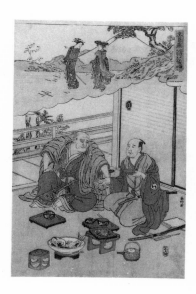
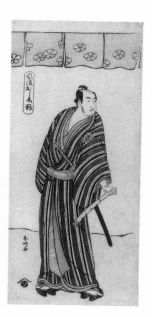
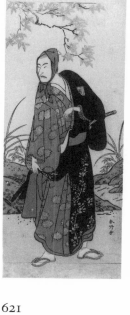
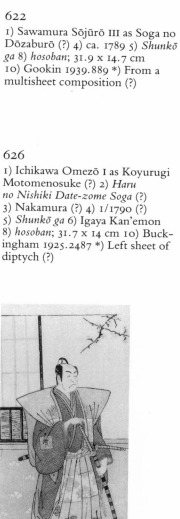

619

1) Scenes from acts seven and eight of *Chūshingura* 4) ca. 1788 5) *Shunkō ga* 6) Uemuraya Kichiemon 8) *ōban*; 32.4 x 24.7 cm 10) Gookin 1939.864 *) Fourth of a set of six prints

620

1) Matsumoto Kōshirō IV as An no Heibei 2) *Edo no Fuji Wakayagi Soga* 3) Nakamura 4) 1/1789 5) *Shunkō ga* 6) Nishimuraya Yohachi 8) *hosoban*; 32.3 x 14.5 cm 10) Buckingham 1929.725 *) One sheet from pentaptych

621

1) Ichikawa Komazō III as Katanaya Hanshichi 2) *Heike Hyōbanki* 3) Nakamura 4) 9/1789 5) *Shunkō ga* 8) *hosoban*; 32.3 x 13.8 cm 10) Buckingham 1925.2397 *) Right sheet of diptych (?)

622

1) Sawamura Sōjūrō III as Soga no Dōzaburō (?) 4) ca. 1789 5) *Shunkō ga* 8) *hosoban*; 31.9 x 14.7 cm 10) Gookin 1939.889 *) From a multisheet composition (?)

623

1) Sawamura Sōjūrō III 4) late 1780s 5) *Shunkō ga* 8) *hosoban*; 30.8 x 13.9 cm 10) Buckingham 1925.2472

624

1) Sakata Hangorō III as Ōmi no Kotōda 2) *Haru no Nishiki Date-zome Soga* 3) Nakamura 4) 2/1790 5) *Shunkō ga* 8) *hosoban*; 31.7 x 14.7 cm 10) Gookin 1939.893 *) From a multisheet composition

625

1) Ichikawa Danjūrō V as Tambaya Suketarō 2) *On'ureshiku Zonji Soga* 3) Ichimura 4) 2/1790 5) *Shunkō ga* 8) *hosoban*; 31 x 13.9 cm 9) FW 10) Buckingham 1925.2471

626

1) Ichikawa Omezō I as Koyurugi Motomenosuke (?) 2) *Haru no Nishiki Date-zome Soga* (?) 3) Nakamura (?) 4) 1/1790 (?) 5) *Shunkō ga* 6) Igaya Kan'emon 8) *hosoban*; 31.7 x 14 cm 10) Buckingham 1925.2487 *) Left sheet of diptych (?)

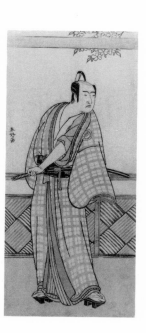
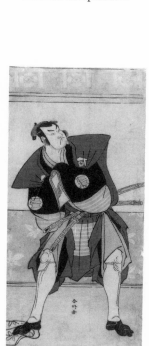
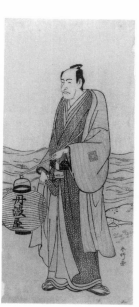
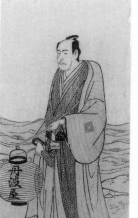

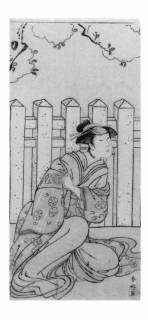

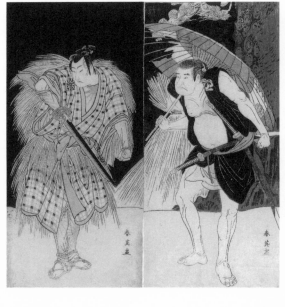

627

1) Osagawa Tsuneyo II as Onoe
2) *Haru no Nishiki Date-zome Soga*
3) Nakamura 4) 4/1790 5) *Shunkō ga* 8) *hosoban*; 30.4 x 13.8 cm
10) Gookin 1939.1828 *) Left sheet of diptych; right sheet shows Onoe Matsusuke I as Iwafuji (SM; HAA)

KATSUKAWA SHUN'EI

(1762–1819)

628

1) Nakayama Kojūrō VI as Ono Sadakurō (R), and Mimasu Tokujirō I as Hayano Kampei (L) 2) *Chūshingura* 3) Nakamura 4) 5/1786 5) *Shun'ei ga* 8) *hosoban*, diptych; 31.6 x 14.7 cm (R), 32.7 x 14.7 cm (L) 9) OMM 10) Gookin 1940.1121 (R), 1939.925 (L) *) See No. 122

629

Iwai Hanshirō IV as Tonase (?)
2) *Kanadehon Chūshingura* (?)
3) Kiri (?) 4) 8/1787 (?) 5) *Shun'ei ga* 8) *hosoban*; 32.7 x 14 cm
10) Gift of Mr. and Mrs. James A. Michener 1958.157

630

1) Segawa Kikunojō III as Okaru
2) *Kanadehon Chūshingura*
3) Morita 4) 8/1787 5) *Shun'ei ga* 8) *hosoban*; 32 x 14 cm 10) Buckingham 1925.2400 *) Left sheet of diptych (?)

631

1) Ōtani Oniji III in an unidentified role 2) *Yukimi-zuki Eiga Hachi no Ki* (?) 3) Nakamura (?) 4) 11/1787 (?) 5) *Shun'ei ga* 8) *hosoban*; 32 x 14.3 cm 9) HAA 10) Gookin 1939.924

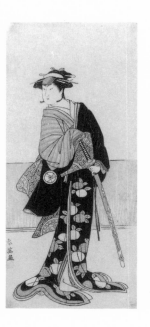

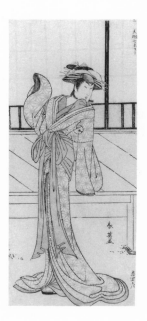

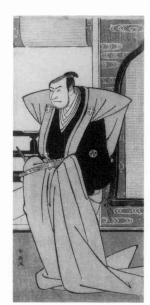

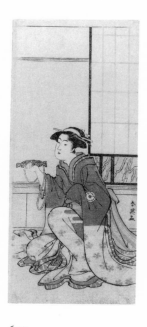

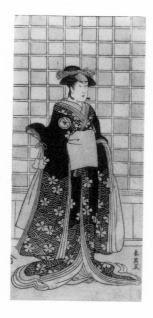

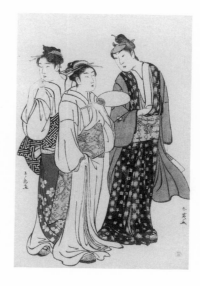

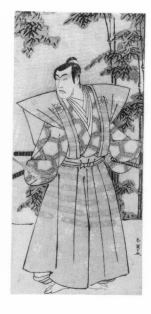

632

I) Iwai Hanshirō IV as Yae (?)
2) *Sugawara Denju Tenarai Kagami*
(?) 3) Kiri (?) 4) 7/1788 (?) 5) *Shun'ei ga* 8) *hosoban*; 31.7 x 13.8 cm
I0) Buckingham 1925.2498
*) Right sheet of diptych (?)

633

I) Iwai Kiyotarō II as Lady Itohagi
(?) 2) *Genji Saikō Kogane Tachibana*
(?) 3) Ichimura (?) 4) 11/1788 (?)
5) *Shun'ei ga* 8) *hosoban*; 30.8 x
13.8 cm I0) Gookin 1939.918
*) Left sheet of diptych

634

I) Iwai Hanshirō IV in street attire
(by Shun'ei) conversing with two
women (by Katsukawa Shunchō)
4) ca. 1788 5) *Shun'ei ga* (R),
Shunchō ga (L) 8) *aiban*; 32.3 x 21.7
cm 9) UT6, pl. 29; NHBZ2, pl. 284
I0) Buckingham 1925.2721

635

I) Matsumoto Kōshirō IV as Hata-
keyama Shigetada disguised as
Honjō Soheiji (?) 2) *Edo no Fuji
Wakayagi Soga* (?) 3) Nakamura (?)
4) 1/1789 (?) 5) *Shun'ei ga* 8) *hoso-
ban*; 30.5 x 13.8 cm I0) Gookin
1939.922 *) From a multisheet
composition

636

I) Ichikawa Danjūrō V as Kudō
Suketsune (R), and Iwai Hanshirō
IV as Soga no Gorō Tokimune (L)
2) *Koi no Yosuga Kanegaki Soga*
3) Ichimura 4) 1/1789 5) *Shun'ei ga*
(L) 8) *hosoban*; 29.3 x 13.7 cm (R),

30 x 13.8 cm (L) I0) Gookin
1939.897 (R), 1939.919 (L)
*) Two sheets of triptych

637

I) Iwai Hanshirō IV as Okumi of
the Mieidō fan shop (?) 2) *Sanjūk-
koku Yobune no Hajimari* (?) 3) Ichi-
mura (?) 4) 5/1789 (?) 5) *Shun'ei
ga* 8) *hosoban*; 30.7 x 13.7 cm
I0) Gookin 1939.916

638

I) Segawa Kikunojō III as Ono no
Komachi (?) 2) *Komachi-mura
Shibai no Shōgatsu* 3) Nakamura
4) 11/1789 5) *Shun'ei ga* 6) Hari-
maya Shinshichi 8) *hosoban*, left
sheet of diptych; 33.5 x 15 cm
I0) Buckingham 1929.739
*) See No. 123

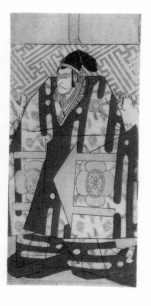

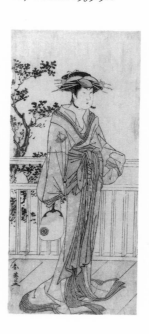

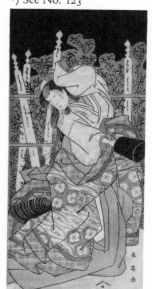

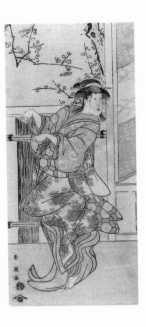

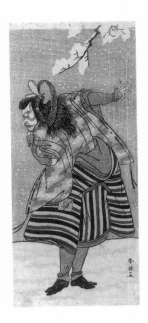

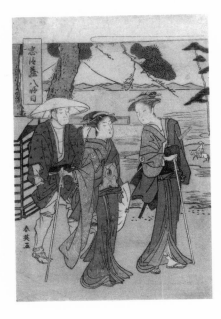

639

1) Segawa Kikunojō III as Kojorō-
gitsune (female fox) disguised as
Omiki 2) *Komachi-mura Shibai no
Shōgatsu* 3) Nakamura 4) 11/1789
5) *Shun'ei ga* 6) Nishimuraya
Yohachi 7) *kiwame* 8) *hosoban*; 30.8
x 13.9 cm 9) TNM 10) Gookin
1939.931

640

1) Ichikawa Danjūrō V as Hei
Shinnō Masakado 2) *Hana no O-
Edo Masakado Matsuri* 3) Ichimura
4) 11/1789 5) *Shun'ei ga* 8) *hosoban*;
32.5 x 14.1 cm 10) Buckingham
1925.2493

641

1) Act eight: The Bridal Journey
(*michiyuki*) 2) *Chūshingura* (Trea-
sury of the Forty-seven Loyal
Retainers) 4) late 1780s 5) *Shun'ei
ga* 8) *koban*; 23.3 x 15.8 cm
10) Gookin 1939.905

642

1) Empress Jingū (L), and her
minister Takenouchi no Sukune
(R) 4) late 1780s 5) *Shun'ei*; printed
imitation of handwritten seal (*kaō*)
8) *koban*; 16.7 x 24.8 cm
10) Gookin 1939.909

643

1) Ichikawa Komazō II as Soga no
Dōzaburō disguised as the ruffian
Tōbei (?) 2) *Haru no Nishiki Date-
zome Soga* (?) 3) Nakamura (?)
4) 1/1790 (?) 5) *Shun'ei ga* 6) Tsuruya
Kiemon 7) *kiwame* 8) *hosoban*; 31.2
x 14 cm 10) Gift of Frederick S.
Colburn 1952.383

644

1) Ichikawa Komazō II as Ono
Sadakurō 2) *Chūkō Ryōgoku Ori*
3) Nakamura 4) 7/1790 5) *Shun'ei
ga* 8) *hosoban*; 31.7 x 14.2 cm
10) Buckingham 1929.740

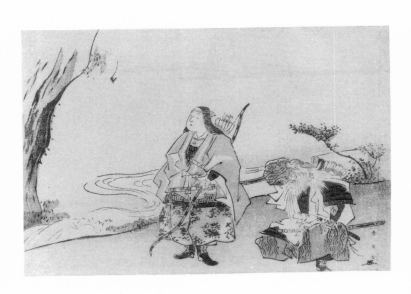

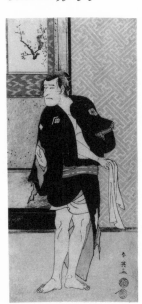

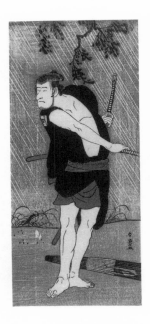

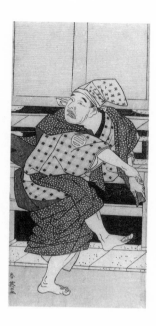

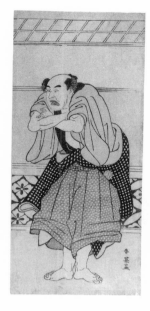

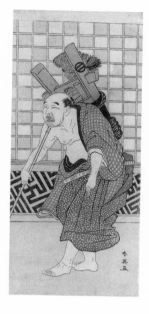

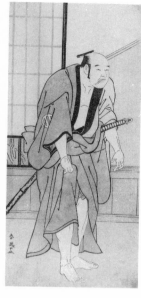

645

1) Asao Tamejūrō I as drunken
Gotōbei 2) *Yoshitsune Koshigoe Jō*
3) Ichimura 4) 9/1790 5) *Shun'ei ga*
8) *hosoban*; 29.4 x 13.9 cm 9) HV;
UT8, pl. 237; VI (1910), no. 521
10) Gookin 1939.912
*) See No. 124

646

1) Asao Tamejūrō I as drunken
Gotōbei 2) *Yoshitsune Koshigoe Jō*
3) Ichimura 4) 9/1790 5) *Shun'ei
ga* 8) *hosoban*; 32.9 x 14.7 cm
10) Gookin 1939.927 *) See No. 125

647

1) Asao Tamejūrō I as drunken
Gotōbei 2) *Yoshitsune Koshigoe Jō*
3) Ichimura 4) 9/1790 5) *Shun'ei ga*
8) *hosoban*; 32.5 x 14.8 cm 9) HV;
MG; MOKB 10) Gookin 1939.911

648

1) Asao Tamejūrō I as drunken
Gotōbei 2) *Yoshitsune Koshigoe Jō*
3) Ichimura 4) 9/1790 5) *Shun'ei ga*
8) *hosoban*; 30.6 x 14 cm 9) MG
10) Gift of Mrs. George T. Smith
1971.494

649

1) Nakamura Kumetarō II greeting
the audience on his arrival from
Osaka 3) Nakamura 4) 11/1790
5) *Shun'ei ga* 8) *hosoban*; 29.5 x
13.2 cm 10) Gookin 1939.913

650

1) Segawa Kikunojō III as Osaku
2) *Sayo no Nakayama Hiiki no
Tsurigane* 3) Nakamura 4) 11/1790
5) *Shun'ei ga* 8) *hosoban*; 29.4 x
13.8 cm 9) TNM 10) Buckingham
1925.2497

651

1) Segawa Kikunojō III as the Dra-
gon Maiden disguised as Osaku
2) *Sayo no Nakayama Hiiki no
Tsurigane* 3) Nakamura 4) 11/1790
5) *Shun'ei ga* 7) *kiwame* 8) *hosoban*;
32 x 14.2 cm 10) Gookin 1939.930

652

1) Segawa Kikunojō III as Otoma
(?) 2) *Sayo no Nakayama Hiiki
no Tsurigane* (?) 3) Nakamura (?)
4) 11/1790 (?) 5) *Shun'ei ga*
6) Nishimuraya Yohachi 7) *kiwame*
8) *hosoban*; 33.2 x 15 cm 10) Buck-
ingham 1925.2505 *) From a
multisheet composition

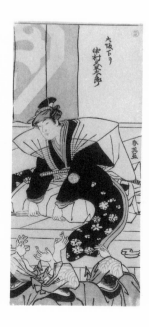

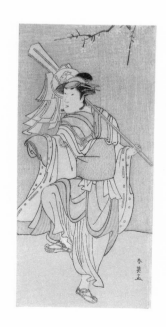

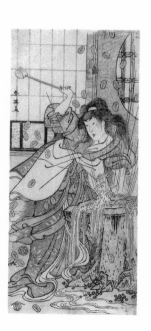

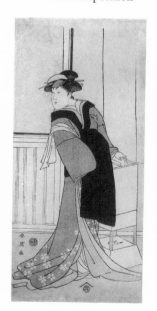

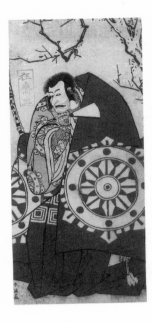

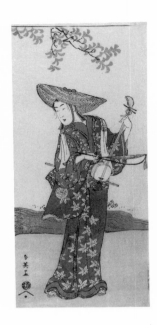

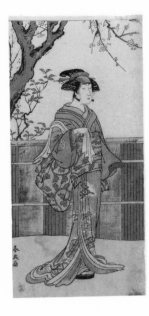

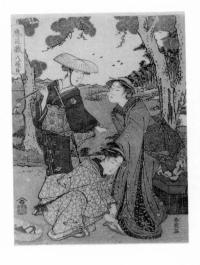

653

1) Ichikawa Danjūrō V as Benkei
2) *Dai Danna Kanjinchō* 3) Kawarazaki 4) 11/1790 5) *Shun'ei ga*
8) *hosoban*; 30 x 13.7 cm 9) FGA
10) Buckingham 1925.2494

654

1) Sawamura Tamagashira as a strolling musician 2) *Dai Danna Kanjinchō* 3) Kawarazaki 4) 11/1790
5) *Shun'ei ga* 6) Harimaya Shinshichi 7) *kiwame* 8) *hosoban*; 31.6 x 14.7 cm 10) Gookin 1939.908

655

1) Sawamura Tamagashira 4) ca. 1790 5) *Shun'ei ga* 8) *hosoban*; 31.2 x 14.5 cm 10) Gookin 1939.917

656

1) Act eight: The Bridal Journey
2) *Chūshingura* (Treasury of the Forty-seven Loyal Retainers
4) early 1790s 5) *Shun'ei ga*
6) Nishimuraya Yohachi 8) *chūban*; 25.4 x 18.8 cm 9) PAM 10) Buckingham 1939.2165

657

1) Act nine: Yuranosuke's House in Yamashina 2) *Chūshingura* (Treasury of the Forty-seven Loyal Retainers) 4) early 1790s 5) *Shun'ei ga* 8) *chūban*; 25.5 x 19.3 cm
9) PMA 10) Buckingham 1925.2377
*) Key-block impression

658

1) Act ten: The Amakawaya House 2) *Chūshingura* (Treasury of the Forty-seven Loyal Retainers)
4) early 1790s 5) *Shun'ei ga*
6) Nishimuraya Yohachi 8) *chūban*; 25.5 x 19 cm 9) MOKB 10) Buckingham 1925.2376 *) Key-block impression

659

1) Youth dancing with a spear
4) early 1790s 5) *Shun'ei ga*
6) Nishimuraya Yohachi 7) *kiwame*
8) *ōban*; 39.4 x 26.4 cm 10) Buckingham 1925.2374

660

1) Ichikawa Komazō II as the spirit of Lady Shiragiku 2) *Hatsu Midori Saiwai Soga* 3) Kawarazaki 4) 3/ 1791 5) *Shun'ei ga* 6) Harimaya Shinshichi 7) *kiwame* 8) *hosoban*; 31.7 x 14 cm 10) Buckingham 1925.2501

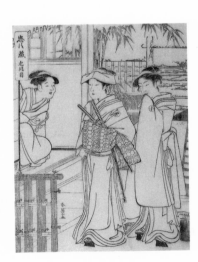

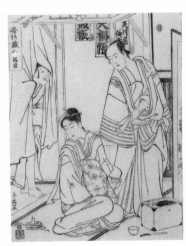

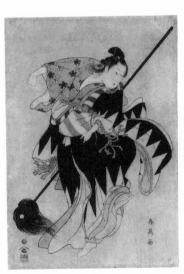

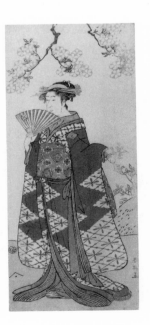

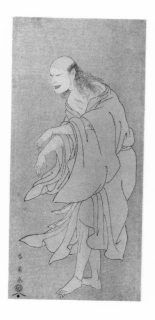

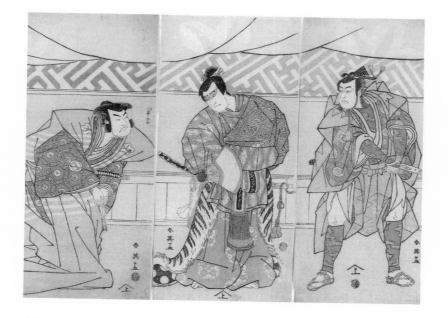

661

1) Onoe Matsusuke I as the ghost of Ki no Natora 2) *Kiku no En Mukashi no Miyako* 3) Nakamura 4) 8/1791 5) *Shun'ei ga* 6) Harimaya Shinshichi 7) *kiwame* 8) *hosoban*; 29.4 x 13.5 cm 9) UT8, pl. 257 10) Buckingham 1925.2507

662

1) Ichikawa Monnosuke II as Mori no Rammaru (R), Sawamura Sōjūrō III as Oda Kazusanosuke Harunaga (C), and Sakata Hangorō III as Takechi Mitsuhide (L) 2) *Kanagaki Muromachi Bundan* 3) Ichimura 4) 8/1791 5) *Shun'ei ga*

6) Kawaguchiya Uhei 7) *kiwame* 8) *hosoban*, triptych; 32 x 14.4 cm (R), 32.5 x 15 cm (C), 32 x 14.6 cm (L) 10) Buckingham 1939.2216 (R), 1980.276b (C), 1980.276a (L) *) See No. 126

663

1) Ichikawa Komazō III in three roles: Nyosan no Miya, Ukare Zatō, and Sakata no Kaidō-maru 2) *Zōho Natsu Matsuri* 3) Kawarazaki 4) 8/1791 5) *Shun'ei ga* 7) *kiwame* 8) *hosoban*; 30.3 x 14 cm 10) Gookin 1939.921 *) See No. 127

664

1) Ichikawa Komazō II as the monk Shunkan 2) *Shunkan Shima Monogatari* 3) Kawarazaki 4) 9/1791 5) *Shun'ei ga* 6) Tsuruya Kiemon 7) *kiwame* 8) *hosoban*; 30.8 x 13.9 cm 10) Gookin 1939.915 *) From a multisheet composition

665

1) Ichikawa Omezō I as Kamei Rokurō disguised as the servant Dadahei 2) *Kimmenuki Genke no Kakutsuba* 3) Ichimura 4) 11/1791 5) *Shun'ei ga* 6) Igaya Kan'emon 7) *kiwame* 8) *hosoban*; 32 x 14.5 cm 10) Gookin 1939.1808 *) Left sheet of diptych (?)

666

1) Nakayama Tomisaburō I as Lady Tokiwa (Tokiwa Gozen) (?) 2) *Kimmenuki Genke no Kakutsuba* (?) 3) Ichimura (?) 4) 11/1791 (?) 5) *Shun'ei ga* 8) *hosoban*; 30.8 x 13.9 cm 10) Gookin 1939.929 *) Left sheet of diptych (?)

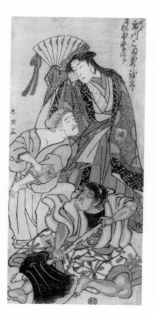

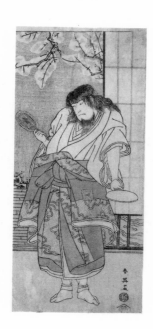

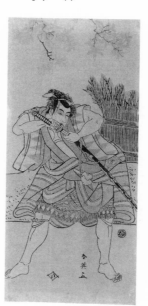

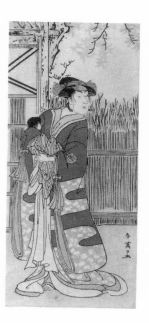

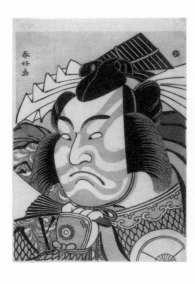 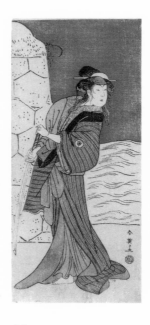 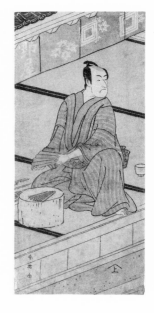

667

1) *Okubi-e* of Iwai Hanshirō IV as
Akita Jōnosuke Yoshikage in a
"Shibaraku" role 2) *Mieikō Nori no
Hachi no Ki* 3) Kawarazaki 4) 11/
1791 5) unsigned; *Shunkō ga* added
by hand 7) *kiwame* 8) *aiban*; 32.3 x
22.5 cm 10) Buckingham
1939.2206 *) See No. 128

668

1) Ichikawa Monnosuke II as Hira-
noya Tokubei (?) 2) *Waka Murasaki
Edokko Soga* (?) 3) Ichimura (?)
4) 3/1792 (?) 5) *Shun'ei ga*
6) Nishimuraya Yohachi 7) *kiwame*
8) *hosoban*; 28.5 x 13.5 cm
10) Buckingham 1925.2503
*) Left sheet of triptych (?)

669

1) Iwai Hanshirō IV as Yaegushi
no Oroku (?) 2) *Keisei Kogane no
Hakarime* (?) 3) Kawarazaki (?)
4) 3/1792 (?) 5) *Shun'ei ga*
7) *kiwame* 8) *hosoban*; 31.6 x 14.2
cm 9) TNM 10) Buckingham
1925.2504

670

1) Ichikawa Monnosuke II as
Daidōji Tabatanosuke 2) *Mukashi
Mukashi Tejiro no Saru* 3) Ichimura
4) 8/1792 5) *Shun'ei ga* 6) Kawa-
guchiya Uhei 8) *hosoban*; 31 x 13.9
cm 9) HRWK 10) Gookin 1939.920
*) Left sheet of diptych (?)

671

1) Segawa Kikunojō III as the
female fox-fairy Otatsu-gitsune
disguised as Shizuka Gozen
2) *Kogane Saku Date no Ōkido*
3) Ichimura 4) 11/1792 5) *Shun'ei ga*
6) Tsutaya Jūzaburō 7) *kiwame*
8) *hosoban*; 30.5 x 13.4 cm 9) TNM
10) Gookin 1939.914 *) From a
multisheet composition

672

1) Ichikawa Omezō I as the boat-
man Takihei (?) 2) *Ōfunamori Ebi
no Kaomise* (?) 3) Kawarazaki (?)
4) 11/1792 (?) 5) *Shun'ei ga*
6) Nishimuraya Yohachi 7) *kiwame*
8) *hosoban*; 32.8 x 15.4 cm 10)
Gookin 1939.933 *) Left sheet of
diptych; right sheet is in NAM

673

1) The sumo wrestler Kurogumo
Otozō with the teahouse waitress
Naniwaya Okita 4) early 1790s
5) *Shun'ei ga* 6) Tsutaya Jūzaburō
7) *kiwame* 8) *ōban*; 39 x 26 cm
9) TS; CST 10) Gift of Mr. and
Mrs. James A. Michener 1958.159
*) See No. 129

674

1) Sawamura Sōjūrō III in cere-
monial attire on the occasion of his
return from Osaka 3) Nakamura
4) 1/1793 5) *Shun'ei ga* 6) Tsuruya
Kiemon 8) *hosoban*; 32.7 x 14.6 cm
10) Buckingham 1925.2500

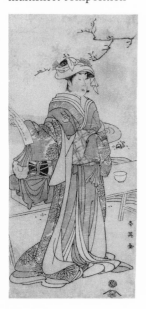 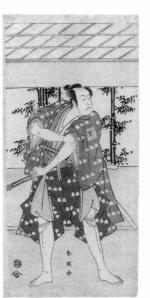 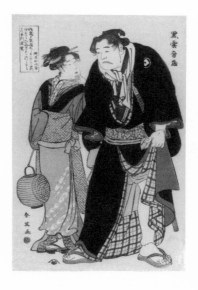 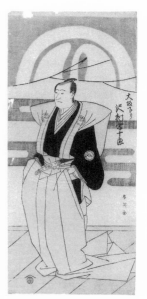

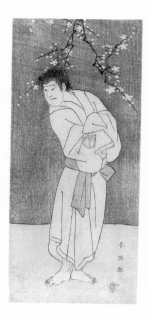
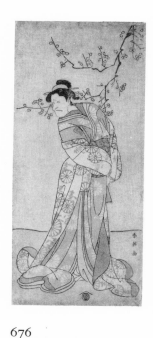
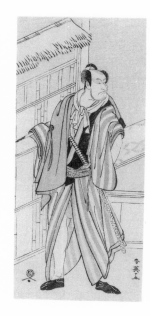
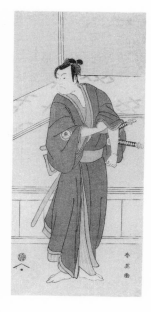

675
1) Sawamura Sōjūrō III as the monk Seigen (?) 2) *Saikai Soga Nakamura* (?) 3) Nakamura (?) 4) I/1793 (?) 5) *Shun'ei ga* 6) Tsuruya Kiemon 8) *hosoban*; 30.8 x 13.7 cm 9) NYPL; HAA 10) Buckingham 1925.2495

676
1) Ichikawa Ebizō (Danjūrō V) as the lady-in-waiting Iwafuji 2) *Gozen-gakari Sumō Soga* 3) Kawarazaki 4) I /1793 5) *Shun'ei ga* 6) Tsuruya Kiemon 8) *hosoban*; 32.5 x 14.6 cm 9) HAA 10) Gookin 1939.928 *) Right sheet of diptych (?)

677
1) Iwai Hanshirō IV as Shirai Gompachi (R), and Ichikawa Ebizō (Danjūrō V) as Banzui Chōbei (L) 2) *Gozen-gakari Sumō Soga* 3) Kawarazaki 4) 2/1793 5) *Shun'ei ga* 6) Harimaya Shinshichi

7) *kiwame* 8) *hosoban*; 30.5 x 13.6 cm (R), 30.8 x 13.6 cm (L) 9) BM (complete diptych); MOKB (R) 10) Buckingham 1928.1029 (R), 1928.1028 (L)

678
1) Segawa Kikunojō III as Lady Tomoe (Tomoe Gozen) 2) *Yasa Gumbai Miyako no Jindori* 3) Miyako 4) II/1793 5) *Shun'ei ga* 8) *hosoban*; 32.4 x 14.5 cm 10) Buckingham 1928.1030

679
1) Iwai Hanshirō IV as a boy blowing on his hands beside a large snowball 2) *Nigiwai Genji Hana Saku Kado* 3) Kawarazaki 4) II/1793 5) *Shun'ei ga* 6) Tsutaya Jūzaburō 7) *kiwame* 8) *hosoban*; 30.9 x 13.8 cm 10) Gookin 1939.932 *) Left sheet of diptych

680
1) Ichikawa Komazō III as Sukeroku 4) 1793 or 1797 5) unsigned; printed *Shunshō ga* added later 6) Murataya Jirobei (Eiyūdō) 7) *kiwame* 8) *hosoban*; 35.6 x 15.6 cm 10) Buckingham 1937.27 *) From a multisheet composition *) See No. 130

681
1) Shōki the Demon Queller 4) ca. 1793 5) *Katsu Shun'ei ga* 6) Murataya Jirobei 7) *kiwame* 8) *hashira-e*; 62 x 12.1 cm 10) Gift of Mr. and Mrs. James A. Michener 1958.158

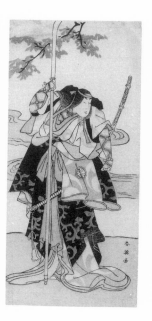
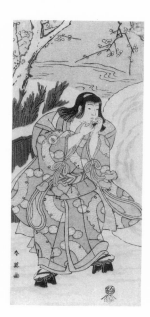
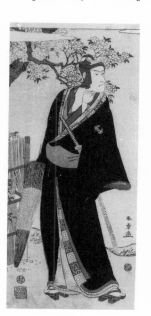
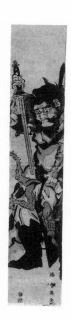

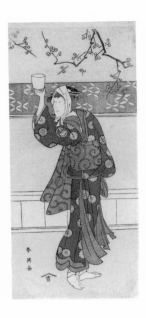
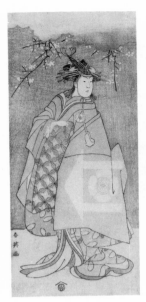
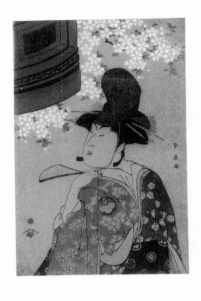

682

1) Segawa Tomisaburō II 4) ca.
1793 5) *Shun'ei ga* 6) Enomotoya
Kichibei 8) *hosoban*; 33 x 14.8 cm
10) Buckingham 1939.2122
*) From a multisheet composition (?)

683

1) Osagawa Tsuneyo II as Ōiso
no Tora (R), and Iwai Kiyotarō
as Kewaizaka no Shōshō (L)
2) *Gohiiki no Hana Aikyō Soga*
3) Kawarazaki 4) 1/1794 5) *Shun'ei
ga* 6) Tsuruya Kiemon 8) *hosoban*;
31 x 14 cm (R), 30.8 x 13.7 cm (L)
10) Buckingham 1925.2506 (R),
Gookin 1939.923 (L)

684

1) Half-length portrait of Naka-
yama Tomisaburō as a *shirabyōshi*
dancer in the Dōjō-ji scene
2) *Hikeya Hike Hana no Kaneiri*
3) Kiri 4) 3/1794 5) *Shun'ei ga*
6) Tsutaya Jūzaburō 7) *kiwame*
8) *ōban*; 37.5 x 24.5 cm 9) OR
10) Buckingham 1930.386

685

1) Ichikawa Yaozō III as Tanabe
Bunzō 2) *Hana-ayame Bunroku
Soga* 3) Miyako 4) 5/1794
5) *Shun'ei ga* 6) undecipherable
8) *aiban*, mica ground; 31.9 x
22 cm 10) Buckingham 1942.106
*) See No. 131

686

1) Bust portrait of Sanogawa Ichi-
matsu III as the Gion prostitute
Onayo 2) *Hana-ayame Bunroku
Soga* 3) Miyako 4) 5/1794 6) unde-
cipherable 7) *kiwame* 8) *aiban*, mica
ground; 31.6 x 21.7 cm 9) HV
10) Buckingham 1942.105

687

1) Yamashita Kinsaku II as the
maid Tsumagi 2) *Otokoyama
O-Edo no Ishizue* 3) Kiri 4) 11/1794
5) *Shun'ei ga* 6) Harimaya Shinshi-
chi 8) *hosoban*; 33 x 14.8 cm
10) Buckingham 1925.2499

688

1) Kataoka Nizaemon VII as
Yoshidaya Kizaemon 2) *Edo Sunago
Kichirei Soga* 3) Miyako 4) 1/1795
5) *Shun'ei ga* 8) *hosoban*; 31.8 x 13.8
cm 10) Gookin 1939.910 *) Left
sheet of diptych (?)

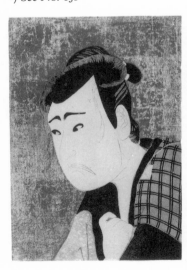
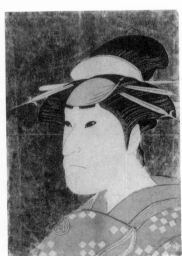
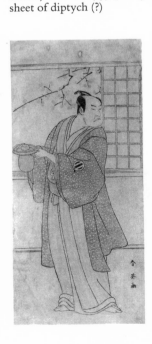

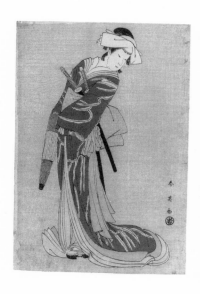

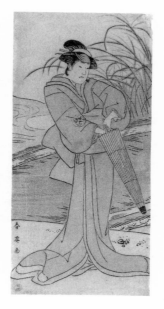

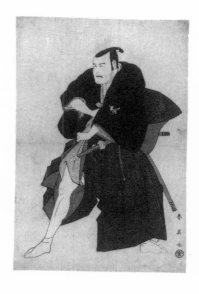

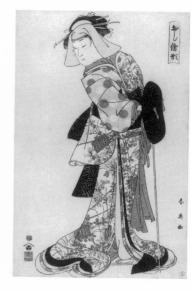

689

1) Nakamura Noshio II as Tonase
2) *Kanadehon Chūshingura*
3) Miyako 4) 4/1795 5) *Shun'ei ga*
6) Iwatoya Kisaburō 8) *ōban*; 37.2 x
25.1 cm 9) TNM; OR; WS; OMM;
VI, no. 554 10) Buckingham
1925.2373 *) See No. 132

690

1) Yamashita Kinsaku II as Okaya
2) *Yomogi Fuku Noki no Tamamizu*
3) Kiri 4) 5/1795 5) *Shun'ei ga*
8) *hosoban*; 29.2 x 14 cm 10) Buck-
ingham 1925.2496 *) From a
multisheet composition

691

1) Matsumoto Kōshirō IV as
Kakogawa Honzō 2) *Kanadehon
Chūshingura* 3) Kawarazaki 4) 5/
1795 5) *Shun'ei ga* 6) Iwatoya
Kisaburō 8) *ōban*; 38.3 x 25.5 cm
10) Buckingham 1925.2375

692

1) The dance interlude (*shosagoto*)
Shinodazuma 2) *Oshie-gata*
(Designs for Patchwork Pictures)
4) ca. 1795 5) *Shun'ei ga* 6) Nishi-
muraya Yohachi (Eijudō) 7) *kiwame*
8) *ōban*; 37.5 x 24 cm 9) MAD; BM;
SA 10) Buckingham 1925.2372
*) See No. 133

693

1) Arashi Ryūzō II as Hachijō
2) *Gempei Hashira-goyomi* 3) Kiri
4) 11/1795 5) *Shun'ei ga* 6) uniden-
tified 7) *kiwame* 8) *hosoban*; 32.2 x
14.9 cm 9) BM 10) Buckingham
1925.2396 *) From a multisheet
composition. See No. 134

694

1) Act one: Tsurugaoka Hachiman
Shrine 2) *Chūshingura* (Treasury of
the Forty-seven Loyal Retainers)
4) ca. 1795 5) *Shun'ei ga* 8) *koban*;
23.8 x 17.5 cm 10) Gookin
1939.898

695

1) Act two: The Quarters of
Momonoi Wakasanosuke 2) *Chū-
shingura* (Treasury of the Forty-
seven Loyal Retainers) 4) ca. 1795
5) *Shun'ei ga* 8) *koban*; 23.8 x 18.2
cm 10) Gookin 1939.899

696

1) Act three: The Quarrel Scene
2) *Chūshingura* (Treasury of the
Forty-seven Loyal Retainers) 4) ca.
1795 5) *Shun'ei ga* 8) *koban*; 23.7 x
17.8 cm 10) Gookin 1939.900

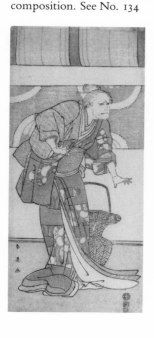

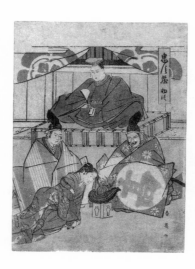

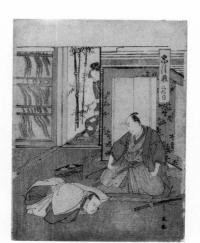

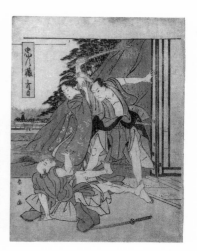

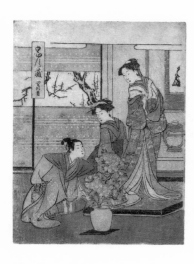
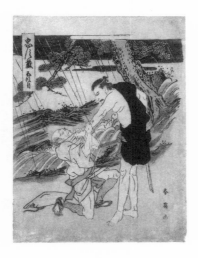
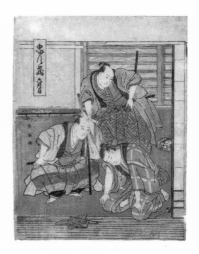
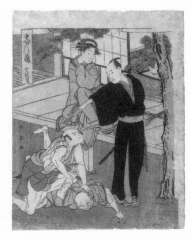

697
1) Act four: Enya Hangan's Castle
2) *Chūshingura* (Treasury of the Forty-seven Loyal Retainers) 4) ca. 1795 5) unsigned 8) *koban*; 23.7 x 18 cm 10) Gookin 1939.901

698
1) Act five: Yamazaki Highway
2) *Chūshingura* (Treasury of the Forty-seven Loyal Retainers) 4) ca. 1795 5) *Shun'ei ga* 8) *koban*; 23.2 x 17.3 cm 10) Gookin 1939.902

699
1) Act six: Yoichibei's House
2) *Chūshingura* (Treasury of the Forty-seven Loyal Retainers) 4) ca. 1795 5) *Shun'ei ga* 8) *chūban*; 23.8 x 18 cm 10) Gookin 1939.903

700
1) Act seven: The Ichiriki Teahouse
2) *Chūshingura* (Treasury of the Forty-seven Loyal Retainers) 4) ca. 1795 5) *Shun'ei ga* 8) *koban*; 23.7 x 18.2 cm 10) Gookin 1939.904

701
1) Act ten: Amakawaya House
2) *Chūshingura* (Treasury of the Forty-seven Loyal Retainers) 4) ca. 1795 5) *Shun'ei ga* 8) *koban*; 23 x 17.8 cm 10) Gookin 1939.907

702
1) Act eleven: Night Raid on Moronao's Mansion 2) *Chūshingura* (Treasury of the Forty-seven Loyal Retainers) 4) ca. 1795 5) unsigned 8) *koban*; 23 x 17.7 cm 10) Gookin 1939.906

703
1) Act five: Yamazaki Highway
2) *Chūshingura* (Treasury of the Forty-seven Loyal Retainers) 4) ca. 1795 5) *Shun'ei ga* 6) Nishimuraya Yohachi 7) *kiwame* 8) *aiban*; 32 x 21.5 cm 10) Gift of Chester W. Wright 1961.202

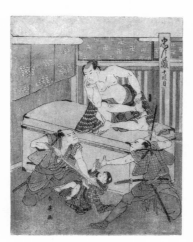
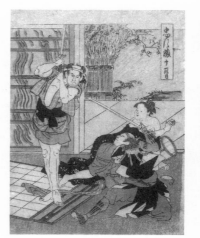
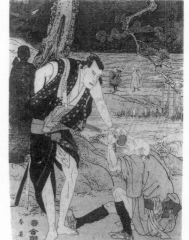

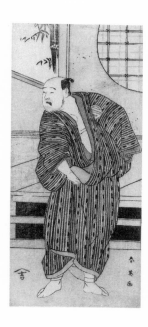

704

1) Kataoka Nizaemon VII as Haya-
kawa Matabei (?) 2) *Furiwake-gami
Aoyagi Soga* (?) 3) Miyako (?) 4) 1/
1796 (?) 5) *Shun'ei ga* 6) Enomoto-
ya Kichibei 8) *hosoban*; 30.5 x
13.8 cm 9) HRWK; UT8, pl. 244
10) Gookin 1939.926

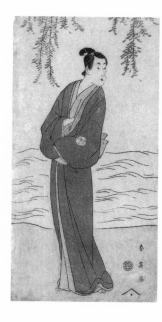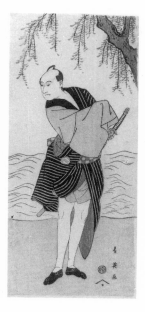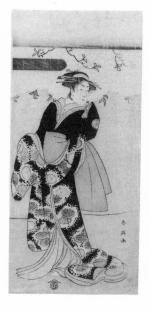

705

1) Sawamura Sōjūrō III as Ume no
Yoshihei (R), and Segawa Kikuno-
jō III as Chōkichi (L) 2) *Suda no
Haru Geisha Katagi* 3) Kiri 4) 1/
1796 5) *Shun'ei ga* 6) Harimaya

Shinshichi 7) *kiwame* 8) *hosoban*;
32.3 x 14.4 cm (R), 28.3 x 14.2 cm
(L) 9) MOKB (L) 10) Buckingham
1925.2401 (R), 1925.2402 (L)

706

1) Segawa Kikunojō III 4) late
1790s 5) *Shun'ei ga* 6) Tsuruya
Kiemon 8) *hosoban*; 32 x 14.5 cm
10) Buckingham 1928.1031

707

1) Court ladies on a balcony
watching a woman and a girl chas-
ing a man in the yard under blos-
soming cherry trees 4) late 1790s
5) *Shun'ei ga* 8) long *surimono*;
19 x 51.7 cm 10) Gift of Helen
Gunsaulus 1954.723

708

1) Rural scene in early summer: peasants transplanting rice and a man washing a horse 4) late 1790s 5) *Shun'ei ga* 8) long *surimono*; 18.5 x 52.4 cm 10) Gift of Helen Gunsaulus 1954.743

709

1) Act five: Yamazaki Highway 2) *Kanadehon Chūshingura* 4) 6/ 1807 5) *Shun'ei ga* 6) Iseya Magobei 7) *kiwame*, with date seal 6/1807 8) *ōban*; 39 x 26 cm 10) Nickerson Collection 1936.86

710

1) Act ten: Amakawaya House 2) *Kanadehon Chūshingura* 4) 6/ 1807 5) *Shun'ei ga* 6) Iseya Mago- bei 7) *kiwame*, with date seal 6/1807 8) *ōban*; 38.3 x 25.5 cm 10) Gift of Mr. and Mrs. Harold G. Henderson 1968.360

KATSUKAWA SHUNCHŌ

(active ca. 1760s–1770s)

711

1) Nakamura Nakazō I as Matsu- kaze (R), and Ichikawa Komazō I as Yukihira (L) 2) *Kuni no Hana Ono no Itsumoji* 3) Nakamura 4) 11/1771 5) *Shunchō ga* 8) *hosoban*; 29.8 x 14.7 cm 10) Buckingham 1925.2693

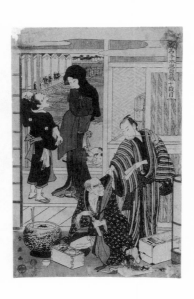

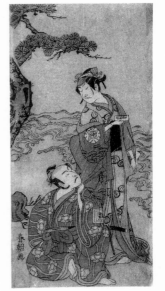

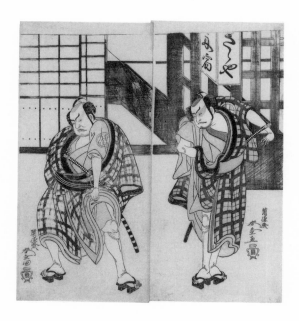

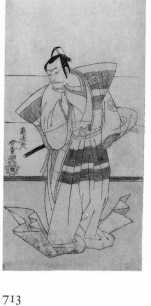

RANTOKUSAI SHUNDŌ

(active ca. 1770–1790)

712
1) Ōtani Hiroji II as Satsuma Gengobei (R), and Nakamura Sukegorō II as Sasano Sangobei (L)
2) *Iro Moyō Aoyagi Soga* 3) Nakamura 4) 2/1775 5) *Rantokusai Shundō*; *Hayashi* in jar-shaped outline
8) *hosoban*, diptych; each approx. 32.3 x 15 cm 9) MAD (L); SM (diptych) 10) Gookin 1939.852 (R), 1939.851 (L) *) See No. 135

713
1) Nakamura Nakazō I as Kudō Suketsune 2) *Edo no Fuji Wakayagi Soga* 3) Nakamura 4) 1/1789
5) *Rantokusai Shundō ga*; *Hayashi* in jar-shaped outline 8) *hosoban*; 31.2 x 15 cm 10) Gookin 1939.850

TAMAGAWA SHUNSUI

(active ca. 1770s)

714
1) Nakamura Tomijūrō I as the spirit of Taira no Masakado disguised as Ōtomo no Kuronushi
2) *Shida Yuzuriha Hōrai Soga*
3) Morita 4) 1/1775 5) *Shunsui ga* 8) *hosoban*; 29.7 x 14.4 cm
10) Gift of Mr. and Mrs. Harold G. Henderson 1962.983

KATSUKAWA SHUNJŌ

(d. 1787)

715
1) Matsumoto Kōshirō IV as Ise no Saburō disguised as Mizoro no Sabu 2) *Mure Takamatsu Yuki no Shirahata* 3) Ichimura 4) 11/1780
5) *Shunjō ga* 8) *hosoban*; 32.2 x 14.5 cm 10) Buckingham 1939.2214

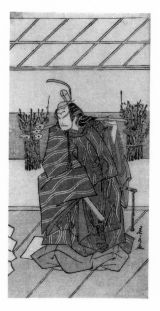

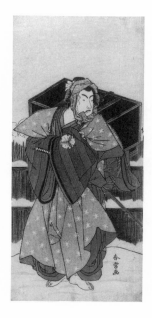

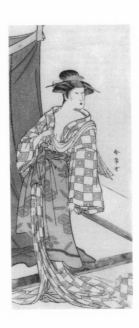

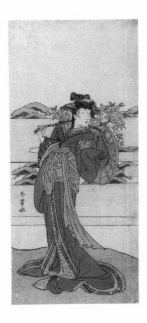

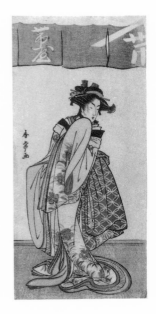

716
1) Segawa Kikunojō III as a courtesan in summer attire 4) early 1780s 5) *Shunjō ga* 8) *hosoban*; 31 x 12.8 cm 9) BM; VI (1910), no. 588; MG 10) Buckingham 1928.1027 *) See No. 136

717
1) Segawa Kikunojō III as Onatsu 2) *Kabuki no Hana Bandai Soga* 3) Ichimura 4) 3/1781 5) *Shunjō ga* 8) *hosoban*; 33.1 x 14.6 cm 10) Buckingham 1925.2509 *) Left sheet of diptych (?)

718
1) Segawa Kikunojō III as Shinanoya Ohan 2) *Kabuki no Hana Bandai Soga* 3) Ichimura 4) 3/1781 5) *Shunjō ga* 8) *hosoban*; 31.7 x 14.6 cm 10) Gookin 1939.857 *) Left sheet of diptych (?)

719
1) Iwai Hanshirō IV in the *Hanagasa* dance 2) *Iromi-gusa Shiki no Somewake* 3) Nakamura 4) 9/1781 5) *Shunjō ga* 8) *hosoban*; 32.2 x 14.8 cm 10) Buckingham 1939.2116

720
1) Another impression of cat. no. 719 10) Buckingham 1925.2508

721
1) Yamashita Mangiku I as Kewaizaka no Shōshō 2) *Nanakusa Yosooi Soga* 3) Nakamura 4) 1/1782 5) *Shunjō ga* 8) *hosoban*; 30.2 x 15 cm 10) Gookin 1939.858 *) Right sheet of triptych

722
1) Nakamura Rikō I as Osen of the Komatsuya house (?) 2) *Nanakusa Yosooi Soga* (?) 3) Nakamura (?) 4) 2/1782 (?) 5) *Shunjō ga* 8) *hosoban*; 32.1 x 15 cm 10) Gift of Mr. and Mrs. H. George Mann 1974.463

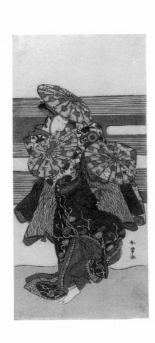

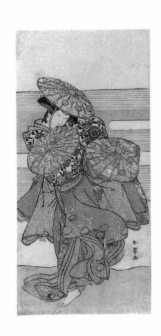

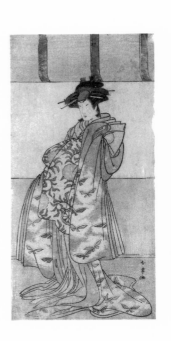

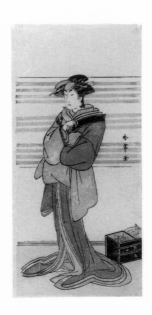

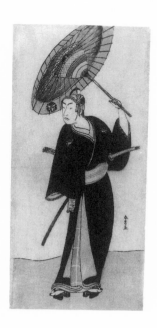 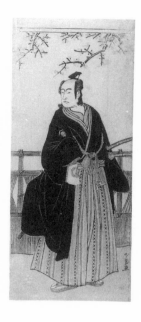 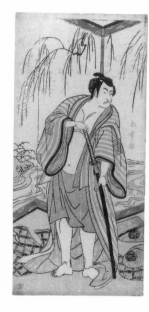 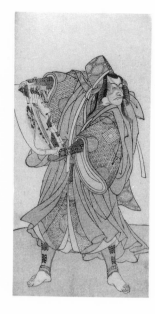

723
1) Matsumoto Kōshirō IV as Sukeroku 2) *Sukeroku Yukari no Edo-zakura* 3) Ichimura 4) 6/1782 5) *Shunjō ga* 8) *hosoban*; 31.3 x 14.7 cm 10) Gookin 1939.861

724
1) Sawamura Sōjūrō III as Soga no Jūrō Sukenari 2) *Edo no Hana Mimasu Soga* 3) Nakamura 4) 1/1783 5) *Shunjō ga* 8) *hosoban*; 31.6 x 13.4 cm 10) Gookin 1939.862 *) From a multisheet composition

725
1) Ichikawa Monnosuke II as the sumo wrestler Shirafuji Genta 2) *Edo no Hana Mimasu Soga* 3) Nakamura 4) 3/1783 5) *Shunjō ga* 8) *hosoban*; 32.4 x 14.8 cm 10) Gookin 1939.863 *) Center sheet of triptych

726
1) Ichikawa Danjūrō V as Kazusa no Akushichibyōe Kagekiyo 2) *Edo no Hana Mimasu Soga* 3) Nakamura 4) 3/1783 5) unsigned 8) *hosoban*; 30.5 x 14.2 cm 10) Gookin 1939.859

727
1) Nakamura Nakazō I as Tenjiku Tokubei (?) (R), and Bandō Kumajūrō as the shopman Dempachi (?) (L) 2) *Keisei Katabira ga Tsuji* (?) 3) Ichimura (?) 4) 8/1783 (?) 5) *Katsukawa Shunjō ga* 8) *hosoban*; 30.2 x 14.1 cm 9) SM; MMA 10) Gookin 1939.855

728
1) Ichikawa Danjūrō V as Akushichibyōe Kagekiyo (?) 4) ca. 1783–1784 5) *Shunjō ga* 8) *hosoban*; 30.8 x 13.9 cm 10) Gookin 1939.860 *) Left sheet of triptych (?)

729
1) Nakamura Rikō I as Lady Mankō (Mankō Gozen) (?) 2) *Soga Musume Chōja* (?) 3) Nakamura (?) 4) 1/1784 (?) 5) *Shunjō ga* 8) *hosoban*; 32.5 x 14.8 cm 10) Gookin 1939.856

730
1) Segawa Kikunojō III as Lady Tomoe (Tomoe Gozen) 2) *Onna Musha Kiku no Sen'yoki* 3) Morita 4) 11/1786 5) *Katsukawa Shunjō ga* 8) *hosoban*; 33 x 15 cm 9) HAA 10) Buckingham 1925.2510

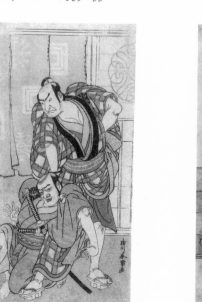 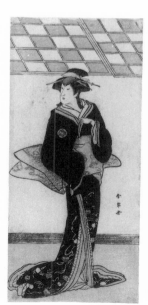

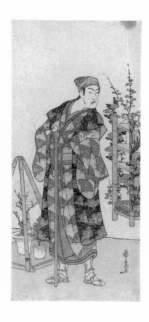

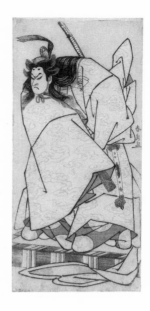

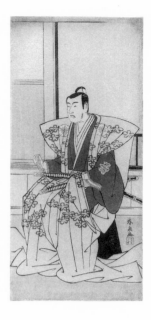

KATSUKAWA SHUNSEN

(active 1780s–early 1790s)

731
1) Matsumoto Kōshirō IV as the plant seller Awashima no Yonosuke 2) *Mukashi Otoko Yuki no Hinagata* 3) Ichimura 4) 11/1781 5) *Shunsen ga* 8) *hosoban*; 32.5 x 14.5 cm 10) Buckingham 1925.2512

732
1) Onoe Matsusuke I as Ashikaga Takauji 2) *Kumoi no Hana Yoshino no Wakamusha* 3) Nakamura 4) 11/1786 5) *Shunsen ga* 8) *hosoban*; 31.5 x 14.7 cm 9) UT8, pl. 287 10) Buckingham 1938.544

733
1) Matsumoto Kōshirō IV as Hatakeyama Shigetada 2) *Edo no Fuji Wakayagi Soga* 3) Nakamura 4) 1/1789 5) *Shunsen ga* 8) *hosoban*; 32 x 14.6 cm 9) UT8, pl. 284 10) Buckingham 1939.2215

734
1) Ichikawa Komazō III as Fuji Sakon (?) 2) *Egara Tenjin Rishō Kagami* (?) 3) Nakamura (?) 4) 3/1789 (?) 5) *Shunsen ga* 8) *hosoban*; 30.8 x 14 10) Gookin 1939.894

735
1) Yamashita Mangiku I as Lady Yuya (Yuya Gozen) (?) 2) *Heike Hyōbanki* (?) 3) Nakamura (?) 4) 7/1789 (?) 5) *Shunsen ga* 8) *hosoban*; 29.2 x 14.2 cm 10) Gift of Mrs. George T. Smith 1971.504

736
1) Asao Tamejūrō I as drunken Gotōbei 2) *Yoshitsune Koshigoe Jō* 3) Ichimura 4) 9/1790 5) *Shunsen ga* 8) *hosoban*; 30.7 x 13.8 cm 10) Buckingham 1925.2511

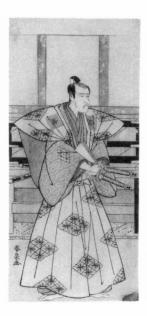

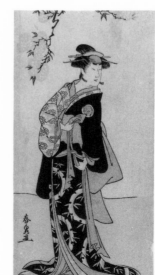

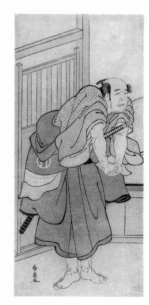

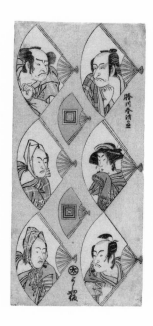

KATSUKAWA SHUNSEI

(active ca. 1780s)

737

1) Bust portraits of actors in folding fans: Ichikawa Danjūrō V, Segawa Kikunojō III, Ichikawa Monnosuke II (right, top to bottom); Nakamura Nakazō I, Matsumoto Kōshirō IV, Bandō Mitsugorō II (left, top to bottom) 4) ca. 1788 5) *Katsukawa Shunsei ga* 6) Yoshiya 8) *hosoban*; 32.6 x 14.9 cm 10) Gookin 1939.1706

739

1) Warrior on horseback 4) late 1780s or early 1790s 5) *Katsukawa Shunsei ga* 8) *chūban*; 25.8 x 19.5 cm 10) Gift of Mr. and Mrs. Harold G. Henderson 1968.331

KATSUKAWA SHUNSEI

(active late 1780s–early 1790s)

738

1) The warrior Kusunoki Masashige (1294–1336) bidding farewell to his son Masatsura 4) 1780s (?) 5) *Katsukawa Shunsei ga* 8) *chūban*; 26.5 x 19.8 cm 10) Gookin 1939.895

KATSUKAWA SHUN'EN

(active ca. 1787–1796)

740

1) Sakata Hangorō III as the guard Yahazu no Yadahei 2) *Otokoyama O-Edo no Ishizue* 3) Kiri 4) 11/1794 5) *Shun'en ga* 6) Nishimuraya Yohachi 7) *kiwame* 8) *hosoban*; 33.2 x 14.8 cm 10) Gift of Mr. and Mrs. Harold G. Henderson 1962.986

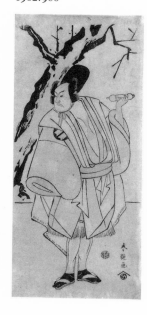

Actors Represented *in the Catalogue: Biographical Data*

OSAMU UEDA

In theory Edo-period society was rigidly and unalterably stratified, and within this theoretical hierarchy Kabuki actors were a despised lot, classified as *hinin* (non-persons) and referred to as *kawaramono* (riverbed vagrants). The reality was otherwise: like contemporary music and movie stars, the stars of Kabuki were idolized and gossiped about, their dress and manner sedulously imitated, pictures and mementos of them avidly collected.

Further, the acting lineages acquired family names (*sei*) and crests (*mon*), both generally the prerogative of the samurai class. Within each acting lineage certain given names (*namae*) were traditional, handed down from one generation to the next, the family name and given name together constituting the stage name (*geimei*). The *namae* reflected varying degrees of excellence, and actors rose from lesser to more illustrious names as they mastered their craft. In addition to his stage name, each actor had a "house name" (*yagō*), invariably ending in *-ya*, and a literary name, or pen name (*haimyō*), used in correspondence and literary composition. Many actors were poets, or at least versifiers, in their leisure.

The capsule biographies below are in alphabetical order by family name and the given stage name by which the actor is most commonly known; the dates below indicate the period during which the actor worked under this stage name. (A date such as "1796/3/29" means "29th day, 3rd month, 1796," according to the lunar calendar in use.)

To the left of each entry appears the actor's crest or crests, the *jō mon* ("standard crest"— generally used by the whole lineage) above, and the *kae mon* ("alternative crest"— generally unique to a single individual) below.

"Speciality" refers to the type of role or the skill for which the actor was best known. *Aragoto*, *jitsugoto*, and *wagoto* denote specific acting styles in masculine roles. *Arogoto* is a style of heroic, even fantastic, bravado. *Jitsugoto* might be defined as the grimly realistic portrayal of an ordinary man beset by tragic circumstances. *Wagoto*, which may have comic touches, expresses softness, even weakness, especially as manifested in love scenes. Useful shorthand translations might be (respectively) "rough stuff," "real stuff," and "soft stuff."

Where the facts of an actor's biography are in dispute, *Kabuki Jimmei Jiten* (1988) has been presumed authoritative.

嵐 雛治 (初代)
Arashi Hinaji I
1763–1777

Birth date: Unknown
Death date: Unknown
Student of: Arashi San'emon V
House name: Yoshidaya
Literary name: Seika
Speciality: Female roles (*onnagata*).
Comments: According to *Kabuki Nempyō*, he moved to Edo from Osaka in 1763. In 1767 he appeared at the Nakayama Theater, Osaka, but was again in Edo 1768–1775. His name does not appear in *Kabuki Nempyō* after 1778.
Entry Nos. 2, 62
Cat. Nos. 98, 214, 216, 254

嵐 雛助 (初代)
Arashi Hinasuke I
1752/11–1786

Birth date: 1741
Death date: 1796/3/29
Son of: Arashi Koroku I (Arashi San'emon V)
Childhood name: Arashi Iwajirō
Later stage names: Kanou Hinasuke, from 1786; Arashi Koroku III, from 1794/1
House name: Yoshidaya
Literary names: Minshi; Minshi (using different character for *-shi*); Koshichi
First stage appearance: 1752/11, at Mimasu Daigorō Theater, Osaka
Specialities: Young female roles (*waka onnagata*); male leads (*tachi yaku*), from 1776; also skilled in playing evil courtiers (*aku kuge*) and in *shosagoto* dance.
Entry No. 92

嵐 音八 (初代)
Arashi Otohachi I
?–1769/3

Birth date: 1711
Death date: 1769/3/25
Student of: Arashi Sangorō I
Earlier stage name: Arashi Otonosuke
House name: Ebisuya
Literary name: Wakō

First stage appearance in Edo: 1732, Nakamura Theater

Specialities: Male leads (*tachi yaku*), buffoons (*dōke yaku*); ranked the best in this latter category.

Comments: He ran a *kanoko-mochi* (rice-cake with sweet boiled beans) shop at Ningyō Street, Edo, which was later managed by the musician Ōta Ichizaemon.

Entry No. 1

Cat. Nos. 73, 89

嵐音八 (二代目)

Arashi Otohachi II

1770/11–1808/5

Son of: Arashi Otohachi I

Brother of: Younger brother of Bandō Matatarō IV

Earlier stage name: Arashi Hikokichi

Specialities: Listed as buffoon (*dōke yaku*) in 1776 and 1777. Listed as evil enemy (*kataki yaku*) in Kyoto in 1779–1783 and in Edo in 1784.

Comments: Not recorded after the fifth month of 1808.

Cat. No. 558

嵐龍藏 (二代目)

Arashi Ryūzō II

?–1797/10

Birth date: 1761

Death date: 1798/11/5

Pupil of: Arashi Shichigorō I

Later stage name: Arashi Shichigorō III (1797/11–1798/11)

Specialities: Arch-villains (*jitsu aku*) and evil enemies (*kataki yaku*).

Comments: While using the stage name Shichigorō III, he also used the house name Kyōya and the literary name Shagan.

Entry No. 134

嵐三五郎 (二代目)

Arashi Sangorō II

1739/7–1797/3

Birth date: 1732

Death date: 1803/5/2

Son of: Arashi Sangorō I

Earlier stage name: Arashi Tomisaburō

House name: Kyōya

Literary names: Raishi; Raishi (using two different characters)

Retired: 1797/2

Specialities: Male leads (*tachi yaku*) and lowly disguise roles (*yatsushi*). Skilled at *shosagoto* dance.

Comments: On retiring from the stage he took the name Kyōya Shichibei. In 1798 he became a monk and assumed the religious name Mitsugen.

Entry Nos. 13, 49

Cat. Nos. 164, 175, 187, 188, 206, 248, 249, 332, 333

浅尾為十郎 (初代)

Asao Tamejūrō I

1756/11–1803/9

Birth date: 1735

Death date: 1804/4/7

Son of: Sugimoto Tamesaburō, a master *shamisen* player in Kyoto theaters

Student of: Asao Motogorō

Earlier stage name: Asao Tamezō

House name: Zeniya

Literary name: Ōzan

Speciality: Arch-villains (*jitsu aku*) in Kamigata theaters.

Entry Nos. 124, 125

Cat. Nos. 647, 648, 736

吾妻藤藏 (二代目)

Azuma Tōzō II

1730/11–1749/2, 1760/11–1776/4

Birth date: 1724

Death date: 1776/4/11

Son of: Nakamura Seishichi

Adopted by: Azuma Tōzō I

Student of: Ichimura Uzaemon VIII

Childhood name: Nakamura Seinosuke

Other stage names: Bandō Kitsusaku; Ikushima Daikichi II (1748); Agemaki Rinya (1756/11–1760/10)

House name: Azumaya

Literary name: Enshi

Specialities: Young male roles (*wakashu*), from 1738; young female roles (*waka onnagata*), from 1741.

Comments: Created the Azuma dance style and was considered the foremost *onnagata* actor of his day.

Entry No. 29

Cat. No. 174

吾妻藤藏 (三代目)

Azuma Tōzō III

1779/11–1798/6

Birth date: 1756

Death date: 1798/6/15, Kyoto

Student of: Azuma Tōzō II; Ichimura Uzaemon IX

Earlier stage name: Azuma Tomigorō

House name: Azumaya

Literary names: Enka; Enshi

First stage appearance: Winter 1769, Ichimura Theater, Edo

Speciality: Female roles (*onnagata*), from 1779.

Comments: His name as a choreographer was Azuma Daikichi. In 1789/11 he went to Osaka, where he became very popular.

Cat. No. 488

坂東彦三郎 (三代目)
Bandō Hikosaburō III
1770/11–1813/11

Birth date: 1754, Edo
Death date: 1828/2/18
Son of: Third son of Ichimura Uzaemon VIII
Earlier stage name: Ichimura Kichigorō (?–1770/10)
House names: Yorozuya; later Otowaya
Literary names: Kisshi; Rakuzen; later Shinsui
First stage appearance: 1759/3
Retired: 1813/11
Specialities: Young male roles (*wakashu*), from 1770; male leads (*tachi yaku*), from 1778/11.
Comments: Noted for *wagoto*. On retiring, he took lay religious vows, adopted the name Hansōan Rakuzen, and moved to Honjo, Edo.
Entry No. 5
Cat. No. 574

坂東熊十郎
Bandō Kumajūrō. (See Sakata Hangorō III)

坂東又太郎 (四代目)

Bandō Matatarō IV
1753/11–1801/9

Birth date: Unknown
Death date: 1801/9/13
Son of: Arashi Otohachi I
Student of: Ichimura Uzaemon VIII
Earlier stage name: Arashi Kyūhachi (1747/11–1753/10)
House name: Tōgokuya
Literary name: Tōzan
First stage appearance: 1747/11, at Nakamura Theater, Edo
Specialities: Evil enemies (*kataki yaku*); *aragoto*.
Entry No. 40
Cat. No. 264

坂東三津五郎 (初代)
Bandō Mitsugorō I
1766/11–1782/4

Birth date: 1745, Osaka
Death date: 1782/4/10
Adopted by: Bandō Sampachi I (1766)
Student of: Bandō Sampachi I
Earlier stage name: Takeda Minosuke

House name: Yamatoya
Literary name: Zegyō
Speciality: *Wagoto*.
Entry Nos. 56B, 65, 68, 81, 90
Cat. Nos. 68, 180, 255, 273, 341, 343, 433, 435, 469, 485, 583

坂東三津五郎 (二代目)
Bandō Mitsugorō II
1785/11–1799/10

Birth date: 1750
Death date: 1829/10/2
Earlier stage names: Onoe Tōzō; Onoe Monzaburō
Later stage name: Ogino Isaburō II (1799/11)
House name: Yamatoya
Literary names: Zegyō; Riyū; Shochō; Zeyō
Speciality: Male leads (*tachi yaku*).
Cat. No. 737

坂東三八 (初代)
Bandō Sampachi I
1750/11–1770/1

Birth date: Unknown
Death date: 1770/1/11
Son of: Nakamura Koyata
Student of: Ichimura Uzaemon VIII
Earlier stage names: Ōta Sanjūrō (as *shamisen* player); Bandō Matahachi (1746/1–1750/10)
House name: Yamatoya
Literary name: Heikyū
Specialities: Skillful *shamisen* player; manservants of samurai (*yakko*); *aragoto*.
Cat. No. 68

坂東三八 (二代目)
Bandō Sampachi II
1770/11–ca. 1779

Birth date: Unknown
Death date: Ca. 1787?
Student of: Bandō Sampachi I
Childhood name: Bandō Kintarō (1755)
Earlier stage name: Bandō Matahachi II (1762/11–1770/10)
House name: Yamatoya
Specialities: Evil enemies (*kataki yaku*); manservants of samurai (*yakko*).
Comments: His name last appears in *banzuke* for the second-month play at the Morita Theater in 1787.
Cat. No. 165

Bandō Zenji I
1768/11–1801/10

Birth date: Unknown
Death date: Ca. 1817
Student of: Bandō Hikosaburō II and III
Later stage name: Bandō Hikozaemon (1801/11)
House name: Chōkichiya
Literary names: Zenkō; Tōgi
Retired: 1811/7
Specialities: Evil enemies (*kataki yaku*); buffoons (*dōke yaku*).
Comments: After the *Chūshingura* production of 1811/7 he retired and lived in Tsukiji, Edo, under the nickname "Zenkō of Tsukiji."
Cat. No. 159

Ichikawa Benzō. (See Ichikawa Monnosuke II)

Cat. No. 8

Ichikawa Danjūrō IV
1754/11–1770/10

Birth date: 1711
Death date: 1778/2/25
Son of: Ichikawa Danjūrō II (raised by Izumiya Kanjūrō, owner of a teahouse in Sakai Street, Edo)
Adopted by: Matsumoto Kōshirō I
Earlier stage names: Matsumoto Shichizō (1719/1); Matsumoto Kōshirō II (1735/11–1754/10)
Later stage names: Resumed Matsumoto Kōshirō II (1770/11–1772/10); Ichikawa Ebizō III (1772/11–1776/9)
House name: Naritaya
Literary names: Umimaru; Goryū; Sanjō; Hakuen; Yauan
Retirement names: Zuinen; Kiba no Oyadama (Boss of the Lumber Yard, Fukagawa)
Specialities: Female roles (*onnagata*); arch-villains (*jitsu aku*); also skilled at *aragoto* and at playing buffoons (*dōke yaku*).
Comments: Noted for his height and strong stage voice.
Entry Nos. 24, 28, 35, 45, 46, 57
Cat. Nos.: Under Matsumoto Kōshirō II: 102, 115, 116, 118, 185. Under Ichikawa Ebizō III: 251, 327, 328, 337–39

Ichikawa Danjūrō V
1770/11–1791/10

Birth date: 1741/8
Death date: 1806/10/30
Son of: Ichikawa Danjūrō IV
Childhood names: Ume-maru; Kōzō

Earlier stage name: Matsumoto Kōshirō III (1754/11–1770/10)
Later stage name: Ichikawa Ebizō (1791/11–1796/12)
House name: Naritaya
Literary names: Baidō; Sanjō; Hakuen; while using the stage name Matsumoto Kōshirō III, he also used the literary name Omegawa
Retired: 1796/12/10, adopting the name Naritaya Shichizaemon
Specialities: Aragoto; female roles (*onnagata*).
Comments: He was the most celebrated actor of the 1770s–1780s. He spent his retirement as a literatus at an elegant retreat called Hogō-an in Mukōjima, Edo. He signed his *kyōka* verses "Hanamichi no Tsurane" (Soliloquy on the Hanamichi).
Entry Nos. 12, 44, 55, 56, 60, 84, 87, 90, 98, 102, 106, 111, 112, 114, 115
Cat. Nos. 113, 114, 131, 132, 135, 138, 139, 154, 160, 178, 180, 183, 194, 198, 207, 210, 218, 256, 257, 276, 278, 297, 340, 344, 348, 364, 366, 374, 376, 386, 394, 396, 399, 401, 414, 423, 433–35, 445, 446, 449, 464, 473, 474, 492, 495, 496, 511, 518, 520, 552, 557, 568, 570, 578, 580, 582, 609, 625, 636, 653, 726, 728, 737. Under Matsumoto Kōshirō III: 19, 20, 70, 108. Under Ichikawa Ebizō: 541, 676

Ichikawa Danzaburō II. (See Ichikawa Danzō IV)

Cat. No. 204

Ichikawa Danzō III
1740/11–1772/6

Birth date: 1719
Death date: 1772/6/24
Son of: ? Matabei, employed by Morita Theater, Edo
Adopted by: Bandō Tasuke (1730); Ichikawa Danzō I (1739/11)
Student of: Bandō Matakurō III (1720–?); Ichikawa Danzō I
Childhood name: Matsusaburō
Earlier stage names: Bandō Jirosaburō; Ichikawa Jirozō; Ichikawa Danzaburō I (1739/11–1740/10)
House name: Mikawaya
Literary name: Shikō
Specialities: Aragoto and martial roles (*budō*).
Comments: Considered almost the equal of Ichikawa Danjūrō II.
Entry Nos. 25, 30, 36, 46
Cat. Nos. 67, 78, 80, 90, 118, 121, 122, 133, 156, 157, 169, 170

Ichikawa Danzō IV
1773/11–1808/10

Birth date: 1745, Kyoto
Death date: 1808/10/9
Adopted by: Ichikawa Danzō III (1772/11)

Student of: Nakamura Tomijūrō I, from 1763; Ichikawa Danzō III, from 1768

Earlier stage names: Kameya Torazō; Nakamura Torazō, from 1763; Ichikawa Tomozō, from 1768/11; Ichikawa Danzaburō II (1772/11–1773/10)

House name: Mikawaya

Literary names: Nikō; Shikō

Specialities: Skillful at martial roles (*budō*) and acrobatics (*chūgaeri*) in dramatic presentations and at *shosagoto* dance.

Comments: Came to Edo in spring 1768.

Entry No. 87

Cat. Nos. 362, 372, 397, 471, 495, 584. Under Ichikawa Danzaburō II: 204

市川 蝦藏

Ichikawa Ebizō. (See Ichikawa Danjūrō V)

Cat. Nos. 540, 541, 676

市川 海老藏 (二代目)

Ichikawa Ebizō II
1735/11–1758/5

Birth date: 1688

Death date: 1758/9/24

Son of: Ichikawa Danjūrō I

Student of: Ichikawa Danjūrō I

Childhood name: Ichikawa Kuzō

Earlier stage names: Ichikawa Kuzō I (1697/5–1704/6); Ichikawa Danjūrō II (1704/7–1735/10)

House name: Naritaya

Literary names: Sanjō; Saigyūsai; Hakuen

Commonly called: Naritaya Jūbei

First stage appearance: 1697/5, at Nakamura Theater, Edo

Retired: 1758/5

Specialities: *Aragoto* and roles of various deities and supernatural incarnations. Also notable for stage voice and diction.

Comments: He studied poetry under Enomoto (Takarai) Kikaku and was famous for his collections of books and antiques.

Entry No. 37

市川 海老藏 (三代目)

Ichikawa Ebizō III. (See Ichikawa Danjūrō IV)

Cat. Nos. 251, 327, 328, 337–39

市川 純藏 (初代)

Ichikawa Junzō I. (See Ichikawa Komazō III)

Cat. No. 152

市川 高麗藏 (二代目)

Ichikawa Komazō II. (See Matsumoto Kōshirō IV)

Cat. Nos. 16, 34, 52, 57, 98, 132, 148, 154, 157, 167, 167a, 173, 643, 644, 660, 664

市川 高麗藏 (三代目)

Ichikawa Komazō III
1772/11–1801/10

Birth date: 1764

Death date: 1838/5/10

Earlier stage name: Ichikawa Junzō I (1770/1–1772/10)

Later stage name: Matsumoto Kōshirō V (1801/11, at Ichimura Theater, Edo)

House name: Kōraiya

Literary names: Kinshō; Kinkō

Specialities: Child roles (*ko yaku*) and young male roles (*wakashu*) (1772/11–1783); later, male leads (*tachi yaku*).

Comments: Considered the best actor of the 1830s. His high-beaked nose earned him the nickname Hanadaka (High Nose) Kōshirō.

Entry Nos. 127, 130

Cat. No. 621. Under Ichikawa Junzō I: 152

市川 門之助 (二代目)

Ichikawa Monnosuke II
1770/11–1794/10

Birth date: 1743, in Ōji Takinogawa, Edo

Death date: 1794/10/19

Adopted by: Family of deceased Ichikawa Monnosuke I

Student of: Ichikawa Danjūrō IV, from 1762

Childhood name: Ichikawa Senkichi

Earlier stage names: Takinaka Tsuruzō, until 1756, Osaka; Takinaka Hidematsu II, from 1759/11; Ichikawa Benzō (1762/11–1770/10)

House name: Takinoya

Literary names: While using the stage name Ichikawa Benzō, he also used the literary name Umi-maru; Shinsha

Specialities: Young male roles (*wakashu*); male leads (*tachi yaku*), from 1777.

Comments: Considered to be one of the four best young actors of his day.

Entry Nos. 67, 90, 95, 96, 106, 116, 118, 119, 126

Cat. Nos. 61, 172, 184, 186, 266, 330, 331, 377, 388, 419, 433, 437, 477, 478, 490, 506, 509, 532, 542, 566, 569, 668, 670, 725, 737. Under Ichikawa Benzō: 8

市川 男女藏 (初代)

Ichikawa Omezō I
1789/11–1824

Birth date: 1781

Death date: 1833/6/7
Son of: Eldest son of Ichikawa Monnosuke II
Student of: Ichikawa Danjūrō V
Earlier stage name: Ichikawa Bennosuke (from 1784/11)
House name: Takinoya
Literary names: Shinsha; Umi-maru
Specialities: Male leads (*tachi yaku*) and arch-villains (*jitsu aku*).
Comments: First used the name Omezō I in performance at the Nakamura Theater, Edo, 1789/11.
Entry No. 106
Cat. Nos. 626, 665, 672

市川雷藏 (初代)
Ichikawa Raizō I
1761/11–1767/4

Birth date: 1724, Kyoto
Death date: 1767/4/12
Student of: Ichikawa Danjūrō V, from 1753
Earlier stage names: Arashi Tamagashiwa; Ichikawa Masuzō (1753–1761/10)
House name: Kashiwaya
Literary name: Hakusha
Specialities: Young female roles (*waka onnagata*) and male leads (*tachi yaku*); especially skilled at *aragoto*.
Comments: Son-in-law of Ōsakaya Jihei; very handsome.
Entry No. 23
Cat. No. 64

市川雷藏 (二代目)
Ichikawa Raizō II
1769/5–1778/1

Birth date: 1754, Edo
Death date: 1778/1/7
Son of: Ichikawa Raizō I
Childhood name: Ichikawa Iwazō
Earlier stage name: Ichikawa Hinazō
House name: Kashiwaya
Literary name: Hakusha
Specialities: Young male roles (*wakashu*); *aragoto*.
Cat. Nos. 203, 545

市川染五郎
Ichikawa Somegorō
1766/11–1771/10

Birth date: Unknown
Death date: 1798/6/15, Osaka
Student of: Ichikawa Komazō II
Earlier stage name: Ichikawa Shōbei (1759/11–1766/10)
Later stage names: Ichikawa Otojūrō (1771/11–1772/10); Ichikawa Ikuzō (1772/11–1798/5)

House name: Kōraiya
Literary name: Gikō
Cat. No. 165

市川八百藏 (二代目)
Ichikawa Yaozō II
1763/11–1777/7

Birth date: 1735
Death date: 1777/7/3
Student of: Nakamura Denkurō II, from 1751; Ichikawa Danjūrō IV, from 1763/11
Earlier stage name: Nakamura Denzō (1751–1763/10)
House names: Tachibanaya; Hōraiya; Yoshimuraya
Literary name: Chūsha
Specialities: Wagoto; jitsugoto.
Comments: He was initially a *gidayū* (narrative chanter), under the name Toyotake Izumidayū.
Entry Nos. 17, 32, 80
Cat. Nos. 2, 51, 60, 96, 143, 158, 168, 171, 202, 217, 252, 302, 336, 337, 345, 550–52

市川八百藏 (三代目)
Ichikawa Yaozō III
1779/11–1804/10

Birth date: 1747
Death date: 1818/12/13, Fukushima
Son of: Eldest son of Sawamura Sōjūrō II
Student of: Segawa Kikunojō II, from 1769; Ichikawa Danjūrō V, from 1779
Childhood name: Sawamura Kimpei
Earlier stage names: Segawa Yūjirō I (1769/winter–1777/10); Sawamura Shirogorō (1767–1769/winter; 1777/11–1779/10)
Later stage names: Suketakaya Takasuke II (1804/10–1806; 1808–1818); Suketakaya Shirogorō (1806–1808)
House name: Kinokuniya
Literary names: Shabo; Kion; Roshū; Chūsha; Kōga
Specialities: Young girls (*musumegata*), from 1769; male leads (*tachi yaku*), from 1777/11. Skilled at *wagoto* and martial roles (*budō*).
Entry Nos. 67, 131
Cat. Nos. 525, 528, 529, 553, 598. Under Segawa Yūjirō I: 277, 322, 329

市村吉五郎
Ichimura Kichigorō. (See Bandō Hikosaburō III)

Entry No. 5

市村羽左衛門（九代目）

Ichimura Uzaemon IX
1762/8–1785

Birth date: 1725
Death date: 1785/8/25
Son of: Ichimura Uzaemon VIII
Earlier stage names: Ichimura Manzō (1731–1745/1); Ichimura
　Kamezō I (1745/2–1762/7)
House name: Kikunoya
Literary name: Kakitsu
Speciality: Master of *shosagoto* dance.
Comments: Became manager of the Ichimura Theater, Edo.
Entry Nos. 49, 85, 86
Cat. Nos. 3, 14, 75, 106, 141, 144, 164, 166, 281, 318, 337, 347,
　363, 381, 389, 392, 483, 484, 494, 565, 599

生島大吉（三代目）

Ikushima Daikichi III
1778/11–ca. 1780

Birth date: Unknown
Death date: Unknown
Earlier stage name: Fujii Hanasaki III (?–1778/10)
Speciality: Young female roles (*waka onnagata*).
Comments: His career is unknown. He came to the Morita
　Theater, Edo, in 1778/4, under the name Fujii Hanasaki,
　which he changed to Ikushima Daikichi III in the eleventh
　month. He performed *onnagata* roles during the year 1779.
Cat. No. 390

岩井半四郎（四代目）

Iwai Hanshirō IV
1765/11–1800/3

Birth date: 1747
Death date: 1800/3/28
Son of: Tatsumatsu Jūzaburō, a puppeteer of Edo
Adopted by: Iwai Hanshirō III
Student of: Matsumoto Kōshirō II
Earlier stage names: Matsumoto Nagamatsu (1753/8–1761);
　Matsumoto Shichizō (1762/1–1765/10)
House names: Zōshigaya; Yamatoya
Literary name: Tojaku
Nicknames: Otafuku Hanshirō (because of his plump face);
　Shirogane no Dayū (Master of Shirogane); and Meguro no
　Dayū (Master of Meguro)
First stage appearance: 1753/7, at Ichimura Theater, Edo
Speciality: Female roles (*onnagata*).
Comments: Together with Segawa Kikunojō III, he was
　considered one of the two best *onnagata* actors of Edo. He
　had a villa at Shirogane in Meguro, Edo.
Entry Nos. 7, 54, 95, 102, 119, 128
Cat. Nos. 17, 28, 38, 39, 52, 137, 158, 159, 167, 167a, 219, 250,
　334, 352, 403, 475, 483, 497, 534, 543, 569, 585, 591, 597,
　610, 614, 629, 632, 634, 636, 637, 669, 677, 679, 719, 720

岩井春五郎

Iwai Harugorō
active ca. 1786/11–ca. 1795

Birth date: Unknown
Death date: Unknown
Student of: Iwai Hanshirō IV
Comments: According to playbills (*ehon banzuke*), he seems to
　have been active mostly in young male roles (*wakashu*)
　from 1786/11 until 1795/9.
Entry No. 95 (?)

岩井喜代太郎（二代目）

Iwai Kiyotarō II
1788/1–1804/11

Birth date: 1722, Edo
Death date: 1844/7/3
Brother of: Fujima Kanjūrō
Student of: Iwai Hanshirō IV
Earlier stage name: Iwai Karumo (1782–1787/10)
Later stage name: Ichikawa Yaozō IV, from 1804/11
House name: Edoya
Literary names: Senchō; Chūsha
Specialities: Female roles (*onnagata*); later, male leads (*tachi
　yaku*).
Entry No. 95 (?)
Cat. Nos. 542, 633

笠屋又九郎（二代目）

Kasaya Matakurō II
1770/11–after 1777/11

Birth date: Unknown
Death date: Unknown
Son of: Kasaya Matakurō I
Childhood name: Kasaya Matasaburō (1755)
Earlier stage name: Kasaya Matazō (1761–1770)
Literary name: Kojū
Speciality: Evil enemies (*kataki yaku*).
Cat. Nos. 153, 172, 213

片岡仁左衛門（七代目）

Kataoka Nizaemon VII
1788/2–1837/3

Birth date: 1755, Kyoto
Death date: 1837/3/1
Student of: Nakamura Jūzō II; later, Asao Tamejūrō I
Earlier stage names: Nakamura Matsusuke; Asao Kunigorō II,
　from 1777
House name: Matsushimaya
Literary names: Gadō; Bairi; Mammaro

Specialities: Good at all kinds of roles and at *shosagoto* dance.
Comments: Younger brother of Asao Kunigorō I and very
prominent in his day.
Cat. Nos. 688, 704

松本大七
Matsumoto Daishichi
ca. 1761–ca. 1778

Birth date: Unknown
Death date: Unknown
Student of: Matsumoto Kōshirō II
Literary name: Shōkyoku
Speciality: Evil enemies (*kataki yaku*).
Cat. No. 179

松本幸四郎（二代目）
Matsumoto Kōshirō II. (See Ichikawa Danjūrō IV)

Cat. Nos. 115, 116, 118, 156, 157, 168–70, 185

松本幸四郎（三代目）
Matsumoto Kōshirō III. (See Ichikawa Danjūrō V)

Cat. Nos. 19, 33, 70, 108

松本幸四郎（四代目）
Matsumoto Kōshirō IV
1772/11–1801/7

Birth date: 1737, Kyoto
Death date: 1802/6/27
Student of: Segawa Kikunojō I, from 1744; Ichikawa Danjūrō
IV, from 1756
Earlier stage names: Segawa Kingo, from 1744; Segawa Kinji,
from 1754/11; Ichikawa Takejūrō, from 1756/4; Ichikawa
Somegorō I, from 1762/11; Ichikawa Komazō II (1763/11–
1772/10)
Later stage name: Omegawa Kyōjūrō (1801/8–1802/6)
House name: Kōraiya
Literary names: Kinkō; Kinkō (using different character for *-kō*)
Specialities: Male leads (*tachi yaku*), from 1754; *wagoto*, from
1757. Especially noted for voice and diction.
Entry No. 97
Cat. Nos. 200, 201, 261, 306, 371, 409, 410, 620, 635, 691,
715, 723, 731, 733, 737. Under Ichikawa Komazō II: 16,
34, 52, 57, 98, 132, 148, 154, 157, 167, 167a, 173, 643, 644,
660, 664

三桝徳次郎（初代）
Mimasu Tokujirō I
ca. 1761–1812/8

Birth date: 1750
Death date: 1812/8/26
Student of: Mimasu Daigorō I
House name: Masuya
Literary name: Gyokō
Nickname: Shōtoku
Speciality: Young female roles (*waka onnagata*), in Osaka.
Comments: Osaka actor who acted in Edo from 1784/1 to
1786/8.
Entry No. 122

宮崎八蔵
Miyazaki Hachizō
1753–1784/10

Birth date: Unknown
Death date: Unknown
Student of: Miyazaki Jūshirō II
Later stage name: Miyazaki Jūshirō III (1784/11–ca. 1806)
House name: Tomoeya
Literary names: Itsujū; Hajū
Speciality: Evil enemies (*kataki yaku*), from 1753.
Comments: Manager of Kawarazaki Theater, Edo, from
1800/11.
Cat. No. 153

中島勘左衛門（三代目）
Nakajima Kanzaemon III
1762/11–1793/11

Birth date: 1738, Edo
Death date: 1794/1/13
Son of: Nakajima Kanzaemon II
Childhood name: Nakajima Dennosuke
Earlier stage name: Nakajima Kanroku III, from 1753
House name: Nakajimaya
Literary names: Zeshō; Tōshi
Speciality: Evil enemies (*kataki yaku*).
Comments: The top-ranked *kataki yaku* actor of Edo in 1775.
Cat. No. 370

中島三甫右衛門（二代目）
Nakajima Mihoemon II
1762/11–1782/12

Birth date: 1724
Death date: 1782/12/17
Son of: Nakajima Mihoemon I
Earlier stage name: Nakajima Mihozō

House name: Nakajimaya
Literary name: Tenkō
Nicknames: Tenjin; Yushima no Tenkō
Specialities: Arch-villains (*jitsu aku*); evil enemies
(*kataki yaku*).
Entry No. 80
Cat. Nos. 168, 169, 315, 337, 375

中村比藏
Nakamura Konozō
ca. 1768–ca. 1799/3

Birth date: Unknown
Death date: Unknown
Speciality: Evil enemies (*kataki yaku*).
Comments: After 1799/3 his name disappears from theater
programs (*ehon banzuke*).
Cat. No. 159

中村傳九郎 (二代目)
Nakamura Denkurō II
1745/11–1775/8

Birth date: 1719 (or 1723)
Death date: 1777/11/15
Son of: Second son of Nakamura Kanzaburō VI
Earlier stage name: Nakamura Katsujūrō, from 1728/1
Later stage name: Nakamura Kanzaburō VIII, from 1775/9
House names: Naritaya; Kashiwaya
Literary names: Bukaku; Kanshi
First stage appearance: 1733/11
Specialities: Male leads (*tachi yaku*); featured in *jitsugoto*,
aragoto, and in *shosagoto* dance.
Comments: He was also a gifted playwright, Tea practitioner,
and *haikai* poet. From 1775/9 he succeeded his elder
brother, Kanzaburō VII, as manager of the Nakamura
Theater, Edo.
Cat. Nos. 154, 173

中村粂太郎 (二代目)
Nakamura Kumetarō II
1784/11–ca. 1806/9

Birth date: 1763
Death date: 1808/7/9
Student of: Arashi Sangorō II
Earlier stage name: Arashi Fusajirō
House name: Daikokuya
Literary name: Richō
Specialities: Young female roles (*waka onnagata*); especially
skillful as wife of a *karō* (principal retainer of daimyo).
Comments: When he succeeded to the name Kumetarō II, he
also became the manager of the Shioya Kuroemon Theater
in Osaka.
Cat. No. 649

中村十藏 (二代目)
Nakamura Jūzō II
1759/11–1788/6

Birth date: 1740, Kyoto
Death date: 1788/6/12 or 13, Osaka
Son of: Ogurayama Hyakusuke, a choreographer
Adopted by: Nakamura Jūzō I (1759/11)
Student of: Nakamura Jūzō I
Earlier stage name: Ogurayama Sentarō (ca. 1748–1759/10)
House name: Hiranoya
Literary name: Koyū
Nickname: Taishō
Specialities: Young male roles (*wakashu*); male leads (*tachi
yaku*), from 1753/11; skilled at choreography.
Comments: Personally charming and a brilliant actor.
Cat. Nos. 179, 196, 209, 271, 274, 295

中村松江 (初代)
Nakamura Matsue I
1761/11–1773/7

Birth date: 1742, Osaka
Death date: 1786/10/11
Student of: Nakamura Utaemon I
Earlier stage name: Nakamura Matsuemon
Later stage name: Nakamura Rikō I (1773/11–1786/8, Ichimura
Theater, Edo)
House name: Sakaiya
Literary names: Rikō; Rikō (using different character for -*kō*)
Speciality: Female roles (*onnagata*).
Comments: Initially an Osaka actor; came to Morita Theater,
Edo, in 1761/11.
Cat. Nos. 36, 171, 197. Under Nakamura Rikō I: 268, 460,
512, 519, 562, 595, 722, 729

中村柏木
Nakamura Kashiwagi
1771/11–1773/5, in Edo

Birth date: Unknown
Death date: Unknown
Speciality: Young male roles (*wakashu*).

中村仲蔵 (初代)

Nakamura Nakazō I

1745/11–1785/10 and 1786/11–1790/4

Birth date: 1736
Death date: 1790/4/23
Student of: Nakayama Katsujūrō (later Nakamura Denkurō II), from 1743
Childhood name: Nakamura Manzō
Earlier stage name: Nakamura Ichijūrō (1743–1745/10)
Other stage names: Nakayama Kojūrō VI (1785/11–1786/10); Shigayama Mansaku VIII (in *shosagoto* dance)
House names: Sakaeya; Sakaiya
Literary name: Shūkaku
Speciality: Arch-villains (*jitsu aku*), from 1765.
Comments: During the period 1745/11–1761/10 Nakazō used a different *naka* character in his name. He was brought up by the *nagauta* master Nakayama Kojūrō V and his wife Oshun (a famous Shigayama school dancing teacher). His interpretation of the role of the vicious Sadakurō in *Kanadehon Chūshingura*, which he first performed in Edo in 1766, made him a star of villainous roles.
Entry Nos. 8, 26, 34, 44, 66, 70, 71, 73, 85, 86, 88, 91, 103, 104, 111, 122
Cat. Nos. 84, 94, 100, 134, 137, 138, 148, 154, 155, 155a, 158, 167, 167a, 172, 262, 269, 299, 300, 303, 307, 309, 312, 320, 326, 335, 349–51, 365, 378, 380, 383, 387, 395, 400, 405, 406, 408, 412, 418, 439, 440, 446, 447, 450, 451, 480, 481, 493, 512, 514, 515, 517, 533, 547, 549, 559, 561, 563, 570, 576, 589, 592, 594, 600, 617, 711, 713, 727, 737. Under Nakayama Kojūrō VI: 522, 523, 526, 527, 602, 628

中村野塩 (初代)

Nakamura Noshio I

1768/11–1777/11

Birth date: 1752, Kyoto
Death date: 1777/11/19
Son of: Kasaya Matakurō I
Student of: Nakamura Tomijūrō I, from 1768/winter
Earlier stage name: Kamogawa Noshio II (until 1768/10)
House name: Tennōjiya
Literary name: Shūka
Specialities: Young female roles (*waka onnagata*); *shosagoto* dance.
Comments: The younger brother of Kasaya Matakurō II, he married the daughter of his teacher, Nakamura Tomijūrō I. In 1770, with his wife and father-in-law, he left Kyoto for Edo, where he became popular in young female roles.
Entry Nos. 18, 60, 61, 82
Cat. Nos. 53, 178, 192, 198, 205, 220, 270, 272, 279, 298, 314

中村野塩 (二代目)

Nakamura Noshio II

1779/11–1800/3

Birth date: 1759

Death date: 1800/3/20
Adopted by: Nakamura Tomijūrō I
Student of: Ikushima Jūshirō; Nakamura Tomijūrō I
Earlier stage name: Ikushima Kinzō
House name: Tennōjiya
Literary name: Rankō
Speciality: Young girls (*musumegata*), from 1773; honored as best actor of female roles (*onnagata*) in Edo in 1798.
Entry No. 132
Cat. No. 689

中村里好 (初代)

Nakamura Rikō I. (See Nakamura Matsue I)

Cat. Nos. 268, 460, 512, 519, 562, 595, 722, 729

中村七三郎 (三代目)

Nakamura Shichisaburō III

1770/11–1778/8

Birth date: 1765
Death date: 1785/7/29
Son of: Grandson of Nakamura Shichisaburō II (Nakamura Shōchō I)
Adopted by: Nakamura Kanzaburō VIII (1777)
Earlier stage name: Nakamura Shichinosuke (1769–1770)
Later stage name: Nakamura Kanzaburō IX (1778/9–1785/7)
House name: Nakamuraya
Literary names: Shōchō; Jakudō
First stage appearance: 1769
Cat. No. 152

中村少長 (初代)

Nakamura Shōchō I

1770/11–1774/7

Birth date: 1703
Death date: 1774/9/3
Son of: Akashi Seizaburō
Adopted by: Nakamura Shichigorō I
Childhood name: Nakamura Seikichi
Earlier stage name: Nakamura Shichisaburō II (1710/11–1770/10)
House name: Nakamuraya
Literary name: Shōchō
First stage appearance: 1711/1
Speciality: Wagoto.
Cat. No. 168

Nakamura Sukegorō II
1763/11–1803/10

Birth date: 1745
Death date: 1806/10/29
Son of: Nakamura Sukegorō I
Earlier stage name: Sengoku Sukeji
Later stage name: Nakamura Gyoraku, from 1803/11
House name: Sengokuya
Literary name: Gyoraku
First stage appearance: 1761/11, at Morita Theater, Edo
Speciality: Evil enemies (*kataki yaku*).
Comments: Especially popular in the 1760s–1770s, when his fame rivalled that of his frequent co-star Ōtani Hiroji III.
Entry Nos. 26, 27, 31, 38, 90, 135
Cat. Nos. 125, 162, 163, 180, 420–22, 433, 435, 436, 572, 712

Nakamura Tomijūrō I
1729/1–1786/8

Birth date: 1719, Osaka
Death date: 1786/8/3, Osaka
Son of: Third son of Yoshizawa Ayame I
Adopted by: Nakamura Shingorō I
House name: Tennōjiya
Literary names: Keishi; Enkyo Keishi; Kinreisha
First stage appearance in Edo: 1731/1, at Ichimura Theater
Speciality: Female roles (*onnagata*).
Comments: Created new styles of choreography for the dance scenes "Shakkyō" (Stone Bridge) and "Musume Dōjō-ji" (Maiden at Dōjō Temple).
Entry Nos. 56D, 81, 83, 85, 86, 108
Cat. Nos. 43, 136, 181, 189, 305, 341, 361, 367–69, 382, 384–86, 548, 560, 714

Nakamura Utaemon I
1741–1782/10

Birth date: 1714, Kanazawa, Kaga Province
Death date: 1791/10/29
Son of: Second son of Ōzeki Shun'an, physician in Kanazawa, Kaga Province
Student of: Nakamura Genzaemon II
Earlier stage name: Nakamura Utanosuke
Later stage name: Kagaya Kashichi, 1782/11, Osaka
House name: Kagaya
Literary names: Issen; Kashichi
Specialities: Evil enemies (*kataki yaku*); arch-villains (*jitsu aku*).
Retired: 1789
Entry No. 39
Cat. Nos. 16, 95, 97, 102

Nakayama Kojūrō VI. (See Nakamura Nakazō I)

Cat. Nos. 522, 523, 526, 527, 602, 628

Nakayama Tatezō II
ca. 1782–1821/10

Birth date: Unknown, Osaka
Death date: Unknown, Edo
Student of: Ichikawa Danjūrō VII, from 1821/11
Earlier stage names: Nakayama Kinzō; Sakakiyama Kinzō; Sakakiyama Shirosaburō
Later stage names: Ichikawa Raizō III (1821/11–1824/10); Ichikawa Omezō II (1824/11–ca. 1853)
Specialities: Male leads (*tachi yaku*); female roles (*onnagata*).
Cat. No. 542

Nakayama Tomisaburō I
ca. 1775–1819/9

Birth date: 1760
Death date: 1819/9/10
Son of: Ichikawa Ikuzō
Student of: Nakayama Bunshichi; Matsumoto Kōshirō IV
House name: Ōmiya
Literary name: Kinsha
Specialities: Began career ca. 1775 playing young male roles (*wakashu*); switched to young female roles (*waka onnagata*) from his arrival in Edo in 1780. Skilled at courtesan and housewife roles.
Comments: His great personal charm and acting skill made him extremely convincing in female roles; nicknamed Gunya Tomi (Coy Tomisaburō).
Cat. Nos. 470, 531, 542, 666, 684

Onoe Kikugorō I
1730/11–1783/12

Birth date: 1717, Kyoto
Death date: 1783/12/19
Son of: Otowaya Hampei (usher at Mandayū Theater, Kyoto)
Student of: Onoe Samon
Childhood name: Onoe Taketarō
House name: Otowaya
Literary name: Baikō
Specialities: Young male roles (*wakashu*); male leads (*tachi yaku*); skilled at martial roles (*budō*) and *jitsugoto*.
Cat. Nos. 111, 162, 444

尾上松助 (初代)

Onoe Matsusuke I
1755/11–1809/10

Birth date: 1744, Osaka
Death date: 1815/10/16
Son of: Tokujirō (a costumer of a small theater in Gion, Osaka)
Student of: Onoe Kikugorō I, from 1755
Childhood name: Onoe Tokuzō
Later stage name: Onoe Shōroku I, from 1809/11
House names: Shin-otowaya; Otowaya
Literary names: Jūsen; Sanchō; Shōroku
First stage appearance: 1755/11
Specialities: Female roles (*onnagata*), 1763–1770; male leads (*tachi yaku*), from 1770/11; later, arch-villains (*jitsu aku*). Famous for his ghost impersonations.
Entry Nos. 93, 113, 117, 120
Cat. Nos. 48, 174, 253, 259, 407, 430, 448, 452, 486, 498, 499, 581, 590, 611, 661, 732

尾上民藏 (初代)

Onoe Tamizō I
1769/11–ca. 1790

Birth date: 1754, Kyoto
Death date: ca. 1790?
Student of: Hanazome Minanojō; Onoe Kikugorō I
Earlier stage names: Hanazome Tamizō; Onoe Kenzō (1768–1769/10)
House names: Aizuya; Otowaya
Literary name: Kōchō
Speciality: Female roles (*onnagata*).
Comments: From 1779/8, he wrote his name, Tamizō, using different characters.
Cat. Nos. 20, 190, 260, 304, 401

小佐川常世 (二代目)

Osagawa Tsuneyo II
1768/11–1808/8

Birth date: 1753
Death date: 1808/8/16
Student of: Osagawa Tsuneyo I
Earlier stage name: Osagawa Shichizō
House names: Yoneya; Wataya
Literary name: Kosen
Speciality: Young female roles (*waka onnagata*).
Comments: One of the three best *waka onnagata* actors, together with Iwai Hanshirō IV and Segawa Kikunojō III.
Entry No. 116
Cat. Nos. 398, 401, 413, 441, 456, 627, 683

大谷廣右衛門 (三代目)

Ōtani Hiroemon III
1762/11–1790/9

Birth date: 1726
Death date: 1790/9/14
Student of: Ōtani Hiroji II
Earlier stage name: Ōtani Kunizō
House name: Surugaya
Literary names: Toshū; Bampū; Bampū (using a different character for *Bam*-); Gyōfū
Speciality: Arch-villains (*jitsu aku*).
Comments: Acclaimed as the best actor of villains in his day.
Entry Nos. 23, 56A, 65, 72, 107
Cat. Nos. 64, 195

大谷廣次 (三代目)

Ōtani Hiroji III
1762/11–1798/7

Birth date: 1746
Death date: 1802/5/11
Student of: Ōtani Hiroji II
Earlier stage names: Yoneyama Tokugorō (or Tokusaburō); Ōtani Haruji (1755–1758/10); Ōtani Oniji II (1758/11–1762/10)
House name: Maruya
Literary names: Tōshū; Jutchō
First stage appearance: 1755/11, Ichimura Theater, Edo
Specialities: Jitsugoto; chivalrous commoners (*otokodate*).
Comments: Extremely popular with female spectators.
Entry Nos. 41, 70, 72, 81, 135
Cat. Nos. 46, 65, 77, 88, 110, 124, 126, 144, 162, 163, 175, 319, 341, 417, 457, 459, 465, 513, 516, 521, 535, 546

大谷鬼次 (三代目)

Ōtani Oniji III
1787/11–1794/10

Birth date: 1759
Death date: 1796/11/7
Student of: Ōtani Hiroji III
Earlier stage names: Ōtani Eisuke; Ōtani Haruji, from 1778/11
Later stage name: Nakamura Nakazō II (1794/11–1796/11)
House name: Masatsuya
Literary name: Tōshū
First stage appearance: 1770/1
Speciality: Arch-villains (*jitsu aku*).
Cat. No. 631

Ōtani Taniji
1770–ca. 1775

Birth date: Unknown
Death date: Unknown
Student of: Ōtani Hiroji III
Speciality: Child roles (*ko yaku*).
Cat. No. 48

Ōtani Tokuji I
1770/spring–1807/7

Birth date: 1756
Death date: 1807/7/17
Son of: Takemoto Handayū, a *jōruri* chanter
Student of: Ōtani Hiroji III
House names: Tamuraya; Maruya
Literary names: Tochō; Bajū
First stage appearance: 1770/spring, Ichimura Theater, Edo
Speciality: Buffoons (*dōke yaku*).
Comments: He and Arashi Otohachi I were the two best *dōke yaku* actors in Edo. From 1783 he owned a *sembei* (rice cracker) shop known as Sugatami Sembei ("actor portraits in the mirror shape," i.e., round like rice crackers) in Setomono Street, Edo.
Cat. No. 465

Ōtani Tomoemon I
1766/11–1781/8

Birth date: 1744, Osaka
Death date: 1781/8/16, Edo
Student of: Ōtani Hirohachi
Earlier stage names: Takeda Tomosaburō (1761); Ōtani Tomosaburō, from ca. 1763
House names: Yamashinaya; Ōsakaya
Literary names: Shiyū; Shiyū (using different character for -*yū*)
Speciality: Evil enemies (*kataki yaku*).
Cat. Nos. 161, 199, 325, 371, 469

Sakata Hangorō II
1749/11–1782/5

Birth date: 1724
Death date: 1782/5/17
Son of: Sengoku Hikojūrō
Earlier stage names: Sengoku Saroku; Sengoku Sajūrō, from 1742
House name: Shōgatsuya

Literary name: Sankyō
Speciality: Top-ranked actor of arch-villains (*jitsu aku*).
Comments: His father, Sengoku Hikojūrō, was a pupil of Sengoku Hikosuke, who specialized in buffoon roles (*dōke yaku*).
Entry No. 90
Cat. Nos. 302, 554, 588

Sakata Hangorō III
1783/11–1795/3

Birth date: 1756
Death date: 1795/6/6
Student of: Ichimura Uzaemon IX
Earlier stage names: Bandō Kumajirō; Bandō Kumajūrō (1771–1783/10)
House name: Shōgatsuya
Literary names: While using the stage name Bandō Kumajūrō, he also used the literary name Kikyoku; Sankyō
Speciality: Arch-villains (*jitsu aku*).
Entry Nos. 119, 126
Cat. Nos. 624, 740

Sakata Sajūrō I
ca. 1760–1770/5

Birth date: Unknown
Death date: 1770/5/3
Brother of: Sakata Hangorō II
House name: Shōgatsuya
Literary name: Santei
Speciality: Arch-villains (*jitsu aku*).
Comments: Listed in *Meiwa Gikan*, 1769 (pp. 17–18). Lived in Kobiki Street, Edo. Began his career in the early years of the Hōreki era (1751–1764), together with his brother.
Entry No. 4
Cat. No. 77

Sakata Tōjūrō III
1740–1774/8

Birth date: 1701
Death date: 1774/8/24, Sendai
Student of: Sanjō Kantarō II; Sakata Heishirō
Earlier stage names: Sanjō Hanya; Sakata Jōshirō
House name: Hiiragiya
Literary names: Sharen; Sharen (using different characters)
Specialities: Wagoto; *jitsugoto*; arch-villains (*jitsu aku*).
Cat. No. 14

佐野川市松 (二代目)

Sanogawa Ichimatsu II
1767/11–1781/10

Birth date: 1747
Death date: 1785/8/26
Student of: Ichimura Uzaemon VIII
Earlier stage name: Bandō Aizō (1757–1767/10)
Later stage names: Matsumoto Sanjūrō, from 1781/11; Bandō Aizō, from 1784/11
House name: Shin-yorozuya
Literary names: Tōka; Seifu
Specialities: Young female roles (*waka onnagata*); young male roles (*wakashu*); young villains (*iro aku*); *jitsugoto*.
Entry No. 69
Cat. Nos. 161, 280

佐野川市松 (三代目)

Sanogawa Ichimatsu III
1784/11–1798/10

Birth date: 1759
Death date: 1813/11/13
Student of: Nakamura Kumetarō I; Ichikawa Danzō IV, from 1798
Earlier stage name: Nakamura Kumejirō, from 1764/11
Later stage name: Ichikawa Aragorō I, from 1798/11
House names: Yoshiya; Miyoshiya
Literary names: Seifu; Ichi-maru
Specialities: Young male roles (*wakashu*); young female roles (*waka onnagata*).
Cat. No. 686

澤村喜十郎 (初代)

Sawamura Kijūrō I
1740/winter–1772/10

Birth date: Unknown
Death date: Unknown
Student of: Sawamura Sōjūrō I, from 1739
Earlier stage names: Okada Kamejirō; Okada Kamejūrō, from 1738; Someyama Kijūrō, from 1739
Later stage names: Sawamura Chōjūrō IV, from 1772/11; Sawamura Kame'emon, from 1787/11
House name: Izutsuya
Literary name: Kichō
First stage appearance: 1737/11, at Nakamura Theater, Edo
Specialities: Evil enemies (*kataki yaku*); arch-villains (*jitsu aku*).
Comments: Nothing is known about him after 1787/11.
Entry. No. 56C

澤村宗十郎 (二代目)

Sawamura Sōjūrō II
1749/11–1770/1

Birth date: 1713
Death date: 1770/8/30, Kyoto
Adopted by: Sawamura Sōjūrō I (1749)
Student of: Tomizawa Montarō I
Earlier stage names: Tomizawa Chōnosuke; Takenaka Utagawa, from 1733/11; Takinaka Utagawa, from 1737; Utagawa Shirogorō, from 1742/11
House name: Kinokuniya
Literary names: Kion; Shozan; Tosshi
Specialities: Female roles (*onnagata*), from 1732/11; male leads (*tachi yaku*), from 1747; arch-villains (*jitsu aku*), from 1756.
Comments: In 1763 ranked as the most talented *jitsu aku* actor.
Entry Nos. 5, 29, 36
Cat. Nos. 15, 68, 99

澤村宗十郎 (三代目)

Sawamura Sōjūrō III
1771/11–1801/1

Birth date: 1753
Death date: 1801/3/29
Son of: Second son of Sawamura Sōjūrō II
Student of: Arashi Sangorō II, from 1770
Earlier stage name: Sawamura Tanosuke, from 1759/11
House name: Kinokuniya
Literary names: Shabaku; Shozan; Tosshi
First stage appearance: 1759/11, Nakamura Theater, Edo
Specialities: Male leads (*tachi yaku*); *wagoto*.
Comments: Younger brother of the actor Suketakaya Takasuke II. In 1790/11 became a manager at Ichimura Theater, Edo. One of the most important male leads of his time in Edo.
Entry Nos. 94, 104, 108
Cat. Nos. 411, 453, 466, 475, 586, 613, 622, 623, 674, 675, 705, 724

澤村玉柏

Sawamura Tamagashiwa
active 1790/11–1792/2

Speciality: Young female roles (*waka onnagata*).
Cat. Nos. 654, 655

瀬川菊之丞 (二代目)

Segawa Kikunojō II
1756/11–1772/2

Birth date: 1741, Ōji, Musashi Province
Death date: 1773/3/13, Edo
Son of: Natural son of Segawa Kikunojō I

Adopted by: Segawa Kikunojō I
Childhood names: Tokuji; Gonjirō
Earlier stage name: Segawa Kitsuji II, from 1750/9
House name: Hamamuraya
Literary name: Rokō
Specialities: Female roles (*onnagata*), from 1758.
Comments: Must have been extremely popular, since several contemporary fashions were named after him, e.g., *Rokō cha* (Rokō's favorite tea), *Rokō musubi* (sash tied in Rokō's style). Commonly called Ōji Rokō, after his birthplace in Ōji, Musashi Province.
Entry Nos. 3, 16, 32, 49
Cat. Nos. 11–13, 41, 49, 54, 163–65, 191

瀬川菊之丞 (三代目)

Segawa Kikunojō III
1774/11–1801/7

Birth date: 1751
Death date: 1810/12/4
Son of: Second son of Ichiyama Shichijūrō, a choreographer in Osaka
Adopted by: The family of the late Segawa Kikunojō II (d. 1773)
Childhood name: Ichiyama Shichinosuke
Earlier stage names: Ichiyama Tomisaburō, from 1765, Osaka; Segawa Tomisaburō I (1773/10–1774/10)
Later stage names: Segawa Rokō, from 1801/8; Segawa Senjo (1807/11–1810/9)
House names: Fujiya; Hamamuraya
Literary names: Gyokusen; Rokō; Senjo; Tōrien
Nickname: Senjo-rokō
Speciality: Ranked the best actor of female roles (*onnagata*) in Edo in 1782.
Entry Nos. 74, 85, 86, 94, 96, 97, 116, 136
Cat. Nos. 296 (?), 301, 310, 311, 313, 317, 321, 333, 379, 391, 402, 404, 416, 438, 454, 469, 476, 477, 482, 489, 496, 497, 508 (?), 510, 555, 567, 573, 575, 596, 603, 604, 608, 616, 630, 638, 639, 650–52, 671, 678, 705, 706, 717, 718, 730, 737. Under Segawa Tomisaburō I: 285, 294

瀬川吉次 (三代目)

Segawa Kitsuji III
1770/11–1785/10

Birth date: Unknown

Death date: 1822/6
Son of: Hamaseya Kin'emon, owner of a teahouse in Sakai Street, Edo
Student of: Segawa Kikunojō II; Ichikawa Danjūrō V, from 1785/11
Later stage names: Ichikawa Hamazō, from 1785/11; Ichikawa Hamazō (using different character for *Hama-*)
House name: Hamaseya
Literary names: Hamase; Rogiku; Juto
First stage appearance: 1764/11, at Nakamura Theater, Edo
Specialities: Child roles (*ko yaku*); young male roles (*wakashu*); male leads (*tachi yaku*).

Comments: According to *Kabuki Nempyō*, his last appearance was in 1802/5.
Cat. Nos. 265, 267

瀬川富三郎 (初代)

Segawa Tomisaburō I. (See Segawa Kikunojō III)

Cat. Nos. 285, 294

瀬川富三郎 (二代目)

Segawa Tomisaburō II
1784/8–1804/2

Birth date: Unknown
Death date: 1804/3/11
Student of: Segawa Kikunojō III
Earlier stage name: Yamashita Matsunojō
House name: Hamamuraya
Literary name: Rochō
Specialities: Young female roles (*waka onnagata*), from 1780; also young male roles (*wakashu*).
Cat. Nos. 618, 682

瀬川雄次郎 (初代)

Segawa Yūjirō I. (See Ichikawa Yaozō III)

Entry No. 67
Cat. Nos. 277, 296 (?), 322, 329

富澤半三郎 (二代目)

Tomizawa Hanzaburō II
1768/11–ca. 1777

Birth date: Unknown
Death date: Ca. 1777
Student of: Nakamura Denkurō II
Earlier stage names: Nakamura Dengo; Miyagawa Hachirozaemon II, from 1757/2
Literary name: Nakaba
Speciality: Evil enemies (*kataki yaku*).
Cat. No. 179

山下金作 (二代目)

Yamashita Kinsaku II
1749/11–1799/8

Birth date: 1733, Osaka or Hyōgo, Settsu Province
Death date: 1799/9/12, Osaka
Adopted by: Yamashita Kinsaku I (1749)
Student of: Nakamura Tomijūrō I
Earlier stage name: Nakamura Handayū, from 1745

House name: Tennōjiya

Literary name: Rikō

First stage appearance: 1747, Nakamura Kumetarō Theater, Kyoto

Specialities: "Pretty boy" roles (*iro ko*), from 1747; young female roles (*waka onnagata*), from 1749/11.

Comments: In 1779 ranked the best actor of female roles in Edo. His last performance took place at the Yamashita Theater, Kyoto, in 1799/8. Also a skilled *haikai* poet.

Entry No. 56B

Cat. Nos. 37, 40, 56, 107, 140, 155, 155a, 178, 193, 208, 258, 275, 308, 355, 415, 431, 432, 442, 443, 571, 687, 690

山下京之助 (初代)
Yamashita Kyōnosuke I
1758–1770/10

Birth date: Unknown

Death date: Unknown

Student of: Yamashita Shirogorō

Later stage name: Yamashita Kamenojō IV (1777/11–1788/8)

Literary name: Tōko

Specialities: "Pretty boy" roles (*iro ko*); young male roles (*wakashu*); later, female roles (*onnagata*).

Comments: In 1766–1767, together with Ichimura Sukegorō, he co-managed the Yamashita Theater, Kyoto. He came from Kyoto to Edo about 1767/10 and performed at Morita Theater 1767/11. Remained at Morita Theater at least till 1788/8, when his name disappears from Kabuki records.

Cat. No. 29

山下萬菊 (初代)
Yamashita Mangiku I
1779/11–1791/4

Birth date: 1763 or 1766, Osaka

Death date: 1791/5/13, Edo

Son of: Yamashita Kinsaku II

Earlier stage name: Yamashita Kintarō

House name: Tennōjiya

Literary name: Rishū

First stage appearance: 1770/11

Speciality: Young female roles (*waka onnagata*), from 1776/11.

Comments: Came to Edo with his father in 1769. His good looks contributed to his great popularity. He became ill on stage at Kawarazaki Theater in 1791/4.

Cat. Nos. 487, 579, 735

山下八百藏 (初代)
Yamashita Yaozō I
1763/11–ca. 1807

Birth date: Unknown

Death date: 1812/3/7

Son of: Yamashita Jirozō I

Student of: Yamashita Kinsaku II, from 1763

House name: Masuya

Literary name: Kikō

First stage appearance: 1763/11, at Mimasu Daigorō Theater, Osaka

Speciality: Young female roles (*waka onnagata*), from 1764.

Comments: A remarkably handsome man. No records of stage performances after 1807.

Cat. No. 170

芳澤あやめ (四代目)
Yoshizawa Ayame IV
1778/11–1787/9

Birth date: 1737, Osaka

Death date: 1792/9/28

Adopted by: Yoshizawa Ayame II

Student of: Yamashita Matatarō I

Earlier stage names: Yamashita Koshikibu; Yamashita Ichigorō; Yoshizawa Goroichi; Yoshizawa Manyo II; Yoshizawa Sakinosuke III (1764/11–1778/10)

House name: Tachibanaya

Literary names: Kokai; Shunsui

Retired: 1784

Speciality: Female roles (*onnagata*).

Entry Nos. 39, 57, 110

Cat. No. 171 (under Yoshizawa Sakinosuke III)

芳澤いろは (初代)
Yoshizawa Iroha I
1766/11–1807/10

Birth date: 1754

Death date: 1810/8/26

Son of: Yoshizawa Ayame III

Later stage name: Yoshizawa Ayame V (1807/11–1810/1)

Literary names: Kōho; Hakō; Ippō

First stage appearance: 1766/11, Osaka

Specialities: Young female roles (*waka onnagata*), from 1771. Became a leading actor of female roles (*onnagata*). Managed a theater in Kyoto for two years beginning 1772/11, and another in Osaka for two years beginning 1779/11.

Cat. Nos. 316, 342

芳澤崎之助 (三代目)
Yoshizawa Sakinosuke III. (See Yoshizawa Ayame IV)

Entry Nos. 39, 57

Cat. Nos. 171, 346

The Print Makers:
Biographical Data

NAOMI NOBLE RICHARD

IPPITSUSAI BUNCHŌ
active ca. 1755–1790

As noted in the discussion of Bunchō's art in "The Two Poles of the Floating World," even less is known about Bunchō's life than about Shunshō's. His abilities are depreciated in *Ukiyo-e Ruikō*, but highly praised by his contemporary Kubo Shunman in the (undated) *surimono* that Shunman designed to commemorate the seventh anniversary of Bunchō's death. Bunchō collaborated on prints with Suzuki Harunobu (ca. 1724–1770) and Isoda Koryūsai (active ca. 1766–1788) as well as with Shunshō, and he was also a painter in the *ukiyo-e* style. Like many of the print designers and the actors they celebrated, Bunchō was also a *haikai* poet, whose verses survive in a number of contemporary anthologies.

KISHI BUNSHŌ
1754–1796

A designer of actor prints, he is said to have been a pupil of Ippitsusai Bunchō. He was more prominent as a *kyōka* poet than as a print artist. (See also No. 21.)

MIYAGAWA SHUNSUI
active early 1740s–early 1760s

He is said to have been a pupil of Miyagawa Chōshun (1683–1753) and teacher of Katsukawa Shunshō. Shunsui produced paintings of beautiful women and some book illustrations (e.g., *Ehon Musha Kagami*). (See also No. 22.)

KATSUKAWA SHUNSHŌ
1726–1792

The few known facts of Shunshō's life, the various probabilities possibilities, and the sources from which these have been deduce are set forth by Donald Jenkins in "The Two Poles of the Floatin World."

KATSUKAWA SHUNKŌ
1743–1812

Shunshō's most important pupil, a leader in the development of the closeup (*ōkubi*, "big head") actor portrait. His personal name was Kiyokawa Denjirō. After the stroke which paralyzed h right arm in about the third month of 1790, he apparently gave u print making but continued to paint, signing his works *Sahitsusa* (Studio of the Left Brush). In 1796 Shunkō was asked to paint Danjūrō V on the occasion of the latter's retirement from the sta in a book published that year to commemorate Danjūrō's career, Shunkō wrote that he was "delighted beyond measure to be able draw him with my left hand..." (*Mimasu Kumi-ire* [The Fitting Three Measures; i.e., Danjūrō's crest]). Debilitating illness marr Shunkō's last years, and he withdrew to the seclusion of a Buddh temple in Tokyo, possibly Zempuku-ji in Azabu (according to *Ukiyo-e Ruikō*) or Zenshō-ji in Asakusa, which houses his grave (See also Donald Jenkins, "The Two Poles of the Floating World

KATSUKAWA SHUN'EI
1762–1819

Another leading pupil of Shunshō, and an ardent devotee of the Kabuki theater. His personal name was Isoda Kyūjirō, his studio name (*gō*) Kutokusai. With rental income from property in Edo, Shun'ei could devote himself to the arts: he was a reciter of *giday* ballad-dramas, accompanying himself on the shamisen. His prin are mostly actor prints, produced from the 1780s to 1797. In the

the dramatic exaggeration of features and expression is greater than in Shunshō's work, though less pronounced than in Sharaku's. Later subjects include warriors, sumo wrestlers, and perspective (*uki-e*) landscapes. Shun'ei also did book illustrations, paintings, and witty sketches, in a light, charming style. He was a prolific artist, with a wide circle of friends and collaborators, including Kitagawa Utamaro, Katsukawa Shunchō, and Utagawa Toykuni I. Some twenty of his students are recorded. He is buried at Zenshō-ji, his family temple in the Asakusa section of Tokyo. At Chōmyō-ji, Ushijima, a memorial stone with text by Ishikawa Masamochi was erected to his memory. (See also Donald Jenkins, "The Two Poles of the Floating World.")

RANTOKUSAI SHUNDŌ
active ca. 1770–1790

Pupil of Shunshō, and before that, perhaps, Shunshō's fellow student under Miyagawa Shunsui (active early 1740s–early 1760s). Rantokusai was his studio name (*gō*). His prints tend to be more strongly colored than Shunshō's. Shundō also illustrated at least seven books. (See also No. 135.)

KATSUKAWA SHUNJŌ
active ca. 1778–1787

One of Shunshō's most remarkable students, and a close follower of his master's style and color harmonies. His personal name was Yasuda Iwazō. Seventy of his actor prints are extant, and he is known to have illustrated at least twelve *kibyōshi* ("yellow-bound" popular fiction) and four *ehon banzuke* (illustrated playbills). His work is notable for evenly balanced composition and for particularized descriptions of actors' features, gestures, and expressions as well as props. Shunjō may have been related to Shun'ei. He was buried at Shun'ei's family temple, Zenshō-ji, within the temple grounds of Hongan-ji in Asakusa.

Bibliography

Works Cited in Text and Suggestions for Further Reading

Asakawa (1956) Asakawa Gyokuto. *Nagauta Meikyoku Yōsetsu*. Tokyo: Hōgakusha, 1956.

Asano Shūgō. "Fūryū Nishiki-e Ise Monogatari." *Ukiyo-e Geijutsu* 96 (1988): 32–44.

Azabu Museum of Arts and Crafts (eds.). *Kabuki Through Theater Prints (Shibai-e ni Kabuki o Miru)*. Tokyo, 1990.

Binyon and Sexton (1923) Binyon, Laurence, and Sexton, J. J. O'Brien. *Japanese Colour Prints*. London: Ernest Benn, 1923; reprint, London: Robert G. Sawers, 1978.

Boller (1953) Boller, Willy. *Japanische Farbholzschnitte von Katsukawa Shunshō*. Bern and Stuttgart: Hallwag, 1953.

Brandon, James R.; Malm, William P.; and Shively, Donald H. *Studies in Kabuki, Its Acting, Music, and Historical Context*. Honolulu: The University of Hawaii Press, 1978.

de Bruijn, R. (1979) de Bruijn, R. "Some Considerations on Ippitsusai Bunchō." In *A Sheaf of Japanese Papers: In Tribute to Heinz Kaempfer on his 75th Birthday*, ed. Matthi Forrer, Willem R. van Gulik, and Jack Hillier, pp. 19–34. The Hague: Society for Japanese Arts and Crafts, 1979.

Clark, Timothy T. "Shunshō's 'Fūryū Nishiki-e Ise Monogatari.'" *Ukiyo-e Geijutsu*, vol. 100 (1991), pp. 72–81.

Edmunds, Will H. *Pointers and Clues to the Subjects of Chinese and Japanese Art*. London: Sampson Low, Marston & Co., 1934.

Edogaku Jiten (1984) Nishiyama Matsunosuke et al., eds. *Edogaku Jiten*. Tokyo: Kōbundō, 1984.

Ehon Butai Ōgi. 3 vols. Edo: Kariganeya Ihei, 1770.

Engeki Hyakka Daijiten. 6 vols. Tokyo: Tsubouchi Memorial Theater Museum, Waseda University, 1960.

Enyū Nikki (1977) Nishiyama Matsunosuke and Hattori Yukio, eds. *Nihon Shōmin Bunka Shiryō Shūsei*. Vol. 13: *Geinō Kiroku 2*. Tokyo: San'ichi Shobō, 1977.

Ernst, Earle. *The Kabuki Theatre*. Oxford: Oxford University Press, 1956; reprint, Honolulu: University of Hawaii Press, 1974.

Ficke, Arthur D. *Chats on Japanese Prints*. London: T. Fisher Unwin, 1915; reprint, London: EP Publishing, 1975.

Genshoku Ukiyo-e Daihyakka Jiten, **vol. 2** (1982) Asano Shūgō et al., eds. *Genshoku Ukiyo-e Daihyakka Jiten*. Vol. 2: *Ukiyo Eshi*. Tokyo: Taishūkan, 1982.

Genshoku Ukiyo-e Daihyakka Jiten, **vol. 7** (1980) Yamaguchi Keisaburō and Asano Shūgō, eds. *Genshoku Ukiyo-e Daihyakka Jiten*. Vol. 7: *Sakuhin 2, Kiyonaga–Utamaro*. Tokyo: Taishūkan, 1980.

Genshoku Ukiyo-e Daihyakka Jiten, **vol. 8** (1981) Yamaguchi Keisaburō, ed. *Genshoku Ukiyo-e Daihyakka Jiten*. Vol. 8: *Sakuhin 3, Sharaku–Hokusai*. Tokyo: Taishūkan, 1981.

Genshoku Ukiyo-e Daihyakka Jiten, **vol. 11** (1982) Narazaki Muneshige, gen. ed., with Kikuchi Akira and Hanasaki Kazuo. *Genshoku Ukiyo-e Daihyakka Jiten*. Vol. 11: *Kabuki, Yūri, Sakuin*. Tokyo: Taishūkan, 1982.

Gookin (1931) Gookin, Frederick W. "A Master Artist of Old Japan, Katsukawa Shunshō: A Review of His Life and Works." Chicago, 1931. Mimeographed. Copy available at The Art Institute of Chicago.

Halford (1956) Halford, Aubrey S. and Giovanna M. *The Kabuki Handbook*. Rutland, Vt. and Tokyo: Charles E. Tuttle, 1956.

Hamada (1985) Hamada Giichirō et al., eds. *Ōta Nampo Zenshū*. Vol. 2. Tokyo: Iwanami Shoten, 1985.

Hayashi (1902) *Dessins, Estampes, Livres Illustrés du Japon réunis par T. Hayashi*. Paris: Hôtel Drouot, 1902. Sale catalogue.

Hayashi (1963) Hayashi Yoshikazu. *Shunshō*. Embon Kenkyū. Tokyo: Arimitsu Shobō, 1963.

Hayashi (1981) Hayashi Kyōhei, ed. "Ippitsusai Bunchō Hanga Sakuhin Mokuroku." In *Ukiyo-e Shūka*, vol. 14, ed. Rose Hempel et al., pp. 203–28. Tokyo: Shōgakkan, 1981.

Henderson, Harold G., and Ledoux, Louis V. *The Surviving Works of Sharaku*. New York: E. Weyhe, 1939.

Hillier, Jack. *Suzuki Harunobu: A Selection of His Color Prints and Illustrated Books*. Philadelphia: David Godine in association with the Philadelphia Museum of Art, 1970.

Hillier (Vever) (1976) Hillier, Jack. *Japanese Prints and Drawings from the Vever Collection*. 3 vols. London: Sotheby's, 1976.

Hillier (1988) Hillier, Jack. *The Art of the Japanese Book*. 2 vols. London: Sotheby's, 1988.

Hirano, Chie. *Kiyonaga: A Study of His Life and Works*. Cambridge, Mass.: Harvard University Press, 1939.

Hizō Ukiyo-e Taikan, **vol. 2** (1987) Asano Shūgō, ed. *Hizō Ukiyo-e Taikan*. Vol. 2: *Daiei Hakubutsukan II*. Tokyo: Kōdansha, 1987.

Hizō Ukiyo-e Taikan, **vol. 9** (1989) Kobayashi Tadashi, ed. *Hizō Ukiyo-e Taikan*. Vol. 9: *Berugii Ōritsu Bijutsukan*. Tokyo: Kōdansha, 1989.

Ihara (1913) Ihara Toshirō. *Kinsei Nihon Engeki Shi*. Tokyo: Waseda Daigaku Shuppanbu, 1913.

Isobe Shizuo. *Edo Okabasho Zue*. Tokyo: Edo Chōmei Rizoku Kenkyūkai, 1962.

Iwasaki Haruko. "The World of *Gesaku*: Playful Writers of Late Eighteenth-Century Japan." Ph.D. diss., Harvard University, 1984.

Joly, Henri L. *Legend in Japanese Art*. London and New York: John Lane, 1908; reprint, Rutland, Vt.: Charles E. Tuttle, 1967.

Kabuki Jimmei Jiten (1988) Nojima Jūsaburō, ed. *Kabuki Jimmei Jiten*. Tokyo: Nichigai Associates, 1988.

Kabuki Jiten (1983) Hattori Yukio et al., eds. *Kabuki Jiten*. Tokyo: Heibonsha, 1983.

Kabuki Nempyō, **vol. 3** (1958) Ihara Toshirō. *Kabuki Nempyō*. Vol. 3: *1748–1765*. Tokyo: Iwanami Shoten, 1958.

Kabuki Nempyō, **vol. 4** (1959) Ihara Toshirō. *Kabuki Nempyō*. Vol. 4: *1766–1784*. Tokyo: Iwanami Shoten, 1959.

Kabuki Nempyō, **vol. 5** (1960) Ihara Toshirō. *Kabuki Nempyō*. Vol. 5: *1785–1815*. Tokyo: Iwanami Shoten, 1960.

Kabuki Nendaiki (1926) Yoshida Teruji, ed. *Kabuki Nendaiki*. Tokyo: Hōbunkan, 1926.

Kabuki Saiken (1926) Iizuka Tomoichirō. *Kabuki Saiken*. Tokyo: Daiichi Shobō, 1926.

Kabuki Zusetsu (1934) Shuzui Kenji and Akiba Yoshimi, eds. *Kabuki Zusetsu*. Tokyo: Chūbunkan Shoten, 1934.

Kanō Shiun (Taizaburō), ed. *Tōyō Gadai Sōran*. Tokyo: Rekishi Toshosha, 1975.

Kenji, Toda. *Descriptive Catalogue of Japanese and Chinese Illustrated Books*. Chicago: The Art Institute of Chicago, 1931.

Keyes, Roger S. *The Art of Surimono*. 2 vols. London: Sotheby's, 1985.

Keyes, Roger S.; Kozyreff, Chantal; Forrer, Matthi; et al. *Berugii-Ōritsu Bijutsu Rekishi Hakubutsukan, Amusuterudamu Kokuritsu Bijutsukan, sonota*. Ukiyo-e Shūka, no. 13. Tokyo: Shōgakkan, 1981.

Kitagawa, Hiroshi, and Tsuchida, Bruce T., trans. *The Tale of the Heike*. Tokyo: University of Tokyo Press, 1975.

Kobayashi Tadashi. *Edo no Gakatachi*. Tokyo: Perikansha, 1987.

Kobori Sakae. "Butai Ōgi no Chimpin." *Ukiyo-e Kai* (August 1939): 34–35.

Koike (1979) Koike Shōtarō. *Kōshō Edo Kabuki*. Tokyo: Miki Shobō, 1979.

Kokuritsu Gekijō Geinō Chōsashitsu, ed. *Kabuki Haiyū Meiseki Benran*. Tokyo: Kokuritsu Gekijō Geinō Chōsashitsu, 1968.

Kondō Eiko, under the supervision of Suzuki Jūzō. *Masterpieces of Ukiyo-e Prints from the Schindler Collection*. Tokyo: The Japan Ukiyo-e Society and Nihon Keizai Shimbun, 1985.

Kühne, H. R. W. "The Tsubo-seals of the Katsukawa Masters." In *The Fascinating World of the Japanese Artist*, ed. H. M. Kaempfer and Jhr. W. O. G. Sickinghe, pp. 76–82. Los Angeles: Dawson's Bookshop, 1971.

Kurokawa Mamichi, ed. *Nihon Fūzoku Zue*. Vol. 11. Tokyo: Kashiwa Shobō, 1983.

Lane (1978) Lane, Richard. *Images from the Floating World*. Oxford: Oxford University Press; New York: Putnam; Secaucus, N. J.: Chartwell Books, 1978.

Ledoux 2 (1945) Ledoux, Louis V. *Japanese Prints by Harunobu and Shunshō*. New York: E. Weyhe, 1945.

Ledoux 3 (1948) Ledoux, Louis V. *Japanese Prints: Bunchō to Utamaro*. New York: E. Wehye, 1948.

Leiter, Samuel L. *Kabuki Encyclopedia: An English Language Adaptation of* Kabuki Jiten. Westport, Conn. and London: Greenwood Press, 1979.

Malm, William P. *Japanese Music and Musical Instruments*. Rutland, Vt. and Tokyo: Charles E. Tuttle Company, 1959.

McCullough, Helen C., trans. *Kokin Wakashū*. Stanford, Cal.: Stanford University Press, 1985.

McCullough (1968) McCullough, Helen C., trans. *Tales of Ise*. Stanford, Cal.: Stanford University Press, 1968.

Michener (1954) Michener, James A. *The Floating World: The Story of Japanese Prints*. New York: Random House, 1954.

Michener, James A. *Japanese Prints: From Early Masters to the Modern*. Rutland, Vt. and Tokyo: Charles E. Tuttle, 1959.

Murasaki Shikibu. *The Tale of Genji*. Trans. Edward G. Seidensticker. New York: Alfred A. Knopf, 1981.

Naitō Masato. "Katsukawa Shunshō no Nikuhitsu Bijinga ni tsuite." *Bijutsushi* 125 (March 1989): 57–81.

Nakada Katsunosuke, ed. *Ukiyo-e Ruikō*. Iwanami Bunko, vols. 2785–2786. Tokyo: Iwanami Shoten, 1941.

Narazaki and Mitchell (1966) Narazaki Muneshige. *The Japanese Print: Its Evolution and Essence*. Trans. and adapted by C. H. Mitchell. Tokyo, New York, and San Francisco: Kodansha International, 1966.

Narazaki (1982) Narazaki Muneshige, ed. *Shunshō*. Nikuhitsu Ukiyo-e, no. 4. Tokyo: Shūeisha, 1982.

Nihon Denki Densetsu Daijiten (1986) Inui Katsumi et al., eds. *Nihon Denki Densetsu Daijiten*. Tokyo: Kadokawa Shoten, 1986.

Nihon Hanga Bijutsu Zenshū, vols. 2, 3 (1961) Yoshida Teruji, ed. *Nihon Hanga Bijutsu Zenshū*. Vols. 2, 3. Tokyo: Kodansha, 1961.

Nihon Zuihitsu Taisei, vol. 4 (1927) Hayakawa Junzaburō, ed. *Nihon Zuihitsu Taisei*. Vol. 4. Tokyo: Yoshikawa Kōbunkan, 1927.

Nippon Sumō Shi, vol. 1 (1956) Nippon Sumō Kyōkai. *Nippon Sumō Shi*. Vol. 1. Tokyo: 1956.

Ochiai Naonari, ed. *Ukiyo-e Kabuki Gashū*. Tokyo: Tōkō Shoin, 1927.

Okamoto Masaru and Kira Sueo, eds. *Kinsei Bungaku Kenkyū Jiten*. Tokyo: Ofūsha, 1985.

Ōta Memorial Museum. *Tsutaya Jūzaburō to Temmei Kansei no Ukiyo Eshi-tachi*. Tokyo, 1985.

Ōta Museum (1983) Ōta Memorial Museum. *Katsukawa Shunshō to sono Ichimon*. (Bessatsu Kobijutsu 4). Tokyo: Sansai Shinsha, 1983.

Riccar (1973) Riccar Art Museum. *Shikago Bijutsukan Ukiyo-e Meihin Ten* (Ukiyo-e Masterpieces from The Art Institute of Chicago). Tokyo, 1973.

Riccar (1978) Riccar Art Museum. *Ippitsusai Bunchō Ten* (Exhibition of Ukiyo-e by Ippitsusai Bunchō). Tokyo, 1978.

Riccar Art Museum (eds.). *Katsukawa-ha no Yakusha-e Ten*. Intro. by Osamu Ueda. Tokyo, 1992.

Rijksmuseum Amsterdam (1977) Rijksmuseum Amsterdam. *The Age of Harunobu*. Amsterdam, 1977.

San-shibai Yakusha Ehon., illustrated by Katsukawa Shunshō, 1772; reprint, Tokyo: Kisho Fukuseikai, 1928.

Sekine (1984) Sekine Shisei, *Tōto Gekijō Enkaku Shiryō*. 2 vols. Tokyo: Kokuritsu Gekijō Geinō Chōsashitsu, 1984.

Shibai Nishiki-e Shūsei (1919) Yamamura Toyonari and Machida Hakuzō, eds. *Shibai Nishiki-e Shūsei*. Tokyo: Seikasha, 1919.

Smith (1988) Smith, Lawrence, ed. *Ukiyo-e: Images of Unknown Japan*. London: British Museum Publications, 1988.

Sōkō Nihon Ukiyo-e Ruikō (1979) Yura Tetsuji, ed. *Sōkō Nihon Ukiyo-e Ruikō*. Tokyo: Gabundō, 1979.

Stern, Harold P. *Master Prints of Japan: Ukiyo-e Hanga*. New York: Harry N. Abrams, 1969.

———. *Freer Gallery of Art Fiftieth Anniversary Exhibition: I. Ukiyo-e Painting*. Washington, D.C.: Smithsonian Institution, 1973.

Succo (1922) Succo, Friedrich. *Katsukawa Shunshō (Haruaki)*. Plauen im Vogtland: C. F. Schulz & Co., 1922.

Suwa (1985) Suwa Haruō. "Temmei Kabuki no Saihyōka." In *Edo no Geinō to Bunka*, ed. Nishikawa Matsunosuke Sensei Koki Kinenkai. Tokyo: Yoshikawa Kōbunkan, 1985.

Tachikawa Emba, with illustrations by Shōkōsai Katsukyū "Tsubo" Shuntei. *Hana Edo Kabuki Nendaiki*. Reprint (2 vols.), Tokyo: Nihon Koten Zenshū Kankōkai, 1929.

Tanaka Kikuo, ed. *Iroha-biki Monchō*. Tokyo: Kyūkyodō, 1881.

Tanaka Tatsuya. "Katsukawa Shunkō I." *Azabu Bijutsukan Dayori* 15 (December 1986).

Tankai no Mitsumaro and Komamine Yōshō. *Meiwa Gikan*. Edo: Fushimiya Seibei, 1769.

TNM, vol. 1 (1960) Tokyo National Museum. *Illustrated Catalogues of the Tokyo National Museum: Ukiyo-e*. 3 vols. Tokyo, 1960.

Tokyo National Museum (1984) Tokyo National Museum. *Ukiyo-e*. (Special exhibition: Ukiyo-e). Tokyo, 1984.

Ukiyo-e Shūka, vol. 5 (1980) Suzuki Jūzō, ed. *Ukiyo-e Shūka*. Vol. 5: *Shikago Bijutsukan II*. Tokyo: Shōgakkan, 1980.

Ukiyo-e Shūka, vol. 9 (1981) Donald Jenkins et al., eds. *Ukiyo-e Shūka*. Vol. 9: *Mineaporisu Bijutsukan*.... Tokyo: Shōgakkan, 1981.

Ukiyo-e Shūka, vol. 11 (1979) Narazaki Muneshige and Yamaguchi Keisaburō, eds. *Ukiyo-e Shūka*. Vol. 11: *Daiei Hakubutsukan*.... Tokyo: Shōgakkan, 1979.

Ukiyo-e Shūka, vol. 13 (1981) Keyes, Roger S. et al., eds. *Ukiyo-e Shūka*. Vol. 13: *Berugii Ōritsu Bijutsu Rekishi Hakubutsukan*. Tokyo: Shōgakkan, 1981.

Ukiyo-e Shūka, suppl. vol. 2 (1982) Waterhouse, David. *Ukiyo-e Shūka*. Suppl. Vol. 2: *Museum of Fine Arts, Boston*. Tokyo: Shōgakkan, 1982.

Ukiyo-e Taika Shūsei, vol. 7 (1931) Ukiyo-e Kenkyūkai. *Ukiyo-e Taika Shūsei*. Vol. 7: *Ippitsusai Bunchō*. Tokyo: Taihōkaku, 1931.

Ukiyo-e Taika Shūsei, vol. 8 (1932) Ukiyo-e Kenkyūkai. *Ukiyo-e Taika Shūsei*. Vol. 8: *Katsukawa Shunshō*. Tokyo: Taihōkaku, 1932.

Ukiyo-e Taika Shūsei, vol. 13 (1932) Ukiyo-e Kenkyūkai. *Ukiyo-e Taika Shūsei*. Vol. 13: *Shunkō, Shun'ei*. Tokyo: Taihōkaku, 1932.

Ukiyo-e Taikei, vol. 3 (1976) Narazaki Muneshige, ed. *Ukiyo-e Taikei*. Vol. 3: *Shunshō*. Tokyo: Shūeisha, 1976.

Ukiyo-e Taisei, vol. 5 (1931) Yoshida Teruji, ed. *Ukiyo-e Taisei*. Vol. 5: *Nishiki-e Shoki Jidai 2*. Tokyo: Taihōkaku and Tōhō Shoin, 1931.

Ukiyo-e Taisei, vol. 6 (1931) Yoshida Teruji, ed. *Ukiyo-e Taisei*. Vol. 6: *Ranjuku Jidai 1*. Tokyo: Taihōkaku and Tōhō Shoin, 1931.

Ukiyo-e Taisei, vol. 7 (1931) Yoshida Teruji, ed. *Ukiyo-e Taisei*. Vol. 7: *Ranjuku Jidai 2*. Tokyo: Taihōkaku and Tōhō Shoin, 1931.

Ukiyo-e Taisei, vol. 8 (1931) Yoshida Teruji, ed. *Ukiyo-e Taisei*. Vol. 8: *Ranjuku Jidai 3*. Tokyo: Taihōkaku and Tōhō Shoin, 1931.

Urushiyama Matashirō. *Ehon Nempyō*. 6 vols. (*Nihon Shoshigaku Taikei* 34). Tokyo: Seisōdō, 1983.

Vignier and Inada (1910) Vignier, M., and Inada, M. *Estampes Japonaises: Harunobu, Koryūsai, Shunshō*. Paris: Musée des Arts Décoratifs, 1910.

Vignier and Inada (1911) Vignier, M., and Inada, M. *Estampes Japonaises: Kiyonaga, Bunchō, Sharaku*. Paris: Musée des Arts Décoratifs, 1911.

Waseda Daigaku Engeki Hakubutsukan (eds.). *Ippitsusai Bunchō (Shibai-e Zuroku 1)*. Tokyo, 1991.

Waterhouse (1975) Waterhouse, David. *Images of Eighteenth-Century Japan*. Toronto: Royal Ontario Museum, 1975.

Waterhouse, D. B. *Harunobu and His Age: The Development of Colour Printing in Japan*. London: The British Museum, 1964.

Yamaguchi Keizaburō. *Nikuhitsu Ukiyo-e*. Vol. 4: *Shunshō*. Tokyo: Shūeisha, 1982.

Yoshida Teruji, ed. *Ukiyo-e Zenshū*. Vol. 5: *Yakusha-e*. Tokyo: Kawade Shobō, 1957.

———. *Ukiyo-e Jiten*. 3 vols. Tokyo: Rokuen Shobō (vols. 1, 2), 1965, Gabundō (vol. 3), 1971.

Yoshida Teruji. "Torii Kiyonaga no Ōban Yakusha-e." In *Ukiyo-e Bisan*, pp. 170–76. Tokyo: Kitamitsu Shobō, 1943.

Zusetsu Nihon no Koten 20: Kabuki Jūhachiban (1979) Gunji Masakatsu, ed. *Zusetsu Nihon no Koten*. Vol. 20: *Kabuki Jūhachiban*. Tokyo: Shūeisha, 1979.

Chronological Listing of Actor Critiques and Kabuki Playbills and Programs

from various collections, used for the identification of the actor prints in this catalogue

Yakusha Hyōban-ki (Commentaries on Actors and Their Performances)

"Nihon ga Hana Hōgan Biiki," Nakamura Theater, 11/1761. (Shunshō 66) Tōyō Bunko Library

"Kagura-uta Amagoi Komachi," Nakamura Theater, 11/1765. (Shunshō 74) Tōyō Bunko Library

"Kogane no Hana Gaijin Aramusha," Nakamura Theater, 11/1766. (Bunchō 1) Tōyō Bunko Library

"Otokoyama Yunzei Kurabe," Ichimura Theater, 11/1768. (Shunshō 88, 89) Tōyō Bunko Library

"Soga Moyō Aigo no Wakamatsu," Nakamura Theater, 1/1769. (Shunshō 95) Tōyō Bunko Library

"Kawaranu Hanasakae Hachi no Ki," Nakamura Theater, 11/1769. (Bunchō 19; Shunshō 101, 102) Tōyō Bunko Library

"Nue no Mori Ichiyō no Mato," Nakamura Theater, 11/1770. (Shunshō 115, 121, 122) Tōyō Bunko Library

"Myōto-giku Izu no Kisewata," Ichimura Theater, 11/1770. (Shunshō 123, 125, 161, 162) Tōyō Bunko Library

"Kuni no Hana Ono no Itsumoji," Nakamura Theater, 11/1771. (Shunshō 173) Tōyō Bunko Library

"Kono Hana Yotsugi no Hachi no Ki," Ichimura Theater, 11/1771. (Shunshō 175) Tōyō Bunko Library

"Fuki Kaete Tsuki mo Yoshiwara," Morita Theater, 11/1771. (Shunshō 178) Tōyō Bunko Library

"Ōyoroi Ebidō Shinozuka," Nakamura Theater, 11/1772. (Shunshō 200, 201) Tōyō Bunko Library

"Izu-goyomi Shibai no Ganjitsu," Morita Theater, 11/1772. (Shunshō 207) Kyoto University, Japanese Literature Study Library

"Gohiiki Kanjinchō," Nakamura Theater, 11/1773. (Shunshō 263) Tōyō Bunko Library

"Chigo Sakura Jūsan-kane," Ichimura Theater, 11/1774. (Shunshō 288, 289) Tōyō Bunko Library

"Oyafune Taiheiki," Ichimura Theater, 11/1775. (Shunshō 315) Tōyō Bunko Library

"Saki Masuya Ume no Kachidoki," Ichimura Theater, 11/1778. (Shunshō 390) Tōyō Bunko Library

"Date Nishiki Tsui no Yumitori," Morita Theater, 11/1778. (Shunshō 395) Tōyō Bunko Library

"Kitekaeru Nishiki no Wakayaka," Nakamura Theater, 11/1780. (Shunshō 446, 449, 452; Shunkō 579) Tōyō Bunko Library

"Tatsutagawa Nishiki no Shirasagi," in the play "Sakikaese Yuki no Miyoshino," Morita Theater, 11/1781. (Shunshō 485) Tōyō Bunko Library

"Onna Musha Kiku no Sen'yoki," Morita Theater, 11/1786. (Shunjō 730) Osaka Women's College Library

Ehon Banzuke ("Picture Programs")

"Imayō Dōjōji," in the play "Edo no Hana Wakayagi Soga," Ichimura Theater, 2/1769. (Bunchō 14, 15) Tenri University Library

"Kagami-ga-ike Omokage Soga," Nakamura Theater, 1/1770. (Bunchō 33) Tenri University Library; Tsubouchi Memorial Theater Museum, Waseda University

"Nue no Mori Ichiyō no Mato," Nakamura Theater, 11/1770. (Bunchō 39; Shunshō 112, 119, 120, 158, 159) Tokyo Hibiya Library

"Kuni no Hana Ono no Itsumoji," Nakamura Theater, 11/1771. (Bunchō 50; Shunshō 169–171) Tenri University Library

"Yukashii ka Miyako no Naredoko," in the play "Kuni no Hana Ono no Itsumoji," Nakamura Theater, 11/1771. (Bunchō 51, 52) Tenri University Library

"Fuki Kaete Tsuki mo Yoshiwara," Morita Theater, 11/1771. (Bunchō 53; Shunshō 177, 181) Keiō University Library

"Haru wa Soga Akebono-zōshi," Nakamura Theater, 1/1772. (Shunshō 184) Tsuchida Makoto collection

"Izu-goyomi Shibai no Ganjitsu," Morita Theater, 11/1772. (Shunshō 205, 206, 208, 209; Shunkō 544) Tōyō Bunko Library

"Gohiiki Kanjinchō," Nakamura Theater, 11/1773. (Shunshō 266) Tokyo National Museum

"Onna-aruji Hatsuyuki no Sekai," Morita Theater, 11/1773. (Shunshō 270, 271, 273) Tōyō Bunko Library

"Kaomise Ama no Iwato," Nakamura Theater, 11/1774. (Shunkō 545) Keiō University Library

"Hana-zumō Genji Hiiki," Nakamura Theater, 11/1775. (Shunshō 307–309, 312) Reprinted copy in The Art Institute of Chicago

"Oyafune Taiheiki," Ichimura Theater, 11/1775. (Shunshō 315) Reprinted copy in The Art Institute of Chicago

"Kigoto no Hana Koi no Ukibune," in the play "Kikujidō Shuen no Iwaya," Morita Theater, 11/1775. (Shunshō 316) Reprinted copy in The Art Institute of Chicago

"Sugata no Hana Yuki no Kuronushi," Ichimura Theater, 11/1776. (Shunshō 346) Nihon University Library; (Shunshō 347, 348) Tōyō Bunko Library

"Masakado Kammuri no Hatsuyuki," Nakamura Theater, 11/1777. (Shunshō 374–376) Tokyo University Library

"Chigo Torii Tobiiri Kitsune," Ichimura Theater, 11/1777. (Shunshō 378–381) Ex-collection H.R.W. Kühne

"Motomishi Yuki Sakae Hachi no Ki," Nakamura Theater, 11/1778. (Shunkō 564) Tokyo National Diet Library

"Sakimasu ya Ume no Kachidoki," Ichimura Theater, 11/1778. (Shunkō 565) Nihon University Library

"Tsutsuizutsu Iro no Minakami," in the play "Kaeribana Eiyū Taiheiki," Nakamura Theater, 11/1779. (Shunkō 571) Tokyo National Diet Library

"Irojitate Momiji no Dammaku," in the play "Azuma no Mori Sakae Kusunoki," Ichimura Theater, 11/1779. (Shunshō 416, 417) Tokyo National Diet Library

"Uta Kurabe Tōsei Moyō," Morita Theater, 11/1779. (Shunshō 418) Tokyo National Museum

"Kitekaeru Nishiki no Wakayaka," Nakamura Theater, 11/1780. (Shunkō 580–582) Nihon University Library

"Mure Takamatsu Yuki no Shirahata," Ichimura Theater, 11/1780. (Shunkō 583) Tōyō Bunko Library

"Jūni-dan Kimi ga Irone," in the play "Mure Takamatsu Yuki no Shirahata," Ichimura Theater, 11/1780. (Shunshō 454) Tōyō Bunko Library

"Tokimekuya O-Edo no Hatsuyuki," Morita Theater, 11/1780. (Shunshō 455; Shunkō 584) Tōyō Bunko Library; (Shunshō 456) Tokyo Hibiya Library

"Shitennō Tonoi no Kisewata," Nakamura Theater, 11/1781. (Shunshō 476) Tōyō Bunko Library; (Shunshō 477–480) Tokyo Hibiya Library

"Mukashi Otoko Yuki no Hinagata," Ichimura Theater, 11/1781. (Shunsen 731) Tōyō Bunko Library

"Taramasari Kimi no Ausaka," in the play "Mukashi Otoko Yuki no Hinagata," Ichimura Theater, 11/1781. (Shunshō 483, 484) Tokyo Hibiya Library

"Nanakusa Yosooi Soga," Nakamura Theater, 1/1782. (Shunjō 721, 722) Tsubouchi Memorial Theater Museum, Waseda University

"Mutsumajizuki Koi no Tedori," in the play "Godai Genji Mitsugi no Furisode," Nakamura Theater, 11/1782. (Shunshō 496) Tōyō Bunko Library

"Godai Genji Mitsugi no Furisode," Nakamura Theater, 11/1782. (Shunshō 495, 497) Tōyō Bunko Library

"Edo no Hana Mimasu Soga," Nakamura Theater, 1/1783. (Shunjō 724) Tokyo National Diet Library

"Oshun Dembei Hanakawado Migawari no Dan," in the play "Edo no Hana Mimasu Soga," Nakamura Theater, 3/1783. (Shunkō 591; Shunjō 725, 726) Tokyo National Diet Library

"Kotobuki Banzai Soga," Ichimura Theater, 5/1783. (Shunshō 513) Nihon University Library

"Edo Kanoko Musume Dōjōji," in the play "Keisei Katabira ga Tsuji," Ichimura Theater, 8/1783. (Shunshō 516) Tokyo University Library

"Soga Musume Chōja," Nakamura Theater, 1/1784. (Shunshō 519) Tōyō Bunko Library

"Fude-hajime Kanjinchō," Nakamura Theater, 1/1784. (Shunkō 593) Tsubouchi Memorial Theater Museum, Waseda University

"Ōakinai Hiru ga Kojima," Nakamura Theater, 11/1784. (Shunshō 520; Shunkō 595) Tōyō Bunko Library

"Jūni-hitoe Komachi-zakura," Kiri Theater, 11/1784. (Shunshō 521; Shunkō 596) Tōyō Bunko Library

"Yukimotsu Take Furisode Genji," Nakamura Theater, 11/1785. (Shunshō 522, 523) Tōyō Bunko Library

"Fūgyoku Edo Geisha," in the play "Yukimotsu Take Furisode Genji," Nakamura Theater, 11/1785. (Shunkō 602) Tōyō Bunko Library

"Shitennō Ōeyama-iri," in the play "Otokoyama Furisode Genji," Kiri Theater, 11/1785. (Shunkō 603, 604) Tōyō Bunko Library

"Sodefuru Yuki Yoshino Shūi," in the play "Kumoi no Hana Yoshino no Wakamusha," Nakamura Theater, 11/1786. (Shunshō 528, 529) Tōyō Bunko Library

"Kumoi no Hana Yoshino no Wakamusha," Nakamura Theater, 11/1786. (Shunsen 732) Tōyō Bunko Library

"Yuki Nazuna Saiwai Soga," Kiri Theater, 1/1787. (Shunkō 609) Nihon University Library

"Midarezaki Hana no Iro-goromo," in the play "Keisei Ide no Yamabuki," Nakamura Theater, 5/1787. (Shunkō 611, 612) Tsubouchi Memorial Theater Museum, Waseda University

"Yo no Uwasa Asu no Yukidoke," in the play "Keisei Natori Soga," Kiri Theater, 2/1788. (Shunkō 616) Nihon University Library

"Edo no Fuji Wakayagi Soga," Nakamura Theater, 1/1789. (Shunshō 532, 533) Tōyō Bunko Library

"Gonin Otoko," in the play "Edo no Fuji Wakayagi Soga," Nakamura Theater, 1/1789. (Shunsen 733) Tōyō Bunko Library

"Koi no Yosuga Kanagaki Soga," Ichimura Theater, 1/1789. (Shun'ei 636) Nihon University Library

"Komachi-mura Shibai no Shōgatsu," Nakamura Theater, 11/1789. (Shun'ei 639) Nihon University Library

"Haru no Nishiki Date-zome Soga," Nakamura Theater, 2/1790. (Shunkō 624) Nihon University Library

"Yaoyorozu Sonou no Umegae," in the play "Sayo no Nakayama Hiiki no Tsurigane," Nakamura Theater, 11/1790. (Shun'ei 651, 652) Keiō University Library

"Kimmenuki Genke no Kakutsuba," Ichimura Theater, 11/1791. (Shun'ei 666) Tōyō Bunko Library

"Waka-murasaki Edokko Soga," Ichimura Theater, 1/1792. (Shunkō 540, 541) Tokyo University Library

"Kogane Saku Date no Ōkido," Ichimura Theater, 11/1792. (Shun'ei 671) Nihon University Library

"Gozen-gakari Sumō Soga," Kawarazaki Theater, 1/1793. (Shun'ei 677) Tokyo National Diet Library

"Yasa Gumbai Miyako no Jindori," Miyako Theater, 11/1793. (Shun'ei 678) Nihon University Library

"Kagurazuki Momiji no Sekifuda," in the play "Nigiwai Genji Hana Saku Kado," Kawarazaki Theater, 11/1793. (Shun'ei 679) Tokyo National Diet Library

"Otokoyama O-Edo no Ishizue," Kiri Theater, 11/1794. (Shun'ei 687) Nihon University Library

"Shinobu-koi Suzume no Irodoki," in the play "Otokoyama O-Edo no Ishizue," Kiri Theater, 11/1794. (Shun'en 740) Tōyō Bunko Library

"Edo Sunago Kichirei Soga," Miyako Theater, 1/1795. (Shun'ei 688) Nihon University Library

"Furiwake-gami Aoyagi Soga," Miyako Theater, 1/1796. (Shun'ei 704) Tōyō Bunko Library

"Suda no Haru Geisha Katagi," Kiri Theater, 1/1796. (Shun'ei 705) Tōyō Bunko Library

Tsuji Banzuke ("Street Posters")

"Katakiuchi Chūkō Kagami," Nakamura Theater, 6/1770. (Bunchō 35; Shunshō 108) Museum of Fine Arts, Boston

"Naniwa no Onna-zumō," in the play "Katakiuchi Chūkō Kagami," Nakamura Theater, 6/1770 (Bunchō 35) Museum of Fine Arts, Boston

"Sakai-chō Soga Nendaiki," Nakamura Theater, 1/1771. (Shunshō 133) Museum of Fine Arts, Boston

"Wada Sakamori Osame no Mitsugumi," Ichimura Theater, 2/1771. (Shunshō 281) Museum of Fine Arts, Boston

"Goku-saishiki Eiyū no Zu," in the play "Hatsu Akebono Niwatori Soga," Morita Theater, 1/1772. (Shunshō 189) Ex-collection H.R.W. Kühne

"Kosode-gura no Tekubari," Morita Theater, spring/1772. (Shunshō 192, 193) Museum of Fine Arts, Boston

"Furisode Kisaragi Soga," Ichimura Theater, 2/1772. (Bunchō 55; Shunshō 190, 191) Museum of Fine Arts, Boston

"Keisei Momiji no Uchikake," Morita Theater, 7/1772. (Shunshō 194–196, 198) Museum of Fine Arts, Boston

"Miya-bashira Iwao no Butai," Morita Theater, 7/1773. (Shunshō 255, 256) Museum of Fine Arts, Boston

"Shitennō-ji Nobori-kuyō," Ichimura Theater, 8/1773. (Shunshō 259) Museum of Fine Arts, Boston

"Shin Usuyuki Monogatari," Morita Theater, 5/1774. (Shunshō 286) Museum of Fine Arts, Boston

"Sugata no Hana Kurofune Zukin," Morita Theater, 9/1774. (Shunshō 287) Museum of Fine Arts, Boston

"Iro Moyō Aoyagi Soga," Nakamura Theater, 2/1775. (Shundō 712) Museum of Fine Arts, Boston

"Muken no Kane," in the play "Kuruwa no Hana Katsuragi no Kane," Ichimura Theater, 3/1775. (Shunshō 301) Museum of Fine Arts, Boston

"Gion Sairei Shinkō Ki," Ichimura Theater, 5/1775. (Shunshō 302) Museum of Fine Arts, Boston

"Shusse Taiheiki," Nakamura Theater, 8/1775. (Shunshō 303, 304) Museum of Fine Arts, Boston

"Keisei Tsuki no Miyako," Morita Theater, 8/1775. (Shunshō 305) Museum of Fine Arts, Boston

"Kammuri Kotoba Soga no Yukari," Ichimura Theater, 1/1776. (Shunshō 327–329) Museum of Fine Arts, Boston

"Sugomori Kado Yuku Chō," in the play "Sono Kyōdai Fuji no Sugatami," Morita Theater, 1/1776. (Shunshō 330, 331) Museum of Fine Arts, Boston

"Sukeroku Yukari no Hatsu-zakura," Ichimura Theater, 3/1776. (Shunshō 334) Museum of Fine Arts, Boston

"Sugawara Denju Tenarai Kagami," Ichimura Theater, 7/1776. (Shunshō 336–339) Museum of Fine Arts, Boston

"Kikyō-zome Onna Urakata," Morita Theater, 7/1776. (Shunshō 340) Museum of Fine Arts, Boston

"Chigo Suzuri Aoyagi Soga," Nakamura Theater, 1/1777. (Shunshō 362) Museum of Fine Arts, Boston

"Tsukisenu Haru Hagoromo Soga," Ichimura Theater, 1/1777. (Shunshō 363, 364) Museum of Fine Arts, Boston

"Wada-gassen Onna Maizuru," Nakamura Theater, 7/1777. (Shunshō 367, 368) Museum of Fine Arts, Boston

"Hōnō Nitta Daimyōjin," Morita Theater, 7/1777. (Shunshō 370; Shunkō 559) Museum of Fine Arts, Boston

"Hangonkō Nagori no Nishiki-e," in the play "Koi Nyōbō Somewake Tazuna," Nakamura Theater, 9/1777. (Shunshō 373) Museum of Fine Arts, Boston

"Kaidō Ichi Yawaragi Soga," Nakamura Theater, 1/1778. (Shunshō 386, 388) Museum of Fine Arts, Boston

"Shinobu Uri," in the play "Edo Meisho Midori Soga," Morita Theater, 2/1779. (Shunshō 405) Museum of Fine Arts, Boston

"Edo Meisho Midori Soga," Morita Theater, 4/1779. (Shunkō 568) Museum of Fine Arts, Boston

"Katakiuchi Adana Kashiku," Nakamura Theater, 7/1779. (Shunkō 569) Museum of Fine Arts, Boston

"Uta-makura Koi no Hatsutabi," in the play "Shin Usuyuki Monogatari," Ichimura Theater, 8/1779. (Shunshō 411) Museum of Fine Arts, Boston

"Kanadehon Chūshingura," Morita Theater 8/1779. (Shunshō 412, 413) Museum of Fine Arts, Boston

"Hatsumombi Kuruwa Soga," Nakamura Theater, 1/1780. (Shunshō 430, 431, 433–436) Museum of Fine Arts, Boston

"Onna Narukami Segawa Bōshi," in the play "Ume-goyomi Akebono Soga," Ichimura Theater, 2/1780. (Shunshō 438) Museum of Fine Arts, Boston

"Ume-goyomi Akebono Sogo," Ichimura Theater, 3/1780. (Shunkō 575) Museum of Fine Arts, Boston

"Sugawara Denju Tenarai Kagami," Morita Theater, 3/1780. (Shunshō 439) Museum of Fine Arts, Boston

"Gotaiheiki Shiraishi-banashi," Morita Theater, 4/1780. (Shunshō 440) Museum of Fine Arts, Boston

"Tsuma Mukae Koshiji no Fumizuki," Nakamura Theater, 8/1780. (Shunshō 442) Museum of Fine Arts, Boston

"Hikeya Tendeni Tsurigane Biiki," in the play "Hatsumombi Kuruwa Soga," Nakamura Theater, 3/1780. (Shunshō 437) Museum of Fine Arts, Boston

"Kanadehon Chūshin Nagori no Kura," Nakamura Theater, 9/1780. (Shunkō 577) Museum of Fine Arts, Boston

"Kuruwa-gayoi Komachi Soga," Nakamura Theater, 2/1781. (Shunshō 466) Museum of Fine Arts, Boston

"Onatsu Seijūrō Michiyuki Hiyoku no Kikuchō," in the play "Kabuki no Hana Bandai Soga," Ichimura Theater, 3/1781. (Shunshō 467; Shunjō 717, 718) Museum of Fine Arts, Boston

"Michiyuki Segawa no Adanami," in the play "Kabuki no Hana Bandai Soga," Ichimura Theater, 3/1781. (Shunshō 468) Museum of Fine Arts, Boston

"Michiyuki Kakine no Kisewata," in the play "Kabuki no Hana Bandai Soga," Ichimura Theater, 4/1781. (Shunshō 469) Museum of Fine Arts, Boston

"Kabuki no Hana Bandai Soga," Ichimura Theater, 6/1781. (Shunshō 470) Museum of Fine Arts, Boston

"Kanadehon Chūshingura," Morita Theater, 3/1781. (Shunshō 471) Museum of Fine Arts, Boston

"Yamato-kana Ariwara Keizu," Nakamura Theater, 5/1781. (Shunshō 474) Museum of Fine Arts, Boston

"Iromi-gusa Shiki no Somewake," Nakamura Theater, 9/1781. (Shunjō 719) Museum of Fine Arts, Boston

"Sukeroku Yukari no Edo-zakura," in the play "Shida Yakata Yotsugi no Hikibune," Ichimura Theater, 5/1782. (Shunshō 494; Shunkō 588) Museum of Fine Arts, Boston

"Oshun Dembei Hanakawado Migawari no Dan," in the play "Edo no Hana Mimasu Soga," Nakamura Theater, 3/1783. (Shunkō 591; Shunjō 725) Museum of Fine Arts, Boston

"Mata Saku Hana Musume Dōjōji," in the play "Edo no Hana Mimasu Soga," Nakamura Theater, 4/1783. (Shunshō 509, 510) Museum of Fine Arts, Boston

"Kotobuki Banzai Soga," Ichimura Theater, 5/1783. (Shunshō 512) Museum of Fine Arts, Boston

"Kanadehon Chūshingura," Ichimura Theater, 6/1783. (Shunshō 514, 515) Museum of Fine Arts, Boston

"Kuruma-gakari Tekuda no Gumbai," Ichimura Theater, 11/1783. (Shunshō 517) Museum of Fine Arts, Boston

"Mitsu Ningyō Yayoi no Hinagata," Nakamura Theater, 2/1785. (Shunkō 599) Museum of Fine Arts, Boston

"Ominaeshi Sugata no Hatsuaki," in the play "Takao Daimyōjin Momiji no Tamagaki," Nakamura Theater, 7/1787. (Shunkō 613) Museum of Fine Arts, Boston

"Keisei Azuma Kagami," Nakamura Theater, 2/1788. (Shunkō 615) Museum of Fine Arts, Boston

"Sugawara Denju Tenarai Kagami," Kiri Theater, 7/1788. (Shun'ei 632) Museum of Fine Arts, Boston

"Sanjūkkoku Yobune no Hajimari," Ichimura Theater, 5/1789. (Shun'ei 637) Museum of Fine Arts, Boston

"Tsuki no Tomo Tsui no Michiyuki," in the play "Heike Hyōbanki," Nakamura Theater, 9/1789. (Shunkō 621) Museum of Fine Arts, Boston

"Hana Miyage Mokuboji no Yukari," Ichimura Theater, 4/1790. (Shun'ei 644) Museum of Fine Arts, Boston

"Waka Murasaki Edokko Soga," Ichimura Theater, 2/1792. (Shunshō 542) Museum of Fine Arts, Boston

"Keisei Kogane no Hakarime," Kawarazaki Theater, 3/1792. (Shun'ei 669) Museum of Fine Arts, Boston

"Mukashi Mukashi Tejiro no Saru," Ichimura Theater, 8/1792. (Shun'ei 670) Museum of Fine Arts, Boston

"Iwata-obi En no Mijikayo," in the play "Yomogi Fuku Noki no Tamamizu," Kiri Theater, 5/1795. (Shun'ei 690) Museum of Fine Arts, Boston

"Sukeroku Kuruwa no Sakurato," Kawarazaki Theater, 3/1797. (Shun'ei 680) Museum of Fine Arts, Boston

Mon Banzuke ("Crest Program")

"Soga Monogatari," Morita Theater, 2/1773. (Bunchō 60) Museum of Fine Arts, Boston

Nagauta Shōhon (Nagauta "Play-book")

"Hatsu Miyuki Miyako no Hana," in the play "Mutsu no Hana Ume no Kaomise," Ichimura Theater, 11/1769. (Bunchō 20) The Art Institute of Chicago

Tomimoto Shōhon (Tomimoto-bushi "Play-book")

"Yayoi Futatsu Omokage-zakura," in the play "Wada Sakamori Eiga Kagami," Nakamura Theater, 3/1773. (Shunshō 250) The Art Institute of Chicago

Index